Best Business Practices for Photographers, Second Edition

John Harrington

Course Technology PTR
A part of Cengage Learning

COURSE TECHNOLOGY
CENGAGE Learning™

Australia • Brazil • Japan • Korea • Mexico • Singapore • Spain • United Kingdom • United States

COURSE TECHNOLOGY
CENGAGE Learning

Best Business Practices for Photographers, Second Edition

John Harrington

Publisher and General Manager, Course Technology PTR:
Stacy L. Hiquet

Associate Director of Marketing:
Sarah Panella

Manager of Editorial Services:
Heather Talbot

Marketing Manager: Jordan Casey

Acquisitions Editor: Megan Belanger

Project Editor/Copy Editor:
Cathleen D. Small

Technical Reviewer: Mark Loundy

Editorial Services Coordinator:
Jen Blaney

Editorial Services Coordinator: Jen Blaney

Interior Layout: Jill Flores

Cover Designer: Mike Tanamachi

Indexer: Kelly Talbot

Proofreader: Sandi Wilson

For product information and technology assistance, contact us at
Cengage Learning Customer & Sales Support, 1-800-354-9706

For permission to use material from this text or product, submit all requests online at **cengage.com/permissions** Further permissions questions can be emailed to **permissionrequest@cengage.com**

All trademarks are the property of their respective owners.

All images © John Harrington unless otherwise noted.

Library of Congress Control Number: 2009933314

ISBN-13: 978-1-4354-5429-3

ISBN-10: 1-4354-5429-4

Course Technology, a part of Cengage Learning
20 Channel Center Street
Boston, MA 02210
USA

Cengage Learning is a leading provider of customized learning solutions with office locations around the globe, including Singapore, the United Kingdom, Australia, Mexico, Brazil, and Japan. Locate your local office at: **international. cengage.com/region**

Cengage Learning products are represented in Canada by Nelson Education, Ltd.

For your lifelong learning solutions, visit **courseptr.com**

Visit our corporate website at **cengage.com**

Printed in the United States of America
4 5 6 7 11

Praise for the second edition of *Best Business Practices for Photographers:*

"Best Business Practices for Photographers *is not exactly a catchy title, but if you are starting as a professional shooter or have been in the biz like me for more than four decades, you better put down your camera and buy this book. I predict it will make your business better and more productive. When it does, drop me a line at david@kennerly.com and give me one example of how it changed your life.*"

—David Hume Kennerly, Pulitzer Prize winner

"*From my perspective of 40-plus years in photography—as shooter, picture editor, and director of photography—*Best Business Practices *is fantastic. This book provides great insights into the business of photography and much more. With the photography business in a state of flux,* Best Business Practices *should be at the top of every photographer's reading list.*"

—Kent Kobersteen, former director of photography, *National Geographic* magazine

"*This is the book every photographer needs. It reveals the terrible truth that taking the photograph is the easy part; dealing with business and legal issues make the difference between success and failure. This encyclopedic book is a vital reference I wish I had starting out 30 years ago.*"

—Art Wolfe, photographer

"*John Harrington's revised edition of his* Best Business Practices for Photographers *goes beyond a few timely updates. Using his own business experiences, John has adjusted his business practices to the changing photography industry. Addressing topics such as pricing your work to stay in business, firsthand insights into an IRS audit, and the timely transitioning to freelance for newspaper staffers entering the self-employed business world, this book delivers business information many of us have learned at the school of hard knocks and most photo schools don't even offer. With this book, readers can learn how to build a successful career.*"

—Richard Kelly, photographer, educator, and president of ASMP

"*It is no longer enough to be a creative photographer. The tough part is navigating through business deals and complicated contracts. John Harrington's book will help readers run a business as the age of the digital technologies reshapes the craft of photography at every level. The book is a virtual knowledge bank and will help readers think cleverly as they negotiate this highly competitive arena.*"

—Ami Vitale, photographer

"*John Harrington has added so much information in his second edition that is relevant to the business climate of photography today. The new edition will be especially helpful to photojournalists who need to be prepared for the future in a changing profession. This needs to be on the bookshelf of every student and photographer.*"

—Dr. Bob Carey, president, National Press Photographers Association

"When I was in photo school, I often asked for resources on how to run a photo business. I wish this book had been available to me then. This is the best source for understanding the business of photography. From basic principles of bookkeeping to the open-ended practice of pricing, this book provides many answers. For me, the best updated information in John Harrington's new edition of Best Business Practices for Photographers is in the area of licensing and how licensing needs to be a part of your fee structure. The inclusion of PLUS (Picture Licensing Universal System) in your business and licensing models is the best advice John has for the professional photographer. It will provide improved management of your licensed images well into the future. John truly contributes to the APA Mission of Successful Photographers."

—Stephen Best, CEO, Advertising Photographers of America

"Harrington's book is a must-read—a valuable resource for photographers of all levels and specialties."

—Jeff Sedlik, former president, Advertising Photographers of America

"Pricing, contracts, copyright, even IRS audits: If you are going to walk through the minefield that is the business of being a professional photographer, you'll want a good map. And Best Business Practices is exactly that."

—David Hobby, Strobist.com

"This book is a must-have for every photographer, amateur or pro, who wants to maximize income with photography. Harrington breaks down the mystery of pricing, negotiation, contracts, and client relationships with real-life examples and provides an excellent template for a stable-growth business method. Also, one of the most important and often neglected aspects of photography, copyright registration, is addressed in depth, including the new eCO electronic filing system. The first edition of this book has been a go-to reference for me for the past few years, and this expanded and updated version will be in my office as soon as it is published. There is no doubt that Best Business Practices for Photographers will pay for itself thousands-fold."

—Chris Usher, photographer

"John's book is a necessity for every professional photographer! It could well be one of the greatest business resources available, helping you get through unfamiliar challenges from IRS audits and licensing your work to developing a relationship with your rep and more. Most photographers are creative and right-brain driven— here's the food your left brain forgot to tell you about!"

—Skip Cohen, president, Marketing Essentials International

Praise for the first edition of *Best Business Practices for Photographers*:

"This is the most comprehensive business guide for professional photographers I have seen. It is a perfect fit for photographers starting out or those in need of a business refresher course. The use of real-world personal examples greatly enhances the book, bringing your solid business concepts to life."

—Susan Carr, past president, American Society of Media Photographers

"Regardless of the level of your photographic skills, if you want a successful photography career, your business skills are what's really going to matter. Every day, the margin for error gets tighter and tighter. This book gives you an excellent insight into how the business works today, as well as providing strategies for surviving and thriving in the marketplaces of tomorrow. The real-world examples and battle-tested methods provide you with the essential business tools that every working photographer needs to make a good living in this demanding profession. Read this book before you shoot another image for a client!"

—Clem Spaulding, past president, American Society of Media Photographers

"Photography is an exciting and rewarding career, but only if you can make a living at it. John Harrington is one of a select few photographers who have worked diligently to share their business knowledge so that the rest of us can make better choices and the industry as a whole can be uplifted. This book deserves a place beside all of the great photo books in your library of inspiration."

—Alicia Wagner Calzada, past president, National Press Photographers Association

"There's a new kind of workflow—it's about prospering from good business practices—and John Harrington has just defined it. In this book he does more than just show you how to do the right thing; he shows you how to grow your business by doing the right thing. A thorough and consummate professional, Harrington delivers real-world counsel on how to succeed from good business practices from top to bottom. This book belongs in every photographer's back pocket."

—George Fulton, past president, Advertising Photographers of America

"It's about time that someone put together a map of how to operate in the photography business world of the new century, and I'm glad John Harrington is the one to do it. So much has changed in our business in the last dozen years. We have gone from a world of the handshake deal to one of multi-page contracts and predatory practices on the part of too many clients. John is very knowledgeable about both photography and business and shares his savvy with those of us who might not be as alert to the pitfalls and possibilities of our new realm. He knows what he's talking about, and this book should save a lot of bad deals from happening and turn many of them into good deals."

—David Burnett, co-founder, Contact Press Images

"If there ever was a 'how to' book on how to better succeed in the business of photography, this is it. For the past 16 years I've been a photography student, intern, freelancer, staffer, contractor, corporate and commercial photographer—and I made it through that journey through trial and error, hard work, my fair share of luck, and a determination to steadily educate myself on all aspects of photography. I've also greatly benefited from shared knowledge from many good friends in the business—something not everyone is fortunate enough to have access to, especially when they're at the start of their careers. Ultimately, there is no true substitute to following in the same path that I did—but this is the best shortcut money can buy. John Harrington's book has so much to offer in so many areas that I'm not sure there is a single photographer out there who doesn't stand to benefit from this book."

—Vincent Laforet, Pulitzer Prize–winning photographer and
former *New York Times* contract photographer

"Creativity is a given, but business is a learned art. Your art is your business. The art of business is equally as important as, if not more so than, creativity itself. While John can't necessarily enhance your creativity, he can certainly increase your knowledge of business and help provide you with the necessary tools for a successful business. As a photographer, improving your bottom line is not just dependent on taking good pictures. Getting the right deal and having the right paperwork can mean the difference between success and failure."

—Seth Resnick, D65.com, and past president, Editorial Photographers

"In the 17 years that I have been successfully freelancing, one of the most painful and exasperating experiences has always been where to find pricing, contract, and negotiating information that actually is based on sound, usable, growth-oriented business information. If you were well connected, there was a chance you could find out how to do things right. If not, you were at the mercy of the whims of predatory clients. There was never one comprehensive source that dealt with doing business skillfully, comprehensively, and successfully. Finally, John Harrington has consolidated great business practices in real-world settings between the covers of this book. Everything that you need to know to be successful as a practicing photographer/businessperson is here. Hallelujah!!!!"

—Rick Rickman, professor, Brooks Institute of Photography, and freelance photographer

To my dad, who inspired my interest in photography.
To my mom, who taught me right from wrong.
To my wife, who is my best friend.

And

To my children, who sustain my belief in the promise of the future and inherent good in everyone.

Acknowledgments

It is with heartfelt thanks that I express my appreciation and gratitude to the professionals, friends, and family who have had an influence on my life and development over the years. To my siblings—Laura Rettinger, Robert Harrington, and Suzanne Seymour—and my extended Seymour/Taylor siblings: Thank you for allowing me to grow up with and through you.

To my editors: project editor Cathleen Small, technical editor Mark Loundy, and acquisitions editor Megan Belanger, thank you for shaping and helping to make sense of the 1,001 ideas, concepts, and thoughts I had as I worked to put them on paper and in some sense of order.

To photographers Cameron Davidson, Bill Auth, Paul Morse, Susan Biddle, Andrea Bruce, Mark Finkenstaedt, and others who read as friends with different perspectives and whose suggestions helped me to clarify what I had to say and how I said it. And to David Love, Kenneth Watter, Peter Hoffberger, and Jamie Silverberg, who also reviewed chapters of the book specific to their professions and made thoughtful suggestions in the insurance, accounting, and copyright chapters.

To my office staff, past and present: Talley Lach, Kristina Sherk, Suzanne Behsudi, Katie Burgess, Audrey Lew, Katie Persons, Nikki Wagner, Noemi de la Torre, Rosina "Teri" Memolo, and the dozens of interns, all of whom have been a part of the growing business I sought to continue. Thank you for helping me make the time to produce the first edition of this book, as well as this second edition.

To Dick Weisgrau, Elyse Weissberg, and Emily Vickers, who started the original ASMP Strictly Business seminar in the early part of my career, from which I learned so much. Especially to Elyse, may she rest in peace, whose keen eye, gentle but firm sense of humor, and compassion for photographers and the work we do helped shape me and my early portfolios. Although we spent hours and hours together, I always left meetings with her looking forward to the next one.

To Lois Wadler, Anh Stack, Ben Chapnick, and Dennis Brack of Black Star. To Lois, who took a chance and saw me without an appointment and ultimately signed me to the agency. To Anh Stack, who works tirelessly on behalf of all her photographers. To Ben Chapnick, who leads the agency and makes available to the world iconic images from some of the world's most prolific photographers. And, to Dennis Brack, who has made more than a few of those images, and with whom I work in Washington, DC as a part of the Black Star team, hoping one day to make just one or two of those caliber of images.

To Ken Weber, who published my first photo essay, which led to my working for my first editor, David Hill, at *The World & I* magazine. Thank you both.

To photographer Nick Crettier, who is a mentor and friend, both professionally and personally. To photographers Michael Spilotro, Ken Cedeno, and Charlotte Richardson, who have challenged everything I know about photography and this business, sometimes just trying to prove me wrong, but always trying to be helpful. And to Mark Finkenstaedt, Cliff Owen, and Jeff Snyder, for your friendship and professional guidance.

And to Anne and Sam Seymour and Keith Taylor, who have for 20-plus years been an integral part of my life, helping to grow, mold, and shape me.

About the Author

John Harrington has built and runs a successful photography business, with income having risen tenfold since he started. He has spoken in the past at numerous courses, seminars, and meetings on the subjects of business practices for photographers and his creative vision. Among the organizations he's made presentations before are the American Society of Media Photographers, Advertising Photographers of America, National Press Photographers Association, Professional Photographers of America, the White House News Photographers Association, PhotoPlus Expo, the Smithsonian Institution, Corcoran School of Art and Design, and the University of Maryland. He has worked for more than 20 years as an active photographer in Washington, DC and around the world, with both editorial and commercial clients. Editorially, his credits have included the Associated Press, the *New York Times*, the *Washington Post*, *Time*, *Newsweek*, *US News and World Report*, the National Geographic Society, *USA Today*, *People*, *MTV*, and *Life*, among hundreds of others. Commercially, John has worked with more than half of the top Fortune 50 companies and even more of the top Fortune 500. Ad campaigns for Siemens, Coca-Cola, General Motors, Bank of America, and XM Satellite Radio, to name a few, have been seen worldwide. In addition to John operating his own business and licensing his own stock, John's work is also represented by the Black Star Picture Agency in New York City.

In 2007, John was honored at the United Nations with their 2007 Leadership Award, given by the International Photographic Council.

In 2009, John was elected president of the White House News Photographers Association.

John's photography has illustrated four books, three specially commissioned by the Smithsonian Institution's National Museum of the American Indian: *Meet Naiche* (2002), *Meet Mindy* (2003), *Meet Lydia* (2004), and *Patriotism, Perseverance, Posterity: The Story of the National Japanese American Memorial* (2001).

John resides in Washington, DC with his wife, Kathryn, and his daughters, Charlotte, Diana, and Grace.

Contents

Notes on the Second Edition . **.xxv**

Introduction .**xxvii**

Chapter 1 You Are a Business–Now Let's Get to Work! .**1**

Whether or Not You Think You're a Business, You Are 1

Making Decisions: Strategic versus Tactical 3

Reviewing Your Current Business Model and Revamping
 What You're Doing . 4

Know What You Don't Know . 6

Creating a Business Plan for an Existing Business 7

**Chapter 2 Professional Equipment for Professional
 Photographers** .**9**

We Are Professional-Grade: Why We Must Use
 That Equipment .9

Pro-Line versus Prosumer-Line Lighting: Why Spend
 the Money? .10

Cameras and Optics: Why You Want the Best12

Computers: Desktops, Laptops, and What's Wrong with That
 Three-Year-Old Computer .13

Specialized Equipment: From Gyros to Blimps to
 Generators .15

Renting to Yourself and Others .16

**Chapter 3 Planning and Logistics: Why a Thirty-Minute
 Shoot Can Take Three Days to Plan****19**

Be Ready for the Unexpected . 20

It All Comes Down to Now! You Better Be Ready 21

Conveying Your Plan to a Prospective Client Can Win
You the Assignment.....................................21
When a Seven-Minute Shoot Becomes Three,
What Do You Do?22
When to Call in a Specialist: From Lighting to Location
Management, Catering, and Security23
Lighting Assistants.................................23
Makeup and Stylist Services24
Location Managers24
Producers...25

Chapter 4 After Staff: Transitioning to Freelance27
Dealing with the Uncomfortable..........................31
Help Out a Staffer31
Where Does All Your Time Go?...........................33
The Conundrum of Doing Nothing34
Doing It without Ruining It (for Others)...................35
Planning (and Prolonging if Possible) the Transition.........37
A Collection of Inconvenient Facts......................39
PLH: Photographer Learned Helplessness40
Zen and the Art of Photography41
Anticipation..42
Trepidation ...42
Inspection ..42
Fulfillment ...42
Evaluation ..42

Chapter 5 Working with Reps, Assistants, Employees,
and Contractors: The Pitfalls and
Benefits43
The Hurdle of Growing from Just You to Having People
Working for You44
Working with a Rep or Consultant44

Who Must Be an Employee?46

The Benefits of Someone Regular versus Various People52

Paying Those Who Make Your Life Easier53

One Solution for Concerned Employers55

Chapter 6 Setting Your Photographer's Fees57

The Time Factor...58

The Uniqueness Factor60

The Creative Factor61

The Risk Factor...62

Bringing the Factors Together..............................63

Chapter 7 Pricing Your Work to Stay in Business69

Valuing Your Work...73

What Are You Worth?......................................74

School of Thought #1: All Creative/Usage Fees Are Listed as
 Single Line Items......................................77

School of Thought #2: There Should Be Separate Line Items
 for Creative and Usage Fees...........................78

Calculating Rates and Fees and Presenting the Figures.......81

Raising Your Rates: Achieving the Seemingly Impossible93

Surveying Your Competition: How to Gather Knowledge
 Without Risking a Price-Fixing Charge...................95

Never Be the Cheapest....................................96

If You're the Cheapest, Find Out What Is Wrong97

What Do You Charge for Whenever You're Working
 for a Client? ..97

Tools and Resources for Understanding the Body Politic
 of Photographic Pricing................................98

Words to Avoid...99

Pro Bono: When To and When Not To....................99

Why Work Made for Hire Is Bad for Almost All
 Non-Employee Photographers100

Working Around Work-Made-for-Hire Clauses 105

You Don't "Sell" Anything. 106

Recommended Reading . 106

 General Books on Negotiating 106

 Books on Negotiating Developed by and for

 Photographers . 106

Chapter 8 Overhead: Why What You Charge a Client Must Be More Than You Paid for It . . .107

What Is Your Overhead? .107

Back in the Day: The $40 Roll of Kodachrome108

Markup: What's Yours? How Do You Establish It Fairly?110

Chapter 9 Who's Paying Your Salary and 401(k)?111

If Everyone Hiring You Has a Retirement Plan, Shouldn't You

 Have One, Too? .111

If Everyone Hiring You Is Paid a Salary, Shouldn't

 You Be, Too? .112

 Establishing a Fair Salary .112

 Targeting That Salary in the Short Term and the

 Long Term .116

Chapter 10 Insurance: Why It's Not Just Health-Related, and How You Should Protect Yourself .117

Health Insurance: Your Client Has It, So You Should, Too117

Life Insurance: Get It While You're Young and

 Protect Your Family .118

Disability Insurance: Think Again if You Believe You'll

 Never Get Hurt .119

Business Insurance: When Things Go Wrong,

 You Need to Be Covered .120

 Camera Insurance .120

Office Insurance121

Liability Insurance121

Errors and Omissions Insurance124

Umbrella Policies124

A Few Insurance Endnotes125

Chapter 11 Accounting: How We Do It Ourselves and What We Turn Over to an Accountant**127**

Software Solutions: The Key to Your Accounting Sanity127

Retain Those Receipts and Don't Give Them to Clients128

A Methodical Filing System134

Longitudinal Accounting: Its Impact on Your Business138

Reimbursing Yourself: Say What?139

Separate Bank Accounts: Maintaining Your Sanity
and Separation140

Separate Credit Card: Deducting Interest Expense and
Other Benefits141

Managing Credit Card Charges: Categorizing Expenses
and Integrating with Your Accounting Software142

When to Call an Accountant (Sooner Rather Than Later)155

What Is a CPA? How Is a CPA Different from a Bookkeeper? .156

Chapter 12 Insights into an IRS Audit**159**

Starting Off on the Right Foot164

In the Crosshairs165

Preparing for the Audit166

Appeals and Wrapping Things Up169

Chapter 13 Contracts for Editorial Clients**171**

"We'll Send Along Some Paperwork": Why You Should
Be the First to Send the Contract171

What an Editorial Contract Must Have174

Using a Word Processor for Contracts versus Dedicated
 Software or Your Own Database .178
How to Work through a Contract Negotiation for
 Editorial Clients .178
Case Study: Portrait for University Magazine184
Case Study: In-Flight Airline Magazine193
Case Study: Major Financial Newspaper196
Case Study: Consumer Magazine .203

**Chapter 14 Contracts for Corporate and Commercial
 Clients** .**217**
What's the Difference between Corporate and
 Commercial? .217
What a Corporate or Commercial Contract Must Have219
Bids versus Estimates .219
Change Orders .222
Purchase Orders .224
How to Work Through a Contract Negotiation for
 Corporate/Commercial Clients .229
Multiparty Licensing Agreements .233
Getting Paid .234
Case Study: Law Firm Portraits .235
Case Study: National Corporate Client251
Case Study: Regional Corporate Client256
Updated Contracts .259

**Chapter 15 Contracts for Weddings and
 Rites of Passage** .**265**
From Time to Time, Even the Non-Wedding Photographer
 Will Cover a Wedding or Rite of Passage265
What a Wedding or Rite-of-Passage Contract Should
 Look Like .267
Negotiation with the Bride, Groom, and (Often)
 Paying Parents .269

Protecting Yourself from Liability .270
Multi-Photographer Events: Calling the Shots and
 Taking Control .271
Recommended Reading .272

Chapter 16 Negotiations: Signing Up or Saying No . . . 273

Negotiating from a Position of Strength274
Creative Solutions in the Negotiation Process279
Teaching People .282
The Power of the Upsell .282
A Triumph of Hope over Experience .284
Defining Your Policies .284
Deal Breakers: What Are Yours? .286
Why "No" Is One of Your Most Powerful Tools286
Predicting the Future? .287
Studying the Aftermath of a Lost Assignment288
Case Study: Science Competition .289
Recommended Reading .299

Chapter 17 Protecting Your Work: How and Why301

It's the Principle of the Thing for Me301
Don't Steal My Work, Period .303
Copyright: What Is It, When Is It in Effect,
 and Whose Is It? .304
Pre-Registration: How to Protect Your Work304
Registering Your Work with the Electronic
 Copyright Office .305
Registration: How to Register Your Work Systematically306
 Title of the Work .314
 Nature of This Work .316
 Year in Which Creation of This Work Was
 Completed .316

Date and Nation of First Publication of
This Particular Work .317

Sign and Date .318

Archival .318

Definitions: Published versus Unpublished–the Debate318

Recommended Reading .320

Chapter 18 The Realities of an Infringement: Copyrights and Federal Court321

What to Do When You're Infringed .321

Timeline of an Infringement .322

Types of Infringers .322

The Preexisting Client .322

The Third Party Who Legitimately Obtained Your
Image(s) but Is Using Them Outside of the
Scope of the License .323

A Licensor Who Stated One (or a Limited, Smaller)
Use and Who Is Using It in a Much More
Expansive Way .323

A Potential Client Who Reviewed/Considered Your
Work and Stated They Were Not Using It,
but Then Did .324

The Outright Thief .324

When to Engage an Attorney .324

Settlement Agreements .325

Case Study: A DMCA Violation .329

Chapter 19 Releases: Model, Property, and Others . . .343

Types of Releases .344

Case Study: The Importance of Releases349

Getting the Release Signed .351

Paying for Model Releases .352

Your Release Form or the Client's? .352

Other Release Issues353

Resources ..355

Recommended Reading355

Chapter 20 Handling a Breach of Contract: Small Claims and Civil Court357

Why You Might Be Better Off in Small Claims or
Civil Court358

What to Expect and How Long It Will Take358

Case Study: A Textiles Company359

Chapter 21 Resolving Slow- and Non-Paying Clients ..361

How to Engage the Client and the Accounting
Department361

You Delivered on Time, and Now They're Paying Late365

Statistics of Aging Receivables, and the Likelihood of
Collecting at All365

Late Fees: A Good Idea?366

My Solution to Late Fees for Some Clients366

Collections Services: An Effective Last Resort367

Chapter 22 Letters, Letters, Letters: Writing Like a Professional Can Solve Many Problems371

E-Mail: The Current Default Communications Tool374

Signatures–and Not with a Pen!377

Summary Letters: What We Discussed378

CCs and BCCs: How and When380

Thank-You Notes: How Much They Do and How Right
They Are380

Recommended Reading381

Chapter 23 Attorneys: When You Need Them,
 They're Your Best Friend (or at Least
 Your Advocate) .383

 What Attorneys Can Do for You .384
 Contract Review and Negotiations384
 Writing and Revising Your Current Contracts385
 Advising You on Legal Matters386
 Taking a Case .386
 What You Can Expect to Be Billed386
 Retainer Fee .387
 Phone Calls .388
 Copy/Fax and Other Miscellaneous Charges388
 Ask Your Attorney Whether It's Economically Sound to
 File Suit .389
 Why Attorneys Are Reluctant to Take Cases on Contingency
 (and When They Will) .389
 When You Pay for Advice, Heed It390

Chapter 24 Office and On-Location Systems:
 Redundancy and Security Beget
 Peace of Mind .393

 Redundancy: What Is It? .393
 Communications Networks .393
 Firewalls and System Security .394
 Port Forwarding: Port What? .395
 Back Up, Back Up, Back Up! .396
 Backing Up Your Desktop .397
 Backing Up Your Laptop .397
 Backing Up Your Work in Progress398
 Dual Backups of Image Archives, Onsite and Off400
 Dual Cameras on Assignment .400
 Excess Lighting Equipment: Don't Take Three Heads on a
 Shoot That Requires Three Heads401

It Only Takes One Flight: Carry On Your Cameras401

Software Validators and Backup Solutions402

The Aftermath: How Do You (Attempt to) Recover
 from a Disaster?404

**Chapter 25 Digital and Analog Asset Management:
 Leveraging Your Images to Their
 Maximum Potential****405**

Recommended Reading: *The DAM Book*405

Solutions Beyond *The DAM Book*: Adapting the Principles
 to a Variety of Workflows406

 Adobe Lightroom406

 Expression Media407

 Aperture408

Evaluating the Cost of Analog Archive Conversions to
 Digital: Is It Worth It?410

Immediate Access to Images Means Sure Sales in a Pinch ...411

Chapter 26 Licensing Your Work**413**

Defining the World of Licensing413

Issues of Exclusivity416

Markets You Will License Within419

Rights Managed versus Royalty-Free419

Electronic Distribution420

Caveats and Other Considerations421

Proceed with Caution: The Retroactive License422

Selling versus Licensing423

Licensing Language and Examples424

The Formatting of a License426

 Some Other PLUS Licensing Examples438

Evolving Toward PLUS439

PLUS in Standalone Applications444

Chapter 27 **Stock Solutions: Charting Your Own Course Without the Need for a "Big Fish" Agency** .453

What's the Deal with Photo Agents These Days?453

Personal Archives Online .455

 PhotoShelter .456

 IPNstock .457

Others .458

Chapter 28 **Care and Feeding of Clients (Hint: It's Not About Starbucks and a Fast-Food Burger)**461

They're Your Clients: Treat Them Like Gold462

How to Improve the Odds That Your Clients Will
 Come Back Again .463

The X Factor .466

A Couple Givens .467

 Voicemail .467

 Appearance .468

Do Something Unexpected, Something Value-Added468

Feeding Clients: Fast Food and Takeout Coffee Won't Cut It.
 Cater and Bill for It! .470

Deliver When You Say You Will or Sooner471

Return E-Mails and Send Estimates ASAP472

Clients and New Approaches to Business474

Recommended Reading .474

Chapter 29 **Education, an Ongoing and Critical Practice: Don't Rest on Your Laurels** . .475

Continue the Learning Process: You *Can* Teach an Old Dog
 New Tricks! .477

Know What You Don't Know (Revisited)478

Seminars, Seminars, Seminars: Go, Learn, and Be Smarter . .478

Subscriptions and Research: How to Grow from
 the Couch .479
The Dumbest Person in Any Given Room Thinks He or
 She Is the Smartest .480

Chapter 30 **Striking a Balance Between Photography
 and Family: How What You Love to Do
 Can Coexist with Your Loved Ones if
 You Just Think a Little About It 481**
When What You Love to Do Must Not Overwhelm
 Those You Love .482
Solutions for a Happier Spouse/Partner and Children 483
Take Your Kids with You .484
Dealing with the Jealousy of a Spouse or Partner 485
Listening to Cues: What Those You Love Are Saying When
 They're Not Saying Anything .486
Vacations: Really Not the Time to Shoot Stock 487

Chapter 31 **Expanding into Other Areas of
 Creativity .489**
Video Services .489
Book Publishing .491
 Vanity Press .491
 Commissioned Photography Books 492

Chapter 32 **Charity, Community, and Your Colleagues:
 Giving Back Is Good Karma 495**
Charity: A Good Society Depends on It496
Pro Bono Work: You Decide What to Do, Not in Response
 to a Phone Call Soliciting Cheap (or Free) Work 496
Engaging the Photo Community: Participating in Professional
 Associations and Community Dialogue on Matters of
 Importance to Photographers .496

Your Colleagues: They May Be Your Competition, but
They're Not the Enemy497
Reaching Out: Speaking, Interns and Apprentices, and
Giving Back498
Pay It Forward499

Index 501

Notes on the Second Edition

Much has transpired in the photographic community since the publication of the first edition of *Best Business Practices for Photographers*. Truly, I have been blown away by the reception of the first edition. Schools all over the country, in cities such as Tampa, Austin, Las Vegas, Minneapolis, Dayton, Wilmington, and many others, have adopted this book as a teaching tool, and that gives me great hope. I have received hundreds of e-mails from individual buyers, young and old, who have shared their appreciation for the book in heartfelt ways. The first edition truly met and then exceeded my expectations for its ability to impact my fellow photographers and, I pray, extend their careers in the field of photography.

When I first considered agreeing to author a second edition, I thought about it for some time. Other than updates to delete companies that were no longer in business and change out a few product versions (such as D2x to the D3 or references from Windows XP to Vista), what else was there to change? Wasn't a best practice supposed to be the best? I expected few changes in much of the text.

Then I stepped back and reconsidered the idea, with the notion that perhaps there were things that needed to be expanded upon. Two of the most popular parts of the first edition were the case studies and the client dialogues, so there are now more of them. One case study I forgot to put in the last edition was how to send a DMCA takedown notice when a website is using your photographs in violation of your copyright. I tried to sneak it in at the last minute in the first edition, to no avail. Now, it has made it in.

Of the many new chapters, three are extensive expansions from just a few paragraphs in the first edition. The need to understand how to best migrate from being a staff photographer to freelance is now a solid chapter with advice not just for the photographer doing the transition, but also for the photo community that the newfound freelance photographer is entering. I even ran it past a dozen of my colleagues who just made the transition themselves, and it proved true and insightful to them. Now, with their blessing, it is here for your reading. I have added a massive chapter on licensing, much more than the chapter section it was in the first edition. I have also expanded the "Pricing Your Work to Stay in Business" chapter into two chapters, one of which helps you set your own fees for shooting. These are just a few of the many additions to the second edition of this book.

There are thousands of you out there who own copies of the first edition. "Often read and heavily dog-eared," wrote one photographer. "It is my desk reference that I turn to several times a week," wrote another. A third wrote, "I am running my business so much more profitably now," in a thoughtful letter. So, as an owner of the first edition considering buying the second edition, you have two questions to answer. The first is, "Is it worth it?" My answer is a hearty, "Yes!" There were 26 chapters before; now there are 32. There were 352 pages before, now there are more than 500. The chapters on licensing and the update of the negotiations chapters alone should earn you enough to easily justify the cost of the book.

The second question you might be asking yourself is, "If I buy it, what will I do with the first edition?" The last three words in your first edition should be your guide. Pay it forward. Pass along the copy to a friend or colleague and encourage them to read it. Tell them when they're finished to buy the second edition and again pass along the first edition to someone they think could benefit from it. You might even design your own bookplate, like a well-read library book years ago, where you could read the previous names of people who checked it out by the library card in the book. Sign your name in the front on your own bookplate and see how many people read and pass it along, signing each time before it leaves their hands. You could use something like "This book was the property of..." followed by your name and the date you passed it along.

Our profession, one we have a passion for, is under pressure from all sides. Photo staffs being slashed all over the country, stock photo prices plummeting faster than a lead balloon, and the constant devaluation of our work by people who own their own digital camera and who think "How hard can it be?" continue to make people believe that being a photographer means you produce a commodity. Photographs are not widgets, interchangeable and sold at lower and lower prices each day. To some entities, they might be seen as such; however, the photographers I encounter in person and meet online, by and large, are succeeding by defining their clientele amongst those who value and respect what creatives bring to the table. The clients for whom price is not a deciding factor, but rather a detail...

You can succeed as a professional photographer. The first edition proved that over and over. This edition expands your toolkit even more. After 20 years in the field, on the front lines of photojournalism and corporate and commercial photography, and in making images for advertising clients, the tried-and-true practices in this book have stood the test of time not just for me, but for the many other people for whom it has been a guide.

Enjoy!

Introduction

Our chosen profession is in the midst of a profound transformation, a sea change. When I became a photographer, 35mm film was the standard for photojournalism. Twenty years earlier, medium format was king, and that had evolved from a 4×5 mindset. Medium format was the format of choice for many magazine photographers, and although many advertising photographers were also using medium format, numerous were large-format only. Ansel Adams, in the introduction to his 1981 book, *The Negative*, foretold the coming digital era when he wrote, "I eagerly await new concepts and processes. I believe that the electronic image will be the next major advance. Such systems will have their own inherent and inescapable structural characteristics, and the artist and functional practitioner will again strive to comprehend and control them." In each successive shift, there was disdain for the new technology, and that held true for digital too, despite Adams' anticipation. Now there are few compelling reasons to use film.

Although there is much discussion and posturing about file formats, workflows, and such, the concepts of running a business have remained remarkably unchanged. From Dale Carnegie's advice in *How to Win Friends and Influence People*, to the requirement that the income we generate *must exceed what we spend* on expenses, solid business principles have stood the test of time. The founding fathers' inspiring notion in the Constitution that you are the creator of your works and, as such, you are entitled to a limited monopoly on them has changed little. When Arnold Newman led a boycott of *Life* magazine in the 1950s, it was over egregious business practices by the publisher, and the photographers won.

The points made in *Best Business Practices for Photographers* about customer service, giving back, the value of asset management, negotiation, and so on are timeless. The opportunity to revise and update this book will no doubt take place during successive printings and editions, but it is my hope that this book and its core messages and lessons will always be a well-worn resource on your bookshelf. Or, perhaps it will be passed along to a colleague or an aspiring photographer who you feel could benefit from these insights and what's written herein.

Photographers may disregard commercial photography, espousing the documentary photographer's status as the most honorable, and hold some irrational disdain for commercial photographers or business practices. So I return to Adams, who is cited by William Turnage of the Ansel Adams Trust in the PBS *American Experience* series *Ansel Adams*. Turnage is credited with securing Adams' financial future shortly after they met, when Adams was 70. Turnage notes, "He and Edward Weston were criticized because they weren't photographing the social crises of the 1930s, and [Henri Cartier] Bresson said, '[T]he world is going to pieces, and Adams and Weston are photographing rocks and trees.' And Ansel was very stung by this criticism. He felt that documentary photography, unless it was practiced at an extremely high level, was propaganda, and he wasn't interested in that. He wasn't trying to send a message."

Turnage then went on to say, "I never met anyone who worked as hard as he did—never took a day off, never took a vacation, ever. He simply worked seven days a week, every day of the year, every year. Even when he was eighty he was still doing that.... [H]is own career was really precarious, economically. [O]ne of the reasons he worked so hard was to make a living, and it was difficult to make a living as a photographer in those days.... [H]e really struggled to pay the rent and to make ends meet, literally. He couldn't go on a trip somewhere to make photographs because he didn't have a hundred dollars to pay the costs all his life."

Turnage was not alone in regarding Adams' recognition of the importance of commercial work and the business of photography. Michael Adams, Ansel's son, notes during an interview in the documentary that his mother "was sort of the unsung hero. My mom had the business in Yosemite—she inherited from her father, after he passed away in the '30s—and that enabled them to live and for Ansel to do the creative work. Commercial jobs were very important, but her support financially allowed him to do a lot of things that he might not have otherwise been doing." And Andrea Gray Stillman, editor and assistant to Ansel Adams, noted that "when [Ansel's wife, Virginia] gave birth to their second child, Ann, in 1935, Ansel was not there. Virginia was in San Francisco; Ansel was in Yosemite on a commercial job."

Frames from the Edge is a documentary about Helmut Newton. When asked, "Are your works for sale? And if yes, how much?" Newton responded, "Not through museums. Museums are not the kind of institutions that sell photographs. Of course they are for sale. For me, everything is for sale. It's just a question of the price! But I do this for a living. I work because I love it and because I love to make money."

To many photographers, appearing in print and achieving a photo credit in a prestigious publication are the ultimate goals, but as poet Dorothy Parker said, "Beauty is only skin deep; ugly goes clean to the bone." When you encounter an offer to work primarily (or only) for a photo credit, and the costs of doing so are greater than your revenue, the beauty of that photo credit is skin deep, but the ugliness of what you are required to sacrifice in order to achieve that goes to the bone.

What's in a photo credit? Validation of your worth as a photographer? Bragging rights? Can you deposit that photo credit in the bank? Pay your rent or mortgage with it? Go to dinner on it?

As I was writing the final chapters of the first edition of this book in the summer of 2006, I had several of my images appear in a number of prestigious newspapers, all of which are viewed with some level of contempt by many in the photographic community for their low pay and insidious contracts. Yet countless photographers line up to sign their contracts, and photo credits read like the names are a revolving door, with photographers staying around for a year or two until they can't afford the "privilege" of working for these publications. My images were not my first, nor will they be my last, appearances within those papers. The images, however, were not produced as a result of an assignment for these papers; instead, they were produced on behalf of other clients—ones who paid a fair assignment fee, paid me for each electronic transmission (read: e-mail), and enabled me to keep my rights (of which being made available to editorial outlets was a part). I stipulated what rights I would license and what fee I would require to perform the work, and I was paid that.

For a long time, friends and colleagues would express joy at appearing in every publication under the sun, literally from A to Z, whatever the name—especially the marquee national and major metropolitan publications. My biography lists a few of the many publications in which my work has appeared, in large part because people who are not in the know judge me and my work based upon this. For those who do, this is such a disservice to both me and my work. A prosaic image suddenly becomes validated because of where it appeared? I think not. My work—and yours—should stand on its own and be valued regardless of where it appears. Yet many of today's problems with contracts, rights grabs, and low pay are because people were willing to accept low pay (outdated in many cases by at least two decades) and suffered under oppressive rights grabs because they erroneously thought that having their work published by so-called "important" publications would validate them and their work. I submit that this is wrong, but worse than that, the more onerous contracts force those same photographers to lose the right to say they are even the authors of the work.

I long ago gave up trying to value my photography based on where it appeared. Instead, I value my images by what's in them; what they convey; and how people respond, react, pause while viewing them, or, perhaps, are enlightened by them.

I wrote *Best Business Practices for Photographers* not only to help photographers see the significant intrinsic value in the work they produce and to minimize their need for validation by photo credit, but also to help them to see how they can evolve their business model. At best, I hope this book helps photographers so that the work they do becomes a more profitable and personally satisfying experience. At the least, I hope this book helps photographers remain in business so that, in the long run, they hopefully can achieve the former objective.

In the documentary *American Masters* series on the legendary photographer Richard Avedon, details about his 1966 contract with *Vogue* were reported. "As the presence of the real world rose into his fashion work...and needing to support his personal work, Avedon accepted *Vogue*'s unprecedented million-dollar offer.... [H]e learned to separate his personal and professional work." Avedon, in his own words, went on to say, "There is no downside to my commercial photography. I am so grateful that I have the capacity and the ability to make a living and support my family—which is the definition of being a man for my generation—and to support my studio, support my special projects by doing advertising."

As you hold in high regard Adams, Newman, Avedon, and others, remember that they held on to their rights and regarded what they do as something worthy of continuing—by having it sustain them spiritually *and financially*. So let this book guide and encourage you to be as successful as possible in your professional work, if for no other reason than to support your own special projects.

Chapter 1
You Are a Business–Now Let's Get to Work!

When this book was first written, it was written for the professional photographer. Since then, however, countless people have selected it as a resource to start their business right and to use in classrooms across the country and around the world. For the professional photographer, it will serve as a helpful guide where you're looking to improve your business, as well as a refresher and an affirmation of what you are doing right. Although it was not originally written for the aspiring photographer looking to get into the photo business, many people have shared with me as they have started their business that it has been an invaluable resource. So, whether you are a seasoned professional or an aspiring photographer, the message of this book, the second edition, is time-tested and was well received by many of your colleagues already. Rest assured, the topics covered in this book will be crucial to your longevity and staying power.

One thing that's not taught to most photographers graduating from college is the skills necessary to be in business as a photographer. The notion that a photography school would fail to teach its students all the necessary skills to pay back their student loans and remain in their chosen profession seems to me incredibly shortsighted. More recently, some forward-thinking schools are beginning to see the writing on the wall and are instituting a required class or two. I have heard from dozens of schools with a photography program that this book is required reading. If you are a student in just such a class, kudos to your professor. Hopefully, this book is one of several that are required reading on this subject. Throughout this book, there are several other books I will be recommending, and I encourage you to read each of the books suggested at the end of the chapters. Art schools, on the other hand, with photography concentrations seem oblivious to the dollars-and-cents aspect of serving their students. I will applaud the day when all photographers graduate from photography programs understanding all that is necessary to hang their shingle out and grow their business responsibly.

Whether or Not You Think You're a Business, You Are

You are a type of business. Not you the photographer, but you the individual. Your ability to generate revenue is seen by the IRS as a form of a business, and you must pay taxes for the right to generate that revenue and reside in the United States. The government has deemed

that your taxes are the necessary amounts they collect to provide you with the services you're better off not paying for yourself—roads, the police, mayors, and so on. A percentage of your revenue goes to these items. How you choose to function as a business is your choice; you may be an employee of a company who pays your taxes out of your earned check, you may opt to be self-employed, or you might choose to run a formalized corporation, LLC, partnership, or the like, but taxes are inevitable and not a matter to take lightly.

What you do for your earned revenue is your choice as well. However, over a period of time, what you earn must exceed what it costs to earn it—not just now, but projected into the future as well. This reality is lost on most graduating photographers and those entering the profession from other arenas. This message is important—not because you're reading this and hoping to go into business; rather, so you can understand that regardless of whether you see yourself as a business, everyone else does—especially the IRS, as well as your family and your current and prospective clients. How you run your business will be the primary determining factor in your success. And remember, vendors—some as simple as MasterCard and Visa, not to mention supply houses and camera stores—see you as a business, and not only expect to be paid promptly, but will cut you off and damage your credit rating if you do not do so.

Save for the independently wealthy, anyone can operate a photography business for free for a short period of time, after which point the money runs out and the debts pile up, and you must then do something else to pay the bills. Understanding this extreme means you can understand that if you have not taken into consideration all of the factors—short term and long term—that go into being in business, at some point the expenses will catch up to you, and you will be required to do something else to earn a living. To a lesser degree, you might eke out a living, renting apartments rather than buying a home, always buying an old used car instead of the occasional new one, and scrimping to afford new clothing and the expense of children (from diapers to graduation and everything in between). While this may be an easy out for the new graduate, it provides no plan to upgrade equipment in a few years or replace the dropped $8,000 camera that is now a paperweight. The eked-out living is worse than living paycheck to paycheck; it's a disaster waiting to happen.

Many photographers approach their photography purely as a calling, and their goal is to change the world by making pictures that reveal poverty, despair, suffering, and the human condition. These photographers believe that making money for these types of assignments is contrary to that effort, but nothing could be further from the truth. If this is truly your philosophy, and you believe that your pictures can and are making a difference, then if you make business decisions that make it impossible for you to remain in business to make this difference in the long term, you are doing the world-changing movement a disservice. It's akin to a physician, who has been trained for years to save lives, not taking the necessary safety precautions (for patients and for himself) of gloves and a mask when working in a Third World clinic. Although such physicians may make a significant difference, their contribution to society may be cut short by contracting the diseases they fought so hard to cure, and they would fail to protect their patients by moving from one to another without wearing fresh gloves. You too must take the necessary business-safety precautions to ensure that you remain in business long enough that *you* make the difference you seek to achieve. Unfortunately, for so many this message that good business practices really matter is either lost or perceived to be too hard to follow. This book aims to change that idea.

Further, if you operate all other aspects of your business profitably and you want to be a modern-day Robin Hood, you can take your profits and self-fund an assignment to document plights and underreported issues of our day. You can then take those stories and present them to media outlets and offer up a written and photographed package that they find very attractive. Absent a printed outlet, there are innumerable outlets with wide audiences on the Internet where you can get your story picked up and start making that difference. Charging enough that you can save for these projects means that you can take assignments from those who can afford to pay you top dollar and then transition those dollars into footing the bill for altruistic projects.

In the chapters that follow, I will provide the resources to answer questions on a wide variety of topics that will direct you through the confusion and give you guidance and insight based upon my own experiences and the lessons I've learned. In some instances, rather than reinvent the wheel, I will direct you to resources on which I rely, from pricing to digital asset management and the like.

Although this book was not originally written for someone who's just starting out, many who have picked this book as their resource have gone on to be successful. It does presume a certain knowledgebase that the beginning photographer might not have. However, that does not mean that a photographer just starting out wouldn't benefit from reading it. In fact, doing so truly can allow you to start out on the right foot. However, some of the content may at first be confusing to the beginning photographer, because you won't find much Business 101 content. The contents are designed to be applied to an existing photography business, so that those in business can take their enterprise to the next level, find poor and underperforming facets of the business, polish and fine-tune them (or make major overhauls), and make an overall improvement in the success of their business or save it from failing. Students or first-year photographers will take away from their reading of this book a roadmap of their future once in business and a practical set of solutions that will help them understand how an established photographer is (or should be) operating his or her business.

Making Decisions: Strategic versus Tactical

You've likely heard the statement about losing the battle but winning the war. This is when you may have made a tactical error in the battle, but your overall strategy was effective enough that you came out on top. Tactics are changeable, whereas strategies are more difficult to switch. The problem is that many photographers are so certain they are going to succeed despite their poor strategies and repeated bad tactical decisions that they continue to follow a path that is not in their best interests. In many cases, there may be a short-term gain but with a significant long-term negative impact. Further, studies in the investing community have shown that of people in the age group of 16 to 24, 20 percent consider "long term" to be three years or less. In the 35-to-44 age group, just over 40 percent consider long term to be more than 10 years, and three out of five believe that five years or fewer constitutes long term.[1] Although this study was investor-focused, the mentality still applies. Someone just graduating from college might well see taking work that does not account for

[1] KUSI News - San Diego. http://www.kusi.com/business/2557181.html.

their true expenses as beneficial and may see their long-term success as only in the next few years. This is a strategy that is sure to backfire.

All tactics you employ must serve the greater strategy, namely remaining in business as a photographer for the long term (and I see that as much more than 10 years!). If you've looked at your annual expenses and divided them by the number of assignments you completed last year (or hope to complete next year), and that number is $178.80, then taking an assignment for a day that pays you $150 is a bad tactic and will lead to a failure of your strategic goal if repeated for long enough. A better tactic would be to spend that day researching higher-paying clientele in your market and developing an outreach plan to obtain work from them.

It is imperative that you look at all the decisions you make as being tactically wise. The purchase of a new computer or software upgrade must make you more productive or efficient. When every photographer had pagers and had to find pay phones or wait until they got home to return a page, or when they had to return home to find a message from a prospective client on their answering machine, it was tactically a good move for me to pay a large amount of money (at the time) for a cell phone and then use my local phone company's call-forwarding feature to forward all my calls to my cell phone when I left home. While prospective clients were waiting for the paged photographers to return their calls, I was already on the phone booking the assignment, and often colleagues would lose assignments to me for no reason other than I was the first photographer the client was able to talk to, and that closed the deal. Each month, more than enough assignments came through to justify the decision to pay for the cell phone. Tactically, it was a good move and served to advance my strategy in a major way.

Today, it's the immediate response to e-mails from clients, followed by immediate estimates, that helps me secure assignments. Tactically, it was a good move to pay the premium to enable my current cell phone to send and receive e-mails. Thirty dollars per month for unlimited e-mail over my cell phone is a small price to pay—just one assignment a year, and the costs for that service, as well as a few dollars a month to add the call-forwarding feature to my landline service, is of great value. This feature has paid for itself over and over—so much so that it now seems irresponsible for me not to do it.

Decisions must be thoroughly considered. Expenditures must be examined, but more important, revenue inflow must be at an appropriate level to cover expenditures. If you're not considering the appropriateness of decisions in the good-tactic/bad-tactic approach, then you are doing a disservice to the strategy.

Reviewing Your Current Business Model and Revamping What You're Doing

Your current business model must be reviewed. Whether you're a freelance news photographer, an advertising photographer, a wedding photographer, or a high school portrait photographer, all good businesspeople sit down and examine what they are doing and how they could do it better. Large corporations have whole divisions dedicated to productivity and efficiency, and you're a micro-version of that corporation—You, Inc.

One example of this is the You, Inc. shipping department. For freelancers, there are two main types of physical shipping—overnight delivery and hand delivery. Consider that You, Inc. actually has a shipping department. If every time you deliver the finished photography to a client by hand, you don't charge a delivery charge, you're taking a loss in two categories—labor and expenses. The labor is your time delivering the materials, and the expenses are the gas and parking (whether garage, meter, or other charge) associated with that the delivery, not to mention mileage. A 10-minute delivery means five minutes parking and going in and 10 minutes back, for a total of just under 30 minutes of your time, plus a few dollars in gas/parking.

Charging a fee of $12 to $18, commensurate with what outsourcing to a courier/delivery company would charge, means you are ensuring that your shipping department is not reliant on the other "divisions" (photography, post-production, reprints, and so on) to sustain it. Furthermore, when you get so busy shooting that you can't take the time to make deliveries, you will have in place a mechanism to charge for delivery, since you are now making more money using that time to shoot, and furthermore your clients now expect to pay for that service. If you can no longer make deliveries when you get so busy and you start charging all your clients a delivery charge at that time, they'll object, and you'll have to deal with angry customers who feel over-billed. Or, you'll have to eat the charge into your overhead. For the last decade, my shipping department has generated enough revenue to cover the expense of the vehicle I use to make those deliveries, including new car payments, insurance, gas, and the like. At the very least, the You, Inc. shipping department should offset those same expenses for you.

And, if you're a staff photographer doing work on the side (weddings, portraits, and so on), you really must examine your freelance business, because when you're no longer staff, you'll want to make sure that the work you're doing can sustain you. If you only establish clientele for a few hundred dollars a day that you can earn on your midweek days off, then when you go freelance (or are forced into freelance by being laid off) and that amount of revenue from an assignment can't sustain you, you won't be able to remain in business. Your existing clients will not understand when you suddenly have to raise your rates to survive, so it's better to use a rate structure that is viable from your first freelance assignment on. Even if you're a staffer, you should treat all assignments as if they were freelance—not only will this create a collection of clients for you that pay a self-sustaining rate, but it also will ensure that you're not cutting your freelance colleagues' throats with low-ball assignment fees that the client will no doubt use to beat down the freelancers in your market. But we'll discuss more on rates and such in Chapter 7, "Pricing Your Work to Stay in Business."

A review of what's profitable and what's not will ensure that you maximize your potential. Some photographers get into the wedding or event business and hope to someday become big-dollar advertising photographers, or they work in the mid-level family portrait business and hope to become a major magazine portrait photographer of the movers and shakers of the world. However, these photographers often become complacent in that model and never work to seek out the types of photography they wanted to do. They remain in a type of photography business that they had not intended to, and then they look back 10 or 15 years later and wonder why they didn't act sooner.

Perhaps having a studio is where you are now, yet you review the expense and find that because a majority of your portrait subjects want to be photographed on location, carrying the overhead of the studio for the small percentage of in-studio portraits you do just isn't wise. Although you don't need to sell the space, taking in two (or more) other photographers to share the studio expense could be a solution that makes more sense for you; alternatively, offering to rent it out and promoting it as available might be a better solution.

Suppose you are taking assignments for editorial work through a typical photo agency that takes 40 percent of the assignment fee, and you keep the remaining 60 percent. Perhaps that is not the best solution, and securing clients directly so that you keep 100 percent of the assignment fee is a more sustainable choice. If you are working for a photo agency and the editorial fee is $450, it means you only get to keep $270. If your per-shoot-day operating expenses are $150, then you only earned $120 for the day, which is not a sustainable figure long term.

A cursory review every two to three years, followed by a serious sit-down every five, will ensure that in 20 years you will not only be in business, but you will be earning a fair wage, and you will be satisfied that you made smart decisions along the way.

Know What You Don't Know

One of the lessons I pass along to every group I speak to on this subject is this mantra: *Know what you don't know.* I know it sounds silly at first blush, but when you stop and think about it, you realize that it's really a wise idea. If you don't know about marketing, don't pretend that you do. Admit that you don't (at least to yourself) and then work to fix that. When you've figured out what you don't know, then and only then can you work to know what you now know you don't know. (*Reread that last part—it's critical that you understand it.*)

Make a list. If you don't know how to find new clients, write that down. If you don't know how to raise your rates, write that down. If you don't know how to charge for post-production of your digital images, write that down, too. Now you are beginning to grasp what you don't know, and you can begin to learn what you don't know.

One problem this brings up is being honest with yourself. Many photographers pride themselves on knowing it all; however, that thought process will backfire. It used to be that technology improved slowly, and all we had to worry about was the newest film emulsion or the improved auto focus or flash TTL technology, but today we must learn and then relearn new software and new-and-improved versions every 18 months. We begin again teaching ourselves (or taking seminars to teach us) just how to use the new software or the latest camera body. There is no shame in sitting down and reading a camera manual from front to back and then doing it again in two weeks to learn what you've forgotten already. There is nothing wrong with calling a colleague, admitting you've never used the latest version of Photoshop, and asking what the difference is between the latest and previous versions.

There are many facets of business that are unfamiliar to photographers. From sales tax, to quarterly payments, to terms such as "2 10 net 30," to profit, to expense ratios—understanding that these are important to the long-term success of your business and that seeking out the answers will serve your long-term interest means that you will be in

business in 20 years. These and innumerable other business facets mean that there's a lot you don't know, and you need to know what you don't know before you're ready to move forward and grow your business wisely.

Creating a Business Plan for an Existing Business

Creating a business plan midstream is like trying to turn an ocean liner 90 degrees in two football fields. Without precise tools and know-how, it's next to impossible. Yet, there are a variety of reasons why it's important to create a business plan. For one, the Small Business Administration won't give you a loan without one. Banks will be reluctant to loan you money as well. But often you're so focused on the next two weeks, you just can't seem to find the time to sit down and write a plan. If you don't know how or where to begin, the Small Business Administration (www.sba.gov) is a great resource with in-person and online classes, as well as samples on just how to do this.

Harry Beckwith, author of *What Clients Love: A Field Guide to Growing Your Business* (Business Plus, 2003), makes this point about business plans that cannot be missed:

> Most people assume that business plans will tell them what to do. Few businesses, however, follow their plans. Things change, assumptions change— and plans change with them, as they should. Yet businesses still plan…. The value of planning is not in the plan but in the planning…. Like writing a book, writing a plan educates you in a way that nothing else can.

Fortunately, you're in business, transitioning from one business to another or from staff to freelance, and you are not trying to start your plan as a pie-in-the-sky idea; rather, you're looking to document what you are currently doing, and this can be an interesting exercise. By analyzing your clientele, marketing efforts (to date), and profits from the various assignment types you complete, you can begin to see patterns emerge. From the type of clients who seem to always pay late (and thus may be enticed to pay on time with discounted rates or surcharges for late payments added); to marketing efforts that used to work, such as the major photo annuals, but that are dying on the vines; to profits, where you can find that clients who used to be profitable are now demanding more for the same price and, therefore, the profits per assignment are below continuing in that line of photography and should be jettisoned from consuming your time and resources—a review of a business plan drafted from existing work is more often than not an enlightening experience.

There are numerous books available and courses (many free or very inexpensive) in communities across the country that you can utilize to help you draft your plan. Bring your tax returns and marketing materials (postcards, websites, and so on) to courses or small business gatherings to meet with other entrepreneurs and even bankers, and in a day or two you'll find that you have a banker's perspective on your business. Bankers are math people who look to make sure that if they loan you the money, you'll be able to pay them back; they have a vested interest in making sure you can do so and that you remain in business.

Whatever course you choose, you'll want to make sure you establish a business plan. If you're not the planning type, think again. You've planned to have the right equipment and the right computers, and you've planned to learn the software necessary to do your

assignment. For assignments for which you're not familiar with the subject or subject matter, you've done your research so you know that SiriusXM Satellite Radio is not a local radio station, but rather the nation's premier satellite radio company, so that when you walk in for your assignment to photograph the CEO, you don't ask where they are on the dial. For your assignment to cover a sports team, you've done research that tells you who the key players are in the game and what to expect from them. For a stakeout, you've studied the entry and exit points so that the indicted politician has to pass by you when he leaves his lawyer's office building. If you're planning all of these things, planning for your future success should be just as important (if not more so). Those planning exercises were tactical—they helped you complete the assignment successfully and hopefully earn another assignment from the client. Developing a business plan in which success is defined as you remaining a photographer is a strategic decision, one that is critical to your future.

Understand, though, that your plans must incorporate the idea that the business of photography is constantly changing. You not only must plan for what you expect, but you must establish responses to unexpected events and responses to those responses, and so on, and so on. By doing so, you will ensure that you are prepared for whatever clients and trends get thrown at you. This is not a plan-it-and-forget-it, check-that-box-I'm-done situation; it's one that will require you to be just as on top of your business as you are on the trends in news, weddings, portraiture, and the like.

Chapter 2
Professional Equipment for Professional Photographers

Top-of-the-line and specialized equipment is expensive for a reason. In many lines of cameras, there are the consumer models, the prosumer models, the professional models, and, in some, the top-of-the-line models.

We Are Professional-Grade: Why We Must Use That Equipment

Can you use a consumer or prosumer piece of equipment and often produce exceptional images? Of course. In fact, there are premium newspapers and magazines that are using some of the prosumer bodies because of the size difference. If, in an analysis of your circumstances, you've evaluated the available equipment, and you are not making the choice on what's cheapest, then the use of consumer/prosumer equipment may be what's best. Otherwise, should you? Not in my book.

Typically, the prosumer lines of camera and lighting equipment have fewer features than the professional line and more features than the consumer line. Further, in many lines, especially in the areas of camera chips and lenses, the purest chips that render within higher tolerances are given to the professional cameras, and the chips that fall out of that tolerance end up in the prosumer or consumer bodies, with the software then dumbed down to limit the functionality of the chip. There are several times when this has occurred. One time in particular was several years back, with Canon EOS Rebel bodies carrying the same chip as prosumer models. There was a great deal of discussion surrounding just how to effect a change in the software to "upgrade" your EOS Rebel to have the functions of its more expensive sibling.

When you're on assignment is not the time to find that you have a need that exceeds your equipment's capabilities, from chip size, to f-stops, to flash duration, to incremental flash settings to a tenth of an f-stop, and so on. If this occurs, you will find yourself making compromises on the quality of your imagery and what you produce creatively for the client.

Pro-Line versus Prosumer-Line Lighting: Why Spend the Money?

I'll be the first to admit that I started with Dynalites 15 years ago. Soon, I got tired of trying to put lights in disparate locations, even with extension cords for the heads. I never had enough extension cords, packs, or f-stop adjustment abilities. As a result, I upgraded to Paul C. Buff's White Lightning line of monobloc heads. I relied on the White Lightnings for a number of years and held the Dynalites in reserve as my backup lighting kit or for use when I had a larger shoot that called for additional lighting. One day, I found myself doing a number of portraits on location, and one room in particular just couldn't be lit the way I wanted it—the White Lightnings just were not powerful enough, so I began to explore my options. I looked at a number of professional-grade lines and settled on Hensels. I liked a number of their features. I'm not saying they are *the* brand to go with, but they are the kind of high-quality gear I strongly recommend. There are numerous reasons to go with pro-level lighting, not the least of which is durability.

Professional-grade lighting has two significant features that are often lost among the less detail-oriented—color temperature shift and flash duration.

Color temperature shift is what it sounds like—the change from 5500°K to, say, 4800°K over the range from full power to 1/4 power. Although technology has advanced over the years to the extent that color shift over lighting power ranges has diminished, there are still a limited number of definitive situations in which this will have an effect. Here are a few:

- ▶ Food photography (especially chocolate)
- ▶ Product photography (consider client logos and Pantone colors)
- ▶ Scientific photography

In addition, a change of even 100°K is a perceptible change in color temperature when two images are placed next to each other with varying temperatures of that small a shift. Further, a shift of 700°K is between a 1/4 and 1/8 CTO and can make your subjects warmer than you expected. Although this shift might have presented a much more significant concern in the days of film, it is still important to know that you are shifting color temperatures when adjusting power on prosumer lines of equipment. This will also explain why your whites are not a pure white, but a warm white when a subject is photographed on a white seamless.

NOTE
CTO is the orange gel that converts daylight to tungsten. A full CTO gel converts 5500°K light to 3200°K, and 1/2 and 1/4 gels are relative reductions in that shift.

The major issue that affects prosumer lighting is flash duration, and it's still a problem with digital cameras. If you've ever seen the Edgerton photograph of a bullet going through an apple or popping a balloon, where everything's frozen and crisp, or one of performers frozen in midair, where you can see every minute detail, then you've seen flash duration at its extreme. While the bullet and apple/balloon photographs are frequently done with

customized flash equipment, the performers frozen in midair are done with professional-grade lighting with extremely short flash durations.

Back in the days of film, I'd use a Hasselblad, and I'd be at 125th of a second at f/22, photographing a subject in the midday sun on ISO 100 film, and I'd want the sky to be deeper than the one stop under that it currently was, so I'd stop down to 250th, and I'd lose a little of the pop directed at the subject. At 500th I'd lose one and a half stops of light, and I'd be stuck. I had to return to, at best, 250th, all because the flash duration was longer than the time the shutter was open, and with all the settings the same, just a shutter speed stop-down, I was losing light.

More recently, I was involved in photographing an ad campaign in which we were shooting day for night. Typically, this is done when you need a scenic vista with some degree of illumination—at night—and you don't have any way to light it. You allow the sun to be your background light to give tone to the shadows, but you want it three to four stops under your strobe, and that means ISO 50 at 250th at f/22 with some clouds cutting the sun down. Having a strobe system with a short flash duration will ensure that you can make a photo of this scene and meet the client's needs. When the ad in this case was delivered, everyone except the art director and subject who were on set was convinced that the shoot had taken place after sunset, yet it had taken place under midday sun.

To understand flash duration, picture a line graph in which the light output looks like a bell curve. At the moment the shutter is tripped, the stored energy in the flash pack begins to be discharged and the element in the bulb begins to brighten to its stipulated power. The first few milliseconds are when the light output is increasing, from zero to a few watt-seconds, and during the next few milliseconds the bulb achieves its maximum brightness and light output and then begins to power down. As it discharges and the power output diminishes back to zero in the last few milliseconds, the illumination is complete. Less like a bell curve and more like a spike means a shorter duration in power up/peak/power down. As a result, a short-duration flash will not have its "tails clipped" as the shutter closes while the flash is still producing output. If all your photography takes place at 125th of a second or slower, and you rarely find yourself using full power on the strobes, then flash duration might not be important to you, nor will it have a significant impact. However, if you get the call for a big assignment that calls for intricate lighting, or you don't want your creativity clipped by long flash duration lighting kits limiting shutter speeds and maxing out at f-stops to "stop down the sun," then you will want a professional-grade flash system. There are, in all fairness, only two systems that can deliver on this level when it comes to battery-powered packs. They are the Hensel lights and the Profoto Pro-7bs. The other systems work well; however, when tasked with the aforementioned big assignment, having—and being familiar with—the right equipment means you will be able to deliver repeatedly.

One last point about lighting equipment that might seem tangential to lighting but is integral: When you arrive at an assignment, don't have multicolored cases, bags, and such. From the outside, your cases should look like they are pieces of a cohesive unit. Typically, this means sticking with one brand or (the safe bet) all black. And when your cases are opened, they should look like the person who packed them knows what he or she is doing. Every time I peer inside the toolbox of an auto mechanic, I am amazed by how every tool is clean and neatly organized. Every tool has its place, and your equipment should, too.

CHAPTER 2

Cameras and Optics: Why You Want the Best

There's a reason why top-of-the-line cameras are so expensive—it's because the R&D going into improving the capture capabilities is extremely high, and the number of cameras they can expect to sell using that cutting-edge technology is relatively small. So, they need to spread the cost of bringing that technology to you over the number of new cameras. Of course, you're also underwriting that R&D, which will eventually find its way into prosumer- and consumer-grade equipment.

Consider that today's professional-grade cameras can capture amazing detail and low noise at 800, 1600, and even 3200 ISO. This capability wasn't available even 18 months ago. Back in the days of film, I could use a camera from the 1970s, load in current-generation film, and compete for image quality against a camera produced in the 1990s. Now, a camera that is 18 months to two years old produces significantly poorer-quality images than today's cameras, and that will change again two years from now.

If you're using a camera with a chip that is not capturing the maximum amount of data, and you're covering a news event where the photographer next to you is capturing the maximum amount of data, he is producing images that have more potential than yours. If he's a bit too wide, he can crop in and still have a sizeable image. If you are too wide, you can't. If the photographer is using a camera with a greater latitude than yours, and she's over/under, a usable image can be obtained after the fact. If your camera only shoots in JPEG or the latitude of your camera's chip is one or two generations back, then you're again at a disadvantage. Of course, when everything goes right, you have no worries. It's when you're too wide/bright/dark that you'll need that extra range to make the difference, and with prosumer and consumer cameras, you're limiting yourself beyond what you'd find acceptable if you were shooting film.

One of the bigger mistakes I see a lot of photographers make is that they don't see the value in the pro-line lenses. The best lenses typically have a maximum aperture of f/2.8 or better and are fairly expensive. This isn't a marketing ploy; the more expensive lenses have better optics. So what does this mean? It means the lens was designed for digital, set up so that all the colors focus at the same point in space (previously, this was referred to as *apo-chromatic*, or *APO* for short). This was only really seen in Leica and Hasselblad (also known as *Zeiss glass*), which accounted for the significant quality shift in images produced through that glass and the high price point for those lenses. They met the highest and most stringent standards for optics, and it sure made a visual difference. The top-of-the-line lenses deliver the purest of optics. You might read a review in a photography magazine on the latest lenses, and for the pro-line lenses they'll list "expensive" in the cons section. As a professional, I don't subscribe to this as a con.

Further, stopping into your glass to f/2.8 is going to give you a sharper image than shooting wide open at f/2.8. What I mean is, if you have an 85mm f/2.8 lens and an 85mm f/1.4 lens, when you are at f/2.8 on the former lens, you are wide open, using the edges of the optics to produce the image at f/2.8. When you stop down to f/2.8 from f/1.4, 2+ stops, you are "deep" into the glass, and the resulting images will generally be sharper because you are using more of the center and less of the edges of your optics.

Computers: Desktops, Laptops, and What's Wrong with That Three-Year-Old Computer

What's wrong with that three-year-old desktop computer? For starters, it's slow. Second, its hard drive will most likely crash sooner rather than later. Computers, like cameras, have a fairly short lifecycle. Friends of mine make sport of my desire to have the best and most useful gear and computers. But in the end, I have the tools to do the job, and that's what the client pays for.

MACS VERSUS PCS

Windows fans cite the statistic that in the U.S. only 10 percent of today's computers are Macs. What that statistic fails to reveal is that approximately 70 percent of the entire group of computer users from which that same 10 percent is drawn are enterprise-level major corporations whose IT departments dictate the PC mantra—in part because it keeps them employed fixing all the PC crashes and the like. When you extract enterprise-level networks from the equation, the Mac percentage skyrockets, and rightly so. Here's why:

▶ **Viruses.** Ninety-nine percent of all viruses (and some would suggest 99.9 percent) are written to take advantage of weaknesses in the Windows operating system. From Internet Explorer to Windows Vista, there's a reason why Microsoft must put out security patches once a month or more. Thankfully, Macs don't incite the ire of hackers wishing to take on (and take down) the behemoth that is Windows. Further, the UNIX operating system, on which Mac's OS X is based, is a better programmed and safer operating system. That said, if you buy a Mac and boot into Windows on it (or use Apple's Boot Camp application to run Windows operating systems on your Mac), you'll be just as susceptible to those viruses.

▶ **Stability.** Microsoft's operating systems constantly face delays on their launch dates and often end up being pared down to meet those pushed-back deadlines because they have not started from scratch since early versions of Windows. As a result, the feared "blue screen of death"—the indication that your PC has fatally crashed—appears far too often in my opinion, and it inevitably occurs when you're on deadline or you have not saved all the Photoshop retouching, for example, and you lose your work and possibly the data on that drive. At some point, Microsoft will begin an operating system from scratch and not build on the faulty and error-strewn code from previous builds. As this book was going to press, Microsoft was launching Windows 7, and Bill Gates was coyly critical of Windows Vista during his 2008 CES appearance, suggesting when he was asked, "What Microsoft product could have used a little more polish before release?" during an interview with the website Gizmodo, "Uh, ask me after we ship the next version of Windows [and then laughed nervously]…then I'll be more open to give you a blunt answer."

Macs have always been the choice of "creatives," from art directors to photographers, illustrators, graphics designers, and the like. Software has been written specifically to take advantage of Mac functionality and often is then transferred over to PCs. The software that best serves this community is often Mac-optimized, Mac-centric, or sometimes Mac-only.

If you are an employee of a large company that dictates you must use a PC, then by all means use a PC and take full advantage of the IT department. Make them your friends by gifting them with gift cards for Starbucks, donuts, or Danish, because you want to be on their good sides.

(continued)

MACS VERSUS PCS (continued)

You want them to help you and look out for you, and java and pastry are an appreciated way to ensure that your IT department looks forward to your calls and panicked visits.

I spent close to eight years running cross-platform with an equal number of PCs and Macs, and every time I had a problem with a PC, it took two to three days to find and fix the problem. Problems with the Mac were fewer and farther between, and they took 30 minutes to an hour to resolve. I finally donated all my PCs to the Salvation Army, took a tax deduction for my donation, and said good riddance. I do, however, keep one PC in the office to use PC-only shipping software, to test CDs with client deliverables, and to remind me of just how much I never want a PC office network again.

That said, there is a studied reason why the latest and greatest machines are worthwhile acquisitions. The first and foremost reason is productivity. If you want to know just how much time and money you can save by buying a new computer on a regular schedule, do a little homework. First, take a hundred Raw camera files and run them through your workflow from ingestion to final deliverable form, timing the entire process. Then, visit a friend who has a faster machine than you and do the same workflow, timing that as well.

Now work the math, in this instance using the Mac pricing as an example. The latest top-of-the-line Mac is around $3,300. Currently, that's a 8-Core 2.26-GHz G5. If you have an older machine, look on an auction website, such as eBay, and review the completed sales to see what the cost differential is. (In other words, if you sold your current machine, what would be the difference between the sold price and the new computer's price?) For example, a Quad 2.5-GHz G5 is selling for around $1,500, and a G4 Dual 1.25-GHz machine is selling for around $400. Taking the G4 as an example, there is a net outlay to you of $2,900 for the latest top-of-the-line machine. So, what does this do for you?

If it takes 38 seconds to process an image in your raw processor on the G4 and another 13 seconds to complete other workflow tasks (metadata application, saving, downsizing, and so on), then you are at 51 seconds per image. However, that 8-Core G5 will take (from my own experience) about six seconds to process that same file and then another eight seconds to complete the rest of the tasks, for a total of 14 seconds—a time savings of 37 seconds per image.

My hourly rate charged to clients for sitting in front of a computer works out to be about $125. This works out to be about 3.5 cents per second. This means that if I am saving 37 seconds of processing time with the new computer, I am *saving* $1.28 per image in processing time. If 100 images used to take 85 minutes to process, with the new machine they take 23 minutes. With a net outlay of $2,900 for the new machine, the machine pays for itself after about 2,300 images processed, and every image after that provides both cost and efficiency savings.

If you offer video as a service, which is very processor intensive, the difference is even more dramatic.

If you've ever sat at a computer and complained that you had to babysit it, you couldn't process the images fast enough to get to other work, or you were overwhelmed with images, then a faster machine will free you up sooner than the older technology.

The next question is whether it's worthwhile to sell that old computer for $1,500 or whether you should keep it as a second machine that you can use to do invoicing, web surfing, e-mailing, and other non-processor-intensive work while your new faster computer is crunching away on images. In my studio, machines migrate from the processor-intensive work to other workstations as new machines become available with significant speed increases. While a jump from a 2-GHz processor to a 2.5-GHz processor might not be a justifiable expense from a cost-benefit standpoint, taking the time to evaluate the speed jumps that are justifiable will mean less time for you watching a progress bar or batch process and more time for doing other things.

For laptops the same speed issues come into play, and as you migrate from a slower machine to a faster one, the immediate past laptop becomes your backup laptop. This way, in the event of an equipment failure or if your primary laptop is in the shop, you have a laptop that allows you to continue to service clients' needs on the road and do other work while away from the studio, whether for a day-long assignment or one lasting a few weeks.

Monitors are another issue altogether. They age, and they all render colors slightly differently. As they age, their rendering capability reduces and then reduces again. The average lifespan of a CRT monitor is between 15,000 and 20,000 hours. Although this may equate to three to five years before the monitor actually ceases to function if used during a typical cubicle-employee's workday, after a period of 18 months to two years of "always on" use, your monitor will fail. To render colors accurately and consistently, you'll want to replace it within 18 months to two years for the average workday and yearly if your computer screen is always being used (by you or a screensaver). On a CRT monitor, the phosphors diminish in capacity; on an LCD, the backlight will dim, change color, or just deliver erratic shifts in both, requiring a replacement every few years. In many cases, the monitor won't be color-calibratable after this time, or the longevity of a calibration will be quite short. If you're buying a used monitor, use as a basis the "manufactured on" date to determine whether it's a good deal or whether you're buying someone else's "aged out" monitor.

Specialized Equipment: From Gyros to Blimps to Generators

Not every assignment can be completed with a 50mm lens. Almost all require a range of lenses, from wide to zoom. Although this might seem like a given, at what point do you begin to have specialized needs? Some photographers will need a range of 24mm to 200mm, and they're A-OK for 98 percent of their assignments. For the other 2 percent, fisheye or 300mm to 600mm+ lenses become necessary. At some point, you'll be called on to utilize specialized equipment, and you can opt to purchase it (recognizing that your ownership of this equipment makes you more valuable to a client) or rent it when necessary, passing along that cost to the client.

Whatever your specialized need, make sure the client understands that you are capable (whether by ownership or by your previous extensive experience with rented equipment) of delivering to meet his or her needs.

Recently, I was called by a major financial cable news program to do photography on set in Washington during an interview. Setting aside the egregious rights demands for the purposes of this example, the client wanted to ensure that I had experience shooting on set and that I had a blimp. A blimp is a customized box that encloses the camera and lenses and dampens the shutter and other camera noises to nearly imperceptible levels from even two feet away. In the past, I've used towels, suit jackets, blankets, and even padded rain shields in an effort to reduce audio on set, and they all pale in comparison to the real thing. Once you've used a blimp, you realize that doing work on a movie set, TV studio, or any other place where your camera's noises will be a distraction is a must. There are other manufacturers out there, but the Jacobson Sound Blimp is the gold standard, and some movie sets require that particular brand be used or you are not allowed to shoot on set. You can find out more information at www.SoundBlimp.com. Further, using the words "camera sound blimp" on search engines will yield additional information on these products and their necessity.

I also find myself being called to deliver photography from either extremely low light locations or from unstable shooting platforms (from the back of a motorcycle to an off-road vehicle or from watercraft to helicopters). If you've ever tried your hand at this, you know that your ratio of sharp/in-focus to blurry images leans significantly to the unusable side. Having a tool such as a Kenyon Gyro (www.Ken-Lab.com) will tip the scales significantly toward the sharp/in-focus side. Once you've used a gyro, you will understand and begin to consider other applications for its use so you can deliver higher-quality finished results to your clients.

On occasion, I end up working on location where my battery-powered strobes won't meet all of my needs. Whether it's more watt-seconds that I need, or computer power, or other power needs that the car's cigarette lighter won't handle (or can't handle because it's not close by), a generator has found its way into my resources collection, and more than once it has been a significant benefit. I've outfitted the generator with multiple power-calming protectors—in-line plugs that ensure no surges will be sent down the power line to fry my laptop/light packs and so on. These plugs will trip before damaging my equipment. To date, I've never had one piece of equipment damaged by the "geni" (my affectionate term for it, pronounced "Jenny"). In fact, following a hurricane, the neighborhood where my studio is located experienced a power outage for six days. I was able to power my entire home office, critical other items (TV, cable box, refrigerator, and strategically placed lights), as well as two neighbors' refrigerators for all six days, nonstop. I just kept refilling the fuel tank until the city's power returned. An $800 investment that paid for itself years earlier on assignments became a critical "must have" during this time, and I will never find myself without one for all of these reasons.

Renting to Yourself and Others

If you own specialized equipment, you can recoup the expense of owning and maintaining it through rental. For years in the video industry, there has been a line item for the camera operator, the sound technician, and camera rental. It didn't matter that the camera operator owned the camera; it was not a part of what came with the camera operator, and in some instances the contracting company provided the camera operator with equipment. So in the

instances when the assigning client wanted the equipment, they paid for the rental. For years, we photographers included our film cameras in our fees. However, during the shift to digital, many photographers did not own digital cameras, so they began to pass along a digital camera rental fee to the client.

Those who made the significant investment began to apply the video model, and a line item on invoices began to appear to amortize the cost of ownership over client requests, in the form of a rental to clients. This model is especially prevalent among those using $20,000 to $40,000 medium-format digital backs and the even more expensive 4×5 digital backs.

This model can extend to other specialized equipment, from ultra-wide angle lenses, to 300mm+ lenses, to blimps, gyros, generators, location vehicles, and even lighting. Many photographers do not own lighting equipment and will rent on an as-needed basis. For those who have a basic lighting kit, some shoots require multiple simultaneous lighting setups or complicated and extensive lighting, so additional kits are necessary. Ensuring that you will be able to rent additional lighting or including a line item for the use of your own lighting or other specialized items is as simple as outlining it on your estimate/contract and, if necessary, being prepared to justify the line item when asked. If you feel that the line item listing of "Lighting kit rental $275" is dishonest because of the use of the word "rental" and the fact that you own the lighting kit, then simply use one of the following:

▶ Lighting kit – $275
▶ Lighting kit charge – $275
▶ Lighting kit, as necessary – $275

or some variation thereof. When a contract is returned signed with that as a line item, it's approved as a client-payable charge. This same methodology applies equally to all other equipment.

For gyros, Kenyon Labs will rent theirs to you for around $200 a week (plus $25 shipping each way). At a purchase price of around $2,500, if you're going to need a gyro more than occasionally, it makes sense to own one and rent it to yourself for $250. After 10 uses, it's now yours. The daily rental charge of the same gyro from rental houses that have them available is $60/day, plus shipping/courier. This, however, presumes that you are local to them. If you are an overnight shipping day away, you're looking at either a two- or three-day rental from them, again approximately $175 to $230. So, establish your own rental charge to yourself (and your colleagues) of $200 for up to a week; it will pay for itself over time and then become a profit center for you.

Jacobson blimps rent for around $50 a day plus shipping if you're not nearby, with an assortment of lens tubes to accommodate your various zooms and fixed focal length lenses. So, it'd be fair to charge, say, $90 a day. Jacobson will sell you a blimp and the three most common lens tubes for around $1,400, so with about 15 days of use, it has again paid for itself and is now a profit center. However, don't try to buy a blimp within a week. Orders can take up to three months from the time you order until you receive it. They are handmade and exceptional pieces of equipment, so don't expect a fast turnaround; however, they are worth the wait.

For generators, a national company such as Sunbelt Rentals will rent to you a powerful generator that delivers 5,600 watts, a peak capability of 44 amps, and a continuous load of 22 amps for $50 a day on average, with a $20 delivery and a $20 pickup charge within 10 miles of their location. You can offer the same generator capabilities from one bought from a national home-products warehouse, plus the power calming cords for $800, for the same price that you were paying to rent it from the rental company. After a few rentals and uses yourself, again it can turn a profit (as with everything else), not to mention get you back up and operating during a lengthy power outage. Few things are worse than being on deadline without power, especially when your client is four states (or a world) away and is not experiencing a power failure, nor seeing your local problems on their news, and thus he or she can't understand why you can't deliver as promised. Further, when you can offer to a client the capability of being up and running during the aftermath of a disaster, you can become a valuable resource to them, either as their onsite photographer or as a logistical command post for the crews they send in. If your local community won't be hiring you anytime soon because of their own loss of business situation, you will need to be able to make your services available in other ways to those coming in from the outside.

Chapter 3
Planning and Logistics: Why a Thirty-Minute Shoot Can Take Three Days to Plan

An oft-heard refrain from the unknowing client is, "Why is it so much? It's only a(n)...

> ► ...30-minute press conference."
> ► ...portrait that will take 10 minutes."
> ► ...hour-long reception."
> ► ...shoot where we need one good photograph."

...and the list goes on.

There is an old story about a customer with an ill-performing car who comes into a mechanic's shop for a repair. The mechanic, after less than five minutes of looking at the car, reports to the owner that the fee will be $250. The customer is relieved that it's not higher and approves the estimate. The mechanic returns five minutes later to report that the car is now repaired and ready to go. The once-happy customer now feels swindled and begins to object. "You took less than 10 minutes total to look at and fix my car, and you want $250? That's outrageous!" To which the mechanic responds, "You're not paying me for my time; you're paying me to know which screw to turn and how much to turn it."

Planning and preparation are cornerstones of success. The Roman philosopher Seneca once said, "Luck is what happens when preparation meets opportunity." I have often found myself in circumstances in which we were told it would be an indoor portrait, and perhaps it was raining lightly that morning as my assistant and I left for the assignment. We arrive, and sure—we could make a nice image of the subject in a boardroom or his office. As we're carting the equipment into the building, I notice the rain has stopped. When we get upstairs, I propose to the subject that we take the portrait outside. He is amenable, plus it gets him out of the office for awhile. We head back outside, where we load the power packs back into the car and pull out a softbox, a scrim, and the battery packs that I packed as well, but which remained in the car.

We set up the softbox and the scrim and make a few tests to ensure we're a stop or so above ambient, out comes the subject, and 10 minutes later we're done and the subject is happy. The client will be too, because they commented that they wanted something outdoors if

possible, but they understood it might not be possible. As we're breaking down, the assistant has, on more than one occasion, remarked, "You were lucky that you were able to make an outdoor portrait." My stock answer is "Yup," but had I not been prepared with the battery packs, we would have missed the opportunity and not been as "lucky."

Be Ready for the Unexpected

When you're doing a portrait of a CEO for the company, do you have additional wardrobe in the event that his shirt is the wrong color, is wrinkled, or has a moments-ago coffee stain? What about a tie alternative? What about the executive who cancels the portrait session because of pink eye? The construction vehicles in the background of a shoot you scouted two days ago, when it was clear? The addition of four people to the portrait you thought was of just one person?

TIP

Hint: Always travel with a nine-foot seamless instead of a five-foot one. You're far more likely to be able to make it happen that way. As a last resort, run the seamless you have horizontally along the wall, taping it at the top and sides with gaffer's tape, instead of hanging it from stands and a cross-pole. Because you billed the client for the seamless, there's no reason not to use it up unless you're at the last eight feet of the seamless and didn't bill the client for it. You did bill for it, didn't you?

All of these are circumstances you could find yourself in, and myriad other things could go wrong, go sideways, or just plain throw you off. If you do not have multiple backup plans and the resources to carry them out (preferably seamlessly), then you are not ready for the unexpected, and this lack of preparation will ruin your shoot(s) at the least desirable times.

Another circumstance occurs when you have a plan for a particular look, lighting setup, backdrop, or otherwise creative concept. You set up for it, set up your equipment for it, move furniture to the best location, and then the subject walks in and objects. Maybe he or she objects to the fact that the furniture was moved or doesn't like the overall backdrop.

On one particular assignment quite early in my career, I traveled to the Los Angeles area for an article on a museum. One setting I wanted was a grand room with chandeliers and an amazing decoupage piano. The problem was, the piano was in the background, and I wanted it as a foreground element. I looked around for the curator and, not finding her, decided to move the piano myself. The photo was great, and I was about to move on to the next scene when the curator appeared and almost had a coronary. It seems that I had moved an antique, extremely expensive, and extremely fragile piano. Not only had I moved it, which she would have expressly forbade, but I had moved it across an extremely rare Persian rug. She informed me that she'd have to bring in expert movers to move it back. Lesson learned, but that photo ended up being the section opener for the magazine, and the art director loved the shot! My bad.

It All Comes Down to Now! You Better Be Ready

I have found myself in numerous very relaxed situations in which, in an instant, we are moving at 100 miles per hour without warning. These situations range from a stakeout of a scandalized politician who makes an unexpected appearance to get the morning paper outside his home; to a CEO whose schedule changed and we had to wait around with lighting already set for what his executive secretary said would be 90 more minutes, but then she announced the CEO would be there in two minutes; to war photographers who can be mid-cigarette when an all-too-close mortar round not only signifies an immediate risk to life, but also, for those with nerves of steel, the beginning of possible news photos.

This is somewhat different than being ready for the unexpected. These are the circumstances that you were expecting at some point, but they arrived sooner or later than you expected or in a manner that generally throws you off. This means that you need to set your lighting and be ready earlier than scheduled, have cards (or film) in the camera, and have nonessential equipment stowed. And neither you nor your assistants are making a bathroom call until the shoot is over.

When you get a message that there is a delay in a subject's availability by 60 minutes, you want to really think about allowing assistants/makeup people to go get a sandwich or otherwise take a break. On more than one occasion, I sent the assistant out just to feed the meter, and when he or she returned not 10 minutes later, the shoot was over. In these situations we were all ready to go, and I successfully completed the shoot, but had something gone awry—head failure, setup change, and so on—I would have had a challenge on my hands.

Conveying Your Plan to a Prospective Client Can Win You the Assignment

Many times during the initial client dialogue—especially when you're an unknown quantity to the client—one of the client's concerns is, "Can this photographer do what I need, when I need it, how I need it?" Of course, the client will try to whittle down prospects by reviewing portfolios, websites, and the like. When the client gets a referral from a colleague, you're even further along the way to winning the assignment.

A few years back, I was called in after a portfolio review to discuss the details of the shoot and do a little brainstorming about it. I wanted to be careful because I didn't want to give them my creative suggestions, only to see them presented as if they were ideas from the client to another photographer, who then would bring the ideas to life. The task at hand was to produce portraits of the CEO and president of a company in three distinct portrait settings, two on location and one in a studio. The challenge was to accomplish all three in less than 60 minutes, including travel time.

During the meeting, I outlined how I would make this work—two assistants in each location, additional rented lighting, a generator, catering at all three locations, a location manager for the two on-location portraits, permits, and so on. I pitched a few nebulous creative ideas for each of the locations, and the client liked them. More important, the client was taken with my grasp of their needs and my solutions to making all three photographs happen within the client's time constraints.

During the course of the conversation, I learned that not only was I bidding against two good friends of mine, but I was also the highest-priced photographer. At the conclusion of the meeting, I knew I had made my best proposal, but I was slightly concerned that the client would go with a lower-priced photographer. In the end, they called the next day to say I was their choice for their five-figure assignment, and they faxed back my contract. We completed all three shoots in 48 minutes, with results better than the client expected.

I find that outlining a scope of work and approach can allay the client's concerns about your capabilities. And if the conversation goes well enough for a mini-relationship to begin to build, the client has told you enough, and you've had a good conversation, they have invested enough in you (in terms of explanation, objectives, and so on) that they say, "I'm just going to give you the assignment." This means that no one they called and left messages with or whom they spoke to and requested a bid from is going to win the assignment.

I find this to be the case quite frequently. One situation was an assignment in which the client was looking for a photographer using the search term "ESPN Magazine cover photographer" on Google. Fortunately, I rank fairly high for these search terms. I note this not for a point about marketing, but because I did not come to be known by this client by any trusted means (referrals, the client having seen my work elsewhere, and so on), but rather from a web search. We began to discuss the shoot, and within a short period of time, an e-mail came though saying, "You can have this assignment. Let's talk today." Bingo! Shoot's mine! Now, this wasn't a small editorial shoot. It was a cover assignment, and the group photograph of players on a basketball court earned roughly $3,000. This was not only a nice "get" that validated the critical nature of my website; more importantly, it illustrates the value of conveying your plan to a prospective client.

When a Seven-Minute Shoot Becomes Three, What Do You Do?

Short answer: Make pictures first, ask questions later. Now, smart answer aside, it's critical that you be prepared and honor the latest instructions about time limits. On more than one occasion—once at the Pentagon, once in the Oval Office, and once at a symposium on cancer research—a painful reduction in my shooting time was passed along with just minutes to make accommodations.

This is the ultimate illustration of why what you charge for your services should not be based upon time. Rather, it should be based on skill, creativity, and usage. Imagine having a seven-minute shoot cut to three—that's a 43-percent reduction! Would you be willing to perform for a comparable 43-percent reduction in your photo fees? I certainly would not. More on this in Chapter 7, "Pricing Your Work to Stay in Business."

First things first, you should have a contingency plan for this, and now is the time to put it into play. Jettison the extra angles/shots you were thinking you could do, knock out one of the accent lights (if you also have to set up within this timeframe) if you can, and make sure your light tests are done with your assistant (or your minder) making sure you stay in line and on schedule, so that every minute is used making images, not tests.

One of the first situations I experienced this in was during the days of film, when we needed to shoot a Polaroid. Ninety seconds was an eternity while it developed. So, even with light tests shot, we first shot a Polaroid and then, without waiting for it, we began shooting film. I refer to this technique as "shooting through the Polaroid." After 90 seconds, halfway through the shoot, the assistant pulled the Polaroid, and if there was a problem, we'd correct it during the remaining 90 seconds. With just three minutes and a fast recycle time (one more reason for high-powered lighting kits, as noted in Chapter 2), we were able to shoot five rolls of 120mm film on a Hasselblad, or 60 frames.

I also made certain that my assistant was tracking three minutes. The assistant's job was to convey to me, "One minute, two minutes, two-and-a-half minutes, time." I didn't want a minder calling the shoot 30 or 45 seconds early. In one case, I said to two world-renowned cancer researchers, "I understand we have you for three minutes"; much to my surprise, they responded, "Yes, and only three minutes," to which I responded, "Yes, and I will have you done within that time limit." Twice during the three minutes, I made frames that ended up capturing one of them as he checked his watch. My assistant gave me the 30-seconds-remaining mark, and after four more frames, I stopped and said, "Gentlemen, thank you for your time." They were pleasantly surprised that I actually was done.

The key is to have planned what to do, what not to do, and what you can do to accommodate a change in the schedule that is beyond your control. Some of the best times to go over these details are prior to arriving at the shoot, during a pre-briefing, or during the car ride to the assignment.

When to Call in a Specialist: From Lighting to Location Management, Catering, and Security

There are times—frequently for the big-time photographer and less so for the middle-of-the-pack photographer—when specialists have a definite role to play. Interestingly enough, many a well-known and highly regarded photographer in New York City couldn't light a candle, let alone an assignment that calls for a basic 3-to-1 lighting ratio, or even light from head to toe on a shadowless white seamless. These photographers rely on talented assistants who can quickly and perfectly light a scene as the photographer (or the art director) describes it.

Lighting Assistants

If you're a photographer who's used to shooting available light, but you get an assignment that calls for lighting expertise, renting the lighting from a local rental house and culling through assistants looking for those who have experience with that brand of light and are

familiar with lighting will be your solution. Although some may suggest that every photographer should know how to light without relying on the talent (and creative contribution) of an assistant, it's one thing to know what look and feel you want and to have an assistant achieve the technical objective and refine it to your direction, and it's another thing for you to tell the assistant to "just light it nice." Unless you've taken the necessary precautions, doing so could result in that assistant taking partial credit for the creative input and coming back for a larger piece of the pie than you'd originally agreed upon.

Makeup and Stylist Services

Many photographers who regularly use assistants rarely use makeup or stylist services, but they should. Consider that every time there is a guest who appears on a television show, they go into makeup—sometimes only to remove the glow, but often for much more. Although today's digital photography–enabled shoots can often have some degree of retouching of bags/shadows under the eyes, problem hairstyles, and the like, even today an often overlooked crew member is the makeup person or stylist. In fact, I've had clients say to me that I was the only photographer who included a makeup person in my estimate, and they knew that I was aware of what went into making the type of photograph they needed, so I got the assignment. When a stylist or makeup artist is a line item, it's easy for the client to suggest it be struck, which will cover you in the event that the subject looks less than he or she could. It could also justify retouching fees to fix the blemishes on the subject's skin. You can also advise the client that you feel strongly about the subject having makeup on hand. On the occasions when I get push back saying that the subject doesn't want makeup, I remind the subject being photographed that if he went on television, he'd have to have it. Besides, we're not doing a makeover, just a light powdering. This usually makes an impact.

Location Managers

A more technical, but no less important specialist is the location manager. It's the location manager's responsibility to secure the location that meets your needs (often by scouting locations themselves or by hiring a location scout on your behalf)—to find just the right basketball court for a sports shoot or the perfect scenic overlook for a particular city you are traveling to. It is even sometimes the location manager's job to meander through the permitting process on your behalf in your own city, either because you are too busy or you just don't know what's involved. In addition to the pre-production days the location manager will be charging you for ($500 to $800 per day is not an uncommon range), he or she will also be on hand the day of the shoot to facilitate load-in and load-out of equipment—making sure you have a permit for rush hour parking, you have backup locations (and accompanying backup permits for them) in the event that your view has been usurped by construction vehicles or some other distraction, and you have or are aware of necessary power resources (whether hardwired or requiring a generator), as well as numerous other items.

Producers

For large-scale shoots (and even complicated mid- and small-scale shoots), a producer can make your life much easier. The producer's job is to handle everything from your arrival to your departure, including making sure you're picked up at the airport and you have local assistants, a competent location manager, talent agencies, and models; facilitating scouting and tech scouting; making sure the client arrives and is taken care of; ensuring there are catering and pre-/post-shoot dining recommendations; making sure there are production vehicles and resources for backup equipment; and obtaining security if required by city permitting ordinances or if you've taken over a large location and need assistance keeping the general public out of your pictures and your set so that equipment doesn't walk away. Imaging arriving, and the only thing you have to worry about is showing up on set, discussing final details of the shoot, making the photographs, reviewing them with the client, and then having everything else taken care of by your crew. If this sounds fantastic (in other words, fantasy, not reality), then you'll be surprised to know that these types of shoots take place numerous times a day, every day, across the country. If you think you'd like to get into this level of work, take the time to call a producer nearby and discuss what he or she can do for you and what the charge would be.

In the end, the more noncreative aspects of a shoot you can farm out to people who not only do nothing but those things, but who really enjoy and thrive on doing them, the more you can concentrate on making great pictures and ensuring the client is happy and your work meets and exceeds their expectations. This will ensure the client comes back to you. In the end, these specialists appear as line items on your estimates and invoices, so you're not covering the cost of their services out of your pocket.

One more thing. If you're hiring a helicopter or other mission-critical transportation (seaplane, boat, desert land rover, and so on), take the advice that leading aerial photographer Cameron Davidson gives: Safety trumps all other concerns. Also, the more people and equipment you are hauling, the less likely you will be to have a good safety margin—then see advice item #1. Just because there might be room in the helicopter for the client, unless he or she absolutely, positively must be in the aircraft with you, the client stays on terra firma. Come back, review the images on a laptop with the client, and then go back up if you have to or can.

Second, do everything you can to have a helicopter with twin engines. If one fails, you can make it back to the ground safely, without having to eat your knees. In addition, make sure your pilot is not some low-hours hotdog or a pilot used to flying a pattern to show tourists the sights of the local area. Choosing a pilot who's experienced in working with aerial film and still photographers and who has *at least* 1,500 hours in the aircraft in which you will be flying will mean better results for the client and a safer return for you.

This holds true for small, fixed-wing aircraft as well. On assignment for the Smithsonian Institution in Alaska for a book I was doing for them, we had to have a pilot who could take off from a grass field and land on a sandbar along the ocean. Further, he had to know when that sandbar was going to disappear because of the tides and how much time it would take to get both plane loads of crew and gear out before then. En route, he also pointed out where

CHAPTER 3

the black bears congregated along the river so we could avoid that area. He was well-versed in these and numerous other details that I was glad I didn't have to worry about. But that's the point—he's the specialist, and we hired him to get us safely there and back home.

If you're in need of someone who does one thing (or just a few) and does them well, reach out and establish relationships, collect names, and understand areas of expertise and associated rates. You never know when you'll need a specialist and the figures and details necessary to complete that estimate you're working on at midnight.

Chapter 4
After Staff: Transitioning to Freelance

The transition to freelance is one of the more difficult transitions to make, usually because it happens to you without notice and when you've not planned for this occurrence. The trend over the years, starting with *Life* magazine and then moving on to *People*, *Newsweek*, and *Time*, is evolving into shrinking photo staffs at newspapers across the country who are now relying on freelancers and either laying off or diminishing full-time, salaried staffs through attrition.

This trend started when papers began hiring freelancers on a regular basis, not because of unexpected breaking news, but as a cost savings over large employee budgets. Soon, the accounting departments learned that a freelancer could deliver the same "all rights forever" package for a fraction of what it cost to maintain an employee. The trend began to spread like wildfire and shows no signs of a reversal. The staff photographer who believes he will have a job in 10 years is kidding himself. Photo departments that used to have six to twenty photographers on staff will now be one- or two-person departments or six- to nine-person departments for the largest papers. The director of photography or photo editor will find himself with a camera in hand occasionally, whereas just a few years ago he thought he'd never pick up a camera again.

The transitional year for me as a staff photographer was 1993. I had spent almost three years traveling the country and the globe, to more than 40 of the 50 states, Cuba, all throughout Eastern Europe and the Americas. As a young staff photographer, I was firing on all cylinders, going at a hundred miles an hour. The problem was, I wasn't wearing a seatbelt, my brakes were shot, and my airbag had malfunctioned. I had no safety measures in place for the letter that I received in the spring of 1994 (see Figure 4.1).

THE WORLD&I

A CHRONICLE OF OUR CHANGING ERA

John Harrington
700 4th St.
Washington, DC 20002-4316

Dear John:

As you are well aware, we have been facing budgetary pressures in this company for a long time and that the cost justification for employing two full-time photographers based on the number of images used has come under scrutiny. I think you also know that my intention when drafting the FY 94-95 budget was to make every attempt to retain both photographers, and accordingly I chose to cut some $35,000 out of our budget for free-lance and agency photography in hopes that we could more aggressively use our staff photographers and thus retain them as full time employees.

Some time after submitting this budget, it became evident that yet further budget cuts would be necessary to bring our spending into line with our projected subsidy and revenue levels. Regretably, your position is being reduced to part time, hourly (20 hours per week, at $15 per hour, without company benefits) as one part of additional budget reductions the company is currently making. This change will be effective July 29, 1994, and you will be eligible to receive any unused vacation pay. Personnel will provide you with all the information necessary to assist you with COBRA insurance continuation, 401K funds, and any other related questions.

I appreciate your efforts on behalf of the magazine, regret sincerely the circumstances that dictate this action, and look forward to your productive contributions in the coming months.

Best Wishes,

Eric Olsen
Associate Executive Editor

A Publication of The Washington Times Corporation
2800 New York Avenue, N.E. • Washington, D.C. 20002 • (202) 635-4000
Telecopier: (202) 269-9353 • Telex (Int'l) (605) 2761932 • Telex (Domestic): 101(650)2761932

Figure 4.1

When I received this letter, I was in shock. Was there something I could do? I was the chief photographer of a monthly magazine—I was responsible for dozens and dozens of photographs each month that were a part of our effort to fill 702 pages a month. How could they survive without my work? Who would travel for them? In came the other staff photographer, who had received the same letter, and he was upset. He was much older than me—probably in his 50s. Both he and I were being cut to half-time. "I can't take half my salary, John," said the other photographer. "I have to find another job that can support my family." And he left the building. For a moment, I was sad for him too, but my survival instinct kicked in, and I thought, "Well, if they can't support two of us full-time and place us both on half-time, and the other photographer leaves, then they can put me back on full-time." My brilliant idea might just save me. Then the word came back. Nope. We'll just have to do with you alone at half-time.

I quickly did the math. My takehome pay would only cover my rent and utilities, nothing more. I stocked up on Top Ramen (both in brick and cup form) and started to see how I would go about freelancing. At the same time I was doing that, I was still tasked with working 20 hours a week and doing my best work for the magazine, and those were some rough times. If I never eat another Top Ramen again, it will be too soon.

As I sought and produced a few assignments a month, I found I could pay things such as car insurance, gas, and a limited amount of savings that I put aside for leaner months. In January of 1996, the same editor handed me the letter in Figure 4.2.

A glimmer of hope! A light at the end of the tunnel! The magazine is doing well—so well, in fact, that I got a three-percent cost-of-living increase, and it was backdated five months! Steak dinner! And, the editor wrote words that made me feel like I was a part of the team: "Your efforts on behalf of the magazine are very much appreciated. Please keep up your good work."

Unfortunately, that light at the end of the tunnel was the freight train barreling toward me, and in August of 1996, just three weeks shy of my date to be fully vested in my retirement savings, I was laid off in a short meeting. I asked for just those few weeks, and the same editor who "very much appreciated" my efforts said no.

There are only two upsides to this story. The first is that I had just over two years—from spring of 1994 until August 1996—to grow a freelance business that was sustainable. The second is that I may well not have become (or survived as) a freelance photographer and thus written this book had this situation not happened to me. Hopefully, you will learn from my example how to best prepare for an unexpected departure from your staff position, even when you think things might be looking up.

Here's an important point: Until you start making a solid amount of income as a photographer, you may have to take another job (in another industry—perish the thought!) to support your freelance career as it gets off the ground. In my case, I had just enough revenue from that part-time work to get things going.

THE WORLD & I

A CHRONICLE OF OUR CHANGING ERA

January 1996

John Harrington
Photographer

Dear John,

 I am pleased to tell you that you will be receiving a three per cent increase in your salary, giving you a new gross annual salary of $16,068. This change will be reflected in your next and subsequent paychecks. In addition, the increase is being backdated to August 1, 1995 and that will be reflected in your next paycheck.

 Your efforts on behalf of the magazine are very much appreciated. Please keep up your good work.

Yours sincerely,

Eric Olsen
Associate Executive Editor

A Publication of The Washington Times Corporation

3600 New York Avenue, N.E. • Washington, D.C. 20002 • (202) 635-4000
Telecopier: (202) 269-9353 • MCI Mailbox (Int'l): (605) 2761932 • MCI Mailbox (Domestic): 101(650)2761932

Figure 4.2

Dealing with the Uncomfortable

I get that dealing with the business end of photography isn't always comfortable. It wasn't for me in the beginning. Whether it's determining the specific fees and applicable production charges for an assignment; providing an explanation to a client about a particular item (such as, "What is post-production? Can't you just copy the photos off the card and burn me a CD? That's all I really need...") so that they not only understand, but they can explain it to their superiors/client and be on board with it; or calling up a delinquent client about an overdue invoice, all of these and countless more situations frequently make photographers queasy and even weak in the knees.

Also something that you may not realize is that you are now your own information technology (IT) department as well. No longer can you just call a help desk to fix things when your computer doesn't work or you need a new cell phone. You are now that IT department.

When you are just starting out or have been forced into freelance from a layoff, don't worry about having an assignment every day or even every week. Worry that each assignment you do is done right—from a qualitative standpoint as well as a business standpoint.

Ensuring that your paperwork is in order, with signatures from clients on contracts/estimates, alleviates other issues down the line, from bad language on purchase orders that come along to misunderstandings over who owns what.

Moreover, practice explaining things such as what post-production is and why the client should be paying for it, why there's a markup on certain items, and what the difference is between a creative fee and a usage fee. Oh, and why the client doesn't own the images to do with them whatever they want.

Discussing these things—especially at first—is uncomfortable. Add to that uncomfortable situation the fact that you want this client to like you, to hire you, and yes, to pay you a fair fee for these things, and it gets worse, because things like money to pay the rent and electricity are on the line.

Help Out a Staffer

Staffers must be prepared to become freelancers unexpectedly. They first need to have a website. I know of several current staffers who have their own websites. Further, that means having their own business cards to hand out where appropriate. This means knowing how to send a contract and figure out rates and rights.

Oh, and if you're friends with staffers who used to look at a $200 freelance job as gravy to complement their meat-and-potatoes staff job revenue, and now those staffers are out of a job, you need to enlighten them that they can no longer afford to work for those clients expecting them at $200. This alone should be an argument for why staffers shouldn't be doing these jobs at side-job rates, not to mention how doing this affects your freelance brethren's ability to charge a living rate in your community.

What must be done by the freelance community that these photographers are joining? I know it sounds counterintuitive, but you need to get them work. Really. The question is how.

If your normal rate for a wedding is $3,500 or press-conference coverage is $750, or your family/pet/child portrait sitting rate is $350, and an enlargement is $950, then rather than trying to convince your newfound friend to charge those rates, book the job on their behalf at those rates. By doing so, your friend will soon realize that this is what he or she is worth and will apply that same rate structure to people calling him or her directly. From time to time, everyone gets a call for a period that they are double-booked. Don't forward on the job and hope your friend does things right—do it right for your friend by taking the job and then hiring your colleague to do the assignment, with you passing through the assignment fee to him or her. What chance to do it right do they have if they've never before negotiated an assignment rate or a rights package?

By embracing and helping out these talented people, not only are you doing a nice thing, but you're also ensuring that your community will remain robust and will survive amidst the constant downward pressure on rates.

Here's a partial list of where these people might need some assistance:

> **Contracts.** If a photographer has been a staffer for awhile, it's likely his or her last agreement to provide photography was done on a handshake. If a photographer has only been on staff for year or so and came straight from school, that photographer, too, doesn't understand the importance of a contract—signed by the photographer and the client. Offer to give the photographer a copy of yours (preferably in a Word document so they can edit it) to get started.

> **Equipment.** They likely need help getting their equipment set up. They may have been given their old equipment from their place of work, but in most cases the gear is on its last legs. Redundant camera bodies and lenses ranging from ultra-wide 14-24mm Nikon or 16-35mm Canon, all the way to 200mm lenses for each, plus two strobes and a Jackrabbit/Quantum battery pack will be sufficient. In the rare case that they are going to do sports or major news events, a 300mm with a 1.4x or 2x teleconverter is useful, but freelancers headed that direction with a need to sustain themselves are not going to find a lot of success chasing sports.

> **Software.** They may have their own laptop but are unclear about the importance of backing up their images and acquiring legal copies of the software they'll need. Don't start them off on the wrong foot by giving them copies of your software. Recommend that they get full versions that are registered in their own name of Photoshop, Photo Mechanic, fotoQuote, Microsoft Office, Lightroom (or Aperture), and QuickBooks Pro.

> **Dealing with clients.** Be sure to tell them that when the client says, "Oh, you're the first photographer I've talked to who has a problem with _____," where the blank is "work-for-hire," "wanting to be paid," "charges for post-production," or "wanting a contract signed," they're being dishonest at best, and more than likely they're lying.

▶ **Marketing.** This one's tricky, because if you're not careful, you'll teach your newfound freelancer friends to compete for your own work—and they will be doing so without the understanding of the true costs of being in their new shoes as self-employed people, and so they may well undervalue themselves. (They did just get laid off, remember? Their self-worth wounds likely need a bit of time to heal before they remember that they're worth a lot.) Most important is to get a website that they can get online quickly and one that is easy for them to update and change. Once they get a website, they can begin their marketing campaign. The notion of having a printed portfolio these days applies to maybe 10 percent or less of the assignment work out there (much of which is in the advertising field), so the online version of that is the best route to go.

▶ **Pricing and rates.** The *first* thing you should do is send them to the NPPA's pricing calculator, which we discuss in Chapter 7, "Pricing Your Work to Stay in Business." This calculator works for the vast majority of photographic fields and gets your colleagues thinking about the true costs of being in business—which in turn will assist them in calculating what they should charge. The biggest problem with photographer's rates is not that they've been artificially inflated to a price that's too high; it's that photographers fail to contemplate the total costs of being in business, and thus they price jobs too low.

▶ **Longevity.** Awhile back, I sat down to dinner with a colleague who thought he'd gotten his golden ticket—a staff job at a community newspaper. Just under three months later, he was laid off. Guess what? He wasn't eligible under the rules that applied to him to even collect unemployment. Everyone is replaceable. No one is safe.

Where Does All Your Time Go?

One of the challenges of being self-employed—especially as a photographer—is the presumption of how your time is spent. Few, if any, photographers know how their day is spent. We can all say with near certainty that it's not spent shooting every moment of every day. I would go so far as to say we're not doing nearly as much shooting as we'd like to.

The follow-up questions become how do we discern this information, and why would we want to in the first place?

To start, grab a notebook—one you can carry around easily. Begin by jotting down everything you do for the next two weeks. Fifteen-minute segments work. Note personal items as such. Use categories such as paying bills, billing clients, doing paperwork, having client conversations, doing other paperwork, researching online, eating, traveling (in your car/bus/plane), doing post-production, marketing, networking, and so on. Oh, yeah, include actually making pictures, too.

At the end of the two weeks, I think you'll be surprised by the numbers. You will learn that the day-to-day small stuff gets in the way of all that. Don't take my word for it—try it on your own and see for yourself.

Learn how to outsource the distracting tasks you're doing. Just as we outsourced color printing and slide processing back in the day, and we continue to outsource having our dress clothes dry-cleaned, so, too, is there value in outsourcing things that are not directly related to growing your business or making photos.

Begin by contemplating outsourcing your scanning of analog-to-digital files, if you still have any. Consider bringing in someone to do your post-production work and take calls when you're out of the office—even if that office is a small portion of your home.

You've got a pretty good list of the distractions from your two-week research. Begin by determining what you could outsource immediately and what you could outsource if you invested time in training someone to do it the way you do.

The Conundrum of Doing Nothing

A few years back, I was on assignment photographing Arlo Guthrie. That week, it was among the assignments I was most looking forward to, hopeful that he'd sing "Alice's Restaurant." Alas, he did not, but he did posit a thought to the corollary:

> The problem with doing nothing is that you never know when you're finished.

During the time we were together, Arlo and I had a chance to talk, and one of the things he said was:

> The art of doing nothin' is probably one of the most profitable things you can do, because it sets you up to be doing something.

This then begs the question, "What *should* you be doing?"

Well, the right thing, of course. But what exactly is the right thing?

Well, in the abstract, when you justify taking an assignment for fees that are too low or that has an excessive rights grab by saying, "Well, it's better than doing nothing," that should be a sign to you that Arlo's thinking should be kicking in.

If your justification for taking an assignment worth $1,000 and doing it for $200 because the client has said, "Two-hundred dollars, non-negotiable, take it or leave it," and you said to yourself, "Two-hundred dollars is better than making nothing tomorrow," then you might need to be thinking like Arlo.

If your justification for taking an assignment and being paid $400 but having to transfer copyright is because "Four-hundred dollars for images that have little resale value anyway is better than not making the $400," then you might need to be thinking like Arlo.

Arlo was talking profitability by "doing nothing." At first blush, it seems contradictory. Yet upon further reflection, it's not. Instead, free yourself up on that day to seek out a better paying client base, and one that does not demand an excessive rights package. These clients are the ones who respect you and your work, and thus your constitutionally guaranteed right to control the rights to your work.

A few days following that assignment, I had a most unpleasant conversation with a client for an assignment the next day, who, after his subordinate signed my contract with a rights-managed rights package, called to say, "I just want to make sure we own all the rights to these photos." I had to explain that this wasn't the case and that outlined in the contract was a rights package that, for the press conference we were covering, was all the common rights needed and what we grant as a part of our standard package. Further, we weren't granting rights to him that we did not have (in other words, those that require model releases when people attending have not signed model releases and thus cannot appear in marketing materials). I noted that I couldn't convey to him "all rights," since "all rights" includes the right to use the photos in ads and brochures and so forth, and I'd be charging him for something I didn't possess.

He then said, "We just have a fundamental difference about how to approach this." I said, "Well, mine is a perspective based upon copyright law and rights granted under the Constitution. Are you suggesting that if an artist produces a song and earns money off the CD that they then shouldn't be paid additionally when their music is used in a movie or a commercial?" And he said, "Well, that's different." I said, "No, actually, it's the same copyright principle."

We completed that assignment, not because the client was happy with the terms, but because they signed a contract with a standard rights package and then after the fact (just a few business hours before the event was to start) thought they would try to renegotiate the terms of the agreement—to terms we cannot convey and that we principally objected to. Thus, the power of the signed contract.

That day, Arlo didn't play "Alice's Restaurant," which was all right by me, since what he did play was amazing in its own right. At first I thought I'd be disappointed that he didn't, but afterwards, and upon reflection, I was exceedingly pleased with what he did play. So, too, was the client who wanted all rights pleased with the work we produced for them. Even if they didn't get every right under the sun, they got quality work from a professional photographer who was "doing something" profitable that day.

Doing It without Ruining It (for Others)

If you are in a position where you have a full-time job, and you want to go semi-pro, it is responsible to ask, "How do I work as a semi-professional photographer without ruining the livelihoods of those who do it full time?"

First, you must determine what your objective is. So, let's make a few assumptions.

▶ You really enjoy photography.

▶ You'd *really* enjoy seeing your work published.

▶ You might consider trading in your cubicle job for a camera and satchel if you could afford it.

If you really enjoy photography, you'll first need to determine whether you just love seeing the photos you took of the local landscape or you feel that you want to try to change the world with your revealing images from [*insert location here*]. Perhaps you enjoy revealing people's outward appearances in a way they've not seen themselves before, or maybe it's the solitude of the studio and still life that gives you peace.

Then, realize that in order to be paid, you'll need to follow someone else's direction. This has the potential of diminishing your enjoyment just a little (but not always). You may find that you have to follow directions you don't like, because even the best of us are called upon to photograph things that are less than exciting. In the end, however, I would speculate that the person dabbling in photography would find that the worst day as a photographer is better than the best day riding the pine in a cube. (Don't get your hopes up, though—it may well not be!)

Okay, so here's where many folks run into trouble. They want to see their works published (hopefully with photo credit). This is really the impetus behind the problems with one-dollar stock photography—people whose enjoyment is derived from just seeing their work published. People with idle time and a digital camera are so eager for (supposed) bragging rights and a split second in any spotlight that they will sell their images for a true loss. They'd enjoy being able to walk into the shipping super's office while on break moving pallets in the warehouse to say to their boss, "Someday, boss, I'm gonna be a photographer. I've got one of my photographs in this magazine ad...says right here in the photo credit.... Oh wait, the ad doesn't have a photo credit.... Well, boss, I tell ya, it's mine, and someday..." Fact is, that moment of excitement pretty much ensures a mindset that they're never going to be able to leave the warehouse and earn a living as a full-time photographer.

The beauty of having a job that pays the bills is that you can choose clients that are paying you appropriately, and only when they are paying you appropriately. When I started out, everyone wanted everything for free (or cheap). But consider this: If you have a job that is paying you $40,000 a year, that equates to about $150 a day [($40,000/52)/5], as to what you're worth in the eyes of the person paying you that annual salary. Next, add in what you would have to charge a client that was hiring you to rent your digital camera, two lenses, and a flash (about $150), and you're near about $300 as a really, really bottom-end valuation of what you bring to the table, which doesn't take anything else into consideration.

Next, step out of the role of salaried employee using that same $40,000 a year figure to calculate what you need to earn each month. Now, say to yourself that if you're really lucky, just starting out, you can do two assignments a month, or 24 a year. That then equates to about $1,666 a day [$40,000/24], plus camera rental of $150, or about $1,800—again, not considering much else expense-wise.

So, as a salaried employee employed full time at a business, this means that when someone calls you, and you have to take a day off from work (didn't you feel that sniffle coming on last night?), it's worth somewhere between $300 to $1,800, easy. And furthermore, since you don't have to take the job, you can afford to say no when they want to pay less or they want all rights.

As you grow your intermittent number of photo assignments, you'll have fewer and fewer vacation and sick days to call upon. Consider this: If you have two weeks of vacation and six sick days a year, plus three personal days, that's 19 days you can take, without any problems, to do assignments. At some point, you are getting consistent calls from your

newfound clients—who respect you and your fees—and as you grow this type of client (rather than the cheap ones who want everything for nothing), you can then consider trading your job for the freelancer's life, but not until then. Or, you can simply remain semi-pro, filling your evenings, weekends, and occasional vacation/sick day with work that pays properly and respects you and your copyright. Furthermore, you can be at peace in the knowledge that you are not doing harm to your colleagues. And, moreover, when you are downsized out or laid off, you will have a backup base of clients to earn money from—at a rate of income that will sustain you! And this applies not just to staff photographers, but also to general employees in other non-photo-related fields.

In fact, you could actually do your local colleagues a favor—whatever you can discern they would charge for an assignment, charge 20 percent more, since you don't have to have the assignment. You can make your colleagues look good by comparison, and when you get that job, you are being paid a premium for the work you'll do, and you'll grow a list of intermittent clients who will pay for you as a premium photographer.

Planning (and Prolonging if Possible) the Transition

When establishing your salary and benefits, it is fair to start with what you are earning now. In addition, your personal economic equation—from mortgage to car payments to other expenses—is tied to what you've been able to afford up until now, and whatever you can eke out in personal expense reductions will end up being a cushion as you make the transition as smoothly as possible.

Of critical importance will be the reality that you don't want to try to make any major purchases—car payments, new homes, refinancing, and so on—for at least two years, maybe three. Bankers want to see a track record of success before they will loan you their money. Although your paystub was voucher enough for them while you were an employee, what will vouch for you now is your track record of success as illustrated by your tax returns. Most lending institutions want to see your last *three* years' worth of returns. Further, this isn't a lesson you want to learn after you've sold a car or decided to move and put up a For Sale sign.

So, to prolong your staff life, you should be encouraging your DOP to pay freelancers a premium and to allow their images to rightfully belong to them. And, because they can't fall into a work-made-for-hire (WMFH) category, they should be paid for the assignment as one-time use only and then paid again when there is a reuse. Not only is this the right thing to do, it will affect the longevity of your staff job for a few more years.

Further, when prospective freelance assignments come into the photo desk, since you don't need the work to make ends meet (now), charge a rate that takes into account the numerous expenses you would incur if you were freelance and begin developing a client base that places a significant value on the work you do so you can rely on *them* in the future. Of equal importance, they are not calling the paper looking for someone who "maybe" could do the work. As a staffer, you have the imprimatur of a talented photographer. You wouldn't

have that same imprimatur in the prospective client's eyes had you not been hired by the paper, and so the notion that they can get a cheap photographer by calling the paper's photo desk should be dismissed as disrespectful of the talent that the paper does have and brings to the community every day.

Lastly, many prospective clients know they can get newspaper photographers "for cheap" because they don't know how to handle a negotiation over rights, and they have little problem doing a work-made-for-hire assignment because that is what they are doing for the publication that employs them. Further, they know that the income from the paper is going to underwrite their budget for what they want photographed. These are not the types of clients you want to nurture relationships with, because they will not sustain you once you are freelance. Quote them the full-freight price and have them take it or leave it—stand your ground.

Unfortunately, getting up to speed can't happen overnight. From the book *How People Learn: Brain, Mind, Experience, and School* (National Academies Press, 2000):

> It is important to be realistic about the amount of time it takes to learn complex subject matter. It has been estimated that world-class chess masters require from 50,000 to 100,000 hours of practice to reach that level of expertise.... Although many people believe that "talent" plays a role in who becomes an expert in a particular area, even seemingly talented individuals require a great deal of practice in order to develop their expertise (Ericsson et al., 1993).

Do not think you can just jump in and run a business because you know how to make great photos. The skills and thought processes of running a business take a great deal of time to master. Think about this: What do you think about when you're on your way home from work? When you get home, after dinner, before you go to bed, what's usually on your mind?

What's wrong with this picture is...where is the planning for the future? I can honestly say that as a young, aspiring photographer, for the hour or two after I woke up and before work, I thought about making great pictures and about my portfolio. On my way home from work, I put the traffic out of my mind. I was thinking about my portfolio. When I got home, I would edit images I made over the weekend. I would caption them and prepare them to send off to publications for consideration. I would scour the newspaper to see what they predicted would be happening the next day. I would watch and see what events were coming up over the weekend. I would check to see what concerts were coming to town so I could seek a credential to photograph them.

Not to show my age, but this was back in the day when I processed my own E-6 film and hand mounted it, printed captions with a dot-matrix printer and affixed a label to each slide mount, and slipped the mounts into a slide page. I did not have the Internet to do my research, so I'd often find myself at a bookstore reading through *Spin*, *Rolling Stone*, and every other magazine where concert schedules were listed. I collected and read the Upcoming Events list on the first weekend of every month in the paper and local city magazine (as well as the free city weekly) so I could see what functions might attract a celebrity, and I'd sometimes call the event organizers and offer my services as a photographer on those evenings—times when I didn't otherwise have work.

The point is, many a friend would be out partying, watching television, and so on. They saw their time off as just time to goof off. I saw that time as time where I could do whatever it took to chart my course for the future. From the minute my eyes blinked open to the moment I drifted off to sleep, I was thinking about being a photographer. I was reviewing in my head, line by line, a conversation I had with a prospective client, determining where I'd failed to close the deal so I could provide their photography or cover their assignment.

When my eyes closed at night, and I could not fall asleep, I would lie in the darkness, the streetlamps glowing dimly through my north-facing window, thinking about how I could improve. Improve my photography. Improve my lighting skills. Improve my negotiation skills. Improve my knowledge about business. I read every book I could, and I pushed myself. I knew that if I just worked harder—and smarter (or as smarter as I could)—than my competition, I could achieve (and sustain) my dream career—one as a photographer, where it's work but not a job.

A Collection of Inconvenient Facts

Ignoring facts cannot change them. Far too many photographers and aspiring photographers simply ignore the facts before them, believing that the laws of physics and economics just don't apply to them.

I see these photographers arrive on the scene and then depart in short order. Many not only leave my city, they leave the profession altogether. The sad fact, too, is they also leave the state of the profession they tried to succeed in just a little worse off as a result of poor business practices.

Here are a few facts for your consideration:

> ▶ **Fact #1.** If every time you produce images, the copyright to them is not yours, you will not earn money—any money—from them in the future. You're a day laborer with some creativity.

> ▶ **Fact #2.** According to the IRS, if 1) you are required to comply with the employer's instructions; 2) the services are to be performed in a particular method or manner; 3) the success or continuation of a business depends on the performance of certain services; 4) the worker personally perform the services; 5) the worker has a continuing relationship with the employer; 6) the worker has to follow a work sequence set by the employer; 7) the worker can't work for more than one employer at a time, and if you're a freelancer and these sound familiar to you, then perhaps you're entitled to be an employee of the employer, including benefits and their payment of the standard part of your taxes that an employer pays.

> ▶ **Fact #3.** Taking standard manufacturers' statistics for the lifespan of equipment (camera and computer), coupled with the amortization tables for deductibility, will give you how much you can reasonably expect to pay over each year. Combine this with other expenses (data lines, software, rent, and so forth), and this is what it costs each year to make pictures. When divided

by 52, if you don't earn that much each week, you will most decidedly not be making pictures professionally very long unless your sustaining income comes from other sources.

▶ **Fact #4.** If your time is not your own, and thus you are doing something at the behest of a client (travel, post-production, planning, and so on), and you are not charging your client for those efforts, you are short-changing yourself and taking a loss on that time.

▶ **Fact #5.** If you charge for your time at an hourly rate, the better you get at completing an assignment, the less you are being paid for your talents. Although an hourly rate may work when you are covering a luncheon or an all-day conference, it doesn't work on most other assignments. Banish "day rate" from your vocabulary before it costs you.

▶ **Fact #6.** Just because a client says they won't pay for something, that doesn't mean you must accept and work under those terms. You have the power to say no.

▶ **Fact #7.** When you are working for just one or two clients, the loss of their work would have catastrophic effects on your revenue stream. You are overly beholden to them and their whims. Diversify your client base for long-term stability.

▶ **Fact #8.** If a client signs your contract and then demands after the fact that you sign theirs to be paid, you do not have to agree to sign or actually sign their contract. Simply point out that you already have a contractual relationship for the assignment. They must pay, pursuant to your contract, or be in breach of contract (or copyright, depending upon the language in your contract).

▶ **Fact #9.** Operating your business without insurance is akin to gambling every day with the likelihood of being able to continue to do the job you love the most. A stolen camera bag or an accident on assignment could easily put you out of business.

These facts may be inconvenient, but that doesn't make them any less real.

PLH: Photographer Learned Helplessness

There's a concept called *Consumer Learned Helplessness*. The Consumerist website notes about this "affliction":

> After getting shocked from every angle for so long, with credit cards' shrinking due dates, flagrant violations of our privacy, rebate scams as acceptable business models, and "it's company policy" as the magic wand to excuse it any time a company screws us, we just lie down and accept it.

So too does this apply to photographers. Thus, PLH.

When your client or a proposed client says things like:

> ▶ You're the first photographer who's ever raised a question about our contract.
>
> ▶ We require original receipts for all expenses.
>
> ▶ Our contract is nonnegotiable. We haven't modified it for anyone else, so we can't for you—sorry.
>
> ▶ Of course we own the reprint rights to the photos and article. We paid you for the assignment.
>
> ▶ We can't pay in 30 days. I know your contract that we signed says that, but we pay in 90 days.
>
> ▶ We can't promise adjacent photo credit or that it will be accurate, but we'll do our best.
>
> ▶ We don't pay a digital processing fee. Don't do any processing; just burn the photos to a CD and send it to us. My assistant can pick out the photos and work on them.

Simply lying down and accepting egregious terms results from PLH. It's as if there are no clients out there who you think respect you, and so you just have to take whatever scraps and morsels of assignment work this client has.

Don't believe these things. I have drawers full of contracts from clients that counter the above. I have FedEx receipts from clients who paid in 30 days (and I have collected administrative fees from those who have not paid within 30 days). I have clients who respect me and what I bring to the table. Did they take time to become my regular clients? Sure. And I surely declined assignment offers where the deal did not show me the respect that a reasonable person should expect.

Avoid PLH. Don't accept deals you know are bad. Sometimes it's easier than others. But in the long run, it's what will sustain you.

Zen and the Art of Photography

A lot goes into that first call. Not the call you make, but the call you earn. Before your phone rang, lots of things had to happen: The client had to decide they needed a photographer, and where there's an ad agency, PR firm, or design firm involved, they had to convince their client they needed photography. Then, they had to decide on candidates for the assignment. And that's where you come in.

There are five Zen-like stages that your clients go through during the entire process:

1. Anticipation
2. Trepidation
3. Inspection
4. Fulfillment
5. Evaluation

Let's look at those closer.

Anticipation

A prospective client is anticipating that you can deliver, based upon your marketing materials—portfolio, website, business card, presentation in person, phone skills, and the appearance of your contract. Based upon this, they book you.

Trepidation

Depending upon how you did in the anticipation phase, the degree of trepidation can vary. Were you a Yellow Pages or search engine find or a referral from a trusted source, or had they used you in the past? Even so, there is a period where the client is worried about the quality of the end result, even when you are a repeat vendor for them.

Inspection

During the shoot and afterwards, they look through your results, contemplating the circumstances that went into the shoot and thus, the results. Was it a rainy day when the shoot called for blue skies, but you had to shoot anyway? Was the model late? Were the VIPs that were the cornerstone of the event absent, and so the client-handshaking with a VIP is missing from the event images? Or, did everything go smoothly, and the client has the highest of expectations after the fact relative to their expectations beforehand?

Fulfillment

Did you deliver as promised? Are they satisfied with the results? Is their client satisfied with the results? Did what you do meet—or better yet, exceed—expectations? You should always strive for a "That photographer sure exceeded my expectations" response. You need to win over even the most critical of clients, so they may become your staunchest advocates.

Evaluation

Would they hire you again? Would they casually recommend you to a colleague? Would they enthusiastically recommend you to a colleague? Or, in the best of scenarios, without provocation, would they go onto their listserv and shout your name from the treetops: "Boy, I just finished this shoot with John Harrington, and if you ever need a photographer, he should be on the top of your list of people to call!" Wouldn't it be great to have an evangelist like that? They do exist. Have you experienced it yet?

Take a piece of paper, print out those five words, and place them in a prominent place near your desk. By understanding the phases of a client experience, you can ensure that you are firing on all cylinders and meeting and exceeding expectations in each phase.

Chapter 5

Working with Reps, Assistants, Employees, and Contractors: The Pitfalls and Benefits

During the early years of my business, it was just me. Not only was I a sole proprietor in the IRS's eyes, I was the sole worker. I was my own IT department, accounting department, new business department, shipping department, and—oh, right, creative department. It got to the point where I could not be in two places at once—creating photographs and sending invoices, planning a shoot and sending estimates. It really became too much. When I began considering bringing on some help, I kept thinking, "Ten dollars times eight hours, times five days a week, times fifty-two weeks a year equals how much?!" I didn't see that I had that amount of "extra" revenue to be able to pay for the extra set of hands. For so long I struggled with this, and I ended up hiring a niece during her summer months between her college studies. I saw this as a way to get my feet wet in having someone help me out. The problems arose come September, when I found myself being far less productive as she returned to school. I looked forward to Christmas break, when she would return for a few weeks—that was my personal Christmas present, and one that gave me the insight that I really needed some help around the office. (When I say "office," what I'm really saying is the second bedroom of my three-bedroom home. The master bedroom was for my wife and me, the larger bedroom in our row house on Capitol Hill was my office, and the smaller one was for our dogs.)

NOTE

In case you're curious, the answer to the math equation about the cost of hiring a new employee is $20,800 per year. By comparison, minimum wage of $7.25 an hour yields $15,080 per year, and minimum wage was not set by the government with the intent that it paid enough to live on alone. It was intended as a minimum wage for youth still living at home or as an entry-level job wage.

The Hurdle of Growing from Just You to Having People Working for You

I evolved from having just summer help to having part-time help twice a week. Every month, I looked at how much I was spending for this assistant, and in a short period of time, I found that I was signing at least two additional assignments each month simply because I had someone in the office not only to handle the phone calls, but to send estimates out and lock in assignments that I couldn't for no other reason than my lack of availability to lock them in myself. I saw these transactions initially as a form of "trade" between my accounting/new business departments and my creative department. The creative department would do two assignments, usually a total of two or four hours in length, and in exchange, the accounting/new business departments got 16 hours a week for four weeks a month in help. This was a really good trade in my mind—four hours of creative for 64 hours of help per month.

NOTE

Sometimes thinking about the various types of work you do as serving different "departments" within your business can help you to understand how you spend your time, and demanding that as many departments as possible remain either profitable or cost-efficient can ensure that you stay focused.

Within a year or so, I realized that incurring the additional expense to have someone in every day of the week was really going to have an impact. This impact would be felt in sending and getting back signed contracts as well as serving client needs, but also because in the downtime between doing these things, the person I hired could work on projects that I needed to get done but just couldn't find the time to begin, let alone complete. This created a new concern that I did not address: Must this person be an employee or a contractor? As a small business, I could not take on the additional work of issuing paychecks that took out taxes, social security, and so on. I needed to ensure that I could handle this extra help as a contractor, not as an employee. I took the time to review the Internal Revenue Service points that they use to determine whether someone you have working for you must be defined as an employee or may be deemed a contractor.

Working with a Rep or Consultant

"The good craftsman is a poor salesman, absorbed in doing something well, unable to explain the value of what he or she is doing." So wrote Richard Sennett in his book *The Craftsman* (Yale University Press, 2008) when speaking about American sociologist Thomas Veblen's 1900 observations about the 1851 London Great Exposition. Thus, the notion that artists are not businesspeople is not new—not by any stretch.

Almost every photographer I know, at one point or another, thought that getting a photographer's representative (a.k.a. a *rep*) to handle all their portfolio presentations, marketing, billing, and so on would solve all their problems. Frankly, it's just not that simple.

First, there are those who are reps and those who are marketing consultants. A rep has an ongoing relationship with you, actively marketing you to prospective clients, and will likely (but not always) be the one handling the negotiations for the assignment. For this, the rep will take somewhere around 20 percent of the photographer's fees as their commission. In addition, you and the rep will often split the costs for marketing outreach. From postcards to promo pieces, new portfolios, e-mail blasts, and so on, you and your rep will work together to get your assignments. Some even handle the billing for the assignments they win for you.

Most photographers would do just about anything to get a rep, but the fact is, the rep would actually be working for you, so you need to actually see whether the rep you are considering is a good fit for you. Do you get along? Do you like his or her style and approach? If you are currently doing annual report executive portraiture, but you really want to expand into high fashion, you need to be upfront with the rep about that. Reps work very hard to ensure that none of their clients would likely be competing for the same projects, and they may already be repping someone for high fashion.

During your review of the rep, confirm what his or her percentage would be and ask about other potential charges. More importantly, ask your prospective rep to see bids he or she has produced and submitted on behalf of other clients. Understanding how the rep works is critical to a good working relationship. A few reps, over the years, have been blacklisted for shady practices in dealing with agencies and firms, and you want to steer clear of reps with a bad reputation.

On the other hand, a marketing consultant will help you prepare your marketing efforts. From advice on the look and feel of your website, to the realities of whatever market you want to go into (fashion, food, industrial, and so on), as well as how to plan a promotional campaign, a marketing consultant can be a great solution to the quagmire of "how do I market myself" that you find yourself stuck in. Plan on between $250 and $350 an hour, and don't think you can get it all done in two hours. Realize that it will take at least an hour for the marketing consultant to listen to you talk and ask you pointed questions. At the end of that first meeting, you will likely get some homework, such as "pick your top 20 dream clients" or "you say you want to do food photography, but you only have three different food shoots on your website, so go out and shoot six self-assignments on food and then let's talk further." You might also be told that your website needs a total redesign. Sometimes, you will get asked, as consultant Selina Maitreya puts it, to "create a swipe file" of several images that are so amazing that you wished you'd thought up the photo and had the commissioning client as your client. Whatever you get told, listen carefully. When I worked with highly regarded rep Elyse Weissberg a number of years ago, before she passed away, she always encouraged me to record our meetings, which I did. Then, on the trip home, I would listen again to the conversation, and I would learn even more that second time through. So, ask whomever you're meeting with on this topic if you can record the conversation so you can go back and review what was said.

Another consultant is one that handles just the bid. Once the prospective client has reviewed your portfolio and wants to get a price from you, the bidding consultant is called in. When the client says, "Can you send me a bid?" just say, "Sure thing. I'll have Jane Doe, who handles that for me, put something together and send it along." Your bidding consultant might charge you $250 to put together a complicated bid, plus a percentage of

your photographer/creative fees if you win the assignment. If you feel like you are getting more and more of these types of high-dollar or production-heavy assignments, a bidding consultant might be willing to take on your first bid together with a reduced fee and/or do it on a contingency, but remember, this is (hopefully) going to be an ongoing relationship, so don't start it out on the wrong (in other words, cheap) foot!

Some bidding consultants will be that Jane Doe and handle the calls and the back and forth, and frankly, that's the best way to do it. However, it may be better for them to work for you privately. In this type of scenario, you will go over the details of the assignment and the rights package, and they will give you advice on how to prepare the estimate, items to include (and avoid), as well as how to handle the calls yourself. They will also prepare you for the curveballs you might get thrown during the negotiations.

Who Must Be an Employee?

The Internal Revenue Service has listed 20 factors in Revenue Ruling 87-41 that it considers in determining whether individuals are employees or common-law independent contractors for federal tax purposes. The degree of importance of each factor depends on the occupation and is case-specific. When evaluating each factor in light of your business practices, remember that a "yes" weighs in favor of assessing a worker as an employee.

To determine whether an individual is a contractor or an employee, all factors must be applied. A fair evaluation would be that if a majority of the 20 factors carry a yes response, then an individual might be considered an employee. If you believe a person working for you should be considered an employee, you must either handle that person as such or make appropriate changes to resolve the situation to achieve an independent contractor status for all individuals providing services to you.

Following are the IRS factors from their website, as outlined in their Revenue Ruling 87-41, and my responses to each:

> ▶ **Factor 1: Instructions.** Is the worker required to comply with the employer's instructions? A worker who is required to comply with other persons' instructions about when, where, and how he is to work is ordinarily an employee. This control factor is present if the person for whom the services are performed has the right to require compliance with instructions.
>
> **Response.** Contractors working for me are given projects and tasks to complete as a part of their responsibilities. Contractors are given significant leeway as to how they wish to complete tasks and when those tasks are to be completed. In instances when tasks are time sensitive (sending out an estimate or reprint order or calling a courier), contractors understand that delays could cause a loss of a photo assignment. However, no requirements such as "within 10 minutes" or "within 20 minutes" are placed on contractors.

▶ **Factor 2: Training.** Is the worker required to receive training from the employer? Training a worker by requiring an experienced individual to work with him, by requiring the worker to attend meetings, or by using other methods indicates that the services are to be performed in a particular method or manner.

Response. Contractors are required to have a basic understanding of photography and computers. Contractors are expected to apply their knowledge of photography when assisting me on location at photo shoots. The role of contractor-assistant is not expected to grow into a position in which the contractor becomes an experienced photographer working for me shooting. Where contractors are not knowledgeable in specific applications (Photoshop, QuickBooks, and so on), the contractor is not trained by attending classes paid for or directed by me; rather, these skills are to be learned on the contractor's own time.

▶ **Factor 3: Integration.** Does the worker provide services that are integrated into the business? Integration of the worker's services into the business operations generally shows that the worker is subject to direction and control. When the success or continuation of a business depends on the performance of certain services, the workers who perform those services are generally subject to a certain amount of control by the owner of the business.

Response. The services provided by contractors are not integrated into the business, but rather, they are of a supportive position to the business.

▶ **Factor 4: Services Rendered Personally.** Must the worker personally perform the services? If the services must be rendered personally, an employer/employee relationship is assumed.

Response. Contractors for me may contact other authorized contractors to perform the services if the contractor scheduled for coverage has other obligations for other clients. This happens often when a contractor has another job they can take, and they then make the substitution with another contractor. In some cases, the contractor simply does not come in without sending a replacement, at their option, if they assess there is no time-sensitive need. Contractors have a responsibility to know whether they have time-sensitive tasks to complete, and they will always confirm their intent to take another assignment before doing so.

▶ **Factor 5: Hiring, Supervising, and Paying Assistants.** Does the worker hire, supervise, and pay assistants for the employer? If the person for whom the services are performed hires, supervises, and pays assistants, it generally demonstrates control. However, if one worker hires, supervises, and pays the other assistants pursuant to a contract under which the worker agrees to provide materials and labor and under which the worker is responsible only for the attainment of a result, this factor indicates an independent contractor status.

CHAPTER 5

Response. No current contractor hires or supervises other contractors. One contractor may be a resource for information about work processes, but all contractors are hired and supervised by me directly.

▶ **Factor 6: Continuing Relationship.** Does the worker have a continuing relationship with the employer? A continuing relationship between the worker and the person for whom the services are performed indicates an employer/employee relationship. A continuing relationship may exist where work is performed at irregular intervals if they are recurring.

Response. Contractors are retained initially on a three-month contractual basis, which is automatically renewed for successive one-month terms, provided the quality of services remains as high as when initially contracted. Further, contractors are allowed and encouraged to work for the competition—and not because we expect (or do) get information. In fact, we are very clear not only that our assistants maintain our confidentiality, but also that we do not ask them about their dealings with the competition. We don't ask for whom they provide their services (although we know they do provide services for other clients), nor do we ask who the other photographer's clients or subjects are. Not only is this bad form and unethical, but it is against an unwritten rule that exists among assistants.

▶ **Factor 7: Set Hours of Work.** Must the worker follow set hours of work? The establishment of set hours of work by the person for whom the services are performed is a factor indicating control.

Response. Contractors understand that the office should be staffed from at least 10:00 a.m. through 6:00 p.m. Monday through Friday. Each contractor determines when it is best for him or her to arrive and when it is best to leave, given the day's flow and activities. No monetary penalties occur (docking of pay and so on) when a contractor arrives after 10:00 a.m., and some contractors opt to come in prior to 10:00 a.m. when it benefits them. Certain events (shoots on location) require specific timing, setup, and so on, and in these instances time is of the essence, so contractors should be at a certain place at a certain time.

▶ **Factor 8: Full Time Required.** Does the worker work full time for the employer? If the worker must devote substantially full time to the job, control over the amount of time the worker spends working is assumed and restricts the worker from other gainful employment. Therefore, an employer/employee relationship is assumed. An independent contractor, on the other hand, is free to work when and for whom he or she chooses.

Response. No contractors work full time. Contractors not only perform services outside of their work for me, but in fact are allowed to (and do) work for businesses that are direct competitors of mine.

▶ **Factor 9: Doing Work on Employer's Premises.** Does the work take place on the employer's premises? If the work is performed on the premises of the person for whom the services are performed, that factor suggests control, especially if the work could be done elsewhere. Work done off premises,

such as at the office of the worker, indicates some freedom from control. However, this fact by itself does not mean that the worker is not an employee. Control over the place of work is indicated when the person for whom the services are performed has the right to compel the worker to travel a designated route or to canvass a designated territory.

Response. Because my contractors have their own offices (whether a desk in their home or a complete room), the possibility exists for these contractors to perform many of their work functions (office work, organizing of receipts, and so on) outside of my office—and in a number of cases, they do. In addition, my contractors perform services at shoots on location—work that could not be performed on premises. Further, contractors often query me for details concerning variables (shoot fees for estimates or category information for receipt organization) and often find it easier to complete these tasks on premises.

▶ **Factor 10: Order or Sequence Set.** Does the worker have to follow a work sequence set by the employer? If a worker must perform services in the order or sequence set by the person for whom the services are performed, that factor shows that the worker must follow established routines and schedules. Often, because of the nature of an occupation, the person for whom the services are performed does not set the order of the services. It is sufficient to show control, however, if the person has the right to do so.

Response. When contractors are completing work, tasks such as filing, reprints, estimates, and cleaning do not have a set sequence. In fact, significant leeway is given as to how and when to complete these (and other) tasks. Where efficiency or client demands are a consideration, the contractor may be asked to complete tasks in a certain order.

▶ **Factor 11: Oral or Written Reports.** Does the worker have to submit regular reports? A requirement that the worker submit regular or written reports to the person for whom the services are performed indicates a degree of control.

Response. No reports are requested or required of contractors.

▶ **Factor 12: Payment by Hour, Week, Month.** Does the worker receive a regular amount of compensation at fixed intervals? Payment by the hour, week, or month generally points to an employer/employee relationship, provided that this method of payment is not just a convenient way of paying a lump sum agreed upon as the cost of a job. Payment made per job or on a straight commission basis generally indicates that the worker is an independent contractor.

Response. Contractors are paid biweekly, on an hourly basis. Due to the highly variable nature of each shoot or project, it is difficult to determine with a reasonable degree of certainty how long each one will take. In addition, the contractor has the right to suspend services to me to meet the needs of other employers or for personal reasons. As a result, the contractors and I have agreed that an hourly fee is a reasonable way to determine work actually performed for me versus time not working for me, but working for others.

▶ **Factor 13: Payment of Business and/or Traveling Expenses.** Does the worker receive payment for business and traveling expenses? If the person for whom the services are performed pays the worker's business and/or traveling expenses, the worker is ordinarily an employee.

Response. I do not pay business or travel expenses for contractors. My contractors are obligated to pay any travel expenses between their office and my offices or on location. In the event that I ask them to travel with me to a distant location to assist me in completing an assignment, the expenses associated with that request are covered by me.

▶ **Factor 14: Furnishing of Tools and Materials.** Does the employer furnish tools and materials? The fact that the person for whom the services are performed furnishes significant tools, materials, and other equipment to do the job tends to show the existence of an employer/employee relationship.

Response. Contractors' primary obligation is the use of their hands and minds to complete tasks. The role of assistant to the photographer does not require any equipment beyond perhaps an assistant's grab bag, which I do not furnish. Contractors are required to have cellular phones, which I do not furnish nor reimburse.

▶ **Factor 15: Significant Investment.** Has the worker invested in facilities used to perform the service? If the worker invests in facilities that he uses in performing services that are not generally maintained by employees (such as the maintenance of an office rented at fair market value from an unrelated party), that factor tends to indicate that the worker is an independent contractor. The lack of investment in facilities indicates dependence on the person for whom the services are performed and the existence of an employer/employee relationship.

Response. Contractors make investments in equipment to further their own businesses (office computers, cell phones, light meters, and so on), and from time to time they use these to provide services to me. Contractors are not dependent on me for the existence of their own businesses; rather, they complete a varying portion of their tasks at my office for the sake of convenience.

▶ **Factor 16: Realization of Profit or Loss.** Can the worker make a profit or suffer a loss? A worker who can realize a profit or suffer a loss is generally an independent contractor. For example, if the worker is subject to a real risk of economic loss due to significant investments or liability for expenses, such as salary payments to unrelated employees, that factor indicates that the worker is an independent contractor. The risk that a worker will not receive payment for his or her services, however, is common to both independent contractors and employees and thus does not constitute a sufficient economic risk to support treatment as an independent contractor.

Response. No profit or loss from a contractor's performance or lack thereof could be a possibility at this time related to their own contractors or employees, given that no current contractor has employees or contractors themselves. However, it is possible for a contractor to make investments in his or her own business or engage in liability for expenses, for which we are not responsible. This possibility could have an adverse impact on the contractor's profit (or loss) during the course of his or her tax year.

▶ **Factor 17: Working for More Than One Firm at a Time.** Can the worker work for more than one client at a time? If a worker performs services for a number of unrelated persons or firms at the same time, the worker is generally considered an independent contractor.

Response. Current contractors not only work for more than one client, but in fact they can work for direct competitors of mine.

▶ **Factor 18: Making Service Available to the General Public.** Does the worker offer services to the public? The fact that a worker makes his or her services available to the general public on a regular and consistent basis indicates an independent contractor relationship.

Response. My contractors not only provide their services to me, but they provide photographic services (as both a photographer *and* an assistant) to the general public as well.

▶ **Factor 19: Right to Discharge.** Can the worker be fired? The right to discharge a worker is a factor indicating that the worker is an employee and the person possessing the right is the employer. An employer exercises control through the threat of dismissal, which causes the worker to obey the employer's instructions. An independent contractor, on the other hand, cannot be fired so long as the independent contractor produces the result that meets the contract specifications.

Response. No contractor can be fired provided that he or she meets the contract specifications. In the event that a contractor fails to produce the results outlined in his or her contract, the contract may not be renewed.

▶ **Factor 20: Right to Terminate.** Can the worker quit without incurring liability? If the worker has the right to end his or her relationship with the person for whom the services are performed at any time without incurring liability, an employer/employee relationship exists.

Response. A contractor has the right to terminate his or her contract with proper notice but cannot quit without incurring liability.

So ask yourself the 20 questions/factors to ensure you don't end up on the wrong end of an IRS or Department of Labor inquiry, or worse. Further, employment law is very complex and varies greatly between jurisdictions. It is critical that decisions about how and when to use contractors be done with the advice of an attorney who is versed in employment and tax law in your area.

CHAPTER 5

The Benefits of Someone Regular versus Various People

So you've decided you want someone to help you out. Now the question becomes who? The first thing *not* to do is take out a classified ad. You are asking for someone to come into your home/office and not only do work for you, but also be there when you're not. That's a big risk and requires a lot of trust. I think the interview process for an unknown person would be far more difficult than for a referral. So, how do you find the right person or persons? First, I'd suggest you choose one person over two, and no more than two to do the job together.

Bringing someone in requires a significant learning curve. You want that person to learn how you do everything, where everything is, and the like. In my experience, it takes a bare minimum of three months for someone to be up to speed when he or she is there full time, so that becomes a much longer period for part-time assistance. After three months, I feel totally comfortable with someone sending estimates and doing invoices and post-production. I remain in an oversight position, spot-checking the paperwork that goes out and giving guidance on the post-production that runs in batches. (I still do the customized retouching for major assignments.) Bringing someone different in each time means that person will have to learn everything from scratch and, further, may not have the impetus to do that extra step that ensures the clients get the best service possible.

In addition, I've found that having people who are interested in the field of photography means they see the work they are doing for you as learning to do something they hope to do themselves someday. Thus, they are more eager to learn to do it right than someone who's just coming in for the paycheck. Further, the benefit of having someone work part-time is that you can encourage that person to get out and shoot or work for other photographers to gain much-needed experience in other working environments on days off.

I first found folks to assist in the office and on shoots at local trade association meetings. From ASMP, to APA, to ASPP, to ADCMW, I found association meetings to be an exceptional resource for talented and enthusiastic assistants, both for on-location photography and in-office help.

When making hires, be absolutely certain that you hire people who have a good disposition. They should be happy people as well. When you find yourself in a position where you've made a mistake, correct it. Replace the person as soon as possible. It's the people you don't fire who will ultimately give you far more headaches and problems than those you do fire.

NOTE

ASMP is the American Society of Media Photographers; APA is the Advertising Photographers of America; ASPP is the American Society of Picture Professionals; and ADCMW is the Art Directors Club of Metropolitan Washington. Those and/or numerous others meet in your area and are an excellent resource.

Today, I draw upon interns who come during or immediately following their studies in college. I'll talk more about the importance of interns and apprentices in Chapter 32, "Charity, Community, and Your Colleagues: Giving Back is Good Karma," but for now I'll simply make note of the fact that interns can be your best source for aid on a more ongoing basis, and they will already know whether working together with you is a good fit for them, too.

Remember, however, to keep your distance and learn to be "the boss." It is more important to be the boss than to overstep a boundary and try to be their friend. That's not to say you can't be friendly or a boss that they like to work for because you're reasonable and thoughtful. However, things such as overlooking transgressions, making inappropriate conversation, making loans, and so on can make many people uncomfortable.

Paying Those Who Make Your Life Easier

This is one of the more difficult issues to review and resolve. On one hand, you may instinctively want to pay the lowest amount you can; on the other hand, you don't want to be cheap, nor do you want to overpay. I've tried to research the landscape amongst photographers and assistants to come to some conclusions that might be helpful as you determine what to pay.

At a minimum, you must pay anyone who works for you minimum wage. Unless you're hiring waiters and waitresses or others who have a tip-based income source, you'll want to make sure you don't run afoul of this rule.

For full-time interns who travel from outside of our region to work with us, we pay $8.00 an hour. This is based upon what I found other companies who are my clients are paying their interns. Although an intern won't get rich from this hourly pay rate, the intent is to cover their expenses while here and give them a bit of savings at the end of the summer.

We work very hard to stay in line with Department of Labor internship standards for students coming from a bona fide educational institution. Although interns are handled as contractors when paid, it should be understood that issues such as legal minimum wage, withholding, and so on relate to traditional employees, not to contractors. Because interns are subjected to more oversight than other contractors, we want to make certain we do not cause them to be considered employees and thus eligible for benefits and such.

From this point, the sky is the limit—or, more definitively, what you pay yourself is the limit! There are a number of ways you can opt to pay—a base hourly plus a percentage of all assignments (say, 5 to 10 percent or so), just a base hourly, or a flat rate.

When contacting a subcontractor, such as a lighting technician, hair/makeup/stylist, production manager, producer, and so on, asking what they would charge to work on your project can be your first inquiry; however, remember that all prices are negotiable.

Assistants who work for photographers on an as-needed basis for assignments typically are paid a flat rate ranging from as low as $150 per day to upwards of $300. These figures are paid whether the assignment is for two hours or ten, but after ten, typically the assistant will charge an overtime charge that should have been agreed to beforehand if going beyond ten

hours was a possibility. Further, although you may technically be getting an assistant for ten hours at that flat rate, if your shoot goes for only three and you then tell the assistant you want him or her to come back to the studio and sweep the floors, organize receipts, or perform other office tasks, you'll not likely get the assistant back again. This practice is considered poor form among assistants, unless you've outlined these terms before the assistant agrees to take the work. Some who assist won't mind, but others will. Ask first.

So, with a floor of minimum wage and a ceiling of $300, you want to find a happy medium for what you're paying. If we use the 10-hour-day rule as a guideline, that works out to between $12.50 and $25 an hour.

There is, however, a great source for the hourly wages paid to contractors who you hire, and it is union scale. The International Association of Theatrical and Stage Employees (IATSE) has a negotiated contract with the Directors Guild of America (DGA) and other unions as it pertains to rules under which they will work, work conditions, and so on. For example, if there is smoke, snow, or a wet work area, contractors get paid more. For example, the 2007 rates in the IATSE Commercial Production Agreement define that the key makeup artist in the LA area makes approximately $340 for eight hours of work, at approximately $42 an hour. Outside of LA, the rate is approximately $315 for eight hours, at about $39 an hour. The key grip, who is the most senior lighting and equipment rigging technician, is listed in 2007 rates at approximately $298 within LA for eight hours and at $276 for eight hours outside of LA. In Chicago, the rate for a 10-hour key grip is approximately $362 for commercials, approximately $342 for a stylist, and $427 for someone who does hair and makeup. The Northeast Corridor, for example, carries slightly higher rates, as does LA, because of increased production costs and individual costs of living. Each year, the negotiated contracts with the DGA and other unions stipulate increases in hourly pay, often approximately three to five percent. So, consider that a 2009 or 2010 rate would likely be about six to nine percent higher than the figures listed here.

Outside of the union scale, there is a common concept across the spectrum of business: Bulk purchases and guaranteed purchases over time should mean discounts over one-at-a-time purchases. Thus, if the pay of $12.50 to $25 is applicable for a one-off, then figures of less than that should apply if you're committing to two or three days a week, every week of the year. It is not unreasonable for an entry-level contractor with whom you contract for large blocks of hours each week or month to be in the $10 to mid-teen range for their hourly wage, especially as they approach the 40-hour mark.

There are, however, many states—California among them—that have very strict labor laws, and you could run the risk of back pay of taxes, Social Security, workers' comp, and overtime, as well as civil penalties in the event that a former contractor/assistant decides that he or she wants to make trouble for you. There is, however, at least one photo-specific solution to this.

One Solution for Concerned Employers

Temp agencies, such as Accountemps or Randstad, could work for you. I would strongly recommend you engage a service like Paychex. ASMP has a relationship with Paychex, and on the ASMP website, they promote Paychex (www.Paychex.com) to photographers as follows:

> Paychex offers a comprehensive business solution that is accurate, confidential, and affordable for small business owners. You will save countless hours of paperwork, as well as avoid any non-compliance penalties, misclassification of workers, missed deadlines, and inaccuracies. Paychex assumes full responsibility for the accuracy and timeliness of your payroll taxes and tax returns, and it delivers the peace of mind that all of your payroll requirements are being handled properly and lawfully.

> Paychex does:

> ▶ Payroll
> ▶ Tax Filings
> ▶ Employee Direct Deposit
> ▶ Check Signing
> ▶ Workers' Compensation
> ▶ Unemployment Claims Management
> ▶ and more.

Technically, when your assignment has been completed, whether in a single day or multiple days, an assistant may file for unemployment in most states if he or she is determined to be an employee. There are exceptions if the assistant is fired "for cause" or if he or she quits, and, as such, any person in any profession could not file for unemployment. However, even when a contract specifies a series of days (say, a week or three months), when the work is done in your mind, the IRS and/or Department of Labor (or state labor agency) could very well find that you laid off the assistant for a lack of work.

A service established through APA is called APA National Payroll (http://smithandstilwell.com/apa/); it resolves the liability issues of workers' comp insurance and the incorrect classification of an assistant as a contractor when he or she is an employee—a scenario that could create a huge expense for you if you are audited by the IRS. With enough years under your belt, such a situation might well run into the tens of thousands of dollars, if not more.

They provide (or if you're using another firm, they should provide):

▶ Withholdings for staff, taking into consideration work done on location in a state other than your own, as well as federal taxes and Social Security

▶ Workers' comp and unemployment insurance

▶ Direct payment to assistants from the firm—not you—when you've approved the payment

▶ In cities that require it, the payment of union fees, dues, or union scale rates, if applicable

Utilizing a service such as this will mean you can have people help you with peace of mind, rather than worrying about the headaches of keeping someone in your office or studio with paperwork and confusing local, state, and federal regulations.

One final note: There is also a risk that if your assistant made a significant contribution to a shoot (light placement, subject direction, camera angle, and so on) and he or she is classified as an independent contractor, the assistant might have a viable claim of joint authorship in the resulting copyrighted image. Classifying the assistant as an employee or using a payroll service that deems the assistant an employee of that service will reduce this risk significantly. In addition, some photographers will ask that assistants sign an agreement waiving any such rights.

Chapter 6
Setting Your Photographer's Fees

So much smoke and mirrors goes into the establishment of a fair and reasonable price for the work that we do that asking any of your colleagues, "What should I charge for this?" will almost always result in, "Well, that depends."

So, what exactly does it depend on?

There are a wide variety of factors that should go into your determination of the fee you should charge associated with your creativity, risk, time, and experience. All these factors come together to develop the fee you charge for your photographic services. It is imperative that you approach what you're doing with the understanding that almost always the least important factor is time, with rare exceptions. (I'll get to those in "The Time Factor" section.) The most significant variations in your income will come from the revenue that arises out of what people are doing with your photographs. This is the case for all artists. And you are an artist, in exactly the same manner that a musician is an artist. When, for example, that musician records a song, usually the initial use is for retail sale on iTunes and on CDs. Secondary uses of that song include use in commercials, movies, video games, television broadcasts, and so on.

So, too, when you produce a photograph, the initial use may be for one client's project. When that project expands (in much the same way a musician has more sales of the song on iTunes), you should earn more money. When that same photograph gets repurposed into another client's ad campaign or promotional material or as stock for an editorial need, again, you need to be additionally compensated.

In some instances, when dealing with some clients, you would call this *photographer's fees*, and in other instances—especially with ad agencies and design firms—these fees are referred to as *creative fees*. Separate from that are usage fees. These are fees that are associated with the use of the creative results of your time. You can read about the question of keeping together or separating creative fees from usage fees in Chapter 7, "Pricing Your Work to Stay in Business," and more is discussed regarding usage fees in Chapter 26, "Licensing Your Work."

So, what about actual numbers? Honestly, every locale in every state in every country of the world has different figures, and suggesting what they are does the locale and the economic climate of that locale a disservice and would be irresponsible. Using the Cost of Doing Business Calculator made available to you by the National Press Photographers Association

(NPPA) at http://nppa.org/professional_development/business_practices/cdb/ is one thing to do to help you establish your own actual CODB for your community and circumstances. If, for example, your CODB is $350 a day, and you are billing out at the rate of $70 an hour, an eight-hour day of shooting grosses $560, leaving you with $210 for that day as a net profit. However, on the next day, if you are not shooting, you still had a CODB of $350, meaning you had a loss of $140, cumulatively.

Remember, too, that even if you do earn that $210 net profit, that is before taxes, and the government will likely take about half of that, leaving you with a net profit after taxes of $105. Further, don't just use the CODB calculator for your current expenses; use it to help you track what your future expenses might be. If, for example, you are getting a great deal on rent at $400 a month right now, realize that in 5 or 10 years, you will be wanting to pay $1,500 a month for a mortgage and that all your other expenses will likely increase, too. Talk to photographers who are 10 years your senior to ask them what their expenses are like, and then use that to see what it will cost you to be in business in 10 years, so you can plot your CODB increases each year.

Again, we are discussing here the establishment of photographer's fees and not usage or licensing fees—those are discussed in other chapters. Further, these are not fees for post-production work that you are doing on digital images. That, too, is discussed in another chapter. How you go about establishing your photographer's fees is something that you do internally and then present to the client. You can speak in general terms about the factors, but do not go into details. It is okay to discuss internally and conclude within your own mind or with a business partner, "My base rate for my time is $70 an hour, then I factored in my own uniqueness, which doubles that rate, and my rate for the creativity needed triples that rate, so my rate per hour is $350, so my fee for the day—since I will essentially be committed to you for eight hours and thus not able to bill myself out to another client—is $2,800," but this information is not something that should be shared externally with any clients. You must, however, be comfortable with establishing and in general terms justifying your rate to your client. Whether you should include the usage/licensing fees in your photographer's fees is another issue that is discussed in Chapter 7.

Now, what are the factors involved in establishing the fees for your photographic services?

The Time Factor

This is an easy one. How long is the entire project going to take you? This is not just the time actually taking the photos, but also in preparing the photos. In addition, an important question is, "How much time do I have to take the photo?" If the answer to that question is 30 seconds, then the reality is that the time allowed is so short that you must be extremely skilled, with a well-oiled team to make sure you actually get a usable image. This happens a lot when you are doing portraits of VIPs. Sometimes, in a large production for a publication, a celebrity, for example, knows he or she is with you for four hours, including wardrobe changes and so on. However, even then you will have the celebrity in front of the camera for a limited amount of time.

In some instances, time is the most significant factor. For a conference or a wedding, where you are shooting for anywhere from four to ten hours or more, this would be the most likely time when you could provide a client with your hourly rate. However, it is extremely important to note that for a wedding/rite-of-passage photographer, that hourly rate should be something like, "The package price is $3,000 and includes five hours of coverage. Each additional hour is at a rate of $200." Thus, each hour of your time in the initial package is worth $200 ($200×5=$1,000), and the remaining $2,000 is your fee for the album/prints, your time consulting with the bride before/after the event, a profit for your business, and so on.

Further, because Saturdays are your most valuable days, you could offer 100 percent of your rate for all Saturday weddings, 85 percent of your rate for Sunday weddings, and 75 percent of your rate for weekday weddings. In addition, you could also offer peak wedding season rates and off-peak wedding season rates. For example, peak wedding season is May/June and September/October. For weddings in the other months, you could offer 10 percent off your rates during those months. Thus, if your peak Saturday season rate is $6,500 for a wedding in, say, May, your rate for an off-peak weekday wedding in February would be 25 percent less ($1,625) because it is a weekday and an additional 10 percent off ($650) because it is off-peak. So, the February wedding would be only $4,225. Again, every market can handle different rates (and in turn has a different cost for you to operate your business), and while these figures may be applicable to an economically stable community, in a small or economically challenged community, these rates may be high.

NOTE

It is reasonable to argue that is still takes as much work to do a wedding in January as it does in June, and it also likely costs you as much to do so. That said, the laws of supply and demand would suggest that you could offer this as an option and see how it works. Brides and grooms working on a tight budget often will consider a Sunday wedding over a Saturday one because reception sites are so much cheaper on Sundays and then again significantly cheaper during the week. This type of discount, if you were to consider employing it, really only works for work that has a seasonal nature to it, such as weddings, senior portraits, and so on. In addition, you might run a special and offer the Sunday rate to brides who book within 24 hours of your initial meeting, and for those family members who expect a discount from you, you can offer them one of the other rates and not just come up with some random amount of money you're going to give them off your package—if you do. (See Chapter 15, "Contracts for Weddings and Rites of Passage," for reasons why you might not want to do this.)

For a conference or a timed event, where you are working with flash on camera, the hourly rate is very applicable (and so can be the creative factor, to a certain degree—more on that later). Often a conference at a hotel starts at 8 a.m. and can go until 9 or 10 p.m. if there is an evening function. Further, these conferences can go on for days. It is not uncommon to have an evening welcome reception the night before, from 6 p.m. until 8 p.m. or so, then an all-day

event the next day from 8 a.m. to 9 p.m., and then a closing day from 9 a.m. until 1 p.m. with a wrap-up luncheon. These would be very common times where you would stipulate your hourly charge, but beware—you should have a minimum number of hours that apply. For example, I have a three-hour minimum charge for event photography. That charge applies if it is a 30-minute press conference or a two-hour luncheon. Also, your time in these instances is what is most valuable. I have had clients who say, "We'll need you from 8 a.m. until 10 a.m., and then from 1 p.m. to 4:30, and then again from 6:30 until 10 p.m." Any time there is not a four-hour window of time between the times they need me, I bill the assignment all the way through. The simple fact is that while they are trying to save money, it is saving money at my expense, since an hour or two between the activities they need coverage of does not allow me to bill that time to another client/assignment. If, however, a client needs me for a luncheon from 11 a.m. until 1 p.m. and then a reception/dinner from 6 p.m. until 10 p.m., I will bill those as separate events.

It may be, for example, that you are shooting a model on white seamless. Although this may seem like the easiest shoot to do, there are factors that go into this. For example, is the model already set, or do you have to spend time casting/choosing the model? Do you have to pay attention to the model's clothing and select/style it? Do you need to book a studio, or are you going on location to set up a studio? Do you own the lights/seamless, or do you need to rent lights and buy a seamless? Will the subject be available for 30 seconds, or can you work with him or her for 20 minutes or an hour? Will you need to have a computer connected to your camera so a client can review the images as they are being shot?

The Uniqueness Factor

This is, in some cases, a bit of a "gotcha" category. If the client cannot get the resulting photo from anywhere else, can't re-create it, and moreover, can't replace the photo with a stock image, then the fee can be higher. But is this fair?

If the uniqueness of the images is because of your creative genius, that is one thing. If, however, you had an exclusive opportunity that was once in a lifetime, then this is where you might be criticized for price-gouging when a client is asking for your fees for their use of the photos after the opportunity had happened.

Further, if the client says to you, "I need a photo of a model holding Widget X," and Widget X is either an unreleased product or a brand-new one, then the likelihood of there being a stock image of this is very low.

Also a part of the uniqueness factor is you. Are you unique? Unique could be as simple as knowing you are the only photographer in your community with underwater cameras and a SCUBA certification or knowing that you are the only photographer available on 30 minutes' notice because the assignment is nearby. This equates to how much leverage you have and how much of a rush the client is in. Or, uniqueness could be that the style and approach you have are so unique that you can command a premium for your distinctive style. In these cases, the client is likely willing to hire you and fly you to wherever the shoot is—and yes, pay the premium rate.

The Creative Factor

Recently, I was called upon to produce an advertisement, and the details for the shoot were extensive. Four actors: mom, dad, son, daughter. A camping scene with four setups: two at a picnic table, one at a campfire, and one fishing. The shoot was to be outdoors and required all sorts of props. The catch in all of this was that the entire shoot was for a television commercial, and my responsibility was to capture still images of the various scenes for the purposes of the print ads that would accompany the campaign.

In this example, I was not the director. The creative ideas were not mine. I did not book the talent, light the set, or direct the actors, and the direction of the print ads art director was, "I need all verticals and lots of negative space for the copy in the bottom," so my composition was even being partially set. In this instance, while my creative contribution to the resulting images was limited, the situation partly made it more of a challenge to meet the client's needs, so the "risk" or challenge factoring came into play more.

The creative factor is often one of the largest contributions to the photographer's fees, and this is why it is often referred to as the *creative fee*. More importantly, the creative contributions of you, the photographer, are so often minimized—by you—and taken for granted—by you—that you sell yourself short.

I can tell you that I do this to myself from time to time—take what I bring to the table for granted. Even after 20 years in the business, I forget that I can make a great photo—especially make a great photo out of nothing, see things in a scene or location that a client doesn't see, or come up with creative ideas that sell the client's product or service. Further, though, I get a great deal out of the client reacting to these realizations—sometimes on set and sometimes after the fact—when they say, "Wow, I didn't see that at all!" or "Wow, these pictures make the event look more impressive than it was!" or some other equally complimentary remark. Do not think that you will ever realize the true reality of your own creative talents, and as such, you will constantly undervalue what you bring to the table.

Sometimes the creative factor is your ability to struggle through the bad concepts and collaborate with the client in an effective way to come to the final result. Sometimes the creative factor is to be able to reasonably and thoughtfully make your case for why the idea you have for the shoot is better than what the client is proposing. I'm not talking about taking the prima-donna attitude here, because in the end, when you're working for a client, it will be the client's call.

When I get a call from a prospective client who wants me to photograph a portrait of a mid-level executive at a nondescript company, and I ask them during the course of the conversation, "What budget are you trying to work within?" and they respond, "Oh, around $200," I conclude that they have placed a near-zero value on my creativity and abilities. I will send along the estimate for the fees at what they should be, and then I will call the prospective client back to get a read on their reaction. I have little to lose because my figures for the job will be so much higher than their planned budget that a call is often the only way to possibly save the assignment. When I call, and they are shocked at the figure and say, "I thought it would cost about $200! Why does it cost so much?" I respond this way:

Me: I understand your perspective. What I would like to do is give you a bit more information. It would cost you more than $200 to send your receptionist down to the local camera store to rent a professional set of lights, softbox, and digital camera and buy the seamless background, and then when you get that equipment to your office, they won't know how to use it. As a part of what I will do for you, I will be bringing my equipment and lighting down and setting them up in your office. In addition, I have been doing this for years, and I know how to make your subject comfortable in front of the camera, the right angles to make the subject look the most flattering, and how to use the equipment to make the photo look its best.

Prospective Client: I just never knew it would be this expensive. I don't know if we can afford you.

Me: I understand. What I will say is that I am available and would love to come down and do this portrait for you. It may be that this time you can't afford me, and I respect that. I would suggest you consider the value of a well-done portrait. When you see portraits that look like snapshots, they make companies look less professional than their website, office décor, or in-person presentations are and can cause people to question whether they want to do business with the company. Honestly, a professional portrait can help sell people's comfort level with a company or individual like nothing else can—even, for some people, an in-person meeting.

Prospective Client: Yeah, I just don't think we can afford it.

Me: That's fine. I think I would bring my skills to this assignment and do a good job, but I encourage you to call around. You may find someone cheaper, and they may be able to take a good photograph for you. If you can't—or worse, if you do find a cheaper photographer and you are not happy with the results—please don't hesitate to call me back, and we will set something up for you.

If you consider that any Joe or Jane could snap the shutter and earn an hourly wage if they could focus the camera and set the shutter speed and aperture, then from there, you need to value your creativity—upwards.

The Risk Factor

This is an interesting factor because the underlying question is, "How much is my life worth?" It is, for example, far riskier to hang out the door of a helicopter with one foot on the skid than to be popping off flash-on-camera images in a hotel ballroom.

The other risk factor, where the risk is more likely assigned as the challenge of completing the assignment successfully, is, "How likely is it that despite all the planning in the world, we could not come back with the image?" It is critical that you convey to your client this risk and demonstrate your planning efforts beforehand, so they know very clearly the risk.

In one instance, I had a client who wanted me to photograph a subject holding a product on the bank of a river. The challenge was that the subject with the product needed to be in front of an ocean-going freight vessel laden down with shipping containers. The purpose of the assignment was to put a face and product on the nondescript nature of the freight vessel, but we were working for the company that employed the person and made the product that in turn was shipped on those freight vessels.

Although it wasn't hard to locate the right riverbank along the path of these ships going to and from the port, getting to know the schedules of the vessels was a problem. The challenge in this instance was that the port operators, as a matter of homeland security, were not going to release the schedule of the comings and goings of the ships using their port. Although this was certainly understandable, it made for a challenge if there were no ships passing by on the shoot day. Fortunately for me, the art director was aware of this, and when we scouted the day before, we essentially sat and waited for a ship to appear downriver and timed how long between when we first saw the ship and when it filled out our background, and then how long we had it as a background. On the scout day, exactly one ship came by, we had three minutes from first sighting to the ship being in position, and we had 10 seconds of it as a background. On the shoot day, we advised our subject that it would be a wait, and we prepared to sit around. For two hours there was nothing, but we were ready. Lights were set up, softbox was in position, makeup was done, and then the ship came by. We got several images that the client liked in the 10 seconds we had, and we were done. The key, however, in this entire scenario is that the client was aware of the risk that the shoot might not produce images if there was no ship.

Bringing the Factors Together

I'd like to put forth a few figures that should reasonably serve as a floor to your rates, and then I submit that there is no limit to the value of your creativity, save for the client's willingness to pay for it.

In the earlier example where I was shooting an ad on a TV commercial set, my creative contribution was limited. So, too, in the movie/film industry can the creativity of the job of "unit photographer" be limited. Generally, the primary task of the unit photographer is to reproduce on a still camera as closely as possible what is captured in the motion-picture camera. That is not to say that the unit photographer does not also capture behind-the-scenes images of the director giving instructions to the actors, overall set images, and so on. That said, however, the creative factor for a unit photographer can be very limited, and while the risk factor may come into play from time to time, the time factor is set by the number of hours on set, and the uniqueness factor is more about the uniqueness of the situation the director is creating than of your creative genius that you are bringing to the table.

Thus, for a unit photographer, the union that governs movie-set photographers (the International Alliance of Theatrical Stage Employees, or IATSE, Local 600 of the Cinematographers Guild) has a set scale that unit photographers get paid, and it starts out at between $500 and $800 a day. (Other factors that affect it are whether it is in your region, out of your region, in country or out, a television production, or a movie.)

CHAPTER 6

I offer this starting union rate that unions pay at the bottom of the scale as a floor for a day's worth of work. The greatest skill of a unit photographer is knowing how to work on a set, what to do, and more importantly what not to do. This is not to say that unit photographers are not creatively talented. They are. Many of them get paid much more than union scale, and many of them bring significant creative talents to bear on set. However, at the bottom end of the union scale, they are not using much of that in their general day-to-day duties.

IATSE UNION REQUIREMENTS FOR BECOMING A UNIT PHOTOGRAPHER

To get into the IATSE photographers' union, you have to:

1. Work on a non-union production that "flips" to a union show. Essentially, if a large enough collection of the people working on a movie decide they want to be in the union, they will call in someone from the union and all sign a document stating they should be union and paid a union scale, and then the document will be presented to the people managing the production. Essentially, this means that all the people who signed are saying they won't continue to work unless they become union and that everyone is a union worker. This type of situation does not happen often and is very much frowned upon by the producers of the project because it means they will have to pay a lot more money.

2. Be grandfathered in. This happens, for example, when the marquee actor, a producer, or the director says they just have to have you as the unit photographer. This happens from time to time and is the fastest way into the union.

3. Work for a total of 100 days over the course of a year (that is, a 12-month period) on non-union productions and provide proof of that work to the union when you are applying to become a member.

Regardless of how you get accepted (in other words, Method 1, 2, or 3 above), the annual union dues are $6,000, and you will have to pay them regardless of whether you get any work. Being a member of this union does not guarantee you any set amount of work, but it does make you eligible for work on union productions.

When they are, they are doing things like a "special," which results in things such as movie posters and marketing materials above and beyond the set stills that are used as PR for the movie, and they are paid significantly more for those uses of their work.

Thus, as a unit photographer, you don't need to use lighting or have assistants, for example. Your time is set by union or production schedules, and so on. Unit photography for non-union productions is, as one would assume, less. Consider, then, that if a non-union rate for unit photography for what is approximately a 10-hour shooting schedule is $400, your time and hourly wage would be $40 an hour. For union work, at $700 a day, you are looking at roughly $70 an hour.

Consider next the photojournalist. If the average photojournalist completes three assignments in a day for a newspaper, and each assignment requires an hour of shooting during the course of the day, he or she is "working" for three hours. If it is a small community newspaper, maybe that equates to the non-union scale, or if it is the big local paper of record for your community (especially if that paper has union employees), a base minimum of $70 for each of those three hours would be applicable.

Further, with photojournalism, there is a lot of travel and sitting around and waiting. Generally speaking, when I bill my time for travel, it is at a rate of 50 percent of the shooting rate. Using this as a basis, an eight-hour day for a photojournalist—three hours at $70/hour and five hours at $35/hour—works out to $385. Then, you add in risk: Is the assignment in a dangerous part of town or a shopping mall? Then, add in the creativity: Is it a portrait of the high school athlete of the week against a wall, or is it the production of the Food Section opener with a stylized picture of a dish of food attractively placed on a table in a restaurant, and so on? Then add in uniqueness: Is the assignment you are called upon to complete one where you are the only underwater photographer certified in your community with underwater cameras to document the raising of a historic relic from the local lake or a stylized above/below water shot showing a bass fisherman's contest that is taking place? Much of the work of a photojournalist requires a great deal of creativity that, frankly, is highly undervalued in their contribution to the publication. It is often argued by photographers that their willingness to shoot for newspapers or other photojournalistic organizations is a labor of love, but it must not be so much so that you suffer close to the poverty line.

Corporate photographers and those doing advertising work for ad agencies and design firms are called upon to produce a wide spectrum of work, where when it comes to time, creativity, and uniqueness, even the sky is not the limit for the creative fees for this type of work. Some can be downright boring, such as covering a conference in a boardroom. You could do this in an equally boring manner, or you could amp up your creativity and capture amazing images showing the interaction between the conference participants. Consider that the PR/communications person for the company could make the boring images himself with a digital camera and that perhaps you are being brought in to make engaging images. So, starting with the baseline rates, add in a creative factor, and you're set.

For an assignment to produce the executive portrait of the CEO for an annual report, the image may be as simple as photographing the CEO in his or her office at headquarters. Or, you could be working to create a setup on a factory floor or, say, in the instance of an environmental company, perhaps amidst the great redwood trees in the forests of California. In any instance, start with the baseline fees, add in the risk factor (is the image being shot on a rocking boat on the ocean, where you could fall in and waterlog your gear, or is it being shot in a corporate boardroom?) and then add in the time factor, which for CEOs is usually 10 to 30 minutes, plus all of your setup, breakdown, and travel times. Note that these fees do not include things that you bring, such as the lighting, cameras, computers, and so on. Although you may roll them all together into your photographer's fee and not include them as line items for whatever reason, you should still be factoring them in, whether as line items or as an all-in-one rate.

Consider next an assignment to produce still-life images of food or a new product. Many of these photographers will include in their photographer's fees the fact that they own a studio, rather than line-iteming it. I would encourage you to list this as a line item, which demonstrates to the client the value of the fact that you are using the studio you own. Listing it as a "studio usage fee" might be more honest than a "studio rental charge," especially if the client knows it's yours. If the client says, "Why am I paying a studio usage fee when you own it, like you own your camera?" the answer is, "Because the studio is not

rentable to other photographers at that rate, and there is prep work that takes place before and wrap-up work afterwards when we utilize the studio."

After you've moved past that issue, let's look at the factors. Studio work can take a great deal of time, establishing lighting, small- or large-set work, pre-production, and then setting camera positions. Following that is set strike (that is, taking down large sets). Beyond that is the creativity factor, and that also includes the lighting and camera positions, of course. However, lens choice, focal length and depth of field, angle of view, product juxtaposition with other elements or a set, and so on are all big considerations.

A large production with multiple paid actors/models calls for you to be able to direct and interact with these people effectively, as well as create a scene out of thin air. You must be able to not only juggle all of the details (or effectively delegate them to a production manager or producer), but also make the magic happen.

There are countless other scenarios I could put forth, but what I am trying to do more than anything is to get you to begin to think about what your rate would be for those various types of photography. This is probably the single most important reason why—especially when you are just starting out—you need to take the information the prospective client gives you and then get off the phone, telling them you will call them back or send them an estimate after you have had a chance to think about everything that will go into the assignment. When a client says, "I need you to shoot a portrait of my CEO," or "I need you to take a photo of my new product," or "I need some photos of our company for a brochure," you need to start asking questions so you can understand exactly what you are being asked to do, and thus what you bring to the table and, in turn, what you should charge. Answers about creativity, time, uniqueness, and risk affect your photographer's fee; answers about how the photo will be used affect the usage fee; and the rest of the answers will affect your expenses, including pre- and post-production, travel fees, and so on.

In the end, you should be setting your fees to sustain and grow your business. The talent you bring to the table cannot alone be quantified by an hourly rate such as minimum wage or by trying to think about your job as 8 hours a day, 5 days a week, 52 weeks a year. You must factor in the reality that even the most successful freelance photographers do not work eight hours a day every workday of the year. Your client, who perhaps might earn $60,000 a year, knows they earn about $30 an hour. When you tell them your rate for the assignment that they know you will accomplish in one day is $2,000, they will do the math. I have listened to the pause on the other end of the phone when I have spoken with them, and in that pause, they did the math in their head and have, on more than one occasion, said, "Two-thousand dollars? For one day?" They have done the math and arrived at the mistaken conclusion that I earn $10,000 week—$520,000 a year—in creative fees. Thus, I generally do not tell them an hourly rate—I convey to them the costs for the complete assignment, including post-production and delivery charges.

A few final notes to keep in mind:

▶ When the economy ebbs and flows and stands for a spell in a valley, lowering your rates is a really, really bad idea. The economy will rebound, and those clients you lowered your rates for will come back to you and expect the same low rates. If for some crazy reason you decide you're going to lower your rates, at the very least make it clear that these are your summer-season rates, low rates through the end of next month, "we offer 10-percent discounts if you book by the end of the wedding expo" rates, or "prepay your child's sports team portrait and save 10 percent over orders placed afterwards" rates.

▶ Plan a schedule for when you will actually raise your rates. The government pays their employees a cost-of-living-adjustment (COLA) almost every year, simply to keep up with inflation. If you plan a schedule of fee increases comparable to a COLA, which can be somewhere between three and seven percent depending upon the year, you will be able to keep up with your own costs of living and of doing business. Otherwise, you will look back and realize you've been charging the same rates that you were 10 years ago.

CHAPTER 6

Chapter 7
Pricing Your Work to Stay in Business

How do you establish your prices? This is seemingly an age-old question, and certainly one that perplexes many of the more experienced photographers, who, when asked, simply shrug their shoulders and respond with something like, "I sort of just guesstimated."

If this is you, don't be alarmed—you're not alone. That doesn't mean you're free and clear; it means you need to reverse-engineer your rates to see whether what you've been doing meets your long-term goals. You also need to know which types of assignments are revenue positive and which may be, without your even knowing, revenue negative. (Yes, that means taking a loss on a job.)

Although 10 years ago resources were few and far between to help you come to reasonable and logical conclusions about rates, they are abundantly available now in books, online, and in software specially designed for photographers.

First things first, though. Repeat the following phrase out loud three times. If you're reading this in midair while flying over country, say it anyway. If you're reading by bedside light and your significant other is asleep, say it anyway. But if you're in a church, then...wait. Why are you reading this book in church? Anyway, say this:

> "I am a profitable business and must remain so. If I am not, I'll be waiting tables soon."

> "I am a profitable business and must remain so. If I am not, I'll be waiting tables soon."

> "I am a profitable business and must remain so. If I am not, I'll be waiting tables soon."

Now, no disrespect to wait staffs all across the country, but I doubt very many of them aspire to be wait staff for the rest of their lives. For most, it's a waypoint during college, while they wait to be discovered and become a famous actor or perhaps someday own the restaurant. Regardless of their goals, yours is to remain a photographer.

Second, in keeping with the mentality of the mechanic who repaired your car in five minutes (as related in the beginning of Chapter 3), the amount of time involved in the shoot is a relatively small factor in determining your rate. In fact, your fees could well be increased conversely to your ability to execute the shoot expeditiously, and thus you should earn a premium. Nowhere else that I know of does someone more skilled get paid less because they completed their tasks faster than another less-experienced person.

Nelson DeMille, one of my favorite fiction authors, wrote a line for one of his characters in his book *Plum Island*, and it has remained with me for at least a decade. He wrote (for his character), "The problem with doing nothing is that you never know when you're finished." I have endeavored, as I recall that sentiment, to always try to do something.

When you are making the strategically smart decision to decline assignments that are below your threshold where you can earn a profit, you must maximize that time "doing nothing" by doing something. Go out and search for new clients, whether by doing research at the magazine stand for prospective editorial clients or online for prospective corporate clients, or even by cold-calling prospects in the marketing or corporate communications offices of businesses that are located in and around where you live.

Taking the approach that being the lowest-priced photographer will earn you all the work you need is a failing goal. The commoditized photographer promotes himself first on price, then on service or style of photography, and then finally on himself.

The best photographer is one who promotes and markets first himself, second his services and style, and finally, his price. Recently, I was CC'd on the following dialogue between one of my existing clients and someone who had sought a recommendation for a photographer from him:

Subject: Re: Photographer Recs Needed

Dear ███,
John Harrington is a great photographer that would more than satisfy your client's needs. ███ ███ uses him almost exclusively… and you may have met him at the recent ████████ event. Go see his website at www.johnharrington.com. His e-mail is John@JohnHarrington.com

Here's the response from the recipient of that e-mail:

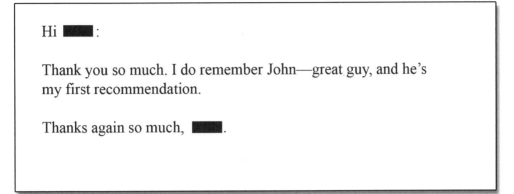

Here is a clear and concise indication of this point. How does the party receiving the recommendation gauge me? "Great guy." This, in my opinion, is a successful referral (and my ongoing goal to receive). I am not going to be compared on price—in fact, I am the top choice before a quote is provided.

Here's another example, where we had already provided the estimate, and the client balked.

Subject: RE: Photo Estimate for: Saturday, May 9

John -

This looks great. We will share with the client and get back to you shortly to confirm.

Here's the response they got from their client:

Subject: Re: Photog estimate

Can you reach out to another photog and get another quote???

My client backed me up and wrote:

Subject: Re: Photog estimate

FYI: He is very good and gets the job done right. ▬▬ pulls this guy in for this type of assignment on a regular basis. He always delivers and is very good on the ground. I don't think you will find anyone better. We are also lucky he is available...he usually books up pretty far in advance.

Then, as a courtesy, the client e-mailed me that back and forth with this message:

Subject: FW: Photog estimate

Make us proud...we just got the approval after the endorsement below. The invoice is going to go to: ▬▬▬

In this example, you have the client going to bat for you. They did not solicit another (expectedly lower-priced) photographer. Earning clients like this takes time, and yes, when I get this type of client going to bat for me, I will be sure to go above and beyond in my efforts to do a great job for them, and, as they requested, "make [them] proud."

Valuing Your Work

The aforementioned client clearly subscribes to the Warren Buffett position that "Price is what you pay. Value is what you get." We deliver valuable photography, and this client knows it.

During the last political season, I received a solicitation from a political candidate with an opportunity to attend this candidate's "summit" (another word for a campaign stop that makes the event seem more important than it really is).

The e-mail listed the following:

Ticket Prices:

$2,300 VIP

Includes full-day Summit, premium Summit seating, and a photograph with

$1,000 Guest

Includes full-day Summit

The e-mail invite makes it clear that you will get your photo taken *with* ▉▉▉▉▉▉▉▉▉▉ *and an actual photograph* if you pay an additional $1,300. About those "premium seats?" Since the photo will, most likely, take place just prior to the candidate taking the stage, they will hold the front-row seats for those who are backstage getting their photos taken, so you can be front and center, rather than getting the back-of-house seats because you're entering the room moments before the candidate begins his or her remarks. Okay, again, no problem with the seating.

What I find most remarkable is the value that is placed upon the 8×10 glossy you'll get. Assume a fair figure of 100 posed photos, which will take about 15 minutes—tops—to accomplish, and you're at $130,000 in *additional* gross revenue *just* from those photographs. Perhaps you'll get an added bonus of having it signed by the candidate as well, with something akin to "Thanks for your support." I make no bones about political candidates generating revenue from these types of events. Instead, I am providing this example to demonstrate the potential value of an 8×10 where your subjects are depicted with a high-profile political candidate.

What, then, is the added value of an 8×10 with an actual high-level elected official? They do political fundraisers all the time, and the stakes are even higher, no doubt.

The next time someone tries to place a value on a print of himself with a VIP—whether political or celebrity—realize that it's worth much more to that person than the cost of the print plus a nominal markup. It could be worth hundreds (or thousands) of dollars to that person for the wall of fame in his office. And, by the time he calls you because you just

happened to be in the right place at the right time to capture it, he has probably already got the space picked out on his wall for it.

I appreciated how highly regarded photographer Bill Frakes made a point during an event where we were both speakers in Atlanta a few years back. Frakes recounted a story where he was asked to shoot a particularly challenging assignment of a sports facility with the sport in question happening. A friend of Bill's had been contacted initially to do the shoot, and he knew he couldn't pull it off, so he passed it on to Bill. Frakes recounted that because the client arrived at his door in that fashion, his first estimate was extremely reasonable. For what the client wanted, Frakes quoted a figure of $10,000 for the assignment, and the client went off, calling into question Frakes' pricing, and just how overboard and beyond the pale it was. The client said they'd hire someone else to do the work who was more reasonably priced, and Frakes thought that was the end of it.

After a few weeks, the client called back, saying that they'd hired another photographer whose work just didn't cut it—the images just didn't work or were otherwise unusable. The prospective client now wanted Bill. Bill responded that the cost for the assignment was $20,000. The client was, as it was recounted, near speechless. How could it now be $20,000? Hadn't he just quoted $10,000, the client wanted to know. Frakes said, "Now you know how difficult the assignment is, so that's what it really should cost." He went on, "I didn't do it for spite. I had the additional information gained in our initial conversation that this was going to be a difficult client to please."

The client paid the new figure.

It helped that Bill's original estimate was only valid for three days, which gave him the leeway to make that adjustment. Not placing an expiration date on an estimate might have created a different—and $10,000 less—outcome in this situation.

Far too often, we make things look easy and really make things run smoothly for clients, and we forget what a significant value that has for clients. We are far too quick to diminish the contributions we make, either in getting it right the first time—or when it really counts—and delivering what they want, when they want it.

What Are You Worth?

There's an oft-repeated quote about pricing:

<p align="center">"Good, Fast, and Cheap. Pick Two."</p>

Think about that for a minute and work out the permutations. You want the photos good and cheap, you'll have to wait until my spare time, which is otherwise non-billable, and when I get around to them, I'll get them to you. Fast and cheap? The photos will look far less than the quality we normally deliver. It's akin to calling an architectural photographer, known for their "shot at dusk, light balanced just right, framed perfectly, and so on" work, and asking for it cheap. The result will be an image they take out the window of their car as they are sitting at a stoplight in front of the building on the way to their kids' soccer practice—and if it's a cloudy afternoon, oh well. And good and fast? That will mean it's going to be expensive. Period.

Like the friend with a pickup truck, for the uncle with a camera, free surely is not a viable solution. During the time when they were opening up pharmacies in their stores across the country, Walmart's CEO was challenged on the notion of giving away free drugs, as some other companies had, to get a toehold in a market. The CEO's response? "We're in business to make money. Free is a price that is not a long-term sustainable position."

You will frequently encounter a client who says their budget is low. "We don't have much for this assignment" is the common refrain. When the client describes the assignment, you will very quickly realize that, in fact, the budget is unreasonably low. I will always send an estimate, but I will say something generic, such as, "Let me see what I can do, and I will get the estimate off to you." Or, I might say something like, "I understand the budgetary concerns you've outlined. Let me put together an estimate for what this assignment will really cost and send it along. After you've looked over it, please don't hesitate to call with any questions or to discuss it further."

So, what about real dollar figures? If an image is worth a thousand words, what does $1,000 get you? A lot of questions. How about $960? Fewer questions, for sure. The figures $960 and $1,020 fall into a concept that is referred to as *odd-number pricing*. To be specific, a 1997 research study published in *The Marketing Bulletin* showed that approximately 60 percent of prices in advertising material ended in the digit 9, 30 percent ended in the digit 5, 7 percent ended in the digit 0, and the remaining seven digits combined accounted for only slightly more than 3 percent of prices evaluated. Thus, my examples that each end in zero supposedly don't fall definitively into this notion of odd-number pricing. However, whereas this concept best applies to products sold at retail, here I am addressing the concept more than the specifics. In our case, a photo fee that is $1,000 seems (to a prospective client) to be more negotiable than one you outline as $960, which seems less negotiable. I posit that if your fee was listed at $999, a client would find that silly.

Consider this, too: Premium pricing applies when the risk of failure in the production of the photo (once-in-a-lifetime moments, costly reshoots, and so on) means that it's worth it to pay the extra money to reduce the risk of failure. Give great consideration to how you price your work and position yourself in the market. Taking the right (and reasoned) approach will make all the difference in the world.

As you present your rates—especially for event coverage, which is one of the very few types of photography where a per-hour rate is fairly applicable—you may get some objection. Some clients will think (and I've experienced this firsthand as they mentally do the calculations), "$100 an hour times eight hours in a day, times five days a week, times 52 weeks in a year…" And they think that you are a $208,000-per-year photographer. They will say, "My attorney/doctor/therapist doesn't get paid that much," and then you have an uphill battle.

Of course, before you charge a profitable rate, you'll need to have a clear understanding of what is required to be in business. Even if you've been in business for years, you may have been allowing your personal expenses to subsidize your business, and as such, you might have been in the dark about what it truly costs to be in business. You'll need to change that to get a handle on your business and move it forward.

There are a few "cost of doing business" (CODB) calculators online. One that I contributed to (no bias here!) is the National Press Photographers Association CODB calculator, which can be found under the Professional Development > Business Practices section of www.nppa.org. Look for the NPPA's Cost of Doing Business Calculator link. An interactive calculator, it pre-populates the form with reasonable numbers for all the categories. In addition, when clicked, a circled "i" next to each category will give extensive information about that category (see Figure 7.1).

Business Practices

Cost of Doing Business Calculator

Annual Expenses

Office or Studio ⓘ	$3,600.00	Advertising & Promotion ⓘ	$1,000.00
Phone (Cell, Office & Fax) ⓘ	$2,400.00	Subscriptions & dues ⓘ	$600.00
Photo Equipment ⓘ	$7,000.00	Business Insurance ⓘ	$1,200.00
Repairs ⓘ	$900.00	Health Insurance ⓘ	$5,000.00
Computers (Hardware & Software) ⓘ	$2,500.00	Legal & Accounting Services ⓘ	$600.00
Internet (Broadband, Web site & email) ⓘ	$750.00	Taxes & Licenses (Business, Property & Self-employment) ⓘ	$6,000.00
Vehicle Expenses (Lease, Insurance & Maintenance) ⓘ	$7,000.00	Office Assistance (Payroll) ⓘ	$5,000.00
Office Supplies ⓘ	$800.00	Utilities ⓘ	$600.00
Photography Supplies ⓘ	$500.00	Retirement Fund ⓘ	$2,100.00
Postage & Shipping ⓘ	$300.00	Travel ⓘ	$1,200.00
Professional Development ⓘ	$200.00	Entertainment (meals with clients) ⓘ	$600.00
Desired annual salary ⓘ	$40,000.00	Total days per year you expect to bill for shooting ⓘ	100.0

Non-Assignment Income

Stock, print, and reprint sales ⓘ $0.00 Submit | Use Defaults | Clear

Results

Total annual expenses (including desired salary)	$89,850.00
Weekly Cost of Doing Business	$1,727.88
Your Overhead Cost for a Day of Shooting ⓘ	$898.50

Figure 7.1
CODB calculator.

After you've determined your CODB, it's time to compare that to what you're charging for what are typically referred to as photo fees on many generic invoices. These are a separate line item from all the expense lines.

Suppose you have an editorial assignment for which you are charging $1,200 plus expenses, and, using the NPPA's default figures for their CODB calculator, your business costs $898.50 per day of shooting. This means that the difference between what you are charging and what your CODB is—$301.50—is either a profit for the business, a usage fee for the use of the images, or some combination thereof. Typically, in this line item of $1,200, you've rolled in your CODB costs as well as usage. There is, however, a school of thought that suggests those two items should be separate, and both sides of the debate are passionate about the issue amongst photographers.

I'll present the two schools of thought as fairly as I can regarding photo fees. Before moving to that, though, it is important to consider whether what you are paying yourself is going to be a fixed cost within the CODB calculation or a percentage of profits. I would submit that you should determine a fair wage and include that figure as a fixed cost, and one that increases annually—not only by approximately 5 percent for standard cost-of-living-adjustments (COLAs), but also commensurate with your growth and increased experience as a photographer. A 5-percent annual COLA and a 10-percent increase every two years would be more than reasonable.

The following sections discuss two schools of thought regarding photo fees.

School of Thought #1: All Creative/Usage Fees Are Listed as Single Line Items

Many photographers simply put both CODB costs and usage fees together. Typically, they do so because they don't want to separate the two or they don't have a solid grasp of how to best separate the two. (Or perhaps they don't know their CODB.) Thus, many photographers list both items as a single line item because they don't want to get into unknown territory. They do what they've done before, which has seemed to work so far.

One argument for keeping them together is that this is the way software companies handle it, and that's a fair comparison. When I purchase my license to use a piece of software, I am obtaining, at nominal expense, the materials (CD, manual, and so on) and, at a larger expense, the license to use the software on one desktop (and one laptop, according to the last EULA I read). If, after buying the software, I learn it's not compatible with my PowerPC machine and only works on an Intel Mac, I opt not to even peel the wrapper off the box. (This is a Mac issue, so you PC users need not worry about this—yet—but it's an understandable analogy, so go with it.) I continue to run the previous version, because all the online reviews say it's better. I then call the creator and say I've opted not to exercise my licensed rights, and, therefore, I would like to not be charged (or to get a refund) for the license.

NOTE

Please make sure you're not using pirated software. Photoshop is one of the more ubiquitous software packages and is highly pirated. If you don't respect others' licenses, you have little room to object when someone steals your photographs.

NOTE

A EULA (*End User Licensing Agreement*) is a standard agreement for which you usually just click Agree when you are installing the software or before you open the CD jewel case. Sometimes it's a sealed envelope with the text printed on it, and sometimes it's a sticker that, by breaking, you acknowledge as having read a printed document that accompanied the CD in the packaging.

The argument is that the license is included in the fee because regardless of whether you've exercised your right to use the photo, you contracted for that fee and are obligated to pay it. Were there to be line items of, say, $1,800 for creative fees and $12,000 for usage fees, if the client specified that they killed the project or the usage is being scaled back to a figure for which you would have quoted a $2,000 usage fee, there is a valid argument as to why they should be paying the lower fee if it's broken down.

Another argument is that clients often come back to photographers for additional uses or to extend the existing rights package to include another six months (or longer), and if you're figuring this based upon the larger creative+usage fee, then the end result is a higher additional fee for the added or extended uses.

School of Thought #2: There Should Be Separate Line Items for Creative and Usage Fees

Some photographers break out these fees, often at the request of clients trying, as they've said to me on more than one occasion, "to compare apples to apples." This means that other photographers are regularly separating the two. In addition, the client can understand that you're not earning $13,800 for the day, but $1,800 for the day, and the $12,000 is for X period of time, during which the client can exploit the work to serve their company's interests. This often makes for a better understanding of the fees outlined on an estimate— something that must be justified to the end client. Even when the bottom-line total is the same, details such as a separation can make a difference.

NOTE

Exploit is not a bad word, so get used to seeing it. It basically means "use to the fullest extent allowable," but it has been perverted into its more commonly used meaning—"to take advantage of." Almost all contracts drawn by lawyers who know what they're doing use the word (albeit sparingly). Dictionary.com's first definition of the word is, "to employ to the greatest possible advantage: *exploit one's talents.*"

A downside that becomes obvious when you apply the math from #1 is that if you're basing your quoted fees for additional or extended uses on the original figure, subtracting $1,800 will reduce your additional fees when you are coming up with a percentage-based rights extension. The upside, though, is that clients understand the percentage better when they see how you arrived at the original, and now expanded, fees.

After you've figured out whether usage is a part of creative fees, then figure out your fees. As a baseline, take your CODB and add 7 to 15 percent as a profit for the business, and consider that as what you charge for an assignment for which you remain in "first gear" (if you're a five-speed manual) and for which little of your extensive skills or creativity are called for. With a CODB of $900, that's a $990 creative fee (which includes a 10-percent profit for the business).

For assignments that require a bit more effort and creativity, consider a percentage-based increase in your creative fee—say 30 percent to hit "second gear," for $1,200. For assignments that require you to get moving (and creatively interesting), you bump to "third gear"—say a 50-percent increase, or $1,350. For assignments that are creatively exciting, you hit "fourth gear" at a 75-percent increase over your CODB, or $1,575. For assignments that are creatively challenging and taxing (and exciting), you could end up at 100 percent of your CODB, or $1,800. For a more extensive discussion, refer to Chapter 6.

On top of all this is usage. With all the resources available to you via software and online sites, you can determine usage guidelines (and modifying factors) fairly easily after you review the available historical surveys, more recent surveys, and, in some instances, factors of a media buy. Following the review, you'll have a good idea of what to add for usage.

A model that has been discussed and debated, and one that I feel is not only fair, but also comprehensible by clients—especially those who are art buyers—is a percentage-based model. I first came across this concept during a panel discussion at a conference where primarily advertising photographers were speaking, and the concept struck a chord with me. Usage, it was suggested, should be based upon a percentage of the media buy, and there are photographers who are having success with this usage pricing model. In many instances, however, usage is limited by the photographer to a specific state, region, ad type (bus backs, billboards, movie theater pre-show screens, and so on), and timeframe, so without knowing the media buy, you are setting a price that will delineate the usage to such an extent that your usage fee set forth is akin to knowing the actual media buy. However, there might be uses within your description that you'd not thought of, and the client may be exploiting the right to employ images for those uses.

In addition, media buys can be a moving target. The initially stated buy could be midsized, so you estimate for that, and then when/if it's reduced (sometimes significantly), your percentage total must go down. Perhaps you'll have a minimum buy, or perhaps you have a sliding scale.

Almost all advertising agencies are paid a commission based upon the media buy, and the commission ranges from 10 to 15 percent. However, for extensive multimillion-dollar buys, agencies have been known to accept commissions as low as 3 percent. This approach of a sliding scale makes a great deal of sense. Although some art buyers may state that they don't know what the media buy is (and that may be the case), more than likely many just do not want to disclose to you the media buy.

Here are a few ranges and percentages that would be fair and appropriate to apply and would take into consideration the value of the usage:

- ▶ $2,000,000 or greater: 3 percent
- ▶ $1,500,000 to $2,000,000: 4 percent
- ▶ $1,000,000 to $1,500,000: 4.5 percent
- ▶ $600,000 to $1,000,000: 5 percent
- ▶ $450,000 to $599,000: 5.5 percent
- ▶ Less than $450,000: 6 percent

There are, however, a few caveats to this list. If it's a full-page ad with a heroic photo that's not yours, and yours is a quarter-page inset photo, then your percentage should be adjusted downward. If it's all your photos in the ad, even multiple photos taken at different shoots, you would have been paid for each of the shoots, but the usage fees would be a single sum combining them all. If nothing else, in the end, you can do the research and find that a full-page ad in a trade magazine with a circulation of 30,000 costs $8,000, and if they want unlimited rights to advertise in all trade magazines for two years, that's 24 months times $8,000, times four or so magazines, or $768,000 in possible media buys. In this case, a 5-percent usage fee is $38,400. Of course, this would be the likely maximum media buy they could make under those rights, but this certainly gives you a starting point to quote from for usage; moreover, you can negotiate downward for the total and the expanse of usage. A percentage such as this is often something that clients can not only get their heads around, but also can accurately and in simple terms convey to their own clients.

At the conclusion of your determination of how much you'll have to put into delivering the best images to meet client needs and usage, you can combine them or not, consistent with your decision about the aforementioned factors involved in delivering a clear and understandable estimate for the client's consideration.

Calculating Rates and Fees and Presenting the Figures

Few questions raise more quizzical looks than one colleague asking another, "What should I charge for this?" Everyone has an opinion on the subject, but few of them are informed well enough to give good advice. The problem is, more often than not, when someone with a modicum of knowledge on the subject says, "That assignment should be $2,750 plus expenses," the inquiring colleague will no doubt say something like, "Wow, that's a lot of money. Really?" And they often will price the assignment at something like $1,800 including expenses, and the downward spiral continues. The same issue arises when the question is, "What should I license this image for advertisement X for?" and the response is, "That should be a license of $4,480." The inquiring photographer can't believe that an image sitting idly on their hard drive is actually worth that much and will, once again, quote some figure like $1,000 and leave several months' rent on the table.

I often hear colleagues counsel their brethren to set up an account on a major stock photography site, such as Getty Images, Corbis, or others, and then find an image like theirs, price it out, and use that rate. Using someone else's assets (that is, pricing information and pricing schedules) for a use that was not intended is, at best, a violation of that company's Terms of Use for their website/service.

Instead, why not get some quality software that has been put together by people with decades in the business to guide you?

First up is Cradoc Bradshaw's fotoQuote. Honestly, for more than a decade, I have relied on Cradoc's products, including fotoQuote, to help me and guide me in fair and reasonable pricing of my images as both stock and assignment work. Often I get a call from a colleague asking me to help him or her price a stock request, and my deal with the colleague is as follows: "I am going to look this up in fotoQuote for you, and I am going to talk you through it, using the usage tips section of the software and the coaching section of the software, and I will add in a few thoughts of my own. But—and here's the catch—when you get the license, you have to go out and buy a copy of fotoQuote yourself, because it is such an amazing piece of software. You will learn so much by using it, and you will become a better negotiator when calls come in in the future."

fotoQuote, in the Spring of 2009, produced an overhaul of their software, with new interfaces, quote packs, and so on. As times change, so does fotoQuote. With this revision, they have added a large number of video-related categories for licensing images for the various video products and services, as well as video assignment requests such as, "Oh, just shoot a little behind-the-scenes video while you're doing the stills shoot so we can share what it was like to be on the shoot with you," and so on.

Figure 7.2 shows one of the 304 different categories that have pricing information in fotoQuote. The figures are based upon extensive research into what is actually being paid, so don't be thrown by the figures. Further—and this is important—these figures do take into consideration that there is a microstock market applying downward pressure on image licensing fees, so don't further discount any figures you see here, thinking these figures don't factor that in.

Figure 7.2
A category with pricing information in fotoQuote.

In Figure 7.2 you see all of the different categories in the Email category. In the center is one of the two most valuable features of fotoQuote—the Usage Tips and Coach tabs. This information is really the heart of fotoQuote, giving you guidance about what to expect during the negotiations and how to ask the right questions. Figure 7.3 shows another of the 304 categories—TV Advertising Cable Stills, with tips and coaching—and then, on the right, are the variations for local, regional, and so on, as well as the number of weeks the ad will run.

In addition to the Stock Pricing tab, there is the Assignment Pricing tab, which has an amazing amount of information for you (see Figure 7.4). It provides coaching information about how to price the assignment when it is event photography. On the right side is background on the type of photography, valuable questions to ask, and so on.

CHAPTER 7

Figure 7.3
Another of fotoQuote's 304 categories.

Figure 7.4
The Assignment Pricing tab.

There are so many other categories in the Assignment tab, and Figure 7.5 shows another—Corporate Jobs.

Figure 7.5
The Corporate Jobs category in the Assignment Pricing tab.

In this category, the information is far-and-away different from the insights and advice for the events photography coaching.

If you are considering this software for use in another country, it's completely customizable for any currency. If you are even licensing just a few images a year, all of the information you will learn from using the software during the course of your negotiations will almost assuredly earn back the cost of the software, which is $139.99 (and less for upgrades). For more information on fotoQuote, visit www.CradocFotoSoftware.com.

Next up is another solution—HindSight's Photo Price Guide. The interface is different, and I know a number of photographers who swear by it. The example in Figure 7.6 considers a price for the use of a photograph in an advertisement that is appearing at a quarter page with a magazine with 20,000 to 49,000 circulation. A multiplier is being viewed, which suggests that if the ad is in a trade magazine, there should be a 10-percent increase in the rate. There is a Tips/Cautions tab and a great deal of other information at your fingertips.

Figure 7.6
HindSight's Photo Price Guide.

Figure 7.7 shows another example—this time for the use of a photograph on a website. I have selected an "inside page," and the square pixels are 200,000 (which equates to roughly a 450-pixel-by-450-pixel ad), and the figure that comes up is $400 for one year's use. Again, a multiplier of 2× is being added because this website is for a general public website with a national audience, so the final figure is $800.

Figure 7.7
Guide for use of a photograph on a website.

Photo Price Guide also has assignment information and guidance. In the example in Figure 7.8, I have clicked on 1 Day in the Annual Report subcategory of Corporate. I have selected "on location—medium production," which does not affect the multiplier, nor does the duration of one year or the region, which is national. I keyed in $1,800, and then I could choose to click Transfer, which would carry the information on to a quote document. Again, the Description and Tips/Cautions tabs are places to visit as you are best preparing your estimate.

Unlike Cradoc's fotoQuote and James Cook's HindSight Photo Price Guide, Lou Lesko's BlinkBid does not have dollar figures or stock pricing tips. However, BlinkBid is among the best solutions I can find for off-the-shelf software to prepare and present your estimates. Lou (like Cradoc and James) is a photographer, and he basically took his experience doing all manner of photography and put together BlinkBid.

In BlinkBid, by clicking Create a New Job, I can enter all of the relevant information about the job, as shown in Figure 7.9, in the Overview tab.

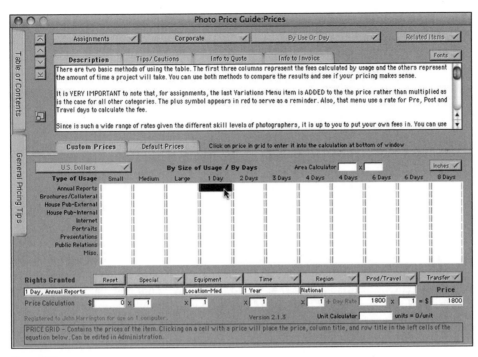

Figure 7.8
Another Photo Price Guide example.

Figure 7.9
BlinkBid's Overview tab.

The next tab is Terms, and this is where you would enter in the rights package and other information. In this case, here are the terms:

▶ **Usage License.** One time use in the 2010 Annual Report of the XYZ Widget Company. Annual Report is defined as "a document issued once each year by a corporation, outlining details of the company's income, expenditures, long-range plans, etc., for distribution to shareholders, the press, and others," and is identified by PLUS PGID#:11840000 0100. Use to appear inside, at a size no less than 1/2 page, and a press run of no more than 50,000.

▶ **Estimate Terms.** Estimate is valid for 15 days from the date of issue. Fees and expenses quoted are for the original job description and layouts only and for the usage specified. Final billing will reflect actual expenses. A purchase order or signed estimate and 50 percent of the estimate total is due upon booking. All rights not specifically granted in writing, including copyright, remain the exclusive property of John Harrington Photography.

▶ **Invoice Terms.** Invoice is payable upon receipt. A late charge of 1.5 percent per month will apply after 30 days. License usage rights are transferred upon full payment of this invoice. Failure to make payments voids any license granted and constitutes copyright infringement. All rights not specifically granted in writing, including copyright, remain the exclusive property of John Harrington Photography.

All of these fields are editable—and in fact, the Usage License box starts empty, so you can put in it whatever you want. Figure 7.10 shows how that screen looks.

Figure 7.10
The Terms page in BlinkBid.

In Figure 7.11, I have pulled together an estimate for an annual report, and by simply clicking Add Line Item, an item catalog comes up with practically every different type of line item you can imagine. In this example, when I clicked Lighting and the Add button, a new window opened up where I could enter the quantity, rate, and other relevant information. Click Add again, and it is added to the estimate in the right place, where the client would expect to see it. So if, for example, I entered all my expenses and then went back and added in the photographer's fee, it would place it at the top of the estimate, where it belongs.

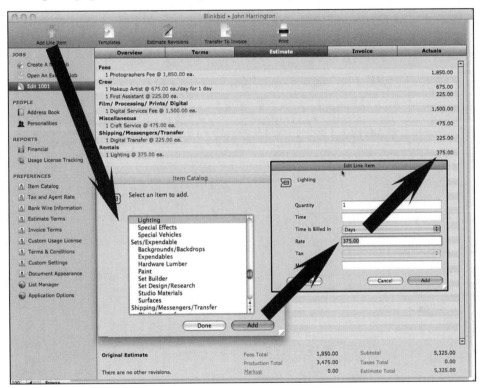

Figure 7.11
Estimate for an annual report.

Once I click the Print button at the top of the window in Figure 7.11, the page shown in Figure 7.12 comes up, and I can print to a PDF for easy e-mailing.

JOHN HARRINGTON
Photography

John Harrington Photography
2500 32nd Street, SE
Washington DC 20020
UNITED STATES

202-544-4578
john@johnharrington.com
www.JohnHarrington.com

Estimate

Mr. Smith	No:	1001
Smith, Jones and Doe	Date:	16 December, 2009
1234 Main Street		
New York NY 10017		

212-555-1212

Job Description
Produce one portrait, on location at XYZ Widgets Company, of the CEO for the 2010 Annual Report.

Usage License
One time use in the 2010 Annual Report of the XYZ Widget Company. Annual Report is defined as "A document issued once each year by a corporation, outlining details of the company's income, expenditures, long-range plans, etc, For distribution to shareholders, the press and others", and is idenfified by PLUS PGID#:11840000 0100." Use to appear inside, at a size no less than 1/2 page, and a press run of no more than 50,000.

Fees
1 Photographers Fee @ 1,850.00 ea. 1,850.00
 Fees total: **1,850.00**

Crew
1 Makeup Artist @ 675.00 ea./day for 1 day 675.00
1 First Assistant @ 225.00 ea. 225.00
 Crew total: **900.00**

Film/ Processing/ Prints/ Digital
1 Digital Services Fee @ 1,500.00 ea. 1,500.00
 Film/ Processing/ Prints/ Digital total: **1,500.00**

Miscellaneous
1 Craft Service @ 475.00 ea. 475.00
 Miscellaneous total: **475.00**

Shipping/Messengers/Transfer
1 Digital Transfer @ 225.00 ea. 225.00
 Shipping/Messengers/Transfer total: **225.00**

Rentals
1 Lighting @ 375.00 ea. 375.00
 Rentals total: **375.00**
 Total (USD) **5,325.00**

Signature_____ Date_____

Signature required before job start.

Estimate Terms
Estimate is valid for 15 days from the date of issue. Fees and expenses quoted are for the original job description and layouts only, and for the usage specified. Final billing will reflect actual expenses. A purchase order or signed estimate and 50% of the estimate total is due upon booking. All rights not specifically granted in writing, including copyright, remain the exclusive property of John Harrington Photography.

Figure 7.12
A BlinkBid estimate, ready for printing.

Another solution to generating estimates, invoices, and image licensing is HindSight's InView and StockView. HindSight is the first to market with full implementation of the PLUS licensing standard that I'll go into great detail about in Chapter 26, "Licensing Your Work." Figure 7.13 shows a main menu (which HindSight calls Flow Chart), showing the interactivity between the modules.

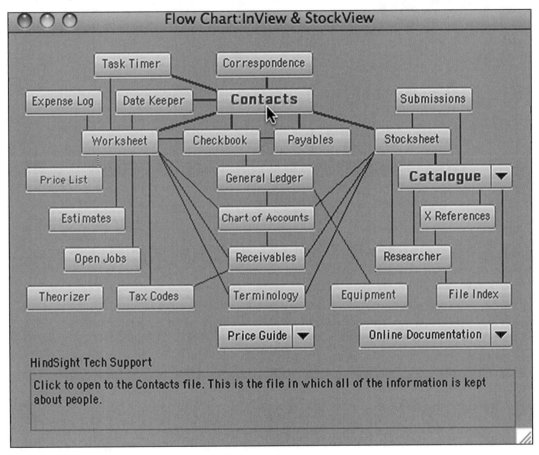

Figure 7.13
HindSight Flow Chart.

By choosing Contacts (as shown in Figure 7.13), you can manage your contacts. Figure 7.14 shows one example.

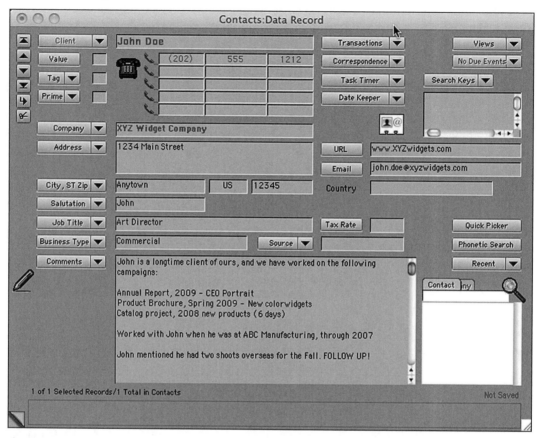

Figure 7.14
Managing contacts in HindSight.

Note that in the Comments area, I can make notes about the contact, what work we've done before, and where they might have worked prior to being in their current position. I could go on and detail a number of other modules (I do detail Terminology and the licensing part in Chapter 26), but suffice it to say this is one solution that deserves serious consideration.

So, which one? Frankly, I strongly recommend you get both fotoQuote and Photo Price Guide, for sure. Both are pricing resources that are invaluable for the insights you can get, and together, they would cost less than $250. (fotoQuote retails for $139.99, and HindSight's Photo Price Guide retails for $99.) Throughout this book, you'll see references to QuickBooks, which is a cross-industry standard for accounting and bookkeeping that will integrate with your accountant's books. For Mac users, from time to time, Quickbooks' maker, Intuit, has suggested they might stop updating Quickbooks and then after a brief hiatus—or even before then—the outcry causes them to reverse course and keep the application. I really like the functionality of BlinkBid and fotoQuote's sister software

application, fotoBiz, for assignment contracts and paperwork. The PLUS-compliant capability of StockView makes it very attractive for image licensing, especially (but not only) for stock. If you go the StockView route, then considering the sister software for that, InView, would be a worthwhile review.

Consider this: When you need advice on something important, do you just ask one friend? Having at your fingertips at any hour of the day or night these tools is a very practical solution. These tools are so invaluable to the operation of your business that the cost to get them is nominal relative to the benefit received. Even if you have all of them, they will last you much longer than a single lens, and they are less expensive than most professional lenses. If you're buying a full version and not upgrading any of them, BlinkBid is $229, and I would recommend looking at InView and StockView without the accounting features (dubbed Studio Pack), which retails for $299, since I recommend the accounting standard of QuickBooks for that aspect of your business. fotoBiz, which is fotoQuote's business management software, includes fotoQuote as well and also retails for $299. All of them have demo modes, so you can give them all a spin and decide which one is right for you. When you do decide to demo a product, it is imperative that you realize that they are all easy to use—once you know how. Think about the first time you sat down with Photoshop, and then realize that learning about each software package will take you some time, but it is time well invested.

Raising Your Rates: Achieving the Seemingly Impossible

No matter what rate structure and fees you've decided are right for you, ultimately you'll need to (and want to) raise your rates. The federal government gives its employees a cost-of-living adjustment (COLA) each year, as do most corporations across the country—or at least they used to! This is done for purely economic reasons. If a loaf of bread cost $1.29 last year, this year it costs $1.35, and the government wants to take this into consideration. Otherwise, over time, you wouldn't be able to afford the same grocery needs that you had, say, five years ago. If for no other reason than "everyone else is doing it," your rates should increase over time. If they don't, everyone but you will have more buying power, and you'll be at a disadvantage. The car that cost $20,000 ten years ago now costs $27,000, and you can no longer afford it—among other things.

Understand, though, that the COLA does not take into consideration promotions and raises that everyone else is striving for in their jobs. You, too, should strive to earn more as an employee of your business than you did last year. How much is up to you. Ten percent? Fifteen percent? Did you do a bang-up job for the business, working extra hours and weekends, outperforming last year? If so, a promotion of 20 or 25 percent is what others are achieving. Yet how do you do this when you are both the raise seeker and the raise approver, as well as the justifier to the customer of the new rates? It's a huge challenge.

Consider the scenario in which you have based your rates and fees on time—typically covering luncheons, dinners, galas, or even rites of passage. I adjusted my rates somewhat quietly. Early in my career, I had a four-hour minimum and was charging $100 an hour—in other words, a $400 minimum—but for that, the client could book me for up to four hours. After a few years, I raised my rates to $125 an hour, reduced my minimum to three hours, and added an administrative fee that was 10 percent of the estimate total—usually around $48 or so. This meant that the combined photo fees and administrative fee was $375+$48, or about $423. In addition, for the clients who did need me for four hours (or booked me for three and then ran over), I was able to bill an additional $125, so my four-hour assignments were bringing in $500, and no one was complaining. In addition, this eliminated situations in which clients figured out that it was the same to have me arrive at 8:00 a.m. for a 10:00 a.m. event concluding at noon as it was for me to arrive at 9:30 a.m. Not only did this save me the headache of fighting rush hour traffic and getting up early (one of my least desirable things to do), but I was able to take assignments that ended, say, at 5:00 p.m. and move on to assignments that were from 6:00 p.m. until 9:00 p.m. Previous clients were having me arrive at 5:00—something that I couldn't do, and thus I had to lose one job or another.

NOTE

A study of my client bookings revealed that most clients hiring me for this type of work only needed me for two or three hours, and my risk involved the few clients who did need me for four hours.

A few years ago, I decided I was busier than I expected, and I thought I might be able to weed out a few clients if I raised my rates again, so I did. I increased them to $150 an hour, with the same three-hour minimum, and the administrative fee jumped to around $68, meaning that a three-hour event earned $450+$68, or $518, and that four-hour event was earning $600+$75 (approximately) in administrative fees, or $675. This was a decent increase over the original $400 of a decade earlier. Is almost a 60-percent increase over, say, 10 years good? Perhaps. Does it take into consideration a COLA? Yes. Did it award me raises and promotions because I am more competent than I was 10 years ago? Maybe.

Other downward pressures are more demands for all rights, buyouts, work-for-hire (more on these later in this chapter), hobbyist photographers who claim to be working photographers capable of filling client needs, and market forces in my community. In the coming year, I am looking to increase my rates again because that previous bump from $125 to $150 didn't cause the reduction in assignment load I had expected.

In the scenario with rates based mostly on creative and not so much on time—often editorial assignments or corporate/commercial/advertising work—how I adjusted my rates did not occur with any more fanfare than necessary. Many of my clients, although repeat clients, are accustomed to receiving estimates before each assignment, so increases were less perceptible, and I certainly maximized my ability to increase my rates during the transition to digital. This not only covered the costs of the transition, but also an increase in overall profitability per assignment. Magazine assignments that used to be $750 including expenses are now in the $1,300 to $1,500 range.

Of course, it's imperative that you (internally) have an hourly rate that you use and apply to your calculations to arrive at your rates as a baseline for services rendered, from photographic to post-production and such. This is not an external figure that you share with clients; rather, it's a figure that helps ensure that you are paid that fixed salary from the CODB calculator.

Surveying Your Competition: How to Gather Knowledge Without Risking a Price-Fixing Charge

One of the ongoing issues among professional trade associations is that they cannot endorse, encourage discussion about, or advise a particular set of rates.

Law.com provides the following definition of price fixing:

> *n.* a criminal violation of federal antitrust statutes in which several competing businesses reach a secret agreement (conspiracy) to set prices for their products to prevent real competition and keep the public from benefiting from price competition. Price fixing also includes secret setting of favorable prices between suppliers and favored manufacturers or distributors to beat the competition.

Discussing with your colleagues and competitors what prices they charge (or would charge) for a particular assignment or type of assignment is not price fixing. If you agree to charge a set price and are among "several" (as noted above) companies that "prevents real competition," then you have a problem. However, many trade associations have worked diligently to avoid even the appearance of a price-fixing charge—an understandable measure of self-preservation, because no one wants to be the subject of a Federal Trade Commission probe. Back in the 1980s, ASMP produced a well thought-out survey of its membership as to the prices they charged (and presumably would charge in the future) for their services. Despite this well-intentioned work product, the Federal Government took a dim view of this and expressed as much to the ASMP in no uncertain terms. This has caused a chilling effect regarding pricing information and how (and by what means) it is shared. However, this should not discourage you from appropriately reaching out to others about pricing you may be less than familiar with.

NOTE
I submit that it would be very difficult to "prevent real competition" in the photographic marketplace with so many providers.

Perhaps your reason for inquiry is that although you can produce the final product you're being asked to, you might not be familiar with all that goes into it. Suppose it's aerial photography, and you don't know the risks to life, delays in weather, and pre-production and post-production demands that go into the final product. A call to an aerial photographer—quite possibly one far outside your market—could yield insights that would give you the knowledge necessary to prepare a proper estimate and equipment rental needs, so that you're not selling yourself short and you don't end up taking a loss on an assignment because of all the non-behind-the-camera work involved.

Perhaps your reason for inquiry is you are new to a market, and your "big city" pricing is turning off many of your clients. You are capable of doing the work in this new-to-you midsized town because you were booked often in your old location, so perhaps a review of your competition's pricing will cause you to reevaluate your pricing. It's not much different than a gas station owner coming to his corner of an intersection and seeing that his competitors on the other three corners have dropped their prices by 33 cents a gallon. He's going to be making some adjustments to his pricing signage post haste, or he'll risk going out of business.

If, when you reach out to others, they are reticent about sharing their prices with you, don't instead have a friend call up and try to book several assignment types from each photographer. That's unethical and dishonest to be sure. Instead, share with the photographers in question that you are hoping to get a fair gauge of the marketplace, and you may not recognize all that is necessary to deliver to clients in that town. Discuss the fact that you may be setting yourself up to over-deliver, and thus over-price, say, raw files and not charge any post-production fees, which would make you under-priced and under-delivering to the marketplace's expectations.

I have found that my website, which contains hundreds of pages of pricing information and an assignment calculator to aid clients in pricing an assignment before they call, is often used by my potential competition both locally and across the country to price their own assignments. This doesn't bother me—in fact, I am happy to know that it's happening. If someone independent of me opts to calculate what I'd charge for an assignment and values their work as I do, then if we both are competing for the same job (and I have no way of knowing whether this is occurring), we will be competing on the level of service, creativity, and quality, not on price.

Never Be the Cheapest

It's true. You *never* want to be the cheapest. I don't want to be the "always low prices, always" Walmart version of photography. Nor do I want to be the Target version. I want to be the Nordstrom, Saks, Tiffany, or other high-end exclusive boutique version of photography. Further, I believe that's the level of service, quality, and commitment I bring to each assignment.

NOTE
I have nothing against Walmart. In fact, I've completed assignments for them. I brought to the assignment a level of service they wanted, and I wasn't the cheapest photographer. The results validated that, as well as their decision that I was the right person for the assignment.

When I am discussing an assignment with prospective clients, they give off cues that they are going to be getting estimates from other photographers, and usually there is a hint of "we're looking at a few photographers' estimates right now" that gives me a clue that they're shopping price, among other things. At this point in the conversation, I attempt to diffuse the price-shopping by stating, "If you're shopping price, I can pretty much assure you that I

am not going to be the cheapest, but I will deliver the quality that you (or your client) demand at a fair price." Sometimes they are taken aback, but if you see that cost comparison down the road, you'll likely lose the assignment anyway, unless the client sees the value you bring. It's beneficial for you to point this out to the client sooner rather than later, and perhaps the other person on the phone—who often isn't the decision maker—will go to bat for you, and you'll get the assignment.

If You're the Cheapest, Find Out What Is Wrong

If you're the cheapest—and finding this out isn't too difficult—you want to know why. Perhaps it was in the expenses area of your estimate because you didn't include catering in a shoot that didn't call for it or a second assistant when the shoot only called for one. Or perhaps it was because you used ambiguous licensing terms that gave away more than you intended without your being paid the correct fees for the assignment.

When on assignment with clients, I often will discreetly survey them about how I came to be their photographer of choice. To date, I've not had a client state that it was due to price; I am aware that I am not the least expensive photographer in my community. Typically, I am a sole-source contractor who came to them by a recommendation, or a review of my website gave them the confidence to book me. If, however, it was because I was the cheapest, I'd ask a few more questions. Perhaps there was a misunderstanding about rights, rush turnarounds, or what was included in the assignment expectations. Either way, asking appropriate questions can give you insight into what you might not have (but should have) factored into the assignment.

NOTE

I know who the cheapest photographers in my community are because whenever I lose an assignment, I always ask to whom, and I always follow that up with, "And was it a matter of price?" Then, I ask what the price difference was. About 80 percent of the time clients tell me who they did hire. Seventy percent of the time they also tell me it was about price, and then they tell me what the differential was. It's amazing what you can learn just by asking!

What Do You Charge for Whenever You're Working for a Client?

One of the most surprising things I see my fellow photographers do is forget when they are free to do as they wish and when they are doing things on behalf of a client. I see my colleagues making lab runs; participating in site visits and conference calls; and doing scouting, pre-production, and post-production—and they worry about billing for these things. Whenever you are working on a part of a project that is for a client, you should charge for that. Period.

We bill for a delivery service to and from the lab, whether we outsource that to a courier company, I send my assistant, or I opt to do it myself. If we have to produce a second CD of images for a client, we bill for that. If we have to pull an archive drive and send out e-mails, that's billable. Retouching blemishes on a face? Billable.

The key is to explain to the client that these things do apply, so there are no surprises. Just as with other professions—lawyers, doctors' initial consultations, general contractors, accountants, and the like—the first meeting or phone call is free, and more often than not, meetings and calls beyond that are billable.

Tools and Resources for Understanding the Body Politic of Photographic Pricing

First, it's important to understand that media giants are *not* producing magazines for altruistic reasons; they are producing magazines to generate revenue. If even a modicum of altruism existed, *Life* magazine—a publication that changed lives and arguably governments—would still be published. In the end, *Life's* circulation declined, and advertisers were not getting the bang for the buck they wanted from the demographic they wanted, so they cut back on the advertising, and "poof," away it went. Oh, and this applies to newspapers as well. The articles, stories, and accompanying photographs are designed to cause you to turn from page to page, seeing the ads that pay the reporters, keep the presses running, and, most importantly, earn money for the owners or shareholders. In the end, editorial publications serve commercial interests. If you have any doubts about this, visit the websites of the parent corporations that own groups of publications, and look under the For Investors tab or the promotional material they make available to potential advertisers to entice them to spend their money in the magazine's pages. You will have a different and less generous purse when considering whether it's smart to take the assignment because the magazine's goals are to change the world.

Advertisers are looking to get the most for the least. Can you blame them? Almost everyone wants this in some form or another. However, in this case, they are paying you the least, and you're usually giving the most. While others involved in the project may believe they are giving the most, in the end, more often than not the image is why readers look at advertisements. Further, lots of people may have had great ideas that contributed to the final image, but in the end, it is the photographer who makes ideas a reality, and while ideas are not copyrightable, the tangible results (that is, your images) are copyrightable. This means that you're getting the short end of the stick more often than not. It's important to realize that how valuable your images are is, as they say, in the eye of the beholder. If they are willing to pay for your talent at your stipulated fees, then you have done a good job of illustrating your value to the project or assignment; otherwise, they'll have gone with someone else for some other reason (cheaper price *or* higher price when they've done a better job at illustrating their value). This is a universal truth for photographers, and it applies to commercial and editorial work alike. It's fair, not some shell game or other deceitful tactic. This is about being paid fairly for your contribution to the assignment. In some cases, you might believe a $30,000 licensing fee is astronomical, but when compared

to the fact that it will be the signature image of an advertising campaign in which several million dollars in media buys will be made, and from that, many more millions will be earned in product sales, it begins to be equitable.

Words to Avoid

Often clients will use words they don't know, often ones that have no real definition. The most common one is *buyout*. It has an ambiguous definition, at best, in the photographic world, and it is open to a wide array of interpretations. A buyout of what? All rights? Exclusively? Forever? Copyright?

Collateral is another word that is ambiguous at best when describing rights that are granted to a client for photographic images. *Advertorial* is another made-up word. Its definition comes closest to "a page in a magazine that is paid at an advertising rate but is designed to look like an editorial page, with a similar typeface and style." Most publications have policies specifying that so-called "advertorial" content not use the same fonts as the editorial portions of the publication. The content is usually not solely controlled by the advertisers, but it is usually written by staffers or contractors in a manner to make the advertisers look good. The content is submitted for review and approval by the advertiser, which means that they want you to charge an editorial rate for an advertising use. Don't succumb to this—consult your advertising pricing guidelines and quote the advertising price. When they come back to you with a quote that's a third of this price, respond that those are your advertising rates, and it's your policy to charge advertising rates for advertising uses, which is what an advertorial is. The same holds true for *custom publishing*, in which an entire magazine is printed and looks like an editorial magazine, but, in reality, it is a brochure disguised as a magazine. That's an advertising rate.

Pro Bono: When To and When Not To

There seems to be an altruistic and socially conscious bone in every photographer's body, and, as such, there is a predisposition to have a soft spot in one's heart for the phone calls that you'll inevitably get espousing every good cause under the sun, asking for free or cheap photography services. Be careful.

First, it should be you who decides which causes you want to support. That means deciding what's near and dear to you and reaching out to those causes. When others call looking for your services, it's easier for you to say, "I've decided which charitable organizations to donate my services to this year, but I would be happy to discuss your needs and see whether I can give you the services you need at a fair price."

When I get a call that starts with, "We're a nonprofit…," I typically (and respectfully) inquire whether the person is a volunteer for the organization or an employee. Ninety-five percent of the time, the person is an employee, and I become far less likely to consider a pro-bono assignment or a discounted rate. If the entire organization is made up of volunteers, that might be an indicator to you that a review of your free time may be in order.

Often there are events that appear to be so worthy, so pure of heart that they call out for someone to help. When you arrive, though, you find out that the event was able to secure a location at a nice hotel and bring in folks from distant locales because the event, for a debilitating disease or condition, is being underwritten by a pharmaceutical company who has a drug that will cure or lessen the effects of the disease, and if their drug ends up on the list of drugs approved for reimbursement by the state or federal healthcare system, they stand to make millions. It's at this time that you feel taken advantage of. This holds true for ad campaigns as well. In addition, nonprofits don't get discounts on their power and telephone service, nor on printers, copier paper, and such. Don't offer special pricing to a nonprofit unless they are special to you, and you decide that's something you want to do.

Why Work Made for Hire Is Bad for Almost All Non-Employee Photographers

We, as members of this society, have agreed to be governed by the laws of the land. And when the laws of the land, as enacted by Congress and signed into law by the President, become a topic of disagreement, the third check comes into play—the judicial branch. Beginning in small claims or Federal courts in districts across the country and culminating at the Supreme Court, along the way the courts, absent prior case law (and often contrary to past case law), look to the debate and dialogue that took place while the laws were being enacted. This is known as the "intent" of the lawmakers. Courts attempt to understand what dialogue and debate made up the final decision so they can test the case before them with Congress' intent. Save for a very narrow scope of work, work-made-for-hire is absolutely contrary to copyright law—a tenet of the Constitutional framers—as well as Congress' intentions. The framers granted artists a limited monopoly over their work for a limited period of time as an incentive for them to continue to create their works and for inventors to do the same. The framers held the value of copyright so sacred that it was a part of the Constitution. They set forth the value of "useful arts" within the first 1,600 words of a 4,500-word document. They protected "useful arts" and commanded Congress to promote them before they defined the Presidency, outlined issues related to the States, and, obviously, before all the amendments!

If you're going to "sell" your copyright, then it must be with an understanding of just what you're selling. Almost everyone has heard of the garage-sale treasures that were purchased for $20 and ended up being extremely valuable works of art. PBS' *Antiques Roadshow* has made a multi-year series out of this reality, in which someone doesn't know the value of what he or she is selling. Understanding the maximum potential for revenue over the life of the image—approximately 100 to 150 years when you factor in your life plus the 70 years that your heirs own and control your copyright—will give you an understanding of just what those images could be worth and how you must be appropriately compensated for that loss (or transfer of revenue potential to a third party).

As an employee of a company, your work is vested with your company the moment it's created. Your employer is the author and owner of the work from its inception. Period. If your employer allows you to use the photographs for your portfolio—or anything, for that

matter—consider yourself lucky. To be especially careful, get this in writing. I am aware of more than one photographer who, when his employer went looking for reasons to terminate a staff photographer, used the photographer's use of the photographs on his own website as grounds for termination. However, if you own your own photography business, once you create images, you are the author and owner of the work, period. You can't go back and sign a WMFH agreement—in fact, backdating an agreement of that nature will most certainly invalidate it. If you sign a WMFH agreement prior to the creation of the images, make sure that at the same time, you get a license for, at a minimum, your portfolio from the author and owner of the images you are about to create. In situations in which you're delivering photography under a WMFH agreement to a stock agency and, say, you go to shoot the U.S. Capitol (or other landmark in your town) at sunset or on a bright, sunny spring day and deliver them to the stock house, you will find yourself in a legal predicament if, separate from your work for them (either off hours or after you've left), you return to a similar spot and make new photos. Those new photos could infringe on the previous photographs, whose copyright is owned by the stock house.

At one point not too long ago, I was presented with the following terms in an "agency" contract:

> Ownership of Assignment Images.
>
> Photographer hereby acknowledges and agrees that, unless subject to a separate written agreement between Photographer and the Company, all Assignment Images:
>
> (i) have been specially ordered and commissioned by the Company as a contribution to a collective work, a supplementary work or other category of work eligible to be treated as a work made for hire under the United States Copyright Act;

This language attempts to portray the work I would have been delivering to them as eligible for WMFH status. This is a problem because there are only nine categories of work that are legally allowed to be categorized as WMFH under part 2 of the definition of Work Made for Hire in the U.S. Copyright Office's Circular 9. They are:

1. A work specially ordered or commissioned for use as a contribution to a collective work
2. As a part of a motion picture or other audiovisual work
3. As a translation
4. As a supplementary work
5. As a compilation
6. As an instructional text
7. As a test
8. As answer material for a test
9. As an atlas

...if the parties expressly agree in a written instrument signed by them that the work shall be considered a work made for hire.

Further on, in Circular 9, it states:

> If a work is created by an independent contractor (that is, someone who is not an employee under the general common law of agency), then the work is a specially ordered or commissioned work, and part 2 of the statutory definition applies. Such a work can be a work made for hire only if both of the following conditions are met: (1) it comes within one of the nine categories of works listed in part 2 of the definition and (2) there is a written agreement between the parties specifying that the work is a work made for hire.

Work shot on assignment for photo agencies is, in my opinion, on shaky footing and could well be rendered as not fitting within the nine eligible categories of WMFH. As such, the contract stipulates in the clause immediately following it:

> (ii) will be deemed a commissioned work and a work made for hire to the greatest extent permitted by law;

Hmmm. Seems I'm not the only one who thinks that there is cause for concern about the classification of the assigned photography as falling within the nine categories—attorneys do, too. In fact, it is not enough that you be given an assignment to cover a news event or produce scenic stock of a city; the photograph must be created at the direction and supervision of the commissioning party. Further, if you're assigned to cover a movie premiere, and en route you come across breaking news of a fire and you make images of that, the client could argue that it was a part of the assignment because they were paying you. But, in fact, they didn't request that you make the photographs of the fire, nor was their request the motivating factor for you to make the photos, so the images would fail the tests that are necessary to create a permissible WMFH circumstance. This direction could be taken a step further. If your client stipulates, "I need tight headshots and full-lengths of the star of the movie," anything else—images of the director, unexpected stars not a part of the movie, other VIPs, and so on—could not fall within the "direction and supervision of the client" test and would be ineligible for WMFH status, hence the next few clauses.

> (iii) the Company will be the sole author of the Assignment Images and any work embodying such Assignment Images according to the United States Copyright Act;

More intent to claim ownership.

> (iv) to the extent that such Assignment Images are not properly characterized as a work made for hire, Photographer hereby assigns, transfers and conveys to the Company all right, title and interest in such Assignment Images, including all copyright rights, in perpetuity and throughout the world. Photographer shall help prepare any papers the Company considers necessary to secure any copyrights, patents, trademarks or intellectual property rights in the Company's name at no charge to Company.

Here, you find that the attorneys and the companies they represent are adding in an insurance policy, whereby you agree to transfer every right (including copyright) to the company at no charge. Would that be no "additional charge?"

Photographer further acknowledges and agrees that the Company will have the right to undertake any of the actions set forth in Section 106 of the Copyright Act (17 U.S.C. §106) with respect to such Assignment Images. This includes, without limitation, the right to sell, license, use, reproduce and have reproduced, create derivative works of, distribute, display, transmit and otherwise commercially exploit such Assignment Images by all means without further compensating the Photographer. Notwithstanding the foregoing, the Agreement is not intended to and shall not prevent Photographer from engaging in assignment photography for Photographer's own account outside of the scope of the Company's representation of Photographer.

There's that word "exploit" again. It's not a bad thing, but it reminds you that they're going to do everything they can to generate revenue from the images. In the end, they remind you that you can work for other companies, and they won't stand in your way.

Suffice it to say, I did not sign this contract. Understand that if you sign and work under a WMFH agreement, you will be required to constantly be generating additional images from additional assignments. At no time will you be able to earn anything from your past work. As you work you're paid, but never again, so you must continue to work and be at the whim of losing those assignments (to someone cheaper?), at which time you would have to seek out more work to pay your bills and feed your family. To quote noted copyright expert Jeff Sedlik, "Copyright is the thin line that separates photographers from day laborers."

In 1955, photographic legend Arnold Newman organized what became a major strike over rights issues at *Life* magazine. This eventually became a fight against copyright transfers, lesser rights, and such. In a 1993 interview by Kay Reese and Mimi Leipzig celebrating the 60th anniversary of the ASMP (the entire transcript is available on the ASMP website), Newman talks about his experiences surrounding this strike. Reese/Leipzig cite what Newman wrote in the foreword to the book *10,000 Eyes: The American Society of Magazine Photographers' Celebration of the 150th Anniversary of Photography*, which celebrated the 150th anniversary of the invention of photography. It reads, in part:

A key victory nearly forgotten and often overlooked was a non-ASMP act. In 1955, Life published nine essays, *Arts and Skills in America*, and sold them to Dutton as a book. Five of the essays were shot by staffers or were handouts. The problem was, they conveniently forgot that the other four were shot by three freelancers: Gjon Mili, Brad Smith, and myself. We naturally requested the additional payment for this unauthorized use. In settlement, *Life* offered remuneration with the stipulation that we sign a contract, also sent out to all their other freelancers, that required us to give up copyrights, reducing or wiping payments for reissues. Our hard-earned rights were threatened, as control over (and indeed the very loss of) our negatives, our work, was at stake. All hell broke loose. Seven other top freelancers refused to sign and, in effect, ten of us went on strike.

CHAPTER 7

In the Reese/Leipzig interview, Newman goes on to talk more about the strike he organized:

> We just simply said we wouldn't work for them anymore. Their attitude was, if you didn't work for *Life*, you weren't a photographer. At that time, the only other magazine (which I'd already begun to work for) was *Holiday*. And there [were] *Bazaar*, *Vogue* and one or two others that didn't compete with *Life*.... We absolutely refused to accept any assignments until it was done. As an aside before I continue, I discovered during that year that I earned more money working for other magazines than I did for *Life*, and it made me much more independent. I had already begun to worry that I had too many eggs in one basket.

An excerpt from Newman's *10,000 Eyes* foreword wraps up the point:

> Alternate contracts were offered and refused, again and again.... The turning point came when *Life*, attempting to divide and conquer, claimed that they could do without five of us. [One photographer] became furious and confronted his friend, *Life*'s editor-in-chief Ed Thompson, saying, "I think Kessel [Dmitri Kessel, a staff member] is going to have one hell of a time crossing any picket line I'm on." *Life* at this point gave up and offered us a fair agreement, restoring all our rights. What would have been a disastrous precedent for all ASMP members was avoided.

In some instances, agreements, if not properly scrutinized, appear at first to be fair, but upon closer inspection turn out to be unfair and unreasonable. I call them "stealth" WMFH contracts. They are all-rights/work-made-for-hire/copyright grabs. Here's an example of one publication's attempt:

> Copyright License – Freelancer shall retain ownership of copyright in the Content, and grants an unlimited worldwide license, for the full duration of copyright, and any extensions thereof, to [publication] to use and to freely sub-license the Content by any means, without further compensation to Freelancer. For greater clarity, this means that [publication] may, for the full duration of copyright, and any extensions thereof, use, publish, re-publish, store, sell, re-sell, distribute, license or otherwise deal with the Content in its sole and absolute discretion.

While this is egregious, it leaves you to think that at least you can license your assignment images as stock. However, it's clear that they too could do this, so you would be competing with the publication for that stock license. And, because the potential photo buyer would be contacting the publication where you were credited for the image, the publication would be offering to license the image, rather than doing what it should—directing the interested party to you, the photographer, for a stock license. However, all of this becomes null and void because of the next clause:

> Exclusivity of License – The above license is exclusive in [country]. [Publication] may make exceptions to this exclusivity to allow Freelancer to publish the Content in another media in [country], but that exception is not valid unless obtained in writing from [publication].

Tricky, isn't it? They have an exclusive license, meaning that all of the rights you grant them are exclusive to them, and you may not exercise any of those same rights without their permission. This is essentially a work-made-for-hire in disguise. What rights do you retain? I see few, if any.

When you are dealing with contracts that prospective clients present to you, be absolutely certain of what you are agreeing to and how, when spread across a multipage document, terms become less offensive one at a time than if they were all lumped together. Yet, in the end, these terms all apply just as if they were lumped together, and you then are signing away rights you thought you were retaining.

Working Around Work-Made-for-Hire Clauses

Everyone's complaining about how clients are demanding WMFH contracts, and legal departments everywhere seem to want that language in their contracts. Okay, put it in and have it apply when you are paid an appropriate fee (as deemed by you) and you agree specifically to it in writing. I have the good fortune of having a few clients for whom I am on a retainer. I am blessed that they call often enough that they don't want to have to sign off on fees and expenses and rights packages every time. So, we set forth an agreement for all work performed for them. This is essentially the same way a magazine handles assignments you do for them—*they present the contract*, you sign once, and everything completed for them after that is under those terms. Here's how I have handled WMFH in my corporate contracts, where the lawyers on the other side wanted to see the words "work made for hire" in the contract:

> Licenses or permissions not expressly stated in this agreement shall not be implied, and all rights not expressly granted to Client are reserved to Photographer. Except in the case of work made for hire, or where provided for in a written agreement between Client and Photographer, licenses and permissions expressly exclude derivative rights. Except in the case of work made for hire or as expressly authorized in writing by the Photographer, work may not be archived or placed in any electronic catalog or electronic delivery service. Work which is to be created as and priced as "work made for hire," if any, shall be specified in writing signed by the Photographer. As to all work, Photographer specifically retains the right to use and display Photographer's work for portfolio purposes.

In this example, the language is in the contract, but in order for the work to actually be work for hire, there has to be a separate agreement specifically stating that and signed by me. Further, as noted above, it has to be priced as such. To date, none of the work done under contracts that include this language has been deemed as such.

You Don't "Sell" Anything

Whether you are just starting out as a young photographer or transitioning from staff to freelance, it is critical that you understand that you are not "selling" anything. Before you can step up to the plate and change a client's thinking on who owns the photography that you create, you must first be definitive about this fact: *You* create images that *you own* and then, in turn, license to your client. For more information on the difference between "sell" and "license," see the section "Licensing Your Work" in Chapter 26.

Recommended Reading

The final section of this chapter includes some recommended further reading for you.

General Books on Negotiating

Camp, Jim. *Start with NO...The Negotiating Tools that the Pros Don't Want You to Know* (Crown Business, 2002).

Cohen, Herb. *You Can Negotiate Anything* (Bantam, 1982).

Fisher, Roger, William L. Ury, Bruce Patton, and Bruce Patton. *Getting to Yes: Negotiating Agreement Without Giving In* (Penguin, 1991).

Ury, William. *Getting Past No: Negotiating Your Way from Confrontation to Cooperation* (Bantam, 1993).

Books on Negotiating Developed by and for Photographers

Pickerell, Jim. *Negotiating Stock Photo Prices* (Stock Connection, 1997).

Wesigrau, Richard. *The Photographer's Guide to Negotiating* (Allworth Press, 2005).

Chapter 8
Overhead: Why What You Charge a Client Must Be More Than You Paid for It

Overhead consists of those expenses directly associated with the production of your photographic services. A few of the numerous examples of overhead include office supplies, from paper for your printers to staples and pens; utilities, including electricity, gas, high-speed data lines, and so on; advertising and accounting; and some might suggest computers and cameras, although those might be debatable, instead allocated as "cost of goods sold" items or such.

Overhead is one of the categories of expenses that photographers most often fail to include accurately in their cost of doing business, and thus they will incorrectly attribute these expenses to the personal side of their tax ledger. Or, they will be significantly less profitable than they expected because they didn't take into consideration certain expenses that they should have.

What Is Your Overhead?

Someone has to pay your overhead, and in the end it's you, but amortizing your overhead over each assignment you expect to do will mean that you pass on to your clients your cost of being in business—something that every other successful business does. If you've been running your business for awhile and you don't know what your total overhead is, it's time to sit down and take one of those non-shooting days to get a handle on this.

First, have a look around your office space. Think about supplies, software, computers, cameras, lighting, accessories, phone and data services, desks, filing cabinets, hard drives for data storage, offsite data storage, and so on.

Next, sit down with your past 12 months' worth of credit card statements and banking statements and see what items you charged that could fall into the category of overhead. Do not count any film processing (if you're still doing that), shipping charges (if you bill each client for their shipping), or other items that are associated with your cost of goods sold or items that are reimbursable expenses by the client for each job.

Take this collection of expenses and review it with an eye toward annual totals for each item. Some might be biennial (computers and cameras) and others will be monthly (data services, cell services, rent/mortgage, and so on), but by making the necessary calculations, you will begin to see a larger picture come into play about what your true overhead is.

Back in the Day: The $40 Roll of Kodachrome

One of the things that arose when the bean counters at the media conglomerates began to try to cut costs and increase profitability of their companies (and thus justify their jobs) was that they began to look at photographers' invoices. The bean counters' personal familiarity with purchasing consumer-grade film at $5 or so a roll did not jibe with seemingly exorbitant prices for rolls of film on the invoices.

What these accountants did not consider was that in order to best have film ready for a client, it had to be ordered and either shipped to you or picked up via courier and brought to you. This incurred an expense. Then, professionals didn't take the film out of the shipping box and shoot an important assignment—they shot a test roll (or two) under controlled conditions and had it processed. This incurred an expense. Then the film came back from the lab— another expense. Then there was time involved to determine the best settings for the use of that film. This was an expense. Then there was the cost of storing the film in a refrigerator. Another expense. Then there was the waste when you were required to have your film x-rayed twice during your trip, and you had to attribute 20-plus rolls of film to "waste" and trash it. This was an expense. All these expenses contributed to a cost per roll of film that was higher than the accountant's $5 roll of film he dropped into his happy-snap camera for family photos, yet he decided that this was an area in which they would establish a new policy regarding only reimbursing actual expenses. This made matters difficult because how do you amortize a courier charge over 20 rolls of film delivered among the numerous other items and then provide the client with receipts? My answer is that I don't.

Our policy—my policy—detailed on my website, which stood for years in response to client demands for receipts back when film was the default medium to deliver photography, is as follows:

> We do NOT supply clients with receipts for any expenses. We do this for several reasons:

> We are independent contractors, not employees. When tax time comes, the IRS requires us to provide receipts to verify expenses deducted on our tax return. The IRS does NOT require you to have those receipts on hand.

> It is critical to the success of our business to maintain a proprietary suppliers network—an absolute cornerstone of a profitable business, and in an insecure environment we do not wish our competitors to learn who our suppliers are. While this is less applicable on film and processing than on unusual items, and from time to time, applies to assistants as well, it is nonetheless critical throughout our supplier chain.

> We have a set fee per amount of supplies or services used (whether film, background paper, courier services, lighting/equipment technicians, and so on), regardless of what was actually paid for it. This is done for several reasons: 1) We keep supplies like background paper, and other expendables on hand to meet last-minute and unusual requests, and 2) for services like a courier or lighting/equipment technician/assistant, we have pre-set rates we charge for these, and in turn, negotiate our costs for that alongside our time in arranging/booking those services.

> By way of example, publishing houses do not request receipts from printing plants for the cost of ink and paper, nor receipts for the wholesale prices paid on the repair of a copier, nor gasoline receipts from the delivery service who delivers the copies of the magazine.

> Please discuss with us any issues you have with this policy beforehand.

This has resolved a number of client issues over the years, and, well, it's our policy—my policy. Understand that just as it's perfectly acceptable and understandable that companies across the country have policies, so too is it acceptable that you have policies! Just as you have policies such as, "I won't allow clients to curse and yell at me on the phone," or "I expect to be paid for my services because I don't work for free," so too can you establish and put forth other policies for clients to adhere to. This isn't to say that policies can never be bent or broken, but that's for *you* to decide when it happens. You'd be surprised at how many accounting departments will appropriately accept the fact that my policy prohibits the disclosure of proprietary supplier information to them in the form of receipts from those suppliers and will pay the bill that they were questioning.

This issue was much more of a problem during the days of film than it is now. However, an updated policy looks like this:

> We have a set fee for delivery services regardless of what was actually paid for it. Examples may include delivery—sometimes delivery services must make second attempts, and we cannot know of these additional expenses until 30+ days beyond an assignment, which must have been billed before we receive the actual bill, or other surcharges may apply. We stipulate delivery charges to avoid this paperwork. Post-production: We allocate our post-production vendor's services over set periods of time, based upon image counts, and outline that expense to you. We pay a set figure to them for each day's work, and that workload is not delineated by the job where hours are allocated to each job. Further, we may work with our vendor to investigate new production techniques, from plug-ins that produce superior raw-to-jpeg conversions, or other services that benefit you, the end client. The cost for this time, billed by staff, must be spread across our assigned fees per assignment.

> By way of example, publishing houses do not request receipts from printing plants for the cost of ink and paper, nor receipts for the wholesale prices paid on the repair of a copier, nor gasoline receipts from the delivery service who delivers the copies of the magazine.

> Please discuss with us any issues you have with this policy beforehand.

Markup: What's Yours? How Do You Establish It Fairly?

Very few things are not subject to markup consideration. I don't mark up my hotel or airfare charges, but the figure I quote on the estimate is what the client is charged and is based upon the quote from the hotel and a nominal charge for our time. Typically, it's very close to the actual charge, but issues such as the time involved in booking the ticket (searching for the right flight, determining excess baggage charges, and so on) are included in this item, rather than as a part of the pre-production charges (although that also could be a fair method).

One way to evaluate what a fair markup rate is for you is to find a day when you are not shooting or doing post-production work for a client and look at the items you typically use for assignments—seamless backdrops, film (if you're still shooting film), packaging materials for shipping and overnight services, and so on. Understand, too, that you will be carrying these expenses for a period of time that ends up being somewhere around 30 to 45 days, with some clients demanding 90-plus days before payment. There are businesses that earn millions of dollars just on the "float" between when they receive payment as a middleman and when they have to pay that money to the ending third party. If you're carrying a $1,000 expense for a client for 60 days at 15-percent APR interest, you're paying $12.50 in interest on your credit card. If you are paying off your balance, that $1,000 you paid off with $1,000 of personal or business resources was not available to earn interest in an interest-bearing checking account or to be invested in higher-yielding accounts.

I know, for example, that when I provide services to a PR or advertising firm, they mark me up somewhere between 12 and 19 percent. Some have pegged their markups at 17.65 percent and printing markup at 20 percent. This covers their cost of hiring me, paying me, dealing with any problems that I may create for them or their client, and dealing with my paperwork. All their client has to do is have me turn up and make photographs. More important, markup percentages are no secret—they are typically outlined in contracts between client and firm. Everyone involved is aware of them, and although there might be some haggling (especially when the client is the federal government or a charity), markups are a given in many business transactions. In cases such as a charity, I have been directed to bill the charity directly, so that they could save the markup on me. Although it is standard for PR and ad firms not to charge a markup for media buys where the client who is making the media buy pays their firm a surcharge, they make their profits on their commission from the media buy, usually paid to them from the publication's advertising department. This is typically done in one of two ways—one where the ad firm delivers published rates, receives payment, and pays a lower figure to the publication, and the other where the client pays the publication the published rate directly, and a commission check is cut from the publication's ad department to the ad firm. For both of these situations, the commission has a range somewhere between 10 and 15 percent. However, on multimillion-dollar media buys, commissions can drop to as low as three percent.

With all of this said and your understanding that markups are a common practice, you should be more empowered to charge markups on everything and not feel any sense of guilt in doing so. I accept a fair markup of around 17 percent for many services we render and expenses we cover on behalf of a client. It's imperative that I not be their "float" and have to leverage my credit cards to service their debts.

Chapter 9
Who's Paying Your Salary and 401(k)?

It's never too late to plan for your retirement. In fact, it's never too early to do so either, and the earlier you start, the better off you'll be when you do retire. Many of us think we'll be making photos until our last breath because we love to, but what if we had to because we'd not planned for retirement?

If Everyone Hiring You Has a Retirement Plan, Shouldn't You Have One, Too?

Most professional employers—the people who will be picking up the phone and calling to give you assignments and projects—have some form of retirement program for their employees. Some are stock programs, 401(k)s, and the like. There is no shortage of retirement benefits for the companies that are hiring photographers, so you'd do well to expect the same from yourself. Factor this into your overhead and cost of doing business. Few photographers I know can tell me what their retirement fund total is, and next to none can say they know what the projected yield is (all things remaining fairly stable) when they reach retirement age.

There are a few tax-deferred plans available to freelancers, but I'd be doing you a disservice if I advised you of the best plan for you and your circumstances. There are skilled investment and retirement specialists at your bank who can send you in the right direction. The important thing to do is to get one started. This tax year, ask your accountant to advise you of the maximum contribution you can make to your account(s). (See Chapter 11, "Accounting: How We Do It Ourselves and What We Turn Over to an Accountant," for a discussion of why you should have an accountant!)

One word of caution: There are a wide variety of financial advisors who are paid a commission based on every time you effect a financial transaction, how much you invest in certain types of investments, or when you put money in investments their financial institution is handling. Make absolutely certain that you are aware of these fees and that the investment advice you may be receiving could be tainted by this. In addition, your accountant should be an excellent resource for qualified investment specialists, and further, both accountants and investment specialists can advise you about retirement planning to maximize your savings and tax liability.

If Everyone Hiring You Is Paid a Salary, Shouldn't You Be, Too?

This idea dovetails well with Chapter 32, "Charity, Community, and Your Colleagues: Giving Back Is Good Karma," where I discuss pro-bono work. If the person hiring you is being paid a salary to do his or her job, then it stands to reason (and common sense) that you're paid a salary by your business! Too often, however, photographers fail to consider themselves as due a salary. This is shortsighted.

Typically, when a photographer's business starts up, every dime gets reinvested in the business, and a scant amount of money gets directed toward non-photo-related endeavors. However, to fairly and accurately pay you, your business must begin to pay you a defined salary sooner rather than later, and it should be a cornerstone of your CODB (cost of doing business).

As times change, you should be getting raises—most of the rest of the working public is, and they're more than likely not working as many hours as you are. To that end, you need to determine just what your salary should be.

Establishing a Fair Salary

Because most photographers tend to undervalue themselves and the contributions they make, let's start with a few figures so you don't sell yourself short out of the gate. The NPPA CODB calculator automatically defaults to a $40,000 salary, and that hasn't changed for several years. Salary.com shows a median amount of $54,210. A survey by Salary.com yields the results shown in Figure 9.1.

With a base salary of $54,210, there are still other things to factor in. Numerous other expenses are associated with an employee whose salary is $54,210. Drilling down into Salary.com's bonus and benefits details reveals an interesting set of additional figures, shown in Figure 9.2.

As shown in Figure 9.2, this same employee is actually costing the company just over $77,000 a year. These aren't made-up numbers; they are real, fair, and most important, *reasonable* figures. Understand that if you were to pay this same amount yourself, you'd have to consider that expenses such as self-employment tax, health and disability, and social security are not expenses that your company (in other words, you) can pay part of or all of, but instead, you are responsible for those expenses.

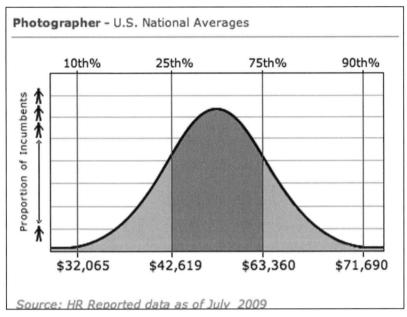

Figure 9.1
Salary.com survey results.

Benefit	Median Amount	% of Total
Photographer – U.S. National Averages		
Base Salary	$54,210	70.4%
Bonuses	$681	0.9%
Social Security	$4,199	5.5%
401k / 403b	$1,976	2.6%
Disability	$549	0.7%
Healthcare	$5,722	7.4%
Pension	$2,525	3.3%
Time Off	$7,178	9.3%
Total	**$77,040**	**100%**

Source: HR Reported data as of July 2009

Figure 9.2
Total compensation as reported by Salary.com.

To see what this same photographer's take-home pay is, Salary.com also provides an insightful breakdown in Figure 9.3.

Photographer – U.S. National Averages

Net Paycheck Estimate $ 1,562.83

Edit Paycheck

Your Estimated Paycheck Results

Bi-weekly Gross Pay	$ 2,085.01
Federal Withholding	$ 362.68
Social Security	$ 129.27
Medicare	$ 30.23
	$ 0.00

Figure 9.3
Total compensation as reported by Salary.com.

That's a whopping $1,562 a paycheck, take home. With these results, you want to consider what value you bring to your own company. And remember—salary comes out of what remains after your expenses and a recurring re-investment in your business. One factor I try to consider is that if the photo editor who is hiring me is making $80,000 plus benefits, maybe I should be making $70,000 plus benefits. Or, if the vice president at the PR firm that is hiring me is making $100,000, then maybe I should be making just as much if I bring to the table a comparable level of skills, or maybe $80,000 if my skills are not quite comparable. And, if the senior photo buyer at the ad agency is making $140,000, then I should be making around that much. Right? Although I don't base my fees or income on what people who hire me are earning, considering them and the realities of their income as a paradigm as you review what your salary/income might be is worth the thought. However, remember that there are a number of photographers who earn a salary of $100,000 when the photo editor who is hiring them is earning $40,000.

It is also critical to understand that if you are billing a total of $70,000 each year, that is in no way, shape, or form the same as earning a $70,000 yearly salary. Costs for cameras, computers, overhead, and such could cause that figure to approach or go below zero. Your salary is what you'd earn before taxes. Don't confuse the two!

A remarkable survey by David Walker was published in *Photo District News* in June, 2006. It was the first survey conducted by *Photo District News* of salaries within the industry, and the response—it was not a random sampling, but a voluntarily contributed to survey—was huge. More than a thousand photographers were among the 2,114 respondents to their survey. The numbers in Figure 9.4 are average income figures—a fraction of the overall

resulting insights, which can be viewed at the PDN website (www.pdnonline.com). There, you'll find breakdowns by state/region, median levels, and other survey results (such as what studio managers, art directors, account executives, art buyers, and photo editors also are earning).

Figure 9.4 shows the average income for freelancers in each category.

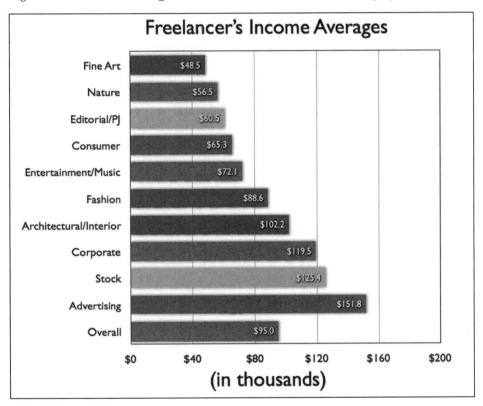

Figure 9.4
Freelance income averages.

For editorial photographers, an average wage of $60,000, with corporate photographers averaging just under $120,000, certainly gives you a good place to begin when thinking about what salary you should be earning. There are a number of factors involved in determining your salary, and because you're the boss and the employee, you'll have to set your own wage. The key is to actually set a wage and work toward achieving it.

Targeting That Salary in the Short Term and the Long Term

If you're just into the business a few years, perhaps your salary should be closer to the left of that bell curve in Figure 9.1, somewhere in the low to mid $30s. This is not an unreasonable salary to expect if you have a baseline skill set that will allow you to meet client needs on a variety of basic assignments. However, you'll want to be realistic about what you pay yourself now versus what you'll be paying yourself in 10 years.

One of the remarkable things that happens to people as they transition from one arena to another is that they have to make an adjustment in their self-perception. During your last year in elementary or middle school, you were on the top of the heap. All the other kids looked up to those in the upper grades, and this was true whether you were the cool kid or the nerd. Even the nerds got respect from those three and four grades below them. However, the tables quickly turned as summer turned to fall, and that top-of-the-heap elementary school kid became a freshman in high school, and it was back to the bottom of the ladder. And so it goes again as a high school senior transitioning to a college freshman. And again, the supposed top-of-the-heap college senior…until you graduate and find yourself in the lifelong climb of the professional world. Even the photo school award-winning valedictorian can easily find himself working for a weekly paper in the middle of nowhere, and this becomes a reality check for that photographer and his salary expectations.

When I graduated, having not studied photography—my degree was in political science, with a minor in economics—I took a job as a staff photographer for a magazine that paid a whopping $15,000 per year. I was by no means at the top of my graduating class, but even this stung a bit. Yet the opportunity to have my own studio sizable enough to fit a car in, my own darkroom and film processing line, as well as an extensive range of cameras from 35mm through 4×5 and more studio lighting than I'd ever seen was a dream come true for an aspiring photographer who'd had a few stories published. The important thing was that I was a salaried employee with benefits paid by my employer, zero investment in capital, and zero risk of no revenue. As long as I did my job, I got my paycheck. Today's starting photographers can hope to find salaries in the low to mid $20s, where they will cut their teeth for a few years.

As you look at your current experience level and do your own research as to what others are earning or what you could earn in another field were you not a photographer, you'll want to choose a salary level that also takes into consideration growth potential over 5-, 10-, 15-, and 20-year periods and target those salary levels in your projections of overhead costs and your cost of doing business. That way, you can incrementally raise your rates to pay you a higher salary as you become more experienced and, more than likely, have familial obligations you didn't have when you graduated.

Chapter 10

Insurance: Why It's Not Just Health-Related, and How You Should Protect Yourself

Insurance is one of the most important things you can have to ensure the longevity of your business. Although you may understand that insurance is important, understanding all the necessary components beyond just health insurance can save you and your business—literally. Insurers will underwrite almost anything for a price. If you are a staff photographer, you have a wide assortment of coverage that you benefit from individually, and usually your employer carries the necessary insurance for your actions on their behalf. When you are transitioning from staff to freelance, you will need to not only secure these insurance types for yourself, but also account for their cost in your overhead. Many freelancers I know carry what they consider to be the bare minimum—health insurance—and more than a few wing it and carry none. When I ask them why they're not carrying the various types of insurance, their response is uniform across the board: "It's too expensive." If it's too expensive to carry these types of insurance, then you are not operating your business in a sensible or cost-appropriate manner. I won't go into health insurance in depth, but I will touch on it briefly because almost everyone seems to understand that it's critical to their own personal well being. However, the following insurance types are crucial to being successful in the long run, protecting what you've earned, and ensuring the well being and safety of family members in the event that you can't work anymore.

Health Insurance: Your Client Has It, So You Should, Too

If you don't have health insurance, you are playing with fire, and you will get burned. One of the secrets of the health insurance industry is that, although you and your insurer are billed the same amount for visits and prescriptions, your insurer is allowed to pay less. This means if you do not have health insurance, and you have to get X-rays done of your wrist after falling while carrying your camera, it will likely cost upwards of $1,000 for the visit, and the hospital will send a bill to either you or your insurer for the same amount. However, when the insurance company pays their standard amount of, say, $450 for the medical attention you received, the hospital will consider that bill paid in full. For you, until you

pay the full amount of $1,000, they will hound you for every dollar. Although this might seem a tolerable amount, for more serious injuries you could literally find yourself destitute for no other reason than you don't have health insurance. This concept of health insurance is called *accessing network plans*, and you'd do well to seek out insurance carriers that can access the local networks of providers, as well as allow you to go out of network for care. If you can't afford health insurance comparable to the one you or your spouse carries (or carried) or one your parents had, at least get catastrophic coverage, which will have a much higher deductible but will still cover you for the big problems.

Life Insurance: Get It While You're Young and Protect Your Family

One type of insurance that is most often associated with the elderly or people in their 40s or 50s is life insurance. Although this sentiment is commonplace, as you evolve from your 20s into your 30s, life insurance becomes much more of a necessity. While this (along with health insurance and disability insurance) might not be a business expense—unless you have employees and are offering it to them as well as yourself as an employee of the company—it is important that you include the expense as a part of your salary/benefits needs. Not only should you plan for the expense early, but the earlier you make the expense a part of your monthly personal financial obligations, the less expensive it will be each month. For example, through a combination of good fortune, healthy parents, and a non-smoking/non-drinking lifestyle, my insurance company considered me a low risk, and for a six-figure life insurance policy, I pay less than $200 a month. As a husband with children, I have significant peace of mind that if the worst were to happen to me, my family would be able to pay the bills and complete their education. Further, my insurance plan includes a tax-deferred savings feature that can be used as a financial tool to assist the business or my family in the event of an emergency or as a retirement supplement.

There are numerous life insurers and types of life insurance. Because I am not an expert on them, I encourage you to seek out the professional advice of a life insurance agent who will help you make the best decision for you and your family. I would, however, encourage you to do a few things on this. The first is to contact an insurance agent who does not represent just one company, but rather multiple companies. Each company has different policy types, and although it may be convenient to use the same company that you use for your homeowner's insurance, auto insurance, or the like (and to obtain discounts associated with doing so), you should work with a professional who spends all of his or her time evaluating policies specific to individual needs. Perhaps, in the end, the benefit of buying a multiple-policy situation through your homeowner's/auto insurer might be the right choice, but you won't know that until you've evaluated your options with a professional.

The second suggestion I would make is to have this expense (with other critical expenses, such as mortgage or rent, health insurance, auto insurance, and so on) automatically deducted from your bank account. This ensures continuity of service and will be one less thing you have to remember to pay each month.

Disability Insurance: Think Again if You Believe You'll Never Get Hurt

When you're young, you're invincible. Maybe you don't wear seatbelts in the car, or you take risks that make many older people cringe. However, the odds of you making it to old age without a disability are not insignificant. The probability of disability between the ages of 30 and 60 is 28 percent, and the odds-makers on this issue are—you guessed it—the insurers. They have very experienced people—whose official title is *actuary*—who do nothing but analyze risks and determine the probability that when an individual exhibits certain sets of risks, he or she will call upon the financial reserves that the insurance company has.

Although it might be obvious to many that a smoker, skydiver, or other risk-taker has a higher probability of disability, health-related issues, or life insurance claims, there are numerous other much less contributory risks (city dweller versus country resident, commuter via car versus commuter via mass transit, and so on) that make up your risk. Further, do not assume that your risk is limited to accident or injury. The risk from a disability that results from illness or infirmary is just as great. Heart attacks, strokes, nervous or mental health issues, as well as crippling diseases are the greatest risks to one's ability to earn an income. As a result, insurance companies offer insurance for disability because there is a probability that you will have a need for this service, and your type of job and other factors will be determining factors in what your monthly payment will be. For me, it's around $500 a year for disability insurance through my membership in a professional organization.

My disability insurance will cover my mortgage and most other household/living expenses in the event that I am disabled and can no longer work or can't work in my current profession. I can't tell you the number of times I walk down a sidewalk at night—especially during the winter when the leaves are off the trees—and get poked in the head by a tree twig. As a photographer, my fear is always that I'll lose an eye, and I panic that the twig that poked me in the cheek could have been two inches higher and poked me in the eye. I worry about an eye infection should I switch from glasses to contacts (which is why I don't wear contacts, since my vision correction is fairly slight), and I worry about other risks to my hands, knees, and mobility—all cornerstones of being a mobilized and active photographer. Although I have these worries, they don't overwhelm me because I know that should something go wrong, I will be protected and my family will, too.

NOTE

In most states, the income from disability insurance is tax-free. Check with your accountant.

Although disability insurance will provide you with income to pay your bills, it won't cover hospital bills if your disability is severe or if the amount exceeds health insurance coverage. In this instance, an adjunct to disability and health insurance is long-term care insurance. When you're talking to your life insurance specialist, ask him about this, too. For young, healthy individuals, it's a very minimal expense and could well save you from having to sell your home and all your assets before Medicare/Medicaid would kick in. Basically, before

Medicare/Medicaid kicks in, you must be essentially destitute. Although you'll ultimately be qualified for some kind of care at this point, the burden your family would fall under so that you could qualify for this government aid would be something that you, today, would be unwilling to subject your loved ones to.

Business Insurance: When Things Go Wrong, You Need to Be Covered

I can't conceive that it would be acceptable to operate a business without some level of business insurance, yet friends and colleagues do it all the time. I just think that's plain crazy. In fact, you won't be able to complete assignments that take place in many locations without insurance for reasons I'll go into later in this chapter, in the "Certificates of Insurance" section. You'll have problems obtaining loans, and the risk of you losing your entire business because of a lawsuit or a catastrophic loss of equipment, other assets, or data is just too great. Many photographer-specific policies are available that will cover your business. The following sections discuss the primary insurance types.

Camera Insurance

The most important tools to your business—equipment valued at tens of thousands of dollars—could disappear in an instant. From your trunk, from your shoulders in a bad neighborhood, from checked luggage—it could happen almost anywhere. Almost everyone knows of someone who's had a lens get stolen, "walk off," or just plain disappear. Many people know colleagues who've had all their gear stolen. All of these incidents would have been covered by the proper insurance, except for the "just plain disappear." That one you'll have a hard time explaining or getting coverage for!

Several years ago, a close friend of mine called me one Sunday from outside of a wire service's offices in Washington. He'd parked next to a church that was across the street from the office to go in and drop off a roll of film from a quick, routine Sunday morning assignment. When he came out, his car had been broken into, and his bag with both bodies, all his lenses, and the like had been stolen. He'd had them covered and was only inside for 10 minutes on a Sunday morning. He was devastated because he didn't have insurance, which meant his considerable talents as a compassionate photojournalist would be put on hold, frozen until he could save up enough money to buy more equipment. For him, this meant odd jobs and such. I asked about insurance, and he'd let it lapse three or four months prior. In the end, I ended up being his temporary insurance, loaning him the previous generation's bodies and lenses that I had yet to sell on eBay so he could do what he does best—make great photos and earn back his equipment, returning my equipment as he purchased replacement equipment for his stolen gear.

I know of a number of people who carry a homeowner's policy and think that their cameras are covered on that. Some homeowner's policies can allow for a *rider*—a schedule of specific items—for professionally used equipment…at an extra cost, of course. There's a problem: Without that rider, your coverage rarely covers your equipment (the coverage is for hobby cameras, point-and-shoots, and so on, not your work tools), and moreover, they're

covered with depreciation. This means if you paid $500 for a camera three years ago, they're not going to give you $500; they will amortize that over the life of the camera (say, five years) and just give you the depreciated value of $200. Although there are numerous other benefits to a professional-level camera insurance policy, one of the regular items in most is "replacement value." So, if you paid $4,500 for a camera body a year ago, you'll get replacement cost reimbursement for that, and the same will hold true for lenses (which tend to hold their value longer than bodies these days). Understand, though, that if you paid $4,500 for a camera body, and the actual cost to replace it after price reductions is now $3,800, you'll get the $3,800, since that is the current replacement value.

Your insurer will usually provide a combination of coverage types for both photo equipment and other equipment necessary for your business. You'll list the brand and model, along with serial numbers and the insured value. You can choose what you want to insure from among your equipment. Most major trade associations have some form of photographer-specific insurance, and all plans make it worth the cost of membership just to join so you can get the discounted rates and options available to members. There are numerous reasons to be a member of trade organizations, but if you're looking for an economic justification, the insurance options alone make it worthwhile. As you sell equipment, contact them to remove the items, and as you buy new or updated equipment, contacting them to add the items will ensure that if a loss occurs, you are covered.

Office Insurance

Although office insurance might seem to only make sense if you have an office in a commercial building (in which case, your lease will require it), operating a business even from your home will benefit from office insurance—not to mention if you maintain a studio space. Most office insurance coverage is a component of the camera insurance policy, or in some cases it is an optional add-on. It covers your computer equipment, desks, office décor, and in more and more policies, the costs to recover data (a.k.a. business records reconstruction) if you lose data due to a crashed hard drive.

List your equipment (laptops, desks, and so on) by serial number and replacement cost. This allows coverage in the event of equipment loss from lightning, theft, or whatever, since little of your equipment, except a desk or laptop, will be covered by your homeowner's or renter's policy. Some office policies have exclusions (flood, hurricane, tornado, or other acts of God), so make sure you know what you are—and are not—covered for. In many cases, you can add on additional protection for a supplementary—often nominal—fee.

Lastly, make a point of doing a biennial review to ensure that as you buy new equipment or take older equipment offline (disposing of it via sale, donation, and so on), you are not carrying items that are no longer assets of the business. Of course, a better tactic would be to add items (especially major ones) as you acquire them for maximum protection.

Liability Insurance

One of the often overlooked benefits of your camera/business policy is the liability insurance that is included in almost all policies. Typically, it's a $1 million policy. We've

extended that for the work we do to $2 million, which is not a significant additional cost for the peace of mind it brings. Many organizations are now requiring this type of liability insurance before you can shoot for them or on their property.

Liability insurance covers you for most accidents or claims brought against you during a shoot (and usually en route to/from it). So if your light stand crashes into a $200,000 painting in a CEO's office and damages it, you're covered. These incidents sometimes occur, and liability coverage will limit your loss. I cannot imagine operating a business and going out on location without insurance. For many businesses—and certainly the government—you won't be allowed to shoot within their property or purview without proof that you do have insurance and include them in the coverage. So how do you do this? With a COI.

Certificates of Insurance

A COI is a certificate of insurance. It is almost always a single-page document that you carry with you (or usually fax/e-mail ahead of time) to the location where you are going to be shooting. The COI not only proves that you have insurance, but also what your limits are. Often a facility or venue where you are shooting will require you to list them as an *additional insured*, which gives them a right to be protected under your policy while you are there. In this instance, you'd ask for how they'd like to be listed on the COI, and they would provide their official corporate name or government entity. Then you'd simply e-mail or fax that information to your insurer, and they would generate the proper form and fax one to you and one directly to the location.

In one situation, I wanted to be doing photography at Niagara Falls during the Millennium celebration, which included fireworks. This required a tripod. A call to my insurance agent the day before—late on a Friday—was all that I needed to add the National Park Service's local division to the COI as an additional insured, and I was all set to make my photographs without any problems.

The federal government, many state governments, and even local governments will require a COI from you before you can shoot. There's a place for the information on the forms you'll fill out, as well as a requirement to attach the COI as a part of your permit application. Frankly, private-property owners should always require a COI, and although many do, the majority of them do not know to ask you for it. On more than one occasion, I've used the fact that I carry liability insurance as a tool to secure an assignment. During the dialogue with a client, when I am able to discern that I am bidding for an assignment, I'll make a point of bringing to the client's attention that a COI will most likely be needed, and not only can we provide that, but we do so on a regular basis. I encourage the client to inquire of the other photographers whether they can also provide a COI, knowing that many can't. Further, if they can, I come across as prepared and knowledgeable about the shoot requirements, so I have a leg up on my competition. However, on more than one occasion I have been told that "all the other photographers had no idea what a COI was." Access to venues that would have been difficult or impossible to get into has been secured when I, or the client, discussed the needs with the property manager and volunteered a COI, offering to name the location as an also insured. It lets the property manager know that they won't be on the line if something goes wrong.

ACORD. CERTIFICATE OF LIABILITY INSURANCE

DATE (MM/DD/YYYY)

PRODUCER

{Your insurance agent's name and address are listed here}

THIS CERTIFICATE IS ISSUED AS A MATTER OF INFORMATION ONLY AND CONFERS NO RIGHTS UPON THE CERTIFICATE HOLDER. THIS CERTIFICATE DOES NOT AMEND, EXTEND OR ALTER THE COVERAGE AFFORDED BY THE POLICIES BELOW.

INSURERS AFFORDING COVERAGE | **NAIC #**

INSURER A: ███ Insurance Company ███

INSURED

John Harrington Photography
John Harrington
2500 Rear 32nd St SE
Washington DC 20020

INSURER B:
INSURER C:
INSURER D:
INSURER E:

COVERAGES

THE POLICIES OF INSURANCE LISTED BELOW HAVE BEEN ISSUED TO THE INSURED NAMED ABOVE FOR THE POLICY PERIOD INDICATED. NOTWITHSTANDING ANY REQUIREMENT, TERM OR CONDITION OF ANY CONTRACT OR OTHER DOCUMENT WITH RESPECT TO WHICH THIS CERTIFICATE MAY BE ISSUED OR MAY PERTAIN, THE INSURANCE AFFORDED BY THE POLICIES DESCRIBED HEREIN IS SUBJECT TO ALL THE TERMS, EXCLUSIONS AND CONDITIONS OF SUCH POLICIES. AGGREGATE LIMITS SHOWN MAY HAVE BEEN REDUCED BY PAID CLAIMS.

INSR LTR	ADD'L INSRD	TYPE OF INSURANCE	POLICY NUMBER	POLICY EFFECTIVE DATE (MM/DD/YY)	POLICY EXPIRATION DATE (MM/DD/YY)	LIMITS	
A	X	**GENERAL LIABILITY** X COMMERCIAL GENERAL LIABILITY CLAIMS MADE X OCCUR	███	01/16/05	01/16/06	EACH OCCURRENCE	$1,000,000
						DAMAGE TO RENTED PREMISES (Ea occurence)	$300,000
						MED EXP (Any one person)	$10,000
						PERSONAL & ADV INJURY	$ excluded
						GENERAL AGGREGATE	$2,000,000
		GEN'L AGGREGATE LIMIT APPLIES PER: X POLICY PROJECT LOC				PRODUCTS - COMP/OP AGG	$2,000,000
		AUTOMOBILE LIABILITY ANY AUTO ALL OWNED AUTOS SCHEDULED AUTOS HIRED AUTOS NON-OWNED AUTOS				COMBINED SINGLE LIMIT (Ea accident)	$
						BODILY INJURY (Per person)	$
						BODILY INJURY (Per accident)	$
						PROPERTY DAMAGE (Per accident)	$
		GARAGE LIABILITY ANY AUTO				AUTO ONLY - EA ACCIDENT	$
						OTHER THAN AUTO ONLY: EA ACC	$
						AGG	$
		EXCESS/UMBRELLA LIABILITY OCCUR CLAIMS MADE DEDUCTIBLE RETENTION $				EACH OCCURRENCE	$
						AGGREGATE	$
							$
							$
							$
		WORKERS COMPENSATION AND EMPLOYERS' LIABILITY ANY PROPRIETOR/PARTNER/EXECUTIVE OFFICER/MEMBER EXCLUDED? If yes, describe under SPECIAL PROVISIONS below				WC STATU-TORY LIMITS OTH-ER	
						E.L. EACH ACCIDENT	$
						E.L. DISEASE - EA EMPLOYEE	$
						E.L. DISEASE - POLICY LIMIT	$
		OTHER					

DESCRIPTION OF OPERATIONS / LOCATIONS / VEHICLES / EXCLUSIONS ADDED BY ENDORSEMENT / SPECIAL PROVISIONS

Video Production

CERTIFICATE HOLDER

{wherever you're shooting needs to be listed here}

CANCELLATION

SHOULD ANY OF THE ABOVE DESCRIBED POLICIES BE CANCELLED BEFORE THE EXPIRATION DATE THEREOF, THE ISSUING INSURER WILL ENDEAVOR TO MAIL 30 DAYS WRITTEN NOTICE TO THE CERTIFICATE HOLDER NAMED TO THE LEFT, BUT FAILURE TO DO SO SHALL IMPOSE NO OBLIGATION OR LIABILITY OF ANY KIND UPON THE INSURER, ITS AGENTS OR REPRESENTATIVES.

AUTHORIZED REPRESENTATIVE

ACORD 25 (2001/08) © ACORD CORPORATION 1988

Page 26

Figure 10.1

In the end, a COI is a required tool for on-location photographers everywhere. Lastly, more and more hotels and other rite-of-passage event venues are requiring photographers to provide a COI and complete forms about their conduct while on site. I know from experience that even when photographing a friend's wedding, the hotel planner at the Four Seasons in Washington D.C. required me to complete the forms and provide a COI, asking the bride-to-be whether I had insurance and such. If you are (or hope to be) doing events of this nature at large hotels and palatial estates, having the right insurance will ensure that you don't get disqualified just because you didn't have insurance.

Errors and Omissions Insurance

Errors and omissions insurance, referred to as *E&O insurance*, is more overlooked than disability and long-term care insurance by photographers, yet it should not be. So, to that end, it is important that I convince you that you need E&O coverage.

E&O coverage protects you in the event that a client holds you responsible (and that usually means they are suing you or threatening to do so) for not delivering the results they were expecting or that you promised. This could mean that you completely failed to provide the services or that you provided them, but the client expected something different. Just as your physician and your lawyer have malpractice insurance, so, too, should you have E&O coverage. They are, generally speaking, the same thing. It is very important to note, though, that E&O coverage, which encompasses professional liability coverage, is not the same as general liability. General liability does not cover things such as contract disputes, for example.

E&O coverage will mean that when you are sued, the costs for you to defend yourself in that lawsuit are covered, including settlements and, if a trial goes to the end and you lose, the judgment. Since everyone makes mistakes, having insurance to protect you against the liability of those mistakes can mean the difference between staying in business and going bankrupt.

To secure E&O coverage, call the company that is already insuring your business and ask them about adding E&O coverage. Be sure to inquire about dates of coverage available and consider the costs of retroactive coverage, which can be worthwhile. Sometimes, you'll be asked to provide copies of the contracts you use (in other words, what you're promising to deliver), and you may be asked to provide evidence of checks and balances you use. For example, do you send your finished product via First Class U.S. Mail, which has no mechanism to track packages, or do you use a shipper that requires a signature to acknowledge that the package has arrived? If your current insurance broker does not offer E&O, they likely can direct you to a company that does.

Umbrella Policies

As if health, life, auto, disability, homeowner, business, general liability, E&O, and the rest of the insurance coverages weren't enough, we have umbrella insurance. In point of fact, it is the very reality that those insurance coverages *are not enough* that means you need umbrella insurance. Umbrella insurance is insurance over and above the insurances you already have. A March 8, 2008, article in the *New York Times*, titled "Umbrella Coverage for

Preventing Your Ruin," notes, "Umbrella and excess coverage are extensions of home and auto insurance. Banks make people buy home insurance to get mortgages, and states require drivers to buy auto insurance. But no one mandates buying a policy that could turn out to be the most important part of your insurance package."

Costs for umbrella polices are nominal. For example, if you have auto insurance that has a $300,000 limit per incident and general liability coverage at a $1 million limit per incident, for anywhere between $100 and $300 a year, you can get coverage that adds $1 million to the protection of your auto insurance for a coverage limit of $1.3 million, and your general liability then covers you up to $2 million. The next million in coverage added on is even less.

A Few Insurance Endnotes

A word about insurance and taxes: First, consult your accountant (see Chapter 11), but there are varying degrees of deductibility for health, life, and disability insurance and the like. Because businesses that offer their employees insurance can deduct that expense of serving their employees, the laws are changing on both federal and state levels about the percentage of deductibility of these insurance expenses. Make sure you are maximizing your benefit by discussing the variety of insurance types with your accountant. Business insurance is deductible, so I see no reason why you shouldn't have it.

Chapter 11
Accounting: How We Do It Ourselves and What We Turn Over to an Accountant

I can't say I know many photographers who enjoy the accounting side of business. In fact, I know more accountants who've left the field to become photographers. There are so many financial transactions to handle—and I'm not even speaking of those photographers who have a large number of invoices. I am referring to the need to track expenses, expense types, vendors, tax records, cash receipts, reimbursement paperwork, and such, before you even have many invoices to handle. How about those credit card bills? That's just one check to MasterCard, Visa, or American Express, but you've got meals, equipment expenses, and numerous other categories of expenses on that one bill. How do you handle all those things? My solution? Accounting software, coupled with a great accountant.

Software Solutions: The Key to Your Accounting Sanity

There are several accounting solutions, from Microsoft Money, to fotoBiz, InView and StockView by Hindsight, and QuickBooks by Intuit. All have their strong suits, and I encourage you to look carefully at all of them to determine which one works best for you, and check with your accountant of choice to determine which he or she uses so you can easily exchange files. Using software, you can track your expenses, bank account balances (many via online integration directly with your bank), credit cards, and cash outlays. Further, by using accounting software, when a lender asks for a profit and loss statement (referred to as a *P&L*), a statement of income, or other forms, these statements and reports are mouse-clicks away, and they are accurate (or at least as accurate as the data you put into them). Almost all software solutions are available as 30-day trials or as demos. For my office, our solution for accounting is QuickBooks, which is available for both the Mac and the PC. Although we use separate software for estimating, our invoicing, bank accounts, and check writing all take place in QuickBooks. One challenge is documenting every expense you make on behalf of the business, so that you are deducting all those expenses from your taxes and conveying that information to your tax preparer accurately and in a format he or she can understand.

Retain Those Receipts and Don't Give Them to Clients

In Chapter 8, I outlined why we do not release our receipts to clients. I will restate what our policy is again because it's an important point:

Our original policy, detailed on my website, is as follows:

"We do NOT supply clients with receipts for any expenses. We do this for several reasons:

We are independent contractors, not employees. When tax time comes, the IRS requires us to provide receipts to verify expenses on our Schedule C. The IRS does NOT require you to have those receipts on hand.

It is critical to the success of our business to maintain a proprietary suppliers network—an absolute cornerstone of a profitable business, and in an insecure environment we do not wish our competitors to learn who our suppliers are. While this is less applicable on film and processing than on unusual items, and from time to time applies to assistants as well, it is nonetheless critical throughout our supplier chain.

We have a set fee per amount of supplies used, regardless of what was actually paid for them. This is done for several reasons: 1) We keep film on file to meet last-minute and unusual requests, therefore we sometimes discard film that does not meet our technical expectations or that has been through several passes of an X-ray machine, and this cost must be split across the cost of actual film shot; 2) time is taken to investigate new films and test films before they are used in shoots, and due to the time taken to go to the various suppliers we use and to maintain the stock necessary, the cost for this time, billed by staff, must be spread across the cost per roll.

By way of example, publishing houses do not request receipts from printing plants for the cost of ink and paper, nor receipts for the wholesale prices paid on the repair of copiers, nor gasoline receipts from the delivery service who delivers the copies of the magazine.

Please discuss with us any issues you have with this policy beforehand."

And our updated version on our website now is:

"We have a set fee for delivery services regardless of what was actually paid for it. Examples may include delivery—sometimes delivery services must make second attempts, and we cannot know of these additional expenses until 30+ days beyond an assignment, which must have been billed before we receive the actual bill, or other surcharges may apply. We stipulate delivery charges to avoid this paperwork. Post-production: We allocate our post-production vendor's services over set periods of time, based upon image counts, and outline that expense to you. We pay a set figure to them for each day's work, and that workload is not delineated by the job where hours are allocated to each job.

Further, we may work with our vendor to investigate new production techniques, from plug-ins that produce superior raw-to-jpeg conversions, or other services that benefit you, the end client. The cost for this time, billed by staff, must be spread across our assigned fees per assignment.

By way of example, publishing houses do not request receipts from printing plants for the cost of ink and paper, nor receipts for the wholesale prices paid on the repair of a copier, nor gasoline receipts from the delivery service who delivers the copies of the magazine.

Please discuss with us any issues you have with this policy beforehand."

One of the issues is that the IRS wants *me* to keep the receipts—the originals. Photocopies make the IRS think that maybe you *and* another business used the same receipt. The following information is from the IRS website:

The following are some of the types of records you should keep:

▶ Gross receipts are the income you receive from your business. You should keep supporting documents that show the amounts and sources of your gross receipts. Documents for gross receipts include the following:

- Cash register tapes
- Bank deposit slips {bank statements and copies of the deposit slips}
- Receipt books
- Invoices
- Credit card charge slips
- Forms 1099-MISC

▶ Purchases are the items you buy and resell to customers. If you are a manufacturer or producer, this includes the cost of all raw materials or parts purchased for manufacture into finished products. Your supporting documents should show the amount paid and that the amount was for purchases. Documents for purchases include the following:

- Canceled checks {the IRS accepts photocopies of checks from the bank, instead of the actual check, as proof of payment}
- Cash register tape receipts
- Credit card sales slips
- Invoices

▶ Expenses are the costs you incur (other than purchases) to carry on your business. Your supporting documents should show the amount paid and that the amount was for a business expense. Documents for expenses include the following:

- Canceled checks
- Cash register tapes
- Account statements
- Credit card sales slips
- Invoices
- Petty cash slips for small cash payments

(continued)

(continued)

▶ Travel, transportation, entertainment, and gift expenses

If you deduct travel, entertainment, gift, or transportation expenses, you must be able to prove (substantiate) certain elements of expenses. For additional information on how to prove certain business expenses, refer to Publication 463, Travel, Entertainment, Gift, and Car Expenses.

▶ Assets are the property, such as machinery and furniture, that you own and use in your business. You must keep records to verify certain information about your business assets. You need records to compute the annual depreciation and the gain or loss when you sell the assets.

▶ Employment taxes

There are specific employment tax records you must keep. Keep all records of employment for at least four years. For additional information, refer to Recordkeeping for Employers.

For more information, refer to their Publication 583, which is available on the IRS.gov website. One note about receipts—official, original receipts are not required for expenses less than $75. However, you must have a self-written note detailing the expense, what it was for, who was paid, how much, and the date of the expense. To be safe, include why— something like "batteries from street vendor for flash," if that's what you just purchased. The note should be timely for best proof—that is, a note made at the time the expense was incurred. Notes made after the fact are less persuasive.

If you are doing business with the federal government (and some state governments), they will require original receipts for travel-related expenses. Be sure to spell out your policy and consider whether you're willing to make an exception to your policy for these clients.

As for just how long you must keep your receipts, your insurance company or a lender might require receipts for longer than the IRS, so be certain you remain in compliance with their policies. However, it's important that you recognize the liability of keeping receipts too long. Statutes of limitations on audits can get confusing, so it is best to consult your own tax expert on this subject. That said, here's the lowdown: The statute of limitations for IRS audits is three years unless greater than 25 percent of gross income is omitted—then it is six years. In the case of fraud, there is no statute. Understand, though, if you do have receipts that go back 10 years and you are audited for a tax return from three years ago, if you say something during the audit such as, "I've been taking that deduction for the last 10 years" and you have your records, the IRS can require them. In a case such as this, your own records may increase your tax audit liability if fraud is found. We'll talk more later in this chapter about why your accountant should be representing you in the unfortunate situation that an audit occurs.

On some large advertising jobs, you may also be asked or required to provide receipts. Again, stressing the importance of keeping the original receipts as required by the IRS, press for providing copies and cite to the client that IRS regulations require you to provide the originals and that your invoice should suffice as a valid receipt for their IRS requirements, but that, if requested, you would provide photocopies of the receipts (if you are willing to do that).

I have spoken with more than one colleague who lists a "documentation fee" when they are required to spend the time producing all of the receipts and the justification for each. The production of this book of receipts includes each receipt attached to sheet of paper with a typewritten description of the purpose for the expense. Producing this book takes a great deal of time, hence you should be paid. You can include in your contract, as a term, something to the effect of: "It is our policy to not provide receipts for production charges or any expenses, as our invoice shall serve as your receipt for the work performed. In the event that we, at our sole discretion, do provide receipts for any charges or expenses, a Documentation Fee of $450 applies to the production and efforts involved in preparing the requested paperwork."

A book of receipts for a large shoot could take you a number of hours to produce, and at the end of that, there should be no question that each and every amount billed was completely a valid expense.

Figure 11.1 shows is an example of an explanation page for a single receipt, whether an excess baggage charge, Starbucks, a hotel bill, or a taxi ride.

One thing I found when I was a staff photographer was that when I turned in my receipts, it took much less time to get paid if I attached each stack of receipts, by category, to a single 8.5×11 sheet of paper and stapled an adding machine tape to it. This made it so the accounting department didn't have to check my math and could put the reimbursement request through. Nowadays, adding machines are few and far between, but there is still a solution. Standard calculator software that comes with every computer's operating system includes a free calculator, and those calculators have "show tape" options. Figure 11.2 shows the one for the Mac.

When you choose Show Paper Tape, the window to the right shows up. When you are done with the calculation, you can choose to print the tape to a printer or as a PDF (see Figure 11.3).

You can then use Excel to summarize the expenses, as shown in Figure 11.4.

CHAPTER 11

JOHN HARRINGTON

P h o t o g r a p h y

Reciept Documentation and Justification

Project Description: XXXXXXX portrait shoot for XXXXX photographed on location in Key West, Florida, February 12 - 15, XXXX.

Agency: ▉▉▉▉▉▉▉▉▉▉ Client: ▉▉▉▉▉▉▉▉

P.O. #: ▉▉▉▉▉▉▉▉▉▉

Purpose for Expense: It was necessary to feed the crew during the lunch time hour, and this item is a part of the line item for catering on the contract.

Total: **98.76** Tip Amount: _____ Included? Yes / No

Was Item on Original Estimate/Contract?: _____

Is a markup applicable to this expense? _____

If so, what %? _____

Amount Markup Amt: _____

Total Billed:

If no reciept is attached, and the amount is under $75, pursuant to IRS rules, this page should serve as a valid reciept for tax purposes. In the event that this expense is in excess of $75, this document, signed by us, along with the statement below, should serve as our validation to you of the expense, and our invoice should serve as a valid reciept for IRS purposes.

Additional Notes/Comments (if any):

I affirm that the attached reciept (or explanation above) was a necessary and appropriate expense for the completion of this project/assignment.

Presented by John Harrington: _____ Date: Mar 22, 20XX

Figure 11.1
Explanation page for a receipt.

Figure 11.2
Show Paper Tape option on a Mac calculator.

Figure 11.3
Paper tape printout.

Figure 11.4
You can use a spreadsheet to summarize the expenses.

A Methodical Filing System

A methodical organization of your receipts related to the operation of your business is a critical cornerstone of a smooth business operation. Here, the use of account numbers to keep your accounting system organized is the solution.

Consider telephone numbers. I know, for example, that phone numbers beginning with the area code 202 are located in Washington D.C., and I know that the prefix 544 is for numbers on Capitol Hill. So too, New York numbers are 212 and 917 (among others), and those in San Francisco are 415. Further, the telephone system was built to be expandable in the U.S., so that as the population grew, the phone system could expand with it.

For your business, the organization of your account numbers is called a *chart of accounts*. The chart of accounts lists not just a number (and possibly a sub-number), but also the name you have given the account. No one system for any photographer will be the same.

Ultimately, you will assign each account to a tax line on your taxes, and those categories—the IRS ones—are standardized; however, organizing and establishing accounts specific to your business is up to you.

Here might be a few categories:

- ▶ 3000 – Draw on Business
- ▶ 3000-01 Personal Expenses
- ▶ 3000-10 Utilities (Non-business portion)
- ▶ 3000-20 Childcare

A note about the above categories. You should not make a habit of writing checks for non-business-related expenses on the business account. However, on occasion, it may be necessary in an emergency, and thus, being able to categorize those expenses properly as non-business in nature is important.

When your business writes a check to the electric company, that expense needs to be split properly. To split the expense, you are simply dividing up a single payment into two (or more) categories. For example, if your business occupies 25 percent of your home, then your payment on your electric bill will need to be properly divided: 25 percent to the business and 75 percent to you personally (in the form of a "draw"). Figure 11.5 shows how you might enter that into the bank account in QuickBooks.

12/09/09	Number	Electric Company		⬍	100.00		*Deposit*	
	CHK	–split–	November bill					

⬭ Record ⬭ ⬭ Restore ⬭ ⬭ Splits ⬭ ☐ 1–Line

Figure 11.5
Recording a split in QuickBooks.

Note the Splits button. Clicking that button allows you to split any one payment into more than one category. I'll go into greater depth on this when it comes to making a payment to your credit card, but for now, Figure 11.6 shows how that split would look when you click the Splits button.

12/09/09	Number	Electric Company		⬍	100.00		*Deposit*	
	CHK	–split–	November bill					

Account	Amount	Memo	Customer:Job	▦	Class	
1700-04 — Utilities Portion for JHP	75.00					⬭ Close ⬭
3000 — DRAW – HARRINGTON	25.00					⬭ Clear ⬭
						⬭ Recalc ⬭

⬭ Record ⬭ ⬭ Restore ⬭ ⬭ Splits ⬭ ☐ 1–Line

Figure 11.6
Your split.

Click the Record button, and your proper accounting of the electric bill is done, with the right amount attributed to an expense of the business and the remainder listed as a draw—as if you had written a check for any other non-business expense.

Here are examples of a few other categories and subcategories that I use:

▶ 350 – Contractors

▶ 350-10 Photographers

▶ 350-20 Assistants

▶ 500 – Dues and Subscriptions

▶ 700 – Photo Equipment Expense

▶ 700-01 Materials and Supplies

▶ 700-02 Repairs

▶ 700-03 Equipment Purchases

▶ 700-04 Rental/Lease of Equipment

▶ 800 – Insurance

▶ 1000 – Office Expense

▶ 1000-10 Office Equipment

▶ 1000-20 Office Supplies

▶ 1000-30 Software

▶ 1100 – Postage and Delivery

▶ 1100-01 – Couriers

▶ 1100-02 – Overnight

▶ 1100-03 – Other

▶ 4300 – Photo Supplies

Please don't lock yourself into these categories or think they are the only way to do it. The thing to do is to sit down and look at the expenses you have that are specific to your business and use them in a manner that makes the most sense to you. Simply looking at your expenses for a previous year and trying to think about how they would best be organized by category will be your best bet.

As you can see, I have left gaps between the numbers for future expansion of my accounting system as my needs evolve.

Let's take a look at how you would set up one expense category in QuickBooks. I'll use one common to all photography businesses—equipment purchases. In Figure 11.7, you will see the fields associated with the sub-account 700 – Photo Equipment: 700-03 – Equipment Purchases.

Once you have set that up in QuickBooks, when you are assigning this category to a check you have written (or a line item within the splits section when it was a portion of a credit card charge—more on that later), you need only type in 700-03, and the category will be chosen and filled out by QuickBooks.

Edit Account

Type Expense

Number 700-03

Name Equipment Purchases

Description Purchase of Depreciable Equip

Note

☑ Subaccount of 700 — PHOTO EQUIPMENT

☐ Track reimbursed expenses in:

Income Account

Tax Line

☐ Inactive

Cancel

OK

Figure 11.7
An expense category in QuickBooks.

When you are organizing your receipts, you need only write on a corner of the receipt the category number (700-03) and file it away. But, how do you file it?

Originally, I filed all my receipts by category alone, but when I went searching for a receipt for any reason, I had to shuffle through so many receipts that it took forever. I learned over time that I have a finite number of businesses I make purchases from, and I learned that the best way was to organize them by vendor, within each category.

So, consider for a moment that we made a purchase from Adorama Camera. We would note on the corner of the receipt 700-03 because in this case it was an equipment purchase, and the receipt would go into the folder pertaining to that expense category.

Note that on the file folder label I've included the parent category and child category in small type, so that when I remove the folder from my filing cabinet and it is returned, it goes into the correct location. This is important because I also have an Adorama folder for category 4300 – Photo Supplies, and since I also have purchased software and office equipment (computers) from them, I also have Adorama folders in the 1000-30 and 1000-10 categories.

The way the receipts are organized in the filing cabinet is that there is a section for the parent category Photo Equipment (700), and then within that section, there is a hanging file folder with a child category on it, like you see in Figure 11.8.

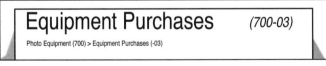

Equipment Purchases *(700-03)*

Photo Equipment (700) > Equipment Purchases (-03)

Figure 11.8
A hanging file folder with a child category on it.

Within that hanging file folder is every vendor folder, alphabetically. Figure 11.9 shows how that looks.

| Equipment Purchases | (700-03) | | Adorama | (700-03) | B&H Photo/Video | (700-03) | Calumet Photo | (700-03) | Penn Camera | (700-03) |

Figure 11.9
Vendor folders listed alphabetically.

Thus, when a vendor's file folder gets removed, it is extremely easy to locate where it should go back to when you're finished with it. However, where do you file the receipt when there are both, say, equipment purchases and photo supplies on it? You may choose to just file the receipt in the folder that has the larger expense. Or, a best practice would be to make a photocopy of the receipt and place a copy of the receipt in each of the proper folders, circling the line item that is relevant for that file folder. Since you are not only keeping the original receipt but also photocopies, there's no problem with the photocopy for tax purposes, because it's really more for organizational purposes. If you get a receipt via e-mail, just print it multiple times for filing purposes.

Each category also has a file folder that is not specific by name—it just says Misc Vendors. That is where the receipt goes for, say, a purchase of a few CF cards for the camera that I made at Joe's Photo Supplies in a small town when I was on assignment and needed a replacement.

At the end of each year, I remove all the file folders and store them in boxes, re-print the file folder labels document we had from the previous year, and start anew. One thing I do as a housekeeping effort is to look for vendors that have no receipts and determine whether I will do business with them again in the coming year. If not, I don't reprint their label. Also, as I choose new vendors, I look through the Misc Vendors folder to see whether there are multiple receipts from one vendor, which would be a signal to me that I will likely be buying from them in the future. Thus, they will get their own folder for the coming year.

Longitudinal Accounting: Its Impact on Your Business

When you get a check from a client for $2,000, you don't immediately say to yourself, "Wow, I just profited $2,000." You recognize that you'll have to pay taxes and cover your overhead with a portion of that money. In other words, you realize that the gross income does not equal net profit. If you don't look at things this way, you would wrongly take the approach that your Accounts Receivable department is the most profitable department in the company. No one looks at things that way.

What if, as the result of an $85 Photoshop workshop, you learned to edit your images faster and more efficiently? How long would it take for that expense to be a long-term cost savings to the business?

Suppose you know that the shutter life of a prosumer camera (say, a Nikon D80, D300, Canon 5D, 40D, and so on) is 50,000 frames, and the cost to replace a shutter is $1,100. The cost of a Nikon D3/EOS 1D Mark III is $5,000, but that camera has a 200,000-frame mean time until the failure of shutter life. Is it possible that it is more cost effective to buy the professional-grade equipment? Moreover, consider not just the loss of the income from the assignment you were working when that shutter failed, but also the lost revenue over time

from the dissatisfied client who won't hire you again, coupled with the cost to you to earn a new client (proportioned marketing/advertising costs and so forth). Given this information, would you first opt for the professional-grade equipment?

If you knew that choosing an off-brand/third-party flash unit with your camera would yield a higher number of images that require exposure corrections after the fact, as compared to a strobe manufactured by the same maker as your camera, at what point would you make the greater upfront investment in the same-manufacturer strobe, instead of paying the initial reduced price for the flash in the first place?

And let's look for a moment at the next wave of photography—multimedia. Doing the math, a photojournalist earning $45,000 a year is paid about $22 an hour. Many of these photojournalists are now migrating to video. Since footage captured on tape ingests in real time, this means that for every hour of tape shot, that's an hour ingesting footage. By contrast, since footage captured to devices such as memory cards or hard drives can be saved at data-transfer speeds, a more expensive camera using those devices can make a huge difference. After just 54 hours of tape, a $1,200 camera-cost-increase or a $1,200 FireStor becomes a quantifiable savings if a photojournalist shoots two hours of tape in a day, at $22 an hour. This does not even begin to take into account the value of getting the finished video project out faster, meeting deadlines, and so forth.

The cost of your education is usually amortized over your career. It's easy to see this when you have student loans to pay, but when you don't, your cost—in both time and money—is not only appropriately amortized over the span of your career, but you also amortize the cost of continuing education—such as that $85 Photoshop workshop.

We don't use these words—*longitudinal accounting*—to describe what we do, but it is what we do, when you think about it. We (should) look at everything along the line of impact, and the concepts—across the spectrum of photography and specifically across every photographer's business—apply. Considering all aspects and facets of your business and how efficiencies in one arena can have a significant impact in other arenas allows you to become more profitable and more efficient.

CHAPTER 11

Reimbursing Yourself: Say What?

Your business and personal expenses are, and should remain, separate. Any time you make a personal (or any non-business) purchase with a business check or your business credit card (and you'd better do this only once in a blue moon) or you withdraw money from an ATM connected to your business' bank account, it is essentially the same as if you owned a brick-and-mortar storefront business, and you walked up to the cash register and removed that amount of money in bills. At the end of the day (or month or certainly year), the business will require you to either document that expense as a draw or provide receipts showing that the removed money was used for business purposes.

Here's how I handle this. Suppose I go to the ATM and withdraw $200 from the business account on February 5. Initially, I classify this as a draw, until such time as I have receipts in hand for those expenses to validate that they are business expenses. Suppose that in June, I have some downtime and a collection of receipts from the beginning of the year for cash

expenses (parking, taxis, small office-supply purchases, and so on). Hopefully I have noted on parking receipts the assignments each one correlated to; however, if I've not done that, it is easy to track an assignment or business-related trip into downtown by date and time and then validate that as a business expense. Suppose my receipts subtotal $86 for five garage expenses in January, $18 for three cabs, and $46.20 for the office-supply store purchase. This totals $150.20. I would take a blank piece of paper and attach all the receipts in groups by type, note the totals for each group, and handwrite a note on it about when I was "reimbursed" for the expense: "Reimbursed by ATM withdrawal on 2/5." However, this leaves $49.80 unaccounted for. This I treat as a draw, so I would note on the piece of paper "Draw: $49.80." I would then go to the line item in my accounting software, split the line item, and assign each subtotaled amount to the correct expense category, including the line item for a draw. I would then file the piece of paper with the receipts under "petty cash reimbursements" in my tax records folder for the current year. Now my accounting software has an accurate accounting of what it had previously listed as a draw, I am properly reimbursed for my business expenses, and whatever unaccounted-for amount between the receipt total and the ATM total becomes a draw. Often I am able to get within $10 of the ATM total.

Another example would be if a spouse made a purchase on the business' behalf, or you had to use a personal credit card for a business expense. (Again, this should be once in a blue moon.) In this case, suppose the expense was for $350—maybe a new flash that either you bought en route to an assignment because yours had broken, or perhaps your spouse was out running errands and you called to ask her to pick up your lab order. In both cases, suppose a personal credit card (or check) was used. There are two ways for you to be reimbursed. The first would be for the business to issue a check to you or your spouse for the exact amount, with the receipt filed with the business expenses. In this instance, I would again attach the receipt to a blank sheet of paper and note the details of the expense. Most importantly, I would record that it had been purchased with a personal check or credit card, and I would then note how it was reimbursed: "Reimbursed via check #12345 on 6/6" or "Reimbursed by ATM charges on 3/6 – $200, 3/19 – $100, 4/15 – $100, balance of $50 listed as draw." I would then go in and classify check #12345 as the proper account for the expense type (equipment purchase or lab processing). For the ATM, I would classify the first and second ATM withdrawals as the correct account type, and then the third would be listed as $50 for that expense type and $50 as a draw.

Although the reimbursement via check is the cleanest and fits the "best business practices" bill, in the end every photographer I know uses the ATM when he or she needs to. If you're not listing these as a draw, you've got to list them as something, and I find this to be an effective way for me, personally, and my business to handle cash expenses between us.

Separate Bank Accounts: Maintaining Your Sanity and Separation

One of the first things your accountant will tell you is that you and your business must have separate bank accounts. In the event of an audit, the IRS takes a dim view of co-mingled funds and expenses, and it's just a bad business practice to keep both accounts together.

Further, when bank fees are charged to you—monthly maintenance fees, bounced check charges, and the like—when the account is strictly for business purposes, those bank fees are a deductible expense. If the accounts are co-mingled, then allocating what part of the fees are personal and what are business is next to impossible, and to be safe, you'd do well to attribute those fees as a nondeductible expense. One new solution is to change from writing checks to many companies you do business with, and instead use a debit card, which is handled by the store as a credit card, but debits your account for the exact purchase amount.

Lastly, you'll be getting checks made payable to your business, not you. For me, clients cut checks to my business—John Harrington Photography—and I have a "dba" on my business checking account. My bank classifies this as a personal account (in other words, it's handled not by the bank's business division, but by their consumer division). This was the original account I used when I started business, and I was able to add the dba (which stands for "doing business as"), which allows me to deposit into that account checks made payable to me—John Harrington—when a client cuts the check just in my name (although I try to avoid this happening), as well as checks made payable to John Harrington Photography. If you don't have a dba on your account, you won't be able to deposit checks made out to your unincorporated business.

When you are trying to balance or reconcile your bank statements every month, knowing for sure that all the checks and deposits to that account are business-related gives you piece of mind. It also means that your spouse won't be writing a check that drops your account total below what you thought you had, so that you inadvertently bounce a check to a vendor, and as a result they put you on a C.O.D. basis for a period of time, plus charge you a large bounced-check penalty (consistent with their policy).

Separate Credit Card: Deducting Interest Expense and Other Benefits

Just as with separate bank accounts, a credit card is a form of a loan, and keeping loans for the business separate from loans for personal uses is critical to maintaining a proper accounting system. One of the big reasons is that, for credit cards, if all your expenses are business-related, and for some reason you don't pay off the bill in the same month, or if you incur a large expense, knowing you will have to pay it off over two months, the interest expense for that carried-over balance is deductible because all the expenses on the card are for the business. If you had personal purchases on the card, allocating the interest to the personal and business expenses properly would be a nightmare and not worth the time or hassle. Further, you can deduct the annual credit card fee as a business expense as well.

Further, if your business is incorporated as an LLC or LLP, your accounting will require separate cards. In some cases, you'll be able to get a credit card with your name, the business' name underneath it, and your business' federal ID number (which is your business' "social security number"), so that should your business go deeper into debt or carry balances, there will be a limited effect on your personal credit. This is not a way to avoid or work around repaying your debts; rather, it is a method to properly allocate liabilities and credit lines to your business.

A note about your federal ID number, also called your *EIN* or *Employer Identification Number*—you should have one. They're free, and you can apply online (via IRS form SS-4) at:

> https://sa.www4.irs.gov/sa_vign/newFormSS4.do

More information about EINs can be found at:

> http://www.irs.gov/businesses/small/article/0,,id=102767,00.html

Part of the application process—for sole proprietors (like me)—requires you to submit your social security number, so the IRS has a cross-reference between you (personally) and your business.

Managing Credit Card Charges: Categorizing Expenses and Integrating with Your Accounting Software

Now, when you have a credit card bill for $3,456.24, you write a check for that amount, but how do you accurately allocate that single expense to the proper categories in your accounting software? You can't just call it "office expense" and be done with it. Expenses such as dining/entertainment are deducted differently than a gift for a client, flowers for a client or business-related person, large equipment purchases that may need to be amortized, office supplies, and the like. Here's how I do it.

Every month I get a statement, and I go through it, classifying every expense by its expense type. I created the Statement Breakdown form in Figure 11.10. Suppose, for example, that there are six charges for gas. A handwritten notation next to each charge on the statement is made with the Legend item C, and they are totaled and entered into the third line of the form: Auto-Gas (200-02). This continues for the entire statement. The most common categories are on the form and corresponding legend, but there's room for the occasional odd charge under Other.

Lastly, I ensure that the total in the Statement Total field matches the actual statement total from the credit card receipt. On the rare occasions when there is a personal charge on my business card, that total amount is listed in the Draw Total field, and then the final business total is entered in the Business Total field.

The Payment Breakdown form shown in Figure 11.11 is identical to the Statement Breakdown form. Each payment is broken down and paid against the statement from the previous month, except when I am paying for a carried-over balance from months prior. Figure 11.11 shows a simplified example.

John Harrington Photography—STATEMENT Breakdown

Credit Card Last 4 Digits: _____ Statement Closing Date: _____
Total Amount Paid: _____ Date Paid: _____
Does amount paid represent complete payment of balance due? Yes_____ No_____

Category breakdowns for tax purposes	Amount	Statement paid on	Split? (Y/N)
Advertising (100)			
Portfolio (100-01)			
Auto – Gas (200-02)			
Auto – Repair (200-03)			
Auto – Parking/Tolls (200-04)			
Auto – Other (200-05)			
Telephone – Local (300-02)			
Telephone – Long Distance (300-03)			
Telephone – Cellular (300-012) (AT&T Wireless)			
Contractors/Photographers (352)			
Dry Cleaning (400)			
Dues & Subscriptions (500) (WHNPA, ASMP, DIRECTV, Publications, etc.)			
Education (600)			
Photo Equipment—Supplies (700-01)			
Photo Equipment—Repairs (700-02)			
Photo Equipment—Purchases (700-03)			
Leasing (700-04)			
Interest Expense (900) (Finance charges on statement)			
Office Equipment (1000-01)			
Office Supplies (1000-02) (Staples, Office Depot, etc.)			
Couriers (1100-01) (Scheduled Express/Speed Service)			
Overnight Delivery (1100-02) (Airborne, FedEx)			
Postage—Other (1100-03)			
Online Services (1200-01) →	TOTAL:		
—Palmnet			
—CS Online			
—AOL			
—Pair Networks			
Security (1300) (ADT)			
Travel & Entertainment—Gifts (1600-01)			
Travel & Entertainment—Dining (1600-03) (Out of town/in-town restaurants)			
Travel & Entertainment—Entertain. (1600-04)			
Travel & Entertainment—Lodging (1600-05)			
Travel & Entertainment—Taxi/Tolls/ Parking/Metro (1600-06)			
Travel & Entertainment—Train/Air (1600-07)			

Category breakdowns for tax purposes	Amount	Statement paid on	Split? (Y/N)
Travel & Entertainment—Office Meals (100% Deductible) (1600-09)			
E-6 Film Purchase (4000)			
C41 Film Purchase (4100)			
B&W Film Purchase (4200)			
Film Processing (4500) (MotoPhoto/Black&White/CapitolColor)			
FOR ANY EXPENSES NOT INCLUDED ABOVE, USE THE "OTHER" CATEGORIES BELOW			
Other: ()			
Other: ()			
Other: ()			

STATEMENT TOTAL: _____

DRAW TOTAL: _____
(3000)

BUSINESS TOTAL: _____

LEGEND

AAdvertising
B...............................Portfolio
C................................Auto—Gas
D...............................Auto—Repair
E................................Auto—Parking/Tolls
F................................Auto—Other
G...............................Telephone—Local
H...............................Telephone—Long Distance
I.................................Telephone—Cellular
J.................................Contractors/Photographers
K................................Dry Cleaning
L.................................Dues & Subscriptions
M...............................Education
N................................Photo Equip.—Supplies
O................................Photo Equip.—Repairs
P................................Photo Equip.—Purchases
Q................................Leasing
R................................Interest Expense
S.................................Office Equipment
T.................................Office Supplies
U................................Couriers
V................................Overnight Delivery
W...............................Postage—Other
X................................Online Services
Y................................Security
Z................................Travel & Enter.—Gifts
2.................................Travel & Enter.—Dining
3.................................Travel & Enter.—Entertainment
4.................................Travel & Enter.—Lodging
5.................................T&E—Taxi/Tolls/Pkg/Metro
6.................................Travel & Enter.—Train/Air
7.................................Travel & Enter.—Office Meals
8.................................E-6 Film Purchase
9.................................C41 Film Purchase
*.................................B&W Film Purchase
#.................................Film Processing

Figure 11.10
Statement Breakdown form.

CHAPTER 11

John Harrington Photography—PAYMENT Breakdown

Credit Card Last 4 Digits: _____ Statement Closing Date: _____

Total Amount Paid: _____ Date Paid: _____

Does amount paid represent complete payment of balance due? Yes_____ No_____

Category breakdowns for tax purposes	Amount	Statement paid on	Split? (Y/N)
Advertising (100)			
Portfolio (100-01)			
Auto – Gas (200-02)			
Auto – Repair (200-03)			
Auto – Parking/Tolls (200-04)			
Auto – Other (200-05)			
Telephone – Local (300-02)			
Telephone – Long Distance (300-03)			
Telephone – Cellular (300-012) (AT&T Wireless)			
Contractors/Photographers (352)			
Dry Cleaning (400)			
Dues & Subscriptions (500) (WHNPA, ASMP, DIRECTV, Publications, etc.)			
Education (600)			
Photo Equipment—Supplies (700-01)			
Photo Equipment—Repairs (700-02)			
Photo Equipment—Purchases (700-03)			
Leasing (700-04)			
Interest Expense (900) (Finance charges on statement)			
Office Equipment (1000-01)			
Office Supplies (1000-02) (Staples, Office Depot, etc.)			
Couriers (1100-01) (Scheduled Express/Speed Service)			
Overnight Delivery (1100-02) (Airborne, FedEx)			
Postage—Other (1100-03)			
Online Services (1200-01) →	TOTAL:		
—Palmnet -------------↑			
—CS Online -------------↑			
—AOL -------------↑			
—Pair Networks -------------↑			
Security (1300) (ADT)			
Travel & Entertainment—Gifts (1600-01)			
Travel & Entertainment—Dining (1600-03) (Out of town/in-town restaurants)			
Travel & Entertainment—Entertain. (1600-04)			
Travel & Entertainment—Lodging (1600-05)			
Travel & Entertainment—Taxi/Tolls/ Parking/Metro (1600-06)			
Travel & Entertainment—Train/Air (1600-07)			

Category breakdowns for tax purposes	Amount	Statement paid on	Split? (Y/N)
Travel & Entertainment—Office Meals (100% Deductible) (1600-09)			
E-6 Film Purchase (4000)			
C41 Film Purchase (4100)			
B&W Film Purchase (4200)			
Film Processing (4500) (MotoPhoto/Black&White/CapitolColor)			
FOR ANY EXPENSES NOT INCLUDED ABOVE, USE THE "OTHER" CATEGORIES BELOW			
Other: ()			
Other: ()			
Other: ()			

STATEMENT TOTAL: _____

DRAW TOTAL: _____
(3000)

BUSINESS TOTAL: _____

LEGEND

AAdvertising
B...............................Portfolio
C...............................Auto—Gas
D...............................Auto—Repair
E...............................Auto—Parking/Tolls
F...............................Auto—Other
G...............................Telephone—Local
H...............................Telephone—Long Distance
I................................Telephone—Cellular
J...............................Contractors/Photographers
K...............................Dry Cleaning
L...............................Dues & Subscriptions
M..............................Education
N...............................Photo Equip.—Supplies
O...............................Photo Equip.—Repairs
P...............................Photo Equip.—Purchases
Q...............................Leasing
R...............................Interest Expense
S...............................Office Equipment
T...............................Office Supplies
U...............................Couriers
V...............................Overnight Delivery
W..............................Postage—Other
X...............................Online Services
Y...............................Security
Z...............................Travel & Enter.—Gifts
2...............................Travel & Enter.—Dining
3...............................Travel & Enter.—Entertainment
4...............................Travel & Enter.—Lodging
5...............................T&E—Taxi/Tolls/Pkg/Metro
6...............................Travel & Enter.—Train/Air
7...............................Travel & Enter.—Office Meals
8...............................E-6 Film Purchase
9...............................C41 Film Purchase
*...............................B&W Film Purchase
#...............................Film Processing

Figure 11.11
Payment Breakdown form.

Suppose that in March, I charge $300 on my credit card. Two-hundred dollars of that was for office equipment (a printer), and $100 of that was for education (a seminar on lighting). That Statement Breakdown would have just those two totals in the Amount column on the form.

When I receive my March statement in April (mine closes around April 6 for all March charges, and it comes in the mail around April 9), I want to pay the $300 in full, which I do. I then complete the Payment Breakdown form, indicating which card I used, the date of the payment, and a reminder to myself about whether this was a payment of the entire balance. (More on that in a moment.) This payment, made in April—say, on April 21—will appear on my April statement, which I will receive on or about May 9, having closed on or about May 6. I will attach the Payment Breakdown for $300 to the month on which the payment appears—in this case, on the April statement that I received in May. This validates that the payment has been made, as well as when it was made, and then outlines the categories to which the payment applies.

I will then enter this into the line item in my accounting software, which only reads Credit Card Payment, and I'll split the payment for $300 into the correct categories in the software. There is now not only a paper trail from the software to the payment, but another one from the payment to the corresponding statement. Further, I have the actual charge receipts filed as well.

While the aforementioned examples are a general overview, let's take a look at a series of charges and walk through the entire process. Consider the following dates, vendors, charge descriptions, and accounting categories for a December MasterCard statement, which closed on January 5th.

- ▶ 12/10 $104.55 – Penn Camera – AA Lithium batteries for flash – 700-01
- ▶ 12/11 $76.80 – Adorama – Two 8GB CF cards – 700-01
- ▶ 12/14 $53.20 – Time Warner – Subscription to Time magazine – 500
- ▶ 12/15 $350.70 – B&H Photo – SB-900 flash – 700-03
- ▶ 12/19 $560.10 – Adorama – Camera lens – 700-03
- ▶ 12/19 $220.50 – Nikon Professional Services – Camera Repair – 700-02
- ▶ 12/23 $375.75 – Canon Professional Services – Camera Repair – 700-02
- ▶ 12/24 $95.60 – Staples – Toner cartridge – 1000-20
- ▶ 12/26 $210.80 – PC Mall – Photoshop upgrade – 1000-30
- ▶ 12/26 $75.20 – Federal Express – Overnight shipping – 1100-02
- ▶ 12/28 $94.50 – UPS – Overnight shipping – 1100-02
- ▶ 12/28 $258.20 – Office Depot – 3-in-1 fax/scanner/copier – 1000-10

The challenge with the above items is that there is information up there that tells you what the purpose of the charge was or what the item purchased was. The credit card statement does not include that level of detail. Figure 11.12 shows how that statement looks.

CHAPTER 11

Payment Due Date	January 25, ▮	
Minimum Payment Due	$63.00	
Previous Balance	$9,439.51	
Current Balance	$ 2,476.30	

MasterCard® Statement

Primary Account Number Ending in: ▮

Statement Closing Date: January 05, ▮

Page 1 of 1

Questions? Call 1-866-▮

Account Summary

Payment Due Date	January 25, ▮	Previous Balance		$9,439.51
Minimum Payment Due	**$63.00**	Payments	-	$9,439.51
Revolving Credit Line	**$10,000.00**	Balance Transfers/Checks	+	$0.00
Past Due Amount	**$0.00**	Purchases	+	$ 2,476.30
Amount Over Revolving Line	$0.00	Service Charges	+	$0.00
Cash Credit Line	$10,000.00	**Finance Charges**	+	**$0.00**
Available Cash Line	$10,000.00	Current Balance	=	$ 2,476.30

Transaction Activity for ▮ - card ending in ▮

PAYMENTS

Trans Date	Posting Date	Transaction Description	Amount
12/28	12/29	Payment Received	-$9,439.51

PURCHASES

Trans Date	Posting Date	Transaction Description	Amount	
12/10	12/10	PENN CAMERA - E ST DC	$104.55	700-01
12/11	12/11	ADORAMA CAMERA - NEW YORK, NY	$76.80	700-01
12/14	12/14	TIME WARNER SUBSCRIPTIONS, Youngstown, OH	$53.20	500
12/15	12/15	B&H Photo/Video, New York, NY	$350.70	700-03
12/19	12/19	ADORAMA CAMERA - NEW YORK, NY	$560.10	700-03
12/19	12/19	NPS Repairs - Melville, NY	$220.50	700-02
12/23	12/23	Canon Professional Services, New Jersey	$375.75	700-02
12/24	12/24	STAPLES ONLINE	$95.60	1000-20
12/26	12/26	PC Mall, CALIFORNIA	$210.80	1000-30
12/26	12/26	FedEX Airbill#34321020301 - Nashville, TN	$75.60	1100-02
12/28	12/28	United Parcel Service, TRK#541230450102, PA	$94.50	1100-02
12/28	12/28	OFFICE DEPOT, Landover, MD	$258.20	1000-10

Detach here. Please make checks payable to Card Services and send this payment coupon in the enclosed envelope. Please allow 7 days for the U.S. Postal Service to deliver your payment.

Figure 11.12

A MasterCard statement.

The receipts over the course of that month, as charges were made in person or online, were filed in a temporary receipts folder by month. When the statement came in from the credit card company, I pulled out the folder and checked which category each charge applied to. For example, there are two Adorama charges here—one for supplies and one for camera equipment purchases. Using the actual receipts, which have descriptions of what the purchases were, I could discern which category each charge applied to. As I reviewed each receipt, I hand-notated on the statement, adjacent to the dollar amount, what accounting code each charge was. Here is one place where the accounting codes are very helpful, as full text category names would just not fit in the margin of the statement. Once these receipts were used for this purpose, then I filed them within the proper category in my filing system, as outlined previously.

Next, using an Excel Spreadsheet, I keyed in each amount in the proper column, breaking down the specifics of the statement itself. In a perfect world, I would pay off the statement completely each month, and usually that is the case, but not always.

Thus, Figure 11.13 shows the Statement Breakdown spreadsheet for this statement.

Note that the statement closing date is January 5th, and the payment is due January 25th. Presume for a moment that I make my payment on January 21st. Figure 11.14 shows how the spreadsheet for the Payment Breakdown would look.

The Payment Breakdown essentially looks identical to the Statement Breakdown, except for the Paid On entry of 1/21, the Total Amount Paid field, as well as the Does Amount Paid Represent Complete Payment of Balance Due? field. As I record that payment in QuickBooks, Figure 11.15 shows how the Splits fields would look.

In this manner, the accounting software has a completely accurate record of the purpose of each charge and category. In the instance where I might make a capital purchase, such as a new computer or a top-of-the-line camera, in the Memo field to the right of the Amount column, I might include information such as Nikon Digital Camera Purchase, Serial #34543, which would later assist in amortizing that purchase. Generally, since the IRS amortization tables for a camera have a camera's lifespan much longer than I keep a camera in service, I write off the entire camera purchase amount the year the camera is purchased and do not amortize it.

However, here is why I do a Statement Breakdown as well as a Payment Breakdown. On occasion, I may not pay off an entire credit card bill in one month. Consider that for this $2,476.30 bill, on January 21st I make just a $1,000 credit card payment, and on February 14th I make a second payment for $1,476.30 (that is, the balance due).

While the Statement Breakdown would remain the same, Figure 11.16 shows the Payment Breakdown for the January 21st payment of $1,000 when $2,476.30 is the amount actually due.

CHAPTER 11

Statement Breakdown			Statement closing date: 01/05/XX		
John Harrington Photography				Statement total: $2,476.30	
Credit card last 4 digits: **XXXX**					

LEGEND	A	B	C	D	E
TAX CATEGORY	Advertising or Marketing	Dues and Subscriptions	Photo Equipment - Supplies	Photo Equipment - Repairs	Photo Equipment - Purchases
Code	(100)	(500)	(700-01)	(700-02)	(700-03)
AMOUNTS		$ 53.20	$ 104.55	$ 220.50	$ 350.70
			$ 76.80	$ 375.75	$ 560.10
TOTALS	$ -	$ 53.20	$ 181.35	$ 596.25	$ 910.80

LEGEND	F	G	H	I	J
TAX CATEGORY	Interest Expense	Office Expense - Purchases	Office Expense - Supplies	Office Expense - Software	Shipping - Couriers
Code	(900)	(1000-10)	(1000-20)	(1000-30)	(1100-01)
AMOUNTS		$ 258.20	$ 95.60	$ 210.80	
TOTALS	$ -	$ 258.20	$ 95.60	$ 210.80	$ -

LEGEND	K	L	M	N	O
TAX CATEGORY	Shipping - Overnight	Shipping - U.S. Mail	Online Services	XXXX	XXXX
Code	(1100-02)	(1100-03)	(1200-01)	(0000-00)	(0000-00)
AMOUNTS	$ 75.60				
	$ 94.50				
TOTALS	$ 170.10	$ -	$ -	$ -	$ -

LEGEND	P	Q	R	S	T
TAX CATEGORY	XXXX	XXXX	XXXX	XXXX	XXXX
Code	(0000-00)	0000-00)	(0000-00)	(0000-00)	(0000-00)
AMOUNTS					
TOTALS	$ -	$ -	$ -	$ -	$ -
			Statement TOTAL:	$	2,476.30

Figure 11.13
Statement Breakdown spreadsheet for the statement.

PAYMENT Breakdown			Statement closing date: 01/05/XX		
John Harrington Photography		Paid On: 1/21/XX		Statement total: $2,476.30	
Credit card last 4 digits: **XXXX**				Total amount paid: $2,476.30	
Does amount paid represent complete payment of balance due? YES					
LEGEND	A	B	C	D	E
TAX CATEGORY	Advertising or Marketing	Dues and Subscriptions	Photo Equipment - Supplies	Photo Equipment - Repairs	Photo Equipment - Purchases
Code	(100)	(500)	(700-01)	(700-02)	(700-03)
AMOUNTS		$ 53.20	$ 104.55	$ 220.50	$ 350.70
			$ 76.80	$ 375.75	$ 560.10
TOTALS	$ -	$ 53.20	$ 181.35	$ 596.25	$ 910.80
LEGEND	F	G	H	I	J
TAX CATEGORY	Interest Expense	Office Expense - Purchases	Office Expense - Supplies	Office Expense - Software	Shipping - Couriers
Code	(900)	(1000-10)	(1000-20)	(1000-30)	(1100-01)
AMOUNTS		$ 258.20	$ 95.60	$ 210.80	
TOTALS	$ -	$ 258.20	$ 95.60	$ 210.80	$ -
LEGEND	K	L	M	N	O
TAX CATEGORY	Shipping - Overnight	Shipping - U.S. Mail	Online Services	XXXX	XXXX
Code	(1100-02)	(1100-03)	(1200-01)	(0000-00)	(0000-00)
AMOUNTS	$ 75.60				
	$ 94.50				
TOTALS	$ 170.10	$ -	$ -	$ -	$ -
LEGEND	P	Q	R	S	T
TAX CATEGORY	XXXX	XXXX	XXXX	XXXX	XXXX
Code	(0000-00)	0000-00)	(0000-00)	(0000-00)	(0000-00)
AMOUNTS					
TOTALS	$ -	$ -	$ -	$ -	$ -
		Statement TOTAL:	$		2,476.30

Figure 11.14
Payment Breakdown spreadsheet.

CHAPTER 11

Figure 11.15
The Splits field in QuickBooks for this payment.

Accompanying that Payment Breakdown Excel spreadsheet would be an entry of those categories into QuickBooks on that same date that would look similar to the one in Figure 11.15. The only difference would be that I might use the Memo field adjacent to the amount to indicate that it was a split with another payment, as I do in the spreadsheet that prints out.

On February 14th, when I make a payment to the credit card company for the balance due of $1,476.30, Figure 11.17 shows what the Excel spreadsheet would look like for that payment.

There is something important to note here. Take a look at the recording of the account category 1000-30. In order to reach the round number of $1,000 for the first partial payment, I simply divided up (or split) one of the charges, applying $89.20 of that $210.80 payment to a portion of that charge, and the balance of that charge gets paid by the second payment amount. I notate that with an entry in the cell next to it (or if there's no room there, outside the box) just for clarity, and I also add in a note at the bottom of the spreadsheet. Also note that in the first Payment Breakdown, a No is entered into the field Is This a Full Payment of Amount Due?, and in the second, the field entry is Yes. Lastly, you may wonder why I organize these Statement and Payment Breakdowns by the last four digits of the credit card account. I do so because in the event a credit card is lost or stolen and I get a new account number, that number changes in these Breakdowns, and in the Notes section, I would indicate something like, "This is the new credit card, which was a replacement for the card I received when the credit card company contacted me because of a fraud warning."

A few notes about the Excel spreadsheets I use. One of the great things about Excel is that you can have multiple sheets in a single Excel document, as shown in Figure 11.18. Sheet 1 in the document has been relabeled Tax Categories, so as I am looking at expenses, if there are any questions about a specific category and account code, a swift click over to that tab gives me the answer. Sheet 2 has been relabeled Cheat Sheet, which is where I store recurring charge types, so, for example, a charge for Comcast High Speed Internet is properly categorized as 1200-01 – Online Services. Sheet 3 is relabeled January (S), where the S refers to the Statement Breakdown, and Sheet 4 is labeled January (P) for the January Payment Breakdown. So, too, with a February (P) we have saved the Breakdown for the February payment, since there were two payments that paid off the January statement.

CHAPTER 11

PAYMENT Breakdown Statement closing date: 01/05/XX

John Harrington Photography Paid On: 1/21/XX Statement total: $2,476.30

Credit card last 4 digits: XXXX Total amount paid: $1,000.00

Does amount paid represent complete payment of balance due? No

LEGEND	A	B	C	D	E
TAX CATEGORY	Advertising or Marketing	Dues and Subscriptions	Photo Equipment - Supplies	Photo Equipment - Repairs	Photo Equipment Purchases
Code	(100)	(500)	(700-01)	(700-02)	(700-03)
AMOUNTS					$ 350.70
					$ 560.10
TOTALS	$ -	$ -	$ -	$ -	$ 910.80

LEGEND	F	G	H	I	J
TAX CATEGORY	Interest Expense	Office Expense - Purchases	Office Expense - Supplies	Office Expense - Software	Shipping - Couriers
Code	(900)	(1000-10)	(1000-20)	(1000-30)	(1100-01)
AMOUNTS				$ 89.20	<-- Split w/2/14
TOTALS	$ -	$ -	$ -	$ 89.20	$ -

LEGEND	K	L	M	N	O
TAX CATEGORY	Shipping - Overnight	Shipping - U.S. Mail	Online Services	XXXX	XXXX
Code	(1100-02)	(1100-03)	(1200-01)	(0000-00)	(0000-00)
AMOUNTS					
TOTALS	$ -	$ -	$ -	$ -	$ -

LEGEND	P	Q	R	S	T
TAX CATEGORY	XXXX	XXXX	XXXX	XXXX	XXXX
Code	(0000-00)	0000-00)	(0000-00)	(0000-00)	(0000-00)
AMOUNTS					
TOTALS	$ -	$ -	$ -	$ -	$ -

Statement TOTAL: $ 1,000.00

Figure 11.16

Payment Breakdown for the January 21st payment.

PAYMENT Breakdown			Statement closing date: 01/05/XX		

John Harrington Photography **Paid On: 2/14/XX** **Statement total: $2,476.30**

Credit card last 4 digits: XXXX **Total amount paid: $1,476.30**

Does amount paid represent complete payment of balance due? YES

LEGEND	A	B	C	D	E
TAX CATEGORY	Advertising or Marketing	Dues and Subscriptions	Photo Equipment - Supplies	Photo Equipment - Repairs	Photo Equipment - Purchases
Code	(100)	(500)	(700-01)	(700-02)	(700-03)
AMOUNTS		$ 53.20	$ 104.55	$ 220.50	
			$ 76.80	$ 375.75	
TOTALS	$ -	$ 53.20	$ 181.35	$ 596.25	$ -
LEGEND	F	G	H	I	J
TAX CATEGORY	Interest Expense	Office Expense - Purchases	Office Expense - Supplies	Office Expense - Software	Shipping - Couriers
Code	(900)	(1000-10)	(1000-20)	(1000-30)	(1100-01)
AMOUNTS		$ 258.20	$ 95.60	$ 121.60	<-- Split w/ 1/21
TOTALS	$ -	$ 258.20	$ 95.60	$ 121.60	$ -
LEGEND	K	L	M	N	O
TAX CATEGORY	Shipping - Overnight	Shipping - U.S. Mail	Online Services	XXXX	XXXX
Code	(1100-02)	(1100-03)	(1200-01)	(0000-00)	(0000-00)
AMOUNTS	$ 75.60				
	$ 94.50				
TOTALS	$ 170.10	$ -	$ -	$ -	$ -
LEGEND	P	Q	R	S	T
TAX CATEGORY	XXXX	XXXX	XXXX	XXXX	XXXX
Code	(0000-00)	0000-00)	(0000-00)	(0000-00)	(0000-00)
AMOUNTS					
TOTALS	$ -	$ -	$ -	$ -	$ -
		Statement TOTAL: $			**1,476.30**

Figure 11.17
Excel spreadsheet for the February 14th payment.

40	TOTALS	$	-	$	-	$	-	$	-	$	-
41				**Statement TOTAL:**			**$**		**1,476.30**		
42											
43	NOTE: The total for the 1000-30 category was $210.80, and split between this payment, and the										
44	payment on 1/21 so this 2/14 payment covers the balance of $121.60 for this category										
45											

| | Tax categories | cheat sheet | January (S) | January (P) | **February (P)** | + |

Figure 11.18
Multiple sheets in a single Excel document.

Further, by using Excel, it will automatically calculate all the totals in each of the category columns for you, as well as add all the different category totals together at the bottom, so you can be assured that your totals all match. When I used to do this by hand, I would find myself $0.06 off or $1.12 off, and it would take forever to figure out where I had made my math error(s). If you don't have a large number of charges each month, it may be easier for you to do things by hand, and I have kept the Payment Breakdown and Statement Breakdown sheets that were included in the First Edition of this book, which you may copy for your own personal use. However, I recommend you use them as a basis for creating your own spreadsheets, because your tax categories as well as accounting codes will most likely be different for your own specific circumstances.

Also, the Excel spreadsheet examples I provided are very simplified versions of the actual spreadsheets I use. The size of this book makes it hard to show the actual spreadsheet, which includes all of my most common accounting categories, some of which show zero items. Doing this saves me from having to re-enter and essentially re-create the spreadsheet every time. If you decide to go the Excel route (which I think is the best route), I recommend you create a spreadsheet template for your business with the most common accounting codes you use and leave three or four empty ones at the bottom for unusual charges that occur on occasion. Doing this will save you a lot of time, and you will get used to knowing that a particular category is in a certain place every month on the spreadsheet.

Finally, I then print out and attach the Statement Breakdown and any Payment Breakdowns for payments that appear on the statement, together with the credit card payment statement itself, and I file them away chronologically.

When to Call an Accountant (Sooner Rather Than Later)

If you are operating a business, you need an accountant. It's that simple. I could just end this section with that statement alone, but I won't. You are a professional photographer, you know all about lighting and f-stops, and you find yourself frustrated when you lose an assignment because a client says, "Oh, I have a friend who is shooting it as a favor," or "We're just going to send someone from the office with a camera." For rites-of-passage photographers, the killer line is, "There's an uncle who has a camera and can take photos, so we're saving money by just having him shoot some photos." Aaaarrrrgggghhhh! You know the results will almost certainly be unsatisfactory, if not downright terrible. Unfortunately, *they* won't know that until it's too late.

If you know this, then you'll want to apply the same mentality to your tax preparation. You can either spend a whole lot of time teaching yourself about all the forms, allowable deductions, limits on deductions, changes in tax law, and the like. Or, you can hire a professional to do it. I recommend that route. Further, your accountant can tell you how much to put away for retirement each year based upon your taxable income and advise you when you have a question about taxes. An accountant is an indispensable resource.

Every accountant has a different pricing structure, and your mileage may vary; however, for significantly less than $1,000 a year, my taxes get completed, including my Schedule C, student loan expenses, mortgages, childcare and medical deductions, income from investments, and several other factors. In other words, my taxes could never be done on a 1040EZ form—what I file approaches 1/3-inch thick each year. Further, my accountant advises me as to how much of that expense is personal (which I pay with my personal credit card) and how much is related to the preparation of the business aspect of my return (which I then charge to my business card).

Now, a word on "tax preparation services." They're good for some folks, but I'd strongly discourage their use for a business. You are building a relationship. You don't want a different tax preparer each year; you want the same person. I have been with mine for almost 20 years, and he keeps track of amortized expenses from year to year, knows me and my business, and asks intelligent questions about how I can save more and earn more. He also advises me of smart (and honest) ways to minimize my tax liability. I can get a copy of my return from four years ago if necessary, and when I have a question, I can call. Depending upon your relationship, that call may well carry a charge for the accountant's time, but it won't be much, and it's certainly a worthwhile expense. Further, in the event of an audit, your accountant can represent you during the audit and will know whether it is necessary to engage the services of a tax lawyer. If the error turns out to be the accountant's fault, although the tax liability will be yours, the accountant will most likely cover the costs of the audit (in other words, their time and possibly your penalties). Also, having an intermediary between you and the IRS will surely minimize the possibility that your audit over one or two questions about an item will become a full-blown audit. (For more on my audit experience with my accountant, see Chapter 12, "Insights into an IRS Audit.") Your accountant is a professional; he or she won't take questions personally from the auditor and will know and look out for your rights during an audit.

To find a tax accountant, ask around. Ask your colleagues or a vendor or client whom you do business with. Although there are many "Smith, Jones, Doe, and Steptoe, LLC" firms, I encourage you to look for a one- or two-person shop. (Besides, Smith, Jones, Doe, and Steptoe, LLC doesn't exist; I made it up.) I feel like I get better service from the guy whose name is on the door, as opposed to an "accounting associate." Ask potential accountants whether they've ever worked with a photographer before—or with someone who may be receiving royalties, and how that income should be handled. Do they work with many self-employed sole proprietors or just the corporations, LLCs, and LLPs?

Lastly, an accountant can and will sit down with you and go over budgets and cost-saving solutions. The role the accountant is fulfilling in this capacity is financial advisor or financial planner, and he or she should be certified as such. The notation "CFP" in an accountant's business name (or his or her name) usually is a good indicator that the accountant has the added expertise that can help you with long-range planning—both for you personally and for the business.

What Is a CPA? How Is a CPA Different from a Bookkeeper?

A CPA is a Certified Public Account. CPAs are licensed to practice public accounting and must meet specific educational and experience requirements and pass Board examinations, similar to an attorney or physician. Typically, a baccalaureate degree concentrating on accounting, combined with approximately two years or 4,000 hours of experience in the public accounting field, will qualify you to take the examination to become a CPA.

NOTE

Each state is different, and the state is the body that issues CPA licenses. The key is that the accountant is licensed/certified.

As a CPA, your accountant is licensed to be in business as an accountant, has more experience, and participates in continuing education (which varies by state but is typically 40 hours per year) to ensure that he or she is serving you best. Further, certain auditing, accounting, and reviews can only be undertaken by a CPA. A CPA will have broader experience working with attorneys and agents, as well as personal and business financial planning. If you can't get a referral, begin by looking for a CPA at the CPA directory website (www.CPAdirectory.com). Locate several candidates near you and meet with them. Ask questions and ask for references. In addition, there are a wealth of resources at the CPAdirectory website about software and other accounting-related questions.

In contrast, in many small businesses a bookkeeper is neither an accountant nor a CPA. In my business, I have an office manager who, among her other duties, fills the role of bookkeeper. Her job it is to generate estimates and send invoices to clients, pay bills for the business, follow up on unpaid invoices, enter in the splits for credit card payments, and

generally use our accounting software from day to day. As my business grew, I trained her to do each of the things I was doing myself, one at a time, and sent her off to learn more about the software. I work closely with her about all things related to the financial aspects of the business. She does not have signatory authority on my checks—that's my check on the work she does. But she does most other things, and I trust her implicitly—otherwise, she wouldn't be doing what she's doing. As your business grows, you might ask someone you've brought in to first do estimates when a client calls and you're out. Then, that may grow to sending invoices and then to paying your bills. Before you know it, you'll have a bookkeeper, too.

CHAPTER 11

Chapter 12
Insights into an IRS Audit

If you are reading this chapter, it is for one of three reasons: 1) you are about to be audited (or you are currently being audited), and you need to know more; 2) you want to avoid being audited and are looking for insights into how to do that; or 3) you want to take some odd pleasure in my audit experience.

Just before the holiday season a year back, an unassuming letter arrived in the mail on November 18. It arrived in duplicate—one for me, one for my wife. It read:

> "Your federal return for the period(s) shown above has been selected for examination."

This baker's dozen of words was terrifying for me. Not, I hasten to add, because I had anything to hide, but because of the amount of time I expected would be involved in preparing for the examination, which was identified as for the year 2006. Unfortunately for me, I grossly underestimated how much time would be involved.

I was instructed to contact the examiner within two weeks (by December 1). Of all my instructions, this was the one I did not follow. Instead, my first call was to my accountant. The document also noted "someone may represent you," which was what I chose to do. This is the *only* sound choice for anyone about to be audited. Even though I am neither an accountant nor a lawyer, I will give you this advice—contact an accountant (preferably the one who completed the return for you) immediately. Your accountant will be objective, has experience doing this, and thus knows the best way to answer auditors' questions. Further, if you are angry, upset, or just want to vent, your accountant will listen and nod his head. It's not that he is necessarily agreeing with you; it's that you're not the first person to vent like that, and your accountant is being kind and listening, knowing you'll be done venting soon—and further, that you are paying him a nice sum per hour to listen.

My accountant made the phone call after the requisite power of attorney documents giving him the authority to represent me were signed, and the process was underway. He phoned the agent a few days before December 1 and left a message. She returned his call on December 2, and they set an appointment for December 30. On December 12, she sent him a letter asking for a lengthy list of items she wanted to examine.

The most significant insight revealed during the December 12 communication from the agent was that she had doubled her request for documentation to not just 2006, but also 2007. So, I was being audited for two years, not one.

Even though we have thorough paperwork and recordkeeping procedures in place, these procedures have evolved over time, and there were receipts that had been misfiled

accidentally or were missing. Recognize that my December of that year, from the 12th through the 29th, was not a period spent enjoying the holidays; it was a time spent preparing for the document request.

Internal Revenue Service

Date: November 17, ▮▮▮

Department of the Treasury
500 N. Capitol Street NW
Room 2604
Washington, DC 20221

Taxpayer Identification Number:
▮▮▮▮▮▮▮

Form:
 1040
Tax Period(s):
 200612
Person to Contact:
▮▮▮▮▮▮▮

▮▮▮▮▮▮▮▮▮▮
2500 32nd Street SE
Washington, DC 20020

Contact Telephone Number:
▮▮▮▮▮

Contact Fax Number:
▮▮▮▮▮

Employee Identification Number:
▮▮▮▮▮

Dear ▮▮▮▮▮▮▮▮▮ :

Your federal return for the period(s) shown above has been selected for examination.

What You Need To Do

Please call me on or before December 1, ▮▮▮ . I can be contacted from 9:00am to 4:30pm at the contact telephone number provided above.

During our telephone conversation, we will talk about the items I'll be examining on your return, the types of documentation I will ask you to provide, the examination process, and any concerns or questions you may have. We will also set the date, time, and agenda for our first meeting.

Someone May Represent You

You may have someone represent you during any part of this examination. If you want someone to represent you, please provide me with a completed Form 2848, *Power of Attorney and Declaration of Representative*, at our first appointment.

If you prefer, you may mail or fax the form to me prior to our first appointment. You can get this form from our office, or from our web site www.irs.gov, or by calling 1-800-829-3676. If you decide that you wish to get representation after the examination has started, we will delay further examination activity until you can secure representation.

Letter 2205 (Rev. 10-2005)
Catalog Number 63744P

Figure 12.1
Initial IRS audit letter.

Your Rights As A Taxpayer

We have enclosed Publication 1, *Your Rights as a Taxpayer,* and Notice 609, *Privacy Act Notice.* We encourage you to read the Declaration of Taxpayer Rights found in Publication 1. This publication discusses general rules and procedures we follow in examinations. It explains what happens before, during, and after an examination, and provides additional sources of information.

Thank you for your cooperation and I look forward to hearing from you by Monday, December 1, █████

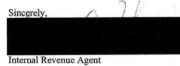

Sincerely,

Internal Revenue Agent

Enclosure:
Publication 1
Notice 609

Letter 2205 (Rev. 10-2005)
Catalog Number 63744P

CHAPTER 12

Figure 12.2
Second page of the initial letter from the IRS.

Form 4564	Department of the Treasury Internal Revenue Service Information Document Request	Request Number 1
To: (Name of Taxpayer and Company, Division or Branch) 2500 32nd Street SE Washington, DC 20020	Subject: 2006 & 2007 1040 Examination	
	Submitted to: Taxpayer and POA	
	Dates of Previous Requests: n/a	

Description of Documents Requested:

Please have the following information. if applicable. available in order to facilitate the expeditious completion of the examination:

1. Presence of person who is most knowledgeable of the business operations and accounting

2. Any and all personal, business or other bank account statements for which either taxpayer had signing authority for the period December, 2005 – January 2008; including a brief list of any transfers or other non-taxable transactions.

3. Documentation substantiating the following expenses on the Schedule A:

 a. Cash Contributions (i.e. cancelled checks or statement from the organization contributed to verifying the amount paid)

4. Documentation substantiating the following expenses on the Schedule C:

 a. Schedule C – Car & Truck expenses (i.e. travel log, receipts, cancelled checks, or other documentation verifying the business purpose for the expense)

 b. Schedule C – Contract Labor (i.e. cancelled checks, Forms 1099, other payment verification documentation, including a list of laborers and their duties)

 c. Schedule C – Depreciation (i.e. detailed description of property being depreciated)

 d. Schedule C – Supplies (i.e. cancelled checks, receipts, or other substantiating documentation and verification of business purpose)

 e. Schedule C – Other Expenses (i.e. cancelled checks, receipts or other substantiating documentation to verify the amount paid and the business purpose)

 f. Schedule C – Business Use of Home (i.e. floor plan or property value statement outlining the square footage of the areas of the home exclusively used for business purposes)

Note: The above items are requested in setting a scope for the examination. Additional information may be requested at a later time.

Information Due By	12/30/2008	At Next Appointment x	Mail In	
FROM	Name and Title of Requestor Internal Revenue Agent U	Employee ID:	Date: 12/12/2008	
	Office Location: 500 N. Capitol Street NW Room 2604 Washington, DC 20221	Phone: Fax:	Page 1	

Form 4564 (Rev. 04/2004) Workpaper #: 610-1.1

Figure 12.3
Follow-up letter from the IRS.

During my meeting with the accountant a few days into the process, I asked him what to expect and what each of the items meant.

I first asked why it had been expanded from one year to two. He responded that this is not all that uncommon, because if the IRS finds something of question in the year being examined, it is likely it was repeated the following year, so they just ask for two years.

I did not understand, for example, why every bank statement for two-plus years was necessary. My accountant explained that the first thing they do is add up every deposit in every bank account you have and then deduct from that total any transfers that took place between those two accounts. And that number needs to match the amount of money you reported receiving on your taxes. That explains why the request from the IRS included asking for "a brief list of any transfers or other non-taxable transactions." This is how the IRS would locate unreported income that you deposited. So, a wedding photographer who deposits a bride's check in his personal banking account or tries to skirt that deposit by going to the bank the bride's check was drawn on, cashing the check, and then depositing the cash will be found out very quickly after just one or two of these cash deposits.

The document request went on to require vehicle expenses, contract labor, depreciation, supplies, and business use of home, and it left the door open for any other items with the broadly worded "the above items are requested in setting a scope for the examination. Additional information may be requested at a later time."

Essentially, this was not a spot check on a few items on a return. This was a full-blown, "we want to see everything" audit.

After a trying two weeks, I delivered all of the required documentation to my accountant on the 29th, the day before the audit was to begin. I asked my accountant how long he expected the auditor would be on hand looking at my tax records, and he surmised that it would be at least two days, given everything she had to look through. At the requisite hour on the 30th when the examiner was to arrive at my accountant's office, where the examination of my records was to take place, my accountant received a phone call rescheduling the appointment for January 13th. So, I spent my New Year's Eve contemplating the examination and trying to read the tea leaves into what the rescheduling might mean. (Answer: nothing.) On January 13, the examiner arrived, and my accountant gave her a cursory overview of the records and left her to her examination. At the end of the day, a Monday, she stated to him that she would come back, she would be selecting items on the returns to spot check, she would provide a list of items she wanted to see receipts and other supporting documents for, and she would provide that list by the end of the week. The beginning of the following week, the list had not arrived, and a call to the examiner revealed that she wanted to see the general ledger for the business, and she would select a series of expense items from that and ask for receipts proving the business purpose for each.

Thus, an audit of an entire two years of business income and expense—every single item was reduced to a spot check of a selection of items. My accountant commented to me that it was the extreme organization of my tax records and their presentation with attention to detail that gave the examiner the impression that we had our act together and everything was in order. During our meeting, he said that some people being audited get angry, dump a disorganized pile of receipts before the examiner, and say something flippant like, "All the

CHAPTER 12

receipts are there. Feel free to find them." This, he said (and I wholeheartedly agree), is the fastest way to antagonize the examiner, who will then approach your audit with vigor and zeal. The first rule of being audited is to avoid upsetting or antagonizing the examiner.

Starting Off on the Right Foot

So, with your first priority actually being to not upset the examiner, you must still ensure that your rights are respected, and you, dear layperson, have no clue what all your rights as a taxpayer are. Your accountant or a tax lawyer does.

When you first get your accountant on board, one of the first things he or she will tell you is this simple fact: The IRS has come to you and is doing an examination of your returns to get more money. This should not come as a surprise, nor should you take offense. It is a fact, and the faster you get over it, the better off you will be. Approximately 25 percent of all IRS employees, both permanent and seasonal, are examiners, and getting more money from each return they examine is their job.

If you're wondering how you came to be audited, for the most part that remains a huge mystery. However, many examinations result from arithmetic mistakes. When your return is first received, it is transcribed and checked for math mistakes. A second transcriber does the same work to double-check the first. Following that, your data is sent to the National Computer Center, and there, statistical models review your entries to see whether you may be a good candidate for an audit. Of all non-business (in other words, individual) tax returns, the National Computer Center sends to each of the regional offices approximately 10 percent of returns. At that point, an actual person looks at your return. Almost all of the returns are weeded out, and between one-half and one percent of these are chosen to be examined.

A 2005 through 2009 strategic plan presented by the IRS sets forth expectations and obligations: "In the United States, the Congress passes tax laws and requires taxpayers to comply. The taxpayer's role is to understand and meet his or her tax obligations. Our role is to help the large majority of compliant taxpayers with the tax law, while ensuring that the minority who are unwilling to comply pay their fair share." This points out something you must remain clear on: "The taxpayer's role is to understand and meet his or her tax obligations." There is no, "Oh, I didn't know…" or "I don't think that is fair" excuses. If it's the law, comply with the law, or contact your elected officials and work to get the law changed.

The same document puts forth their mission statement:

> "Provide America's taxpayers top-quality service by helping them understand and meet their tax responsibilities and by applying the tax law with integrity and fairness to all."

If you are curious about your own tax history, including dates the IRS shows you paid taxes, made quarterly payments, filed your returns, and so on, you can get that transcript of activity, or Master File Transcript (MFTRA). For those of you who are listed as a business, be sure to get your Business Master File, or BMF. A phone call to the IRS at (800) 829-1040 will get the process started for you. This document is very helpful for you because if there is an

error or a payment that wasn't properly credited to you, you'll want to clear that up.

Of the more than 8,500 pages of tax code, the vast majority does not apply to you. However, deciphering what does and does not is the purview of trained tax professionals. There is one thing you need to understand, though. While you are obligated to self-assess your tax liability and to pay your taxes, unless you earned less than the annual minimum income amount, not paying your tax obligations is not an option.

In the Crosshairs

The difference between what you owe and what you pay is referred to as the *tax gap*. For self-employed people, you are square in the crosshairs. In the book *Taxing Ourselves: A Citizen's Guide to the Debate over Taxes* (MIT Press, 2008), it is reported:

> About two-thirds of all underreporting of income happens on the individual income tax. Of that, business income—as opposed to wages or investment income—accounts for about two-thirds... In a recent survey, 96 percent of people mostly or completely agreed that "it is every American's civic duty to pay their fair share of taxes"; but also 62 percent said that "fear of an audit" had a great deal or somewhat of an influence on whether they report and pay their taxes "honestly."

In a *New York Times* article from March of 2009—"Let's Talk About Tax Cheating: A Freakonomics Quorum," by Stephen J. Dubner—Peggy Richardson, who was the IRS Commissioner from 1993 through 1997, wrote, "Probably the most pervasive forms of 'tax cheating' are not the large tax-shelter scams that have garnered headlines in recent years, but less 'sexy' and more mundane forms of 'cheating,' such as underreporting of income and claiming excessive deductions by large numbers of taxpayers. For example, people who are self-employed often fail to report all of their income properly."

With these types of statistics, it becomes understandable why self-employed businesspeople have such a high probability of being audited. On the opposite end of the spectrum, businesses that are corporations account for about 1 percent of all audits, according to my accountant.

The 2009 IRS annual data book, released in March of 2009, shows the following statistics:

1. For nonfarm business returns by size of total gross receipts: under $25,000, 1.2% (down from 1.3% for FY 2007); $25,000 under $100,000, 1.9% (down from 2% for FY 2007); $100,000 under $200,000, 3.8% (down from 6.2% for FY 2007); and $200,000 or more, 0.6% (down from 1.9% for FY 2007).

2. For returns with total positive income (TPI) of at least $200,000 and less than $1 million, the audit rate was 2.6 percent for non-business returns (down from 2 percent for FY 2007) and 2.8 percent for business returns (down from 2.9 percent for FY 2007). For returns with TPI of $1 million or more, the audit rate was 5.6 percent (down from 9.3 percent).

3. The audit rates for entities were as follows:

 a. Corporations with less than $10 million of assets, 1.0 percent (up from 0.9 percent for FY 2007)

CHAPTER 12

 b. Corporations with $10 million or more of assets, 15.3 percent (down from 16.8 percent for FY 2007)

 c. S corporations, 0.4 percent (down from 0.5 percent for FY 2007)

 d. Partnerships, 0.4 percent (same as FY 2007)

Historically, your odds were better for not being audited, but let's look at things in a relative fashion.

If you are a sole proprietor, your odds of being audited, according to the 2006 IRS data book, were 0.97 percent (in other words, less than 1 percent). However, if you were an S-corp or a partnership, your odds were 0.38 and 0.36 percent, respectively. Contemplated a different way, you are 2.6 times less likely to get audited if your business is an S-corp or a partnership. Further, just 23.6 percent of audits of individuals were done in person by an examiner. Thus, more than 75 percent of audits were done as *correspondence audits*, where you and the IRS simply exchange letters and information, and there is no in-person examination of your books.

Lastly, according to the 2009 data book, the no-change rate—that is, returns accepted without any changes following an examination—is 11 percent for in-person examinations and 15 percent when the examination is a correspondence audit.

While one Yankelovich poll reports that one in five taxpayers admits to cheating on their taxes, it could be argued that it is how you define cheating, in degrees. If you made a personal phone call on a business telephone or mailed a letter using a stamp that the business paid for, in the most technical of senses, you have cheated. The IRS is not spending examination time on those types of tax cheats; it is the people who make egregious deductions that are personal but that are classified as business.

So, you may ask, with so few people getting audited, why devote an entire chapter of this book to the audit? Photographers all too often find themselves in an audit situation, and it can be one of the scariest times because of the unknown.

Preparing for the Audit

Here is a short list of things you should do to prepare for the audit.

1. Understand that this is not a personal attack on you. It is just business, and the IRS is there to get more money from you, but that money is what you legally owe, if you legally owe anything more than you said you do.

2. Get an accountant, preferably the one who prepared the return for you and signed the tax form along with you. Having an accountant prepare a return for you in the first place is a lot less expensive than you think, so look into it. (Refer to Chapter 11.) If you are someone who likes to take big risks and goes it alone, when you find yourself in over your head during an audit examination, and you realize you should have consulted with a tax professional, you may request a recess of the audit to consult with (and hopefully by this time hire on) a tax professional.

3. Validate and locate every receipt. In my case, there were receipts for small software purchases I made that I had not printed out when the receipt was e-mailed to me from the online vendor. Since I keep as much of my e-mail as I can, a search of my computer yielded many of the receipts that did not get printed out and put into the files. Further, educational expenses for photo-related books I had purchased from Amazon had not made it in there. Not only did I have e-mails of those, but Amazon and many other online retailers maintain a long history of your purchases, and you can get to them very easily.

 Further, you can contact your bank for missing statements going back several years (sometimes for a fee), as well as a number of other businesses from which you made purchases. You would be surprised at the help you get from customer service agents when you call and say, "I wish I wasn't calling you today, but I am in the middle of an IRS audit. I have a credit card charge for $176.11 that was posted on my account on March 27 two years ago, and I do not have a copy of that receipt for my audit records. I need you to help me get a copy of that receipt, please." It may take just a minute or two to get an e-mail, an hour or two to get it faxed, or a week or so to get it via postal mail, but you can get it. This is called *reconstructing tax records*, and it is allowable by the IRS. In some cases, this may be the basis for you to request a delay in the audit process so you may wait for these records to arrive in the mail.

4. Thoroughly review that what's in the records you are providing is just what belongs there. For example, when I store my tax records for each year, I store with them my insurance policies that include itemized items covered, the policy term documents, and so on. That item is not a receipt, it is the product/service we purchased, and what is required to be included in the insurance receipts folder is the invoice from the insurance agent only. If the examining agent wants to see evidence that the policy covers just business items, he or she then would request the policy itself, but it is not a tax record any more than including your Photoshop software license or DVD is. Further, I also store correspondence I had with the bank when they wrote to me confirming a wire transfer overseas or a request for new checks. These are not receipts, but convenience called for me to store them with the tax records each year. When delivering the records to your accountant, include just the receipts that prove the purchases you made and deducted as an expense, or whatever else was asked for.

5. Relative to item 4, deliver what is asked for and only what is asked for. If the examiner asks for your receipts proving equipment purchases, do not include receipts for photo supplies or other non-germane receipts. Not only will they be additional documents that could get in the way of the examiner's review, they could also trigger a broadening of the audit if the irrelevant receipts raise a flag for the examiner. Do not include previous years' returns unless they are requested. Your accountant will help you present only what is asked for and will help you to clarify what any ambiguous request calls for.

CHAPTER 12

6. If possible, avoid hosting the auditor in your business or home office. The audit can take place in the offices of your tax professional or at the IRS' offices. Not only will an auditor in your business or home office be a distraction from the daily operation of your business, but questions that were not initially being asked may arise. If an IRS examiner turns up at your business or home office, unless they have a court order, you do not have to let them in, and the only person who can invite them in is someone who is a rightful occupant of the home office or, in the case of a brick-and-mortar standalone business, an employee of the business. Note, however, that if you deny the auditor access to your home office, he or she may disallow your home office deduction. In my case, the auditor did want to validate the amount of space being used solely for the business, and my accountant indicated that he would come by beforehand and would be the only one present in the home office during the auditor's home office examination. The purpose for my accountant's visit prior to the auditor's visit would be for me to show him around and answer his questions, which would be likely questions the examiner might have.

7. Understand and pay careful attention to the rules on charitable giving. Visit the IRS website (www.irs.gov) and search for "charitable giving." Each year tax laws change, especially on this topic, so be sure you are looking at the rules for the time period being examined. For example, if you complete an assignment for a charity that you would normally have billed $1,000 for, but you "donated" the assignment, you will likely only be able to deduct the overnight shipping charge and the cost for raw materials involved in that donation, which would likely amount to less than $100. In recent years, and repeatedly, artists groups have tried to get enacted into law legislation that would permit the donation of time by artists. Until that law is enacted, you can't donate your services or a $25 8×10 that only cost you $0.75 in raw materials.

 Be sure not to throw away clothing items that no longer fit. Organizations such as Goodwill or the Salvation Army will take them, and you may calculate the value of these donations with the help of their online guides. Donations of outdated camera equipment to educational institutions qualify for a tax deduction in many cases. Document these donations to legitimate charities to minimize your tax liability. For example, if you donate an amount less than $500 in one instance to Goodwill and get a receipt from them, that receipt serves as valid proof of the donation. Amounts greater than $500 require additional documentation. Be sure to read very carefully the IRS rules for the year you are making your donations so you have your paperwork in order.

8. Keep receipts for small amounts. If you get into a taxi while on business, and the taxi ride is $40, but you pay with cash so the driver cannot provide a receipt, under current tax records requirements, you may make a handwritten (or printed, if you're so inclined) receipt yourself, which includes the date, amount, business purpose of the expense, and to whom the money was paid (be sure to note the taxi company as he is driving away!). That collection of

information on a piece of paper services as a legitimate receipt, for, as of this tax year, $75 or less. That said, if you have hundreds of receipts like this, you can be sure the examiner will look with a critical eye at their collective legitimacy.

9. During the course of the audit, you may be approaching the date to file your taxes again. Unless you have to for some reason, don't. Certainly make any estimated payments you may need to make, but avoid actually filing the return. Doing so could cause the examiner to then include that return in the audit as well.

10. The rules for each state are different. States can audit you as well, but most audits are for your federal returns, and that is what we're focusing on here. State audits as they pertain to photographers often revolve around sales tax issues, independent contractor versus employee issues, or the payment of property taxes for the equipment used by the business. Because every state is different, this book cannot begin to address the tax laws for all 50 states, nor can it provide updates to those as they change each year.

Appeals and Wrapping Things Up

If you find yourself on the "owing more money, plus interest and penalties" end of an audit, there is further recourse. The IRS' own statistics show that many of the appeals result in significantly less being owed than was put forth by the initial examining agent.

The first phase of an appeal is where the examining agent's superiors reassess the audit results. If, during that phase, you still cannot reach an agreement with the IRS, you wind up in Tax Court. When the dispute is for less than $10,000 for a single year, the Tax Court has a Small Tax Case division, and that process is fairly smooth and quick. In the end, if you wind up owing money after all the appeals are exhausted, you will have to pay the taxes as well as interest from the date those taxes were first owed.

The IRS guidance for their examiners is to close examinations within 28 months of when your tax return was filed, according to former IRS Special Agent Burton J. Haynes, in an IRS Audit FAQ on FindLaw.com. Haynes notes:

> "For example, if you filed your 2004 return on April 15, 2005, the IRS wants the audit completed by August 15, 2007. Legally, the IRS has an additional eight months (until April 14, 2008), but auditors are instructed to complete the audit with at least eight months to spare so the IRS has time to process any appeals.

> "If you haven't heard from the auditor, it could mean a number of things. The auditor may have been transferred or terminated. Or your file may be sitting in a pile awaiting processing somewhere in the IRS. When your file resurfaces, a new auditor is under a deadline to close it, which can work in your favor. And, in the best of all worlds, the time limit for completing the audit may expire while your file is in IRS never-never land. So leave the sleeping dog alone."

It is entirely possible that at the end of the audit, there will be no change in your tax liability. It may even be that you paid too much in taxes because, during your receipts

organization, you found a series of receipts you had misfiled and thus did not take deductions for. Or, you may end up owing them more money, plus penalties and interest. If you cannot pay and are not appealing, asking for the taxpayers advocate and discussing with them payment options will be the best way to begin to pay your tax liability.

One way to make it easier for you to pay your estimated taxes is to enroll in the Electronic Federal Tax Payment System (EFTPS). Information on it can be found at www.eftps.gov/eftps. From their website: "EFTPS is a service offered free by the U.S. Department of the Treasury to help business and individual taxpayers conveniently pay all their federal taxes electronically." There, you can schedule payments in advance, directly debited from your checking account, and stipulate what each payment applies to.

Now, to close up the story on my audit experience. The examiner was scheduled to come back a few days before the end of January, but we never received the request for the items to spot-document. At the end of March, two months later, we received a return phone call from the examiner, indicating that she was not going to be doing the spot-check, but that she only wanted to do a home office visit to validate the percentage of the home that was attributed to the business. Having been exceedingly methodical about the floor plans provided during the December preparations, including transparent overlays on the floor plans for each floor showing not only the office space areas, but also the desks, chairs, and workstation positions, I felt confident about that documentation, and my fears began to subside even though the audit was still active. What happened in my audit preparations was that I learned I had been underestimating the percentage of the home and detached studio space that was 100-percent attributable to the business, and as such, the IRS would end up owing me money if we opted to re-file, or we would have something to offer as a counter should there have been a suggestion that some other deduction was disallowed. Thus, one might offset the other, and there would be no net difference in the end. I asked my accountant, "If the only thing in the end that gets questioned is the home office percentage, since there is a significant difference between the reported amount and the greater actual amount, should we re-file and recoup that income?" His advice was, "Let sleeping dogs lie—don't re-file. Those tax years are now closed." Advice well given, and thus acted upon.

Chapter 13
Contracts for Editorial Clients

Editorial contracts run a very wide gamut in terms of rights needed, rights demanded, prices paid, and numerous other seemingly egregious demands by publishers. In the end, there are far more disagreements—many of them public—over rights grabs and low-paying publications. Yet, a contract is defined as a "meeting of the minds." It is an agreement between two (or more) parties who have a transaction they wish to make to either do (or not do) something. Examples of the "not to do" things would include farmers paid by the government not to farm a particular crop on their land, or an agreement not to disclose where (or how) a photograph was made or that it was ever made at all (often called a *non-disclosure agreement*).

When you are entering into a contract, it is important that you not only understand what the contract says you and the other party or parties *will* do (for example, "I will take photos for you" and "When I receive the photos you made for me, I will pay you"), but also that you understand what each of you will *not* do. If the contract specifies that you agree to embargo photos for 90 days from the date of publication, then you must not allow them to be published during that term. If the contract specifies that the client must pay you on receipt of the images (as opposed to paying upon publication) and that they cannot use the photos again without additional compensation to you, then they must pay upon receipt and not use the photos again without compensating you.

The contract often spells out what happens in these cases. When you are contacted by a publication, they might attempt to send you their contract. That's like you presenting your own contract to the mechanic who's going to work on your car or a lab that is going to process your film. In both cases, the mechanic and lab will most likely refuse the contract. They have their own paperwork, and they feel protected when you sign it so they can do the work you need. You, too, should be the one sending out the contract.

Further, as you begin to negotiate contracts, you must understand what you're negotiating. If you don't understand what a package of rights is or the extent to which you are granting rights, then you need to know these things—and their ramifications—before you agree to them.

"We'll Send Along Some Paperwork": Why You Should Be the First to Send the Contract

You should be sending the contract simply because it's easier for you to agree to negotiated changes in your contract than it is to amend, delete, and otherwise revise the client's contract, which is no doubt geared toward the client and written under the laws of the state in which

the company is based. Because the work is being performed by you, and you were solicited in your state, and often the work is in your state, not only is your contract language the most likely to hold up in your state, but you also won't be subject to the laws of a state with which you're not familiar, nor would you have to travel there to litigate a dispute if one should arise.

As a conversation is concluding about my availability, fees/expenses, and the creative aspects of the assignment, the first thing I do is state, "Okay, let me put together some numbers, and we'll send along some paperwork for you to review. Let me know if you have any questions, and I look forward to working with you on this assignment!" It's an upbeat and positive conversation, and it's a way to wind down the conversation. On occasion, they might say they have an assignment sheet they need to send or some other paperwork of theirs. Often it's just their standard assignment sheet, not a contract, and it might be a W-9 form for me to complete. In some instances, it's their "standard" contract. I'll review it to see what they're thinking, but rarely do I sign it. They've sent me their contract as a set of "proposed" terms under which I might consider working. I instead send along my standard contract, with terms under which I am going to be most comfortable working.

There are cases where what they've sent includes objectionable terms, such as:

▶ Photographer agrees that this assignment is "work made for hire."

▶ Photographer consents to the reuse of assignment images in future issues without additional compensation.

▶ Photographer shall indemnify and hold harmless publication in the event of a claim arising out of the assignment or use/misuse of images by publication or a third party.

▶ Photographer acknowledges that publication may grant reprint rights to the story to interested third parties, and agrees that in such an instance, where the story is reprinted, no additional payments are made for such reprints to photographer.

▶ Photographer agrees that this assignment is speculative in nature, and publication shall not be obligated to pay anything should publication opt not to use any images.

▶ Photographer shall deliver all original receipts, for which actual expenses shall be reimbursed without any markup, and photocopied receipts or expense items for which no receipt is provided shall be rejected.

When they include such terms in their contract, I know and anticipate that my contract might be met with some objections, and I prepare for the conversation and the potential that I might not be chosen to do the assignment. In many cases, our contract comes back signed, without changes, and we complete the assignment even when their proposal included those objectionable terms (and many others I've seen).

In some instances, there are negotiated points in the contract. Some of their responses/objections are:

▶ We can't pay an interest charge if there is a late payment.

▶ We can't pay within 21 days; we pay within 30 (or 45) days.

▶ We pay on publication.

▶ We credit photos in the back of the magazine, not adjacent to the photo.

▶ We can't pay $x for post-production; our maximum is $y.

▶ We can't have a second assistant on any shoots.

▶ We have an arrangement with a preferred shipper; I need the CD shipped with our account number and shipper.

These are all negotiable portions of the contract. Some are stylistic (photo credit location), some are accounting policies (pays in 45 days, not 21), and some begin to interfere with the creative options on an assignment where the shoot is outdoors with large soft boxes and equipment (no second assistant). However, in the end, I am amenable to a number of solutions that would resolve their concerns while still offering terms with which I am comfortable.

If your contract has 21 terms and theirs comes to you with 10, and there are only 2 or 3 of their 10 that are substantially similar to yours, you'll end up striking 7 or 8 of their terms and then adding in 18 of your own. In such cases, negotiation back and forth can become more of a challenge than it should be. It'll be an uphill battle from the beginning. However, if there are only a few changes that need to be made to yours to make it amenable to the client, then it will be easier to work past those issues.

There are some organizations that have decided that it's their right to issue iron-clad, nonnegotiable contracts, purportedly that every single photographer who's ever worked for them (or ever will) must sign, or there will be no work from them. Sometimes, the contract comes after a last-minute assignment has been completed. To address the nonnegotiable aspect: In a worst-case scenario, a photographer has a single publication as their only client, and a new contract foisted upon him or her without any warning, consideration, or consultation places the photographer in a precarious position that will always have the photographer get the short end of the deal. A contract that has no negotiable terms is termed a *contract of adhesion*. Although this type of contract might be suitable for insurance companies—in the end, courts often rule against the insurance company when there is ambiguity in the terms or language—it is neither suitable nor fair for any offering of a photographic nature.

Law.com defines "adhesion contract" as follows:

> *n.* (contract of adhesion): A contract (often a signed form) so imbalanced in favor of one party over the other that there is a strong implication it was not freely bargained. Example: a rich landlord dealing with a poor tenant who has no choice and must accept all terms of a lease, no matter how restrictive or burdensome, since the tenant cannot afford to move. An adhesion contract can give the little guy the opportunity to claim in court that the contract with the big shot is invalid. This doctrine should be used and applied more often, but the same big guy-little guy inequity may apply in the ability to afford a trial or find and pay a resourceful lawyer.

This sounds remarkably like many a proposed editorial contract from a major publishing conglomerate. Little known, however, is what some photographers have changed in their contracts with these publishing houses. In some instances, when contracts are changed to be more balanced (in other words, fairer or better paying), a clause can be included, as noted in the beginning of this chapter, *not* to do something—namely disclose that the photographers have a contract that is not the same as the rest of the contracts that photographers are publicly objecting to.

What an Editorial Contract Must Have

As noted earlier, a contract is "often" signed. For me, *all* contracts *must* have my signature and the client's signature. Although a verbal contract is just as enforceable and binding as a written one, the problem with a verbal contract is that people have different recollections of what they agreed to, from rights granted, to allowable expenses, to numerous other issues. The devil is in the details.

It is my policy that an assignment is not undertaken without receipt of a signed contract from the client. This alone alleviates almost all disagreements about what was agreed to, with the exception of the client who, when presented with an invoice for $2,300 for an assignment that was originally estimated at $1,500, states, "I didn't know that when you called to say that the shoot had to be cancelled and rescheduled for two days later because of a torrential downpour, I would incur an $800 weather day charge. I didn't read the contract." Now, who do you suppose was at fault here? The assigning client's signature appears at the bottom of page two of our contract, and above the signature are all of the terms and conditions, including a weather day term. My ringing the client up at 9 a.m. for the 11 a.m. call time was to advise her of the weather issue, and my assumption was that she would either: A) ask that we move indoors, or B) allow for the weather day additional charge. However, this assumption is based upon the expectation that the client read the document she was signing—a reasonable supposition from my perspective.

Having all this in writing and agreed to by the client also diminishes the belief that we are trying to pull one over on a client and covers the fact that we were unable to complete other assignments on that day and will also be unable to take on other assignments for the new day needed to complete the assignment. In most cases, however, in addition to the assumption, I usually will say, "We're going to run into a weather charge, as well as another booking of assistant(s) for the next day," and this will either prompt the client to move the shoot indoors on the same day or accept the additional charges.

An editorial contract must also spell out usage—typically one-time usage in one edition of the publication, plus an allowance for the reuse of the cover that includes your image for advertising (if you're doing a cover shoot) for a set fee. I indicate whether the assignment is an inside use and the maximum size or number of images, or whether it's a cover use, and that affects our rates, of course. In some instances, we'll outline the fee plus expenses and then state that any use beyond a single image plus a table of contents use will incur additional usage fees. This is what is referred to as a guarantee against space. If the client tells me that the use is going to be a half-page horizontal opener of the subject, I'll quote slightly less than if the client states that it'll be a full-page vertical. What I want to avoid is a

six-page article, which ends up being a full page vertical, with a triptych on one (or two) of the other pages, for a total of seven images being used. To avoid this, I'll stipulate that usage beyond what is outlined will incur additional space rate use, which I spell out as quarter, half, full, and double page.

Back in the 1970s, the concept of a *day rate* came into being. Avoid this two-word nightmare. It might have been suitable back when feathered hair and bell-bottom jeans roamed the land, but day rate should be just as banished from your lexicon as your bell bottoms and bleached jeans are exiled to your attic or jettisoned to a landfill.

When day rate originated, it was what a publication such as *Time*, *Newsweek*, or *US News & World Report* paid, as a minimum, for an eight-hour day for a photographer to go out and cover something, regardless of whether the publication ever published a single photograph from the assignment. While this figure was the downside of the assignment, directly tied to the day rate was a guarantee-against-space concept. This meant that if you made an image that ran a quarter of a page, that space rate was somewhere near $250, but you were compensated at $400 to $450 for your day rate plus expenses of film, parking, shipping/couriers, and often meals if it really was an eight-hour-plus assignment. If the photo ran half a page, because the space rate might have been $700, you'd earn that plus expenses instead of the day rate minimum. Where things got especially beneficial was when a full page ($1,500), double page ($2,500), and cover ($3,000) came into play. For the fortunate photographer, a week's minimum of $2,000 for five days' work could result in two full pages and a half page, paying $3,700, and this might result from just a single assignment day rate.

If this model works for you and the publication agrees to it today, then by all means continue, but understand that day rates are still hovering around $500 for the aforementioned publications, and that does not even keep up with inflation from when they instituted and set their day rate and space rates, yet their advertising rates have risen tenfold since the 1970s.

So why haven't their day rates risen? I'd submit that a higher assignment fee should be your approach, and you should allow for a set maximum number of images published and define the images as inside or cover-plus-inside use. If you've got days before and days after working on the pre-production and post-production, call them pre-production days and post-production days. Further, would it be acceptable during this "day" that you complete an assignment of a portrait and then a second assignment during the eight hours without additional compensation? Whatever you finally decide, make sure that your assignment rate you proffer or accept is higher than your CODB for the day, or you'll be paying for the privilege of working and subsidizing multimillion-dollar corporations.

Oh, and one more thing about day rates: If you are tiptoeing around banishing "day rate" from your lexicon, wringing your hands and all, under no circumstances should you be billing a half-day rate! This is a cheapskate's way of slicing in two your day rate. What about the talented photographer who can slip in and out of a portrait of a subject in an hour? Should that photographer be paid a quarter-day rate, whereas the beginning photographer will take six hours to light the same assignment, fighting the light, and get a day rate out of it? Although there are photography models based upon time (a corporate assignment covering an all-day conference or VIP reception, and so on), editorial is definitely not one of them. This would mean you'd earn less as you became more talented and could problem-solve a shoot faster!

A final note about what contracts must have: All amendments must be in writing. These amendments are typically referred to as *change orders* and are more prevalent in corporate and commercial assignments than in editorial ones. (See the "Change Orders" section in Chapter 14, "Contracts for Corporate and Commercial Clients," for an example of a change order form.) One very tricky (and in my opinion deceitful) contract amendment is the "by endorsing" back of paycheck "amendment." Here you have a client who changes the terms of an agreement by having the back of the check they pay you with, which a bank requires you to sign (or endorse), also include language about rights transferred, work-made-for-hire, and so on.

In the case of Playboy Enters., Inc. v. Dumas[1], *Playboy* and Dumas were arguing over ownership of works the artist Patrick Nagel had produced for or were commissioned by Playboy and that were published by them. (Dumas, as in *Jennifer Dumas*, was the widow of Patrick Nagel.) No contract or other formalized document existed that would outline the terms of ownership, save for what Playboy placed on the back of every check that was required to be endorsed by the recipient prior to deposit. The Court, in reviewing this case, first held:

> We therefore find that the 1976 Act requires that the parties agree before the creation of the work that it will be a work made for hire. We are not convinced, however, that the actual writing memorializing the agreement must be executed before the creation of the work.

Further, the Court reviewed the differing language on the backs of the checks. Between 1974 and 1979, the back of the check reads:

> Any alteration of this legend agreement voids this check. By endorsement of this check, payee acknowledges payment in full for the assignment to Playboy Enterprises, Inc. of all right, title and interest in and to the following items: (a description of a painting followed)

Because this language does not specifically state "work made for hire" or "work for hire," it does not fulfill §101(2) of the Copyright statute, holding that "the parties expressly agree in a written instrument signed by them that the work shall be considered a work made for hire." As a result, the courts found that all works between January 1, 1978 (the date upon which the 1976 Copyright Act, as amended, went into effect) and July of 1979 were not subject to the "work made for hire" term.

However, the Court then examined the changed check language, which did meet the §101(2) requirement. The second check back was used between September of 1979 and March of 1981 and reads:

> Any alteration of this legend agreement voids this check. By endorsement, Payee acknowledges payment in full for services rendered on a work-made-for-hire basis in connection with the Work named on the face of this check, and confirms ownership by Playboy Enterprises, Inc. of all right, title and interest (except physical possession), including all rights of copyright, in and to the Work.

[1] 53 F.3rd 549 (2d. Circuit, 1995)

A third revision, which went into place in March of 1981, following on the previous language, and was used until May of 1984, reads:

> Any alteration of this legend agreement voids this check. It contains the entire understanding of the parties and may not be changed except by a writing signed by both parties. By endorsement, Payee: acknowledges payment in full for the services rendered on a work-made-for-hire basis in connection with the Work named on the face of the this check and confirms ownership by Playboy Enterprises, Inc. of all right, title, and interest (except physical possession), including all right of copyright, in and to the Work.

With the previous two bodies of text being almost identical, the important part of the text is that it contains the words "work-made-for-hire," thus it meets the §101(2) requirement. The check was signed (on the front) by Playboy and by Nagel on the reverse, and although the agreement in each case was not memorialized by these signatures until after the work was performed, which would seem to make the agreement to do so invalid, the Court held that Nagel's repetitive acceptance of these "back of the check" agreements constituted an ongoing understanding of a WMFH agreement that would create an expectation that each subsequent check would carry the same language. There is extensive additional information online about this case. For those interested, a search for Playboy v. Dumas or Playboy Enters., Inc. v. Dumas will yield a broad amount of information about the case.

NOTE

Had Nagel instead granted "all rights" to Playboy or a copyright transfer, for all works created 35 years following publication or 40 years following the agreement (for work created after 1977), Nagel (or his estate) could have had all those rights revert back to him—a significant distinction between a WMFH and an all rights grant or copyright transfer. From the Copyright Office website:

> Section 203 of the Copyright Act permits authors (or, if the authors are not alive, their surviving spouses, children or grandchildren, or executors, administrators, personal representatives or trustees) to terminate grants of copyright assignments and licenses that were made on or after January 1, 1978 when certain conditions have been met. Notices of termination may be served no earlier than 25 years after the execution of the grant or, if the grant covers the right of publication, no earlier than 30 years after the execution of the grant or 25 years after publication under the grant (whichever comes first). However, termination of a grant cannot be effective until 35 years after the execution of the grant or, if the grant covers the right of publication, no earlier than 40 years after the execution of the grant or 35 years after publication under the grant (whichever comes first).

This might seem like an extensive example of an amendment, but that small body of text on the back of a check constituted a contract, and could also, as with the later check language, nullify your contract, especially if you do ongoing work for this publication.

This practice still occurs among some publications and media outlets, so be cautious about amendments of which you may be unaware.

Using a Word Processor for Contracts versus Dedicated Software or Your Own Database

When I began my business, I had my contracts in WordPerfect, and I would go in and change each one from my standard language to meet the specific needs of the client resulting from a negotiation we'd had. It was easy to do, but a few mistakes occurred. In some instances, I'd do the math wrong and either have to eat the mistake or have an understanding client see my mistake and accept the higher estimate figures once they appeared on the invoice. After a few of these mistakes, I began using some simple tables in the word processor that would do the math for me and would be an integral part of the document. This worked for a long time.

I considered switching to any one of the several options of software written for photographers to do contracts and such. One exceptionally well-designed one was integrated with a supply reseller, which would allow you to track your inventory of film, and when you'd shot and billed a certain number of rolls of film, the software would realize you were low on film and offer to reorder it for you. Unfortunately, this software doesn't exist anymore, but a few others have remained. However, I was always worried that others would go the way of the aforementioned one, so I decided to learn how to make a basic database in FileMaker, and I transitioned to tracking my contracts there and still being able to modify them when necessary.

If you're evolving into a more business-oriented operation (which I'd expect because you're reading this book), I'd recommend you start with word processor files but learn about the ability to use tables within word processing files and their ability to calculate for you. Start with my language if you'd like, and modify it to suit your state's requirements or your specific needs. Or, turn to one of several trade organizations who, as a part of their membership, offer contracts that are an excellent starting point for you to establish your own.

How to Work through a Contract Negotiation for Editorial Clients

One of the biggest challenges, which I'll tackle in Chapter 16, "Negotiations: Signing Up or Saying No," is negotiations. This section of this chapter will deal specifically with editorial clients, although many of the issues will be similar for corporate/commercial work, with just a few differences.

First, you have to understand who you are negotiating with. There's a hierarchy at publications. It usually goes:

▶ **Art Director/Creative Director.** This person is responsible for the entire look and feel of the magazine, from font choice to page numbers and other layout details—everything visual for the publication.

▶ **Director of Photography.** While the AD is responsible for photography, illustrations, and graphics, the Director of Photography usually reports to the AD (if there is one) for all photo-related issues. They carry out the stylistic vision of the AD as it pertains to photos.

▶ **Photo Editor(s).** These folks are usually the ones who do the heavy lifting— booking photographers, handling problems that photographers run into, coordinating with subjects, and generally doing whatever is needed to accomplish the assignments.

▶ **Assistant Photo Editor(s).** These folks will research and locate several photographers in a market where they don't have a relationship with a photographer, will handle image intake (whether film or digital), and generally support the PE. The APE will convey photographer options to the PE for the unknown market, and the photo editor will generally make the decision about whom to contact. For covers or major stories, the DOP or AD will get involved.

In many cases there are no APEs, and the PE/DOP role is one person. In very small publications (trade or niche publications), there is no AD. For a publishing conglomerate, one AD handles multiple titles. The key is to know who you are dealing with and who has the ability to sign off on your negotiated points.

Because of the frequency with which editorial clients assign photography, they are the ones most likely to have a set budget for each issue and often for each assignment. I have found myself in situations in which I have been told that the budget to hire me was higher than normal because they got handouts from companies for other stories in that issue, so they could hire me at my rates.

One of the first questions I ask is, "What's your budget for this assignment?" This is typically met with something along these lines:

"We pay $250, flat rate, for each assignment, including expenses."

"We pay $600, plus expenses for an inside story, which is typically just one image used."

"We need to keep the assignment for the cover, which includes one image used inside, to a total of $1,500 including expenses."

"As long as we can stay under $3,000 for everything, that should work."

Regardless of the actual numbers, these are the types of comments I get. Regardless of whether I'll take the assignment, I want to know where they are so I can gauge the likelihood that I will get the assignment. Even for the first response—seemingly too low to consider—I'll send them my paperwork. I do this for several reasons.

▶ Some prospective clients are trying to get their work on the cheap, and they figure they'll start low and see what bites.

▶ Some prospective clients will actually weed out the ones who accept the cheap fees, especially when it's an important assignment.

▶ Many clients who call have experience with a lower rate in their town and will experience sticker shock when trying to book in a larger community. On the other end, in cities such as New York and Los Angeles, some photographers will accept these lowball (below CODB for almost anybody) rates because if they don't, they (wrongly) surmise someone will.

▶ Once a client gets over their sticker shock, I want to be in the running for the assignment. If I dismiss requests for my services and don't bother to send the estimate, I am completely out of the running when others send in comparable estimates and the client becomes educated about the market just by the estimates they receive.

I will then work through the numbers. Do I need just one assistant or two? Is it just one portrait of the subject or two? How many subjects? What other complicating factors are there? Will there be staging/propping or a set-building requirement? Do I need permits? A studio? Catering? What about post-production? Is this to become a photo illustration, requiring lots of post-production work?

I will then look into their circulation figures. Sometimes I know the figures because I'm familiar with the publication; other times I have to look the numbers up in the "advertise with us" section of their website. While there, I usually bring myself into reality by finding out what they charge for full and half-page ads in the publication. Knowing this can make my rates of even several thousand dollars seem cheap in comparison!

From there, I'll check with software such as fotoQuote to see what a stock image would cost them to license for the magazine. This often might be a choice that the client is considering behind the scenes and which you may be unaware of. If the only portrait of a subject or photograph of a product is available, but that photographer has quoted a fee of $3,000 for one-time use, the client might be considering you as a possibly cheaper option to produce an image. If fotoQuote reports a stock fee of $1,750 for a cover use for this circulation trade magazine, and you know your expenses are going to be around $700, then a fee including expenses certainly would be fair at $2,400. The question the client will have to ask is, "Should I commission the work for $2,400 and hope for a great photo or license a photo that I know will be great for $3,000? What is that $600 variance worth?"

Usually, this research takes less than five minutes and, after sending the quote as a PDF via e-mail, I will follow up with a phone call, ostensibly to see whether they've received the quote, but actually to get a read from them as to whether I am way out of their expectations or to see whether I can get them to commit to me right then, over whoever has not returned their voicemail and might be sending an estimate in an hour when they get home and call. Hopefully, by the time that other photographer sends his or her estimate, the client will say, "We're all set; we've found another photographer." Having been on the receiving end of that before, I do everything in my power to respond immediately to all client calls and inquiries.

During the call, I'll also talk about some creative ideas I've had about the shoot, and I make sure to express that I am excited about the project. This cannot be stated enough—you must be enthusiastic about each assignment for which you are being considered. Nothing sours a prospective client more than a lackadaisical attitude about the assignment they are considering giving you. There is truth to the theory that you should smile when you're on the phone, because people on the other end can tell that you're happy when you do. This applies to enthusiasm, too.

Even if I can't get a commitment from the client (and I've followed up by a request that they sign and return the contract at their earliest convenience, because we're not committed until we have a signed contract back), I'll ask when they hope to have a decision, and then I'll let them know that I'll follow up with them…and then I do. I might even follow up the phone call with a short e-mail as a courtesy, if I feel it's appropriate and not going to come across as pushy or overbearing.

If I don't get a signed contact back, but the client seems amenable (or is not objecting) to the contract, I'll ask about the subject and take the approach that the assignment is mine. If the client offers the subject's contact information, I'll gladly take it and reach out to the subject about dates, times, and setting a tentative date. Once I've done this, I convey this to the client in an e-mail. If at a later date (which still must be before we do the shoot) the client has a problem with a term in the contract, I am negotiating from a position of strength because I am already familiar with the assignment and have a tentative date set to photograph the subject. If it's a term I am comfortable with modifying (such as pays in 45 days, not 21), then we're fine. If it's a deal breaker (such as WMFH, reuse in other sister publications with no additional compensation, and so on), then I gently convey this in some manner akin to "It's our policy that we do not do WMFH" or "We are happy to license to your sister publication usage, but it's not included in the fee I've presented for your publication; it's our policy to charge an additional license fee for these secondary uses."

One term that has been demanded—but which the client has relented on—has been the attempt to insist that there be no additional fee for magazine reprints that the subject might want. Because magazine reprints are not editorial—they are of commercial benefit to the subject photographed, with the added endorsement of the publication—editorial rates do not apply to these uses. Magazine reprints are a substantial source of income for many publications, and the photographs often play a major role in the reprint—frequently becoming the cover of the reprint when the subject was not on the cover in the first place. I'm just not willing to forgo my piece of the pie from this use of my work.

Recently, I was contacted to produce more than 20 portraits for a publication, and the publisher was insisting upon the inclusion of reprint rights. When I discussed this further, it was stated by the publisher's representative that, in fact, they expected to generate several thousand dollars' worth of revenue from each of the reprints, and they were unwilling to pay me more for those reprints. The revenue from the reprints alone would have paid for my photography fees and would have turned a profit off of me to boot. Understand that if you do an assignment, the assignment can generate more revenue for the publication through reprints than from the actual editorial usage.

My contracts all have a place for the client to sign at the bottom of the second page. Back in the day, documents such as Delivery Memos, which accompanied film, had a place for a signature on the front and an entire page of Terms and Conditions on the reverse. This led some clients to attempt to get out of any term they wanted (usually the $1,500 valuation per image for 60 images sent and now lost) by saying they never saw the T&C, and in some states—California among them—some T&Cs must appear on the front of a document for them to be binding. Now, all my documents have the signature space on the bottom of page two, so the signature appears on the page with the T&C. If your contract has the client signing on page one, make sure there is a place on the subsequent page(s) for their initials and that each page is labeled "Page X of Y." This will minimize the client's ability to suggest they never saw the T&C.

Following are several case studies from actual client negotiations. The names have been removed because it's not necessary to know who the client is or what publication they might be from; the important part is to see how the transaction took shape.

Before moving on to the case studies, there's one tangential aspect of many editorial assignments that needs to be addressed. Often subjects have never had a photograph that they like, or if they did, it's no doubt outdated. They frequently will ask, "So are these photos yours or the magazine's?" To which we respond, "They're ours." The client's next question is, "So how do we get in touch with you about the photos if we like them?"

I typically have with me a printed single-page piece of paper, often in an envelope, and I give it to the client's assistant. If I don't have the information with me, I point the client to a page on my website with the same information. It reads:

INFORMATION REGARDING PERSONAL (AND COMMERCIAL) USE OF THE PHOTOGRAPHS WE HAVE CREATED

Thank you for your interest in the photography we just created. When photography is done for a magazine or other publication, there is usually a one- to three-month delay in the images being returned to our offices from the date of the shoot or available to other parties.

We are more than happy to facilitate requests for a review of the photographs we have created, but in order to properly facilitate your request, we need to know what the use of the images would be if copies were to be provided. If the print is for personal use (for a family member or to frame on a wall), then only the costs to reproduce the image(s) are incurred. (Print costs, couriers/shipping, etc.)

If the images are to be distributed in press kits, on a website, or for other uses beneficial to the company or your own commercial interests (speaking engagements, etc.), then there are fees involved for those uses, and those prices are dependent upon how broad (or narrow) the use is.

When images are delivered to you that are indicated for personal use only, a permanent ink stamp is placed on the back of the print, indicating that that image cannot be used in publication or on the Internet. When images are delivered to you that have a specific license for use(s) you have requested, paperwork accompanies the deliverables that outlines the uses for the photography, the length of time for the use of the images, and the fees involved.

Use of images outside of the scope of the license provided, or *any* use of a "personal use" image other than hanging on a wall or framed on a desk, is a breach of our copyright. You may ask, "Why do I have to pay to use a photograph I let you take of me?"

(continued)

INFORMATION REGARDING PERSONAL (AND COMMERCIAL) USE OF THE PHOTOGRAPHS WE HAVE CREATED (CONTINUED)

Simply, you were contacted by a publication that believed their readers would benefit from seeing your image in the publication, and you determined that you would benefit from appearing in the publication. We were compensated by the publication for using our creative processes to give them a desirable image. We specifically granted one-time-only permission to the publication, and they do not have permission to re-run any of the images, nor produce reprints of the article, without additional compensation. Our fees were based upon this one-time-only use.

For you to receive additional benefit (beyond the scope of the magazine in which the image(s) appeared), we, as the creator of the image, need to receive an additional benefit. The more additional benefit you receive (usages), the more we need to receive. This concept, in principle, took hold during the Constitutional Convention of 1787. James Madison suggested that the Constitution include language "to secure to literary authors copyrights for a limited time." The provision passed unanimously. It is found in Article I, Section 8 of the U.S. Constitution. It states "The Congress shall have Power… To promote the Progress of Science and useful Arts by securing for limited Times to Authors and Inventors the exclusive Right to respective Writings and Discoveries."

We welcome the opportunity to discuss with you or your marketing department the costs of using the images we have created to benefit your organization. While the fees associated with the varying uses may seem high to you, your advertising agency, marketing department, or public relations firm will be familiar with the cost structure that is standard in the creative community for these varying types of uses.

I refer to a one- to three-month delay on images being returned from the publication, and it is important to note that because I cannot remember the last time I actually shot a film assignment, and this was typically a film delay, the concept of "returned from publication," although not applicable in today's digital environment, usually still applies in the form of embargoes from the publication on our doing anything else with the images during that time. Feel free to copy and use this text for yourself when you find the same request being made of you.

Figure 13.1 shows a reproduction of one of the stamps we have used when we are providing a client with a print for their own personal use. The stamp clearly indicates that I am the copyright owner, as well as my contact information and that the image is not for publication. Feel free to use this stamp example as a basis for your own stamps.

Figure 13.1
Our stamp we place on the back of each print we deliver for personal use.

Case Study: Portrait for University Magazine

Client type: Publication for a state-run university's school magazine.

Assignment: Portrait of a single subject, on location outdoors in Washington, DC.

Deliverables: Single image via e-mail, suitable for a full-page inside use.

Technical notes: No permits necessary, single head on battery pack strobe pack. Total time shooting: 10 minutes; total setup and breakdown: 1 hour.

This was the initial inquiry:

From: ██████████████
Subject: Request for estimate
Date: ████████████ 2:20:38 PM EDT
To: ██████████████████

John,

My name is ████████████, and I am the editor for the ████████████
████████████████████████. I found your name through the Adobe
Photographers Directory and was very impressed with your portraiture.

Would it be possible for you to give me an estimate for a photo shoot
in D.C.?

I am looking for a portrait shot of an alumna we are writing a feature story
on; she ████████████████████████████████ to present a case before the
U.S. Supreme Court. I am envisioning a portrait shot or two of her in front
of the U.S. Supreme Court building, looking powerful, regal, etc. My
timeframe is ████████████████████.

I appreciate your help and look forward to your response.

Many thanks,

██████████████

We responded one hour and 37 minutes later:

From: ███████████████████
Date: ████████████ 15:57:35 -0400
To: ████████████
Subject: Photo Estimate for Alumna Portrait

Dear ██████████ ,
Attached is a PDF of the estimate you requested for your upcoming
photography needs for a portrait and other shots of a ████████████
████████████ alumna for the ████████████████████████████ .

Please look the attached estimate over, call with any questions, and sign
and fax it back to confirm. Please note we don't guarantee or commit our
photographers' time until we've received the signed estimate back.
Please fax it to ████████████ .

We look forward to working with you and the ████████████████████
████████ .

We followed up with a phone call and were told that he'd look over it in the next few days.
More than a week later, we received this response:

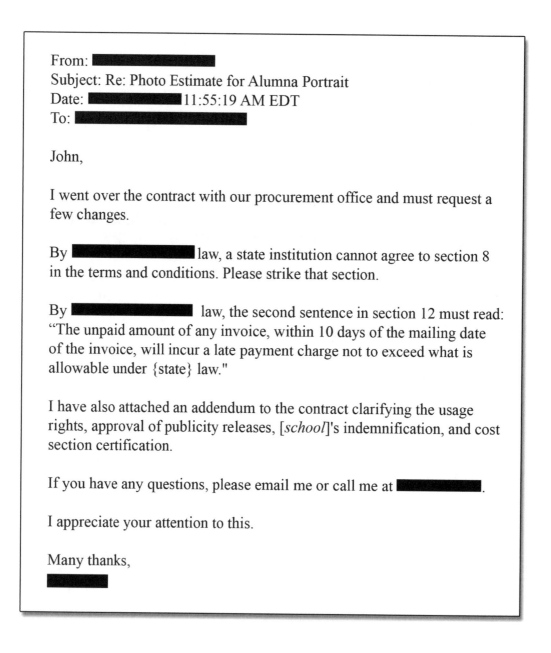

From: ▬▬▬▬▬▬▬▬▬
Subject: Re: Photo Estimate for Alumna Portrait
Date: ▬▬▬▬▬▬ 11:55:19 AM EDT
To: ▬▬▬▬▬▬▬▬▬

John,

I went over the contract with our procurement office and must request a few changes.

By ▬▬▬▬▬▬▬▬ law, a state institution cannot agree to section 8 in the terms and conditions. Please strike that section.

By ▬▬▬▬▬▬▬ law, the second sentence in section 12 must read: "The unpaid amount of any invoice, within 10 days of the mailing date of the invoice, will incur a late payment charge not to exceed what is allowable under {state} law."

I have also attached an addendum to the contract clarifying the usage rights, approval of publicity releases, [school]'s indemnification, and cost section certification.

If you have any questions, please email me or call me at ▬▬▬▬▬▬▬.

I appreciate your attention to this.

Many thanks,
▬▬▬▬▬

The addendum contained the following *proposed* addendums, and we treated them as proposed. They were:

Addendum to Contract

GENERAL: The photographer (or "contractor") will provide the [*school*] exclusive non-commercial usage rights.

APPROVAL OF PUBLICITY RELEASES: The contractor shall not have the right to include the [*school*]'s name in its published list of customers, without the prior approval of the [*school*]. With regard to news releases, only the name of the [*school*] and the type and duration of contract may be used, and then only with prior approval of the [*school*]. The contractor agrees not to publish or cite in any form any comments or quotes from [*school*] staff. The contractor further agrees not to refer to the award of this contract in commercial advertising in such a manner as to state or imply that the products or services provided are endorsed or preferred by the [*school*].

INDEMNIFICATION: The [*school*], its officers, agents, and employees shall be held harmless from liability from any claims, damages, and actions of any nature arising from the use of any materials furnished by the contractor, provided that such liability is not attributable to negligence on the part of the [*school*] or failure of the [*school*] to use the materials in the manner outlined by the contractor in descriptive literature or specifications submitted with the contractor's proposal.

COST SECTION CERTIFICATION: I hereby certify that the price included in this proposal is accurate and binding and that all costs are shown and accurately reflect my total proposal cost.

That's a pretty big difference between "one time use" and "exclusive non-commercial usage rights." A response was in order, and we replied later that same afternoon.

CHAPTER 13

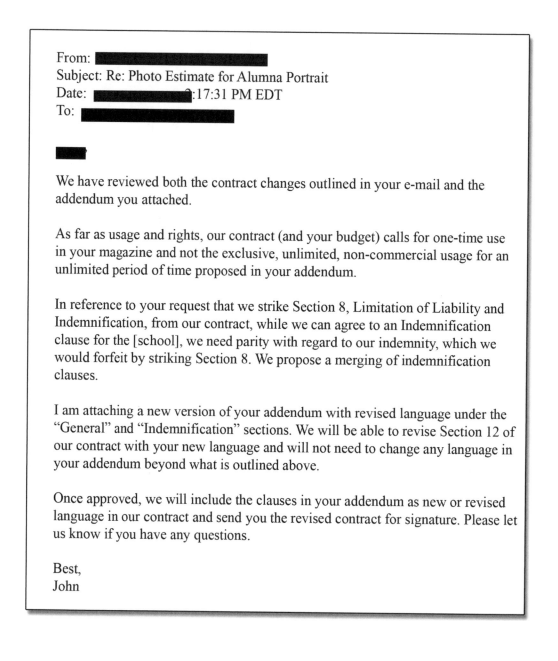

From: █████████████████████
Subject: Re: Photo Estimate for Alumna Portrait
Date: ████████████:17:31 PM EDT
To: ████████████████

███████

We have reviewed both the contract changes outlined in your e-mail and the addendum you attached.

As far as usage and rights, our contract (and your budget) calls for one-time use in your magazine and not the exclusive, unlimited, non-commercial usage for an unlimited period of time proposed in your addendum.

In reference to your request that we strike Section 8, Limitation of Liability and Indemnification, from our contract, while we can agree to an Indemnification clause for the [school], we need parity with regard to our indemnity, which we would forfeit by striking Section 8. We propose a merging of indemnification clauses.

I am attaching a new version of your addendum with revised language under the "General" and "Indemnification" sections. We will be able to revise Section 12 of our contract with your new language and will not need to change any language in your addendum beyond what is outlined above.

Once approved, we will include the clauses in your addendum as new or revised language in our contract and send you the revised contract for signature. Please let us know if you have any questions.

Best,
John

Addendum to Contract

GENERAL: The photographer (or "contractor") will provide the [*school*] with first world usage rights of image(s), and upon publication of a single image from the assignment, all images from the assignment are released from this embargo. In the event no images are published, after one year, the embargo lapses. The use by [*school*] of image(s) from this assignment remains a one-time use, consistent with the terms of the contract that this addendum applies to.

APPROVAL OF PUBLICITY RELEASES: The contractor shall not have the right to include the [*school*]'s name in its published list of customers, without the prior approval of the [*school*]. With regard to news releases, only the name of the [*school*] and the type and duration of contract may be used, and then only with prior approval of the [*school*]. The contractor agrees not to publish or cite in any form any comments or quotes from [*school*] staff. The contractor further agrees not to refer to the award of this contract in commercial advertising in such a manner as to state or imply that the products or services provided are endorsed or preferred by the [*school*].

INDEMNIFICATION: The [*school*], its officers, agents, and employees shall be held harmless from liability from any claims, damages, and actions of any nature arising from the use of any materials furnished by the contractor, provided that such liability is not attributable to negligence on the part of the [*school*] or failure of the [*school*] to use the materials in the manner outlined by the contractor in descriptive literature or specifications submitted with the contractor's proposal. The [*school*] shall indemnify, defend, and hold Contractor and Contractor's representatives harmless from any and all claims, liabilities, damages, and expenses of any nature whatsoever, including actual attorneys' fees, costs of investigation, and court costs arising from or relating to the [*school*]'s direct or indirect use of the Image(s) or in connection with Contractor's reliance on any representations, instructions, information, or materials provided or approved by the [*school*].

COST SECTION CERTIFICATION: I hereby certify that the price included in this proposal is accurate and binding and that all costs are shown and accurately reflect my total proposal cost.

Note the changes to the usage and indemnification clauses.[2] The resulting e-mail from the client then struck the indemnification for both parties, and I responded:

Dear ,

Attached is a PDF file of the estimate you requested for your upcoming photography needs. I've struck Clause 8 and replaced it with your Approval of Publicity release text, and I've added the Cost text to the end of my Term 2, so we should be all set.

We look forward to working with you.

Best,
John

The shoot terms were agreed to, and we completed the photography as requested, having negotiated from our contract terms as a basis. The client indicated initially that they'd want to accomplish the shoot for less than $1,000. Because we were delivering only a single image, I was able to reduce my post-production charges below what we'd normally charge. The final redacted contract follows.

[2] In the "publicity release" section, there is a note about not publishing or citing any comments or quotes from the staff. Because not only is the individual not identified, nor the publication, nor the school or state, and these quotes are not comments nor quotes, per se, but rather an ongoing dialogue over negotiated contract points between myself and the school, and further the disclosure of this does not breach the spirit of the proposal—to preclude the appearance of an endorsement of my services by a state-run and taxpayer-funded institution—and further, because the intent of this case study is to educate, it is the author's position that this body of text falls outside of the restriction that finally was embodied in Clause 8 of the author's contract with the school.

CHAPTER 13

JOHN HARRINGTON
P h o t o g r a p h y
2500 32nd Street, SE Washington, DC 20020
(202) 544-4578 Fx: (202) 544-4579

Estimate and Contract

Date: Tuesday,

Job #: A2006-132

A.D.

To:

Tel#

Art Buyer:

Fax#

Client:

EMail: Client #: **CL2006-1527**

Description of Services and Rights Licensed: Produce portrait of alumna in front of the Supreme Court for feature story plus smaller supporting images inside story in Magazine. Rights include first world usage of image(s), and upon publication of a single image from the assignment, all images from the assignment are released from this embargo. In the event no images are published, after one year, the embargo lapses. The use by the of image(s) from this assignment remains a one-time use, consistent with the terms of the contract.

Fees Main Illustration $750.00

Weather Days @ $422/day $750.00

Production Charges
Crew - 1 - Assistant; $95.00

$95.00

Photographic Imaging Charges Photographic Imaging Charges - Computer/System Time and CD delivery-$100; $100.00

Third Part Fees Billed Direct to Client: Subtotal $945.00
Talent: (Talent fees and the scope of releases are the sole responsibility of Client.) Sales Tax
Other: **Total** $945.00

Terms: All fees and charges on this invoice are for service(s) & **Advance**
licensing described above. I certify that the price included in this
proposal is accurate and binding, and that all costs are shown and
accurately reflect my total proposal cost. **Balance Due:** $945.00

Rights are licensed only upon full payment of this invoice, subject to terms and conditions on second page.
(Page 1 of 2)

ALL SERVICES AND LICENSES OF LICENSOR ARE SUBJECT TO THE FOLLOWING TERMS AND CONDITIONS

1. **DEFINITIONS:** This Agreement is by and between John Harrington Photography ("Licensor") and ("Client") which includes Client's representatives . Licensor's relationship with Client is that of an independent contractor. "Image(s)" means the visual and/or other forms of materials or digital information supplied by Licensor to Client. Licensor is the sole creator of the Image(s). The Image(s) are Licensor's interpretation, rather than a literal copy of any concepts or layouts provided to Licensor by Client. "Service(s)" means the photography and/or related digital or other services described on the front of this Agreement that Client is specifically commissioning Licensor to perform pursuant to this Agreement. "Transmit" or "Transmission" means distribution by any device or process whereby a copy of an Image is fixed beyond the place from which it was sent. "Copyright Management Information" means the name and other identifying information of Licensor, terms and conditions for uses of the Images, and such other information that Licensor may prescribe.

2. **FEES, CHARGES AND ADVANCES:** Client and Client's representatives are jointly and severally responsible for full payment of all fees, charges and advances. The rights licensed, fees, charges and advances set forth in this Agreement apply only to the original specification of the Services. Additional fees and charges shall be paid by Client for any subsequent changes, additions or variations requested by Client. All advance payments are due prior to production. I hereby certify that the price included in this proposal is accurate and binding, and t hat all costs are shown and accurately reflect my total proposal cost.

3. **POSTPONEMENTS AND CANCELLATIONS:** If Client postpones or cancels any photography "shoot date" or other Service, in whole or in part, without first obtaining Licensor's written consent, Client shall pay Licensor 50% of Licensor's quoted fees. If Client postpones or cancels with less than two business days' prior written notice to Licensor, Client shall pay 100% of Licensor's quoted fees. Client shall in any event pay all expenses and charges incurred in connection with any postponed or canceled shoot date or other Service.

4. **FORCE MAJEURE:** Licensor shall not be in default of this Agreement by reason of its delay in the performance of or failure to perform, in whole or in part, any of its obligations hereunder, if such delay or failure results from occurrences beyond its reasonable control and without its fault or negligence. Client will pay 100% of Licensor's daily weather delay fee (as set forth on the front of this Agreement) for any delays due to weather conditions or any acts or occurrences beyond Licensor's reasonable control, plus all charges incurred.

5. **CLIENT APPROVAL:** Client is responsible for having its authorized representative present during all "shooting" and other appropriate phases of the Service(s) to approve Licensor's interpretation of the Service(s). If no representative is present, Licensor's interpretation shall be accepted. Client shall be bound by all approvals and job changes made by Client's representatives.

6. **OVERTIME:** In the event any Services extend beyond eight consecutive hours in one day, Client shall pay overtime for crew members and assistants at the rate of 1 1/2 times their hourly rates or fees, and if the Services extend beyond 12 hours in one day, Client shall pay overtime for crew members and assistants at the rate of double their regularly hourly rates or fees.

7. **RESHOOTS:** Client shall pay 100% of Licensor's fees and charges for any reshooting or redoing of Services requested by Client. If the Image(s) become lost or unusable by reason of defects, damage, equipment malfunction, processing, or any other technical error, prior to delivery of the Image(s) to Client, Licensor will perform appropriate Service(s) again without additional fees, provided Client advances and pays all charges, and pays all fees and charges in connection with the initial Services.

8. **APPROVAL OF PUBLICITY RELEASES:** The contractor shall not have the right to include the ███████ name in its published list of customers, without the prior approval of the ██████. With regard to news releases, only the name of the ███ and the type and duration of contract may be used, and then only with prior approval of the ██████. The contractor further agrees not to refer to the award of this contract in commercial advertising in such a manner as to state or imply cite in any form any comments or quotes from █████ staff. The contractor further agrees not to publish or that the products or services provided are endorsed or preferred by the █████ by the ██████roved by Client.

9. **RIGHTS LICENSED:** The licensed rights are transferred only upon: (a) Client's acceptance of all terms contained in this Agreement, (b) Licensor's receipt of full payment, and (c) the use of proper copyright notice and other Copyright Management Information requested or used by Licensor in connection with the Image(s). Licensor is willing to license the Image(s) to Client only upon the condition that Client accepts all of the terms of this Agreement. Unless otherwise specifically stated on the front of this Agreement, all licenses are non-exclusive and the duration is one year from the date of Licensor's invoice and for English language use in the United States of America only. Licensor reserves all rights in the Image(s) of every kind and nature, including, without limitation, electronic publishing and use rights, in any and all media, throughout the world, now existing and yet unknown, that are not specifically licensed or transferred by this Agreement. No license is valid unless signed by Licensor. Client shall not assign any of its rights or obligations under this Agreement. This Agreement shall not be assignable or transferrable without the prior written consent of Licensor and provided that the assignee or transferee agrees in writing to be bound by all of the terms, conditions, and obligations of this Agreement. Any voluntary assignment or assignment by operation of law of any rights or obligations of Client shall be deemed a default under this Agreement allowing Licensor to exercise all remedies including, without limitation, terminating this Agreement, obtaining all net worth or financial information of any assignee and full and timely performance of all obligations and complete and substantial assurances of all future performance.

10. **RETURN OF IMAGE(S):** Client assumes all risk for all Image(s) supplied by Licensor to Client, from the time of Client's receipt, to the time of the safe return receipt of the Image(s) to the possession and control of Licensor. If no return date appears on the front of this Agreement or on any related delivery memo, Client shall return all Image(s) in undamaged, unaltered and unretouched condition within 30 days after the first publication or use of the Image(s), whichever occurs first Client agrees to destroy all digital files within one week of reproduction. If the files were sent on digital media, all such material must be returned in undamaged condition within 30 days of reciept.

11. **LOSS OR DAMAGE: IN CASE OF LOSS OR DAMAGE OF ANY ORIGINAL IMAGE(S), CLIENT AND LICENSOR AGREE THAT THE REASONABLE VALUE OF EACH ORIGINAL IMAGE IS $2,500.** Once original Image(s) are lost or damaged it is extremely difficult and impracticable to fix their exact individual value. Accordingly, Licensor and Client agree that the reasonable liquidated value of each original Image is $2,500. Client agrees to pay Licensor $2,500 for each lost or damaged original Image and Licensor agrees to limit Licensor's claim to that amount without regard to the actual value of such Image. An Image shall be considered an original if no high reproduction quality duplicate of that Image exists.

12. **PAYMENT AND COLLECTION TERMS:** Invoices from Licensor are payable upon re The unpaid amount of any invoice, within 10 days of the mailing date of the invoice, will incur a late payment charge not to exceed what is allowable under South Carolina law. In any action to enforce the terms of this Agreement, the prevailing party shall be entitled to recover their actual attorneys' fees, court costs and all other nonreimbursable litigation expenses such as expert witness fees and investigation expenses. No lawsuits pertaining to any matter arising under or growing out of this Agreement shall be instituted in any place other than Washington D.C.

13. **TAX:** Client shall pay and hold Licensor harmless on account of any sales, use, or other taxes or governmental charges of any kind, however denominated, imposed by any government, including any subsequent assessments, in connection with this Agreement, the Image(s), the Service(s) or any income earned or payments received by Licensor hereunder. To the extent that Licensor may be required to withhold or pay such taxes Client shall promptly thereafter furnish Licensor with funds in the full amount of all the sums withheld or paid.

14. **RELEASES:** NO MODEL, PROPERTY, TRADEMARK, OR OTHER SUCH RELEASE EXISTS FOR ANY IMAGE(S) UNLESS LICENSOR SUBMITS TO CLIENT A SEPARATE RELEASE SIGNED BY A THIRD-PARTY MODEL OR PROPERTY OWNER.

15. **ELECTRONIC RIGHTS:** No electronic publishing or use of any kind is licensed unless specifically stated on the front of this Agreement. The use rights reserved by Licensor include, without limitation, all rights of publication, distribution, display, Transmission, or other use in electronic, digital and other media of any kind, now existing and yet unknown. Any rights licensed by Licensor for any use in a collective work exclude all use rights for any kind of revision of that collective work including any later collective work in the same series.

16. **MODIFICATIONS, GOVERNING LAW AND MISCELLANEOUS:** This Agreement sets forth the entire understanding and agreement between Licensor and Client regarding the Service(s) and/or the Image(s). This Agreement supersedes any and all prior representations and agreements regarding the Service(s) and/or the Image(s), whether written or verbal. Neither Licensor nor Client shall be bound by any purchase order, term, condition, representation, warranty or provision other than as specifically stated in this Agreement. No waiver or modification may be made to any term or condition contained in this Agreement unless in writing and signed by Licensor. Waiver of any one provision of this Agreement shall not be deemed to be a waiver of any other provision of this Agreement. Any objections to the terms of this Agreement must be made in writing and delivered to Licensor within ten days of the receipt of this Agreement by Client or Client's representative, or this Agreement shall be binding. Notwithstanding anything to the contrary, no Image(s) may be used in any manner without Licensor's prior written consent, and Client's holding of any Image(s) constitutes Client's complete acceptance of this Agreement. The formation, interpretation, and performance of this Agreement shall be governed by the laws of Washington D.C., excluding the conflict of laws rules of Washington D.C. All paragraph captions in this Agreement are for reference only, and shall not be considered in constuing this Agreement. This Agreement shall be construed in accordance with its terms and shall not be construed more favorably for or more strongly against Licensor or Client.

_____ _____
Client Signature Date

(Page 2 of 2)

Case Study: In-Flight Airline Magazine

Client type: Publication for an in-flight airline magazine.

Assignment: Portrait of a single subject, on location indoors and possibly outdoors in Washington, DC.

Deliverables: Several via e-mail or FTP, suitable for a full-page inside use and cover.

Technical notes: One or two heads. Total time shooting: 30 minutes; total setup, breakdown, and waiting time: 4 hours.

The initial inquiry came via phone call and was followed up same day with an estimate. Following is our e-mail to the client accompanying our estimate:

Dear ,

Attached is a PDF file of the estimate you requested for your upcoming photography needs.

Please look the attached estimate over, call with any questions, and sign and fax it back to confirm, and we can firm up specific dates/times. While we are currently indicating we are available, we don't guarantee or commit our photographers' time until we've received the signed estimate back and have agreed to the date(s). Please fax it to ▬▬▬▬▬ .

Once you've confirmed the assignment, please forward, at your earliest convenience, any comps, layouts (draft or final), and/or any other details you have that may help us in the planning and creative development of the assignment. Please e-mail it to this address: ▬▬▬▬▬▬▬ .

We look forward to working with you!

Best,
John

JOHN HARRINGTON
P h o t o g r a p h y
2500 32nd Street, SE Washington, DC 20020
(202) 544-4578 Fx: (202) 544-4579

Estimate and Contract

Date: ▮▮▮▮▮▮▮▮▮▮▮
Job #: A2006-134
A.D.
Art Buyer:
Client:
Client #: **CL2006-1530**

To: ▮▮▮▮▮▮▮▮▮▮▮ Tel# ▮▮▮▮▮▮
▮▮▮▮▮▮▮▮▮▮▮ Fax# ▮▮▮▮
EMail: ▮▮▮▮▮▮▮

Description of Services and Rights Licensed: Portrait of ▮▮▮▮▮▮▮▮ for one time use in
▮▮▮▮▮▮ Magazine. Images include two portrait settings, and candid "Q&A"-type images of subject talking and not
looking at camera, with a variety of gestures from subject to choose from.

Fees		
Main Illustration & secondary images		$1480.00
Weather Days	@ $827/day	$1,480.00

Production Charges		
Crew - 1 - Assistant;		$175.00
Miscellaneous - Expendables-$30;		$30.00 $205.00

Photographic Imaging Charges Photographic Imaging Charges - Computer/System Time&
CD-$260;

$260.00

Third Part Fees Billed Direct to Client:
Talent: _____ (Talent fees and the scope of releases are the sole responsibility of Client.)
Other: _____

Terms: Final billing will reflect actual, not estimated expenses, plus applicable
sales taxes. All fees and charges on this invoice are for service(s) & licensing
described above. Fees for licensing of additional available rights will be quoted
upon request.Late charge is 1 1/2% per month after 30 days.

Subtotal	$1,945.00
Sales Tax	
Total	$1,945.00
Advance	
Balance Due:	$1,945.00

Rights are licensed only upon full payment of this invoice, subject to terms and conditions on second page.
(Page 1 of 2)

ALL SERVICES AND LICENSES OF LICENSOR ARE SUBJECT TO THE FOLLOWING TERMS AND CONDITIONS

1. DEFINITIONS: This Agreement is by and between John Harrington Photography ("Licensor") and ("Client") which includes Client's representatives . Licensor's relationship with Client is that of an independent contractor. "Image(s)" means the visual and/or other forms of materials or digital information supplied by Licensor to Client. Licensor is the sole creator of the Image(s). The Image(s) are Licensor's interpretation, rather than a literal copy of any concepts or layouts provided to Licensor by Client. "Service(s)" means the photography and/or related digital or other services described on the front of this Agreement that Client is specifically commissioning Licensor to perform pursuant to this Agreement. "Transmit" or "Transmission" means distribution by any device or process whereby a copy of an Image is fixed beyond the place from which it was sent. "Copyright Management Information" means the name and other identifying information of Licensor, terms and conditions for uses of the Images, and such other information that Licensor may prescribe.

2. FEES, CHARGES AND ADVANCES: Client and Client's representatives are jointly and severally responsible for full payment of all fees, charges and advances. The rights licensed, fees, charges and advances set forth in this Agreement apply only to the original specification of the Services. Additional fees and charges shall be paid by Client for any subsequent changes, additions or variations requested by Client. All advance payments are due prior to production.

3. POSTPONEMENTS AND CANCELLATIONS: If Client postpones or cancels any photography "shoot date" or other Service, in whole or in part, without first obtaining Licensor's written consent, Client shall pay Licensor 50% of Licensor's quoted fees. If Client postpones or cancels with less than two business days' prior written notice to Licensor, Client shall pay 100% of Licensor's quoted fees. Client shall in any event pay all expenses and charges incurred in connection with any postponed or canceled shoot date or other Service.

4. FORCE MAJEURE: Licensor shall not be in default of this Agreement by reason of its delay in the performance of or failure to perform, in whole or in part, any of its obligations hereunder, if such delay or failure results from occurrences beyond its reasonable control and without its fault or negligence. Client will pay 100% of Licensor's daily weather delay fee (as set forth on the front of this Agreement) for any delays due to weather conditions or any acts or occurrences beyond Licensor's reasonable control, plus all charges incurred.

5. CLIENT APPROVAL: Client is responsible for having its authorized representative present during all "shooting" and other appropriate phases of the Service(s) to approve Licensor's interpretation of the Service(s). If no representative is present, Licensor's interpretation shall be accepted. Client shall be bound by all approvals and job changes made by Client's representatives.

6. OVERTIME: In the event any Services extend beyond eight consecutive hours in one day, Client shall pay overtime for crew members and assistants at the rate of 1 1/2 times their hourly rates or fees, and if the Services extend beyond 12 hours in one day, Client shall pay overtime for crew members and assistants at the rate of double their regularly hourly rates or fees.

7. RESHOOTS: Client shall pay 100% of Licensor's fees and charges for any reshooting or redoing of Services requested by Client. If the Image(s) become lost or unusable by reason of defects, damage, equipment malfunction, processing, or any other technical error, prior to delivery of the Image(s) to Client, Licensor will perform appropriate Service(s) again without additional fees, provided Client advances all charges, and pays all fees and charges in connection with the initial Services.

8. LIMITATION OF LIABILITY AND INDEMNITY: Even if Client's exclusive remedy fails of its essential purpose, Licensor's entire liability shall in no event exceed the license fee paid to Licensor. UNDER NO CIRCUMSTANCES SHALL LICENSOR BE LIABLE FOR GENERAL, CONSEQUENTIAL, INCIDENTAL OR SPECIAL DAMAGES ARISING FROM THIS AGREEMENT, THE SERVICE(S), THE IMAGE(S) OR ANY ACTS OR OMISSIONS OF LICENSOR. Client shall indemnify, defend and hold Licensor and Licensor's representatives harmless from any and all claims, liabilities, damages, and expenses of any nature whatsoever, including actual attorneys' fees, costs of investigation, and court costs arising from or relating to Client's direct or indirect use of the Image(s) or in connection with Licensor's reliance on any representations, instructions, information, or materials provided or approved by Client.

9. RIGHTS LICENSED: The licensed rights are transferred only upon: (a) Client's acceptance of all terms contained in this Agreement, (b) Licensor's receipt of full payment, and (c) the use of proper copyright notice and other Copyright Management Information requested or used by Licensor in connection with the Image(s). Licensor is willing to license the Image(s) to Client only upon the condition that Client accepts all of the terms of this Agreement. Unless otherwise specifically stated on the front of this Agreement, all licenses are non-exclusive and the duration is one year from the date of Licensor's invoice and for English language use in the United States of America only. Licensor reserves all rights in the Image(s) of every kind and nature, including, without limitation, electronic publishing and use rights, in any and all media, throughout the world, now existing and yet unknown, that are not specifically licensed or transferred by this Agreement. No license is valid unless signed by Licensor. Client shall not assign any of its rights or obligations under this Agreement. This Agreement shall not be assignable or transferable without the prior written consent of Licensor and provided that the assignee or transferee agrees in writing to be bound by all of the terms, conditions, and obligations of this Agreement. Any voluntary assignment or assignment by operation of law of any rights or obligations of Client shall be deemed a default under this Agreement allowing Licensor to exercise all remedies including, without limitation, terminating this Agreement, obtaining all net worth or financial information of any assignee and full and timely performance of all obligations and complete and substantial assurances of all future performance.

10. RETURN OF IMAGE(S): Client assumes all risk for all Image(s) supplied by Licensor to Client, from the time of Client's receipt, to the time of the safe return receipt of the Image(s) to the possession and control of Licensor. If no return date appears on the front of this Agreement or on any related delivery memo, Client shall return all Image(s) in undamaged, unaltered and unretouched condition within 30 days after the first publication or use of the Image(s), whichever occurs first Client agrees to destroy all digital files within one week of reproduction. If the files are sent on digital media, all such material must be returned in undamaged condition within 30 days of receipt.

11. LOSS OR DAMAGE: IN CASE OF LOSS OR DAMAGE OF ANY ORIGINAL IMAGE(S), CLIENT AND LICENSOR AGREE THAT THE REASONABLE VALUE OF EACH ORIGINAL IMAGE IS $2,500. Once original image(s) are lost or damaged it is extremely difficult and impracticable to fix their exact individual value. Accordingly, Licensor and Client agree that the reasonable liquidated value of each original image is $2,500. Client agrees to pay Licensor $2,500 for each lost or damaged original Image and Licensor agrees to limit Licensor's claim to that amount without regard to the actual value of such Image. An Image shall be considered an original if no high reproduction quality duplicate of that Image exists.

12. PAYMENT AND COLLECTION TERMS: Invoices from Licensor are payable upon receipt by Client. The unpaid amount of any invoice, within 10 days of the mailing date of the invoice, will incur a late payment charge of 1-1/2% per month but not in excess of the lawful maximum. In any action to enforce the terms of this Agreement, the prevailing party shall be entitled to recover their actual attorneys' fees, court costs and all other nonreimbursable litigation expenses such as expert witness fees and investigation expenses. No lawsuits pertaining to any matter arising under or growing out of this Agreement shall be instituted in any place other than Washington D.C.

13. TAX: Client shall pay and hold Licensor harmless on account of any sales, use, or other taxes or governmental charges of any kind, however denominated, imposed by any government, including any subsequent assessments, in connection with this Agreement, the Image(s), the Service(s) or any income earned or payments received by Licensor hereunder. To the extent that Licensor may be required to withhold or pay such taxes Client shall promptly thereafter furnish Licensor with funds in the full amount of all the sums withheld or paid.

14. RELEASES: NO MODEL, PROPERTY, TRADEMARK, OR OTHER SUCH RELEASE EXISTS FOR ANY IMAGE(S) UNLESS LICENSOR SUBMITS TO CLIENT A SEPARATE RELEASE SIGNED BY A THIRD-PARTY MODEL OR PROPERTY OWNER.

15. ELECTRONIC RIGHTS: No electronic publishing or use of any kind is licensed unless specifically stated on the front of this Agreement. The use rights reserved by Licensor include, without limitation, all rights of publication, distribution, display, Transmission, or other use in electronic, digital and other media of any kind, now existing and yet unknown. Any rights licensed by Licensor for any use in a collective work exclude all use rights for any kind of revision of that collective work including any later collective work in the same series.

16. MODIFICATIONS, GOVERNING LAW AND MISCELLANEOUS: This Agreement sets forth the entire understanding and agreement between Licensor and Client regarding the Service(s) and/or the Image(s). This Agreement supersedes any and all prior representations and agreements regarding the Service(s) and/or the Image(s), whether written or verbal. Neither Licensor nor Client shall be bound by any purchase order, term, condition, representation, warranty or provision other than as specifically stated in this Agreement. No waiver or modification may be made to any term or condition contained in this Agreement unless in writing and signed by Licensor. Waiver of any one provision of this Agreement shall not be deemed to be a waiver of any other provision of this Agreement. Any objections to the terms of this Agreement must be made in writing and delivered to Licensor within ten days of the receipt of this Agreement by Client or Client's representative, or this Agreement shall be binding. Notwithstanding anything to the contrary, no Image(s) may be used in any manner without Licensor's prior written consent, and Client's holding of any Image(s) constitutes Client's complete acceptance of this Agreement. The formation, interpretation, and performance of this Agreement shall be governed by the laws of Washington D.C., excluding the conflict of laws rules of Washington D.C. All paragraph captions in this Agreement are for reference only, and shall not be considered in construing this Agreement. This Agreement shall be construed in accordance with its terms and shall not be construed more favorably for or more strongly against Licensor or Client.

_____ _____ P_____

Client Signature Date

(Page 2 of 2)

Case Study: Major Financial Newspaper

Client type: Major financial newspaper.

How they found us: A search on the Internet resulted in us being listed #3 for their search term.

Assignment: Portrait of a Washington, DC sports team for a special section of the paper, indoors in Washington, DC.

Deliverables: Several via e-mail or FTP, suitable for a full-page special section cover use.

Technical notes: Two complete setups in a sports arena, requiring six to eight heads per setup, and two assistants. One scouting visit. Total time shooting: 15 minutes; total setup, breakdown, and waiting time: 3 hours.

The initial inquiry came via phone call and was followed with sample photos of large groups of people via e-mail attachments.

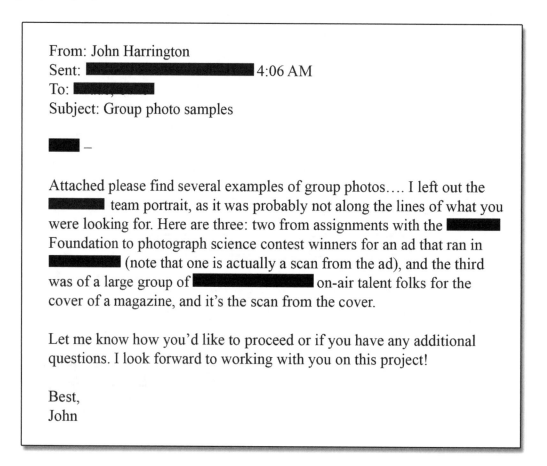

From: John Harrington
Sent: ███████████████████ 4:06 AM
To: ███████████
Subject: Group photo samples

███████ –

Attached please find several examples of group photos…. I left out the ███████████ team portrait, as it was probably not along the lines of what you were looking for. Here are three: two from assignments with the ██████████ Foundation to photograph science contest winners for an ad that ran in ██████████ (note that one is actually a scan from the ad), and the third was of a large group of ████████████████ on-air talent folks for the cover of a magazine, and it's the scan from the cover.

Let me know how you'd like to proceed or if you have any additional questions. I look forward to working with you on this project!

Best,
John

The next morning, the client responded:

From: ███████████████████

Subject: RE: Group photo samples

Date: ████████████ 10:18:26 AM EST

To: ██████████████████

Thanks John.

It turns out that there will be many fewer players in the photo than I thought. More like nine at the very most. So that should be much easier to work with and easier to set up something more creative.

You can have this assignment. So let's talk today.

I am out of the office. Let me know when is a good time to reach you or if I should just e-mail all the details now.

████████

The words "you can have this assignment" mean the client won't be talking to whomever else she contacted. The next e-mail included mockups from the client:

John,

Attached are files with details. I've included a variety of possible layouts just so you can see that I will design the page around your photo composition. I can have any amount of body text on the cover. Any questions, please let me know via e-mail, or you can reach me at

████████████

████████

I scheduled a time to scout the location and e-mailed the client low-rez files from the scout. A truncated version of the dialogue follows:

██████ –

Today, I was finally able to get in to see the ███ at █████ and scout out the arena. I've got some preliminary ideas and images to accompany them that I wanted to share and get your feedback on.

Option 1 – I see this as my favorite option....

Option 2 – I see this as a variation on #1≥.

Option 3 – In this, the players position themselves amongst the seats.... A strong vertical.

Option 4 – I see this as one of the least attractive options....

Option 5 – Originally, I thought this could be a dynamic option, but....

I'd like to think we could do two options—perhaps 1 and 3 to give you some variety, unless you feel you really like one over another.

Let me know your thoughts/preferences....

Best,
John

The client responded:

Thanks John.

I agree that #1 works best. I also like #3 as long as the ▇▇ is visible on the floor. Will you have time to possibly do both variations? Attached are some rough layouts. Although I don't know if I will keep the ▇▇▇▇ image in the headline, especially if there will be ▇▇▇▇▇ in the photo.

▇▇▇▇

With the client and me in sync, I was able to put together final paperwork. I sent along an e-mail with dates locked down. And then I sent this e-mail:

▇▇▇ –

As you can see from the other e-mail I just sent, we're all set for the ▇▇▇ shoot now.

A few notes for you:

—Because we're lighting two areas within a huge gym and a large group, I need to rent supplemental lighting.

—Because we are in two scenarios within a short timeframe, we are bringing in a second assistant.

Let me know if either of these is problematic for you. Attached is our paperwork, now that we have a date and details. If you'd sign and fax it back, that'd be great.

Best,
John

Later that day, I received the following e-mail, affirming the contract and additions. This is important because although we had an affirmation of the contract and additions, we'd not actually received the signed contract back. We would not be releasing high-resolution files until this occurred, but I felt that the "this should be fine" response to the contract I sent was also a contract approval, just not as final as a signature would be. She wrote:

Thanks John. This should be fine. Glad everything is set. Also, I just wanted to mention that the layouts I sent you were just some possible ideas. Please shoot what makes a great image, and I will work it out from there.

Talk to you next week.

█████

Following the shoot, I reported in:

████████

The shoot went great. We were able to get both perspectives we discussed of the coach and players (and some variations within each), and I think you'll be pleased with the results!

You can view the images in a web gallery at: ████████████████

Please let me know which image(s) you select and what dimensions and dpi you need, and I will reopen the raw files and produce optimized images, dust spotted, etc., at that size and post them on FTP for you to download.

On a housekeeping note—if you would be so kind as to sign and fax the contract back, that'd be great. I know you acknowledged in the last e-mail that it was fine, but having the signed paperwork is necessary for our records.

Thanks again for calling on me. I'd love to get a PDF of your mockups with these once you've played around with them some.

Sincerely,
John Harrington

Later that day, an e-mail came in along with a fax of the signed contract. The response was:

> Hi John,
>
> Photos look great. Just called your studio and asked for some larger jpgs to work with before I decide on a final. I'm also attaching some ideas that I am working on. What I'd really like to do is have the image bleed. So in the end the final image will probably be about 12×12". Hope there is enough resolution to do that.

We wrote back:

> ▉ –
>
> We're working on them now. I will have them to you as 12×12, 300dpi, 8-bit JPEGs. When you make the final selection, I will deliver it as a 16-bit TIF at 12×12 300 dpi. Thank you for the revised comps. I am excited to see their incorporation into the page.
>
> Best,
> John

A few days later, the client reported the final results:

> John
>
> The report is on the newsstands today. Looks great. Hope you like it, too. I'll send you some copies and a pdf at some point.
>
> Thanks,
> ▉

The front page of the contract follows. Since the back page is identical to the previous example, there's no need to include it.

JOHN HARRINGTON
P h o t o g r a p h y
2500 32nd Street, SE Washington, DC 20020
(202) 544-4578 Fx: (202) 544-4579

Estimate and Contract

Date:	▮▮▮▮▮
Job #:	A2006-127
A.D.	
Art Buyer:	
Client:	
Client #:	CL2006-1485

To: ▮▮▮▮▮

Tel# ▮▮▮▮▮

Fax#

EMail: ▮▮▮▮▮

Description of Services and Rights Licensed: Produce on location, environmental portrait of ▮▮▮▮▮ coach of ▮▮▮▮▮ and members of the team for one time use on the cover of ▮▮▮▮▮, in one (and if possible two) setups as discussed following scouting. Shoot to take place the evening of ▮▮▮▮▮ with images available the next day via online gallery, and final high resolution TIF's delivered to size and lpi specs via FTP.

Fees			
Main Illustration		$2150.00	
			$2,150.00

Production Charges			
Crew - 2 - Assistants;175 ea		$350.00	
Lighting Rental		$250.00	
Travel - Parking/Tolls/Gas/Mileage--$20;		$20.00	
Miscellaneous - Expendables-$30;		$30.00	$650.00

Photographic Imaging Charges Photographic Imaging Charges - Computer/System Time - $250;FTP/Digital delivery-$85;

			$335.00

Third Part Fees Billed Direct to Client:
Talent: _____ (Talent fees and the scope of releases are the sole responsibility of Client.)
Other: _____

Terms: Final billing will reflect actual, not estimated expenses, plus applicable sales taxes. All fees and charges on this invoice are for service(s) & licensing described above. Fees for licensing of additional available rights will be quoted upon request. Late charge is 1 1/2% per month after 30 days.

Subtotal	$3,135.00
Sales Tax	
Total	$3,135.00
Advance	
Balance Due:	$3,135.00

Rights are licensed only upon full payment of this invoice, subject to terms and conditions on second page.
(Page 1 of 2)

Case Study: Consumer Magazine

Contract: Major consumer magazine.

How they found us: Internet search engine.

Assignment: They needed a portrait of a subscriber who was participating in a fitness challenge. The initial dialogue began on a Monday for an assignment the next afternoon, Tuesday. The film went to our lab Wednesday and was shipped out Thursday for Friday delivery.

Deliverable: 120mm film.

Technical notes: Two setups at a gym: one on client-specified color seamless and a secondary image as an alternate of the subject using a piece of exercise equipment. Location was entirely in a gym, and it was two setups with a total of three lights for each.

We proposed a fee of $925, they countered with $450, and we settled on $675. The client was specific about a backdrop color, and we included that in the estimate. Further, in the end, we purchased a second backdrop after the contract was signed, which was included on the invoice. Although the photo editor signed the contract, after we had received the signed contract from the PE, her assistant sent us the magazine's standard contract, which was highly objectionable. After the fact, we also were confronted by the client's demand for the receipts—we responded, and our issue was resolved.

The following correspondence includes:

▶ Our contract's first two pages, which includes the dollar figures

▶ Their counter contract

▶ Our e-mail traffic regarding the negotiation over the photographer's fees

▶ Our e-mail to the client with the attached invoice and their receipts problem

▶ Our e-mail response to the client regarding their problem and their acceptance

▶ Our "receipt" for the expenses

NOTE

If we had agreed to their contract, we would not have been able to facilitate the best film processing, nor could we have made our copies for copyright registration, because they would have held the film for six months.

From: ████████████
Sent: ████████████████ 3:26 PM
To: ████████████
Subject: Sterling VA Shoot ████

████████████ ,

Thanks for calling regarding the shoot for tomorrow. I look forward to hearing back from you at your earliest convenience regarding the seamless. We'll need to send a courier up to the local supply house to get the #62 seamless, or we'll drop the seamless from this estimate if you have ████ ship the seamless to us from NYC. If you do, please have them ship it and "HOLD FOR PICKUP AT FEDEX LOCATION" in Washington, DC. Attached is our contract. Please look it over, call with any questions/concerns, and sign and fax back to confirm.

Thanks!
John

From: ████████████
Sent: ████████████████
To: ████████████
Subject: RE: Sterling VA Shoot ████

Hi John: Everything looks good except your rate. We pay $450.00 a day against page usage. At this point, we are only going to be doing one page, but since we are going to be following the progress of these women who lost weight, we will be shooting again down the line. Hope our rates work for you.

Thanks,
████████████

From: ▆▆▆▆▆▆▆▆
Sent: ▆▆▆▆▆▆▆▆▆▆▆▆ 3:39 PM
To: ▆▆▆▆▆▆▆
Subject: RE: Sterling VA Shoot ▆▆

▆▆▆▆▆▆ ,

Thanks for the info on the rate. If the shoot was right in DC, it would be easier to come down to that rate, but with the travel time to/from Sterling (i.e. 1–1.5 hrs outbound, rush hour, and 1 hr back during non-rush time), it'll take a bit longer than our normal shoot. Can we meet in the middle between your $450 and my $925, at, say, $675?

Thanks,
John

From: ▆▆▆▆▆▆▆▆
Sent: ▆▆▆▆▆▆▆▆▆▆▆▆ 3:52 PM
To: 'John Harrington'
Subject: RE: Sterling VA Shoot ▆▆

Works for me. Thanks!

From: ▆▆▆▆▆▆▆▆
Sent: ▆▆▆▆▆▆▆▆▆▆▆▆ 3:47 PM
To: ▆▆▆▆▆▆▆
Subject: RE: Sterling VA Shoot ▆▆

Great. Attached is the revised contract! Please sign and fax back, and at your earliest convenience let me know about the paper....

Best,
John

From: ▮▮▮▮▮▮▮▮▮▮
Sent: ▮▮▮▮▮▮▮▮▮▮▮▮▮▮▮ 3:56 PM
To: ▮▮▮▮▮▮▮
Subject: RE: Sterling VA Shoot ▮▮▮

OK—#62 works for you…. I'll get it sent down from the local supply house for me. Consider it done….

Best,
John

From: ▮▮▮▮▮▮▮▮
Sent: ▮▮▮▮▮▮▮▮▮▮▮▮▮▮ 4:31 PM
To: ▮▮▮▮▮▮▮
Subject: RE: Sterling VA Shoot ▮▮▮

Ok, I just wasn't sure if we spoke about that or not. It's been THE most crazy day here today…. Thanks for everything!

From: ▮▮▮▮▮▮▮▮
Sent: ▮▮▮▮▮▮▮▮▮▮▮▮▮ 5:08 PM
To: ▮▮▮▮▮▮▮
Subject: RE: Sterling VA Shoot ▮▮▮

Marybeth –
Can you fax back the contract before you leave today? If not, I'll need it in the AM tomorrow.

Thanks,
John

From: ███████████
Sent: ████████████████████ 5:18 PM
To: ████████████
Subject: RE: Sterling VA Shoot ████

Ooops, will take care of it right now.

From: ████████████████
Sent: ████████████████████ 5:21 PM
To: ████████████████
Subject: SHOOT DETAILS? Sterling VA Shoot ████

████████████

When you can, would you also forward the address/name/phone#/etc. for the subject, and if you have a low-rez file of the other shots you want matched (i.e. lighting, full-length/half-length/etc.), that would be great.

Best,
John

From: ██████████
Subject: RE: SHOOT DETAILS? Sterling VA Shoot ████
Date: Monday, ████████████████ 5:47 PM EDT
To: 'John Harrington'
Cc: ██████████████████ [introduces her colleague with whom I'll be working via a CC]

Can ██████ send everything to you tomorrow? She's the one who's been working on this shoot, and she has the folder with her at home. (She was out today.) I'll make sure she gets it out to you first thing. That ok?

██████

From: ██████████████
Subject: RE: Sterling VA Shoot ████
Date: Tuesday, ██████████████ 10:48:19 AM EDT
To: 'John Harrington'

Again, thank you so much for doing this photo shoot for us today. Attached please find our photographer's contract along with our model release. Note: Our contract has the special agreed fee of $675. Please sign it and include it when you send us the film along with the signed model release. I will also fax you a copy of a layout that our Creative Director enjoyed—the way the angles are. Again, shoot her on both the white background and also the purple background. These shots are all full frame. Have her sitting Indian-style on the floor, jumping up and down, arms crossed and uncrossed, just standing there smiling, and some not smiling. Again, we have to have the same shots on both backgrounds. This is very important. Then she will change her top and just do some exercises with her trainer. These shots are all environmental.

Please call me when you receive this note. I am at ██████████████ .

From: John Harrington
Sent: Tuesday, ██████████████ 5:04 PM
To: ██████████████
Subject: RE: Sterling VA Shoot ████

██████ ,

Thanks for the model release—I'll present it to the subject for her to sign (actually, now, we've just spoken, and I will await the NEW release). I have already forwarded—and received back signed—our standard photography contract, from ██████████ . The variation between yours and mine in terms of layout and content are so different that marrying them together isn't possible, really.

Thanks,
John

From: ███████████████
Subject: RE: Sterling VA Shoot███
Date: Tuesday, ███████████ 5:06:44 PM EDT
To: 'John Harrington'

Thanks again for everything. Here is the additional information. I'll call you tomorrow to find out how everything went.

From: ████████████
Sent: Friday, ███████████ 9:54 AM
To: ██████████████
Subject: Invoice

Dear ██████,

Attached is a PDF file of our invoice from the portrait shoot. As this is an electronic original, and due to US mail slowdowns, we are not forwarding printed invoices at this time. Please take a look at the invoice and call with any questions. If you require a printed invoice, please call our office and let us know, and we can either fax it to you or mail it out.

Thanks,
John

From: ██████████████
Sent: Friday, ███████████ 9:59 AM
To: 'John Harrington'
Subject: RE: Invoice

Thanks, but I need the backup for the expenses. Accounting will not pay without receipts.

From: John Harrington
Sent: Friday, ▮▮▮▮▮▮▮▮ 11:48 AM
To: ▮▮▮▮▮▮▮▮
Subject: Receipt

▮▮▮▮,

I have attached the best receipt I can prepare for you. Our website states our policy regarding receipts, in that we do not turn over receipts as a part of the
invoicing process.

To see this, please visit http://www.johnharrington.com/rates and click on the link, but the information on the website appears below:

> We do not supply clients with receipts for any expenses. We do this for
> several reasons:
>
> —We are independent contractors, not employees. When tax time comes, the
> IRS requires us to provide receipts to verify expenses on our Schedule C. The IRS
> does not require you to have those receipts on hand.
> —It is critical to the success of our business to maintain a proprietary suppliers
> network—an absolute cornerstone of a profitable business, and in an insecure
> environment we do not wish our competitors to learn who our suppliers are. While this is
> less applicable on film and processing than on unusual items, and from time to time ap-
> plies to assistants as well, it is nonetheless critical throughout our supplier chain.
>
> We have a set fee per amount of supplies used, regardless of what was actually paid
> for it. This is done for several reasons: 1) We keep film on file to meet
> last-minute and unusual requests, therefore we sometimes discard film which does
> not meet our technical expectations or which have been through several passes of an
> X-ray machine; this cost must be split across the cost of actual film shot, and 2) Time
> is taken to investigate new films, test films before they are used in shoots, go to the
> various suppliers we use, and maintain the stock necessary. The cost for this time,
> billed by staff, must be spread across the cost per roll.
>
> By way of example, publishing houses do not request receipts from printing plants
> for the cost of ink and paper, nor receipts for the wholesale prices paid
> on the repair of a copier, nor gasoline receipts from the delivery service who
> delivers the copies of the magazine.
>
> Please discuss with us any issues you have with this policy beforehand.

The IRS does not require you to have any documentation other than our invoice,
which serves as your proof of expense. Please confirm that our policy will not delay
payment being made.

Best,
John

John Harrington Services
2500 32nd Street, SE Washington DC 20020 (202) 544-4578

DATE: April 22, ██████ Job Reference: ██████Magazine

Backdrops – two @ $72.00 each	$144.00
Kodak EPP 120 film, nine @ $5.00 each	$ 45.00
E-6 Processing, nine rolls 120 @ $37.00 each	$333.00
Courier service, Round-trip service	$ 23.50
Assistant's fee	$175.00
Expendables	$ 25.00

TOTAL $745.50

From: ████████████████
Sent: Friday, █████████████ 12:08 PM
To: 'John Harrington'
Subject: RE: Receipt

We understand that some photographers will not turn over original receipts
for tax purposes, which is why we do accept Xerox copies as backup. But,
our accounting dept. has guidelines and has to adhere to the same rules and
regulations when we have our annual audits. They need backup for every bill.
What you sent me is fine. Please just send another one for your assistant.
This is the only expense you did not include.

Thanks,

██████

From: John Harrington
Sent: Friday, ███████████ 12:18 PM
To: ███████████
Subject: RE: Receipt

██████,

I have just revised the previous receipt to include the assistant's fee.
Thanks….

Best,
John

While this concluded our negotiations, I think it's helpful for you to read the text of the proposal they sent over. In addition, note that we did the follow-up shoot for them two months later, without further objection as to pricing or receipts policy.

PHOTOGRAPHY COMMISSIONING AGREEMENT

█████ MAGAZINE

Issue: July ████ Special Fee: $675 page plus expenses

Photo Shoot: █████ Challenge: ███████████

Photographer: John Harrington

███████████ (the "Magazine") welcomes the opportunity to publish your photographs. Quality photographs are an important factor in the Magazine's success. You and ████████ ███████████████████████████ , on behalf of the Magazine, hereby agree as follows:

1. ███████████ will commission you to take photographs on specific photo shoot assignments from time to time for use in stories appearing in the Magazine (the "Photographs") in accordance with the following terms and conditions for each assigned photo shoot (the "Photo Shoot").

 a) ███████████ will pay you a sum calculated at the Magazine's current standard rate of $_____ per day of the Photo Shoot.

(continued)

b) In addition to the payment in paragraph 1(a), ███████ will pay you the difference, if any, between the sum calculated at the Magazine's current space rate of $450.00 per page of Photographs used in the story, and the payment in paragraph 1(a), except as provided in paragraph 1(d).

c) If ███████ accepts one (1) or more of the Photographs for use on the Magazine's Web site, currently located at ███████████████, (the "Web Site"), in addition to the payment in paragraph 1(a), ████████ will pay you a one-time fee of One Hundred Dollars ($100.00).

d) If ███████ accepts one (1) or more of the Photographs for use on the cover of the Magazine, in addition to the payment in paragraph 1(a), ████████ will pay you the difference, if any, between the sum calculated at the Magazine's current premium cover rate, and the payment in paragraph 1(a).

e) If, for any reason, ███████ does not wish to use any of the Photographs, in full consideration for your services in connection with the Photo Shoot, in addition to the payment in paragraph 1(a), ███████ will pay you the difference, if any, between a kill fee calculated at fifty percent (50%) of the Magazine's space rate for the space in the Magazine planned for the Photographs, and the payment in paragraph 1(a), and all right in the Photographs granted to ███████ pursuant to paragraph 2 will revert back to you.

f) ███████ will also pay your expenses for the Photo Shoot according to its current practices, upon submission of copies of receipts. All payments made under this Agreement, including those for expenses, will be reported as income on your year-end 1099 tax form. In addition:

 i. You must make all travel and hotel arrangements and car rental through ███████ corporate account unless ███████ agrees otherwise in advance;

 ii. ███████ will pay the current IRS-allowable rate for mileage for use of your own car and its current standard rate, now $_____ a day, for travel time;

 iii. ███████ will arrange locations, studio booking and crew lunches;

 iv. ███████ will pay its current standard rate, now $175.00 a day, for an assistant; for more than one assistant, the rate will be paid as agreed in advance;

 v. Prior approval by the Magazine's photo editor (the "Photo Editor") is needed before renting any photographic equipment, which should be ordered, along with film and other photo supplies, through ███████ ;

 vi. You must process film with one of the Magazine's "approved" labs; and

 vii. You must deliver all film to the Photo Editor only through ███████ messenger service, the identity of which should be requested through the Photo Editor.

(continued)

2. You hereby grant to ▉▉▉▉▉▉ the following rights in each Photograph taken by you for a Photo Shoot:

a) The exclusive right to publish the Photograph in the Magazine prior to publication by any third party, in any form throughout the World, and the right to reproduce, use and distribute the Photograph as part of the issue of the Magazine in which it appears;

b) The exclusive right to use the Photograph for a period of six (6) months from its first publication pursuant to paragraph 2(a);

c) The ongoing right to publish and use the Photograph as well as your name, likeness and biographical information, to advertise and promote the Magazine and/or ▉▉▉▉▉▉ ;

d) The ongoing right to publish, use and distribute the Photograph, as well as your name, likeness and biographical information, on the Web Site;

e) The ongoing right to publish and distribute the Photograph in any special interest publication or book of the Magazine, or in any other magazine or publication published or distributed by ▉▉▉▉▉▉ , upon payment of such publication's then-prevailing space rate;

f) The ongoing right to include the Photograph in a print anthology with other material published in the Magazine, upon payment of ten percent (10%) of the original rate pursuant to paragraphs 1(a), (b) and (d);

g) The ongoing right to license rights to publish the Photograph to other periodicals throughout the world directly or through a syndication company, upon payment of fifty percent (50%) of the net proceeds ▉▉▉▉▉▉ receives for such license; and

h) If the Photograph is used on the cover of the Magazine, the ongoing right in all media to use the Photograph as it appears on the cover for editorial, advertising and promotional purposes, and to license third parties to use such cover upon payment of fifty percent (50%) of the net proceeds received for such license (in addition to the Magazine's current premium cover rate).

3. The original separations and all seconds will be kept by ▉▉▉▉▉▉ for possible future use. The remaining film will be returned to you. You agree not to sell this film or photographs similar to any Photographs to any women's service magazine or related Web site, including, but not limited to, ▉▉▉▉▉▉▉▉▉▉▉▉▉▉▉▉▉▉▉▉▉ ▉▉▉▉▉▉▉▉▉▉▉▉▉▉▉▉▉▉▉▉▉▉▉▉▉▉▉▉▉▉ ▉▉▉▉▉▉ , for at least six (6) months from the off-sale date of the issue of the Magazine in which such Photograph first appeared.

4. You will be credited in the Magazine, in any other ▉▉▉▉▉▉ publication in which any of the Photographs appear, or on the Web Site if the Photographs appear thereon, consistent with that particular publication's or the Web Site's style.

<div align="right">(continued)</div>

5. You should retain duplicate prints of the Photographs. ███████ will take good care of any original prints and color negatives while it has possession but shall be responsible for each only up to the rate paid for use under this Agreement.

6. You warrant and represent that the Photographs are original to you, you have the right to grant the rights granted herein, there has been no prior sale, publication or transfer of rights to the Photographs, and publication of the Photographs will not infringe upon any other person's copyright or other rights, including, without limitation, the rights of privacy or publicity. You agree to indemnify and hold ███████ harmless from any and all loss or expense suffered by reason of the breach of any of these warranties.

7. Upon request, you will furnish ███████ with properly executed model releases on the Magazine's standard form supplied by the Photo Editor.

8. Payment will be made upon separate invoice for each Photo Shoot. You shall include on each invoice (a) the name of the story for which the Photographs are taken and the Magazine issue in which such story is scheduled to be published, both of which shall be supplied by the Photo Editor, and (b) a list of fees and expenses incurred in connection with such Photo Shoot, separately itemized. You shall attach to each invoice model releases and copies of all receipts for fees and expenses. Payment will be made in the ordinary course of ███████ business after ███████ receipt of the above.

9. The parties acknowledge that the services performed by you under this Agreement are performed as an independent contractor, not as any employee or agent, and that you are responsible for the payment of all federal, state and local personal income taxes and any other taxes arising out of payments made under this Agreement. You acknowledge that unemployment compensation will not be available as a result of services performed under this Agreement and that ███████ is not responsible for obtaining insurance or other compensation covering accident or injury arising out of the performance of this Agreement or otherwise.

10. This Agreement shall be governed by the laws of the State of New York. This letter and the Magazine's schedule of current photography rates shall constitute the entire agreement between you and ███████ regarding its subject matter. No amendment or waiver shall be valid unless it is in writing and signed by both you and ███████.

If the foregoing correctly states the agreement between you and ███████, please sign and return both copies of this letter.

Sincerely,

███ Magazine

ACCEPTED AND AGREED TO:

Name: _____

Date: _____

Social Security Number: _____

Chapter 14
Contracts for Corporate and Commercial Clients

Corporate and *commercial* photography are phrases that are often used interchangeably. Sub-types within those types of photography, including annual reports, PR, advertising, catalogues and brochures, executive portraiture, and internal communications materials, are among the numerous derivations of these two "parent" types of photography. One key thing to understand is that these types of photography are *not* editorial—someone has quantified a benefit to the bottom line, either in the short term or the long term, by engaging photographic services. An editorial shoot ultimately has to benefit the bottom line of a publication by contributing to retaining existing subscribers or influencing new readers to subscribe, which will increase the eyeballs looking at the publication, which in turn will validate or increase ad sales. The cause and effect in editorial is not as distantly related (for the most part) as that of corporate or commercial types of photography.

What's the Difference between Corporate and Commercial?

Corporate photography is initially best defined as what it's not. It's not photography created to offer or promote a particular commodity. It is usually organizational statements, which seek to clarify an organization's "brand." The photographs tend to have more of a purpose beyond selling, and they are usually more serious in tone. Most (but not all) annual report work I would term corporate, even though the imagery might seem to be of a product or service the company offers. Executive portraits of the CEO, president, CFO, COO, and other company officers used on the organization's website or intended to be made available to the press would fall under the corporate rubric. Also in this category would be "feel-good" public efforts to establish a company as compassionate, caring, or connected to a community, as well as imagery for organizational communications that seek to inform or educate their internal audience of employees and vendors.

Corporate-type photography is by no means limited to corporations. Numerous other entities employ corporate photography, such as philanthropic organizations seeking to promote their causes or efforts to make the world a better place; organizations seeking cures to terminal diseases by illustrating the end stage, waypoint conditions, or how these diseases affect everyone; and disaster aid organizations who do good after a community or nationwide

incident and document that work not only to justify their outlays to the disenfranchised, but also to ensure an ongoing influx of donations to maintain their existence and make a difference in the future. As a way to illustrate the separation of style from how the photography is used, schools that teach photojournalism often use the work of Angus McDougall. McDougall produced photography for International Harvester's in-house publication, *International Harvester World*, back in the late '60s and early '70s. His work was stylistically photojournalism, but was, in fact, corporate work for what was termed a corporate magazine, following his work for the *Milwaukee Journal* and *Life* magazine.

Commercial photography is essentially photography created to offer or promote a particular commodity, from services of every form and type to physical products from A to Z. There are media buys in editorial publications, sales materials, consumer brochures, posters, billboards and transit ads, stills in television commercials, tradeshow booths, product photography, and the list goes on and on. One variation on this type of work is when you are working for a political campaign, which is definitely not editorial, but is used to promote the candidate rather than a corporation. As noted in Chapter 21, "Resolving Slow- and Non-Paying Clients," make sure that you are paid in full before or upon delivery. It is standard practice that all work done for political campaigns is paid without the extension of terms such as 30 days or 60 days.

It might be easier to understand if you consider that when you're doing corporate or commercial photography, there will usually be many more people giving direction and signing off on the finished product. I have found myself waiting hours as a photo I produced at a public "news" event, which was covered by the news media, is pored over and an excruciatingly correct caption is written by a legal department. Coming from an editorial background, I know that the photo desk and a final editor are no doubt going to rehash the caption if it ever runs in the first place.

Consider an example, written by me, the editorial photographer assigned to cover the news event. This isn't a real caption from a real event—that should be obvious. It is, however, nearly identical to incidents and caption delay experiences I have had for corporate clients with whom and for whom I have worked.

> As Anytown High School junior Gina Jones (left) looks on, Honda CEO Phil Albertson (right) explains how the new Acura runs off hybrid technology, Monday, February 29, 2009, in Detroit, Michigan. Jones won an essay contest that will award her the Acura, and Honda donated the car to the local Sierra Club chapter for the contest.

When lawyers and numerous other "communications" experts get involved, here's an example of what you might get:

> Honda North America Consumer Division President and CEO Phillip E. Albertson Jr. (right) demonstrates the safety and clean-running features of the 2010 Honda Acura ELX Clario-Hybrid™ technology, the first of Honda's USA-branded products to carry the technology, to Anytown, USA High School student and Sierra Club 2009 essay contest winner Gina Jones (left), who wrote about how the planet could be saved if more Americans looked to safer and cleaner fuel

technologies, such as those that Honda has introduced, two years before the Congressional mandate to include the technology as an option. The 2010 Honda Acura, on display here in Detroit, Michigan, is on a nationwide tour to demonstrate the technology and as an award to 10 students across the country. The tour began today, February 29, 2009, and runs through April 1, 2009.

From my perspective, I don't need to know much of the second example's sales lingo. I am not about to put a trademark symbol in my caption. My caption meets AP style, and mine would have made the East coast deadlines and been put into newspapers, whereas the second caption came two hours later and was approved by Honda's lawyers, Clario's lawyers, and the Sierra Club's vice president for communications, among others.

What a Corporate or Commercial Contract Must Have

Corporate and commercial contracts, on a basic level, must have the same things as an editorial contract—a signature, rights outlined, fees agreed to, and the like. For a more in-depth outline of those, see Chapter 13. However, there are other issues at stake. It's important to detail exactly who the end user of the images is.

If your client is Docomo Shoes, you were hired to cover their donation to the Race for the Cure footrace in your community, and all the shoe wearers are cancer survivors whose participation in the race is sponsored/underwritten by a pharmaceutical company, you have potentially three parties who could use your photos, but only one should be licensed to do so, unless you enter into a multi-party licensing agreement (MPA). More on MPAs later in the chapter.

There must also be an understanding about who has final authority to sign off on the resulting imagery from an assignment. Suppose an AD is at the shoot with a PE, the AD heads for a lengthy restroom break, and the PE gives you what you think is approval on two images with the phrase "looks good." But suppose you come to find out after the fact that the PE was offering his opinion, and only the AD could sign off before the next image. Now you've got a problem. Typically, my contracts state that the client must always provide someone onsite to approve images, and, absent that, they agree that I may make the determination as to suitability of images and setups without penalty or withholding of payment.

You'll want to know whether the process is A) a bid, which implies a fixed or "do not exceed" cost outline; B) a quote, which implies concepts similar to a bid; or C) an estimate.

Bids versus Estimates

If the client has requested a bid (or quote), realize that producing bids is a process that requires a great deal of finesse. Further, you are committing that the cost to produce the project—as outlined—will be what you have placed on the bottom line of the bid.

More and more, our clients are being asked by their clients to *triple bid* the project. This is done largely for two reasons. The first reason is that you and two other photographers with similar capabilities (and usually slightly different approaches) are presented to the client. With three to choose from, the client makes the decision about who will shoot the assignment.

The second reason is financial. Sometimes, the low bidder wins, but often the middle-priced photographer wins the bid, with the low bidder being identified as not knowing what goes into the shoot or the correct costs associated with completing the assignment, and the high bidder being so out of touch with reality that his or her prices are outrageous. There is a degree of manipulation here, because savvy art buyers will call in photographers who they know will be the high- and low-bidders, thus giving you the project. After all is said and done, ask the art buyer whether he or she was looking for you to fill in the low/high position for an assignment or whether the deciding factor was creativity, and you just weren't to that client's liking. It stands to reason and fairness that a client that needs you to be the low/high eventually will owe you a few assignments for the time you put in doing bids you know you're not getting to actually do.

In the instance where the bid is for a government agency, and you are bidding directly to the government, they are obligated to tell you who the other bidders were and what the bottom-line figure was.

Whether a bid or an estimate, shoots are not always "grab the camera and strobe and go" or "grab the camera, laptop, and lighting kit and go" types of shoots. In many instances, pre-production days, post-production (or set-strike) days, tech-scouting days, casting days, and so on are a critical part of the assignment.

For pre-production days, you may be pulling together a specialized set of equipment; making all sorts of travel arrangements; getting permits, building props, or sets; meeting with clients face to face or on multiple conference calls; and so on. The list really does go on and on. During this time, you cannot be out shooting and doing other things, so it is fair and reasonable to charge the client a fee for this.

If you are doing a three-day shoot, accomplishing three setups a day, and you have calculated that your creative fee for this is $5,400, then it stands to reason that you are billing $1,800 per day. Note: Day rates imply that you are an eight-hour-a-day person, and whatever can be accomplished in eight hours is what you can/will do. If, in your own professional estimation, you can do two setups in a day because one shot is in an indoor warehouse on one side of a client's plant and the other is across the plant, then you would outline a fee of $1,800 for two setups. If, however, you are working on one floor of an office building, then perhaps you could accomplish five setups in a day...still $1,800. You might think to yourself, "I want $1,800 a day for this annual report shoot"—that's not a problem. However, using the words "day rate" as shorthand to discuss this with your client is, as previously mentioned, a bad idea. So, if you are looking to earn $1,800 for a single day's photography (whether two setups or five setups), billing a pre-production rate at 50 percent of that figure is fair and reasonable. So, too, do I bill at 50 percent for all travel days.

Post-production days are slightly different. If you own a studio, and it takes two days to break down and remove an elaborate set, your studio is not available to you for other shoots, so 100 percent of that same $1,800 is reasonable. However, if you are spending a day meeting with the client to review images, return props/equipment, and so on, then a figure of 50 percent might be more reasonable. That said, an even more cost-saving approach would be for you to pay an assistant to do that work, if possible.

A tech scouting day is another billable day, again between 50 and 100 percent of a creative fee charge for the day. Suppose you have a location scouted by an assistant who has gone to a half-dozen locations, and you have narrowed it down to two. You and the client visit the location at the exact time of day when the shoot will take place to ascertain light/shadow issues and perhaps the ability to access the location at that time—or whether nearby restroom facilities might be closed because it is after 5 p.m. for your sunset shot, and the store is closed. This tech scout would reveal that you need to contact the shop owner and offer him or her several hundred dollars to stay open just for you, since you need restrooms and a place to pull electricity from. It also allows you to see whether things such as construction cranes have appeared out of nowhere or if traffic flows through your background at exactly that time.

Unlike editorial clients, who have their own contracts to send (or that they try to send), most corporate and commercial clients do not and will expect you to send yours, which should be thorough and clear. One thing that will get many an estimate nixed is when there is a six-hour shoot in some far-off location, and you have not included catering in the estimate. Is everyone supposed to just scatter to the four directions when they get hungry? Little things like this can illustrate to a client that you know what you're doing on an assignment.

If the corporate photography is "event-type" coverage of a press conference, an all-day symposium, an awards banquet, a foot race, or other activity-related photography, your start and wrap times are essential and must be outlined with ways to calculate overages when things run late.

If you're called into a law firm to photograph a dozen attorneys, make sure your paperwork details that it's for 12 portraits and allow for additional portraits (time permitting) for an additional fee. I can't tell you how many times I have found myself called in for a dozen portraits, only to end up doing more than 20. Having a clear understanding of how this will affect the final bill means that the client is informed and minimizes the client's ability to object when the final invoice arrives.

All the contracts I send out are estimates. They carry the understanding that there could be fluctuation in the costs when circumstances change.

CHAPTER 14

Change Orders

When the parameters or circumstances change for a shoot, so do (or should) the figures involved in the estimate. As with an editorial assignment, in which the concept of a "change order" is less common, change orders are a frequent necessity for corporate and commercial assignments. When the client adds an additional subject, look, or second setup "just in case," that additional time, effort, and creative energy carries additional charges and expenses. You'll want to make sure you understand and agree with who's booking (and paying) talent if models are necessary, and affirm that their usage is consistent with the client's. Back in the day, models were not concerned about usage; now they are.

You would do well to have a few change orders on hand at all times. In a multiday, on-location assignment situation, the change might come into play on Day 2, and you can go back to the hotel business center and print out one. If you are in a studio, there is likely a printer you can get something printed out on. Or, the person on site may not be authorized to sign off on the change order, so you'll want to be able to outline the changes in a Word file and/or send a PDF to the client's office, where it can be signed by the appropriate person. If you are in a situation where a computer-generated change order is not practical, having a few blank ones in your job folder is the next best solution, and you can hand-complete the form. If that is not workable, send a quick e-mail to a client (even when they are on set with you) and write, "Please reply to this e-mail acknowledging that we have agreed that the fourth and fifth setups we are doing will incur an additional $1,290 each, separate from the model's additional fees." If even that won't work, then at least get a verbal agreement and back it up with something signed as soon as possible—certainly before any high-resolution files are delivered. Figure 14.1 shows an example of a change order.

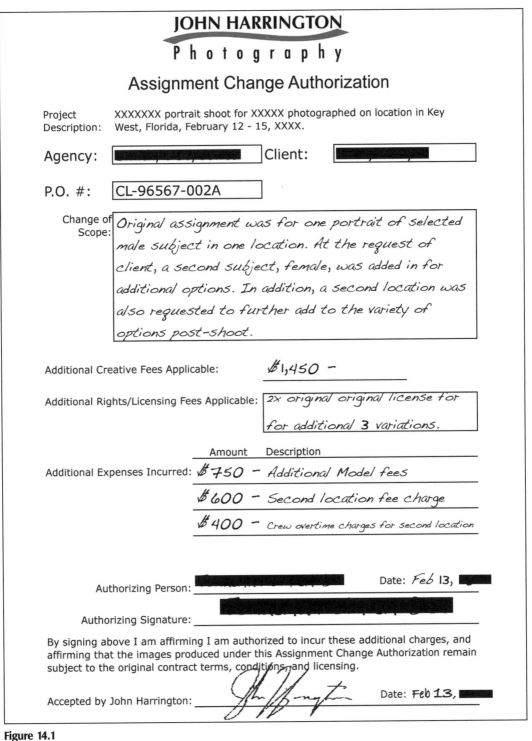

JOHN HARRINGTON
P h o t o g r a p h y

Assignment Change Authorization

Project Description: XXXXXXX portrait shoot for XXXXX photographed on location in Key West, Florida, February 12 - 15, XXXX.

Agency: ▓▓▓▓▓▓▓▓▓▓ Client: ▓▓▓▓▓▓▓▓

P.O. #: CL-96567-002A

Change of Scope: *Original assignment was for one portrait of selected male subject in one location. At the request of client, a second subject, female, was added in for additional options. In addition, a second location was also requested to further add to the variety of options post-shoot.*

Additional Creative Fees Applicable: *$1,450 –*

Additional Rights/Licensing Fees Applicable: *2x original original license for for additional 3 variations.*

Amount	Description
Additional Expenses Incurred: *$750 –*	*Additional Model fees*
$600 –	*Second location fee charge*
$400 –	*Crew overtime charges for second location*

Authorizing Person: ▓▓▓▓▓▓▓▓▓▓▓ Date: *Feb 13,* ▓▓▓

Authorizing Signature: ▓▓▓▓▓▓▓▓▓▓▓

By signing above I am affirming I am authorized to incur these additional charges, and affirming that the images produced under this Assignment Change Authorization remain subject to the original contract terms, conditions, and licensing.

Accepted by John Harrington: _____ Date: *Feb 13,* ▓▓▓

Figure 14.1
Example change order.

CHAPTER 14

Purchase Orders

Purchase orders are commonplace in corporate America. While you may have a client sign a contract with you, and that contract may well be perfectly valid, the company that person works for is almost always required to secure a purchase order, or PO, through their accounting department in order for you to get paid. Here's how and why.

Suppose your client, working on behalf of Widgets USA, has a contract of $120,000 a year to spend. This equates to $10,000 a month. The contract your client has calls for them to handle advertising, marketing, and grassroots outreach for Widgets USA. In this case, those three things are almost always handled by three different people. When your client, who handles marketing, calls you, books you, and signs your contract, they have contracted with you to pay you, say, $4,000 for an assignment. If, unbeknownst to the client, the advertising person commits to spending $6,000 on advertising space, and the grassroots person commits to spending $2,000 for an advocacy campaign, the accounting department won't know that they are $2,000 over budget until they are looking at invoices due for work already performed. So, in order to avoid this, the client requires, internal to the client's company, that a PO be issued before your work is performed. That PO locks out others also working on that account from spending that money, and it also lets you know that the money has been set aside and is reserved for you. To make things easier, including the PO number on your invoices can mean you get paid much faster.

One of the major problems with POs is the fine print on them. They are drafted to encompass every type of service and product, and frequently, much of the language does not apply to you. More importantly, when you write in your own contract "this contract may not be modified, except in writing," the PO language that your client presents to you is one vehicle by which your carefully negotiated contract could be modified. Often, POs have work-made-for-hire language, liability waivers, and other very problematic language in them.

Figure 14.2 shows an example of a purchase order from a client. Note under Billing Instructions it reads:

> All Invoices, packages and references to the order must contain our Purchase Order number, job number and name of client and be accompanied by a bill of lading and/or receipted invoices when transportation or third-party charges are paid by supplier. Issue a separate invoice for each Purchase Order.

PURCHASE ORDER: 006-00 ███████████

	Date: 01/28 ███
	Page: 1 of 1
Client Name:	███████████
Project ID:	███████████
Project Desc:	
Freight Terms:	Destination
Ship Via:	COMMON
Buyer:	
Tax Exempt?:	N ID: ███

New York, NY 10019

Ship To: ███████████
New York NY 10019·
United States

Vendor: 0000039166
John Harrington Photography
2500 32nd Street Southeast
Washington DC 20020-1404
United States

ATTN: ███████████

Billing Instructions: All Invoices, packages and references to the order must contain our Purchase Order number, job number and name of client and be accompanied by a bill of lading and/or receipted invoices when transportation or third-party charges are paid by supplier. Issue a separate invoice for each Purchase Order.

Line-Schd	Description	Item ID	Quantity	UOM	PO Price	Extended Amt
1 - 1	Photographer ███████	400	1.00	UNT	4,619.70	4,619.70

Total PO Amount	4,619.70

THIS ORDER IS SUBJECT TO ALL TERMS AND CONDITIONS SET FORTH BELOW

This purchase order ("Order") is given by ███████ on behalf of Client, upon the condition to which Supplier agrees by acceptance, signing or fulfillment of the Order, that all artwork, photography, drawings, slides, negatives, transparencies, digital images, ideas, concepts and other property furnished hereunder (the "Material") shall be to the satisfaction of ███████. Supplier hereby sells, transfers and assigns to Client all right, title and interest in and to the Material, including without limitation the copyright in the Material. Accordingly, Client shall have unlimited usage rights to the Materials in all media, including without limitation, all print, broadcast and electronic media now known or hereafter devised, worldwide and in perpetuity. Supplier warrants that it has full right to sell the Material and that same may be used or reproduced for advertising or trade purposes without violating any laws or the rights of any third parties. Supplier further agrees to indemnify and hold harmless ███████ and Client against any and all loss, claim, expense, judgment or other damage or liability of any kind arising out of, or resulting from, the performance of this Order by Supplier (including, but not limited to, Supplier's employees, agents, subcontractors, and others designated by Supplier) or the use or reproduction in any manner whatsoever, including for advertising or trade purpose, of the Material.

CHAPTER 14

Figure 14.2
Example purchase order.

The problem arises, though, in the fine print at the bottom:

> This purchase order ("Order") is given by ▬▬▬▬▬▬▬, on behalf of Client, upon the condition to which Supplier agrees by acceptance, signing or fulfillment of the Order, that all artwork, photography, drawings, slides, negatives, transparencies, digital images, ideas, concepts and other property furnished hereunder (the "Material") shall be to the satisfaction of ▬▬▬▬ ▬▬▬▬ . Supplier hereby sells, transfers and assigns to Client all right, title and interest in and to the Material, including without limitation the copyright in the Material. Accordingly, Client shall have unlimited usage rights to the Materials in all media, including without limitation, all print, broadcast and electronic media now known or hereafter devised, worldwide and in perpetuity. Supplier warrants that it has full right to sell the Material and that same may be used or reproduced for advertising or trade purposes without violating any laws or the rights of any third parties. Supplier further agrees to indemnify and hold harmless ▬▬▬▬ ▬▬▬▬ and Client against any and all loss, claim, expense, judgment or other damage or liability of any kind arising out of, or resulting from, the performance of this Order by Supplier (including, but not limited to, Supplier's employees, agents, subcontractors, and others designated by Supplier) or the use or reproduction in any manner whatsoever, including for advertising or trade purpose, of the Material.

In this language, you are transferring all rights, including copyright. Here is how we negotiated the language to be more in line with our contract. Note that this PO arrived from the PO administrator after our assignment was complete. It helped that we'd had this issue with this client once before. Here is the exchange:

From: PO Administrator
To: John Harrington
CC: Client

Dear Vendor,

Attached is ███████████████ PO for Photographer ████████████████ in the amount of $4,619.70. Please be sure to include this number on your invoice when submitting for payment and attach a copy of the PO along with the invoice. Failure to do so could result in a delay of payment.

Note:
As per SOX guidelines, please make sure that the invoice is issued after the date on the PO. We will NOT be able to process the invoice if the invoice date is prior to the PO effective date.

If you have any questions, please feel free to respond to this email address.

Thank You.

It is important to understand why they want the date on the invoice to be prior to the PO date. First, having an invoice dated prior to a PO would suggest that the client incurred the liability to pay you prior to reserving the funds in the monthly budget to do so. Further, the date of the PO would be the date at which the modification of the terms of the contract took place, and your actions of sending an invoice dated after that date could be easily construed as your acceptance of the new contract terms and an invoicing under the new terms where…you guessed it, you turn over copyright.

So, we wrote to our client:

> From: John Harrington
> To: Client
> CC: PO Administrator
>
> Dear Client,
>
> We ran up against this last time, where the PO language is not consistent with the rights in our contract. The rights at the bottom of the PO specify we transfer all rights, and that is not our policy, nor the terms of the contract. I believe that last time the PO language was modified, so we need to have that happen again this time.
>
> Best,
> John

Following this e-mail, the client e-mailed the PO administrator and CC'd me:

> From: Client
> To: PO Administrator
> CC: John Harrington
>
> Can we remove the second and third sentences in the terms of the PO and reissue it? We did the same last year in working with John's team.
>
> The sentences in question are:
>
> *Supplier hereby sells, transfers and assigns to Client all right, title and interest in and to the Material, including without limitation the copyright in the Material. Accordingly, Client shall have unlimited usage rights to the Materials in all media, including without limitation, all print, broadcast and electronic media now known or hereafter devised, worldwide and in perpetuity.*
>
> Let me know if there are any questions or anything we need to discuss further.
>
> Thanks for your help.

Then, the client sent me a private note:

From: Client
To: John Harrington

Sorry, John. I forgot about this issue. Hopefully you saw my earlier note to address it.

This is a fair, reasonable, and thoughtful client and one we enjoyed working with and for in the past and that we look forward to working with in the future.

How to Work Through a Contract Negotiation for Corporate/Commercial Clients

Unlike editorial clients, who have a much higher tendency to object to expense types and levels, it has been my experience that corporate/commercial clients have fewer objections to expense line items. Although they might suggest that a star trailer or production trailer is not necessary for the assignment, and they will feel free to tell you so, they won't object to the other items that they know will contribute to a smoother, stress-free assignment. In fact, as noted about catering, leaving out things such as permits for the CEO's radio car to remain on location in a rush-hour lane of traffic during the on-location shoot or having a makeup person and a stylist for their annual report portrait can leave the client wondering whether you're the right person for the assignment.

Negotiations for these types of assignments usually first center around the photographer's creative fee, which is also seen as their assignment fee or, as noted before, their day rate. Once the client moves past that, they'll be reviewing your usage terms and figures. I often try to get a feel for what the prospective client is looking for. Early on, I'll always pose the question, "What kind of budget are we working with for this project?" Responses usually are:

▶ Our budget for the photography at the press conference is $1,000.

▶ We have $4,500 for the three days of symposium photography.

▶ We need to keep this under $5,000 for the ad.

▶ Our entire budget for the assignment, including expenses, is $8,000 per shoot, and there are five shoots.

▶ We have $15,000 to pay for you, the eight models over two days, and the printing for the brochure, soup to nuts.

Often, the client might say they don't know, and sometimes that's true—they don't. They do, however, know what level of production they want. Here are a few examples of the variances:

▶ Everyone cabs to/from the assignment location versus the photographer booking a sedan service to collect the client in one car and the ad agency people in their own car.

▶ We order pizza delivered to the shoot location versus catering it with food trays we bring in versus having a catering vehicle on set.

▶ We have the subject bring a selection of clothes based upon our guidance versus we have a stylist shop for the subject with a selection on set.

▶ We have one person who does hair/makeup/styling versus three separate people specialized to those skill sets.

▶ We are photographing a few of the client's attractive friends or colleagues versus booking talent from a modeling agency versus street-casting the people in the shoot.

▶ We are photographing at a location where we are comfortable with the color of the house and trim versus first finding the best location and then painting it the color we want and then paying to paint it back to its original colors.

Asking things such as, "Will you need us to book and include the cost of a car service for you?" or "Will we be booking models, or do you have the people already in mind for the photos?" can get you some of the answers as to what the client is expecting. The issue is what degree of production, pre-production, and post-production is expected.

These questions give me a good feeling for what the client is expecting and whether the budget is realistic. Just as with a low-budget editorial assignment, I will send an estimate for the project because I know when a stated budget is just too low and when I can't see how anyone would be able to satisfactorily complete the assignment for that figure. As such, I want the client to consider me, so I won't blow off the assignment estimate by thinking they'll never go for me. I send it, and often I get the assignment. Contrary to many people's opinions, money is not always the deciding factor. On many occasions I have been the most expensive photographer, but the client has confidence in my abilities based upon my experience, track record, or how I presented myself during our conversations.

Often, a client will say, "We need a buyout," or "We need all rights," or some other absolutely untrue or liability-laden ambiguous statement. Any proposed definition of buyout is a dubious one, and I can't fathom any company actually needing all rights, let alone needing any rights in perpetuity.

What these clients want is protection. They want protection from you using the image in a manner they don't want, protection from being gouged on prices later when they need to extend or expand a licensing package, and protection from you suing them when they use a photo for something they genuinely think is within their license, but you believe is not. These concerns can be alleviated by an accurate and clear licensing agreement.

Here are some examples of workarounds for these types of circumstances:

▶ For the life of the campaign, photographer grants non-exclusive rights to use photography in all non-paid media placements in the United States.

▶ For 24 months following the conclusion of the symposium, photographer grants exclusive rights to client to promote future symposiums in electronic, printed brochures, and trade advertising client may produce, as well as "handout" images as a part of a press kit to other trade press writing about the symposium.

▶ During the lifespan of the product, photographer grants client the exclusive right to use photographs produced to sell, promote, or advertise the product in print and electronic mediums, within the United States and the European Union.

Any of those workarounds would be far less egregious than "all rights," WMFH, or the dubious "buyout."

During the negotiations, you'll want to learn who the other stakeholders in the event are. If it's an awards ceremony at which three pharmaceutical companies are getting commendations for their good deeds, and you are working for the event, you'll want to make sure you're comfortable with these companies using your work in their press outreach for the event. If you're working for one of the companies, when the PR/communications person you're working with comes over and says, "Hey, make sure you shoot the CEO from the other two companies, too," you'd do well to discuss with him at your earliest convenience that, although you are working for him/her, if the other companies are going to be using your work, you'll need to make those arrangements directly with them. These things happen when the other companies forget to bring a photographer (or decide it's not important) and then your client offers to split your fees and expenses with them. This isn't fair, and you should preclude this from happening by clearly stating on your contracts that "Company X is granted the following rights." You could even state that the rights are not conveyable or transferable to third parties.

For advertising work, you will almost always be dealing with someone from an ad agency or a knowledgeable person in a company's marketing or external affairs department. You'll want to make sure they're providing you with comps (mockups or draft layouts) for the assignment and ask what the media buy will be. Further, what other uses do they anticipate?

Realize that often the client has a favorite. Frequently I will ask, "Am I estimating this as a courtesy because you have someone in mind and need three estimates? Am I that person? Or are you open to seeing what you come up with on the estimates and awarding the work based upon that?" Many times the favorite is a repeat photographer for the firm or company or someone they've wanted to work with now that they have the budget to afford that photographer.

Sometimes you may be asked to shoot a pitch campaign, which is a situation where the client essentially wants to do the shoot they envision doing for the purposes of showing that imagery to the client they are try to pitch to win the account. In this case, the agency is underwriting the entire cost of the shoot, hoping that it will win them the overall business. In this case, the overall business could be a very lucrative revenue stream for you, so be sure to convey, "Hey, if you win this pitch, I hope you'll be calling on me to produce the image for it." Likely they will, but it can't hurt to ask. This also may be a reason why you might discount your estimate, and further, you may do it "bare bones" for the pitch shoot and with

CHAPTER 14

a much higher production level (car service and so on) for the actual shoot when the account has been won. That said, somewhere in your contract for the pitch campaign, you might want to note that this discounted shoot is in anticipation of being a part of the team should the campaign be won.

I will also make a point of asking who else they are talking to, and most of the time they tell me. If I know I am bidding against a former assistant and a weekly newspaper photographer 10 years my junior, as with editorial clients, I am likely to let them know that they're not really comparing apples to apples, that there is a breadth of experience differential between us, and that I will more than likely not be the least expensive.

On the occasions when I do not win the assignment, I will ask a few follow-up questions. First, I will call the client and thank them for the opportunity to be considered. I tell them that although this may not have worked out, I hope to work with them in the future. I then ask whether the main criterion for choosing the photographer was price. With that answer (regardless of the answer), I'll ask who they chose. I make an absolute point of not being petty and finding fault with the choice, although it might be easy to do when I know that the photographer in question, although having a great website, just graduated from photo school and will have challenges I don't think they can surmount for this assignment. I close the conversation by saying, "Thanks again; I look forward to the possibility of working with you in the future."

You'd be surprised by the number of times over the years that the client has come back a few days after the date of the shoot and hired me on an expedited basis because they did not get the results they needed from their first choice for the assignment. I am always gracious and enthusiastic about making the assignment happen. Not only was my initial observation correct (which I would never point out), but I know I have won a client for a long time to come. I have clients who have left over rights issues (in other words, they wanted all rights, and I didn't concede to that), only to come back after lackluster results from their choice, saying, "What do all those rights do for us if the photos are not as good as we need in the first place?"

One major caution when granting rights to event photography beyond editorial or "press" use: If you're licensing "all rights," which includes advertising, the web (which can be a form of commercial, corporate, or even editorial use), brochures, and so on, you must be absolutely certain you have releases from everyone in the photos that grant you the authority to license those rights. Imagine a scenario in which you buy a car with an AM/FM radio. You drive it for three months and then finally get around to listening to the radio, since you're mainly a CD person. You are greeted with a message that says, "The manufacturer of this car included the capability of FM broadcasts, but you must pay an additional licensing fee for the use of the patented technology that enables FM to work." You'd sue, and rightfully so—you bought a car with an AM/FM radio, but you can't use the FM without paying more. This is the same as a situation in which you agree to license all rights, and the client exploits that clause and uses the photos in brochures and such, and several of the subjects see themselves in these brochures or trade ads, so they contact the company. The company can easily stand behind the "we licensed all rights from the photographer" claim, and then the subjects will be hot on your trail for licensing rights that they never granted you, and then you're on the hook. If you have a model release, then by all means license away, but absent that, don't license to third parties rights that you yourself don't have.

Additionally, when addressing the issue of use of photography on the web, many editorial clients might try to stipulate that their web editions are extensions of their print editions. The easiest way for you to stop this attempt at a connection is to illustrate that the advertising in the print edition is not the same as that of the online edition, and as such, the publication is charging separately for the web edition's advertising. It is recommended that you handle both separately and bill for both separately. A clear example of this was the case of Jonathan Tasini vs. the *New York Times* that made its way to the Supreme Court and resulted in a finding in favor of the author, not the publisher.

Multiparty Licensing Agreements

In more than one instance, I have been faced with circumstances in which my work, commissioned by one party for their nontransferable use, winds up being used by a third party without my permission. Here are two situations.

The first was a promotional campaign for an association that represents a number of similar industry-related companies. The photograph that I produced used an employee of one of the member companies depicted in a manner that placed the industry (and, as such, that company) in a positive light. Although the association had the right to use the images, no license existed for the member company, who decided to use the photograph in an advertisement, which I stumbled across one day by accident.

The second instance was an event I was photographing that included several prominent individuals from different companies. All were presenting their positions on a subject at the event, and as such, I was photographing all speakers. However, I was hired by only one speaker. My client representative, when approached by one of the other company's representatives, seemed to intimate that not only would they provide copies of all of the images, but that they would then just split the costs of my services. A delicate conversation ensued between me and the originating client representative.

In both of these circumstances, an amicable solution was reached. However, having the proper paperwork in place beforehand can eliminate misunderstandings and build a stronger case for you should you and the other parties fail to come to an amicable solution. Consider this extremely simplistic example: Your photography fees for Client A are $1,000, and your expenses associated with that assignment are $500, for a total of $1,500. By expanding the agreement to one that includes a second party, whereas their license could also be $1,000, they would split the expenses, so both parties would pay $1,250. A variation on that is to extend to both clients a discount as an incentive to collectively license their own rights packages and reduce each by a percentage—say, 10 percent. So, this would reduce both parties to a $900 assignment/licensing fee and the split expense of $500, for a total of $1,150 for each party.

Multiparty licensing agreements frequently come into play where the initial client is the architectural firm, and the secondary client may be the builder, and even a third client may be the owner. Further potential licensing parties could be building management and major tenants. However, these are agreements that are entered into before the assignment occurs. Avoid the concept of allowing for a retroactive assignment for one of the potential parties who was unwilling to sign on before the assignment took place. That client should now be

licensing the work you produced for the original client as stock. Offering additional parties an after-the-fact deal would be unfair to the other parties who assumed the risks inherent in commissioning the work beforehand.

Another school of thought is to establish the fee for the original shoot and then add between 20 and 30 percent of the photographer/licensing fees per additional client and then divide the total among the assigning clients. This works well when all clients need a similar rights package. Where clients' licensing needs differ between licensors, simply allocate fairly the base rights package as before and then add in an additional licensing fee for the expanded uses.

It is critical for all agreements that all parties are signed on to the contract before the work begins. This means signatures from all parties, literally. Whether all parties sign the same document or you present to each separate documents, make sure that everyone understands what's going on. It is absolutely imperative that you are up front and clear about the terms among all clients. Fostering long-term and open relationships with all the parties ensures that no one feels they are being taken for a ride. Further, although there is one school of thought among some photographers that one party can handle the overall sum and single contract with you and the other parties can deal with them, I discourage that because it causes the one party to falsely believe they have some degree of ownership of the images. Moreover, should the other parties down the line wish to extend or expand a license, there is already a relationship between you and that party.

There's an important point, especially for architectural or fashion photographers, or for almost any circumstance in which what you are making images of is the work of another. When, for example, you are photographing buildings on assignment for the architect, you are not a part of the build/design team. You are utilizing your creative vision to provide your interpretation of their work, and that work is yours. Further, that architect may feel he can sublicense or transfer his license to other interested parties, so make certain that your language precludes this. Working with an attorney, you can, with limited expense, create boilerplate language that will be useful for a wide variety of situations.

Getting Paid

Once the contract has been signed, the PO issued, and the invoice sent, you of course want to be paid. If, however, the project is a large one with a great deal of upfront costs, many clients are willing to receive an advance invoice from you, which usually covers many of the production charges associated with the shoot. In some instances, where you are concerned that a client may skip out on the contract altogether, it is not unreasonable to ask for a 100-percent prepayment for the assignment. This is easy to do when you take credit cards and the assignment is just a few thousand dollars, but it can be more problematic if it is a $20,000 assignment.

One of the policies I implemented following the 2000 dot-com bust was that all high-technology companies were required to prepay their assignments. I had gotten stung by a $2,200 unpaid invoice when a dot-com went bust, and I was determined not to let that happen again.

Lastly, determine when your "due by" period is and, more importantly, determine when a client's accounting department plans to pay you. Few these days are paying in 30 days. Some pay in 45, 60, or 90 days. In these cases, be sure to date your invoice the date the shoot took place or the day after and try to get an advance invoice paid to minimize your having to carry expenses from month to month.

Case Study: Law Firm Portraits

Client type: Law firm in need of portraits of several attorneys.

How they found us: A referral from one of their clients.

Assignment: Portraits against seamless, head and shoulders.

Deliverables: A CD including the selected image of each attorney, and one 5×7.

Technical notes: This was a fairly straightforward shoot—single softbox front left, hair light rear right, LiteDisc reflector on subject's right to reflect back onto the subject the falloff from the softbox on the front, and a graduated background light on the five-foot-wide seamless. In addition, we had on location our laptop, which allowed for the preview and approval of each subject's image before he or she left the room.

Initial inquiry came via the following e-mail, and the dialogue continues after that:

CHAPTER 14

From: █████████████
Subject: Attorney Portrait
Date: Tuesday, May 25, ██████ 5:23:08 PM EDT

To: 'John Harrington'

Hi –

I am seeking a photographer in the Metro DC/Virginia area to take our new attorneys' corporate/promotional photos. Our requirements include:

- The ability to have a photographer come to our office in McLean for a half- or whole-day photo shoot—we currently need portraits taken for five attorneys.
- The ability to make appointments at the photographer's studio on an "as needed" basis—perhaps even one attorney at a time.
- High-resolution images for use in promotional materials.
- Low-resolution images for use on our website.
- The selected image(s) are to be delivered to me in Virginia via CD, plus one color 5×7.

I look forward to hearing from you soon.

Sincerely, ██████

From: 'John Harrington'
Sent: Wednesday, May 26, ████ 4:19 PM
To: ██████████████
Subject: Requested Estimate for Attorney Portraits

Dear ████,

Attached are two PDF files of the estimates you requested for eight portraits, with an additional "one-off" portrait estimate included. The location/additional information we have for this event is: ███████████████████, VA.

Please look the attached estimate over and call with any questions. Please let us know when you have a date, and we will send you a dated contract identical to those attached for your review and confirmation. While we are currently i ndicating we are available for the date and time you have requested, we don't guarantee or commit our photographers' time until we've received the signed estimate back.

Please ask the subject(s) being photographed, for men to wear solid-color shirts (preferably white) and suits that are not solid black, and for women to wear blouses that are not overly patterned. For men, they should plan to shave within 2–3 hours before the shoot, and women should bring their makeup for touchups just before the shoot will occur.

We strongly encourage the use of makeup services for this portrait shoot. For an explanation as to why, please review:

http://www.johnharrington.com/whymakeup

We look forward to working with you.

Best,
John

From: ███████████████
Subject: RE: Requested Estimate for Attorney Portraits
Date: May 26, ████ 4:35:45 PM EDT
To: 'John Harrington'

Thanks so much. How does June 7–9 look on your calendar?

From: 'John Harrington'
Sent: Wednesday, May 26, ████ 9:04 PM
To: ███████████████

Subject: Re: Requested Estimate for Attorney Portraits

████ –

Currently all three days are available. I have something in the evening on
the 7th and midday on the 9th, although I do expect those days to book up
probably midweek next week, as I often get commitments a week or so out.

I look forward to the possibility of working with you!

Best, John

From: ▮▮▮▮▮▮▮▮▮▮
Subject: RE: Requested Estimate for Attorney Portraits
Date: May 27, ▮▮ 3:36:50 PM EDT
To: 'John Harrington'

Hi John –

Let's go ahead and book time—half-day probably—for June 8, a Tuesday.
When would you like to start?

Thanks, ▮▮▮▮

From: 'John Harrington'
Sent: Thursday, May 27, ▮▮▮10:17 PM
To: ▮▮▮▮▮▮▮▮
Subject: Re: Requested Estimate for Attorney Portraits

▮▮▮ ,

Great! I am happy to be doing your firm's portraits! Let's arrive at 11am.
It takes about an hour to set up, so we'll start with folks around noon. Plan
20–30 min (max) per person. Let me know if you'd like to get started earlier.
Once you let me know that those times are okay, I'll forward the dated
contract for your review and signature.

Best, John

CHAPTER 14

From: ███████████████

Subject: RE: Requested Estimate for Attorney Portraits

Date: May 28, ████ 6:34:11 AM EDT

To: 'John Harrington'

I think that should be fine, but we will be lucky to get each person for 10–15 minutes—they tend to show up and run. :o) I will book them for 20 minutes apart, except for the challenging ones, which I will book 30 minutes. Can you tell me, the first photo will be at 11am?

Thanks again, ███████

From: 'John Harrington'

Sent: Tuesday, June 01, ████ 9:21 AM

To: ███████████████

Subject: Re: Photo Estimate for: Monday, June 7

We'd arrive at 11am, and the first appointment would be at noon.

From: ███████████████

Subject: Contract

Date: June 1, ████ 12:06:09 PM EDT

To: 'John Harrington'

John –

Here is a scanned PDF of our signed contract. Can we give you a check on Monday for the full amount?

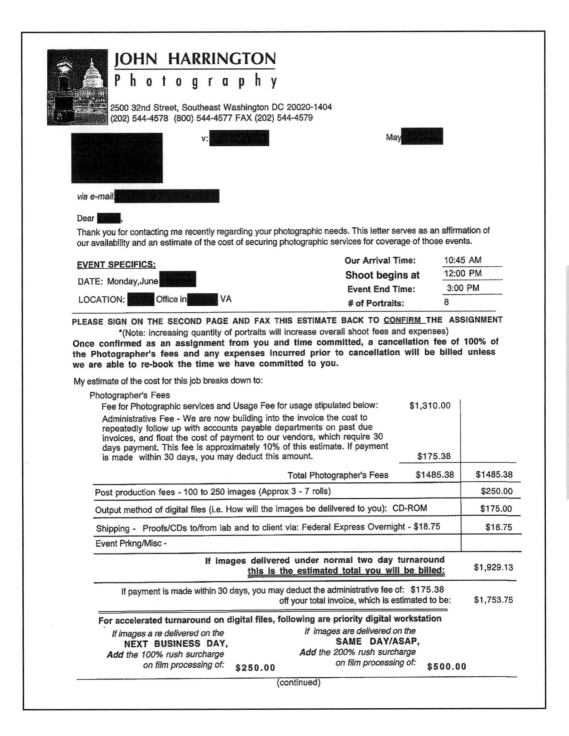

JOHN HARRINGTON
Photography

2500 32nd Street, Southeast Washington DC 20020-1404
(202) 544-4578 (800) 544-4577 FAX (202) 544-4579

v: May

via e-mail

Dear ,

Thank you for contacting me recently regarding your photographic needs. This letter serves as an affirmation of our availability and an estimate of the cost of securing photographic services for coverage of those events.

EVENT SPECIFICS:

DATE: Monday, June

LOCATION: Office in VA

Our Arrival Time:	10:45 AM
Shoot begins at	12:00 PM
Event End Time:	3:00 PM
# of Portraits:	8

PLEASE SIGN ON THE SECOND PAGE AND FAX THIS ESTIMATE BACK TO <u>CONFIRM</u> THE ASSIGNMENT
*(Note: increasing quantity of portraits will increase overall shoot fees and expenses)
Once confirmed as an assignment from you and time committed, a cancellation fee of 100% of the Photographer's fees and any expenses incurred prior to cancellation will be billed unless we are able to re-book the time we have committed to you.

My estimate of the cost for this job breaks down to:

Photographer's Fees

Fee for Photographic services and Usage Fee for usage stipulated below:	$1,310.00		
Administrative Fee - We are now building into the invoice the cost to repeatedly follow up with accounts payable departments on past due invoices, and float the cost of payment to our vendors, which require 30 days payment. This fee is approximately 10% of this estimate. If payment is made within 30 days, you may deduct this amount.	$175.38		
Total Photographer's Fees	$1485.38	$1485.38	
Post production fees - 100 to 250 images (Approx 3 - 7 rolls)		$250.00	
Output method of digital files (i.e. How will the images be delivered to you): CD-ROM		$175.00	
Shipping - Proofs/CDs to/from lab and to client via: Federal Express Overnight - $18.75		$18.75	
Event Prkng/Misc -			
If images delivered under normal two day turnaround this is the estimated total you will be billed:		$1,929.13	
If payment is made within 30 days, you may deduct the administrative fee of: $175.38 off your total invoice, which is estimated to be:		$1,753.75	

For accelerated turnaround on digital files, following are priority digital workstation

If images a re delivered on the **NEXT BUSINESS DAY,** *Add the 100% rush surcharge on film processing of:* $250.00	*If images are delivered on the* **SAME DAY/ASAP,** *Add the 200% rush surcharge on film processing of:* $500.00

(continued)

Please note:
We have estimated that we will produce between 100 and 250 digital images and the post production charges for the time spent processing and preparing those images will be $250. If we produce a number of images greater than 250 digital images the post production charge will increase to : $500.00. In addition the output charge would increase to: $250.00. This would mean an additional cost of : $325.00.

In addition to a CD-ROM, we can also provide proofs for an additional $146, contact sheets for an additional $70, and/or online delivery for an additional $175, based upon the estimated quantity of images we'll produce. These figures will increase if we produce more than 250 digital images.

Expenses include but are not limited to film, processing, prints, parking, and shipping. The usage of images provided is for: 1)for use on ▮▮▮▮ Website 2) publishing images in newspapers and trade publications, and 3) in-house promotional use and press kits, for a period of one year. Images may be used for mementos, gifts, and other personal use without restriction. Should you have any questions regarding this please feel free to contact me so that we can negotiate any additional or alternative use. Use on the internet is not included for liability reasons unless specifically included in licensing above. For an explanation of this issue, please visit our website section on this - www.JohnHarrington.com/about-the-web.

Critical Note: Until a digital file is permanently written to a CD-ROM, it's existence (and thus, the portrait(s) we produced for you) is in a fragile state.Interferance such as x-rays, physical damage, viruses, system crashes, and other unknown issues can affect the archiving of imagery. We are more protective of the fragile nature of digital storage media than we are of canisters of film,however, our liability is limited to the waiving of our fees in the event more than 50% of images from your portrait session are damaged otherwise, full charges apply.Normal turnaround time for post-production is 48 hours. Faster turnaround, including same day/ASAP service is available when necessary, but there are surcharges of 100% for 24 hour and 200% for ASAP service on the digital imaging workstation.This estimate and the rush charges do not include rush charges for proofs. Proofs have a two business day normal turnaround time, but can be accelerated for the same 100% and 200% rush surcharges.Please visit: www.JohnHarrington.com/reprints for a complete schedule of reprint fees, from quantities from 1 through 1,000, and offering pricing discounts for longer turnaround times.

Thank you for your time and consideration. I look forward to working with you.

Sincerely,

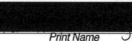

John Harrington

To confirm this assignment, please sign and fax this estimate back acknowledging the estimated charges, fees, and other contents.

_____ _____ _____
Signature Print Name Date

We concluded the shoot, and the client was satisfied with the final results. During the course of the assignment, the client indicated they had more attorneys they wanted photographed because the ability to display and do light retouching as the subject watched (and approved) was invaluable, and the office manager no longer had to chase people around and get their approvals on photos after the fact. They asked us to follow up in a month or so, so we did. Here is that dialogue:

From: 'John Harrington'
Sent: Wednesday, August 25, ▉▉ 11:55 AM
To: ▉▉▉▉▉▉
Subject: Portraits

▉▉▉ –

Wanted to check in with you to see about the remaining portraits you have. You'd indicated back in June there were a few other attorneys that needed to be photographed, so I just wanted to check in with you.

Best, John

From: ▉▉▉▉▉▉▉▉
Subject: RE: Portraits
Date: August 25, ▉▉ 11:53:02 AM EDT
To: 'John Harrington'

Hi John –

Yes, we will have probably have another 12 or so to do in October. People just raved about your photos! What is your schedule looking like the weeks of October 12 and October 25?

Thanks, ▉▉▉

From: 'John Harrington'
Sent: Wednesday, August 25, ███ 12:01 PM
To: ███████████
Subject: Re: Portraits

██████ –

Glad to know they went over so well! I am wide open during both weeks. Monday and Friday mornings always work best for us, but when you're ready, let me know…I just wanted to check in.

Best, John

From: ████████████████
Subject: 10/13 Photo Shoot
Date: September 15, ████ 1:02:54 PM EDT
To: 'John Harrington'

Hi John –

You were such a BIG hit last time, that we have at least 17 people scheduled for the shoot on Oct. 13. Below is the tentative schedule. I hope it looks OK for your schedule. Please let me know what time you would like to set up.

We will be in our new offices by that date. Our new address is:

████████████████████████
███████████████

Time	Name	Phone Ext.
11am	██████████	x██████
11:20am	██████████	x██████
{continues through 4pm, with a lunch break of one hour}		
4pm	██████████	x██████

Thanks much, ████████

From: 'John Harrington'
Sent: Tuesday, October 05, ██████ 8:31 PM
To: ██████████████
Subject: Re: 10/13 Photo Shoot

████████

No problem, we're all set for the 13th. I think we had originally estimated for 17, but this shows 19. Is that the revised total and/or do you expect dropouts and add-ins throughout the day?

Thanks, John

From: ██████████████████
Subject: RE: 10/13 Photo Shoot
Date: October 6, ██████ 7:31:05 AM EDT
To: 'John Harrington'

We had two new hires that I added. Sorry so last minute. I am hoping this is the total, but you met our group—ya never know—they are not exactly predictable. ;o) Can we go with 19 and hang loose with the idea of a possible last-minute change or addition?

From: ███████████████
Subject: Confirmation 10/13 Photo Appt.
Date: October 12, ████ 12:24:21 PM EDT
To: 'John Harrington'

Hi John –

We are looking forward to seeing you tomorrow and to the new photos!
I have you arriving around 9–9:30AM. Please come to the 1st floor reception
area; my assistant will come down and show you to the conference room. She
will also show you where a phone, kitchen, and bathroom are located and give
you a list of appointments/extensions.

Everyone has been reminded of their appointments, and they should be on
time. Just call anyone at their extension if they are late or dial 0 and ask to
page them. I should be arriving in the office around 11AM.

Will you be giving me an invoice tomorrow? I would like to try to get your
check cut by Thursday and overnighted to you if that is OK.

From: ███████████████
Subject: Lunch?
Date: October 12, ████ 12:38:36 PM EDT
To: 'John Harrington'

John –

One more thing—can we provide your team with lunch tomorrow? It appears
you will be working thru lunch, and we would be happy to order something.
Please let me know what you would like and at what time.

Thanks, ██████

From: ███████████
Subject: Payment
Date: October 20, ███ ▌:59 PM EDT
To: 'John Harrington'

Hi John –

Just want to confirm that you received our check. Also, do you think we
will have the disk by next Monday? Thanks much, ████

Several months after the conclusion of this shoot, we received yet another request for our
services from the same firm. After an initial inquiry for 10 portraits, they postponed early in
the dialogue and then came back a few months after that seeking 20 to 25 portraits. The final
estimate swelled to what ended up being 31 portraits. The dialogue continues below:

From: ███████████
Subject: Scheduling Photo Shoot Appt.
Date: July 27, ████ 3:35:13 PM EDT
To: 'John Harrington'

Hi John –

Our firm needs to schedule an appt with you to shoot approx 10 people.
Please let me know what your schedule looks like. A few date options would
be best. Hope you are having a wonderful summer.

Best, ████

From: ███████████
Subject: RE: Scheduling Photo Shoot Appt.
Date: August 8, ████ 12:20:58 PM EDT
To: 'John Harrington'

Hi John –

The firm has decided to postpone this photo session until October. Please advise of available dates for early that month. We will probably have about 15 people to do. Dates available include: 10/03 and 10/10.

Thanks, ██████

From: █████████████
Subject: 10/19 Shoot
Date: October 11, ████ 3:21:58 PM EDT
To: 'John Harrington'

Hi John –

Well, it appears we are filling up very quickly for the photos. Can you stay a bit longer that afternoon—'til 5 or so? I have 17 slots filled so far and may have as many as 20–25. I didn't expect such a response, but they love your photos!

In the end, the 20 to 25 estimate became 31, and we sent along a revised estimate for 31 portraits. This client continues to be one of several returning clients, from law firms, to associations, and other organizations in need of portraits for their website and the occasional speaking engagement. Following is the estimate we sent for the 31 portraits.

JOHN HARRINGTON
P h o t o g r a p h y

2500 32nd Street, Southeast Washington DC 20020-1404
(202) 544-4578 (800) 544-4577 FAX (202) 544-4579

v: ▮▮▮▮ August ▮▮▮▮

Dear Paula,

Thank you for contacting me recently regarding your photographic needs. This letter serves as an affirmation of our availability and an estimate of the cost of securing photographic services for coverage of those events.

EVENT SPECIFICS:	Our Arrival Time:	8:00 AM
		9:00 AM
DATE: Wednesday,October 19, 2005	Event End Time:	6:00 PM
LOCATION: 31 Portraits at ▮ offices, ▮▮▮▮	# of Portraits:	31

PLEASE SIGN ON THE SECOND PAGE AND FAX THIS ESTIMATE BACK TO <u>CONFIRM</u> THE ASSIGNMENT
(Note: increasing quantity of portraits will increase overall shoot fees and expenses)
Once confirmed as an assignment from you and time committed, a cancellation fee of 100% of the Photographer's fees and any expenses incurred prior to cancellation will be billed unless we are able to re-book the time we have committed to you.

My estimate of the cost for this job breaks down to:

Photographer's Fees

Fee for Photographic services and Usage Fee for usage stipulated below:	$3,985.00	
Administrative Fee - We are now building into the invoice the cost to repeatedly follow up with accounts payable departments on past due invoices, and float the cost of payment to our vendors, which require 30 days payment. This fee is approximately 10% of this estimate. If payment is made within 30 days, you may deduct this amount.	$478.10	
Total Photographer's Fees	$4463.10	$4463.10
Post production fees -250 and 500 images (7 - 14 rolls)		$500.00
Output method of digital files (i.e. How will the images be delilvered to you): CD-ROM		$250.00
Shipping - Proofs/CDs to/from lab and to client via: Federal Express Overnight - $18.75		$46.00
Event Prkng/Misc -		
If images delivered under normal two day turnaround **<u>this is the estimated total you will be billed:</u>**		$5,259.10
If payment is made within 30 days, you may deduct the administrative fee of: $478.10 off your total invoice, which is estimated to be:		$4,781.00

For accelerated turnaround on digital files, following are priority digital workstation

If images a re delivered on the **NEXT BUSINESS DAY,** **Add** *the 100% rush surcharge* *on film processing of:* **$500.00**	*If images are delivered on the* **SAME DAY/ASAP,** **Add** *the 200% rush surcharge* *on film processing of:* **$1000.00**

(continued)

Upon request, we will digitally deliver images properly sized and encoded with metadata. Prepared images delivered via email are $65ea, and images coded and prepared for publication that are posted via FTP download on our server are $75ea, up for 7 days.

Please note:
We have estimated that we will produce between 250 and 500 digital images and the post production charges for the time spent processing and preparing those images will be $500. If we produce a number of images greater than 500 digital images the post production charge will increase to : $750.00. In addition the output charge would increase to: $520.00. This would mean an additional cost of : $520.00.

In addition to a CD-ROM, we can also provide proofs for an additional $302, contact sheets for an additional $100, and/or online delivery for an additional $250, based upon the estimated quantity of images we'll produce. These figures will increase if we produce more than 500 digital images.

Expenses include but are not limited to film, processing, prints, parking, and shipping. The usage of images provided is for: 1) Submission to wire services, 2) publishing images in newspapers and trade publications, and 3) in-house promotional use and press kits, for a period of one year. Images may be used for mementos, gifts, and other personal use without restriction. Should you have any questions regarding this please feel free to contact me so that we can negotiate any additional or alternative use. Use on the internet is not included for liability reasons unless specifically included in licensing above. For an explanation of this issue, please visit our website section on this - www.JohnHarrington.com/about-the-web.

Critical Note: Until a digital file is permanently written to a CD-ROM, it's existence (and thus, the portrait(s) we produced for you) is in a fragile state. Interferance such as x-rays, physical damage, viruses, system crashes, and other unknown issues can affect the archiving of imagery. We are more protective of the fragile nature of digital storage media than we are of canisters of film, however, our liability is limited to the waiving of our fees in the event more than 50% of images from your portrait session are damaged otherwise, full charges apply. Normal turnaround time for post-production is 48 hours. Faster turnaround, including same day/ASAP service is available when necessary, but there are surcharges of 100% for 24 hour and 200% for ASAP service on the digital imaging workstation. This estimate and the rush charges do not include rush charges for proofs. Proofs have a two business day normal turnaround time, but can be accelerated for the same 100% and 200% rush surcharges. Please visit: www.JohnHarrington.com/reprints for a complete schedule of reprint fees, from quantities from 1 through 1,000, and offering pricing discounts for longer turnaround times.

Thank you for your time and consideration. I look forward to working with you.

Sincerely

John Harrington

To confirm this assignment, please sign and fax this estimate back acknowledging the estimated charges, fees, and other contents.

_____ _____ _____
 Signature Print Name Date

Case Study: National Corporate Client

Client type: Regular client who represents a company having a corporate event in Washington.

How they found us: Existing relationship.

Assignment: All-day corporate symposium in a hotel ballroom.

Deliverables: CD with a loose edit of images.

Technical notes: The stage was well lit, so on-camera flash was not necessary except for break periods, where candids and posed group photos would be taken.

The initial inquiry came via telephone, and during that time there was a dialogue about using images of company executives in a brochure. We advised them of the issue of model releases and received assurances that the images would only be of company executives in the company brochure. We recommended obtaining releases from each person participating and were advised that they would.

Our dialogue with the client:

To: ▮▮▮▮▮▮▮▮
Subject: Photo Estimate for: Thursday, June 8
Date: June 1, ▮▮▮▮3:15:29 PM EDT
From: 'John Harrington'

Dear ▮▮▮,

Attached is a revised PDF file of the estimate you requested for your event on Thursday, June 8. Please note the added line item regarding brochure use of images from the event.

Please look the attached estimate over, call with any questions, and sign and fax it back to confirm. While we are currently indicating we are available for the date and time you have requested, we don't guarantee or commit our photographers' time until we've received the signed estimate back. Please fax it to ▮▮▮▮▮▮▮▮.

Once you've confirmed the assignment, please forward at your earliest convenience a schedule/timeline of the events and/or a copy of the press release for the event so that we may best prepare coverage plans. While not a requirement, it helps us to know what to expect. Please e-mail it to this address: ▮▮▮▮▮▮▮▮▮▮▮▮.

We look forward to working with you and ▮▮▮▮▮▮▮ again.

Cheers, John

From: ███████████████
Subject: Fw: Images from Thursday's Event
Date: June 12, ████ 10:12:14 AM EDT
To: john@johnharrington.com

John:

Thanks for your time this morning. Attached is the e-mail from our client at
████████ requesting photos of ████████, Secretary ███████, and ████
██████. Below are their titles, and attached is a copy of one of the final drafts of
the show/program "tic toc," which should help as you go through the images.

- ████████████, ███, Senior Staff Vice President
- ███ Secretary █████████████, Keynote Speaker
- ██████████, Division President, National ████████████████

Please e-mail or call me with any questions.

Thank you, ██████

From: ██████████████
Subject: Emailed Photographs
Date: June 12, ████ 12:19:15 PM EDT
To: 'John Harrington'

Thanks for your help on this and the quick turnaround. Thanks, ██████

The following figures show the contract and invoice for the assignment. Note that the client
called and ordered three e-mails and a second copy of the CD via telephone, and those
additional items are reflected on the final invoice.

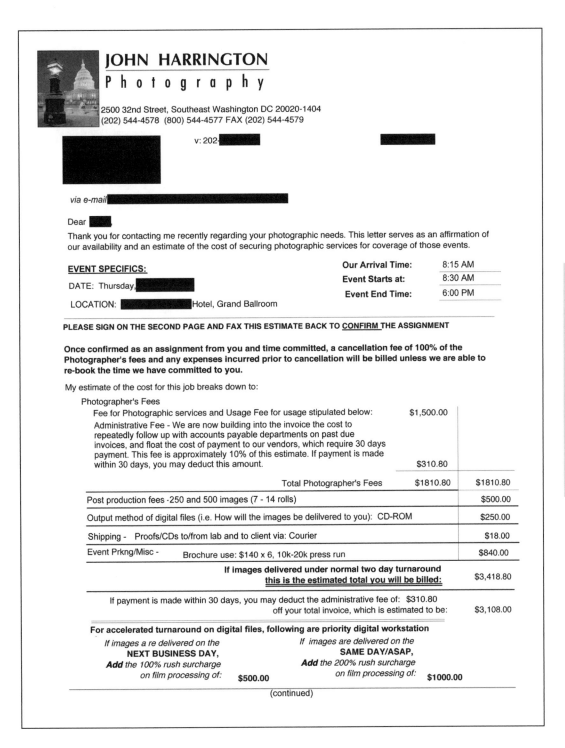

JOHN HARRINGTON
P h o t o g r a p h y

2500 32nd Street, Southeast Washington DC 20020-1404
(202) 544-4578 (800) 544-4577 FAX (202) 544-4579

v: 202-███

via e-mail ███

Dear ███,

Thank you for contacting me recently regarding your photographic needs. This letter serves as an affirmation of our availability and an estimate of the cost of securing photographic services for coverage of those events.

EVENT SPECIFICS:

DATE: Thursday, ███

LOCATION: ███ Hotel, Grand Ballroom

Our Arrival Time:	8:15 AM
Event Starts at:	8:30 AM
Event End Time:	6:00 PM

PLEASE SIGN ON THE SECOND PAGE AND FAX THIS ESTIMATE BACK TO <u>CONFIRM</u> THE ASSIGNMENT

Once confirmed as an assignment from you and time committed, a cancellation fee of 100% of the Photographer's fees and any expenses incurred prior to cancellation will be billed unless we are able to re-book the time we have committed to you.

My estimate of the cost for this job breaks down to:

Photographer's Fees

Fee for Photographic services and Usage Fee for usage stipulated below:	$1,500.00	
Administrative Fee - We are now building into the invoice the cost to repeatedly follow up with accounts payable departments on past due invoices, and float the cost of payment to our vendors, which require 30 days payment. This fee is approximately 10% of this estimate. If payment is made within 30 days, you may deduct this amount.	$310.80	
Total Photographer's Fees	$1810.80	$1810.80
Post production fees -250 and 500 images (7 - 14 rolls)		$500.00
Output method of digital files (i.e. How will the images be delilvered to you): CD-ROM		$250.00
Shipping - Proofs/CDs to/from lab and to client via: Courier		$18.00
Event Prkng/Misc - Brochure use: $140 x 6, 10k-20k press run		$840.00
If images delivered under normal two day turnaround <u>this is the estimated total you will be billed:</u>		$3,418.80
If payment is made within 30 days, you may deduct the administrative fee of: $310.80 off your total invoice, which is estimated to be:		$3,108.00

For accelerated turnaround on digital files, following are priority digital workstation

If images a re delivered on the **NEXT BUSINESS DAY,** **Add** the 100% rush surcharge on film processing of: **$500.00**	If images are delivered on the **SAME DAY/ASAP,** **Add** the 200% rush surcharge on film processing of: **$1000.00**

(continued)

CHAPTER 14

Upon request, we will digitally deliver images properly sized and encoded with metadata. Prepared images delivered via email are $65ea, and images coded and prepared for publication that are posted via FTP download on our server are $75ea, up for 7 days.

Please note:
We have estimated that we will produce between 250 and 500 digital images and the post production charges for the time spent processing and preparing those images will be $500. If we produce a number of images greater than 500 digital images the post production charge will increase to : $750.00. In addition the output charge would increase to: $520.00. This would mean an additional cost of : $520.00.

This estimate outlines the cost of the time we will be committing to you. Should your needs be extended, additional time is billed hourly at $150 per hour thereafter if we are available to extend our time. Further, for pre-shoot meetings or extensive conference calls, the fee for that time is billed at $150 per hour, with a two hour minimum.

In addition to a CD-ROM, we can also provide proofs for an additional $302, contact sheets for an additional $100, and/or online delivery for an additional $250, based upon the estimated quantity of images we'll produce. These figures will increase if we produce more than 500 digital images.

Expenses include but are not limited to film, processing, prints, parking, and shipping. The usage of images provided is for: 1) Submission to wire services, 2) publishing images in newspapers and trade publications, and 3) in-house promotional use and press kits, for a period of one year. Images may be used for mementos, gifts, and other personal use without restriction. Should you have any questions regarding this please feel free to contact me so that we can negotiate any additional or alternative use. Use on the internet is not included for liability reasons unless specifically included in licensing above. For an explanation of this issue, please visit our website section on this - www.JohnHarrington.com/about-the-web.

Critical Note: Until a digital file is permanently written to a CD-ROM, it's existence (and thus, documentation of your event) is in a fragile state. Interferance such as x-rays, physical damage, viruses, system crashes, and other unknown issues can affect the archiving of imagery. We are more protective of the fragile nature of digital storage media than we are of canisters of film, however, our liability is limited to the waiving of our fees in the event more than 50% of images from your event are damaged, otherwise, full charges apply. Normal turnaround time for post-production is 48 hours. Faster turnaround, including same day/ASAP service is available when necessary, but there are surcharges of 100% for 24 hour and 200% for ASAP service on the digital imaging workstation. This estimate and the rush charges do not include rush charges for proofs. Proofs have a two-business-day normal turnaround time, but can be accelerated for the same 100% and 200% rush surcharges. Please visit: www.JohnHarrington.com/reprints for a complete schedule of reprint fees, from quantities from 1 through 1,000, and offering pricing discounts for longer turnaround times.

Thank you for your time and consideration. I look forward to working with you and Porter Novelli again.

Sincerely,

John Harrington

To confirm this assignment, <u>please sign and fax this estimate back</u> acknowledging the estimated charges, fees, and other contents.

_____ _____ _____
Signature Print Name Date

JOHN HARRINGTON

P h o t o g r a p h y

2500 32nd Street, SE • Washington, DC 20020
Office: (202) 544-4578 • Fax: (202) 544-4579
Email: John@JohnHarrington.com

Invoice

Date	Invoice No.
██████	████

Bill To: ████████████

	P.O. No.	Terms	Due Date
		NET 30	███████

Description	Amount
Assignment: Photo coverage of event at the ████████████ Hotel on ████████.	
Photo Fees	1,810.80
Post production-250-500 images (retouch/color correct/file conv)	500.00
Fee for digital output to CD of 250-500 images	250.00
2nd CD (1/2 cost of original CD output)	125.00
Image prep, production & coding (metadata) via e-mail, 3 e-mails as requested by ████████ on ████████	195.00
Parking	20.00
Courier shipment, 1 way to ████████	18.00
Brochure usage: $140 x 8, 10k-20k press run	840.00

Federal ID #████████ Net 30 Days

Total	$3,758.80

Case Study: Regional Corporate Client

Client type: Local/regional company.

How they found us: Client referral.

Assignment: Company was looking to showcase their "human capital" in one or two full-page ads in a trade magazine read by non-political decision makers in the federal government, hoping to win future government contracts. Photograph was to be of key company staff.

Deliverables: Single image chosen from film produced.

Technical notes: Shoot required four heads. Two on softboxes to light the front of the group, and two to light the background, and a hair light provided on the backs of the subjects.

The initial inquiry came via telephone, and we were advised that we were the sole photographer considered for the assignment. I asked the question, "Do you have a budget for this?" The client advised me that he'd like to come in around $5,000 for the project, and this was a reasonable figure for the scope and usage of the work. We prepared an estimate and sent it along. It was signed within two days and returned. Following the successful completion of the assignment, the same company called us again the following year for another assignment of a similar type for a similar use.

JOHN HARRINGTON
P h o t o g r a p h y

2500 32nd Street, SE Washington DC 20020-1404
Local Office: 202.544.4578 National Office: 800.544.4577
Fax: 202.544.4579

Estimate and Contract for Photographic Services

This is an:	Estimate and Contract		Client:	███████████
Version:	1.0		Agency:	███████
Time:	4:20 pm		Agency Contact:	████████
Date:	███████		Art Director:	███████

Job Description:

Create 1 photograph of group of 6 or 7 company executives in a highly stylized and brightly lit image for promotion of the company to a government reading audience. Image should have a "high fashion style" look.

Usage:

Usage in two issues as a full page advertisement in ████████████ Magazine, with a circulation of 66,000, and use for a period of one year on the company website.

NOTE: Fees for usage do not include scouting time for locations (if necessary) nor location fees for the venue in which the photography will be produced. All location permits (where applicable) to be handled by client or agency.

Category	Description	Qty	Rate	Fees	Sub-Totals
Fees	Photography - On Location -	1	4420.	$4,420.00	$4,420.00
Film/Lab:	Film/Processing	5	42.	$210.00	
	Polaroids/per pack -	1	38.	$38.00	
	Digital Scans	0		$0.00	$248.00
Crew:	Location Manager	0		$0.00	
	Wardrobe 2 half-days	2	300.	$600.00	
	1st Assistant	1	150.	$150.00	
	2nd Assistant	0		$0.00	
	Makeup	1	600.	$600.00	$1,350.00

(Page 1 of 5)

CHAPTER 14

Rental	Lighting			$0.00	
	Generator			$0.00	
	Production Vehicle			$0.00	$0.00
Travel	Parking/Tolls/Gas			$0.00	
	Meals			$0.00	$0.00
Misc.	Catering			$0.00	
	Messenger/Shipping	3	22.50	$67.50	
	Gratuities			$0.00	
	Long Distance Phone			$0.00	
	Mobile Phone			$0.00	
	Expendables	1	30.	$30.00	$97.50
Talent	Adults - See separate estimate			$0.00	
	Children			$0.00	$0.00

Total Estimated Fees:		$4,420.00
Total Estimated Expenses:		$1,695.50
Insurance	Certificates	$0.00
	Liability	$0.00
Grand Total:		$6,115.50

<div align="center">Subject To Terms and Conditions Below</div>

This agreement will serve as a contract between John Harrington Photography and ▮▮▮▮▮▮▮▮▮ (hereafter Client) its successors and assigns.

This agreement sets forth the rights and obligations of John Harrington Photography and Client for the acquisition of rights to photographs to be provided by John Harrington Photography. Client accepts delivery of said photographs expressly on the following conditions which embodies all of the understandings and obligations between the parties hereto.

ALL PHOTOS COPYRIGHT 2001 BY JOHN HARRINGTON.

1. Commissioning of Photography

Updated Contracts

On a regular basis, we review and revise our contracts to reflect client feedback in terms of clarity, our own needs for ease of use, the transition from word processor to our FileMaker database we wrote, as well as changes in contract law that would reveal that perhaps there was a loophole or other cause for concern in the contracts. Following are our latest contracts (as of late 2009) that we have put into use. We engaged our attorney to review existing contract language, terms and conditions, and such and to apply his knowledge to the laws in Washington, DC—the jurisdiction where we'd need to enforce the contract if there was a dispute—as well as to apply his expertise in contract and copyright law.

I encourage you to review these contracts and the boilerplate contracts that are available through trade organizations such as the American Society of Media Photographers (ASMP), the Advertising Photographers of America (APA), the National Press Photographers Association (NPPA), Editorial Photographers (EP), and the Professional Photographers of America (PPA), among others. All have guidance and suggestions, and you should have their language reviewed by your attorney and modified to comply with the laws of your state and locality, because each is different. A few hundred dollars of attorney time can save you from a loophole in your contract that is created by state law invalidating one of your contract terms. And, the client who has unjustly enriched themselves with your work won't be able to drive a truck through the loophole all the way to the bank, impervious to your claims.

Following is the basic outline of job-specific details and the terms and conditions for the work we perform for the client. This layout can be blended with the PR/event contract and modified to satisfy editorial and commercial clients as well.

My logo appears at the top, followed by the job-specific information collected and outlined on Page 1 of each contract. Here's the information:

CHAPTER 14

Authorized Representative

Client Name

Client Address

Telephone

ESTIMATE

Event Information

Date

Time

Arrival

Start

End

Location

Description of Services:

Deliverable Material(s)

Schedule

Media

Date Deliverable

Permissions:

Media

Duration

Territory

Term

CMI:

Fees

Services

Administrative Fees

Post Production

Output

Shipping

Misc.

Same Day

Next Day

See Terms and Conditions Attached

JHP signature

Client Signature

That concludes Page 1. It's important that Pages 1 and 2 have places for the client to sign. This signature acknowledges that they've seen both pages.

Page 2, the terms and conditions, follows. Although we used to have this document as a single-page, doubled-sided form, 100 percent of our contracts are e-mailed PDFs now. As such, they become two pages.

1. Invoices. Client shall pay JHP invoices upon receipt. There will be a 1.5% late payment charge on amounts due and unpaid within ten (10) days of the mailing of the invoice. On all amounts thereafter due and unpaid there will be a 1.5% per month interest charge, accruing daily, until the amount due is paid in full, not to exceed the maximum amount permissible by law. Client shall be solely responsible for the payment of applicable sales, use, personal property, and other taxes assessed upon the Estimated and billed services and expenses, and shall hold JHP harmless for and from any liability assessed therefore. All fees shall be paid in U.S. Funds without deduction for any applicable foreign taxes withheld at the source

2. Services & Costs. Estimated amounts are only for the services and costs described in the Estimate. There will be additional charges for any additional services and costs rendered or incurred for performance. Additional charges will be invoiced to Client.

3. Cancellation, Postponement, Delay, And Additional Time. If Client postpones or cancels services or expenditures once this agreement has been confirmed, and time committed, the full amount of the photographer's fees and any expenses incurred that are associated with this assignment shall be due and payable to JHP as a cancellation or postponement charge. The Client will be charged the full amount of the Estimate, in addition to the cancellation or postponement charge, where the Estimated services or expenditures are performed or incurred after a cancellation or postponement. The Client will be charged for any delays in performance which are not the fault of JHP, and as set forth in the Estimate. In the event that JHP services which are Estimated for any day extend beyond eight (8) consecutive hours in such day, there shall be additional charges to Client for assistants and crew members, which shall be one and half times their hourly rate for more than eight and up to twelve hours, and which shall be double their hourly rate for more than twelve hours in such day.

4. Approval. Client's authorized representative shall be present during photography to approve JHP's photographic services and changes thereto. The client shall not participate in or interfere with JHP 's performance of photographic services, and JHP shall be solely responsible for and shall exercise its sole discretion, for determining the artistic content, composition, audience appeal, and outcome of the work performed. Work which the Client does not reject, or which Client does not request JHP to correct during the performance of photography, at the time the services are being performed, shall be deemed accepted.

(continued)

CHAPTER 14

5. Photographic Material. The photographic materials referenced in the Estimate are deliverable only in the format therein specified. The photography services performed by JHP will be those of JHP or its employees or contractors. JHP shall make a good faith effort in the performance of all services. No release exists and none shall be provided by JHP for any other component of the photographic material including without limitation those for models, minors, rights of publicity, privacy, property, trademarks, copyrights, patents, misaffiliation, defamation or for any other cause for liability or otherwise, unless expressly listed in the Estimate and provided in writing by JHP at the time of JHP's delivery of the photographic material. JHP may but shall not be required to keep archives or copies of the photographic materials. Except for those expressly identified as being for permanent transfer to Client, and unless otherwise specified by the express terms of the Estimate, all photographic materials, remain the property of JHP and shall be redelivered to JHP within thirty (30) days of first publication, or within sixty (60) days of delivery, whichever occurs first. Client shall destroy all digital files within one week of first publication, or at the conclusion of the term that the rights have been licensed for. As reasonable liquidated damages, Client agrees to pay JHP $2,500.00 for any original image which is lost by Client, its carriers, consigns, and bailees, unless JHP has a high quality reproducable duplicate of such original image.

6. Limitations on Liability. The photographic material is deliverable in the specified format, AS IS, where is, at the place designated in the Estimate, or if none, at JHP's principal place of business. Except as provided for in the Estimate, the photographic materials will not be insured. JHP shall not be responsible for the risk of loss for the photographic materials while the same are in JHP's posession or in the hands of any carrier, beyond the amount of any insurance, if any, procured by JHP for Client at Client's written request and expense as shown in the Estimate. Except as expressly provided for in the Estimate, JHP shall obtain no independent insurance for the Photographic materials. JHP makes no warranties, express or implied, with regard to the deliverable photographic materials. ALL WARRANTIES OF MERCHANTABILITY AND OR WARRANTIES OF FITNESS FOR A PARTICULAR PURPOSE, AND ANY AND ALL OTHER WARRANTIES EXPRESS OR IMPLIED, ARE EXPRESSLY DISCLAIMED to the fullest extent permitted by law. In the event that JHP work becomes lost, unusable, or damaged due to equipment malfunction, processing, or technical error prior to delivery, JHP shall at JHP's sole election be provided by Client with a reasonable opportunity to perform the photographic services to replace the lost, unusable or damaged work; and JHP may require that JHP first be paid in full for such work. JHP's liability to client for any acts or omissions arising out of or in connection with this agreement shall not, in any event, exceed the amount paid by Client to JHP under this agreement. In no event shall JHP be responsible for incidental, or consequential damages. Client shall indemnify, protect, hold harmless, and defend through Counsel of JHP's choosing, JHP from and for any and all claims, demands, actions, proceedings, and costs (including without limitation reasonable attorneys fees, court costs, and litigation related expenses) which arise out of or in connection with JHP's performance of services for Client, or Client's use of JHP work, except where the same arises solely from JHP's own negligence.

(continued)

7. Rights. Except as expressly licensed in the Estimate, all right, title, and interest, in and to the photographic materials, including without limitation the copyrights, design patents, publicity, attribution (and other rights in the photographic materials), including without limitation any renewals or extensions thereof, now or hereafter arising, shall be and shall remain except as may be subsequently licensed by JHP the sole property of JHP in perpetuity, throughout the world. All permissions must be signed by JHP in writing and are otherwise invalid. Permissions granted to Client are expressly conditioned upon payment in full; absent full payment such permissions shall be deemed void ab initio. Except as expressly licensed in the Estimate, permission to include JHP work in a collective work includes the work only in the stated media and excludes permission to include the work in other media, or any revision of the collective work or later series. The client is not authorized to remove copyright management information from JHP work, and any authorization granted to client to use JHP work is conditioned on the Client's inclusion of the copyright management information which is designated in the Estimate, which in no event shall include less than JHP's authorship designation and copyright notice, and such other information as would permit through a reasonably diligent search the identification of JHP as copyright owner. Permissions granted may not be assigned or sub-licensed.

8. Disputes. In the event of a dispute arising under this agreement such dispute shall at JHP's election be resolved exclusively by binding arbitration in accordance with the rules of the American Arbitration Association. The arbitrator shall determine the prevailing party and shall order that they be reimbursed their arbitration fees, arbitration costs, and legal fees and costs incurred for and in connection with the arbitration. The arbitration shall be conducted in Washington, DC and the decision of the Arbitrator shall be final, binding, and enforceable in any court having jurisdiction. The parties consent to the personal jurisdiction and exclusive venue of the courts of the District of Columbia for any litigation commenced under or in connection with this agreement. The laws of the District of Columbia, without regard to its rules for conflicts of law resolution, shall apply in the construction of this agreement. Actual attorneys' fees and all actual costs shall be awarded to the prevailing party against the losing party in any such litigation.

JHP Signature:

Client Signature:

CHAPTER 14

This is the end of Page 2. Note that you might want to change term 8 from binding arbitration to the courts in your jurisdiction.

Chapter 15
Contracts for Weddings and Rites of Passage

There are numerous types of rites-of-passage photography. Several of the major ones are weddings, births, deaths (yes, deaths), christenings, brises, sweet sixteen parties, bar and bat mitzvahs, senior portraits, engagement parties, honeymoon photography, anniversary parties, and school reunions. There are countless other types of photography—horse shows, dog shows, school portraits, family portraits, sports league photography, senior prom photography, and the list goes on and on. I have known many "true photographers" who disrespect their brethren for earning an excellent living doing these types of photography. Frankly, I consider this disrespectful attitude just plain wrong. What I have seen occur, however, often gives me a chuckle in the "watch what you say, because someday you might have to eat your words" category.

NOTE

People who consider themselves "true photographers" are usually among photojournalists, corporate/commercial, and advertising photographers. I'd recommend a reexamination if this is your perspective. To me, this perspective is bad karma.

From Time to Time, Even the Non-Wedding Photographer Will Cover a Wedding or Rite of Passage

Usually this situation happens with a relative the photographer knows who is getting married. The photographer hears that a family member or close friend of the family is getting married, and the couple has budgeted $2,000, $3,000, or $5,000+ for photography. "Are they out of their mind?" is usually what the photojournalist will wonder out loud. "Tell them to give me the names of the photographers they're looking at, and I'll tell them which one will be the best for them." In short order, the photojournalist has a list of five or so names and is surfing to their websites. At the first one, they look at the price list and are incredulous. By the fifth, they are saying to themselves, "Hey, I can do *that* type of photography almost with one eye closed…maybe I'll look into this more." And they do.

Along the way, the photographer will make a recommendation based on the quality of the photography, but there's so much more that goes into being a wedding or rite-of-passage photographer that it's an education unto itself.

For those of you who are looking to focus on rites-of-passage photography, there are several good books on the subject, and I'll list them at the end of this chapter. Further, there are excellent traveling road shows put on by the likes of legends Jerry Ghionis, Denis Reggie, Gary Fong, and others, all of whom will school you in weddings. The Professional Photographers of America have schools, books, and other materials that will help you to grow that type of business correctly. However, this book cannot, in one chapter, provide the breadth and depth that all of them bring to the table. What I will do is give you some tools and insights into the business and encourage you, ever so strongly, not to dive into the business doing weddings for a few hundred dollars as side income on a Saturday or Sunday (or other days when rite-of-passage events are occurring) and wreak havoc on the businesses of professional rite-of-passage photographers. They have enough "Oh, the bride's uncle owns a camera and he's pretty handy," or "At $1,500, heck, I'll get my cousin Joe who's a photo student to take a family portrait for a quarter of that" types of problems—they don't need you, dear reader, contributing to that. So please recognize that being a photographer whose business is serving those rites of passage is truly a full-time business.

It's a full-time business because many brides (I'll use them as the example for all rites-of-passage participants) experience sticker shock when they see a $3,000 price tag on a wedding. "For $3,000, that photographer better be frickin' Annie Leibovitz" is something I've heard brides mumble (or write on bridal chat forums) until they have a bit of an attitude adjustment. And, for the record, while I highly doubt anyone could convince Ms. Leibovitz to photograph a wedding, her assignment fees range from the mid-five figures to sometimes as high as six figures for the work she chooses to accept. That, in the commercial/corporate/ad world, is something worth aspiring to.

What takes some time to learn—and what a skilled photographer will give insight into—is that it's not $3,000 for the single day; there's myriad other work that goes into the photography aspect of the bride's day, just like everything else. There's pre-production, client interviews, re-interviews, then client meetings, then harried/concerned phone calls from the bride/bride's mother/groom/groom's mother that need to be handled. Sometimes the package price will include an engagement portrait. And then, there's post-production, just like in all other types of photography. Then post-ceremony bride meetings sometimes occur, and there's uploading to an online service and preparing an album. Some of these things can be outsourced, but many photographers keep the work in house. I'd say that a wedding photographer has about the same number of days off as any other photographer and is working just as hard.

Further, their business (as with all rites-of-passage photo businesses) is seasonal. A responsible wedding photographer will not book more than one wedding a day (from my perspective) and can only really count on two a weekend at the maximum. Sure, every weekend someone somewhere is getting married, but the "high season" is usually May/June and September/October.

I think that most wedding photographers would like to do between 20 and 40 weddings a year. Some might do more because they have to make their revenue requirements in volume. However, the wedding photographer who does 20 a year at $5,000 a day is going to be fresher on each day than the guy who's a "wedding mill" and does one Saturday morning, one Saturday afternoon, and another on Sunday, doing 50 to 80 a year at $1,000 to $1,500 per wedding. That photographer is going to burn out, and I don't want him or her anywhere near a couple I know, because it's just one more gig to that photographer...something to get through. I want the photographer to be excited (or at least enthusiastic) about being there.

So make sure that when you realize there is good money to be made doing this type of photography, you enter into this field the right way. Consider all of the business models, such as "I can only really count on working on Saturdays and maybe some Sundays" if it's weddings you're looking to do. This means a maximum of 52 Saturdays and maybe a maximum of 24 Sundays that are available to you. Although the norm for many photographers looking to fairly evaluate their CODB figures 100 days of shooting, clearly that's just too much for the wedding photographer. For prom season, it's Friday and mostly Saturday nights during April, May, and June. You get the picture: Think through what your potential days are and combine work types to achieve a good mix of the types of services you offer.

What a Wedding or Rite-of-Passage Contract Should Look Like

A rite-of-passage contract will be a lot simpler than your standard editorial/corporate contract. These photographers worry more about their clients using scanners and about Walmart mini-labs absconding with their print revenues—taking a $40 8×10 and having it printed poorly for 99 cents from Walmart—than they do with rights packages and usage. The worst part about the client who tries to get his or her proofs enlarged to 8×10 is that, as you know, the print will look soft, contrasty, and usually not like the right colors because the lab is neither color managed nor professional. And then, the bride says, "My photographer was John Harrington," and the viewer (while saying to the bride, "Wow, that's nice!") is mumbling under his or her breath, "I'll never use him; that photo looks like crap! Heck, my uncle takes better photos than that!"

The contract should include the following terms:

> It is understood and agreed to that John Harrington Photography is the exclusive official photographer hired to provide photographic services for the wedding day.

These terms are necessary so the photographer doesn't show up and have Uncle Joe posing the bride before and after the ceremony and otherwise taking time away from and interfering with the job the photographer is trying to do. Moreover, this wording ensures that the bride isn't hiring three photographers without each of the others knowing it. Although this clause may be struck in that instance, this ensures that the photographer will be alerted to the circumstance. In fact, some photographers have been known to include the clause:

> Bride and groom agree that no guests may be permitted to take photographs while the official photographer is taking photographs.

CHAPTER 15

To me, it's either just plain egotistical or greedy if the photographer doesn't want family and friends snapping away during the posed photos and taking away their reprint sales. The argument could be made that with other guests taking photos, it's possible that eyes will be averted from the official photographer, but this is usually resolved by having the assistant ask that guests pause their own photo taking during the time that the photographer is taking photos. Further, there are some photographers who rely on slave triggers that are not infrared or radio and instead react to any flash firing, and they may be trigged moments before they are supposed to be by a guest's point-and-shoot strobe. Thus, the flash pack is not recharged for the needed image. I've known, however, more than one photographer who has been more than happy to let his lighting kit go off while guests are snapping away, with his attitude being that none of the photos will come out because of the overwhelming flash output of their flash kit. I think this is a bit over the top.

> Orders, either in part or in full, shall not be delivered until the balance due is paid in full.

I think this is fair, especially for reprints. Unlike businesses, it's time-consuming to track down a deadbeat individual—especially one who has quite likely gone into deep debt to pay for her wedding—and you don't want to be in line with the rest of the creditors.

> Negatives, raw digital files, and proof/preview prints remain the property of the photographer.

This makes sense, just as it does in the editorial/corporate world.

> Photographer reserves the right to use photographs taken during the course of their work for display, advertising, or other promotional use.

Couples can be funny about this one. I once had a bride who was a lawyer, and she rewrote this entire clause, which was fine by me.

> Should the wedding be cancelled or postponed, all fees and deposits paid are nonrefundable.

It happens, and it's regrettable. However, you've lost the ability to earn an income on one of the few days you can during the year, and you should not be left holding the bag. Further, caterers, locations, and other vendors involved also have similar cancellation clauses. If you'd like to soften it, you can try something like this:

> Should the wedding be cancelled or postponed, all fees and deposits paid are nonrefundable, unless Photographer is able to rebook the date he has committed to you for an equal (or greater) contract.

This next term is critical:

> Photographer represents that extreme care is taken with respect to capturing, developing, digital processing, storing, and delivering images. However, in the event that Photographer fails to comply with the obligations of this contract, for any reason, including but not limited to events outside of the photographer's control, the photographer's liability shall be limited to a refund of all payments.

This protects you in the event your cards fail, your hard drive fails, your camera fails, and so on. It protects you in the event that you're in a car accident and can't make it. And the phrase "for any reason, including but not limited to" also means you could technically bail for a higher-paying wedding and just refund them their deposit. But that's just plain wrong, unethical, and unfair. Don't do mean things like that. The couple (or you, proactively) might wish to remove these words, but make sure you're protected for the things that could go wrong outside of your control.

> Unless specifically requested and stated on this contract, all images will be produced digitally.

Some brides might still be expecting film. This makes it clear you're not shooting film.

The contract should also state that obtaining your commitment for the date requires a signed contract and deposit paid. Further, I require final payment of the package price seven days before the service. On their big day, I don't want to have the couple fishing around for their checkbook or forgetting it and wanting to pay me after the honeymoon. However, I have been known on occasion to adjust this to "day of" payment. But payments for the package on a date following the ceremony are a deal breaker for me.

I also ask for the bride's address, the groom's address, and their address following the wedding. Further, the contract includes the place where they want me to report to, as well as where the ceremony and reception sites are. I then detail their package—whether it's a time-limited event; approximately how many images they can expect; whether albums, reprints, or engagement portraits are included; whether a second photographer will be used; and so on.

The last detail that I ask is that both the bride and groom sign the contract. Until they are married, one cannot legally engage the other into a contract or obligation. Having them both sign precludes problems down the line and makes for a cleaner contract. Further, since they are also signing to allow you to use images of them for your marketing/advertising, having both sign ensures that you can fully use the images for your marketing materials.

There are many forms available through professional organizations that you can use. I know of several photographers who outline on a two-page letter, with places for signatures at the bottom, the dates, the times, and the package elements.

Negotiation with the Bride, Groom, and (Often) Paying Parents

The negotiations with the decision maker in terms of who the photographer will be are significantly different than when such negotiations are engaged with a publication or organization. In the latter instance, you are dealing with someone with line items and budgets, and it's somewhat impersonal. In contrast, the dialogue with the "media buyer" for a rite of passage is 100-percent personal. Of course you have to be capable, but I can't imagine anyone reading this book who isn't. You must connect with the prospective clients, and they must like you, get along with you, and think you're an easygoing person. Prima donnas are just not going to get the assignment.

CHAPTER 15

The dialogue and where it occurs—the interview/meeting—is all about these issues. This is a job interview, only it's for one day's work. Dress for success. If your meeting is in the exclusive community in your area, you must not turn up in jeans or business casual. A business suit is appropriate, especially if the meeting is with the bride's parents or the parents for a rite of passage for a child. If, however, you are meeting with a couple in their apartment, then business casual is most appropriate. I can't imagine any circumstances in which jeans and a polo shirt would be appropriate for a meeting.

Prior to the meeting, there should be no surprises. The clients should know your pricing structure. Nothing is worse than putting the couple in the predicament that after they listen to you tell them all about what you can do for them, you start quoting $3,500 packages when they are dealing with a maximum budget of $1,500 or $2,000. There's no way you can move them to $3,500, like you might be able to if their ceiling was $3,000. That is an insurmountable gap. Further, you'll want to make sure that they know what your style is (mostly posed/setups versus photojournalism/reportage style). The "media buyer" should have prequalified you down to a small group of providers who are available, capable of meeting the style and client needs, and within the client's budget. If any of those factors is not met, you're out of the running. Avoid wasting your time and theirs.

Many photographers have packages for rite-of-passage photography, and often there may be a gap when the client considers all of the items you're offering and what he or she can afford. I recommend you consider what the rock-bottom price you're willing to shoot for is—perhaps photography/expenses only, and the client can review the proofs (although they are not a part of the package), and they must be returned after the order. Or, perhaps they can only view the photos via an online service that carries watermarked screen-resolution images for their review. What would you charge? If your $3,500 package includes a 15-page album and 10 8×10s, plus eight hours of your time, are you backing out $800 for the album and $400 for the 8×10s and making your rock bottom-rate $2,300? Consider this as an option, or at least a point for negotiation. Perhaps the rock-bottom price is $2,600, and if they were to order the prints/album after the fact, it would give you a $200 premium. Many people order these in the end, so the extra work is compensated for with this premium.

You can expect that people are more interested in negotiating when it's their own after-tax money they are spending for you.

Protecting Yourself from Liability

When you sign a contract to render your services, most photographers take the approach that, "They signed, the deposit's arrived, great. That's one more locked assignment for the year to make my annual goal." What these photographers are not focused on, however, is their obligation to provide those services. Yes, there's the clause, "*However, in the event that Photographer fails to comply with the obligations of this…the Photographer's liability shall be limited to a refund of all payments*," that may protect you, but in the end you'll have to refund the monies and suffer a loss of your reputation.

Many families will ask the question, "What happens if you're sick and can't come? Do you have a backup photographer?" What this question is really asking is, "Do you have someone

as capable as you, who you are guaranteeing will be available at the last minute and won't be booked themselves, to cover for you *just in case* you fall sick?" That's a fair question. You can say all you want—"I've never missed a ceremony in 10 years"—but that won't make them much more comfortable because their fear is about *their* ceremony. Engaging the services of someone capable or maintaining one or two regular assistants you work with and who, in an emergency, could step in could mean saving yourself and your clients a great deal of angst.

In addition, you'll want to look into insurance that would cover you in the event that something goes wrong. We discussed Errors and Omissions insurance as well as Umbrella policy insurance in Chapter 10, and this is one place where those types of insurance will cover you. There have been legendary stories of photographers having their film go bad and then paying to fly every wedding party member back to the wedding site, renting tuxedos for them, and reshooting the photos. Would this happen today if a Flash card was to crash? Establishing a system (which I will go more into depth about in Chapter 24, "Office and On-Location Systems: Redundancy and Security Beget Peace of Mind") will give you a workflow to point to when, after the fact, someone calls into question how serious your protections are to make sure that valuable photos are not deleted/corrupted/ruined.

Multi-Photographer Events: Calling the Shots and Taking Control

One thing I often find funny (yet understandable) is when I am at a news conference or other event where there are multiple photographers, and they all have gathered/clumped themselves into one area—all essentially getting the same photograph from a nearly identical perspective. I find it understandable because in many instances, that is the best view/angle that juxtaposes multiple elements into the frame. Of course, I encourage photographers to think beyond the expected and do something unexpected. That will be how you differentiate yourself. Sometimes that means forgoing the best angle for something offbeat or unique. For a rite-of-passage ceremony, such as a wedding, the kiss is usually followed by the "down the aisle" procession, so when you're a one-person show and that's such an expected photograph, you really need to capture it. For an event where your newspaper has assigned you to cover something that you know will have the wire services on hand, the thoughtful photographer will look for the unique angle and allow the wire services to get the head-on or 45-degree angle shots. In this way, you can get something different. Of course, the risk is that the paper will run a wire photo instead of yours, but in the end, establishing a body of work (clips) that show you can think differently will make a difference in your marketability down the line. I'd treat their existence and the angles they are shooting from as a known quantity and work around that.

In a similar fashion, if a client hires multiple photographers for an event, they are all going to want to get the same angle/shot. Yet, if you're the photographer who subcontracts the others, you are in charge—you choose coverage perspectives, and as such, you can significantly enhance the event coverage. I have covered major news events as the photographer for the event organizers, and I have been responsible for directing multiple

others. In those instances, I can assign someone to stick with the VIPs, someone to get crowd participation, someone to make sure to document corporate sponsorship logos/signage to validate that they had a major presence there, someone on the finish line of a foot race, and so on. For a multi-photographer wedding, you can direct someone in the balcony shooting head-ons and wides of the overview, someone in the front of the church at an angle getting the "cutaway" shot of the bride/groom when their backs are to the audience, and someone to get reaction shots of the family in the front pew, and so on.

The challenge is convincing the people hiring you—whether the bride and groom, parents (in the event of a wedding or other rite of passage), or others—to have you be in charge. Much of this is moot if you're the only person covering the event, but for large ceremonies, it's not uncommon to have multiple photographers. If you're not the one in charge, make certain that your role is specifically defined. When you are working for a fellow photographer verbal direction makes sense, but if you're working directly with the client, and they are then essentially directing each of the photographers, make sure your contract spells out these things. It may be that in the example of the kiss and walk down the aisle for a wedding, the bride wanted the insurance of two photographers in the back or wanted the feel of paparazzi as they exited the church. I would always try to be the one in charge so that I could choose the photographers I was comfortable working with and who I felt were best for the job.

Recommended Reading

Cantrell, Bambi and Skip Cohen. *The Art of Digital Wedding Photography: Professional Techniques with Style* (Amphoto Books, 2006).

Sint, Steve. *Wedding Photography: Art, Business & Style* (Lark Books; Second Edition, 2005).

Chapter 16
Negotiations: Signing Up or Saying No

Were it so that clients paid our stated rates with no haggling! Were it that car dealers didn't try to get you to pay extra for the superior underspray versus the standard underspray. During a college summer, I took a job for one day selling cars. I spent the day in training, learning how to convert a $6,000 car to an $11,000 sale and that the difference between the standard underspray and the superior underspray was that the aftermarket service the dealership paid a pittance to do the spray had a worker stand on one foot when spraying the superior spray. I kid you not. At the end of the day, I decided I could not stomach being a car salesman even for a summer during college, so I did not return for the remaining training days. However, I learned more about car sales than I ever thought I would—how they adjust your interest rate based upon the value of your trade-in and how they get you to pay overpriced charges. Car dealers make haggling over prices almost a requirement of buying a vehicle. But negotiating is a way of life, and, in truth, you can negotiate almost anything. The key is knowing your parameters—what are you actually negotiating for and negotiating away as a part of the process. If you are someone who's adamant that you will not execute a copyright transfer of your work, yet you agree to:

> "an unlimited grant of rights for an unlimited period for an unlimited number of media"

not only have you done the same, but you've precluded yourself from using the images because one of the rights that was not limited was the exclusive versus non-exclusive. When you license to a client exclusive rights, they, for the period of time, control those rights. This means you cannot license the same rights to another party, nor use them yourself. A non-exclusive granting means just the opposite. You can license the same images to other parties for the same rights. Instead, try:

> "a non-exclusive unlimited grant of rights for an unlimited period for an unlimited number of media"

This alone grants you not only permission to license the work to others, but also to use it yourself. But one thing's missing—you've granted them the right to re-license the work to third parties. Instead, try:

> "a non-exclusive unlimited grant of rights for an unlimited period for an unlimited number of media, for the sole use of XYZ corporation"

Your terms in the contract should also stipulate that rights are transferable only with the sale of the client's company to another company. Following is a clause from one of our contracts. This clause in our contract was inspired by, and based in part on, terms and conditions from the Advertising Photographers of America boilerplate language.

> The licensed rights are transferred only upon: (a) Client's acceptance of all terms contained in this Agreement… Unless otherwise specifically stated on the front of this Agreement, all licenses are non-exclusive. Client shall not assign any of its rights or obligations under this Agreement. This Agreement shall not be assignable or transferable without the prior written consent of Licensor and provided that the assignee or transferee agrees in writing to be bound by all of the terms, conditions, and obligations of this Agreement. Any voluntary assignment or assignment by operation of law of any rights or obligations of Client shall be deemed a default under this Agreement allowing Licensor to exercise all remedies including, without limitation, terminating this Agreement….

But I'm getting ahead of myself. The point here is to know what you're negotiating before agreeing to anything. Know the value of what you have.

Negotiating from a Position of Strength

When you're hungry with an empty pantry, or you feel as though you don't have two sticks to rub together, it's definitely not the time to try to effectively negotiate prices and rights for an assignment. You're much more likely to give in when your senses are affected. Consider this: When you go grocery shopping and are hungry, how often do you find that there are more "immediate gratification" purchases lining your shopping cart than the sundries you came looking for? I have often bought a soda and sandwich from the grocery store deli and eaten them and then gone shopping. The cost of the sandwich ends up being far less than all the chips, snack foods, and other items I'd have bought while shopping on an empty stomach. Yes, yes, I know—have a little self-control. But the problem is I was negotiating with myself from a position of weakness. No biological instincts are more powerful than hunger, which is a sub-instinct of the self-preservation instinct. The drive for sex runs a close second, but that's another book and another type of negotiation.

As photographers, positions of strength come from a number of areas:

▶ An award-winning photographer will negotiate for better rates and more control over the direction of a story being considered, especially right after the conveyance of the award. Years later, the sheen of the award will have worn off, and self-doubt will return.

▶ A photographer with numerous bookings will negotiate for better rates and be able to put off rights demands.

▶ A photographer with a roof over his or her head and a full pantry will negotiate better than one with a stack of collections notices in the mailbox

▶ A photographer who has other resources to draw from to cover expenses, such as a part-time job or a full-time job that allows for weekends free to provide rites-of-passage types photography, will negotiate better.

INDEPENDENTLY WEALTHY PHOTOGRAPHERS

Some photographers are independently wealthy, perhaps from an earlier career from which they retired young. Some have family money from an inheritance, or perhaps they have a well-off spouse. These photographers are in an enviable position, but one that carries a responsibility to the profession. Just because you don't have to worry about making a minimum monthly income/profit level, that doesn't mean you can take assignments for the pleasure of seeing your photo credit. Doing so sets a standard that is unattainable by those who do have to make monthly minimums to survive, and you do those you admire as fellow photographers a disservice and make their lives miserable in the process. This may be one legitimate reason why the phrase "trust-fund photographer" came into parlance and is used in a derogatory manner. But one photographer who worked in the field of photography very early on did a service to the community as a trust-fund photographer—Alfred Stieglitz. He worked diligently to improve the gallery showings, pay, and general circumstances of his fellow photographers. Those with similar good fortune would do well to follow his lead. A documentary on his life and exhibitions of his work are ways to learn more about the man.

There are many photographers I know who made pictures and waited tables to pay the bills in the early stages of their careers. Waiting tables, they could make $200 a day before taxes, and they wouldn't take off a day to do an assignment that paid less. This makes sense, and it allowed them to accept only appropriately paying assignments.

My situation was somewhat different. As I outlined in Chapter 4, after several years as a staff photographer at a magazine, I was told that another photographer and I would be offered a single full-time position to split. When the other photographer said he couldn't do it, I thought for sure I'd get the work he said he couldn't take, but instead of offering me the full-time position, the managing editor sought to keep me at the part-time level. At the time, I was very unhappy about this; yet looking back, it was very beneficial to me. It was this income that paid my rent, utilities, and such and allowed me to grow my business by turning down bad deals (whether "pay-bad" or "rights-bad") and securing long-term clients who were reasonable on rights and rates.

Practice makes perfect. Although you know that's true for dealing with difficult subjects, challenging lighting setups, driving, and everything else in the world, somehow people believe that they can never be good at negotiating. This just isn't true. Really.

Whatever your position, do everything you can to ensure that you're not negotiating "on an empty stomach" and you don't end up taking bad deals just because you're hungry. Further, you should never find yourself in a position where the loss of any one assignment (or a few in a row) would put you out of business. If you are in that predicament, then you need to reevaluate your business model from the ground up.

In his book *You Can Negotiate Anything*, Herb Cohen talks about three factors that govern most negotiations—an "imbalance in information, apparent time pressure, and perceived power." If you are the only person available within two hours of a location, and it's a last-minute event, you're more likely to be able to set your terms—if you have some way of knowing this, or the editor happens to mention that everyone else is booked and it's an important assignment. Now you have perceived power from the prospective client's time pressure and the information that you're the only one.

If you say, "Great, I don't have anything to do today," you're diminishing your position. When you quote your price of, say, $750 to cover the assignment, the editor will say, "Oh, we can't pay that. Our rate is $300." The editor is attempting to equalize the situation by using what Cohen terms "the power of precedent" and the learned knowledge that you're not committed to something else. Surely you, the photographer, wouldn't dare to ask more than they're offering or have paid others in the past. The editor didn't even say, "Our rate is *usually* $300" or "We *try* to pay $300 an assignment," which might give you some insight into wiggle room.

Instead, you could have said, "You know, I've got several projects I am working on, but I think I can rearrange those commitments to take this assignment for you." Because you're always doing *something*—looking for new clients, working on marketing materials, reading about the latest equipment, reviewing other photographers' work online, or just generally doing busywork that needs to get done, you do, in fact, have to rearrange *something* to take the assignment.

Cohen further says:

> In any type of negotiation, quick is always synonymous with risk…. Undue haste puts one party in potential jeopardy. Who takes the risk in a quick settlement? The person who is less prepared and cannot determine equity. Let's say that I cannot ascertain, based upon my data and observation, that your proposal is fair. Instead, I must rely totally upon your representation.

Sound familiar? "Every other photographer we deal with has signed this 'all rights in the universe' contract." Or how about, "I am leaving for vacation and need this buttoned up before I leave, so can you do the assignment at this rate?"

First, get off the phone. I almost never give a quote over the phone because I haven't had a chance to think it through, nor have I done any research on this "over the transom" inquiry. Take the time to think through the specifics of the request and come to an understanding of what you'd like to get. Then put it in writing. Things in writing are usually perceived as being less negotiable than things simply said over the phone. When you've drafted your estimate, send it along and follow up with a phone call to begin the negotiations. For a broader review of negotiations and how you should approach them in general, consider that there are effective rules you should apply when negotiating.

NOTE

I refer to clients who have come to me through no direct effort of mine as "over the transom" inquiries. Although there is some belief that the term "over the transom" is a nautical one, it actually has its roots in publishing. A small window that could be opened over the top of a door, often used in the days preceding air conditioning, was called a transom. Book proposals and manuscripts would come to a publisher's home or place of business unsolicited by being dropped through the open transom. One other possible origin suggests that the phrase stems from the Copper Kings in Montana bribing officials by tossing payoffs through the transom into their hotel rooms.

Before you begin the negotiation process, consider what Leigh Steinberg, author of *Winning with Integrity: Getting What You Want without Selling Your Soul*, defines as "the twelve essential rules of negotiation" (followed by my application of them to aspects of photography):

1. "Align yourself with people who share your values."

 This means photo editors you admire and publications whose reporters you trust and whose stories you respect. In the instance of companies or organizations, perhaps it's humanitarian aid organizations or the philanthropic arm of a corporation. For example, suppose a company such as Ford has a separate charitable organization, the Ford Foundation, that does good in the name of Ford.

2. "Learn all you can about the other party."

 This is applicable not only to the photo editors as individuals, but also to the potential contract terms you might face and have objections to, the state of the company (flush with profits or facing cutbacks and recent staff layoffs), and so on.

3. "Convince the other party that you have an option."

 If they're not sure you're capable of the assignment, convey past successes (without appearing to boast), working relationships with other editors they may have worked with in the past, or your track record with a challenging assignment type (underwater, aerials, and so on).

4. "Set your limits before the negotiation begins."

 I made the point earlier about negotiations that are too quick being a possible risk, but so too can long, drawn-out negotiations be. You don't want to look back at a multipart negotiation and realize that you'd never have agreed to the deal had you not been incrementally moved to the point you are now at.

5. "Establish a climate of cooperation, not conflict."

 Begin, as has been noted in earlier chapters, by engaging the client about the project—let them know that you're interested in the project, are excited to talk through some ideas you have, and so on. If conflict is going to come in the form of "take it or leave it" contract language, it's going to come. Further, there may be a dozen clauses, three which just need clarification and two with potential deal-breaker points in them. Resolve the first three first—getting repeated "yes, that's fine" answers to your requests will make resolving the final two problematic clauses easier when you are operating from the initial spirit of cooperation instead of starting with conflict out of the box.

6. "In the face of intimidation, show no fear."

 When faced with "Every other photographer has signed…," I often *think*, "Well, why are you calling me then?" or, "I'm not every other photographer," but of course, I'd discourage those smart-aleck remarks from actually passing your lips. Yet it's a mindset that can drive a more reasonable dialogue with the client. Try responding with, "It has been my experience that signing contracts with those terms isn't conducive to a good working relationship, and it is against my policy without reasonable modifications to it."

7. "Learn to listen."

Although this might seem obvious, pay attention to what the other party is saying, rather than preparing your next objection. I have found many a creative solution by listening to what people are saying and offering a solution.

8. "Be comfortable with silence."

If you make an offer or respond to the client's request for a concession, and then there is silence, do not speak just to fill the void. By doing so, you begin to negotiate with yourself because you feel that silence is non-acceptance of your offer or response.

9. "Avoid playing split the difference."

Suppose your estimate is $4,500 for an assignment, and the client says they only have $2,500, so you suggest, "How about $3,500?" You're setting yourself up to appear as if you were padding your estimate by $1,000. If you're going to come down, there needs to be a good reason why. Perhaps you can eliminate an assistant, catering, or extensive retouching, or perhaps you can learn that the client does not need five years of rights to the images, and only two are necessary.

10. "Emphasize your concessions; minimize the other party's."

Outline how you'll cover the expenses without an advance, with a delay until payment upon publication, with an extended rights package, and the like.

11. "Never push a losing argument to the end."

There's no reason, really. You hope next time to deal with this person either at this organization or another down the line. If you know that they demand WMFH and they have never negotiated that, then don't waste your time or their time. Many times, a photo editor who is requiring WMFH knows that it's bad for you, and there's no sense debating the issue, but saying something nice such as, "I understand that's your policy, and mine is counter to that. I hope that in the future it will change, or that should you find yourself at another organization down the line, you'll consider calling on me when that term is not etched in stone." This will let the PE know that you're a reasonable person, and the editor will respect you for that. Further, let the photo editor know that you'd be happy to talk further down the line if he or she is unsuccessful in finding a satisfactory photographer who will agree to those terms. And lastly, when you object to a term and the call ends, there are times when the client will be calling back to offer you something better. Most publications have tiered contracts, and everyone gets offered the most egregious one first and the more equitable ones after they object to the first one.

12. "Develop relationships, not conquests."

This is absolutely true in the photographic community and is a great follow-up to my comments from the previous rule. The community of people who contract with photographers is very small, and as you evolve your business, ensuring you've not burnt bridges or taken advantage of a client's circumstances will ensure your own longevity and respect among prospective clients and peers.

Creative Solutions in the Negotiation Process

There are numerous ways to get to 10: one plus nine, two plus eight, three plus seven, four plus six, and so on. All achieve the number 10. Similarly, there are numerous ways to achieve an agreement to make pictures on behalf of someone. For me, WMFH is the equivalent of *pi*. Given the infinite nature of *pi*, no matter how hard I try, I can't get to 10. If I turn a blind eye or compromise *pi* to 3.14, then of course I can get to 10, but that's including a fudge factor. Absent my *pi*—my deal breaker—I can usually get to 10. You'll need to define your parameters to achieve an agreement and then operate within those parameters, yet be open to suggestions that a client might offer, as they should be open to yours.

NOTE
For the curious, in September of 2002, a professor at the University of Tokyo calculated *pi* to 1.2411 trillion digits, a world record. For more fun facts on *pi*, visit www.joyofpi.com.

Suppose your client is a small design house, and they have to print something for a client that is 8.6"×13" and the press they need to be on runs 12"- and 24"-wide paper. Because the client has been presented with the added costs to go from 12" to 13" and approved it for their own reasons, they'll need to be on 24" paper stock, leaving roughly 11" of waste all along the job. In lieu of the additional $1,000 you wanted for the job, you could propose to the client to gang up a promotional piece 10" wide that you are looking to have done alongside the client's job, making that waste beneficial to the client and to you. If you don't, chances are the client will print some of their own promotional material in the waste area, so this is not an unusual request.

NOTE
The truly critical photographer might find this ganging-up of print jobs objectionable because the client's piece will be what they are watching the color on, and your promo piece might come out slightly different than you wanted. Print houses frequently gang print press jobs and know how to maximize the quality of both jobs—but yes, yours might suffer.

You might find that a magazine may not be able to pay you an extra $300 for a cover assignment, but you might be able to negotiate that they send you 100 copies of the magazine where your photo is featured attractively on the cover. In turn, you can send these copies out to other prospective clients, which might garner you future work for other publications. Because the newsstand price of that magazine is $3.95, you're ahead—or, if the magazine is $2.95, you've at least broken even.

One creative "solution" often suggested by a client is "do this one for me, and I'll make it up to you next time." The problem is, in 16-plus years of photography, I have *never* heard of any client making good on this offer. The experience becomes one in which the PE shops around to all the photographers, never making it up to anyone, and when they do have an

assignment that pays well, they go to the photographer they've always wanted to use but could never afford...*until now*. That person should be you. Further, the client won't respect you if you agree to this "solution." It's a wholly different thing if you've done five or six covers at $1,300 each for a client, and then they come to you to do an inside image for $400 or $500, or a cover for $1,000 because there's $300 in modeling fees for this particular cover, and they don't have a budget for it. This might give you pause to consider doing it, but you could counter with, "Okay, but I'd like to hire models, which will allow me to shoot additional images of them that I can then use as stock."

In response to the "cheap one now, paying one later" query, I've found myself, as I see the end stages of the negotiation arriving with a breakdown point being price, making the following offer:

> **Client:** "I'd really love to have you do this assignment; I just don't have $500 for it. The most I can pay is $400. We do plenty of assignments in your area, and I'm glad to have your name because I am sure I can make it up to you next time."

> **Me:** "My fee to shoot that assignment would be $500, and we're about 20 percent apart. How about this? Since you're sure to use me frequently in the next year, why don't you pay me the $500 for the next four assignments, and the fifth one will be free. I'll even memorialize that in the contract and keep track of it in each subsequent contract. Because you'll no doubt need me that often, at the fifth assignment they'll all have averaged out to $400, and your photo budget will be where you say it needs to be when the end of the fiscal year arrives."

Think that has ever worked? Nope. They get it. I get it, and I am polite about it. And sure, you bet—if I make that offer and someone takes it, I'll keep up the terms of the agreement. What I'd want to know is, who have they been using for all those previous assignments in my city, and why aren't they using that person now?

Often, I've had calls from clients in which the dialogue is along these lines:

> **Client:** "Wow, your website is great; I love your portraits. How much would you charge for a portrait?"

> **Me:** "Let's see, a few questions first—tell me about the magazine. Name, circulation, is this for the cover or inside, and did you have a budget you were trying to work within?" (For a corporate client, it'd be, "Tell me about what the portrait is for," and then a follow-up about annual reports, website, PR, and so on.)

> **Client:** "We're *Widgets Today*, we publish monthly, our subscribers are in the trade, and we have a circulation of about 14,000. It's a portrait for inside the magazine. We fairly frequently have assignments in DC, so we are glad to know about you now. Oh, and we normally pay $250 for this type of assignment."

> **Me:** "Have you been pleased with the results of the other photographers you've called in DC?"

> **Client:** "No, not really, which is why we're happy to find you. I really like your style and use of light."

Me: "Thanks! The thing for me is, I think part of the reason you've not been happy is that the photographers you're working with and paying $250 to have not been producing satisfying results, and I hear that happening often. I am happy to send along an estimate for the assignment, but the concern I have is that you're expecting the quality of the work I produce for $250. I'll do the best I can with my estimate, but I don't think I can make that figure."

Client: "Okay, well, send me the estimate, and I'll see what I can do."

Then, I do my research and find that with that circulation, a fair rate would be $650 plus expenses for an inside portrait, so I send that along. Those who have been doing the assignments for $250 would be surprised at how many times clients assign the photography at the rates I am providing.

Recently, I negotiated a license from a series of images I produced of a helicopter in flight. It was air-to-air work, which has its own set of challenges. One of the parties associated with the aircraft (not the original assigning party) wanted to obtain the images. They'd appeared on the cover of two aviation magazines and therefore had a value established for them from their perspective. Here's the actual dialogue that took place via e-mail, which had creative options that produced a solution that appealed to the client:

Client: "We have varied needs for photos like this, as you can imagine. Do you offer a cost for purchasing the photographs outright or for unlimited use?"

Me: "As I mentioned, my work is licensed for use, and typically companies have logo changes, color/style changes, and changes in products in use, which would age the photography. So, from a value-to-use standpoint, licensing the images for an unlimited period of time isn't cost-effective, both from that standpoint and the standpoint of an overall cost.

"For example, use of a single image for a period of six months in a full-page trade magazine ad would run around $2,500. For use in tradeshow displays, a three-square-foot panel for one show ranges from $400 to $750, and a six-square-foot panel usable for 36 tradeshows would range from around $2,800 to $5,600. Continuing to add brochures, sales materials, websites, and such for one to five years can begin to add up.

"A few figures for your review, single image:

▶ Unlimited non-exclusive use by your company in all print and electronic media formats, worldwide, for the term of Copyright: $25,000.

▶ Unlimited non-exclusive use by your company in all print and electronic media formats, worldwide, for the life of the helicopter: $21,000.

▶ Unlimited non-exclusive use by your company in all print and electronic media formats, worldwide, for 10 years: $17,000.

> ▶ Unlimited non-exclusive use by your company in all print and electronic media formats, CONUS, for the term of Copyright: $22,400.

> ▶ Unlimited non-exclusive use by your company in all print and electronic media formats, CONUS, for the life of the helicopter: $19,200.

> ▶ Unlimited non-exclusive use by your company in all print and electronic media formats, CONUS, for 10 years: $14,600."

NOTE

CONUS stands for Continental United States.

These terms gave the client several options and allowed them to make their decision based upon a choice. I also made a point of outlining for the client just how broad a use they would have for the image. Further, I specified "non-exclusive" because my initial client wanted use of the image as well, and I expected other broad uses of the image. The illustration of the extensive scope of use could also serve to have the client pare down their use if they wanted five years, three years, or all company materials except paid advertising placements, and they didn't want to pay the proposed figures.

Teaching People

If every time you speak to a prospective client, you capitulate on demands, you deserve the bad deal you get. Recently, we had a client experience where we sent them an estimate with our standard limited rights package. First, they called wanting to limit reuse, with the stated objective that the subjects didn't want to end up on my website or as stock. Okay, I can work with that. Then they wanted a broader rights package, then they wanted 10 years' use, then unlimited use. Then, when we outlined the additional fees that would apply, they balked, wanting to pay the original fees for the broadest of uses. Then they opted for just a five-year package, but again wanted not to pay any additional fees. Then when we stuck to our guns, they started in with, "Is that the best you can do?" to which I responded, "Yes," and stopped talking. Then they tried the "We are expanding in DC, will need photography in the future, want to be able to use you, and want to know whether this is the best you can do for us." I thought to myself, "Did I just hear an echo?" "Yes, this is the best I can do. You've expanded the rights package, and as such, the fees increase—that's only fair." "Okay, fine," was her response, and the deal was done.

The Power of the Upsell

If you've ever been to a fast-food burger shop, you've heard the question, "Would you like some fries with that?" Everyone I know—certainly almost everyone in the civilized world—has been upsold on something, from fries to dessert at the end of a meal that you didn't plan on having. Heck, "Would you like bottled water or tap?" is such a profit center for

restaurants that National Public Radio did a piece on it. Just how, then, can you upsell? Photo Packaging for Professional Photographers did a nice piece on the benefits of proper packaging/presentation, writing:

> That photograph would look absolutely lovely in a frame. Shall I show you our framing options? I can offer you a reduced price on the frame since you have already decided to buy from us.

Okay, though, if you're not in the retail photo business, what can you upsell as an editorial or corporate/commercial photographer?

Answer: Online galleries, retouching, e-mails, additional CDs, rush turnarounds, onsite printing, a second photographer, makeup services, and so on.

Clients who used to want a CD of the images can also be enlightened as to the benefits of an online gallery. When you have a client who is in your locale, but their client is across the country or around the world, being able to view and download the files is a very attractive offer. More and more, my clients are excited about the opportunity to view and download images from an online system.

Retouching is integral to many portraits we do, and many a client has expressed concern about bags under their eyes, pimples, facial blemishes, and wrinkles. Although we include a nominal/baseline amount of retouching for portraits we do for clients, extensive retouching, such as the removal of double/triple chins, tie changes, and so forth, are upsell options, and clients welcome this flexibility.

E-mails may be one of the many services that photographers simply give away. When we conclude an assignment, our work on behalf of that client ends until we sit down to do their post-production over the next 48 hours. (Our delivery commitment is that the post will be done in two business days.) However, many clients need immediate access to one to five images, meaning that our work for the client does not end when the camera is put away. We need to make time to immediately process the best images from the event and e-mail them. That extra work carries an additional charge—$65 for each image transmitted (and these are transmitted individually), to be exact—and many a client is more than happy to pay that. We often counsel the client to only request one or two because that's all they really need; however, I have had clients request as many as 27. You do the math.

Speaking of rush services, that, too, is a service we offer. We put the images in our queue and process images in the order they were shot. As you know, post-production takes time, even with the fastest computers. If the client wants to hop to the front of that line, that will incur a rush charge. For commercial/PR events with a normal turnaround of two business days, if the client wants it turned around in one business day, they add a 100-percent surcharge of the post-production charges to that. For same day/ASAP turnaround, they add 200 percent.

Extra CDs? No problem. Heck, design departments at ad agencies and design firms charge their clients $100 to make a copy of a CD. I charge comparably—50 percent of whatever the charge was for the first CD. So, if CD output of an assignment incurred a $75 charge, then it's $37.50 for a second CD. If the CD charge was $175, then it's $87.50. Just three days ago, a client ordered two additional copies of a CD. "No problem," we say.

Onsite printing, which is a staple of many an event photographer, is something we do only upon request. It's not something I regularly do or offer; however, we have the capability and do it upon request more than as an upsell. It can be cost prohibitive for the client, but if it's needed, we'll do it.

Sometimes an event is so large that one photographer can't do it alone. Rather than have the client search and shop around for a second photographer, we offer to provide one ourselves. There are many more reasons to handle it ourselves than the upsell, and that deserves its own blog entry—or you could read about it in Chapter 15.

Makeup often is a critical component of an assignment, so it's not always seen as an upsell. If we're responsible for paying the makeup person, it gets a nominal markup for our handling of it.

Last is the extended rights package. If the client is asking for one-time use, but you feel they'll want to use the images for other projects, offering that to them up front can generate additional assignment revenue and increase the benefit and usefulness of your images to the client in the long run.

There are many ways to increase your revenue on any given assignment. This increase is, of course, beneficial to you; however, in the end, the client truly sees the value in what you're offering, or they wouldn't choose to make the added expense. It just doesn't hurt to ask!

A Triumph of Hope over Experience

Remember when the client said, "I don't have much money, but if you'll do this one at this price, I will make it up to you with the next one?"

When hearing this, I am reminded of one of England's great literary figures, Oscar Wilde, who said that "while a first marriage is the triumph of imagination over intelligence, second marriages are the triumph of hope over experience." (This is sometimes also attributed to a Wilde predecessor, also a literary figure, Dr. Samuel Johnson.)

Bringing up a more timely analogy, as J. Wellington Wimpy said to Popeye, "I will gladly pay you Tuesday for a hamburger today."

In more than 20 years, I have never experienced this as a promise kept, and I have long since abandoned any hope.

What I have done is said, "Let me send you an estimate at the rates I can do this assignment for and then let's have a conversation." My estimate goes out, and I'd say that 80 percent of the time I complete the assignment at my rates, and moreover, those clients return time and time again.

Defining Your Policies

Policies work both ways. Your policy is to charge more on any given day than it costs you to be in business for that day. Period. Herb Cohen, author of *You Can Negotiate Anything*,

illustrates the points of policies, which can manifest themselves as a part of the "power of legitimacy" discussed earlier in the chapter, with an example of the Holiday Inn.

The Holiday Inn has a sign stating their checkout time, which is 11:00 a.m. The sign appears not only at the registration desk, but also on the inside of the door next to the fire route map and often on your registration paperwork. When Cohen was asked how many people actually check out by that time, he thought about it and answered, "Forty percent." Later, he learned from Holiday Inn themselves that "roughly between ninety and ninety-five percent" check out by that time. I often ask for, and almost always receive, an extension on my checkout time for no additional charge. Although it is necessary to have policies about how your business will function, it is necessary to know when there needs to be an exception to a policy.

Almost everyone I know has run up against an adamant customer service person who says (imagine a nasally voice here), "I'm sorry, sir. Our policy is that...and we just can't do that. Is there anything else I can help you with today?" We're frustrated and hoping that *something* can be done—an exception made, a rule bent. However, we accept the notion that our request is a special one, not to be expected. Even credit card companies can be convinced to waive a month's interest charges and penalties if your payment's a day late and you have a history of paying off your card every month. (Really, they do! I've been successful at that request.) However, they keep notes on every call you make to them and all requests made (even when declined), so don't try it too often. The point is, once you establish your policies, make sure you know where exceptions can be made and, more importantly, where they cannot.

Don't make exceptions on your ethical, moral, or legal policies. I subscribe to a point made by Norman R. Augustine, Chairman Emeritus of Lockheed Martin and Professor of Mechanical and Aerospace Engineering at Princeton University. When speaking to a group of business leaders, he said that "there is no higher responsibility than ethics, and ethics are founded on truth, and ethics is followed closely by one's own reputation."

You may make policy exceptions to a rate structure, a pro bono client, a late payment penalty, and such, but make sure you consider the exception and let the client know that you are making an accommodation and why.

The problem is, too many photographers fail to believe that they can have policies in the first place. Several seemingly silly policies that you probably have are:

> ▶ I will not set up the lights and adjust the camera to its proper settings and then hand it to the client to make the photos.

> ▶ I will not give a prospective client the names of my competition who will do the job for less than I will.

> ▶ I will not shoot an assignment naked. (It may be just me who has this one.)

> ▶ I will not be treated like a child or an imbecile by any client.

With those in mind, you undoubtedly have other policies that you've not stated, put in writing, posted for clients to see, or otherwise formalized. Once you outline your policies and you feel that, outside of the scope of a specific assignment's dealings, they are fair and reasonable, then you can begin to live by them. You'll be surprised by how a client reacts when you say, "It's not our policy to...." As was evidenced in Chapter 13 with an editorial magazine and elsewhere in this book, clients understand policies—they have them, too.

Deal Breakers: What Are Yours?

Everyone has deal breakers. Mine involve my "no naked photography" policy and no WMFH. Back in the dot-com era, I learned that high-tech companies need to pay in full before an assignment is completed, so my deal breaker for high-tech companies is "no pay, no play." This also extends to my work for political campaigns.

Deal breakers are similar to policies, but they are usually encountered in the negotiations process. Setting aside ethical, moral, and legal policies, which are given deal breakers, here are a few more:

▶ I won't work for a company that sells tobacco products or things I consider addictive. Having had loved ones die from cancer-related illnesses makes this a deal breaker for me.

▶ I won't sign a contract that includes a clause requiring binding arbitration unless, in rare cases, I feel it's in my best interests to do so.

▶ I won't sign a contract whose governing law is not workable for the client and me.

▶ I won't sign a contract that requires "all rights throughout the universe." That's just a stupid and offensive clause.

NOTE
Dictionary.com defines stupid as "marked by a lack of intelligence or care, foolish or careless," and goes on to another definition of stupid as "pointless; worthless."

▶ I won't deal with a client who thinks a photographer is an overpaid button-pusher.

Those are some of my deal breakers, among others. In the end, it's necessary to define your terms and what you will and won't accept and then to stick to it.

Why "No" Is One of Your Most Powerful Tools

It's true: If there weren't any no's in a negotiation, then you'd have an agreement. Your position is different than prospective clients', and your objective is to overcome as many of their no's as possible while minimizing the no's that you concede to. There are few true negotiations in which no's can't be surmounted. Sometimes a prospective client says, "Sorry, the contract's nonnegotiable—take it or leave it." Then you've been given an ultimatum, and if you aren't prepared—you have a zero bank account and an empty pantry—then you're at a steep disadvantage. You might as well take it...or leave it. Your fear of losing the assignment will reveal itself in how you discuss the assignment with the client, and your negotiations will be handicapped.

NOTE
A "take it or leave it" contract is not a meeting of the minds and can become what was mentioned in a previous chapter—a contract of adhesion.

Saying, "No, I just can't accept the assignment on those terms," or "No, I won't ask my assistant to also be the makeup person/stylist," or "No, you can't just do anything you want with the photos" can often be what changes the direction of the negotiations. Sometimes the client is just trying to see what they can get out of you, and sometimes it's a legitimate need they have to stay within a budget that might work in smaller Midwest towns but couldn't work in a major metropolis. Being polite during the "No, I can't" process is important. Be certain that during the conversation, you say something like, "But I'd be interested in working with you in the future on an assignment; please consider me then. Further, if the photographer you do end up with doesn't meet your expectations, I am happy to see whether we can accommodate a last-minute assignment for you."

A final point about "no." As Dick Weisgrau, the former Executive Director of the American Society of Media Photographers, once said during the first ASMP "Strictly Business" traveling program that I attended early in my career, "No photographer went out of business after saying 'no' to a bad deal, but many have done so by saying 'yes' to the bad deals." Weisgrau has written an extensive and well thought-out book, *The Photographer's Guide to Negotiating*, which is a must-read for a thorough examination of photographer-specific techniques and strategies for achieving success in negotiations.

Predicting the Future?

A wise philosopher once said, "You can never predict the future, only your responses to it."

Indeed.

I consider that one of my axioms. Every time the phone rings, I can see my responses to every question and follow-up question that will take place. I am not predicting the future, per se, but rather all the potential responses to what the future holds. I am almost never surprised by an inquiry. Rather, like the branches of a tree, I've travelled from trunk to branch to limb to twig to leaf so many times, along all the possible paths, that I am prepared. Some are short stumps of a limb, such as, "We want your copyright...," at which point the branch ends abruptly. We instead must tread in reverse to another branch that is more suitable, such as, "I will extend a license to use the work in all media for the life of the product." And we then trek farther down the branch that is sturdier and that is well worn by repeated visits. We arrive at a mutually beneficial agreement.

With a complicated travel plan from, say, New York City to San Francisco, a map is your answer book. So, too, should you map out how you'll respond to varied questions and inquiries. At first, you'll need to consult the map. After a dozen trips from NY to SF, you won't need the map. Then again, you'll need it part of the way from NY to LA. Then again, from NY to DC.

Prepare your responses. When you get stumped, don't cave. Ask the client whether you can call them back if you have to. Write down how you'll handle it. Perhaps instead you can say, "I think I have a solution. Let me put it in writing and e-mail it to you," and do just that. Get out of the hot seat and cool off; consider what they want and how you can give it to them reasonably and in a way that you are comfortable with. Then, memorialize it in writing and send it off.

This results in another of my axioms: "Luck is what happens when preparation meets opportunity."

Studying the Aftermath of a Lost Assignment

On one occasion, six or seven years ago, I got a call from the premier association of physicians in the US for press-conference coverage on Capitol Hill. They'd regularly used a photographer who was not available, and the work bounced from him to two friends and then finally to me. I quoted my normal event rate, which for a press conference ran into my minimum rate of around $650, including expenses, with a normal two-day turnaround of the proofs. Consistent with the Associated Press' charge of $100 to scan and transmit an image for someone who walked in off the street, I, too, would charge that rate upon request of a scan, and this was outlined in my contract. Further, my rate for same-day delivery of the proofs was a 200-percent surcharge on top of my normal $35/roll charge, meaning $105 per roll, and I'd shot three rolls at the press conference. Following the event, the client called for two scans to be transmitted and wanted the CD the same day, incurring the 200-percent charge as well. This assignment blossomed from $650 to $1,060, adding $200 in scans and a rush charge on the three rolls that added $70×3, or $210. The bill was sent and paid on time.

When they called the next time, they commended me for doing a great job the last time, and I made a point of asking whether they'd contacted their primary photographer. I make it a point not to steal a client referred by a colleague from the referring photographer. I just think that's bad form. The client said they had contacted their primary photographer (which I verified before sending the estimate), and I said it'd cost the same as last time, which they said was fine. I sent along another contract, which was signed and returned, and again, same charges.

This happened a total of four times. The client was happy, and I was too. I also made a point of conveying these figures back to the initial photographer, who'd only charged them a flat rate of $300 for everything for which I'd charged $1,060. I then learned, through a mutual friend, that the initial photographer was upset with me. Why? Because that association's photo budget was wiped out, and they couldn't hire photographers for another six months, so he had to wait for their new fiscal year before they could hire him (or anyone else) again.

I don't get it! This photographer should have instead learned how little he was charging and just how much the client was prepared to pay for the same services and then considered that perhaps he could/should raise his rates. Further, the client would have legitimate cause to go to their budget people and outline how their photo budget for the previous year was not enough, and they had several events they couldn't cover as a result of that. This would then allow for a strong argument to raise the budget—something that would benefit everyone.

Although this example is the analysis of a colleague's lost assignment from the standpoint of the photographer who ended up with the assignment, he failed to do what I am recommending: Think through what your experience was regarding the assignment and how you could have steered it to a different conclusion. Sometimes, the impasse is just too big; other times perhaps there isn't a full outline of the needs, and your understanding is different than the reality.

The first thing I do when I learn a contract didn't come through is ask, "Who'd you end up going with?" Most of the time they tell me. I then ask, "Was it a matter of price?" And when they say yes, I ask, "How much of a difference was there between the other photographer and me?" When they say they thought the other photographer's approach was different or more in line with their vision, I can accept that.

When there is a substantial price disparity or the other photographer "gave away the farm" for the assignment, that's when you might consider a cup of coffee with the other photographer. However, that might come across as sour grapes if not handled correctly or if you don't know the other photographer well. What I'll do is wait for a client we both were in a dialogue with and who selected me as the photographer for the assignment. Learning from the client who the other photographers were that vied for the contract and that the client ultimately selected me without shopping for the lowest price gives me an opportunity. Without taking a holier-than-thou approach, I'll take this opportunity to share my figures with the photographer who didn't get the assignment, who may have feared raising his or her rates. At no time do I say, "You need to raise your rates," or "We should agree to...." The fact that the photographer is looking at a contract that was awarded to a more expensive colleague may well give the photographer the fortitude to raise his rates the next time around, regardless of whether he is competing with me.

Whatever the circumstances surrounding a lost assignment, I encourage you to make a point of learning why each one was lost and what steps could be taken to avoid that outcome in the future.

Case Study: Science Competition

Several years ago, I was contracted to photograph an event in Washington—the awarding of a science medal to two students during a competition. The license was my standard one for events, and it expired after a year. On the reverse of the photographs was my copyright notice, phone number, and roll and frame numbers. A science book publisher, obtaining those proofs, wanted photographs of the students for a textbook on science and contacted me by telephone.

The initial inquiry came into my office while I was out on an all-day assignment. My office manager called to give me the details of the inquiry. I asked her to research pricing through the software resources we have, and I reached the conclusion that for the use they initially stated they were looking for pricing on, I'd quote $275 per image, or $550 total. The back and forth begins below, and note how when we provide a quote based upon the expanded usage, the media buyer for the organization steps in to attempt to negotiate downward. The end result that they wanted to spend was between $450 and $500. In the end, for both, they ended up paying just over $1,900.

Here, we've forwarded to them a selection of five images because they only had two in hand. The dialogue begins with that e-mail:

From: 'John Harrington'
Subject: Other images of the ██████████
Date: February 27, ████ 8:48:58 PM EST
To: '██████████' {'Photo Editor'}

████ —

Here are the images we have…they can be further enhanced/scanned, if you'd like. Best, John

From: '██████████' {'Photo Editor'}
Subject: Re: Other images of the ██████████
Date: February 28, ████ 10:50:22 AM EST
To: 'John Harrington'

Thank you for sending the images. We are going to use images 16 and 22 and we would love to get hi-res scans of them! Below is our intended usage…I just need your e-mail OK.

The rights we are requesting for image use are:
- Non-exclusive, World English language distribution including DODDS military schools;
- Student Edition/Teacher Edition combined units of 60,000;
- Minor revision granted for six (6) years (minor defined as less than 10% of the photo content changes from the original product), or until a major revision, whichever comes first.

Thanks again, ████

From: 'John Harrington'
Subject: Re: Other images of the █████████████
Date: March 1,████ 1:59:25 AM EST
To: '█████████████' {'Photo Editor'}

████ —

The rate I quoted you of $275 was for 60,000, English language only, US, as I mentioned, and your request, as outlined below, is broader than that. Here are adjusted numbers based upon your request, in an a la carte manner, with some additional options.

Media Use/Rights Licensed (PER IMAGE):

• Use in one edition of textbook: Non-exclusive, editorial North American (including DODDS military schools) English language rights as follows:

 • SE/TE print edition, press run = 60,000 – 1/4pg inside 275.00
 • Minor revision editions (<10% of contents) for 6 year period – 185.00
 • WORLD RIGHTS: 100% for world rights in one language, 200% for world rights in all languages. Expanded rights package discount available if licensed together (10%).
 • ADDITIONAL LANGUAGES: 25% for each additional language and/or each additional country.
 • *SE/TE CD-ROM, Adobe PDF Format 72dpi non-printable – 255.00
 • *Internet/extranet, 72dpi – 225.00

It appears as if you're not asking for CD/PDF/Internet, so, while those wouldn't apply, they also are not included. In the event you are planning on those or end up wanting that use, please let us know. For your request—print edition only, minor revisions editions for six years, you are looking at $275 + $185 = $460, and world rights adds 100%, totaling $920, less a 10% discount for multiple rights types, or $92, bringing the per-image total to $828.

Clearly, you've requested a much broader use of the image than our original conversation. If you want to add in the CD/PDF/Internet, let me know. We can provide images 16 and 22 via FTP, at 1/4 page specs—3×4, 300dpi.

Let me know if you'd like us to proceed with the high-resolution scans—the costs for those and any retouching are included in the above figures and will commence once we get word that these adjusted numbers are approved. Credit should read "©████ John Harrington" for both images.

Sincerely, John Harrington

From: '██████████' {Permissions Coordinator}
Subject: RE: Other images of the ██████████
Date: March 3, ████ 10:25:55 AM EST
To: 'John Harrington'

Dear John,

I am a Permissions Coordinator with ██████████████████. The email that you sent to ████ {'Photo Editor'} regarding the pricing of your images was forwarded to my attention. I have looked over the pricing that you have provided and it appears to be higher than the pricing we have received for similar images from other vendors for this project. The pricing that we have received has been around $450–$500. Any consideration that you can extend toward the pricing of your images would be greatly appreciated. Best regards,

████████████

From: 'John Harrington'
Subject: Re: Other images of the ██████████
Date: March 3, ████ 11:42:50 AM EST
To: '██████████' {Permissions Coordinator}

████████ —

Thank you for writing. As you know, these are images are not available through any other sources. As you are licensing two images, I will reduce the per-image figure from $828 to $750, provided payment is received within 30 days—preferably by credit card—a savings of over $150 of the previous quote. Understand, also, that we did not charge a research fee to locate and retrieve the images from our archives, and we are not charging any scanning or delivery fees.

Please let me know if you would like us to forward an invoice. The invoice will reflect the $828 per image licensing fee, the licensing language below, with a note outlining the deduction for timely payment that will reflect $750 per image. As noted earlier, Credit should read "©████ John Harrington".

Sincerely, John Harrington

From: '███████████' {Permissions Coordinator}
Subject: RE: Other images of the ███████████
Date: March 3, ████ 4:11:50 PM EST
To: 'John Harrington'
Cc: '███████████'

John – Thank you for your response. I am forwarding this on to Jennifer Modrell, who is also working on the project. She will contact you if our editorial group is still interested in using your images in our project. If so, we will use your original quote of $828 per image. Regards, ████████

From: 'John Harrington'
Subject: Re: Other images of the ███████████
Date: March 3, ████ 4:45:35 PM EST
To: '███████████' {Permissions Coordinator}

Heather – That's fine—it sounds as if you cannot make payment within 30 days, and thus would not be able to take advantage of the $150+ savings I was offering. If not, that's unfortunate; however, I look forward to hearing back from you. Sincerely, John Harrington

From: '███████████' {'Photo Editor'}
Subject: Re: Other images of the ███████████
Date: March 6, ████ 12:19:45 PM EST
To: 'John Harrington'

John – We would like the hi-res of IMG 22 and IMG 16. Thank you very much!

– ████

From: 'John Harrington'
Subject: Re: Other images of the ███████████
Date: March 6, ████ 2:04:43 PM EST
To: '█████████████' {'Photo Editor'}

████– Attached are the two images, scanned from the film. Please let me know if you would like any additional adjustments/size changes/etc.

Sincerely, John Harrington

From: '███████████████' {'Photo Editor'}
Subject: Re: Other images of the ███████████
Date: March 7, ████ 5:20:48 PM EST
To: 'John Harrington'

John,

Editorial has changed its mind and now they want to use the ████ in jeans instead of them being given the award. May I have the hi-res of the attached image?

Many thanks, ████

From: 'John Harrington'
Subject: Re: Other images of the █████████
Date: March 8, ████ 3:28:45 AM EST
To: '█████████████' {'Photo Editor'}

████ – Here are the two from that setting…I think one has better "eyes" than the one you were looking for, but here are both, 4"×6" at 300dpi. Best – John

From: '█████████████' {'Photo Editor'}
Subject: Re: Other images of the █████████
Date: March 8, ████ 4:36:13 PM EST
To: 'John Harrington'

John – Thank you for the speedy turnaround!!

From: '███████████' {Permissions Coordinator}
Subject: Invoice ██94
Date: May 4, ███ 4:22:39 PM EDT
To: 'John Harrington'

Dear John,

I'm writing in regards to your invoice # ██94 for our project ██████████
███████████. Our original request was 60,000 units; we would like to
extend the terms of your current invoice to planned sales of 100,000. Can
you tell me if there will be an additional fee for the additional units requested?
Please let me know if you have any questions, and I look forward to hearing
from you soon.

Best regards, ████████

From: 'John Harrington'
Subject: Re: Invoice ██94
Date: May 04, ███ 9:21 PM
To: '███████████' {Permissions Coordinator}

████████ –

We can and will forward you the details of that additional usage Friday. We
will revise the invoice #██94, unless you have already submitted it for
processing, in which case, we will invoice for the difference and provide you
with invoice #██94A for that purpose.

Regards, John

From: '██████████' {Permissions Coordinator}
Subject: Re: Invoice ██94
Date: May 05, ████ 3:45 PM
To: 'John Harrington'

Hello John,

Your invoice has not been submitted for processing. You may revise invoice #██94 for the total amount with the extended terms. Please let me know the details for these terms as soon as possible.

Best regards, ██████

From: 'John Harrington'
Subject: Textbook invoice
Date: May 11, ████ 11:03:12 AM EDT
To: '████████████ {'Photo Editor'}
CC: '████████████' {Permissions Coordinator}

██,

Attached is the revised invoice for the usage of the images in your textbook with the higher press run, totaling $1,904.40. Please let me know if there is anything else I can do for you.

JOHN HARRINGTON

P h o t o g r a p h y

2500 32nd Street, SE • Washington, DC 20020
Office: (202) 544-4578 • Fax: (202) 544-4579
Email: John@JohnHarrington.com

Invoice

Date	Invoice No.
03/06/███	███

Bill To: ███████████

	P.O. No.	Terms	Due Date
		NET 30	04/05/███

Description	Amount
Assignment: High-res scans of two photos from ███████████████ in 2001, rights as follows.	
Image 1	952.20
Non-exclusive, World English language distribution including DODDS military schools, Student Edition/Teacher Edition combined units of 100,000, Minor revision granted for (6) years (minor defined as less than 10% of the photo content changes from the original product), or until a major revision, whichever comes first.	
Image 2	952.20
Non-exclusive, World English language distribution including DODDS military schools, Student Edition/Teacher Edition combined units of 100,000, Minor revision granted for (6) years (minor defined as less than 10% of the photo content changes from the original product), or until a major revision, whichever comes first.	
NOTE: If payment is received in the next 30 days you may pay $750 each for a total of $1500.	

Federal ID #███████ Net 30 Days

Total	
	$1,904.40

Recommended Reading

Cohen, Herb. *You Can Negotiate Anything* (Jaico Publishing House, 2004).

Steinberg, Leigh. *Winning with Integrity: Getting What You Want without Selling Your Soul—A Guide to Negotiating* (Three Rivers Press, 1999).

Weisgrau, Richard. *The Photographer"s Guide to Negotiating* (Allworth Press, 2005).

Ziglar, Zig. *Secrets of Closing the Sale* (Revell; Updated Edition, 2004).

CHAPTER 16

Chapter 17
Protecting Your Work: How and Why

The thing about copyright is that it's your right. Hence "copy" and "right." You have been given a limited monopoly over your creative endeavors to give you the incentive to create more. After you're gone, and then after 75 years, your work belongs to your family or estate, and they can continue to benefit from your genius. Later, it becomes wholly owned by the public, and anyone can do whatever they want with your endeavors.

I think this is pretty great. I have been given the incentive to be a photographer. And I own my work. I can recall with great detail the environment surrounding most of the photos I've made. Often I can recall the weather, the challenges of the client, the lighting setup, and who was on that shoot, whether colleagues or assistants. That means the shoot is a piece of me, and I feel protective about these little pieces of me and how someone might use them.

It's the Principle of the Thing for Me

Don't confuse my incentive to be a photographer with greed or anything of the sort. I'd make images without being paid—although it's work, it's definitely not a job. However, when someone wants to exploit my work—pieces of me—for their own gain, I expect to be compensated for their use of my work.

For most editorial magazines, if they have 30 pages of advertising and 30 pages of editorial content, it's those 30 editorial pages that the subscriber/reader wants to see. They've agreed to page through the 30 pages of ads because the value of the editorial content is enough for them to do so. In some cases, such as a fall fashion magazine or an annual automotive magazine with the next year's line of cars, the ads may be a draw; however, these circumstances are the exception rather than the rule. So, if I have contributed a full-page image from an assignment, I have directly contributed to the value of the publication, and thus I should be compensated. If the magazine sells ad space at a rate of $18,000 for a full page, that means they earn $540,000 per issue from advertising. It's fair for me to be appropriately compensated for my contribution. In the circumstance of a corporate/commercial shoot, I am directly contributing to the sale of their product or the public perception of their company, and, again, compensation commensurate with their benefit is appropriate.

As a freelancer, the notion that these companies want to own the copyright, feel they deserve the copyright, feel they are entitled to it, or take the attitude that "I paid for it, so I own it" shows ignorance about the intent of the framers of the Constitution and the law today. Let's take a look at an example. If, when driving through New York City, a Californian comes to a stop at a stoplight and then makes a right on red, that driver will get a ticket. You can't expect that your explanation to the issuing officer ("But officer, I didn't know I couldn't do that!") will mean you don't get or don't deserve the ticket. Further, an infrequent Manhattan driver in Manhattan might make the same claim.

Someone who has never licensed photography is similar to the aforementioned California driver in Manhattan. For the driver, there may be some room to get a warning ticket. And the photographer may be afforded an explanation by a copyright owner about how he can and can't use the work created.

In the case of the infrequent Manhattan driver, he lives in New York City and is obligated to know his city's driving rules—just as the ad agency or publishing conglomerate must know about the rules of copyright and the consequences for an infringement.

To give you an understanding of just how much the founders of the United States valued the concept of copyright, consider this. The Constitution begins "We the People," and the first section—the *first*—stipulates what legislative powers are held by Congress, as well as who can be a member of Congress and who can be a Senator. In Section 8, the Constitution stipulates that Congress *shall*:

> "promote the Progress of Science and useful Arts, by securing for limited Times to Authors and Inventors the exclusive Right to their respective Writings and Discoveries;"

This limited exclusive right is the basis for US copyright. At the end of the chapter, I'll include suggested books that go into detail on how the US copyright is based upon English law. These books are excellent resources to understand the birth of copyright. This exclusive right delineation comes before a discussion of who can be the president and how. It comes before the rules and obligations of the states. Further, it comes before Constitutional corrections—things they forgot about or were wrong about and needed to fix or add—the Bill of Rights, ending slavery, the right to bear arms, and such, which became the various amendments to the Constitution. I say this because I hear all too often how copyright is not important to some photographers and that they don't really care or enforce their copyright.

Just as I get incensed over violations of a citizen's civil rights or prejudice against race or sex, I get angry on principle when people infringe on my right, given to me at the same time as senators and representatives, and before the president, and before the states, and before the right to bear arms, and before the numerous other amendments. The framers hundreds of years ago and people throughout time since have recognized the value of "useful arts" and sought within the first 1,600 words of a document that, without amendments, is approximately 4,500 words in length. When I hear a fellow artist say, "Oh, I really don't care about copyright," I find that offensive. I think that if "copyright" were to be substituted for "the right to keep and bear arms" or "the abolition of slavery" or "equal rights for men and women," almost everyone else would be offended by the artist's statement of disinterest. Yet it was these rights that were parts of the Bill of Rights—that were *amendments* to the

constitution. The basis for copyright was not an amendment; it was in the body of the Constitution. So I encourage anyone who "doesn't care" about copyright, who is willing to sell it for a minute fraction of what it's worth, or who looks at someone who is enthusiastic about protecting their own copyright with disdain to rethink their own principles and perspective. Yes, I believe in copyright laws, and you should, too!

Don't Steal My Work, Period

With the position I've described, I've found myself in several situations in which my work has been infringed. *Stolen* is a better word, but *infringed* is the technical term. To that end, use the term in dialogues when you're infringed. To that point, your work *will be* infringed. If you're displaying it, sharing it, or otherwise distributing it, I can practically guarantee that you will be infringed upon. If I told you that I could provide the same guarantee that you would have someone break into your house, would you buy an alarm? How about a guarantee that you'd have an auto accident at some point in your life—would you get insurance? I suppose the answer is the same in both cases. Trust me—you will have your work infringed. To that end, protect yourself.

That said, if you're unhappy about Adobe's requiring you to activate your software, thank the thieves. In an April 2005 interview with the *San Francisco Chronicle*, Adobe CEO Bruce Chizen said that one third of their revenue is lost to software thieves. I encourage you to learn more about piracy in general at sites such as www.bsa.org/usa/antipiracy, because piracy of software has similar arguments and issues as infringement in photography.

The software fotoQuote, which was the precursor to fotoBiz, was almost put out of business because photographers were stealing the software. Photographers steal Photoshop. They steal FTP software—even software that costs less than $40 is being infringed. I could not see my way clear to demand one cent from someone else who has stolen my work if I were infringing upon others' creative endeavors, whether software, movies, music, or the like. Further, if I can't afford something so absolutely integral to my business as Photoshop, then there are significant problems with my revenue totals—so much so that I can't afford an initial $600 and upgrades of $200 or so every 18 months for something I use for extended periods of time almost every day. Further, it is important to note that Adobe, as a normal part of their file-handling process, generates a unique document ID for every image it handles for you. This generated ID is unique to you—or more specifically, your registered version of Photoshop—because it integrates the serial number of the program into the ID. And, as any program evolves, you can expect this handling of your files and the legality (or lack thereof) of your installed version of Photoshop (as well as other applications) to be a growing issue as all software companies seek to combat piracy, just as you would like as many tools as possible to protect you from people stealing your photography.

Copyright: What Is It, When Is It in Effect, and Whose Is It?

Copyright is exactly that—the "right to copy." And, it includes the converse—"the right to preclude a copy." Copyright is also, as noted earlier, the right to display (that is, present—or not—in a gallery, on a website, and so on); the right to perform and the converse (prevent a performance of), which is not as prevalent an issue for photographs; the right to distribute or opt not to allow distribution; and a variation of the right to copy—that is, make a derivative (or, again, to preclude someone else from doing so). For photographers, producing work now causes your work to be copyrighted the moment the shutter closes and the image is fixed in a flash card chip (or on film if you're still so inclined). Were someone to steal that card and publish your work, you are protected—not as well as if you'd registered the work, but you're protected because you've been infringed. All you'd have to do is secure the file, compare the metadata that includes the camera's serial number in it, and then sue not just for infringement in federal court, but also for theft of physical property (the flash card) in civil court.

NOTE

In this instance, if the infringing publication did so within 90 days and you did not have the CF card, you could actually register the image within that 90 days and still sue for statutory damages.

Registering your works gives a greater extent of protection, and there are multiple books that go into great detail as to what the differences are between registered and unregistered work, so I will not endeavor to detail that in this book. I will simply state that you should register your work. Few, if any, attorneys will take an infringement case that involves unregistered images.

Although it might seem obvious, it's worth repeating: In almost all cases, unless you signed a work-made-for-hire document before the work was completed and fell into one (or more) of the nine categories previously listed in Chapter 7, as well as all the other conditions, the work is owned by you. If you instead signed a document that stipulated copyright transfer, then your work is not owned by you. If you are an employee of a company as a photographer, then the work you do for them on assignment is theirs, regardless of whether you signed or didn't sign anything. However, this book is geared more toward the freelance photographer (or the staffer who freelances on the side or wants to leave their employment for the freelance world).

Pre-Registration: How to Protect Your Work

Pre-registration has great promise for a number of different types of photography—movie set work, advertising that goes through multiple revisions or approvals, and such. It is a new service of the copyright office, and it is done online. You do not need to provide copies of the work; you just provide a description and other details about the assignment, and at least one of the images for the work that will ultimately be copyrighted has to have been made. For more information, visit www.Copyright.gov to learn more.

Registering Your Work with the Electronic Copyright Office

Before I get into the next section, it is important to discuss the latest offering of services by the Copyright Office—the Electronic Copyright Office, or eCO. Effective August 1, 2009, the fees for online registration are $35, but the Copyright Office has proposed that the $45 fee for the filing of a paper Form VA be increased to $65. Even with this, there are a number of problems that make using the eCO something I would advise you to avoid. Here are a couple of the problems:

▶ Unless you are registering images first published on the same date or in the same "unit" of publication (book, magazine, and so on), you cannot use the eCO to register your work. In other words, since I currently register together the work I produce during the course of a single month, I cannot do that on the eCO. Eventually, they will sort out this problem, but as of this writing, the Form VA (shown in Figure 17.1) and the Short Form VA are the only ways to register a group of published photographs with different publication dates in the same calendar year. You can, however, register groups of images that were unpublished together, even across years.

▶ For a long period of time between when the eCO was officially launched and about mid-2009, whatever you uploaded as a single file had to upload in a total of 30 minutes. That time, as of mid-2009, was increased to an hour. However, that means the single file you upload (that is, a compressed zip file of all the images) can't be bigger than about 11 MB if you are using a dial-up 56k modem and about 170 MB if you are using FiOS optical high-speed Internet. So, you will have to assess how many of your images will fit into a compressed zip file and still be at or below those file sizes. You can upload more than one zip file per registration, but the effective date of the registration will be the date of the last upload, not the first.

Once you decide to venture into the eCO and register your work, you'll want to first create a log-in. This is not an instantaneous process. You register, and then you'll get an e-mail confirming your registration. Be sure that you use the right web browser. For Macs, currently you should be using Firefox; for PC users Firefox or newer versions of Internet Explorer are usable.

Payments can be made either with a credit card or with a copyright office deposit account, which I recommend you set up. One potential interim solution that could be useful once the eCO accepts group registrations is that you can use the eCO to file your registration and then mail in your CD/DVD of images. The eCO website allows you to send in these hard-copy deposits as follows:

> You may submit an application and payment in eCO and then create and print a shipping slip to be attached to the hard copy(ies) of your work for delivery to the Copyright Office via mail/courier.

▶ You should see a Payment Confirmation screen upon completion of payment (if not, refer to the Troubleshooting section). Click the "Submit your work" button toward the top of the page.

▶ Click the Send by Mail link in the Deposit Submission table.

▶ Click the Shipping Slip link that appears in the Attachments table to generate a shipping slip to be attached to your work(s).

The shipping slip includes the correct mailing address and zip code for the class of work(s) being registered. To avoid misrouting, please be sure to attach a shipping slip directly to each work or set of works that you submit.

Eventually, programs such as Adobe Lightroom, Apple's Aperture, Microsoft's Expression Media, and others will all have plug-ins that will allow you to submit your registration from within the application, and the software will handle the uploads. Once that situation arises, I can see myself and many others fully embracing the eCO.

As the eCO continues to evolve, I want to encourage you to visitwww.copyright.gov/eco/ index.html. There you will find the main page for the eCO website. Near the top of the page, you will find an eCO Tutorial PDF that will show you the most current capabilities, as well as step-by-step instructions for exactly how to use the eCO system.

Registration: How to Register Your Work Systematically

This section provides an example of how we register my work using the Form VA. I encourage you to consider whether this registration method will be similar to yours, because this system might demystify the problems photographers have with filling out the forms. This system and the thoughts behind it will easily translate to the new eCO in terms of file naming, registration titles, and so on. For a vast majority of registrants who shoot on assignment, Figure 17.1 shows approximately the way the front side of your Form VA will look. You can download this version at my website: www.Best-Business-Practices.com/form_va_sample.pdf.

The document also includes comments as a form of "stickies" that will give you guidance as to how to enter the fields.

Form VA
For a Work of the Visual Arts
UNITED STATES COPYRIGHT OFFICE

REGISTRATION NUMBER

VA VAU

EFFECTIVE DATE OF REGISTRATION

Month Day Year

Copyright Office fees are subject to change.
For current fees, check the Copyright Office
website at *www.copyright.gov*, write the Copy-
right Office, or call (202) 707-3000.

DO NOT WRITE ABOVE THIS LINE. IF YOU NEED MORE SPACE, USE A SEPARATE CONTINUATION SHEET.

1

Title of This Work ▼
John Harrington Miscellaneous Published Photographs May 2006
(Ref# P0609), 4,378 files on 2 cds containing 4,378 photographs

NATURE OF THIS WORK ▼ See instructions
GROUP REGISTRATION/PHOTOGRAPHS
4,378 Photographs

Previous or Alternative Titles ▼

Publication as a Contribution If this work was published as a contribution to a periodical, serial, or collection, give information about the collective work in which the contribution appeared. **Title of Collective Work ▼**

If published in a periodical or serial give: **Volume ▼** **Number ▼** **Issue Date ▼** **On Pages ▼**

2

a

NAME OF AUTHOR ▼
John Harrington

DATES OF BIRTH AND DEATH
Year Born ▼ Year Died ▼
1966

NOTE

Under the law,
the "author" of
a "work made
for hire" is
generally the
employer, not
the employee
(see instruc-
tions). For any
part of this
work that was
"made for hire"
check "Yes" in
the space
provided, give
the employer
(or other
person for
whom the work
was prepared)
as "Author" of
that part, and
leave the
space for dates
of birth and
death blank.

Was this contribution to the work a "work made for hire"?
☐ Yes
☑ No

Author's Nationality or Domicile
Name of Country
OR { Citizen of USA
 Domiciled in

Was This Author's Contribution to the Work
Anonymous? ☐ Yes ☑ No
Pseudonymous? ☐ Yes ☑ No

If the answer to either
of these questions is
"Yes," see detailed
instructions.

Nature of Authorship Check appropriate box(es). **See instructions**
☐ 3-Dimensional sculpture ☐ Map ☐ Technical drawing
☐ 2-Dimensional artwork ☑ Photograph ☐ Text
☐ Reproduction of work of art ☐ Jewelry design ☐ Architectural work

b

Name of Author ▼

Dates of Birth and Death
Year Born ▼ Year Died ▼

Was this contribution to the work a "work made for hire"?
☐ Yes
☐ No

Author's Nationality or Domicile
Name of Country
OR { Citizen of
 Domiciled in

Was This Author's Contribution to the Work
Anonymous? ☐ Yes ☐ No
Pseudonymous? ☐ Yes ☐ No

If the answer to either
of these questions is
"Yes," see detailed
instructions.

Nature of Authorship Check appropriate box(es). **See instructions**
☐ 3-Dimensional sculpture ☐ Map ☐ Technical drawing
☐ 2-Dimensional artwork ☐ Photograph ☐ Text
☐ Reproduction of work of art ☐ Jewelry design ☐ Architectural work

3

a
Year in Which Creation of This Work Was Completed
2006
This Information
must be given
Year in all cases.

b
Date and Nation of First Publication of This Particular Work
Complete this information
ONLY if this work
has been published. Month May Day 01-31 Year 2006
United States of America Nation

4

See instructions
before completing
this space.

COPYRIGHT CLAIMANT(S) Name and address must be given even if the claimant is the same as the author given in space 2. ▼
John Harrington
2500 32nd Street, SE
Washington, DC 20020

Transfer If the claimant(s) named here in space 4 is (are) different from the author(s) named in space 2, give a brief statement of how the claimant(s) obtained ownership of the copyright. ▼

APPLICATION RECEIVED

ONE DEPOSIT RECEIVED

TWO DEPOSITS RECEIVED

FUNDS RECEIVED

DO NOT WRITE HERE
OFFICE USE ONLY

MORE ON BACK ▶ • Complete all applicable spaces (numbers 5-9) on the reverse side of this page.
 • See detailed instructions. • Sign the form at line 8.

DO NOT WRITE HERE
Page 1 of _____ pages

CHAPTER 17

Figure 17.1

Figure 17.2 shows the first field you'll enter (and this is one that will change with each registration—more on that later in this chapter). This field is for the title of your work. Here's mine. I will go into detail as to why I've titled the work this way later in the chapter.

Title of This Work ▼

John Harrington Miscellaneous Published Photographs May 2006 (Ref# P0609), 4,378 files on 2 cds containing 4,378 photographs

Figure 17.2

Figure 17.3 shows the second field you'll enter—the nature of the work. Technically, you'd just need to write "Photographs"; however, if you are doing a group registration (that is, a registration of works published on more than one day) and using this form, copyright regulations require that you'll need to use the two words "Group Registration" at some point within this Section 1. I have chosen this area of Section 1 because it makes the most sense. I have also chosen to include the quantity of images I am registering. Note that although I refer to them as "images," the copyright office best recognizes the word "photographs." The one caveat is that you'll need to modify the PDF that the copyright office makes available to allow for two lines—one for that text and then a second line that indicates the quantity and type, if you choose to do that. To do this, you'll only need to open the blank PDF once and change the field information. I have done this already, and you can download it from the aforementioned link.

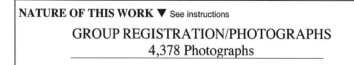

Figure 17.3

Fig 17.4 is fairly straightforward—type your name.Figure 17.5 is also fairly straightforward.

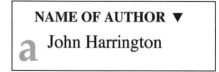

Figure 17.4

Note that when you click into the box, this small checkmark is entered. This is the way that the LOC form handles a check for their check box. I'd prefer an X that fills it, but this certainly works. You'll note this is the same elsewhere in the form. Because it was not a WMFH, nor will any of your other registrations be, checking this once and then leaving it as your default is easy.

> **Was this contribution to the work a "work made for hire"?**
> ☐ Yes
> ☑ No

Figure 17.5

Figure 17.6 is also self-explanatory. However, if you are a foreign citizen living in the US, you can register your work for protection. For more information on limitations/restrictions for foreign citizens, see the LOC instructions for this field.

> **Author's Nationality or Domicile**
> Name of Country
> **OR** { Citizen of ___ USA ___
> { Domiciled in ___

Figure 17.6

The form section in Figure 17.7 is obvious, and because you're interested in registering the work in your name, choose No for the contribution details. Note again the small checkmarks.

> **DATES OF BIRTH AND DEATH**
> Year Born ▼ Year Died ▼
> 1966
> **Was This Author's Contribution to the Work**
> Anonymous? ☐ Yes ☑ No If the answer to either
> of these questions is
> Pseudonymous? ☐ Yes ☑ No "Yes," see detailed
> instructions.

Figure 17.7

Figure 17.8 is again an obvious choice. Even if you're photographing jewelry design, you, as a photographer, are registering the photograph, not the design, nor the work of art, and so on. Enter the checkmark once and leave it.

> **Nature of Authorship** Check appropriate box(es).**See instructions**
> ☐ 3-Dimensional sculpture ☐ Map ☐ Technical drawing
> ☐ 2-Dimensional artwork ☑ Photograph ☐ Text
> ☐ Reproduction of work of art ☐ Jewelry design ☐ Architectural work

Figure 17.8

Figure 17.9 obviously changes once a year. This is not when the work was published, but when the work was completed.

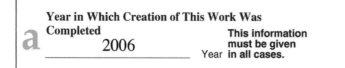

Figure 17.9

Figure 17.10 shows one other field that will change for each registration of published works. If unpublished, these fields are blank. However, if you are indicating group registration in Section 1, then you'll need to indicate the range. It does not need to be monthly. For example, you could enter April–June in the Month field and 28–11 in the Day field. The Month field is limited in the content, and the Day field is also limited, in the LOC version, to two characters. I have modified mine, which you can download, or you can do that yourself.

These dates should be the date of publication. Further, the Copyright Office will accept (and you should seriously consider including above the Date field) the terms "approximately," "not before," "not after," and "on or about." We have begun adding these additional descriptors and permanently including them on the registration form separate from the modifiable Month/Date fields. Adding in this information will provide for greater clarity should you wind up in court and the dates are challenged. I'll address the arguments of published versus unpublished and how I, in consultation with my attorney, derive the "date of publication" at the end of this chapter, in the section entitled "Definitions: Published versus Unpublished—the Debate."

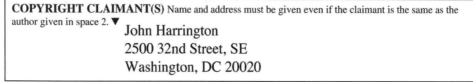

Figure 17.10

Although the field in Figure 17.11, too, is obvious, here's a note to consider. You'll want to choose an address that will change as infrequently as possible. Further, there is a system within the Copyright Office to file a change of address form with them.

> **COPYRIGHT CLAIMANT(S)** Name and address must be given even if the claimant is the same as the author given in space 2. ▼
> John Harrington
> 2500 32nd Street, SE
> Washington, DC 20020

Figure 17.11

Here we are on Page 2, as you can see in Figure 17.12. It's a fairly easy back-of-the-form entry, and the main thing that will change is the date that accompanies your signature.

EXAMINED BY	FORM VA
CHECKED BY	

☐ CORRESPONDENCE
Yes

FOR
COPYRIGHT
OFFICE
USE
ONLY

DO NOT WRITE ABOVE THIS LINE. IF YOU NEED MORE SPACE, USE A SEPARATE CONTINUATION SHEET.

PREVIOUS REGISTRATION Has registration for this work, or for an earlier version of this work, already been made in the Copyright Office?

☐ **Yes** ☒ **No** If your answer is "Yes," why is another registration being sought? (Check appropriate box.) ▼

a. ☐ This is the first published edition of a work previously registered in unpublished form.

b. ☐ This is the first application submitted by this author as copyright claimant.

c. ☐ This is a changed version of the work, as shown by space 6 on this application.

If your answer is "Yes," give: **Previous Registration Number** ▼ **Year of Registration** ▼

5

DERIVATIVE WORK OR COMPILATION Complete both space 6a and 6b for a derivative work; complete only 6b for a compilation.

a. Preexisting Material Identify any preexisting work or works that this work is based on or incorporates. ▼

b. Material Added to This Work Give a brief, general statement of the material that has been added to this work and in which copyright is claimed. ▼

6

a
See instructions
before completing
this space.

b

DEPOSIT ACCOUNT If the registration fee is to be charged to a Deposit Account established in the Copyright Office, give name and number of Account.

Name ▼ **Account Number** ▼

John Harrington

7

a

CORRESPONDENCE Give name and address to which correspondence about this application should be sent. Name/Address/Apt/City/State/ZIP ▼

John Harrington
2500 32nd Street, SE
Washington, DC 20020

Area code and daytime telephone number (202) 544-4578 Fax number (202) 544-4579

Email John@JohnHarrington.com

b

CERTIFICATION* I, the undersigned, hereby certify that I am the

check only one ▶

☒ author
☐ other copyright claimant
☐ owner of exclusive right(s)
☐ authorized agent of _____
Name of author or other copyright claimant, or owner of exclusive right(s) ▲

of the work identified in this application and that the statements made by me in this application are correct to the best of my knowledge.

8

Typed or printed name and date ▼ If this application gives a date of publication in space 3, do not sign and submit it before that date.

John Harrington **Date** June 00, 2006

Handwritten signature (X) ▼

X _____

Certificate will be mailed in window envelope to this address:	**Name** ▼ John Harrington	YOU MUST: • Complete all necessary spaces • Sign your application in space 8
	Number/Street/Apt ▼ 2500 32nd Street, SE	SEND ALL 3 ELEMENTS IN THE SAME PACKAGE: 1. Application form 2. Nonrefundable filing fee in check or money order payable to *Register of Copyrights* 3. Deposit material
	City/State/ZIP ▼ Washington DC 20020-1404	MAIL TO: Library of Congress Copyright Office 101 Independence Avenue, S.E. Washington, D.C. 20559-6000

Fees are subject to change. For current fees, check the Copyright Office website at www.copyright.gov, write the Copyright Office, or call (202) 707-3000.

9

*17 U.S.C. § 506(e): Any person who knowingly makes a false representation of a material fact in the application for copyright registration provided for by section 409, or in any written statement filed in connection with the application, shall be fined not more than $2,500.

Rev: August 2003—30,000 Web Rev: June 2002 ♻ Printed on recycled paper U.S. Government Printing Office: 2003-496-605/60,029

Figure 17.12

Figure 17.13 applies when you're trying to do advanced registration types beyond what I am hoping you'll achieve—a general registration of your work in the first place. There are numerous reasons why these fields are valuable and important; however, if you're doing anything other than choosing No, you'd do well to follow the instructions accompanying the form, available from the LOC website. In presenting this, I am taking the position that you are systematically registering work you shoot on assignment or on spec, that you are not registering work as published that you previously registered as unpublished, that you are the copyright claimant and that someone else (in other words, your agent or coauthor) did not previously register the work, and that you're not registering a retouched version of a work previously registered.

PREVIOUS REGISTRATION Has registration for this work, or for an earlier version of this work, already been made in the Copyright Office?

☐ Yes ☑ No If your answer is "Yes," why is another registration being sought? (Check appropriate box.) ▼

a. ☐ This is the first published edition of a work previously registered in unpublished form.

b. ☐ This is the first application submitted by this author as copyright claimant.

c. ☐ This is a changed version of the work, as shown by space 6 on this application.

If your answer is "Yes," give: **Previous Registration Number** ▼ **Year of Registration** ▼

Figure 17.13

Figure 17.14 is applicable if you have a deposit account. I do, and it's under my name, but I've blanked the account number so hooligans don't start charging their registrations to my account. Set up your own account; it's easier than sending in a check every time, and you can easily replenish it with a credit card.

DEPOSIT ACCOUNT If the registration fee is to be charged to a Deposit Account established in the Copyright Office, give name and number of Account.
Name ▼ **Account Number** ▼

John Harrington

Figure 17.14

In Figure 17.15, if the copyright office has a question or concern, this is the address and other contact information they will use to correspond with you about it. Otherwise, this field will not really be used for anything.

CORRESPONDENCE Give name and address to which correspondence about this application should be sent. Name/Address/Apt/City/State/ZIP ▼

John Harrington
2500 32nd Street, SE
Washington, DC 20020

Area code and daytime telephone number (202) 544-4578 Fax number (202) 544-4579

Email John@JohnHarrington.com

Figure 17.15

For Figure 17.16, if you're having someone legally act on your behalf to fill out and sign the form, they should choose Authorized Agent, or if you have rights to the work being registered, choose the Other Copyright Claimant or Owner of Exclusive Right(s) option. In all likelihood, you'll choose Author and be done with it.

Figure 17.16

For Figure 17.17, enter your name as you'll sign it below. For the date, we leave the 00 in the field, just to remind us that it's not complete until we know when we are going to the LOC to drop off the package. If you're registering work and mailing/shipping it to the Copyright Office, enter in the date you signed the document. The actual date of registration is the date the Copyright Office receives the form. For me, I sign it the day I am taking it down and dropping it off to them by hand, so the effective registration date and this date match.

> **Typed or printed name and date ▼** If this application gives a date of publication in space 3, do not sign and submit it before that date.
> John Harrington
>
> Date June 00, 2006

Figure 17.17

Figure 17.18 is important because it is this field that will show through the window of the envelope they use to send back your completed registration form. So, type clearly and include your ZIP+4 zip code (obtainable at www.usps.com) to make it arrive faster and more efficiently. Further, when you key in your address to get your Zip+4, you'll get how the post office prefers to have your address look. Follow their lead on this.

Certificate will be mailed in window envelope to this address:	Name ▼ John Harrington
	Number/Street/Apt ▼ 2500 32nd Street, SE
	City/State/ZIP ▼ Washington DC 20020-1404

Figure 17.18

At this point, you have your own PDF template. Save it as such. You'll more than likely never go back to change almost all of the fields, save for the ones I am about to outline. This makes these few changes fast, simple, and efficient. Now, on to the fields for which there are changes.

CHAPTER 17

Title of the Work

I considered a number of methodologies to determine my nomenclature for naming my registrations. I consulted a number of people on the subject, most notably photographer Jeff Sedlik, who is also an expert in copyright litigation. He's not an attorney, but when it comes to copyright, he's an invaluable resource if you are taking someone to court and need an expert on the subject. I considered the following titles for my registrations when cataloging an entire year's worth of work:

▶ John Harrington 1999 Collection 01 11,841 Photographs

▶ John Harrington 1999 Catalog 01 11,841 Photographs

▶ John Harrington 1999 Volume 01 11,841 Photographs

Although technically the title of your work does not matter to the Copyright Office—and further, it does not affect the rights you have—there's a problem with these titles. Using the words *volume*, *catalog*, or *collection* might cause the person you're suing (or more correctly, his or her lawyer) to attempt to make the claim that their infringement of six of your photographs from that registration is only a single infringement of a collective work, which would limit your statutory award to a maximum of $150,000, whether it's six or sixty images infringed from that registration. Although this is not likely—in fact, I'd go so far as to say it'd be unlikely—avoiding that risk simply by being clearer in your title would be beneficial.

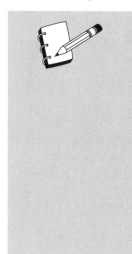

NOTE

A word about the inevitable infringement you'll experience. Although there is no case law I am aware of, and you are technically protected just as much by registering a single image as you are 10,000, this argument—that multiple images infringed that were a part of a single registration only qualify as one infringement of one work—regardless of titling, could be a method of diminishing your damages. Further, where there is a maximum award of $150,000 per infringement, and you registered 1,000 images in that single registration, an attorney on the other side might try to divide $150,000 by 1,000 and argue to your attorney and perhaps a less-than-knowledgeable judge that you should only be entitled to $150 per infringed image. I think this argument is dubious at best, and more accurately, fatally flawed. It's the only reason (in addition to the "collective work" claim) that I can find to not register as many images in one registration as possible.

For works, I resolved to use the following titling nomenclature for an entire year's worth of work:

John Harrington Miscellaneous Unpublished Photographs 1999 (ref#U0608), 1,102 files on 2 CDs containing 11,841 photographs.

This naming nomenclature—annually delineated—is how I handled the titling when I needed to go backward to register work previously unregistered. Note the difference between the number of files and the number of photographs. In this case, the file was a single image

of a 20-slide slide page, and it was important to note that the file is not "the image," but that the file/image is a functional device to document the 20 images on the page, so I wanted to draw that distinction.

> **NOTE**
>
> It's important to note that each slide page contained from one to twenty images, and when the caption changed, the slide page changed. This allowed for maximum flexibility in my filing system. Therefore, each page had a date associated with when the image was produced, and this was the filename it would be assigned. Often, it was a news event with the date of the news event on the slide mount caption label. Where there may be some ambiguity in the exact date, see the Figure 17.22 notes later in this chapter. In a clear case in which a page of photographs was taken on May 1, 1994, the filename would be 19940501_NW_001.jpg, where I assigned NW to refer to the images' category "Newsmaker Washington" and others for other types. A submission, even with that filename, was followed up on by the Copyright Office, who requested a date associated with each file, so I produced a word processing document that included the filename along with the date and included that as a part of the submission. This satisfied the Copyright Office examiner. They might have preferred the official continuation form they offer, but it was not required. Yes, this took some time, but I was able to do it during downtime on assignments while waiting for a subject, assign it to someone who works for me when they had spare time while watching a batch process complete, or do it on trips from Point A to Point B.

Once I had caught up, I then registered images by month. In the instance that I was publishing *unpublished* work, each month was named as follows:

> John Harrington Miscellaneous Unpublished Photographs May 2006 (ref#U0605), 4,378 files on 2 CDs containing 4,378 photographs.

In this nomenclature, the ref#U0605 is my own assigned reference number. The U indicates the images were unpublished, 06 is the year, and 05 indicates it was the fifth registration for 2006. To remain consistent with the "by year" registrations and because someday I might need to again register more than one photograph per file, I continue to notate the number of files and photographs separately. Further, I indicate that there are two CDs so that they do not mistakenly believe that they're duplicates, but rather that each contains separate files.

I fill in that entire title in the Form VA Title of Work field, as in Figure 17.19.

Title of This Work ▼

John Harrington Miscellaneous Published Photographs May 2006 (Ref# P0609), 4,378 files on 2 cds containing 4,378 photographs

Figure 17.19

With respect to published work:

> John Harrington Miscellaneous Published Photographs May 2006 (ref#P0605),
> 4,378 files on 2 CDs containing 4,378 photographs.

Note the P within the reference. In this, the P is not a published subset of the U registration, but rather, just an example of how I would do the same registration were it a group of published photographs.

Nature of This Work

Section 202.3 - Registration of Copyright, section b, subsection 9, part vii, states in part, "The applicant must state 'Group Registration/Photos' and state the approximate number of photographs included in the group in space 1 of the application Form VA." Now, I have indicated that I place that text under Nature of This Work; however, part vii goes on to stipulate "under the heading 'Previous or Alternative Titles' (e.g., 'Group Registration/ Photos; app. 450 photographs')." In a meeting I had with examiners of the Copyright Office, I questioned the clarity of this point, because this is descriptive and not a title, and they stated that the text "group registration/photos" or "group registration/photographs" appearing anywhere within Section 1 of the application would meet the regulation, and as such, I notated that in the Nature of This Work subsection of Section 1, as you can see in Figure 17.20.

NATURE OF THIS WORK ▼ See instructions

GROUP REGISTRATION/PHOTOGRAPHS

4,378 Photographs

Figure 17.20

I encourage you to make your own determination as to what you want to do with this information and these insights in mind.

Year in Which Creation of This Work Was Completed

This is pretty straightforward. Of course, there are always exceptions. If the assignment started December 31, suppose your assignment was to document the change of the New Year. In that case, your assignment would be completed on January 1 at, say, 1 a.m. Although I would register them with a date of January 1 because that was when the assignment was completed, your attorney might feel differently. Ask your attorney, since he would be the one defending the infringement on your behalf. Figure 17.21 shows this field on the form.

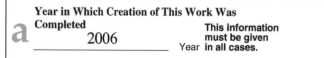

Figure 17.21

Date and Nation of First Publication of This Particular Work

If you're registering unpublished work, leave this section blank and skip over this text. For published work (and I make the assumption that it's published in the USA), as previously noted, a range is acceptable. There is, again, an indication that you may use the continuation form, but it is not required.

b Date and Nation of First Publication of This Particular Work
Complete this information ONLY if this work has been published.
Approx.
Month ___ May ___ Day ___ 01-31 ___ Year ___ 2006 ___
United States of America ___ Nation

Figure 17.22

This, from the Copyright Office:

> The Office recognizes that some commenters have previously expressed the view that photographers sometimes have difficulty knowing exactly when—or even whether—a particular photograph has been published. With respect to date of publication, it should be noted that the Office's longstanding practices permit the claimant some flexibility in determining the appropriate date. See, e.g., Compendium of Copyright Office Practices, Compendium II, Sec. 910.02 (1984) (Choice of a date of first publication).... The Compendium of Copyright Office Practices, Compendium II, Sec. 904 states the Office's general practice with respect to publication, including that "The Office will ordinarily not attempt to decide whether or not publication has occurred but will generally leave this decision to the applicant." 1) Where the applicant is uncertain as to which of several possible dates to choose, it is generally advisable to choose the earliest date, to avoid implication of an attempt to lengthen the copyright term, or any other period prescribed by the statute. 2) When the exact date is not known, the best approximate date may be chosen. In such cases, qualifying language such as "approximately," "on or about," "circa," "no later than," and "no earlier than," will generally not be questioned. Further in the regulations, it states "The date of publication of each work within the group must be identified either on the deposited image, on the application form, or on a continuation sheet, in such a manner that one may specifically identify the date of publication of any photograph in the group. If the photographs in a group were not all published on the same date, the range of dates of publication (e.g., January 1–March 31, 2001) should be provided in space 3b of the application."

Further, this from the Copyright Office's 37 CFR Part 202, [Federal Register: July 17, 2001 (Volume 66, Number 137)] [Rules and Regulations] [Page 37142-37150]:

> Each submission for group registration must contain photographs by an individual photographer that were all published within the same calendar year. The claimant(s) for all photographs in the group must be the same. The date of publication for each photograph must be indicated either on the individual image or on the registration application or application continuation sheet in such a

manner that for each photograph in the group, it is possible to ascertain the date of its publication. However, the Office will not catalog individual dates of publication; the Copyright Office catalog will include the single publication date or range of publication dates indicated on the Form VA. If the claimant uses a continuation sheet to provide details such as date of publication for each photograph, the certificate of registration will incorporate the continuation sheet, and copies of the certificate may be obtained from the Copyright Office and reviewed in the Office's Card Catalog room.

Sign and Date

Again, the field in Figure 17.23 is pretty obvious, but it's a field you can't forget to overlook! Make sure to sign and date the form!

Typed or printed name and date ▼ If this application gives a date of publication in space 3, do not sign and submit it before that date.
John Harrington

Date June 00, 2006

Figure 17.23

Archival

We have a system for how we archive our registrations. Each registration submission form is filed in its own file folder, along with a duplicate of the CD that was submitted to the Copyright Office. When we receive the final certificate, that original document is filed in the file folder, and they are stored safely. If you are someone who has a fair amount of spare time, scanning and converting both sides of the document into a PDF might serve you well in the future. Further, there is a significant fee to have another original registration form produced from the Copyright Office, so treat these as valuable as a birth certificate. In a way, that's one of the things it stipulates—who the images belong to and when they were created.

Definitions: Published versus Unpublished–the Debate

Language on the Copyright Office website, derived from the copyright regulations, defines publication as such:

> "Publication" is the distribution of copies or phonorecords of a work to the public by sale or other transfer of ownership, or by rental, lease, or lending. The offering to distribute copies or phonorecords to a group of persons for purposes of further distribution, public performance, or public display, constitutes publication. A public performance or display of a work does not of itself constitute publication. 17 U.S.C. 101.

This means that displaying your work in a gallery is probably not publication. My position, and one which my attorney has stated he is comfortable defending, is this:

> I undertake assignments for which I am paid. There is a part of the contract that requires the client to pay, and there is also a part of the contract that grants rights to the client that allow them to further distribute the work to their clients, subscribers, viewers, or the like. We offer to our clients all images produced under the assignment, and their purpose is to further distribute that work or display it publicly, and thus, it meets the requirement for publication. As such, at the conclusion of each month, we begin the process of burning a CD of all the images we produced on assignment for clients, stipulating the dates as the first date of the first assignment and the last date of the last assignment—since we offer to clients the opportunity to have the images delivered to them same day, and they dictate when they would like to receive them.

My recommendation is that you establish a relationship with a good copyright attorney and solicit from him or her guidelines for your specific circumstances that the attorney is comfortable defending on your behalf.

If, despite all your best efforts to determine the answer during the course of your registration, you still are not sure whether to register your images as published or unpublished, you should register as published. The reason for this is that the Copyright Office will allow you to amend your copyright registration from published to unpublished; however, you cannot amend from unpublished to published. Be sure to consult an attorney to reaffirm this for you.

As to "group of persons," there is little significant case law that I am aware of that properly defines this term. That group could be two or three photo editors or a photo editor and another designer, or it could be the entirety of the staff of the publication, since they have access to and are participating (on various levels) in the distribution of the work to the public.

In the event that I am shooting work for a photo agency—even supposedly speculative assignments—their intent, as well, is to further distribute it. Further, the posting of images on a website in and of itself does not constitute publication, especially if it's a hidden section of your website. However, if it's in a section, such as on the PhotoShelter online delivery platform, where there is an offering to license the work for a fee, that would constitute an offering for the purposes of further distribution and would meet the "published" requirements.

Further, the rulings in many cases state that the distribution of just a single copy to a single company or individual can constitute publication. Although case law deals with differing degrees of use and the inevitable inconsistencies among the various courts as to interpretation, an overarching guideline is whether a copy (and a copy can include an original) was distributed with restrictions on the further distribution or use of the copy. The only real reason that "published" mattered was that the origins of federal copyright required work to be published in order to enjoy the benefits of copyright, and that is the basis for much of the confusion that exists today.

Recommended Reading

Duboff, Leonard D. *The Law, In Plain English, for Photographers* (Allworth Press; Revised edition, 2002).

Krages, Bert P. *Legal Handbook for Photographers: The Rights and Liabilities of Making Images* (Amherst Media, 2001).

Lessig, Lawrence. *Free Culture: How Big Media Uses Technology and the Law to Lock Down Culture and Control Creativity* (The Penguin Press HC, 2004).

Litman, Jessica. *Digital Copyright: Protecting Intellectual Property on the Internet* (Prometheus Books, 2000).

Patterson, Lyman Ray. *Copyright in Historical Perspective* (Vanderbilt University Press, 1968).

Thierer, Adam D. and Wayne Crews. *Copy Fights: The Future of Intellectual Property in the Information Age* (Cato Institute, 2002).

Vaidhyanathan, Siva. *Copyrights and Copywrongs: The Rise of Intellectual Property and How It Threatens Creativity* (New York University Press; Reissue edition, 2003).

Chapter 18

The Realities of an Infringement: Copyrights and Federal Court

As noted in Chapter 17, copyright infringement is not a matter of *if*, it's a matter of *when*. Knowing this, like knowing, say, that you will likely have your home broken into at some point, allows you to plan for this eventuality. Photographers covering a football game will, in addition to their long lenses on monopods, also wear (usually around their neck and at the ready) a body and a wide lens, planning on the likelihood that a pass will come their way and they'll want the shot. We carry more than one memory card in case we need it, and we have numerous other solutions that mean protection from the unknown eventuality. That said, you'll want to be prepared for what you can expect.

What to Do When You're Infringed

When you discover an infringement, get upset. Someone has just stolen something from you. Surely you get upset when your wallet is stolen, or your car, your money, or any other asset you've worked hard to earn. One day, I was walking the halls of Congress with John Sebastian, a well-known musician, and I was accompanying him to then-Rep. Sonny Bono's office for a meeting on protections for songwriters. I asked him how he handled copyright infringements. He responded that infringements are like water in a sieve: "You'll never catch them all, but when you do, go to the hilt to protect yourself and your work." I thought this was pretty good advice.

Now that you've gotten all worked up, stop and think about how it occurred. Was it lifted from your website or your agent's website, or was it a client who assigned you to shoot something for a prescribed fee and associated license and then used it beyond that scope, either maliciously or accidentally?

I often find that the infringement is a use by a preexisting client who was not versed in the limitations of their license. However, I have experienced outright theft of my work. Typically, my approach is to consider the facts of a situation and either call an attorney or, without limiting my "down the line" options, send my own cease-and-desist letter if the use is ongoing. If I am going to seek compensation, I will weigh very carefully my predilection to send a demand for $X compensation of some sort, because the establishment of that figure

could hinder future negotiations. Further, as John Sebastian pointed out, you may not fully know the extent of the infringement until you inquire informally (via e-mail, correspondence, and so on) or you learn through discovery (the legal procedure).

When you've gotten yourself together and given the situation some thought, begin to gather all the facts you can. These facts range from contracts signed by the client, to e-mail dialogues between you and the client, to proof of the infringement when it's ongoing (for example, a PDF printout of the website), to photographs of a billboard that has your image, and so on. Collect whatever proof you have that your work was infringed.

The most important thing will be to obtain your Copyright Registration Certificate for the registration that contains that image. You didn't have it registered? Well, register it right away. I mean today. That registration is your ticket into federal court. Without it, you may not file a copyright infringement suit, and the first thing that will happen when your attorney contacts the client's attorney is that the client's attorney will ask, "Was the alleged infringing image registered?" Once the Copyright Office has received the paperwork, as of that date the work is registered, so the truthful answer will be, as of the day after it was sent via overnight express, "Why yes, that image was registered." Of course, the next question will be "When?" And your attorney will have to then defer this answer, if possible.

This brings me to the "should I get an attorney" question, and the short answer is an emphatic yes! The long answer is also yes, but more on how/why/when later in this chapter. If you go it alone, you'll be at a disadvantage because you will be dealing with an attorney on their side who knows all too well how to distract, evade, diminish the value of your work, and collect statements from you that could come back and have a negative impact on your case.

Timeline of an Infringement

First things first: You'll become aware of the infringement. Whether you stumble across it or search for it because you thought it might exist or a colleague tells you about it, the genesis of your circumstances is your awareness of it. This, however, should not be confused with when the infringement began or the extent of it. The infringement could have been going on for some time, in many areas and in numerous media. Do not assume that the first time you became aware of it is when the infringement started.

Types of Infringers

Because there are numerous types of infringers, I would first reach out to the infringing party. The following sections discuss the most likely ones, but the list is by no means complete. These simply are the ones you are most likely to encounter and my approach to them.

The Preexisting Client

For preexisting clients, the infringement may be an oversight. I tend to take a lighter approach to dealing with these types of infringements. Usually, an amicable resolution can be achieved, especially when it's fairly easy to see what the original terms were, and a

reasonable person will conclude that the infringement is outside of that scope. However, the settlement is not typically the same fee you'd have charged had they negotiated this use in advance. The settlement is for a *retroactive license* and is much more costly than if things had been handled correctly in the beginning.

The Third Party Who Legitimately Obtained Your Image(s) but Is Using Them Outside of the Scope of the License

In some instances, you might have licensed a portrait to a client for publicity surrounding an event. As a result, the client distributed the image(s) to the news media, who may have legitimately used the image in a story about the client, but then two years later, when that individual leaves the company or is at another company, your photo may reappear outside of the term of the license time-wise or not in conjunction with the original commissioning party. When you point this out to the publication—often a newspaper—they will begin by stating their file photo policy, but that doesn't mean that the policy can be the basis for protection from an infringement, especially if there was a sticker or imprint on the reverse of the print with your name/contact information/rights granted/term of granting or that same information was in the metadata of a file. You will also likely find yourself settling these types of infringements.

Case Study: A Quickly Resolved Infringement

I was photographing the inventor of a device that almost every American uses at least three to four times a week. This device was being inducted into a museum, and I was contracted by a party affiliated with the device to photograph the induction ceremony. I did, and the images were distributed to the news media. Although it was appropriate to use the image of the inventor with the device, repurposing the photograph into an online encyclopedia that one media conglomerate had was not consistent with the rights granted. A brief dialogue with the infringing party resulted in a reasonable settlement agreement.

A Licensor Who Stated One (or a Limited, Smaller) Use and Who Is Using It in a Much More Expansive Way

These folks can sometimes be deceitful. They may decide they only want to pay a few hundred dollars for a quarter-page one-time use in a 5,000 press run brochure, and so they make that statement. Then, they run off tens of thousands of brochures or use the image in more than one brochure or in a larger size. Sometimes with a change of personnel there might be an attempt to suggest the infringement was innocent or accidental, but even in an accident such as between two drivers, someone has to pay the wronged party. I feel that for this type of infringement, especially when it was a lower press run that turns into a larger one, a much more aggressive approach should be taken. Depending upon the extent of the infringement, although a settlement is likely, it might take a formal filing of an infringement claim to force constructive settlement talks.

A Potential Client Who Reviewed/Considered Your Work and Stated They Were Not Using It, but Then Did

This type of infringement is, in my book, worse than outright theft. To me, there's outright malice in this infringement. In short, more often than not they lied to avoid paying you, and you caught them. Sure, I accept that there are circumstances in which an "innocent" mistake or oversight might have occurred, but that doesn't mean there are not consequences for this. I'd be much more inclined to bring a claim early, because I don't take kindly to thieves.

The Outright Thief

These folks often—especially with online uses and blogs—misappropriated your work from your website. Sometimes a cease-and-desist letter is all that is really necessary (discussed in Chapter 22, "Letters, Letters, Letters: Writing Like a Professional Can Solve Many Problems"). However, sometimes an aggressive approach directly to the legal department and a call to your attorney are warranted sooner rather than later.

But there are others, such as the company who contacted you for stock use of an image and who stated that they'd just shoot their own when you quoted your licensing fee—and theirs is really a copy of yours. And, there are a number of other infringers.

From this point, you'll come to a determination that either a settlement or a formal court filing is necessary. A settlement is going to be most likely when the infringing party recognizes their error, and you then go through the motions of coming to an understanding of the scope of the misuse. There is then a determination on your part of what you would have charged and what you feel is fair as a retroactive licensing fee. A court filing will come into play if the infringing party feels they had the right to use the image or is otherwise unwilling to be reasonable in their negotiations with you.

Rather than try to spell this out as 1) You'll file, 2) They'll respond with a request for dismissal, 3) You'll respond, 4) There will be depositions, 5) There will be pretrial motions, 6) There will be a trial, 7) There will be a verdict, I'll try to explain it somewhat differently.

An infringement suit will take years to resolve. All the while, you will be incurring charges for every e-mail exchange your attorney has on your behalf with you and/or the defendant, as well as all their time reviewing case law and drafting memorandums, and so on. The expenses of an infringement suit can easily grow to $50,000 to $100,000 when all is said and done. In the end, when the images are registered, all these bills are often paid by the infringing party (as is allowable by law for registered images), but they are not a factor when the image was not registered beforehand, save for your inclusion of consideration of the bills when engaging in settlement talks. Thus, the cost and difficulty of registering are grossly outweighed by the successful conclusion of even one case of infringement.

When to Engage an Attorney

The short answer to the question of when to engage an attorney is as soon as possible. You'll be a "newbie" to the process, at least for the first infringement you have to handle, and an attorney will use his or her years of experience to ensure that you (and your rights) are not

trampled on or limited. In all candor, an attorney's willingness to take the case will in large part be based upon whether you've registered your images in a timely manner prior to the infringement in question.

An attorney will know to ask about other uses. He will not make statements such as, "We'll be charging three times the original licensing fee," because that will limit your ability to make a larger claim later. He will appropriately press for other infringing uses, and he will be taken seriously when he calls the infringing party's legal counsel. In most cases, a call by you will not be taken seriously or even routed to the proper company officials. You will be at a disadvantage.

Before an infringement occurs, take the time to find a local attorney. Usually, meeting with the attorney the first time is free, when you simply are indicating you'd like to be able to call upon the attorney when you're infringed. This first meeting gives you a chance to decide whether you like this person, and the attorney can decide whether you're someone he'd want to represent. This preliminary meeting should cost you nothing, but it should give you peace of mind, knowing just who you'll actually call when you write to an infringing party, "You'll be hearing from my attorney." Make sure, though, that your attorney is qualified to be handling this type of case!

There are several resources that can assist you in hiring an attorney. My first recommendation would be to seek out word-of-mouth recommendations from colleagues. If you are not satisfied with those recommendations or you are not getting the information that way, I would recommend contacting a professional association you are a member of (such as ASMP, APA, NPPA, PP of A) or reviewing ads in photo-related trade journals, such as *Photo District News*. Typically, attorneys who have aligned themselves with photo-trade organizations or are actively pursuing that line of business are likely to be more aware of photo-related infringement issues and case history.

Settlement Agreements

A settlement agreement takes a basic form:

> ▶ We did nothing wrong, and this agreement does not admit wrongdoing.
> ▶ You've made a claim, and this agreement does not validate that claim.
> ▶ We both agree that a settlement for $XX,XXX is in both parties' best interests to resolve this matter.
> ▶ You agree not to sue us about this ever again.
> ▶ (Optional) We both agree to the nondisclosure of this agreement's terms or payment.

During the course of "official settlement talks," your correspondence will usually include a sentence such as "in an effort to pursue non-judicial avenues for a settlement of this matter, this offer is made without prejudice and made for the sole purpose of settlement." Absent that type of a sentence, correspondence about your offers could be disclosed during a trial, which could severely limit your ability to collect above and beyond the figures you cite,

which is why sending an invoice for three times what you would have originally charged, or even a letter offering a retroactive license for that amount of money, could be a problem.

One other thing to be aware of: If you do go to trial, often attorneys will (at least 10 days before trial) make a Rule 68 offer of judgment, which can put you in a problematic position. Suppose you have opted to sue for $75,000 for the infringements, and those you are suing offer you $20,000 as their offer of judgment. If you reject (let lapse) the offer, it could come back to haunt you. Suppose, when all is said and done, you win the trial, but the court awards you just $15,000. Because the infringer's offer of judgment was greater than the final court award, the infringer can present their offer of judgment to the court, and then you will in all likelihood be compelled by the court to pay most of the court costs that were incurred by the infringer from the date of their offer of judgment until the end of the trial. Thus, you would likely lose much (if not all) of what you won.

During a settlement agreement, you'll want to make sure you can bite your tongue over the "we did nothing wrong" clause. That's pretty standard, and the likelihood that you'll get an admission of wrongdoing in your settlement agreement is very slim. Further, the nondisclosure clause is one to which you must adhere. Make sure that it includes "shall not further disclose," because in the course of your negotiations, you have no doubt consulted with colleagues and shared terms of the proposed agreement, and you cannot be responsible for their nondisclosure.

In just a moment, you'll see the basic outline of a settlement agreement, in which the infringement was by a preexisting client. Understand that whatever you might get from their legal department will likely not look as fair as this one, at least initially. Usually their company will want a clause that "saves and holds harmless" them, should you do something you shouldn't, but they won't initially include that same precaution for you. Further, in Term 3 of the agreement, make note of this information:

> *Photographer* does hereby forever release and discharge *infringer...* from any and all claims... **now known**, and *Photographer* hereby states *Photographer* knows of no other disputes, claims, causes of action, ... as of the date of the execution of this agreement, arising from or related to the use of the Photographs by *infringer....* [bold added]

This is an important term, and one that probably won't be in their proposed agreement, because it's beneficial to you. Specifically, it protects you in the event that you only brought to their attention the one infringing use you found, and it agrees to a settlement for that infringement. Should you become aware of other infringements down the line, they are not protected.

Further, the "collectively" definition below should be your last name and their company name, not the generic terms I've used for this example, where a preexisting client had infringed.

So, without further ado, here it is:

RELEASE, SETTLEMENT AND LICENSE AGREEMENT

This "Release, Settlement and License Agreement" (the "Agreement") is effective as of the date on which this Agreement is executed by all of the parties (the "Effective Date") by and among: [infringing party and address] on behalf of itself and its subsidiaries (collectively "*infringer*," [your name and address], an individual, (collectively "*Photographer*").

WHEREAS, *infringer* entered into an agreement with *Photographer* to photograph [x, y, and z, as applicable] and to license *infringer's* use of those photographs for [original terms of contract];

WHEREAS, on or about [initial date of infringement], *infringer* [uses stated that were not a part of the original contract];

WHEREAS, in [date of first contact with infringer], *Photographer* contacted *infringer* objecting to the use of the Photographs;

WHEREAS, *infringer* immediately acceded to *Photographer* 's demand and *infringer* ceased the objected uses of the Photographs by *infringer*; and

WHEREAS, the parties desire to amicably resolve the controversies between them by this Agreement.

NOW, THEREFORE, for good and valuable consideration, the receipt and adequacy of which is hereby acknowledged, the parties hereto agree as follows:

(1) *Photographer* hereby grants *infringer* a non-exclusive, non-transferable, license to use the Photographs for [initial non-contractually allowed infringing use]. *Photographer* represents and warrants that (a) *Photographer* owns all copyrights in the Photographs necessary to grant the License to *infringer*. Photographer shall at all times indemnify and hold harmless infringer from and against any and all claims, damages, liabilities, costs and expenses, including reasonable outside counsel fees, arising out of the breach by Photographer of the aforementioned representation and warranty.

(2) *infringer* hereby represents and warrants that their exercise of any license of the Photographs has not, nor does not, infringe on any third party right, including but not limited to individuals depicted in the Photographs, and that *infringer* is solely responsible for securing any releases, permissions, or other paperwork necessary to effect releases or permissions for any individuals depicted in the Photographs, and is responsible for any payments to depicted individuals that result from the aforementioned releases or permissions. *infringer* shall at all times indemnify and hold harmless *Photographer* from and against any and all claims, damages, liabilities, costs and expenses, including reasonable counsel fees, arising out of the breach by *infringer* of the aforementioned representation and warranty.

(continued)

(3) *Photographer* does hereby forever release and discharge *infringer*, their respective parent companies, subsidiaries and affiliated business organizations, successors, present and former employees, officers, directors, assigns, agents and representatives from any and all claims, causes of action, losses, disputes, liabilities and demands of whatever kind or character, now known, and *Photographer* hereby states *Photographer* knows of no other disputes, claims, causes of action, losses, disputes, liabilities or demands as of the date of the execution of this agreement, arising from or related to the use of the Photographs by *infringer* (hereinafter "Claims").

(4) *infringer* agrees, within five (5) business days of the Effective Date, to provide a single payment to *Photographer* in the total amount of $XX,XXX.XX U.S. dollars via wire transfer. *Photographer* has provided *infringer* with the bank account information required in order for infringer to effect such a wire transfer payment to *Photographer*. *Photographer* acknowledges that *infringer*'s provision of the foregoing consideration is made in full settlement of all Claims referred to herein and *Photographer*'s license grant in Section (1) above.

(5) Effective as of the Effective Date, the parties hereto agree not to disclose the terms of this Agreement to anyone. This is a material provision of this Agreement. In furtherance of this material provision, the parties agree that they shall not at any time publicize or cause to be publicized, by any oral or written communications to any third person whatsoever, the facts or circumstances surrounding the claims resolved by this Agreement, or the terms, conditions, or negotiations of this Agreement. The parties agree, however, that the confidentiality provisions contained herein do not apply as to any inquiry by federal or state tax authorities, or in response to a discovery request in litigation, lawful subpoena or court order.

(6) It is understood and agreed by the parties that this Agreement is in compromise of a disputed claim and that consideration paid is not to be construed as an admission of liability on the part of *infringer*.

(7) This Agreement contains the entire agreement of the parties with respect to the matters covered by this Agreement. No other agreement, statement or promise made by any party, or any employees, officer or agent of any party, which is not contained in this Agreement shall be binding or valid.

(8) If any term, provision, covenant, or condition of this Agreement is held by a court or regulatory body of competent jurisdiction to be invalid, void, or unenforceable, the rest of the Agreement will remain in full force and effect and shall in no way be affected, impaired, or invalidated. Furthermore, in lieu of such illegal, invalid, or unenforceable provision, there will be added automatically as a part of this Agreement a provision as similar in terms to such illegal, invalid, or unenforceable provision as may be possible and legal, valid and enforceable.

(continued)

(9) The parties agree that this Agreement may only be modified by an instrument in writing duly executed by an authorized representative of each of the parties hereto.

(10) The parties hereto state that they have carefully read this Agreement, that they fully understand its final and binding effect, that the only promises made to them in signing this Agreement are those stated above, and that this Agreement is executed freely and voluntarily after consideration of all relevant information and data.

(11) This Agreement shall be construed and interpreted in accordance with the laws of the State of [your state, or theirs, depending upon how you negotiate].

(12) This Agreement may executed in multiple counterparts, each of which shall be an original as against the parties who signed it and all of which shall constitute one and the same document. Any facsimile signature of any party hereto shall constitute a legal, valid and binding execution by such party.

IN WITNESS WHEREOF, the undersigned have executed this Agreement on the dates specified below.

[They sign, you sign.]

One final note about settlements. Corporations typically have insurance or a sizeable bank balance that will cover them in the event of a loss that results from an infringement claim. Do not let your settlement negotiations become personal. The company can outspend and out-lawyer you tenfold. Be fair and be reasonable when considering settlement offers and making responses to them. I'll paraphrase from the movie *Top Gun*, where the lead character, Maverick, was dangerously showing off during a flight school demonstration and was admonished, "Don't let your ego write checks that your body can't cash." So, too, don't let your ego write checks that your bank account can't cash.

Case Study: A DMCA Violation

More and more, you will find infringers on the Internet—from the mindset of "If I found the photo on the Internet, it must be okay to copy" to "What harm was done? I put the photo up on the Internet. It's not like I am selling copies or it or making money from it." These and countless other examples will be the response when you tell someone that they have infringed your copyright by placing images of yours on the Internet without your permission.

Fortunately, the Internet service providers that own the computers that make up the Internet did not want to be held legally liable for any copyright infringements committed by their customers. Enter the Digital Millennium Copyright Act. In short, the DMCA stipulated that the Internet service providers couldn't possibly police what their customers were uploading to the Internet and that, they should not be liable for the acts of their customers. The DMCA provides that these corporations provide clear contact information and are responsive to the requests of copyright owners to remove the infringing images, these corporations were absolved of liability in these instances.

The good thing about this is that you don't actually have to go to court and get a judgment against these companies in order to file a "DMCA takedown notice"; you need only make a statement to the person in charge of DMCA at the corporation that the image is yours, and they will remove it. This does not preclude you from bringing suit against the person or company that did the infringing, but it does give you the tools to get the infringing to stop. Further, the people at each of the corporations that own those computers approach DMCA compliance very seriously, unlike the people who are posting images with reckless abandon and disregard for your intellectual property rights.

Here is one example. The corporation that owns the computers is Google, the infringer is a blogger, and the copyrighted photos are mine.

I happened to stumble upon my images on a blog hosted on the Blogger platform. The first thing you do is go to Network Solutions and do a WHOIS search, as shown in Figure 18.1. You can find Network Solutions at www.NetworkSolutions.com.

Figure 18.1
A WHOIS search at Network Solutions.

At WHOIS, you are able to determine who owns a particular website address, but most importantly, you are able to determine the *name* of the server where the entire website is stored, sometimes referred to as *domain server*. Enter the top-level domain name plus the .com/.org/.net extension, as shown in Figure 18.2. The top level is the information working backwards from *before* the .com, .org, or .net to the first dot. So, the top-level domain for johnharrington.com is johnharrington, and the top-level domain for widgets.xyzcompany.org

would be xyzcompany. As a result, you want to look at the information under NAMESERVER (or Domain Server) near the bottom. In this case, the nameserver listed is ns2.google.com with backup servers ns1.google.com, ns4.google.com, and ns3.google.com. Those are the servers that would send the website in the event that the first nameserver—ns2.google.com—is down.

Figure 18.2
Enter the top-level domain name plus extension.

Figure 18.3 shows the resulting page when I looked up blogspot.com.

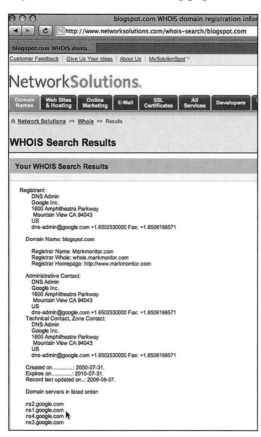

Figure 18.3
Information about blogspot.com.

With the nameserver information, head over to copyright.gov. At the homepage, visit the link for Online Service Providers, as shown in Figure 18.4.

Figure 18.4
Choose the Online Service Providers option.

Once you click there, you will see the page that talks about DMCA and explains why every nameserver owner interested in limiting their liability has listed themselves in this database (see Figure 18.5). Some ISPs may be resellers or under a parent company's ISP, so you may need to do some research.

On that page, you can click to browse the directory of the agents that each of the companies has designated to take your DMCA takedown notice. In this case, I clicked that link to locate Google, as shown in Figure 18.6.

There, a few scrolled pages down, is Google, Inc. Clicking on that link brings up a PDF that Google submitted to the Copyright Office with their contact information. Figure 18.7 shows that PDF. The Copyright Office redacted the actual signature that was on the document, and I redacted the person's name.

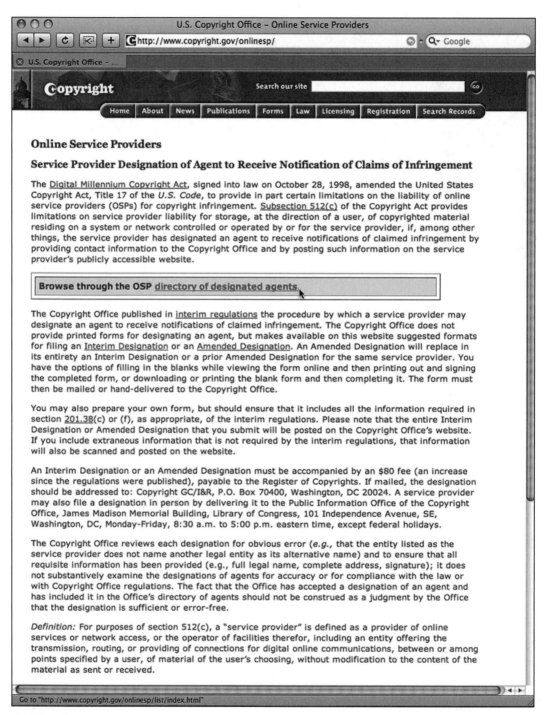

Figure 18.5
Information about DMCA.

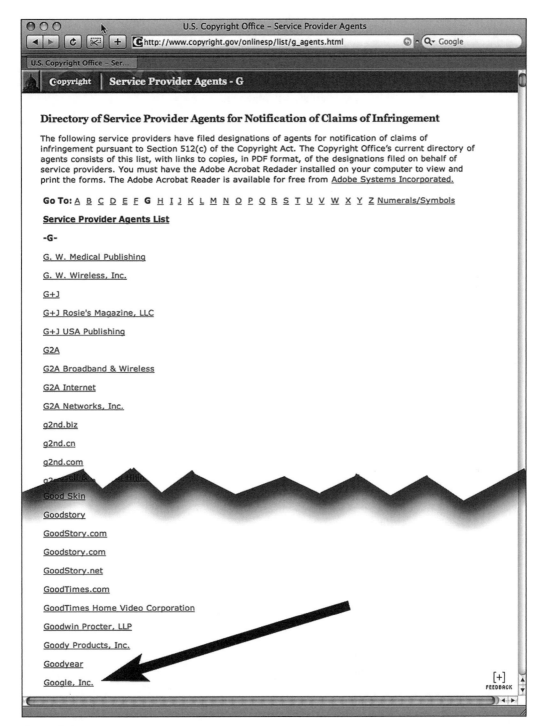

Figure 18.6
Locating Google in the directory of agents.

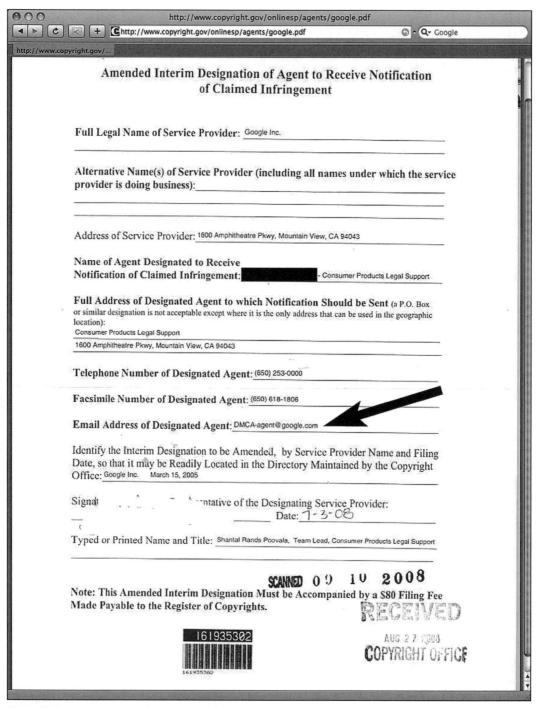

Figure 18.7
Google contact information for a takedown notice.

Although I've made this a very detailed step-by-step process, it is really easy and quick to do. Now, with the contact information, I begin my dialogue with the point of contact at Google:

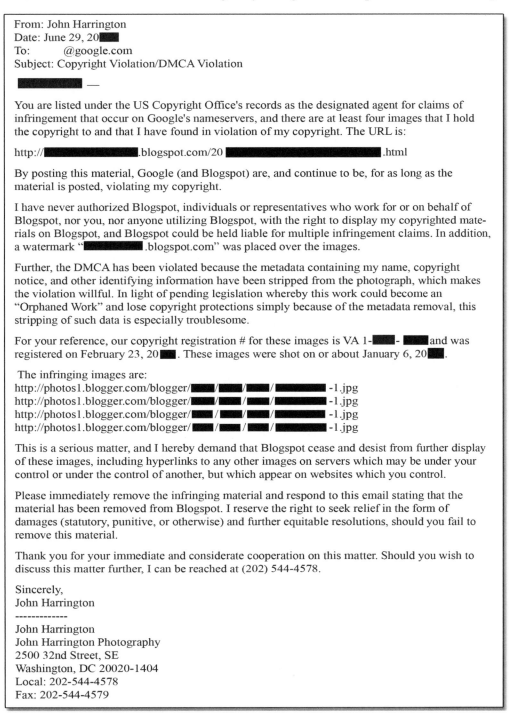

From: John Harrington
Date: June 29, 20██
To: @google.com
Subject: Copyright Violation/DMCA Violation

██████████ —

You are listed under the US Copyright Office's records as the designated agent for claims of infringement that occur on Google's nameservers, and there are at least four images that I hold the copyright to and that I have found in violation of my copyright. The URL is:

http://█████████████.blogspot.com/20██████████████████████.html

By posting this material, Google (and Blogspot) are, and continue to be, for as long as the material is posted, violating my copyright.

I have never authorized Blogspot, individuals or representatives who work for or on behalf of Blogspot, nor you, nor anyone utilizing Blogspot, with the right to display my copyrighted materials on Blogspot, and Blogspot could be held liable for multiple infringement claims. In addition, a watermark "████████.blogspot.com" was placed over the images.

Further, the DMCA has been violated because the metadata containing my name, copyright notice, and other identifying information have been stripped from the photograph, which makes the violation willful. In light of pending legislation whereby this work could become an "Orphaned Work" and lose copyright protections simply because of the metadata removal, this stripping of such data is especially troublesome.

For your reference, our copyright registration # for these images is VA 1-████-████ and was registered on February 23, 20██. These images were shot on or about January 6, 20██.

The infringing images are:
http://photos1.blogger.com/blogger/████/████/████/████████-1.jpg
http://photos1.blogger.com/blogger/████/████/████/████████-1.jpg
http://photos1.blogger.com/blogger/████/████/████/████████-1.jpg
http://photos1.blogger.com/blogger/████/████/████/████████-1.jpg

This is a serious matter, and I hereby demand that Blogspot cease and desist from further display of these images, including hyperlinks to any other images on servers which may be under your control or under the control of another, but which appear on websites which you control.

Please immediately remove the infringing material and respond to this email stating that the material has been removed from Blogspot. I reserve the right to seek relief in the form of damages (statutory, punitive, or otherwise) and further equitable resolutions, should you fail to remove this material.

Thank you for your immediate and considerate cooperation on this matter. Should you wish to discuss this matter further, I can be reached at (202) 544-4578.

Sincerely,
John Harrington

John Harrington
John Harrington Photography
2500 32nd Street, SE
Washington, DC 20020-1404
Local: 202-544-4578
Fax: 202-544-4579

Within 24 hours, Google's contact responded with the following e-mail:

From: "Blogger Help" support@blogger.com
Date: June 29, 20█
To: john@johnharrington.com
Subject: [#63530000] Alleged copyright violation on ███████.blogspot.com

Hello John,

Thank you for your e-mail of 6/29/█ to ████ ████████ regarding your claims of copyright
infringement on ████████.blogspot.com/ ████/ ███████████.html. To comply with your request to
remove the copyrighted images, please submit a DMCA notice of infringement to u
s by fax or mail. Instructions to file such notice follows:

It is our policy to respond to notices of alleged infringement that comply with the Digital Millennium Copyright
Act (the text of which can be found at the U.S. Copyright Office website: http://lcWeb.loc.gov/copyright/) and
other applicable intellectual property laws, which may include
removing or disabling access to material claimed to be the subject of infringing activity.

To file a notice of infringement with us, you must provide a written communication (by fax or regular mail, not by
email) that sets forth the items specified below. Please note that pursuant to that Act, you may be liable to the al-
leged infringer for damages (including costs and attorneys' fees) if you materially misrepresent that you own an
item when you in fact do not. Indeed, in a recent case (please see
http://www.onlinepolicy.org/action/legpolicy/opg_v_diebold/ for more information), a company that sent an in-
fringement notification seeking removal of online materials that were protected by the fair use doctrine was or-
dered to pay such costs and attorneys' fees. The company agreed to pay over $100,000. Accordingly, if you are
not sure whether material available online infringes your copyright, we suggest that you first contact an attorney.

To expedite our ability to process your request, please use the following format (including section numbers):

1. Identify in sufficient detail the copyrighted work that you believe has been infringed upon. This must include
identification of specific posts, as opposed to entire sites. Posts must be referenced by either the dates in which
they appear or the permalink of the post. For example,
http://example.blogspot.com/archives/2003_01_21_example_archive.html#2104575.

2. Identify the material that you claim is infringing upon the copyrighted work listed in item #1 above.

YOU MUST IDENTIFY EACH POST BY PERMALINK OR DATE THAT ALLEGEDLY CONTAINS IN-
FRINGING MATERIAL. The permalink for a post is usually found by clicking on the timestamp of the post.

3. Provide information reasonably sufficient to permit Blogger to contact you (email address is preferred).

4. Include the following statement: "I have a good faith belief that use of the copyrighted
materials described above on the allegedly infringing web pages is not authorized by the
copyright owner, its agent, or the law."

5. Include the following statement: "I swear, under penalty of perjury, that the information in the notification is
accurate and that I am the copyright owner or am authorized to act on behalf of the owner of an exclusive right
that is allegedly infringed."

6. Sign the paper.

7. Send the written communication to the following address:

Google, Inc.
Attn: Blogger Legal Support, DMCA complaints
1600 Amphitheatre Pkwy
Mountain View, CA 94043

OR Fax to:
(650) 618-2680, Attn: Blogger Legal Support, DMCA complaints

Sincerely,
The Blogger Team

It is important to note what Google is saying. Google is warning you against making false claims, and moreover, with items 4 and 5 you are swearing to the truth of your claim. So, I copied my e-mail into a Word document, added in the two statements they required, and sent it, signed:

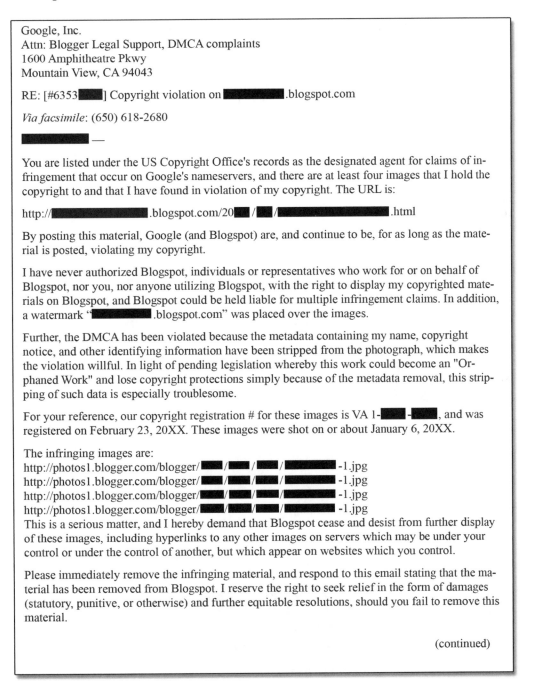

Google, Inc.
Attn: Blogger Legal Support, DMCA complaints
1600 Amphitheatre Pkwy
Mountain View, CA 94043

RE: [#6353█████] Copyright violation on ████████.blogspot.com

Via facsimile: (650) 618-2680

████████ —

You are listed under the US Copyright Office's records as the designated agent for claims of in-fringement that occur on Google's nameservers, and there are at least four images that I hold the copyright to and that I have found in violation of my copyright. The URL is:

http://████████.blogspot.com/20██/██/████████████.html

By posting this material, Google (and Blogspot) are, and continue to be, for as long as the mate-rial is posted, violating my copyright.

I have never authorized Blogspot, individuals or representatives who work for or on behalf of Blogspot, nor you, nor anyone utilizing Blogspot, with the right to display my copyrighted mate-rials on Blogspot, and Blogspot could be held liable for multiple infringement claims. In addition, a watermark "████████.blogspot.com" was placed over the images.

Further, the DMCA has been violated because the metadata containing my name, copyright notice, and other identifying information have been stripped from the photograph, which makes the violation willful. In light of pending legislation whereby this work could become an "Or-phaned Work" and lose copyright protections simply because of the metadata removal, this strip-ping of such data is especially troublesome.

For your reference, our copyright registration # for these images is VA 1-████-████, and was registered on February 23, 20XX. These images were shot on or about January 6, 20XX.

The infringing images are:
http://photos1.blogger.com/blogger/████/████/████/████████-1.jpg
http://photos1.blogger.com/blogger/████/████/████/████████-1.jpg
http://photos1.blogger.com/blogger/████/████/████/████████-1.jpg
http://photos1.blogger.com/blogger/████/████/████/████████-1.jpg
This is a serious matter, and I hereby demand that Blogspot cease and desist from further display of these images, including hyperlinks to any other images on servers which may be under your control or under the control of another, but which appear on websites which you control.

Please immediately remove the infringing material, and respond to this email stating that the ma-terial has been removed from Blogspot. I reserve the right to seek relief in the form of damages (statutory, punitive, or otherwise) and further equitable resolutions, should you fail to remove this material.

(continued)

CHAPTER 18

As per your request, I include the following two statements:

1) "I have a good faith belief that use of the copyrighted materials described above on the allegedly infringing web pages is not authorized by the copyright owner, its agent, or the law."

2) "I swear, under penalty of perjury, that the information in the notification is accurate and that I am the copyright owner or am authorized to act on behalf of the owner of an exclusive right that is allegedly infringed."

Thank you for your immediate and considerate cooperation on this matter. Should you wish to discuss this matter further, I can be reached at (202) 544-4578.

Sincerely,

John Harrington

John Harrington
John Harrington Photography
2500 32nd Street, SE
Washington, DC 20020-1404
Local: 202-544-4578
Fax: 202-544-4579

Again within 24 hours, I received the following e-mail:

From: "Blogger Help" support@blogger.com
Date: June 30, 20██
To: john@johnharrington.com
Subject: [#6353██] DMCA Complaint Received

Hello John,

We have received your DMCA complaint dated 6/29/██ regarding the image URLs listed at the end of this email. We are currently reviewing the complaint and will contact you when we have completed processing the request. We appreciate your patience with this process.

Sincerely,

The Blogger Team

Image URLs:
http://photos1.blogger.com/blogger/██ / ██ / ██ -1.jpg
http://photos1.blogger.com/blogger/██ / ██ / ██ -1.jpg
http://photos1.blogger.com/blogger/██ / ██ / ██ -1.jpg
http://photos1.blogger.com/blogger/██ / ██ / ██ -1.jpg

Then, within less than an hour, I received this:

From: "Blogger Help" support@blogger.com
Date: June 30, 20██
To: john@johnharrington.com
Subject: [#6353███] DMCA Complaint processed

Hello John,

In accordance with the DMCA, we have completed processing your infringement complaint regarding the following URLs:

http://████████blogspot.com/20██/██/████████████.html
http://photos1.blogger.com/blogger/███ ██ ██-1.jpg
http://photos1.blogger.com/blogger/███ ██ ██-1.jpg
http://photos1.blogger.com/blogger/███ ██ ██-1.jpg
http://photos1.blogger.com/blogger/███ ██ ██-1.jpg

We appreciate your patience as we work to remove all of the images from our servers. Please note that all cached versions should expire within a week.

Please let us know if we can assist you further.

Sincerely,
The Blogger Team

The end result? The page was immediately gone, as shown in Figure 18.8, and, to date, that page has not returned, nor have I located those images anywhere else.

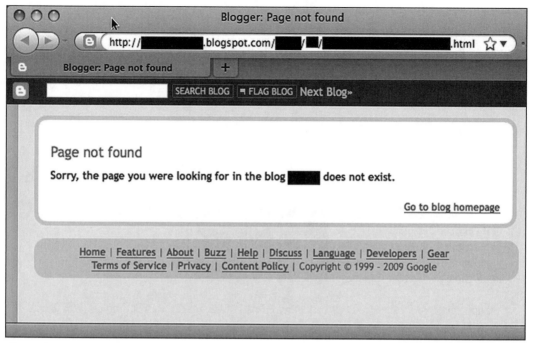

Figure 18.8
The page with the infringed images can no longer be found.

You must be extremely vigilant in protecting your copyright. Unfortunately, sending out DMCA takedown notices will have to happen more often, not less.

Chapter 19
Releases: Model, Property, and Others

What is a release? A release, whether model, property, trademark, or any other type, is a legal instrument (whether written, audio, or video) that, once executed, terminates or transfers liability between the parties involved in the document, to the extent documented in the release. For the purposes of photography, we call the photographer the *releasee* and the subject photographed the *releasor*. But, is it that simple?

In cases of children, they are not allowed to engage in legal contracts such as releases, so a parent or legal guardian must sign a minor release. In instances where the subject being photographed is an item that is property—whether a house, a particularly unique tree on private property, a custom car, or even an animal—a different release called a *property release* is the legal instrument that applies.

Next to no one will believe a verbal release, and its standing in court is highly suspect because of the biased nature of the releasor. While I could swear on a stack of Bibles, "That man said I could take his picture and he didn't care what I did with it, and he gave me his permission to use it for X," I have an incentive to lie, and if "that man" came forth later and said, "I never said that," it would be his word against mine. However, if I have several people who are unrelated to me and do not have an incentive to lie, and they heard the statement of "that man," these witnesses could serve to validate my (potentially) biased statement. In a few states—California, Florida, Nebraska, Oklahoma, Tennessee, Utah, and Washington (state)—a verbal granting of permission is permissible, but in my opinion, it is something to strongly avoid.

Other legal instruments could be an audio or video recorded statement, such as, "My name is Jane Doe, and I hereby waive all right to review the photographs that are about to be taken of me, and I grant John Harrington the full and complete right to license, sell, or otherwise use photographs of me, or which I may appear in, without restriction, in perpetuity."

I have seen variations of this sample language used on nationally syndicated radio programs. Usually, the release is read by the guest before the program. However, on television broadcasts, a production assistant usually comes into the green room beforehand, clipboard in hand, presents the document, and says, "We need you to sign this before you go on air." That is smart, because if the interview doesn't go well, and the assistant tries to get the release signed afterward, the person may refuse.

Types of Releases

There are a few different types of releases; following are the three most common.

▶ **Adult release.** This is the most common type of release, and it is executed by anyone over the age of 18. Or, in rare cases, the person signing the release could be deemed to be a legal guardian if the subject is considered not capable of executing a release (say, unconscious, incapacitated, or with a diminished capacity). I've included an example of an adult model release that we used on an assignment; see Figure 19.1.

▶ **Minor release.** In instances where the subject being photographed is under the age of 18, a minor model release is required. The language is very similar to that of the adult release; however, in the minor release, the person is certifying that they are the parent or legal guardian of the minor, and they have the right to release the releasor. When a minor model release is executed, once the child turns 18, there is no legal precedent I am aware of that would allow that child to rescind the contract/release that his or her parent engaged in on his or her behalf, nor am I aware of any requirement that you secure an adult release from the subject at that time. In a best-case scenario, you would have both parents sign a minor release; however, a signature of one parent should suffice. The problem arises because of the possibility that one parent might attempt to rescind the granting of the release after the fact. This issue arose once when a popular celebrity couple was divorced, and the mother of the children became a reality television star and signed releases for her children to appear in the show. The father decided to try to preclude that, and the question became one that went to court. In Figure 19.2, you will see an example of a minor model release that I used for an assignment that included both mother and child. The mother also executed an adult release.

▶ **Property release.** When a piece of property is photographed, getting a release from the owner can be beneficial. However, I am not aware of any legal precedent that demonstrates that a property release or the suggestion of a lack of a property release resulted in litigation. Consider that perhaps you photographed someone who lives in a one-of-a-kind tree house. After the shoot, you make a few images of that tree house, and then, in turn, a financial institution wants to use that image for the purposes of promoting a product or service offered, with the tag line "unless you live in a tree…" or some variation thereof. The challenge here is that the homeowner's identity may be associated with that, and a good lawyer could try to make a case out of it. However, property releases also apply to other things you may own. For example, when I photographed a restored antique car, I secured not just a model release from the person, but a property release for his vehicle as well. To be safe, securing property releases, while a best practice, has no precedent-setting cases to date. Figure 19.3 shows the property release for the car in that shoot.

Adult Release

In consideration of the engagement as a model, and for other good and valuable consideration herein acknowledged as received, upon the terms hereinafter stated, I hereby grant to John Harrington ("Photographer"), his/her legal representatives and assigns, those for whom Photographer is acting, and those acting with his/her authority and permission, the absolute right and permission to copyright and use, re-use, publish, and re-publish photographic portraits or pictures of me or in which I may be included, in whole or in part, or composite or distorted in character or form, without restriction as to changes or alterations from time to time, in conjunction with the my own or a fictitious name, or reproductions thereof in color or otherwise, made through any medium at his/her studios or elsewhere, and in any and all media now or hereafter known, for art, advertising trade or any other purpose whatsoever. I also consent to the use of any printed matter in conjunction therewith.

I also consent to the use of any printed matter in conjunction therewith.

I hereby waive any right that I may have to inspect or approve the finished product or products or the advertising copy or printed matter that may be used in connection therewith or the use to which it may be applied.

I hereby release, discharge and agree to save harmless Photographer, his legal representatives or assigns, and all persons acting under his permission or authority or those for whom he is acting, from any liability that may occur or be produced in the taking of said pictures or any subsequent process thereof, as well as any publication thereof.

I hereby warrant that I am of full age and have every right to contract in my own name in the above regard. I state further that I have read the above authorization, release and agreement, prior to its execution, and that I am fully familiar with the contents thereof.

Dated: 3|3|██

Signature

Print Name

Address

City State Zip BG An MD 21015

Phone #: 410 ███████

Witness: ███████

Print Name: ███████

Figure 19.1

CHAPTER 19

Minor Model Release

In consideration of the engagement as a model of the minor named below, and for other good and valuable consideration herein acknowledged as received, upon the terms hereinafter stated, I hereby grant to John Harrington ("Photographer"), his legal representatives and assigns, those for whom Photographer is acting, and those acting with his authority and permission, the absolute right and permission to copyright and use, re-use, publish, and re-publish photographic portraits or pictures of the minor or in which the minor may be included, in whole or in part, or composite or distorted in character or form, without restriction as to changes or alterations from time to time, in conjunction with the minor's own or a fictitious name, or reproductions thereof in color or otherwise, made through any medium at his studios or elsewhere, and in any and all media now or hereafter known, for art, advertising trade or any other purpose whatsoever. I also consent to the use of any printed matter in conjunction therewith.

I hereby waive any right that I or the minor my have to inspect or approve the finished product or products or the advertising copy or printed matter that may be used in connection therewith or the use to which it may be applied.

I hereby release, discharge, and agree to save harmless Photographer, his legal representatives or assigns, and all persons acting under his/her permission or authority or those for whom he is acting, from any liability by virtue of any blurring, distortion, alteration, optical illusion, or use in composite form, whether intentional or otherwise, that may occur or be produced in the taking of said picture or in any subsequent processing thereof, as well as any publication thereof, including without limitation any claims for libel or invasion of privacy.

I hereby warrant that I am of full age and have every right to contract for the minor in the above regard. I state further that I have read the above authorization, release, and agreement, prior to its execution, and that I am fully familiar with the contents thereof.

This release shall be binding upon me and my heirs, legal representatives, and assigns.

Dated: 2-29-▮▮

▮▮▮▮▮▮▮▮▮▮▮▮
Minor's Name

▮▮▮▮▮▮▮ Crofton, MD 21114
Minor's Address/City/State/Zip

▮▮▮▮▮▮▮▮
Father/Mother/Guardian's Name

▮▮▮▮▮▮▮▮
Father/Mother/Guardian's Signature

Phone #: 202-▮▮▮▮▮

Witness: ▮▮▮▮▮

Print Name: ▮▮▮▮▮

Figure 19.2

Property Release

For good and valuable consideration herein acknowledge as received, the undersigned, being the legal owner of, or having the right to permit the taking and use of photographs of, certain property designated as *1967 PONTIAC LE MANS* , does grant to **John Harrington** ("Photographer"), his heirs, legal representatives, agents, and assigns the full rights to sue such photographs and copyright same, in advertising, trade, or for any purpose.

The undersigned also consents to the use of any printed matter in conjunction therewith.

The undersigned hereby waives any right that he/she/it may have to inspect or approve the finished product or products, or the advertising copy or printed matter that may be used in connection therewith, or the use to which it may be applied.

The undersigned hereby releases, discharges, and agrees to save harmless Photographer, his/her heirs, legal representatives, and assigns, and all persons acting under his permission or authority, or those for whom he/she is acting, from any liability by virtue of any blurring, distortion, alteration, optical illusion, or use in composite form, whether intentional or otherwise, that may occur or be produced in the taking of said picture or in any subsequent processing thereof, as well as any publication thereof, even though it may subject me to ridicule, scandal, reproach, scorn, and indignity.

The undersigned hereby warrants that he/she is of full age and has every right to contract in his/her own name in the above regard. The undersigned states further that he has read the above authorization, release, and agreement, prior to its execution, and that he/she is fully familiar with the contents thereof. If the undersigned is signing as an agent or employee of a firm or corporation, the undersigned warrants that he is fully authorized to do so. This release shall be binding upon the undersigned and his/her/its heirs, legal representatives, successors, and assigns.

Dated: 3 | 3 | ███

██████████████████████
Signature

██████████████████████
Print Name

██████████████████████
Address

BEL AIR MD 21015
City State Zip

Phone #: *410* ████████████

Witness: ████████████

Print Name: ████████████

Figure 19.3

▶ **Trademark release.** Although you will likely never see a trademark release, you may see it in the form of a trademark license, and I want to discuss both variations here. When, for example, I photographed the vehicle that I obtained a property release for (as referenced a moment ago), there was a risk that the owner of any trademarks that appeared in that photograph might have a case to be made against me. If I photograph a person, and that person is wearing a Nike logo, the appearance of that trademark in the photograph would likely require a release. Trademark releases come into play often in movies, and almost all manufacturers of products grant releases for their products to be used in movies and television because of the potential benefit from the free advertising and/or brand awareness that ensues. In fact, this type of brand awareness has become so valuable that companies often pay a significant fee to have their product or logo in a movie. However, in most cases, the manufacturers want to ensure their product is appearing in a positive light. Further—and this may fall between trademark and property issues—if you are using a product in an advertisement, it may be best to call up a prop maker and commission the item be made for you for the shoot. One colleague of mine once commissioned a New York City umbrella maker to make an umbrella for a high-profile shoot a number of years ago, in order to avoid the risk that the umbrella manufacturer would object to their product appearing in the ad campaign that this photographer was working on. In the end, the legal department of a corporation that owns a trademark is going to be the one signing off on your use of the image, and that will likely be a major undertaking.

Here is how a trademark license agreement might begin:

Licensor owns and/or has the right to license certain "Licensed Properties" (defined below) and other intellectual properties contained in; used with, or associated with the "Licensed Images" (defined below). The Licensed Properties have, through extensive use and advertising around the world, achieved widespread fame, celebrity, and goodwill among the trade: and among the general public, are associated exclusively with Licensor and Licensor's products, and are valuable assets of Licensor. Licensee desires to use the Licensed Properties in association with the production and creation of "Licensed Images" as well as the manufacture, sourcing, distribution, marketing, advertising, promotion and sale of "Licensed Products" (the "Licensed Products"), as described below. Having negotiated the terms and conditions of such a license in good faith, the parties desire to enter into a licensing agreement upon the terms and conditions set forth in this Agreement;

After a number of recitations, it would also include:

2 GRANT OF LICENSE

2.1 Licensor grants to Licensee, during the Term, a non-exclusive, non-transferrable, revocable license to use the Licensed Properties solely upon and in connection with (i) the production and creation of Licensed Images, (ii) the right to appoint

Authorized Manufacturers to print materials containing a depiction of Licensed Properties, and/or to manufacture Licensed Products on its behalf subject to the terms and conditions set forth in Schedules X and Y, and (iii) the distribution, advertising, promotion, and sale of Licensed Images or Licensed Products in the Territory under terms of this Agreement. Nothing herein shall prohibit the Licensor, or any other licensee of Licensor, to exercise any of the same rights regarding during the term hereof. Licensee agrees to use the Licensed Properties only in a manner that promotes the goodwill of the Licensed Properties, and is not detrimental in any way to that goodwill or the reputation of the Licensor.

2.2 No Sublicenses. Licensee expressly acknowledges that it will not have the right to grant sublicenses to this Agreement. Any attempted sub-license by Licensee will be void, without effect, and may be grounds for immediate termination of this Agreement. Appointments of third party printers or manufacturers by Licensee shall be considered void sublicenses, except as permitted under Section II hereof.

An entire trademark license agreement or a trademark release is most assuredly going to be nonexclusive, unless you are obtaining exclusivity within a product line (say, a poster line or a garment line), and the document will be far more lengthy than a single-page release we use for models.

Herein lies an important point about these releases. Now that you are aware of the existence of—and further, the importance of—a trademark release/license, make certain that your contracts stipulate something to the effect of "...client hereby certifies that they will not exercise the rights under this contract unless and until they have obtained all permissions and releases required to do so, including trademark releases...." Further, in the event that the client does use the photos without a trademark release, language such as "...client hereby saves and holds harmless Photographer in the event of a claim made by a third party for uses outside the scope or permission of this contract...."

Case Study: The Importance of Releases

Here is one case that should prompt you to secure model releases if you plan to use the photographs for anything other than editorial uses. Quite literally, it is a case—Andrew Marsinko v. John B. Burwell, et al, case # CL07001070-00, filed in the Circuit Court for the County of Roanoke, in Virginia. In this case, the photographer, as suggested in the suit, was allegedly working for the State Fair of Virginia corporation and was commissioned to make a series of images of people at the fair, and it was suggested in the lawsuit that the images were being made for the purposes of promoting the fair. However, this case is one where one of the subjects that was photographed sued the photographer, and the client was not involved.

Reasonably, as many photographers do, as they considered the specifics of this assignment and how to price it, they likely contemplated the value of the work in terms of the time involved, the use of the images by the clients and the value that work brings, and the potential value that that image may have in the future as re-licensable work.

The photographer was almost certainly required to secure a release under the obligations to the client, since it was purported that the images would be used in marketing or advertising. Following the conclusion of that project, Burwell did what he had the right to do (provided he didn't sign a contract with his client precluding this)—generate additional revenue for the duration of his copyright to his creative works by placing the images with a stock library. Revenue can come in many forms. If no release existed, he still could have licensed the image for editorial purposes, provided no libel was involved. With a release, a broad scope of licensing opportunities is available. In this case, he licensed the images through Jupiter Images, now a part of Getty. As a part of his submission to them, he likely was required by Jupiter to submit a copy of his model release or to certify to them that he did in fact have a release. An important point is to be made here. This chapter includes an example of a release that includes language like this:

> "permission to copyright and use, re-use, publish, and re-publish photographic portraits or pictures of me or in which I may be included, in whole or in part, or composite or distorted in character or form, without restriction as to changes or alterations"

Further, and to really drive home the message, the releases that I have used here include this language:

> "I hereby waive any right that I may have to inspect or approve the finished product or products or the advertising copy"

Now, I don't know if this language was in the releases that Burwell received, because every release is different. Some releases are extremely specific—for example, on assignments where I was photographing a celebrity, the model release was several pages long, with all sorts of restrictions and caveats. In other cases, a release could be as short as "For the sum of $5, I agree that you may use my photograph for whatever you want forever," and it could be on a napkin, handwritten and signed. The question, first, is the extent of the release.

Whatever the extent, it is the final responsibility of the end user to affirm that the release he has does, in fact, cover the uses being planned. And, for most responsible businesses, it is required to confirm not only the validity of a properly executed release, but also that the content of the release covers the intended use.

In the lawsuit filed, the farmer's complaint alleges that Burwell licensed the image "knowing they did not have a release" and then suggests that because they "represented to the world on the internet…that [they] had a signed release," they were guilty of "statutory conspiracy."

All of this because of a single stock sale of an image for a greeting card, which then resulted in a $7,500,000 lawsuit. Fortunately for Burwell, he is a smart businessman who has business insurance that covers this type of liability, and as such, his insurance company is defending him—otherwise, he likely would be bankrupt.

It is my sincere hope that not only do you get model releases wherever possible, but that they are as ironclad as possible and that you have insurance to cover you for lawsuits like these. Lastly, this is why stock photo agencies include language like this in their contracts that you sign to be represented by the agency:

"You agree to indemnify, defend and hold harmless [agency] from and against any and all suits, losses, claims, demands, liabilities, damages, costs and expenses (including reasonable legal fees and expenses) arising from or relating to any material or content you submit... your violation of any applicable law, statute, ordinance, regulation or any third party's rights, including but not limited to, copyright infringement, harm to a third party's trademark or other intellectual property rights, or any claim of defamation, libel or slander."

Thus, when Marsinko sued, Getty Images and Jupiter Images would have every right to turn to Burwell, cited this clause, and say, "You're defending us, too, and paying the costs to do so," and he wouldn't have much choice.

All of this for a single stock sale, and presuming that Burwell has a model release signed by Marsinko, he still has to spend the money defending himself and his right to license this image. The case, which was brought in September of 2007, was still ongoing in mid-2009 when this book was written.

Getting the Release Signed

Getting the release signed before the shoot is critical. However, how soon? I submit that you should get releases signed as soon as possible after you get the client to sign off on your contract. Surely, you need releases signed before you book airfare in the name of a model if you are traveling for the assignment. Years ago, a well-known fashion photographer in New York City recounted to me an experience where she had flown the models to the Caribbean and done the shoot, and after the shoot had been completed—but they had not returned home yet—the models balked and would not sign, while they were sunning themselves on the beach, on a trip paid for by the photographer. In all cases, you should secure a release before the first image is created.

For shoots where we are seeing the subjects for the first time as we are setting up lights, I usually task an assistant to secure the signing of the model release by the subject. This is almost always the case for editorial shoots, street photography, or low-production-level shoots.

On one commercial shoot I was hired for, we were photographing individuals on the street, and the client wanted releases. As we found someone we wanted to photograph, I would task my assistant with approaching that person to get his or her permission. Once the person said it was okay and signed the release, we photographed him or her with the assistant holding up the release alongside the subject, so we could later identify each subject with his or her name.

However, who should witness that the release was legitimately signed, and not under duress or a degree of incapacitation (such as inebriation)? The challenge of having an assistant witness it is that since the assistant is working for you, his or her impartiality as a witness could be called into question. A witness is better than no witness, though, and sometimes we ask the client or another party to witness the signing. In some instances, we'll take a photograph of the person signing the release, which not only serves to affirm they signed it, but also helps us cross-reference the subject and the signature. In the end, an impartial witness—or absent that, the least potentially biased witness available—should be the one to witness the release. And make sure they actually do witness it!

When the subject is a professional model, the release is almost always specific to the shoot at hand and has a duration as well. Just as we earn a living from licensing our images, models earn a living from licensing their appearance. If you secure a release for all rights from an unsigned model who is 19 and at the beginning of her career, and then that model signs a modeling contract and gets booked for a hair-care product line for a year, your release may legally entitle you to license that image to a competing line of hair-care products, and that would be the beginning of a huge lawsuit. Models license themselves for editorial, commercial, exclusive, nonexclusive, exclusive-to-industry, and most every other derivation of their likeness that we do of our photographs. You will want to send the release to the modeling agency and get the model to sign off on the release before you are on set. Presenting a model release to a professional model on set is a recipe for disaster.

Paying for Model Releases

For a contract to be binding, *consideration* must be exchanged. Consideration can be many things besides actual dollars. Photographers like to talk about always carrying dollar bills around with them on shoots, so they can pay for the model with a single dollar. When I tried that once, I felt like I was insulting the person I was photographing. Further, it's cash, so that might be one angle they might try to argue that the consideration wasn't received.

Consideration could also be a print or an agreement for you to provide rights for them to use the image for their own benefit. It could be a lot of things, but it must be something of value. Wherever possible, you should be paying models with a trackable form of payment, such as a check or money order.

To ensure that there are no questions that the model was paid, releases are best written with the language "for good and valuable consideration herein acknowledged as received," so that the release is not only a release for the use of the photo, but also a written acknowledgement that the payment was made.

On one commercial shoot I was hired for, where we were photographing individuals on the street and the client wanted releases, the client instructed me to give out gift cards, and I was instructed that the value of that gift card was to be $5. This got me to thinking—I could use Starbucks gift cards in this same manner, it wouldn't come across as insulting, and it would look better than the passing of a $1 or a $5 bill. On occasion, I have given Starbucks gift cards valued at $5 in exchange for a model release.

Your Release Form or the Client's?

Often a client will have a release that their legal department drafted, and that release releases just the client and may not cover you. Since we are the ones who are licensing the right to the client, it stands to reason that we should be the ones securing the release to us and then, in turn, transferring that right to the client (upon full and complete payment, of course.) Yet more than one client has insisted that the release be theirs and has provided it to us. We request the release in the form of a word-processing document so we can insert any language we need into their document, and in some cases we have the subject sign two releases.

In as many cases as possible, you should secure your own releases, which serve to protect you the most.

Other Release Issues

There are certain issues that arise where releases may be invalid or called into question. One area of concern is images made in a hospital. A 2002 article in the *Journal of the American Medical Association* titled "Commercial Filming of Patient Care Activities" points out some concerns in doing this: "[P]atients may feel obliged or compelled to appear at the behest of those who are in charge of their care and welfare. Filming in the emergency setting poses particular problems because patients may either lack capacity to consent or may feel under duress to give consent. Another vulnerable setting is the operating room, where an unconscious patient undergoing emergency surgery might not have the opportunity to consent to filming in advance." The article goes on: "To preserve patients' rights to control their privacy during filming, a priority is to obtain informed consent from an individual with intact decisional capacity under conditions of nonduress. Under informed consent, patients may accept a certain risk, usually in exchange for some hoped for benefit, but it is not clear whether patients always understand the risks and consequences of filming and freely agree to accept them."

One other area of significant concern is the use of images in which a government official or government employee (especially one in uniform) appears. Government officials in their official capacity are expected to remain impartial and not appear to endorse a product or service. As such, the ability for you to secure a legitimate model release from a government official, whether elected or a career employee, in their capacity as a representative of the U.S. government or a state, county, or local government is not likely to ever occur. While a government employee may sign a model release for their likeness to be used when made not in conjunction with the government, were they to do so in their capacity working for the government, government ethics rules would suggest that they were therefore using their public office for personal gain, and as such, this would be a problem.

When traveling out of the country, you may find yourself in need of model releases in a foreign language. Further, releases that are a full page in length can often be intimidating to people you are approaching in the street. For an assignment in Japan, I had a model release translated into Japanese, and adjacent to the Japanese text, I included the English version. If you are headed to a country with a foreign language, having those forms can not only be helpful, it could reasonably be argued that if someone does not speak the language that they signed, unless the witness to the document is also the person who translated it or witnessed the translation, the release might be deemed invalid. Figures 19.4 and 19.5 show the English and the English/Japanese versions of a release I used on an overseas trip.

In two states, Kentucky and Texas, the heirs to someone who is deceased are required to sign a release, and in nine states (as of this writing), a person's "right to publicity" explicitly requires a model release be signed. Those nine states are Illinois, Indiana, Massachusetts, Nevada, New York, Ohio, Rhode Island, Virginia, and Wisconsin.

Photographic Model Release

For a valuable consideration, receipt of which I hereby acknowledge, I assign to:

John Harrington

his representatives, successors, and assigns all rights to reproduce in whole or in part for the purpose of illustration, advertising, or publication in any manner, any photograph he has taken of me.

Date:_____

Signature:_____
 (Sign Name) *(Print Name)*
Witness:_____
 (Sign Name) *(Print Name)*
If under 21 years, guardian sign here:_____
 (Sign Name) *(Print Name)*

Figure 19.4

Photographic Model Release

For a valuable consideration, receipt of which I hereby acknowledge, I assign to:

次下の文を読んで、同意する場合はご署名ください。

John Harrington

his representatives, successors, and assigns all rights to reproduce in whole or in part for the purpose of illustration, advertising, or publication in any manner, any photograph he has taken of me.

写真家ジョン・ハリントンが撮った私の写真の著作権は、ハリントン当人に帰属するものとし、出版・広告等の目的による写真の再生・編集の権利をジョン・ハリントンに譲与いたします。

Date:_____

Signature:_____
 (Sign Name) *(Print Name)*
Witness:_____
 (Sign Name) *(Print Name)*
If under 21 years, guardian sign here:_____
 (Sign Name) *(Print Name)*

Figure 19.5

Resources

When you are on the road, you may find yourself having run out of releases, or an absent-minded assistant may have forgotten them back in the studio. One solution that has saved me on more than one occasion is to have the model releases on my website, in a hidden folder. For example, posting a single HTML webpage at www.JohnHarrington.com/Adult_Release.html would create a URL that you could easily click to anywhere there is a computer and a printer available. I've done this in office buildings, hotel business centers, airport kiosks, and even in private homes. In the example at the beginning of this chapter for the property release, we hadn't planned to have the car in the photograph, and I did not have a property release with me. Once it was determined that we were going to use the car, I asked the subject if I could use his home computer to print out the release, and all it took was a visit to a URL on my website that had that. One added benefit is that the web browser can be set (it is usually set to by default) to print out the date and time that the page was printed, which serves to bolster the validation of the release. Most importantly, it can get you out of a tight spot when you really need a release.

The American Society of Media Photographers (ASMP) site maintains an excellent resource for model release information, which can be found at www.asmp.org/commerce/legal/releases, where releases are discussed in great depth, with releases that are updated as new cases are decided that might call for a change in a model release form.

The Advertising Photographers of America site maintains and periodically updates model releases in their members-only section of the website, available at www.APANational.com.

The National Press Photographers Association also has a great resource for model releases, available at nppa.org/professional_development/business_practices/releases, as well as encouraging the purchase of the Tad Crawford book below.

Finally, I would strongly advise that you utilize the resources of the ASMP, APA, NPPA, or the books on this subject listed below as a starting point. Take the releases, provide them to an attorney, and have the attorney make any necessary changes to the documents to apply to your state laws, account for any changes in technology, and also factor in how they might apply in other states you might be working in.

Recommended Reading

The final section of this chapter includes some recommended further reading for you.

American Society of Media Photographers. *ASMP Professional Business Practices in Photography*, Seventh Edition (Allworth Press, 2008).

Crawford, Tad. *Business and Legal Forms for Photographers*, Third Edition (Allworth Press, 2002).

Chapter 20
Handling a Breach of Contract: Small Claims and Civil Court

Before you begin tossing around the phrase "I'll see you in court" (at which time, you've probably lost the person as a client), you need to actually know which court you'll be seeing that person in—federal, criminal, civil, or civil's little sister: small claims. Because we're not talking about criminal (in almost all cases), and federal will most likely apply to copyright suits, instead, you're dealing with civil or small claims. Often, these courts can prove to be a more expeditious way of resolving your dispute.

First, though, it is important to understand the different types of breaches. There are a few types of contractual breaches:

▶ **Fundamental breach.** This breach is so significant that not only can the contract be terminated, but the wronged party may bring a suit against the other party or parties. An example of this might be a circumstance in which models are contracted for and flown to a distant tropical island for a fashion catalog shoot, and upon their arrival they demand additional consideration (such as pay, workload lightening, and so on) or they will refuse to participate, bringing the entire shoot to a halt and thus delaying the catalog's production.

▶ **Anticipatory breach.** This breach may be fundamental, material, or minor and must indicate with certainty that a party to the contract shall not perform to the contract's specifications when called upon. An example of this might be a publication that, after they sign your contract and you perform the photographic services, states that they won't pay you unless you sign their contract. Although the statement of nonpayment for services already rendered is anticipatory, there are some complications in that additional— likely unsatisfactory—terms are being demanded by the client. However, this is an anticipatory breach.

▶ **Minor breach.** This breach is only a partial breach, such as a payment in 45 days instead of the contractually obligated 30. Although this may be deemed a material breach in that an interest penalty might have been applied to the $5,000 invoice, in this circumstance only the wronged party's actual damages

can be collected. In this instance, the actual damages on an 18-percent APR interest penalty would amount to approximately $37, and thus this would be the maximum damages that could be collected.

▶ **Material breach.** This breach is more substantial. If, for example, you are contracted to shoot an assignment with Nikon cameras because of a relationship your client has with Nikon, and you instead use Canon, your client can either compel you to use Nikon or collect damages that could include all the costs to reproduce the shoot, plus any expenses involved in rush charges to get the project back on track to accommodate for the delays your breach caused.

Why You Might Be Better Off in Small Claims or Civil Court

For many photographers, bringing their case before a civil court can be less expensive and shorter in time than a federal case. The details of how you handle your contracts will provide you with remedies as the aggrieved party.

Should your contract stipulate that unauthorized uses of your photographs are copyright infringements, then federal court is the place you'll end up, and if you try to bring a suit in civil court, the defendant's attorney will file to this effect, insisting that the case be tried in federal court. They would, of course be doing this to force you to give up the claim because of the timeline and expense of federal court over civil court.

However, if you allow for the possibility of adjudication in civil courts, for these same uses, in certain circumstances, you may be at an advantage. In cases that fall below a state-specified threshold, your case might wind up in small claims court. Ceilings for claims range from $2,500 to $10,000 depending upon the state, but there are benefits to small claims. For example, you are not required to have an attorney represent you, and in some states you are precluded from doing so. The exception to this in almost all circumstances is when you are suing a corporation. In this case, it is not the officers of the company who appear, but rather their corporate counsel or designated attorney.

This can work out to your advantage. If you are suing for a few thousand dollars, the company might decide that, although you may well have a case and they feel they did nothing wrong, the cost to them in attorney's fees will exceed the expense they hope to avoid, so instead they might offer you 25 percent, 50 percent, or even 75 percent of the amount you are suing for, just to settle the claim. Because you do not have an attorney, the benefit of traveling this path is substantial for you and should be considered.

What to Expect and How Long It Will Take

You can expect that the defendant will do everything in his or her power to diminish your claim, attack your credibility, seek a pre-trial dismissal of the suit, and, usually at the eleventh hour, seek a settlement. Settlements can occur in as little as a month, and trials can

take several years, especially in complicated cases. And, at any point during the trial, up to the moment before the jury has reached a verdict, both parties can come to settlement terms and the case ends up being dismissed.

In fact, many states have mandatory arbitration/settlement talk requirements before a judge will even see you. In this situation, you and those you are suing (or their representatives), will sit down with an impartial mediator who hopes to get both of you to come to an agreement. If this occurs, in many instances the court will enforce the settlement agreement as if it was a decision of the court following a trial.

The first thing you'll do in small claims court is to file your claim. All small claims courts have easy-to-follow forms and instructions, and your total cost to file the claim will likely be less than $50, recoverable plus interest should you be the prevailing party. The defendant will respond, and a court date will be set. Usually after the date is set, an attorney for the other side (if a company) will likely reach out to you to try to settle the case. If it is another individual— say a bride and groom who haven't paid you—you'll likely just wait for your day in court.

Absent something very unusual, your case usually will be resolved the day it is heard. You will present your contract, signed by both parties, and the defendant will have a hard time outlining a material or fundamental breach of the contract that would allow him to not pay you or to try to force his contract on you after yours has been signed. There is no jury in small claims, and it's up to the judge to understand the case, ask thoughtful questions, and render his decision.

When the case is decided in your favor, the judge will order payment terms, which include court filing costs and (in many states) interest from the date you filed your claim. Typically, this is a 30-day term, sometimes within seven days, and other judge-stipulated timelines can be imposed. If necessary, you can return to the court to order liens placed on property owned by the parties who owe you money. A nominal fee usually totaling less than $50 will allow you to have an Abstract of Judgment-Civil issued, as well as cover the cost to send that Abstract of Judgment to the County Recorder's office in the county where your debtor owns, or is likely to own, real property. Although you will not automatically be paid, interest will continue to accrue on what you are owed. Whenever your debtor tries to sell or refinance that property, your lien will stop that entire process in its tracks. The debtor must pay you, and you must then remove the lien before the sale or refinancing can take place.

Case Study: A Textiles Company

One year, I was contracted by a magazine to produce a portrait of three owners of a major textiles company in Washington, DC, for an article on this family-run business. Following the article, for which I was paid, the design company for the subject's company contacted me to review the transparencies from the assignment. I personally delivered the images, along with a delivery memo. While the delivery memo was never signed, the design company's actions—specifically, having seen the delivery memo and not objecting and returning the images to me—accepted the terms by holding and reviewing the images.

After several months went by, I contacted the firm. Presuming that my work had been used without my permission, I posed the question, "So, how many images did you use?" To which the response was "Oh, only one." I then asked, "And, when were you going to contact me to obtain permission to use that image?" Then the design firm said that the company that had hired them and whom I had originally photographed had committed to doing that. When I asked that company about this, they said that I had already been paid by the magazine, so I was not entitled to be paid again for the use of the photograph, and that although they might have paid a few hundred to use the photo, there was "no way in Hell" they were paying $700, let alone more than that.

I prepared an invoice for the company. The original use fee would have been around $700, provided that I was contracted beforehand, but that had not occurred. The contract called for a triple penalty in this instance, as well as holding charges for all the images that had not been returned to me. With numerous images, the figure began to mount. Then, when I turned up at the company's offices to collect my transparencies, I learned that one image—the one they had used—was missing. When all was said and done, I submitted an invoice to them for $4,200. They refused to pay or even return phone calls on the matter. Some time passed, and I would often see their delivery trucks on the streets of Washington. Each time, I would get angry at myself and swear that I needed to do something. Finally, six or so months passed, and I filed my case in small claims court, which had a ceiling of $5,000 at the time.

Significant back-and-forth exchanges between their attorney and me ensued. At first, they offered $600 to settle. Next they offered $1,200. Then, they had the gall to suggest that I had no right to license commercial rights to the company because I did not have model releases from the company. I laughed and said that it was the officers of the company who had looked to secure the rights to the image in which they appeared, and as such, that was tacit permission for the use of the photograph.

With each lengthy phone call, I was aware that this attorney's time was accruing expenses, while I was not expending anything other than my spare time. The Friday before the Monday trial, their attorney called to say that their final settlement offer was being made. He outlined a slight error in my reading of my own contract, which meant that the maximum I could hope to actually get was near $2,600. He offered $1,800 and said that their offer to settle would diminish over the weekend as he expended expenses on behalf of his client, who would be more likely to make it go away by paying that money to me. Thus, I agreed to the settlement offer, not only because it was a fair offer, but moreover, because it was significantly more than the "no way in Hell" amount that one of the company's owners had emphatically and with bravado stated he'd pay. Now when I see those same trucks making deliveries, I express my satisfaction in knowing that a wrong was righted.

Chapter 21
Resolving Slow- and Non-Paying Clients

Every client for whom I provide photography services signs a contract with me, and this contract always stipulates the timeline for payment Almost always the contract is the one I presented, but in circumstances in which a client-presented contract contains nothing objectionable, I am comfortable signing theirs. The payment timeline varies. Sometimes it's "due upon receipt," "due in 30 days," or requires "full payment prior to publication." However, despite this fact, we have found over the years that when it comes to our deliverables, time is always of the essence, yet I have more than my fair share of slow-paying clients. When this happens, there is a well-worn path between my office, the accounting department, and the originating individual within the client's company.

An important rule—in fact, I'd say one of *the* most important rules—is, in the endeavor to collect on the unpaid invoice, do everything within your power to ensure you don't lose the client in the process! Remember to be polite. Later in this chapter, in the "Collections Services: An Effective Last Resort" section, there are examples of how a collections service works and contact information for one.

How to Engage the Client and the Accounting Department

More often than not, the client has received the invoice and just forgot to take action to begin the payment process. When we mailed invoices, we always heard, "Oh, I never got it." So, we began delivering invoices in the envelope that included the deliverable. Then, we'd get, "Oh, I didn't see it in there. Can you resend it?" So, we began to actually wrap the deliverable with the invoice, and we'd get the same response. Faxing always seemed an excuse for the client to say their fax machine was down or they still didn't get it. One solution has proven to be far less susceptible to these excuses. (Or are they explanations?)

E-mail. If they didn't get it, you'll get a bounce-back telling you so. If your e-mail program includes a return receipt function and you enable it, you'll know when the client opened the e-mail. (We don't actually do this, though, because we think it's annoying.)

Back when accounting departments stipulated that they wouldn't pay faxed invoices, we began referring to our invoices as "electronic originals," and that seemed to suit the accountants just fine. We produce an Acrobat PDF document that we attach to our correspondence.

NOTE

For Apple users, the Save as PDF option appears whenever you use the Print function in any application. For PC users, the full Adobe Acrobat application is necessary to create a PDF.

Although you're more than likely using some form of invoice-generating software, if it's just a word processor, understand that the accounting department will want the word "Invoice," the invoice number, the date, and your full address on the invoice somewhere. When an invoice is missing these things, it will often be the culprit of a late-paying client.

The subject line we use is usually "Photo Invoice – Widget Ad Photography." This makes it clear that there's something important in the e-mail. Lines such as "Greetings again," "Hi there," or "Nice working with you" will almost always be overlooked, and moreover might end up in the spam folder. Many e-mail applications allow you to flag an e-mail as high importance, which can reduce the likelihood that it will end up getting lost or be considered spam by their spam filters.

My e-mail usually goes something like this:

Dear Client,

Attached is invoice #12345 for the Widget Ad we produced for you last week. If you have a Purchase Order number for us, please forward that for our records. Please let me know if you need anything else or if you have any questions.

We look forward to working with you again in the future!

Regards,
John

John Harrington
John Harrington Photography
2500 32nd Street, SE
Washington DC, 20020
(202) 544-4578
email: John @ JohnHarrington.com

This is short, sweet, and to the point. It also reminds the client to get a PO number if their company requires it. If we've already received the PO number, I am sure to include that on the invoice.

At this point, the next time you contact the company, your best call is to the accounting department. Depending upon my workload, I will try to call the accounting department two weeks or so after we've sent the invoice. If it's a small company, then a call to the originating individual is warranted, but almost always it's a larger company with people dedicated to paying invoices.

The conversation usually goes something like this:

Them: "Accounts payable, how can I help you?"

Me: "Hi, this is John Harrington Photography calling regarding an invoice that is coming due soon. We were calling to make sure it is in your system and set to pay."

At this point, we get one of the following:

Them: "Yes, but we need a W-9 from you."

Them: "You're talking to the wrong office. You need to call...."

Them: "No, we have no record of having received your invoice."

If you get the first response, offer to e-mail *that* person your PDF of your W-9. If you get the second response, make a note of the new information (because you'll probably need it) and then start from the beginning. However, you'll usually get the third response. So, the dialogue continues:

Me: "Okay, well, we performed the services for the company more than two weeks ago, and we forwarded the invoice the next day to the person who hired us. If I can get your e-mail address, I will send it directly to you."

Them: "Sure, please do."

Me: "Great. I'll send it now, and I will follow up with you in a few days to see where we are."

The point about following up lets them know you're going to be calling again, so they don't think you are being annoying, but rather, firm in your inquiries. Remember, be *polite*, but also be *firm*. Doing so also gives the client or accounting department an indication that they'd be best served by handling this one sooner rather than later. I'll also print out the invoice and put it in a folder on my desk that reads "Payment Issues Ongoing." I hand-notate every e-mail, phone call, and message left, reminding me of who it was with and what was said, so that for seriously delinquent invoices, we have a trail of notes and dates to back up our story. This is especially important when the originating individual has left the company, and you have to deal with his or her replacement or boss.

Then, when we send the invoice, we make a point of CCing the e-mail to the originating individual. Because ultimately the accounting department will need to get an approval from the originating individual anyway, having their e-mail as a part of the dialogue facilitates

that. Plus, when the originating individual gets the CC'd e-mail, he or she can simply reply to the accounting department that the invoice is approved. That e-mail usually looks like this:

To: Jane Doe, Accounting Department
CC: Sally Doe, Originating Individual
Subject: Missing Invoice – As we discussed

Dear Jane –

Thanks for taking the time to look into this invoice. As we discussed, the invoice is not yet late; however, we wanted to call proactively to ensure that it was in your system, and we are glad we did. We understand that time is necessary for you to process payments, and our terms for timely payment are 30 days. With that date coming up in just over a week or so, we wanted to call to check. Sally, who is CC'd on this e-mail, was our original point of contact, and we forwarded the invoice to her back when the work was completed. Perhaps it ended up in her spam inbox or there was just a simple oversight. Either way, please let me know if there's anything else you need from us to get this into your system and approved for payment. I or someone in my office will follow up with you in a few days to make sure you've received this e-mail and to find out whether payment can still be received on time. Perhaps an expediting of the check could take place?

Regards,
John

This lets the originating individual know—politely—that she overlooked us and gets the ball rolling in the right direction. Then, a few days (or a week) later, a follow-up call to the accounting person usually results in the invoice at least being in the system and sometimes awaiting approval. We continue to stay in contact with them until they say, "It will go out in this check run on Thursday, so if you don't have it by next week, give me a call back." And then it does arrive, with few exceptions.

You Delivered on Time, and Now They're Paying Late

Every client who signs a contract with me agrees to a payment schedule. Almost always it's the one I presented—30 days—but in some circumstances it might be longer. Sometimes it's 45/60/90 days, sometimes it's "pays on publication," and for rites of passage, there is usually a 50-percent deposit when the contract is signed, with the remainder due a week before the ceremony.

In the end, we deliver the client's images on time every time—we bend over backward to make sure this is the case. We beg the overnight service to open the door so we can give them our packages, we miss dinner with the family to work on images, and we even sometimes serve as courier, traversing town at rush hour to ensure that the package arrives before the client's office closes.

However, it seems all this is often forgotten when it comes to paying the bill on time. I cannot tell you how frustrating this is. In the end, it reminds me that we are doing business, and it's not personal. I don't take it personally, but I also will work to make sure that payment is received, and I do my darnedest to make sure I do it in as friendly a manner as possible. Remember: *Be polite but be firm*. This all-important rule is worth repeating: In the endeavor to collect on the unpaid invoice, do everything within your power to ensure you don't lose the client in the process!

Many times, photographers (and my contracts include this) stipulate that a license to publish the image is contingent upon payment in full. When push comes to shove, this is a large stick you can wield against a non-paying client.

Statistics of Aging Receivables, and the Likelihood of Collecting at All

There are some fairly solid statistics regarding the likelihood that you'll be paid as the bill gets older and older. However, as with all statistics, the basis for those numbers is always where things can skew. For example, if you're doing business direct to businesses (that is, B2B), your likelihood of being paid is greater than when you're dealing with business to consumer (B2C). Further, a B2B engagement in which you are working with major corporations or media conglomerates means the statistics skew again. With all of this said, the statistics are important to look at and understand so that you can be sure to stay on top of the bills that will ultimately allow you to pay your own bills.

Statistics show that an invoice more than 60 days old has only a 70-percent chance of being collected in full. After 90 days, the chance of collecting the invoice in full drops to 45 percent, and after 120 days, it falls to 20 percent. It diminishes further beyond that. So, make sure you get paid sooner rather than later.

Late Fees: A Good Idea?

Late fees are quite a challenge to enforce, in my opinion. It's easy when you are a credit card company, the electric company, or you have significant leverage with the client on an ongoing basis to apply late fees. In the end, when a client receives an invoice for $1,300 and then 60 days later gets the same invoice with $40 or so tacked on, I think the likely response will be a negative one, and you will run up against accounting departments who attempt to state that they don't pay late fees or that their policy is to pay in 60 or 90 days and that you're out of luck. If you are in a field of photography in which you can effect late fees and it won't cause a strain on client relations, then perhaps it will work. However, my solution, which I have employed for over a decade, has worked very effectively.

My Solution to Late Fees for Some Clients

There are benefits to offering to take credit cards as a tried-and-true method of being paid on time. This does, in fact, work very well—however, many of our clients just don't want to pay with a credit card. So, I modified a standard concept in accounting—a discount for timely payment.

I remember learning about an accounting term—2/10 net 30—during a course when I was in college. This essentially meant that for a bill that was, say, $1,000, the entire amount was due in 30 days, but for payments received within 10 days, a 2 percent (or $20) discount would be taken off the entire bill. Some firms use 1/10 net 30, and there are numerous variations—2/15 net 30, 3/15 net 40, or any combination thereof.

If you'd like to offer a discount, the US Treasury has an interesting discount calculator, which advises government employees if the discount offered by a vendor is in the government's best interest. The URL is www.fms.treas.gov/prompt.

For example, the government has concluded that they should pay a 2/10 net 30 invoice in the discount period, and, as such, Federal Acquisition Regulations advises them to do so. However, I decided to reverse and modify this concept. For all corporate and commercial clients, as well as a number of editorial clients, I have employed a pre-billed late fee, incorporated into the estimate and initially added to the invoice. And, the discounting of the total due is only allowed when payment is received in 30 days. My contracts stipulate:

> Administrative Fee – We are now building into the invoice the cost to repeatedly follow up with accounts payable departments on past-due invoices and float the cost of payment to our vendors, which require 30-day payment. This fee is approximately 10% of this estimate. If payment is made within 30 days, you may deduct this amount.

So, as illustrated in Figure 21.1, suppose the photographer's fees are $450, expenses are delineated as $455, and the administrative fee is $90.50. We advise the clients that they'll be billed for the larger, administrative fee–inclusive figure and further indicate that the administrative fee may be discounted if payment is made within 30 days.

My estimate of the cost for this job breaks down to:

Photographer's Fees

Fee for Photographic services and Usage Fee for usage stipulated below:		$450.00	
Administrative Fee - We are now building into the invoice the cost to repeatedly follow up with accounts payable departments on past due invoices, and float the cost of payment to our vendors, which require 30 days payment. This fee is approximately 10% of this estimate. If payment is made within 30 days, you may deduct this amount.		$90.50	
Total Photographer's Fees	$540.50	$540.50	
Post production fees -100 to 250 images (Approx 3 - 7 rolls)			$250.00
Output method of digital files (i.e. How will the images be delilvered to you): CD-ROM			$175.00
Shipping - Proofs/CDs to/from lab and to client via: Courier			$18.00
Event Prkng/Misc - Parking			$12.00
If images delivered under normal two day turnaround this is the estimated total you will be billed:			$995.50
If payment is made within 30 days, you may deduct the administrative fee of: $90.50 off your total invoice, which is estimated to be:			$905.00

Figure 21.1

I cannot recall the last time a prospective client, when seeing this on the invoice, objected, and we lost the assignment. On the rare occasions that clients have objected, our friendly response is, "No problem—paying on time means that doesn't apply to you." This circumstance has one added benefit—the inevitable calls from nonprofits. Now, I am not going to go into the fact that that is a tax status, not a license to lowball every vendor they come in contact with. Instead, I am saying that when a client asks whether I have a nonprofit discount, I respond with, "You may take a 10-percent discount if you pay on time, and this will be reflected in the estimate we are going to send you." They get excited and are adamant that they'll pay on time. Then, lo and behold, they don't, and they lose the discount. And, as such, we have built into our paperwork and pre-billed that administrative fee, and we have been very upfront about it.

One last point: This fee does not have a ceiling. On some estimates, we have $3,500 to $4,500 figures for PR portraits in quantity, or even $1,800 for longer days' shooting and expenses, and that means $350, $450, or $180 in administrative fees. If you're looking for a way to validate the expense of hiring an office manager whose job it is to send and collect on invoices, just a few invoices late per week will more than cover the costs of paying for the office manager and will mean less time for you sitting in front of the computer doing paperwork.

Collections Services: An Effective Last Resort

I have been fortunate that, in more than 20 years in business, I have had fewer than 10 clients who have skipped out on their responsibility to pay. I have, however, had a few who, after all the courtesy calls, friendly reminders, and resending of invoices, have become

nonresponsive. With all, I have found there to be a 90-percent success rate in using a collections service. Once it was a political candidate, once it was a nonprofit, and once it was a major public affairs firm. When all else fails, in my book, it's time to call in the best threat—a blemish on the client's credit and, where warranted, a legal proceeding.

We use Receivable Management Services (RMS) collections. Understand that sending a client to collections is a serious matter, and you will get only a portion of the total amount due. When you use the service I use or a similar one, you can opt to have just a letter written or phone calls and a letter. Either way, engaging collection proceedings against a company is a serious action that may result in a "Placed for Collection" notice in your client's D&B business report.

The letter they will send essentially reads:

Dear Client –

John Harrington Photography has placed your account with us for further collection processing. If the amount shown above is just and correct, and unless you dispute the amount, we ask that you send your check directly to John Harrington Photography for this amount.

If you'd like to discuss this account with John Harrington Photography, you may contact John Harrington at (202) 544-4578.

Next, they'll send something like:

Dear Client –

Because you have not responded to our previous notice, we request that you send your check to avoid further collection activity.

Please mail your payment directly to John Harrington Photography for this amount.

If you'd like to discuss this account with John Harrington Photography, you may contact John Harrington at (202) 544-4578.

And it goes on. Understand that when a letter comes from Receivable Management Services, accounting departments who may have previously ignored demands for payment will usually stand up and take notice. RMS's literature lists several features of their domestic collections offer, among them:

▶ **Telephone demands.** Immediate and multiple contacts, experienced negotiators.

▶ **DebtAlert letters.** RMS's ability to report debtor information to Dun & Bradstreet credit file commands attention (at your option).

You may escalate your collection requests with their Attorney Collections service. A few highlights of this level of their services are as follows:

▶ **Law firm name and stationery.** Escalates your demand for payment to a new level.

▶ **Resolution and payment.** Preferred in lieu of litigation.

▶ **Full litigation services.** On accounts that warrant it.

There are two basic ways to go. You can pay for the letter-writing service, which runs $25 for a single letter or $40 for a series of letters, or you can use their "contingent upon collection" fee-based service. For $15 they will make telephone calls in accordance with state laws and send letters as well. This option incurs just the $15 and contingency fees as well. We often opt for the contingency option. I have sent a client to collections for as little as $100. That one was a wealthy woman in a tony part of town who just had to have a print that was a 5×7 cropped in deep into a much larger film frame that, had the entire negative (800 ISO) been enlarged, would have been a 30×40. I warned her that it would be grainy, but she just had to have it. So, we delivered. And she then balked. The total was around $100, including the cost of the print, couriers to/from the lab, and a courier to her.

Here are the (relevant) terms from RMS's form regarding their services, contingent upon collection:

a) Collection services. RMS will make written, telephone, and/or personal demands for payment. Charges contingent upon collection are 30% for the first $501 to $3,000 collected, 27% of the next $3,001 to $10,000 collected, 22% of amounts collected in excess of $10,000 with minimum charges of $150 on collections of $301 to $500, and 50% on collections of $300 or less. On accounts where the oldest invoice is more than one year old, a rate of 33.3% will be charged. If customer withdraws an account, settles directly, or accepted returned merchandise, the customer may be charged these rates.

b) Forwarding service. RMS will forward accounts to attorneys on the customer's behalf and will transmit and conduct the necessary correspondence, in accordance with the customer's instructions. Charges contingent upon collection for services of RMS and attorneys are the same as outlined in section (a) above. Not withstanding the single combined charge to Customer upon collection, RMS and attorneys each have separate and individual fees, and there is no sharing of each others' fees. There may be additional charges by attorneys when suits or other legal proceedings are authorized by the customer, consisting of an

administrative charge, suit fee, advance costs, and in some cases, a retainer. RMS also reserves the right to charge an administrative fee for processing and handling of accounts forwarded to attorneys at the customer's request.

All you have to do is fax a form to RMS with the name of the debtor, the address, the city, the state, the zip, the phone number, the amount owed, and the date of their last invoice. You do not need to provide a copy of the invoice (in the beginning) or any documentation that the debt is valid, unless/until the issue escalates or the debtor states that they do not owe any money to you.

This service, previously a part of Dun & Bradstreet, is now a standalone business. You can find more information on their website. As of this writing, the URL is www.rmsna.com.

Further, you also might be able to submit your debt claim online, once you set up an account (free, as I recall) at the RMS site: www.rmsna.com/khome.htm.

From my experience, unless the bill is more than about $2,000, for the amount of time involved in letter writing, phone calls, e-mails, more letter writing, and so on, as well as the mental anguish of being upset that someone to whom I delivered on time and as required services is now ignoring me, I just go with RMS. Typically, I send them $600 to $1,400 past-due invoices, and with rare exceptions, they get results. At that point, it is worth it for me to give them a few hundred dollars, not only for all the hassle they saved me, but for the knowledge that there is now a black mark on the client's credit, and the wrong has been righted on principle. In the end, I'd happily send RMS a $200 past-due bill, let them go through all the hassle of writing letters and so on, and in the end net $100, because it's more than likely $100 more than I'd get from someone who won't return my calls or who objects. When the client gets a collections notice, they pay attention to it.

Having been through small claims (and federal) court, I can say that although they are rewarding, when you have to give up a day (or more than one day if there is a continuance at the last minute) and turn away assignment(s) for that day to be in court, you'd lose the amount you might have won in court from the lost assignments. So, farming out the collections with the muscle of RMS just makes the most sense.

Chapter 22
Letters, Letters, Letters: Writing Like a Professional Can Solve Many Problems

Letters, correspondence, notes, and such are truly the foundations of communication. Battles waged, lives lost, and unintended consequences have all resulted from poor writings. The importance of good and accurate letter writing cannot be underestimated. The misplacement of a comma by Lockheed Martin cost them $70 million in a contract for their services. On June 18, 1999, the Associated Press reported that "An international contract for the U.S.-based aerospace group's C-130J Hercules had the comma misplaced by one decimal point in the equation that adjusted the sales price for changes to the inflation rate." In Europe, commas are used instead of periods to mark decimal points. "It was a mistake," the newspaper quoted James A. "Mickey" Blackwell, president of Lockheed's aeronautics division, as saying. But the customer, who Lockheed refused to name, held them to the price.

Consider this circumstance. Suppose your assignment was to produce images for a brochure for a resort. In your correspondence, which accompanies your contract, you write:

> Photographs shall be produced that illustrate guests in the following capacities: relaxing, dining, sleeping, exercising and recreating in resort facilities.

NOTE
Avoid the use of "shall." Writers, especially lawyers, have an addiction to the word, and its use is unsafe. The California Supreme Court has said, "It is a general rule of construction that the word 'shall,' when found in a statute, is not to be construed as mandatory, unless the intent of the legislature that it shall be so construed is unequivocally evidenced." Use a word such as "will" or omit the word altogether instead.

Is that *four* images as a deliverable or *five*? You might consider exercising and recreating to be a single thing, such as playing tennis or jogging. However, the resort may have just put in a $2 million state-of-the-art gym, and when you deliver images that do not include a guest using the gym, you've got a problem. I can see myself standing outside a gym during a scout visit, looking in and thinking, "Yes, they're exercising, but not really recreating, so let's skip that," and combining the two.

Instead, include the comma and change "shall" to "will"—or even better yet, use a bulleted list:

> Photographs will be produced that illustrate guests in the following capacities: relaxing, dining, sleeping, exercising, and recreating in resort facilities.

When counseling attorneys on the importance of good grammar, Richard Wydick, author of "Should Lawyers Punctuate," from a 1990 issue of *The Scribes Journal of Legal Writing*, illustrates the point thusly:

> Maligned though it may be, punctuation can affect the meaning of an English sentence. Consider, for example, the [U.S. Constitution's] Fifth Amendment's due process clause. As punctuated by its drafters, it reads:
>
> > "[No person shall] be deprived of life, liberty, or property, without due process of law...."
>
> Guided by the punctuation, our eyes quickly tell us that the phrase "due process of law" modifies the verb "be deprived." Thus, the Fifth Amendment requires due process if one is to be deprived of life, liberty, or property. But suppose the drafters had omitted the comma after "property." That would permit a lawyer to argue (in defiance of the provision's long history) that "without due process" modifies only "property." Thus, the Fifth Amendment would forbid deprivation of property without due process and would absolutely forbid both incarceration and the death penalty. Such is the power of a comma.

Your correspondence between you and a client or vendor should follow a standard path. For nearly a decade now, I have had an intern program in my office, and all of my interns have sent cover letters as a part of the application process. It is almost a guarantee that you will not be considered if your cover letter/e-mail is poorly written, contains spelling errors, or doesn't follow the common letter format.

E-mails contain dates, author name, and such by their very nature. However, in attached word processing files, these items are often missing. Make certain you include your name, company name, address, city/state/zip, and phone number, along with the date, in all such files. For faxes, and in some cases, within the e-mail itself, there is value in including the time that you wrote it.

When I am writing formal correspondence that I print out and mail, via postal, overnight, fax, or as an attachment, it is important to include the method of delivery below the recipient's address and above the "Dear Mr. Smith" salutation, usually in italics, as such:

> *Via Facsimile: (202) 555-1212*
>
> *Via Postal Mail*
>
> *Via Overnight Express*

Via E-Mail: [recipient's e-mail address]

By Courier

By Hand

When transmitting your letter via fax or e-mail, there should be a disclaimer or notice on the cover page or within the body of the e-mail, somewhere along the lines of:

NOTICE: This facsimile [or e-mail] contains privileged, confidential, or proprietary information and is intended only for the person or persons named. If you are not that person or a representative of that person, your use, distribution, dissemination, or reproduction of this or any attached documents is prohibited. This notice also hereby requests you notify us immediately by return facsimile or collect-call telephone at (202) 555-1212.

There may be some who would contend that this notice can be easily overturned; however, it is my opinion that there is value in having it, and thus, we use it.

Further, it is important that you actually call, especially for faxes. Unless you are certain that the fax machine is right next to this person's desk, has paper, and won't jam when printing your fax, call to confirm complete receipt of all pages.

When you are writing, it's okay to use jargon, but make sure that the recipient will understand it. If you're not sure, then explain it or use laymen's terms. And make sure you're writing in active tense, not passive.

The word "including" can also be dangerous when not used properly.

In addition to the photographer's fees outlined on the attached contract, client is also responsible for expenses, including assistants' fees, mileage, and meals.

What it should say is:

In addition to the photographer's fees outlined on the attached contract, client is also responsible for expenses, including, but not limited to, assistants' fees, mileage, and meals.

Or:

In addition to the photographer's fees outlined on the attached contract, client is also responsible for expenses, including, for example, assistants' fees, mileage, and meals.

This way, when you have a parking garage expense or you have to buy seamless or a prop, you'll not risk having the expense reimbursement denied.

Also, be consistent with words and terms. For example, don't say "this contract," and then later on say "the agreement."

Throughout this book, I make recommendations for reading that I consider to be useful for a further understanding of the chapter's topics. One online solution, however, is free. It is William Strunk's 1918 classic, *The Elements of Style*. It can be found at www.bartleby.com/141 as of this writing; however, if the URL changes, a search of the Internet should turn it up, or

CHAPTER 22

you can turn the pages of it in paperback form if that's your preference, by picking up a copy from your preferred bookseller. The book contains many rules that you should employ to make your letters clear and concise. Some examples include:

▶ "Make the paragraph the unit of composition: one paragraph to each topic."

▶ "As a rule, begin each paragraph with a topic sentence; end it in conformity with the beginning."

▶ "Use the active voice."

▶ "Put statements in positive form."

▶ "Omit needless words."

▶ "Avoid a succession of loose sentences."

▶ "Express coordinate ideas in similar form."

▶ "Keep related words together."

▶ "In summaries, keep to one tense."

▶ "Place the emphatic words of a sentence at the end."

E-Mail: The Current Default Communications Tool

E-mail is often the fastest route to get directly to someone, and it has emerged as the mainstream form of communication, usurping faxes and letters by a long shot. An exceptional book on how to best communicate via e-mail is *The Elements of E-Mail Style: Communicate Effectively via Electronic Mail* (Addison-Wesley Professional, 1994), by David Angell and Brent Heslop. It is a follow-up to Strunk and White's *The Elements of Style*, and it explains how to properly write an e-mail, what proper e-mail etiquette is, how to make your messages simple and yet powerful, and how to ensure that your tone is not misconstrued.

E-mail can bypass even the most protective secretary or assistant, provided you have the right e-mail address (which is usually as simple as figuring out the client's e-mail nomenclature). You can be certain that it's not left on a fax machine or in a junk-mail pile.

Suppose, for example, you are looking to do business with Smith and Jones Advertising, and their website is sjadvertising.com. Do a search on the Internet for @sjavertising.com, and invariably it will turn up numerous names, so you learn that the e-mail address for Richard Smith is Richard_Smith@sjadvertising.com or maybe rsmith@sjadvertising.com or some variation thereof. However they structure it, you can then use that same naming convention to reach the person you are trying to without much problem at all. This works about 95 percent of the time, save for when a firm uses just the person's first name and there's more than one person with that name or when it's a major corporation and you are trying to reach John Smith, as there is likely more than one person with that name.

Be very judicious about how you reach out to people with whom you've not been in a previous dialogue or with whom you've not interacted in some time. You do not want to end up on a spam blacklist. As such, the art of subject lines, salutations, and the first few sentences is critical to ensure that your e-mail doesn't get trashed.

Also, it is possible to take something written out of context because it lacks vocal tone. So many people become incensed at reading an e-mail that was written in haste. This can be avoided if you simply read the e-mail back to yourself to ensure it says what you want it to say.

For example, when we send a client an estimate, the subject line is something like:

- ▶ Photo Estimate for: Wednesday, February 29, 2006
- ▶ Photo Estimate, as requested
- ▶ Photo Estimate for cover assignment of CEO Portrait

When we send invoices as PDFs via e-mail, the subject line is something like:

- ▶ Invoice for photography on Feb29-2006
- ▶ John Harrington Photo Invoice #12345

And when we correspond with the client regarding past-due invoices, the subject line is something like:

- ▶ Checking in RE: past-due photography invoice(s)

And in instances in which we are re-sending an e-mail, we use the subject line:

- ▶ RESEND: Photo Estimate for cover assignment of CEO Portrait

When we have, as the result of a dialogue with the client, made adjustments to the estimate or invoice that was previously sent, we use:

- ▶ REVISED: Photo Estimate for cover assignment of CEO Portrait

These e-mails result in maximizing the possibility that the message will be seen and noticed as something other than spam, and thus, read.

Of the utmost importance is the change in the attached file's filename. Knowing that the files will go into the same Attachments folder that the client's e-mail uses or will be saved to a desktop, you don't want your current attachment to overwrite the original one. Further, when the file is on the client's desktop, although it might make sense to you to give it the client's last name or company name, the client probably has numerous other files similarly named. Choosing a name such as JHPhoto-Inv1234 or some variation thereof will give the client instant recognition of what the file is and what to do with it (hopefully pay it!).

Elsewhere in this book, there are numerous examples of my e-mail style and what my salutation, e-mail body, and closing look like, so I will not rehash it extensively here. However, it should be something like:

Dear *[client's first name]* –

Thanks for taking the time to talk with me regarding….
…I look forward to the possibility of working with you and [company name] on this project.

Best,

John

I would encourage you to use the client's first name, instead of Mr. *[client's last name]*. You're on equal footing with this client, and the "Mr." sets a tone that is just a bit too formal. There are circumstances when it is appropriate (such as when you are writing to someone who stole your work, the head of an accounting department who's not paying your bill, or such), but most client correspondence, for me, is slightly less formal than that which calls for a "Dear Mr." to precede the client's name.

That said, a study cited in another must-read book on e-mail etiquette and style, *Business E-Mail: How to Make It Professional and Effective* (Writing & Editing, 2002) by Lisa A. Smith, details the importance of e-mail professionalism. "Research by Christina A. Cavanaugh, a professor of management communications at the University of Western Ontario, shows that 'the major cause of e-mail stress in the workplace is in its inappropriate use as a communication tool, not its volume," and she goes on to conclude that correspondence via e-mail is "heavily judged on their appearance and the care taken in their construction."

Smith goes on to talk about templates. "Clients feel depersonalized when they realize you are serving them with templates…. It pays to pay attention to such details; they generate goodwill by pleasing clients and customers."

And one last note about being professional in your correspondence. Just as with voicemail, clients expect to hear back from you within a day, if not sooner. Disregarding their attempt to contact you to get answers or fulfill their requests could very well result in them calling someone else—if not on this assignment, then certainly on the next. If you don't have answers for them, at least let them know you will get back to them shortly with an answer. That way, they know you have received their request and are working on it.

Signatures–and Not with a Pen!

You see e-mail signatures all the time, usually coming from clients. They look like this:

```
-----------
John Doe
Creative Director
Talented Professionals Cooperative
1234 Main Street
Anytown, USA 12345
(800) 555-1212 – Office
(887) 555-1212 – Fax
www.TalentedPros.com
John_Doe@TalentedPros.com
```

They appear at the bottom of everyone's correspondence to you, but are you using one during your correspondence? All of it? If not, you should. Mine reads:

```
-------------
John Harrington
John Harrington Photography
2500 32nd Street, SE
Washington, DC 20020-1404
National: 800-544-4577
Local: 202-544-4578
Fax: 202-544-4579
e-mail: John@JohnHarrington.com
http://www.JohnHarrington.com
```

It's important that you indicate your name, even if it's in your company name. Further, in the event that you have people working for you, they should use the same signature, just with a different e-mail address and, if applicable, direct-dial phone numbers.

After I've exchanged e-mail with a client a few times, I may shorten my signature to look something like this:

```
-------------
John Harrington
John Harrington Photography
Local: 202-544-4578
John@JohnHarrington.com
```

This will still give them information, just not to the detail that the first signature does. In addition, I often will include my cell phone number in the signature because I want clients to be comfortable calling me there, too, although that information is also on my voicemail message.

Lastly, a number of mail applications allow for the inclusion of a graphic—usually a JPEG or GIF—that is a part of the signature. When I am sending an estimate to a prospective client, I will use a signature specific to that estimate type—portrait, ad, event, and so on—that

includes a montage of images that's about an inch and a half tall and about seven inches wide. This montage includes images that will further sell me as the best choice for the assignment. Here's how one would look for a portrait estimate request:

John Harrington
John Harrington Photography
2500 32nd Street, SE
Washington, DC 20020-1404
National: 800-544-4577
Local: 202-544-4578
Fax: 202-544-4579
e-mail: John@JohnHarrington.com
http://www.JohnHarrington.com

The graphic appears below the last line of the signature. It's wide enough to be appreciated, yet small enough not to bog down the transmission due to a huge file size. The graphic varies from assignment type to assignment type.

It might also be appropriate to include the disclaimer notice (that is, the one that includes "privleged, confidential, or proprietary" mentioned earlier in this chapter) below your signature, but as a part of the signature. However, in the end, the use of a signature will improve the professional look and appearance of the correspondence you send via e-mail.

Summary Letters: What We Discussed

All too often, there is a miscommunication resulting from a telephone call between you and the client. Usually, people do not intentionally misremember points of a conversation—they just honestly don't remember.

Although we talk with clients all the time about various things, when there is a point about changes in location, clarifications on stylistic details of an assignment, or other things that could adversely affect the outcome of the assignment, a letter summarizing the conversation can assist by providing a point of reference in the future. This is also helpful when, for example, an accounting department person says they are going to get the check cut "this week."

Further, should you end up in court, summary letters—more than likely summary e-mails—are admissible as evidence in most circumstances. So, if nothing else, write a CYA summary

to send to the client. It will make your life so much easier and the resolution so much swifter if you have the letter in your archives.

Following the same style for e-mails (or letters) mentioned earlier in this chapter, the body could read something like this:

Dear Jane –

Thank you for taking the time to clarify the style you are looking for as we produce the portrait of the CEO. As I understand it, you would like the portrait to take place outdoors but still be attractively lit with lights. Further, since it's for the cover, we will produce most, if not all, of the images as verticals and leave enough room at the top for the magazine's name and such.

For the image of the CEO on the production line, we recommended we use some colored gels to spruce up the equipment's appearance in the background, but you've indicated that your Editor-in-Chief dislikes this type of photography, so we will use no gels and make a more natural-looking portrait indoors in an environmental fashion, not against seamless. I understand you are looking for almost all of these images to be horizontals, as your magazine's style is to open an article with a half-page image of the subject, eyes forward. Once we feel we have a variety of choices from this set up, I may try a few subtly gelled variations—time permitting, of course.

Should there be any additional changes or updates, please don't hesitate to call. I am looking forward to completing this assignment for you!

Sincerely,

John Harrington

That will make sure that the client knows that you're doing "almost all verticals" for the cover idea and "almost all horizontals" for the inside idea. It also puts them on notice that you're not going to use gels (well, maybe a few subtle ones), and it keeps the communication lines open between the two of you. This e-mail also gives the client peace of mind that you heard what he or she was saying. And, it is a professional way to bring closure to the pre-shoot dialogue.

CCs and BCCs: How and When

It's important to be very thoughtful of who the message is to and who should get a CC and a BCC. In case you're not aware of what these mean, CC means *carbon copy* and BCC is *blind carbon copy*. These terms originated when business correspondence was all via paper and everyone receiving the correspondence needed to know who else had received it, and those BCC'd needed to know that others didn't know they had seen it. Today, with e-mail, the CC indicates everyone who's copied on the message, and a BCC hides the recipients.

Be extra careful—many a problem has arisen when someone BCC'd hits Reply to All and reveals that they have seen the message. Instead, use the Forward feature to forward the e-mail to those you were going to BCC, in order to avoid this potential revelation.

Ask yourself, though, does everyone in the To, CC, and BCC lines need to see the e-mail? Also, how would you feel if the contents of the e-mail became public knowledge?

CCs are typically done for legal reasons, to ensure a broader paper trail, and to keep a colleague or client abreast of developments associated with what you're working on.

I typically use the BCC when I want my office manager or production manager to see that I made a promise to a client about a deliverable, a change to paperwork, or another internal issue that needs to be done on behalf of whomever I was sending the e-mail to. I will, though, use the Forward option if I need to pass along guidance to those in my office, rather than use the BCC. If you are sending out a mass e-mail (and be careful about that!), especially to a group of unrelated recipients, make darn sure that you use the BCC field. Perhaps it's a promotional e-mail to existing clients and fellow photographers. If you did that in the To field or the CC field, all your clients would know who the others were, and your colleagues could learn who your clients are. Not cool.

One last point: Some corporate e-mail servers handle CCs, and especially BCCs, very carefully. CCs usually get through, but BCC is the preferred method of most spammers. One solution is to send the e-mail to yourself in the To line and then include the string of recipients in the CC line.

Thank-You Notes: How Much They Do and How Right They Are

In this fast-paced world, the use of a simple handwritten thank-you note has all but vanished from the mail-scape of interpersonal communications. As such, a written note by you to a client, thanking them for the assignment, will almost without exception be well received and regarded as a thoughtful reminder of your work and you.

Here's an example of a thank-you letter:

CHAPTER 22

Dear Client,

Thank you for choosing me as your photographer for the portrait assignment. I was excited to receive your request initially, and I feel that the finished work illustrates that.

If you have any other needs regarding this assignment (such as additional retouching or a change in the image selected), please don't hesitate to call or e-mail. It is you, my client, who I want to ensure is completely satisfied with the work done, as each assignment is undertaken with the intent to produce work that meets and exceeds your expectations. Your assignment and kind referrals are examples of the trust you put in me and my work, and I look to honor you as a valued client whose repeat business is greatly appreciated. Should you have any questions about this or future assignments, please don't hesitate to call!

Sincerely,

John Harrington

In Robert Solomon's *The Art of Client Service* (Kaplan Publishing, 2008), he makes this important point. "It's amazing how much power those two words have. A simple thank you...to clients for their business should be a given. Yet it often is not. People assume that others know they are grateful.... Go out of your way to say thanks, for the smallest favor, for the biggest help, and for anything in between." In today's busy world, when do you find the time? The same way you find the time to surf the web or shoot the breeze on an assignment. I recommend you make the time and make a difference in a client's day when they get the note and think well of you.

Recommended Reading

Griffin, Jack. *How to Say It at Work: Putting Yourself Across with Power Words, Phrases, Body Language, and Communication Secrets* (Prentice Hall, 1988).

Kirschman, DeaAnne. *Getting Down to Business: Successful Writing at Work* (LearningExpress, 2002).

Kramon, James M. *You Don't Need a Lawyer* (Workman Publishing Company, 2002).

Smith, Lisa A. *Business E-Mail: How to Make It Professional and Effective* (Writing & Editing, 2002).

Sterne, Jim and Anthony Priore. *Email Marketing: Using Email to Reach Your Target Audience and Build Customer Relationships* (Wiley, 2000).

Strunk, William Jr. and E. B. White. *The Elements of Style* (Longman; Fourth edition, 2000).

Chapter 23
Attorneys: When You Need Them, They're Your Best Friend (or at Least Your Advocate)

The best time to engage an attorney is prior to actually needing one. Whether it's for contract language review, queries about how to register a copyright, the legality of running a business from your home, or myriad other reasons, taking the time to learn what an attorney can do for you prior to actually needing one can save you time, money, and a lot of headaches.

Consider this: A respected and well-off businessman in the community receives a message from his lawyer, quite insistent on a meeting at the businessman's earliest convenience. Having been in meetings and unreachable all day, this message has floated to the top of his message stack. Upon turning up at his lawyer's office, he makes his way directly to see his attorney.

"I have really bad news and terrible news. Which do you want to hear first?" posits the lawyer.

"Usually, I look to the good news to cushion the bad, but if those are my options, I'll take the bad first."

The lawyer responds, "Your wife has found a photograph worth at least a million dollars."

The businessman is puzzled and bemused. "Bad news? How's that bad news? What on earth could the terrible news be?"

The lawyer states, "The photograph—it's of you and your secretary."

Everyone has a good lawyer joke—this one was inspired by a similar joke, the author of which is unknown. People love to poke fun at lawyers until they need them. Then an attorney is the only thing that will keep you from jail, a bankrupting judgment, and/or theft of your intellectual property, to name just a few things. Although this chapter won't deal with how you might resolve criminal proceedings brought against you, nor civil proceedings resulting from your car crash or your dog that bit the neighbor, it should shed some insight into how a good attorney (or an attorney who specializes) will be one of the better investments you can make.

NOTE

Disclaimer: My attorney advised me to tell you, dear reader, that I am not an attorney, nor have I played one on TV, and as such, the counsel in this chapter, the chapters on copyright, and in fact this entire book is to be construed as general advice. Should you need legal advice on any matter, you should consult with a qualified attorney licensed to practice in your jurisdiction and preferably in the jurisdiction(s) in which you may be forced to bring your suit, should the defendant be successful in forcing a change of venue for whatever reason.

Whew.

What Attorneys Can Do for You

Attorneys abound in every town, from the southern tip of the Florida Keys (albeit probably semi-retired attorneys) to the oil fields on the North Slope of Alaska, and probably wherever two roads intersect between those two points. Some are generalists, dealing with all sorts of law, but a photographer in business will usually need an attorney familiar with (or preferably specialized in) contract law, intellectual property, and copyright. Usually one attorney or a firm can handle all of these, provided they also don't do divorce, family law, or personal injury. Those attorneys usually don't handle the types of cases that a business will likely need. However, if you are irresponsible enough to not carry liability insurance for your business, you may need a personal injury attorney to defend you if someone gets hurt while on a shoot you are in charge of.

Contract Review and Negotiations

Almost all professional organizations make available to their members boilerplate contracts that are exponentially better than what almost any photographer could produce by staring at a blank word processing document. Yet, these boilerplate contracts are just starting points.

For example, many states have a requirement that a "liquidated damages" clause will be deemed invalid unless specifically agreed to in advance and/or initialed by the assigning (hiring) party. Other clauses in a contract may be inconsistent with state law and, as such, could create holes in the terms under which you and the client undertook and commissioned the work. You may provide to your attorney the boilerplate agreements and ask him or her to affirm that they are consistent with state laws and to make revisions where it is in your best interests to do so. This might also serve to reduce your costs for the review because the attorney is editing a document, rather than crafting one from scratch.

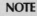

NOTE

You might be most familiar with "liquidated damages" in reference to your credit card bill or mortgage, in the form of a late fee. In other words, the "liquidation" is the contractually agreed-to amount of damages that shall be paid, regardless of what the actual damages are. So, for example, if you and a bride agree to a liquidated damages amount not to exceed what you were paid to provide wedding photography, she cannot come back and sue you for the costs to re-create her wedding (from renting the venue, to tuxes, to flying guests back in, and so on) when you fail to deliver the photography services you were contracted to. But be careful—unless the groom also signed the contract, he is a separate entity from the bride until such time as they are married, and even then may still be deemed legally separate based upon the date of the contract. This means he could sue you outside of the limitations of the wedding contract unless he signed it as well.

Further, you might find that, especially when negotiating with a client who wishes to engage your services under a retainer, having an attorney draft the agreement and negotiate legalese (leaving fees, expenses covered, and rights to you) may make for a better final document.

NOTE

Whereas you might be more familiar with retainers when you are paying them, they can just as easily apply to your services. For example, if there is a local theater that needs photography of all its performers and images of their dress rehearsals for promotion of the plays, a retainer whereby you agree to provide a certain number of days of photography in exchange for a monthly payment by the theater might be optimal for both you and the theater.

Lastly, where there is an infringement, it might be best for your attorney to be the one to write the letter or make the call to the soon-to-be-defendant's counsel to begin what, at that point, will be a serious dialogue. During that call, be sure that you've given your attorney some guidance about what you hope to get (a quick payment without further discovery of other unknown infringements, cease and desist, and so on), so that he can effectively convey the scope of the situation to his counterpart.

Writing and Revising Your Current Contracts

If your photographic specialty is unique, or you've found significant objection by clients to certain terms of your contracts, an attorney can be your best resource for revising your contracts or writing them from scratch. Further, many existing trade organization contracts have been the basis for litigation in the past, and case law "holes" may have been found that could diminish the validity of certain terms. A lawyer you engage could write you new clauses (or a whole contract) based upon his own present-day knowledge of case law, so that your contract is as up to date as possible.

Advising You on Legal Matters

There are many legal matters beyond contracts and copyright on which your attorney can advise you or direct you to a colleague who is versed in those areas. From sales tax issues, to zoning for a business, to labor laws, to estate planning, numerous issues could have an adverse effect on you and your business and could be avoided simply by engaging the services of an attorney for a few hundred dollars to get the right answers, specific to you and your business. And, in the end, if you find yourself in court about that issue, your attorney will be the one you'll want to call on to defend the position in which his advice placed you.

Taking a Case

If you have a relationship with an attorney, he'll be more likely to take a case that, had you wandered in off the street, he would have turned down. In either case, the issue you have may be equally of concern to you, but without that preexisting relationship, the attorney will be less inclined to help.

Understand also that when you have the attorney you want, you are his client, and when there is a dispute between you and *your* client, if the attorney has a preexisting relationship with your client (or even a distant past relationship), he might find that it is a conflict of interest and turn down your case. Although the availability of intellectual property attorneys and contract lawyers may be high in major metropolitan areas, in smaller parts of the country, there may be just a few who are best suited to accomplish what you need. In one instance, for example, I had a dispute in California and sought to engage an attorney in the municipality where the infringing party was incorporated. However, because all three firms in that city had, at one point or another, provided legal services for the eventual defendant in the case, none could take on my case. I had to hire an attorney nearly a hundred miles away.

What You Can Expect to Be Billed

One of the eye-openers when first hiring a lawyer is the variety of things you are billed for. Although it might come as a surprise, instead, it could give you an insight into how you might consider your own billing. Two charges I began to apply to clients were the pre-event conference call and the site visit for assignments that either did not really need one or for which I did not initially include a line item. These were inspired in part by bills for 15 minutes of conversation with my attorneys. I thought, "If they're doing a professional billing like this, it stands to reason that I can too—and, in fact, I should be doing the same." You'd be amazed at how many conference calls I no longer have to participate in and how much more participative I am for the ones in which I do participate.

Retainer Fee

Here's how a retainer might look (in part):

LEGAL SERVICES RETAINER AGREEMENT

This Agreement is entered into by and between the {firm name} (hereinafter "Attorney") and {your name} (hereinafter "Client"). Client hereby retains the services of Attorney, its staff attorneys, paralegals, law clerks, and any other employees or independent contractors, at Attorney's discretion, at present, or in the future, to perform the following work:

Case Staffing

Attorney, at their sole discretion, has the exclusive right to take on additional attorneys to assist in the case. Client does hereby assign to all lawyers, paralegals, law clerks, and others who are now, or may be during the course of the case, the power to work on this case. Attorney shall not perform any work or service for or on behalf of client unless specifically outlined in this Agreement.

Control of Case

Client does hereby assign to Attorney all rights necessary for this case that Attorney deems worthwhile, including the filing of claims, suits, motions, or other legal papers. Where Attorney determines it is best to do so (as in, waivers, for example), Attorney will accede to client to make decisions.

No Guarantee of Results

At no time, has, or will ever, Attorney make any guarantees to Client as to the outcome or success of the case.

Billings

Attorney shall bill, and Client agrees to pay legal fees, as outlined below:

Client agrees to pay Attorney a minimum, non-refundable retainer fee of $2,500. This retainer fee provides for time to be set aside by Attorney, on behalf of client, to take on this case. This payment is for services to be rendered, and shall not be held in trust on behalf of Client, and in the event less than this fee be used in performance of Attorney's duties, no refunds of any remaining amounts shall be made.

All work done by Attorney shall be billed against the retainer, at an hourly rate of $200 per hour. This is the billable rate whenever Attorney works on this case. This includes, but is not limited to research, interviews, preparation of legal documents or court appearances, depositions, phone calls, expert meetings, waiting time, and any other work performed for this case, at the sole discretion of the Attorney. Any work performed on this case which takes place after 6pm or before 8am during the work week, on federal holidays, or weekends, or otherwise on a "rush" basis, shall be billed at an hourly rate of $350 per hour.

Where Attorney engages the services of a law clerk, legal aide, or paralegal, the following rates apply: For Law Clerks – $125 per hour, for Legal Aides – $90 per hour, and for Paralegals – $140 per hour. The same basis for these applies—i.e., any time they work on the case with, or on behalf of, Client at Attorney's direction. Further, it is understood that any conversations between Client and these individuals is not legal advice.

(continued)

Fees and Expenses beyond Retainer

Client has reviewed in full this Agreement, and understands that the final fees and expenses will almost certainly exceed the retainer paid under this Agreement.

Non-Payment by Client

It is Attorney's policy that bills are payable as denoted on invoices, usually 30 days from date of invoice. Attorney is willing to make fair and reasonable arrangements for Client to establish a payment plan following the exhaustion of the retainer. In the event that Client fails to make timely payments of invoices presented, or make suitable arrangements for a payment plan, Attorney shall effect a Motion to Withdraw at the soonest possible time, and make efforts to collect payments for all billed fees and expenses, in addition to late fees, whether by collection service or lawsuit.

The retainer agreement would go on to make other recitations and further define what's being done for you and what they will not do. Don't be put off by the document; they're usually pretty fair and are a cornerstone of all work done for you.

Phone Calls

Attorneys and those who work for them will be billing you for any phone calls "of substance." This means that if you call to set up a conference call or ask that the attorney call you back, or if you call to discuss with the attorney when you will be coming in to sign documents, you won't be billed. But if you call and ask a question about a case or you call asking for the definition of, say, published versus unpublished for purposes of submitting an accurate copyright registration, you can expect to be billed, usually in 15-minute increments, for their time. So, unless you're in a hurry, save up two or three questions to ask all at once. However, you should be watching the clock, or you might find yourself learning a lot during the conversation but spending more time (and money) on the phone than you'd expected.

Copy/Fax and Other Miscellaneous Charges

You can expect to be billed for numerous seemingly insignificant expenses that are, when combined over the course of the month, actually significant. The attorney's receipt and cursory review of a fax from you will likely incur an expense. If the attorney has to make photocopies for you or your case, they'll probably cost around $0.20 per page. That might seem insignificant at first blush, but consider that over a month, those items could become several hundred dollars as a line item expense.

Many attorneys have a case establishment fee, which means that when the attorney takes a case for you, there is an initial $75 to $250 (or much higher) fee for the attorney to get you set up in his system for accounting, filing cabinet space, and such. Just as you should take the approach that whenever you are working on behalf of your client for an assignment, it should be billable (or at least accounted for when preparing your quote), your attorney will follow the same principles.

When you establish a relationship with an attorney and use him with some degree of consistency, some of these fees may be waived (as in the case establishment fee and so on). Further, there will be less time spent by the attorney familiarizing himself with you and your work if he has worked with you consistently, so savings can occur in that instance as well.

Ask Your Attorney Whether It's Economically Sound to File Suit

Sometimes one of the more difficult things to do is to not file a case. You've been wronged, you know it, and the potential defendant knows he or she was in the wrong, but is it worth it? Maybe it's a missing or illegible signature on contract language in dispute, maybe you didn't register your copyright, maybe you did but the use will be argued as the amoeba-like "fair use," or maybe your life at that point is personally too troubled to withstand the demands of your time and mental energy required to take on the case. Or, perhaps you have the best case in the world, but you don't have the resources to see the case through to the end or to a likely point where a settlement offer may be made.

Cases are decided all the time based upon economics. The suit I filed against the Textiles Company, as discussed in Chapter 20, was almost certainly settled (to my benefit) for these reasons. The attorney could not have been clearer about his client's willingness to settle being in part based upon whether I agreed to their settlement offer prior to the weekend, because the attorney would have to incur a significant amount of billable time, and these monies could instead be applied by the company to the settlement figure. Because, as I outlined, I was in small claims court and not paying an attorney, and their offer was certainly fair, I accepted. This company made their decision on the economics of the suit, not on whether they were right.

When these or myriad other potential circumstances apply, asking your attorney about the case's viability and likely outcome might net you the best counsel they can provide. Although there are a few attorneys who will salivate over taking on your case, almost all will give you objective advice, especially if you have all your ducks in a row. If the attorney doesn't take your case, it's likely he has other cases, so he's not looking at you as his next meal ticket. (Beware those attorneys who are!)

Why Attorneys Are Reluctant to Take Cases on Contingency (and When They Will)

This brings me to taking your case on a contingency—that is, for a piece of the pie. Most personal injury lawyers take cases on contingency, and this is usually because whomever they will be representing will be suing a person with assets or an insurance company, and the likelihood of a settlement is extremely high because the "economics of a trial" (as noted previously) are much higher than the formula for calculating a settlement.

CHAPTER 23

Other reasons for taking a case on contingency are notoriety (in other words, how much free publicity the attorney will get by representing you) or service to the downtrodden (that is, you were the aggrieved party from some big corporate conglomerate and you can't even begin to defend yourself, or you've had your civil rights violated or something along those lines). Sometimes, attorneys will take a case on contingency out of the goodness of their heart. Ultimately, the attorney (or his or her firm) will be the sole arbiter of the choice to take you on contingency. For copyright, a usual "contingency deal breaker" is the lack of registration, and for contract law it might be the absence of evidence of a "meeting of the minds" (whether a signature, correspondence indicating agreement, and so on).

NOTE

"A meeting of the minds (also referred to as mutual assent or consensus ad idem) is a phrase in contract law used to describe the intentions of the parties forming the contract. In particular it refers to the situation where there is a common understanding in the formation of the contract. This condition is often considered a necessary requirement to the formation of a contract.... [O]nly when all parties involved are aware of the formation of a *legal obligation* is there a meeting of the minds." This was the definition from Wikipedia as of late 2009, and while that body of text may change, this definition is exceptionally well stated in this incarnation, so it warrants citing here.

Even in cases taken on contingency, you, the plaintiff, will usually have to cover court costs— the costs of discovery and depositions. Except in rare circumstances in which the law firm bankrolls every expense (as in many personal injury cases, in which the plaintiff is practically indigent), these costs are significant. The "contingency" part almost always only covers the law firm's billable time for attorneys, legal researchers and assistants, and other staff time.

When you ask an attorney to take a case on contingency, you are asking him or her to take a gamble on you and your case. Attorneys are, by their very nature, mostly adverse to risk, so you'll need to make a compelling case or find that needle in the haystack who has a soft spot for the wronged photographer.

When You Pay for Advice, Heed It

There is an old adage that advice is worth what you pay for it. This is usually attributed to those who offer unsolicited advice on life's trials and tribulations. Although this adage is questionable, the converse is certainly true. When you're paying an attorney to make objective determinations and the resulting counsel, heed that counsel, or at the very least consider it when making your own tactical and strategic decisions. Either way, you will be billed for that advice, so make it worthwhile.

Oh, and one last point. It is a sad fact that photographers have one of the highest divorce rates in the world. Respected photographer and fellow espouser of good business practices, Rick Rickman, now a professor at Brooks Institute of Photography, penned an article in 2002

on photographers and divorce rates. Rickman, in a conversation with David Burnett, co-founder of Contact Press Images and an icon in the photographic community, reported that "he [Burnett] sometimes felt as though his career had been slowed by the fact that he devoted time to his family, but that he wouldn't change his life in any way." I will touch more on Rick's and David's sentiments in Chapter 30, "Striking a Balance Between Photography and Family," but know that you might also find yourself in the position where a divorce attorney is needed if you don't pay attention to the more important aspects of your life—family. I do hope that this is never the case, but if it is, at least it's not in the same league as our lout from the beginning of the chapter.s

CHAPTER 23

Chapter 24
Office and On-Location Systems: Redundancy and Security Beget Peace of Mind

The simple fact is you have office systems and camera systems. If you are absolutely certain that at no time will any of those systems fail, nor be hacked, then you can consider skipping this chapter. You can also go to Las Vegas and put your entire fortune on red or consider living life without health insurance or savings for a rainy day. Skip this chapter at your own peril.

In May 2006, the Small Business Administration reported that "a University of Texas study reports that 43 percent of companies experiencing a catastrophic data loss never recover, and half of them go out of business within two years. So businesses, and for that matter anyone who owns a home computer, should back up financial records and other vital information stored on hard drives." Although this message was intended for those preparing for natural disasters, the statistics, without equivocation, apply to our everyday business activities. So, in the event that you have a catastrophic data loss, a 43-percent chance of your business shuttering is statistically close to betting the farm on red.

Redundancy: What Is It?

Redundancy, when referring to data, office, or photo equipment, is a state in which you have duplicative systems and storage so that should one fail, the other may be drawn upon to restore or re-create valuable data. If you're speaking of duplicate cameras, you can complete the assignment with the second camera if need be. There are numerous systems to employ, some of which you may be doing already. It might be simple things, such as making copies of an important receipt or installation serial number for Photoshop or creating a CD with all your best portfolio images. Maybe you even clicked Yes in the occasional pop-up window from your accounting software, prompting you to back up your financial data. I hope.

Communications Networks

In my office, every day we transmit images directly to clients, to our own FTP servers where clients can retrieve them, and to online galleries for client review prior to the delivery of final images. All of this is in addition to the lifeline that is the sending and receiving of e-mail. Of

late, we have also switched to Voice over IP (a.k.a. VoIP) telephone service. I have contracted with the fastest cable Internet provider available to me. Yet, should that service go down—for weather reasons, a service provider outage, or a tree falling on the cable line—I will be dead in the water. With a single cable modem line costing $60 to $90 a month, that equates to about $2 to $3 a day. If my service were to go down for even two days, the costs to my business would far and away exceed the cost for several months of service.

As a result, because my location offers at least two Internet service providers, I have contracted with both to provide Internet access. This gives me peace of mind, knowing that I will be able to continue to function should one of my providers fail. As a last resort, the cellular modem I have can be configured to provide a third level of service. And, as a redundancy for the laptop, I have a no-monthly-fee (pay-per-use) WiFi service provider so I can find a wireless access point when traveling and take care of e-mail and file transfers where necessary.

Firewalls and System Security

Firewalls are hardware and/or software whose purpose is to prevent unwanted access into your internal office/studio network from the outside. The term *firewall* came from safety walls in construction, but you might be more familiar with it in relation to your car, where the firewall is the wall between the engine compartment and the passenger compartment that will minimize (or hopefully prevent) a fire from the car's engine from making its way to the passengers.

It is a fact that every second of every day, hackers are scouring the Internet looking for "zombie computers." These are computers that are hacked not because the hacker thinks you have any valuable information on it (although if you do, they'll exploit that, too), but because they can take control of your computer, allowing them to launch attacks that look like they are coming from your computer. A *PC World* article by senior writer Tom Spring reports that between 50 and 80 percent of all spam polluting the Internet is generated by these computers. Law-enforcement traces will turn up you, not the hacker, and it is your bandwidth that is being used to send all the e-mail, not theirs. One of the significant benefits of using a Macintosh computer is that there are few known viruses attacking and thus taking control of this operating system. PC users beware, though.

Nowadays, almost every router from the more reputable manufacturers has some degree of a software firewall and can be configured easily. If you're looking for sophisticated hardware firewalls, I encourage you to contact a local network engineer; the demands of setting up such a firewall are not insignificant, but the end result is valuable.

Consider the critical importance of securing your network from the outside. Take the time to protect yourself now, so that you are not stuck with authorities knocking on your door or your financial data being compromised.

Port Forwarding: Port What?

Before I go into what port forwarding is, you need to know what a port is. You might wonder how you can surf the web, send an e-mail, and FTP down a file from a remote computer all at the same time, without the data from each conflicting with the data from the other. Your use of the Internet travels via a port. An http request typed into your browser travels through port 80 on the server to which you're connecting, for example, and an ftp request travels through port 21. Gaming software uses other ports. E-mail typically travels through port 25; however, some Internet service providers, in an attempt to get you to use only their e-mail service, will block that port, and a savvy secondary ISP—usually the one with which you have your website hosting—will offer a secondary port number. This is the case with my ISP.

Ports can also work to route traffic to where you want it. For example, suppose your cable modem/DSL provider provides you with a static IP address of 128.176.0.12. As you might be aware, every website name is actually a representation of an IP address, and every time you type in Google.com, for example, your web browser goes to an Internet "address book," called a *domain name server*, and retrieves the IP address for that name, and returns it. Then, your browser requests of your ISP that you be connected to that IP address anywhere in the world. All of this happens in a split second. The IP address just mentioned is one of Google's IP addresses. If you were outside of your office and wanted to connect to your home computer, all you would need is the IP address your ISP provided you with and one additional configuration—port forwarding.

NOTE

An IP address is the address that you are assigned by your Internet service provider. For example, using the White House, presume that every street in Washington DC has a numerical representation—1st Street is 01 and, say, Pennsylvania Ave is 132. And, with 50 states in the US, say the District of Columbia is 51, and the zip code for the White House is 20500. That would mean that 1600 Pennsylvania Ave, Washington DC, 20500 would translate into an IP address of 1600.132.51.20500. Now, this is a concept only, since IP addresses are between 0 and 255, but you understand the concept. A generic IP address is something like 192.168.102.1. For your computer to make a request for a website, the website has to know where to send it. The IP address your ISP assigns you, whether static (that is, unchanging) or dynamic (meaning it can change every time you log onto the Internet), is how that information is delivered to you.

In your network router—the box that connects your computer to your cable or DSL modem—you can configure various ports to do various things. Typically, all ports are closed from external access into your home or office network. You must turn them on and then configure them to do what you want. There are two sets of IP addresses—internal (or *intranet*) addresses and external Internet addresses. Although the international governing body of the Internet assigns blocks of IP addresses to every ISP on the planet, and you

cannot choose or set your external/Internet address, you are that governing body for your internal/intranet IP assigning. The most common IP ranges are the 192.168.xxx.xxx and 10.0.xxx.xxx. For the sake of clarity, I will use the 10.0.xxx.xxx range for this example.

Suppose you have a cable modem router—this is where the IP addresses are determined. You may choose 10.0.1.1 for the cable modem. The first computer on your network will then likely be 10.0.1.2, the second computer will likely be 10.0.l.3, and so on. Once you know these numbers, you can go into the port forwarding section on your router and assign all requests for websites (http or port 80) to be forwarded to the second computer on your network—10.0.1.3. Thus, all views of your website are delivered to the World Wide Web directly from your computer in your office.

Although I would caution you against doing this for bandwidth and other reasons, there is a reason to use port forwarding: You can allow clients to securely access a folder on your computer where they can FTP images directly to themselves from you. This means that you do not need to e-mail image(s) to them or upload them to your own offsite FTP servers. You need only e-mail them the link: ftp://192.168.102.1/clientfile.zip. When that request is made, it reaches your router, and your router, seeing the "ftp," looks up the port forwarding number for port 21 (the FTP port) and finds the address of 10.0.1.3. It then sends that request directly to the computer in your office, which will then verify that "clientfile.zip" is in that folder and begin to deliver it to the client. This does, however, potentially create a whole host of security concerns. Most important, you should have hard-to-remember passwords and such on your computers, and you should change them regularly.

There is one other benefit to knowing what and how port forwarding works. Using applications such as Timbuktu on the PC or Apple Remote Desktop on your Mac, you can access your computer at home from anywhere you have Internet access (at a decent speed). All you need to do is configure port 407 on your router for Timbuktu, or for Apple Remote Desktop, 3283, 5900, and 5988. Both applications allow you to modify the port number(s), and there are other applications besides these two that can provide this functionality for you.

The beauty of this is that you can access all your data at home, send e-mail from your home computer, and even help an assistant figure out a problem working on your computer in your office if you're at a remote location. The benefits of this functionality should not be underestimated. If you have ever been out of the office and realized you left a document, file, or image on the computer at home, this is a lifesaver. If you want other solutions, solutions such as GoToMyPC.com for the PC or MobileMe's Back To My Mac will make it even easier to access your computer from a remote location.

Back Up, Back Up, Back Up!

A study by the Gartner Group reveals that 60 percent of backups are incomplete, 50 percent of restores fail, and only 25 percent of backups are stored offsite. The study further indicates that 64 percent of small and mid-sized businesses maintain their backups onsite. This is a catastrophe waiting to happen. It is imperative that you establish and implement a routine backup solution—preferably for all your systems, but at least for your critical data.

Here are some sobering statistics from their report:

▶ Eighty percent of all business data resides on computers.

▶ Thirty-two percent of all data loss is the result of user error.

▶ Ten percent of all laptops are stolen each year.

▶ Fifteen percent of all laptops suffer a hardware failure each year.

For my mission-critical data (other than digital images), I utilize my MobileMe service. Each night, my computer connects to .Mac and uploads the last accounting software file, my address book, my calendar of assignments, my e-mail accounts and settings, and a few other pieces of data that I cannot live without. For PCs, there are offsite solutions with which you can accomplish a similar level of protection; Carbonite.com and Mozy are two excellent choices. Although I am not familiar with all the brands, I can tell you that for around $100 a year, it's one of the better investments you can make in your backup plan. Additionally, I carry a thumb drive that can hold 2 GB of data for a very reasonable price. I can carry with me all my financial data (encrypted with password protection in case I lose the thumb drive), my address book, disk images of my critical applications (such as Photoshop and others), plus my serial numbers in the event that I have to reinstall my software in some remote location.

Backing Up Your Desktop

Setting aside for a moment the loss of data, there is another very important reason to ensure that your desktop computer is entirely backed up—the cost of restoration. No doubt you have spent a great deal of time personalizing your computer, from the mundane (such as bookmarks in your web browser), to installed programs, to the settings of those programs. If you've ever had to erase a computer and start all over from scratch, it usually takes at least a day, and then you spend a great deal of time reinstalling small applications or Photoshop plug-ins to do what you normally do. There are numerous solutions for backing up your desktop computer, and the benefit is that if your hard drive or other equipment fails, all you need to do is make the necessary replacement and then use the Restore Backup feature of the software, and your computer will be just like it was the last time you backed up. A truly safe computer user will have two backups, one that it does weekly and one that it does nightly. Although I think hourly backups are overkill, there are some who find them comforting.

The important thing is to establish a backup solution and then be vigilant about maintaining it.

Backing Up Your Laptop

With the figures mentioned earlier in this chapter, you have a one in ten chance of having your laptop stolen and a one in seven chance of it crashing. With odds like those, how soon do you think it will happen to you (or happen again)? And, do you think you'll likely be on the road, without access to your home computer for a period of time when this happens? My solution, as with my desktop, is to maintain a vigilant backup plan for my laptop as well. The one difference is that I always take my nightly backup on the road with me—it is a 100-GB pocket disk drive that takes up little space. Further, should my machine fail, with my Mac I can find any current-model Apple and reboot, holding down the Option key, and

choose my backup pocket drive as the boot volume. Then, I'm up and running on my system, with my data, on someone else's hardware. Even the desktops at an Apple store will do. (Although you will probably incite a bit of consternation from the employees, but maybe it's only for a few minutes or while you are waiting for them to ring up your replacement laptop!) Plus, when you boot the laptop—again a benefit of Macs—you can, within just an hour or two, transfer all the settings from the drive to your new machine. PCs have comparable software from companies such as Symantec and others that will provide a similar level of backup and restore capability. This would mean that you could be back up and running when you wake up the next morning after your restore was completed, if not between lunch and dinner.

NOTE
As a kind of "the gods are watching" aside, at 2:00 this morning I found myself needing to get up from my laptop to attend to my daughter, who was having a bad dream. As I moved away from my laptop, my foot caught the power cord, and the laptop went crashing to the floor. Fortunately, it was a carpeted floor and no damage was done; however, it was an eerily coincidental occurrence while writing this chapter.

Backing Up Your Work in Progress

In addition to keeping two backups of every digital file I create (as I will outline in a moment)—one that I keep onsite and one that I keep offsite—I also keep a backup of my working drive. I have one computer in the office that I dedicate to doing post-production. That computer has two internal drives, one of which contains the operating system and all the applications. The second one is what I refer to as the *Working Drive*. Keeping a single physical drive dedicated to your data benefits you in two ways. One, you're not causing severe fragmentation of your drive as you save, open, close, save, delete, and then save other files, nor are you taking up scratch disk space from applications such as Photoshop. Second, in the event that your machine *does* fail, you can simply remove the Working Drive hard drive, put it into a secondary machine, and continue working. That drive is backed up to an external drive every night, so that should it fail, not only will I have a backup of the work, but I'll also have a backup of all the work that I've done to the file since I ingested it into the computer.

THE 12 STEPS OF PHOTO ARCHIVERS ANONYMOUS

1. Admit that you have a problem and are not backing up images.

2. Understand that you do not know how to best resolve your problem.

3. Agree to establish a system that works specifically for your workflow.

4. Review the size and scope of your current archive and know what you're dealing with.

5. Contact/research friends/colleagues/services who might be able to help.

6. Choose whose system you'll use and acquire the equipment, then schedule a time to begin the problem solving and archiving.

7. Document your workflow so if you forget, you can refer back to your own diagram and thoughts.

8. Get your drives up and running and test them (nightly backups and so on) before beginning the full organization.

9. Start with your new system from the first day of a month forward and begin the move to your new system, verifying each copy to ensure they're properly copying. (An application such as Synchronize! Pro X will do this just fine.)

10. Locate and integrate stray image folders into your image archiving system, updating and fine tuning your own workflow documentation as you use it to be more clear and concise.

11. Review and research ways to tweak your system to improve it based on your own specific needs as you better learn how it works.

12. Spread the gospel of proper image archiving and pay forward your knowledge, because it is only through the teaching of a system that you begin to truly understand how it works and how you can continue to improve on its functionality and clarity. Continue to practice the gospel of proper image archiving.

I put together a set of PDFs from the variety of talks I've done. It illustrates graphically my entire workflow, from ingestion to final archiving. You can access this set of PDFs at ftp://best-business-practices.com/harrington_archive_system.zip.

Further, as images are ingested into my Working Drive, they are simultaneously being ingested into a second location—a drive I have labeled Redundancy Drive. That drive's purpose is solely to be available should the Working Drive fail before the images make it to the image archive drives outlined in a moment or are archived that night. The Working Drive contains newly ingested files and those that have not been worked on, works in progress (such as a conversion from CR2 to DNG, full-rez JPEGs, deliverable files, and so on), images that have been delivered to the client but not stored on the Image Archive 00x drive, and lastly, my most recent assignments, which *have* been stored on the Image Archive 00x drive. This way, when I switch to a new pair of drives at the end of a second month, I still have the last 10 to 20 assignments available "live" on my Working Drive. The nightly archive of the Working Drive is intended to ensure the security and integrity of my post-production work, not to ensure against the potential loss of the images altogether. (Although

CHAPTER 24

it *does* ensure against a loss of the images, that's not its original intent.) The Redundancy Drive *does* ensure against the potential loss of the images altogether should the Working Drive fail and the cards have been wiped/shot over.

One solution would be to use something called Network Attached Storage (NAS), which would reside on your network, usually within your intranet. NAS is simply a hard drive that is accessible over a CAT5 (or CAT6) Ethernet cable. If you want to use NAS, make sure that it supports 1000mb/sec (a.k.a. gigabit Ethernet), and most importantly, your computer's network adapter is also capable of handling that speed.

Further, with correct configuration or the use of dedicated in-office servers, these images could be available from a remote location as well. Keep in mind that you'll be quite limited, to about 350kb/sec access, because that is probably your up speed on DSL/cable modems, and the up speed will be your limiting factor.

Dual Backups of Image Archives, Onsite and Off

Every job/assignment folder has an exact copy residing on a duplicate hard drive that is stored offsite. In the event of a disaster rendering my office inaccessible or destroyed, my images will be safe. We only access those drives for three reasons:

1. When the onsite drive fails and we need to restore it
2. Every few months to "spin up" the drives so that the drive bearings and lubrication do not degrade
3. When we migrate from that storage type (in other words, hard drives) to the next generation of storage type (as yet unknown)

Due to the current use of drive space, we are consuming one set of 250-GB drives per month, or half a terabyte of storage.

Dual Cameras on Assignment

With all this talk of office equipment, it's easy to forget about the redundancies that should be employed when you are on assignment. Just as you should take extra batteries and flash cards, you should also have a secondary flash and camera on hand, in the event that your working camera fails. More than once, I have had a camera fail mid-assignment. It's easy to simply put that one down and pick up the backup camera to continue the assignment.

Other times a flash will break off. It might be just the hot shoe on the flash, but on one occasion, the hot shoe remained in the flash attachment, and the entire top of the camera broke off. In the former circumstance, you'll want to make sure you can continue the assignment with the secondary flash.

If you are traveling to a distant location, it might be of value to bring some secondary lenses as well. Planning for the worst will give you peace of mind, especially when you drop your prime lens off the starboard side of the boat you are working from or down a ravine during a hike to the location you selected at the top of the mountain.

Excess Lighting Equipment: Don't Take Three Heads on a Shoot That Requires Three Heads

A fairly standard lighting setup for a headshot is a main light at about 45 degrees off axis to the left, a reflector on the right to fill in the right side of the subject, a hair light opposite the main light behind the subject, and a light on the seamless backdrop. That's three lights. Ask yourself, which one can you do without? I suppose the hair light, but then you lose much of the separation and dimension of the image. Now, this isn't a complicated lighting setup, and perhaps you could do without one head, but there are a number of shoots where that's just not the case.

When you arrive at the shoot, perhaps a clumsy assistant will drop the light case. Perhaps it's just the time in that flash tube's life to go to light-bulb heaven. Perhaps the light stand will be knocked over by the client, and the head will go crashing to the floor. Or, perhaps the power pack will receive a surge of electricity from the wall outlet. For lighting kits in which a pack feeds multiple heads, you'd be best served to have more than one pack, if for no other reason than that stretching the cords to their maximum lengths to get the lights where you want them can often be difficult and risky. But should a pack go down, you won't be dead in the water. For lighting kits in which each head is its own self-contained pack and head (sometimes referred to as a monobloc), you'll want at least one additional backup head should a head fail.

Taking these precautions will mean you are minimizing the likelihood that your shoot will be scrubbed because of lighting equipment failure.

It Only Takes One Flight: Carry On Your Cameras

I am often amazed at the lack of thinking that goes on in the minds of the flying public. There was a recent reality television show that documented the behind-the-scenes trials and tribulations of an airline as they dealt with difficult passengers, delayed flights, and lost luggage. Time and time again, passengers depicted on the show reported that they had packed their medication in the luggage that was checked and now missing, routed to a distant location, or didn't make it onto the plane. And this wasn't medication for a headache; it was medication for heart ailments, allergies, and other life-threatening ailments. Medicines like this are so small that they can easily fit in a purse, pocket, or even the smallest carry-on bag. Also, you are often told not to pack jewelry, cash, or other valuables that could be missing upon your arrival at your destination—this includes cameras.

And don't pack your cameras in bags that scream, "I am a camera bag; steal me!" Some current models of camera bags are nondescript. Some look like generic satchels, some like school backpacks, and some like your basic carry-on bag, which brings me to my point. It used to be that when I would travel with cameras and film, the cameras and lenses were the absolute "must have," and the hundred-plus rolls of film could be replaced if necessary. However, on my return flight, I would never let the exposed film leave my sight or proximity. You are allotted one carry-on and one personal item—a purse or laptop case. Thanks to the hard work of the American Society of Media Photographers, the

Transportation Security Administration now allows you to have a second piece of carry-on luggage, provided it contains photographic equipment. However, the baggage must still conform to size and weight restrictions, and there are times when the overhead bins may be full. But you should carry on the things you can't live without—medication, your laptop, money, client contact and trip information, and your cameras and lenses.

If you have a significant amount of equipment, carry on the primary body and lenses. If the flight attendants tell you that the overhead bins are full, on most airlines you can carry on a camera that is not considered your allotted personal item or carry-on bag. Although this rule is meant more for a point-and-shoot or a small SLR, a professional-grade body with a 300mm lens attached to it falls into that category. So carry that on the plane on your shoulder and put several of your lenses into pants and jacket pockets if you have to. Somehow, you should get the most critical pieces of equipment on board and fit them under the seat in front of you. Aside from theft, there are baggage loaders who seem to have a constant disregard for luggage marked "fragile"; it'll get tossed around just like all the other bags.

One final solution is to ask that your bag be "gate checked." This is what happens to strollers and children's car seats. At the bottom of the jetway, an attendant takes your bag and gives you a claim check. When you get off the plane—even if you're in a connecting city—you wait in the same place after you deplane, and a baggage handler will bring up your bag when he or she brings strollers and other gate-checked items, thus minimizing the risk to the bag. Although attendants accept gate checks without a moment's thought for strollers, it might take a courteous request or two before they take your camera bag. Make sure when they do take your camera bag that it will come back up to the arrival city jetway, rather than being sent to baggage claim.

With the changes that continue to evolve regarding airport security, make certain that whatever carry-on bag you have can survive as checked baggage. You may find that during heightened states of security, you might not be allowed to carry on any baggage, and this may happen mid-trip or be different when you depart a domestic city en route to an international city, where carry-on luggage is allowed upon your arrival but disallowed in that same international city upon your return home. Lowe Pro and Think Tank are among the manufacturers that have excellent solutions for protected carry-on baggage that meets airline standards and is able to be checked and survive.

Software Validators and Backup Solutions

For many computers, when you select a number of files or a folder containing a number of files and drag and drop your selection onto a destination, if there is an error, you usually cannot discern exactly which file caused it. In fact, you also cannot know that all the images were copied perfectly. I trust the Synchronize! Pro X application to verify the integrity of copied data and also to perform the manual mirroring of my dual archive drives—Image Archive 00x and Image Archive 00x Backup. The software can test for numerous exacting details—data forks, total bytes, checksums, and so on. This is a Mac application, and a seven-day trial is available. From their website:

Native on Intel Macs - Synchronize! Pro X runs natively on Intel Macs. Bootable backups can be made to both FireWire and USB 2.0 external hard drives. Intel Macs will boot from backups on either type of drive, while PPC Macs will not boot from USB drives. While you can use Synchronize! Pro X to put a bootable backup of a PPC Mac on one partition and a bootable backup of an Intel Mac on a different partition of the same hard drive, and you can start up the PPC or Intel Mac from the appropriate partition on that drive, you can't start up an Intel Mac from a bootable backup of a PPC Mac, or vice versa.

Leopard compatible - Synchronize! Pro X works on Leopard, Tiger, and Panther. On Leopard and Tiger, Synchronize! Pro X copies "extended attributes", which are attached to many files.

Bootable OS X backups - Synchronize! Pro X backs up your OS X startup disk to another hard disk, so that the backup disk is bootable. Make a copy of your system so that you can start up any Macintosh from the backup, or move your current OS X system from one computer to another—even to a different model Macintosh.

Speed - On Mac OS X 10.5 (Leopard) and later, Synchronize! Pro X scans folders as much as 10 times faster. New technology makes it possible to reduce the 10 minutes or more for a bootable backup scan to a typical time of under 1 minute.

Real-time syncs - Synchronize! Pro X watches for folder changes and copies files when changes occur. Available on Mac OS X 10.5 (Leopard) and later.

Archive old files - Keep old files in an archive, so that you can go back to them if you need to. Archived files can be grouped for convenient burning to CD. As the archive fills up, the oldest files in the archive are automatically removed to make space for newer files.

Quickly update your backup - Subsequent backups copy only the files that have changed, instead of copying all your files over again, so that updating the backup is much faster.

Schedule your backup - Run your backup automatically at a convenient time, when you're not using your computer.

Their website is www.qdea.com/synchronize_pro_x_intro.html.

I am almost certain that the functionality of this application is available in other applications, but for about $100, it has become an application that is used almost daily in my office, and it gives me peace of mind that I have two true and accurate copies of each image. There are also PC applications that do something similar, and I strongly encourage you to research the best solution that works for you.

CHAPTER 24

The Aftermath: How Do You (Attempt to) Recover from a Disaster?

There are solutions for the physically failed hard drive—two of the most notable are DriveSavers and Ontrack. The cost is somewhere between $900 and $3,500 depending upon the work involved. In addition, the crash might be a corrupted directory, and there are applications, such as Data Rescue II, DiskWarrior, Techtool Pro, and programs offered by Symantec, that offer solutions as well.

Know, though, that you will spend a significant amount of time restoring your files, software, images, and such. It can easily take a week to get one computer back to where it was before a crash. Having a secondary computer in your office for this purpose, as well as having this same computer to turn to when your primary machine is running a processor-intensive task, such as converting images from RAW to DNG, will minimize the effects of a computer crash and, as a fringe benefit, make you more efficient.

Do not underestimate the potential risk to your business from natural disasters or a terrorist incident. Have a plan of action not only to evacuate yourself, your pets, and your family, but also to reestablish your business—whether temporarily or permanently—in a new location. The annual arrival of hurricane season (and tornado season for those in the Midwest), and the ongoing earthquake "season" I grew up with in California means few areas of the country are immune from a natural disaster. Moreover, just as the priceless negatives of Jacques Lowe, President Kennedy's personal photographer, were destroyed in the vault of JP Morgan underneath the World Trade Center, numerous photographers lost their entire photographic collections following Hurricane Katrina, as well as others before her.

Other solutions outlined previously in this chapter—offsite data storage of invoice records and redundancy of image archives—will be your saving grace when a crash happens. Note that I said *when*, not *if*. With statistics such as those outlined in the beginning of the chapter, you won't be able to dodge a bullet or a lightning striking forever.

Chapter 25
Digital and Analog Asset Management: Leveraging Your Images to Their Maximum Potential

During the days of film, there were a few ways the images we produced generated assets. We would deliver them to a photo agency, such as mine—Black Star—or all assignments would be in response to an assignment request, delivered to the client, and then returned to us and filed away. There was little to be done save for promoting your library of images to magazines, who would then call and request that you overnight the images to them, and then would return them to the agent again.

With digital files, there's no physical representation of the images unless you open and view the images, and the collection of files that you have compounds every day, with every assignment. Moreover, multiple versions of the same file emerge, causing more confusion.

By aggregating your image assets and then employing solutions to make them viewable to a photo buyer, you can exploit their value and earn more from each assignment—an idea that is the cornerstone of copyright.

Throughout this book, I have placed the recommended reading section at the end of most chapters. This is in no way meant to diminish the critical value of doing the homework, but, in continuation of the school concept, this is "in-class" homework. In this instance, there is a book that is a milestone in the development of a workflow to handle your image assets.

Recommended Reading: *The DAM Book*

Peter Krogh has written an exceptional book on the subject of digital asset management, *The DAM Book: Digital Asset Management for Photographers*—DAM for short. In the spring of 2009, Krogh updated the book to the second edition, and it's even better than the first edition. In it, Krogh sets forth solutions that are well worth putting to work for you.

Krogh outlines the critical value of metadata, including proper captioning, ownership information, and the ultimate in metadata value—the keyword. The more thoughtful you are about including in the keywords not just the who, what, when, where, and why, but also conceptual ideas, the higher your return on the images will be.

For example, consider an image of a young man and his father out fishing. The caption might read, "Father and son go fishing." But keywords for that same image could be "parenting," "quality time," "bonding," "lake," "fatherhood," and on and on. These are the search terms that photo buyers start with—commonsense thoughts—and then they will progress from there should their search results not yield images that meet their needs.

Krogh goes on to discuss hardware systems to properly accomplish the workflow goals set forth—everything from drive sizes, types, and quantities (for redundancy), to the promotion of DVDs as archive solutions.

Solutions Beyond *The DAM Book*: Adapting the Principles to a Variety of Workflows

When *The DAM Book* was written, Krogh made a thoughtful and, in my opinion, thorough review of the software available and integrated it into the book's workflow solution. I already had several of his ideas in place, and I gained more than a few insights into how I could improve my workflow. I applied that knowledge to make my post-production operations more efficient.

There are a few applications that are out there for your consideration. What we're not talking about here are *browsers*. Browsers are simply tools that allow you to browse your images. Browsers allow you to rename files, manage the moving/copying of files (especially off of memory cards), and apply metadata, including the rating/ranking of images using the star-rating or color-label systems. The two best known are Adobe Bridge, which comes with Photoshop, and Camera Bits' Photo Mechanic. Bridge, in my opinion, is a bit unwieldy for fast, on-the-fly browsing of images. Photo Mechanic, on the other hand, is an amazingly fast program that gives you incredible control over the browsing of your images. I can't imagine any photographer who wouldn't benefit from having Photo Mechanic in their toolkit for fast and easy access to their images. Run, don't walk, to www.CameraBits.com and get your copy. That said, for archiving, cataloging, and other long-term image management needs, the following sections describe three of the best solutions for your consideration.

Adobe Lightroom

I consider Lightroom the best all-around solution for photographers. I have tried the others, and Lightroom just comes out on top.

First, the downsides... Lightroom does not support a number of file formats, such as video and PDFs, and unless you select Maximize Compatibility when you are saving an Adobe PSD file, Lightroom won't support it fully. In addition, certain TIFs with compression settings, as well as the newer JPEG formats, are not usable in Lightroom.

That said, Lightroom supports fully all major cameras' raw files, reads and writes DNG files, exports great JPEGs, and is highly customizable for presets for all of the repetitive things you do. It is fully functional with all manner of metadata, and whatever metadata you add to an image that resides in the Lightroom catalog, you can instruct Lightroom to write that back to the file itself—so if you were to open the file outside of Lightroom (in Photoshop, Photo Mechanic, and so on), you would see your metadata. Although there are some potential pitfalls in using the color labels, Lightroom otherwise keeps your metadata as you intend it.

In addition, Lightroom does a great job of handling catalogs across multiple hard drives, as well as having multiple catalogs. You can't have more than one catalog open at a time, nor can you search across closed catalogs (as you can in Expression Media), but the organizational functionality of Lightroom makes it the best solution for me. Tom Hogarty, who works for Adobe and leads the Lightroom team, recommends that if you want to use multiple computers to access your images, you utilize a primary computer for image management using Lightroom and all other computers connect to that computer across your network and access the images using Bridge (or, we might suggest, Photo Mechanic). Lightroom is both a PC and a Mac application.

Expression Media

iView MediaPro became Expression Media when it was purchased by Microsoft. It certainly lives up to its name. For pure cataloging and organizing, Expression Media offers capabilities that Lightroom does not.

First, the downside… Expression Media lets you organize and edit metadata, but if you want to do image editing, color correction, or other visual adjustments, you are out of luck and will need to use an image editing application, such as Photoshop. Because of this (and it was never intended to do this), and further, because Lightroom handles cataloging very well, Expression Media misses the mark for me. In addition, there are a number of issues when you are dealing with a camera's raw files, because, although it is possible to write XMP sidecar files in Expression Media, they will overwrite your previous XMP sidecar files (if you had them), and any color settings or instructions will vanish.

That said, Expression Media has a sync feature that will write directly to the raw file. However, it is limited in that it only writes legacy IPTC information, unless you write to DNG, which you should be doing anyway. In addition, Expression Media supports IPTC core metadata as well as the star ratings; however, the color labels are not directly interoperable with Lightroom.

On the plus side, Expression Media handles the broadest number of file types, including many videos, PDFs, fonts, GIFs, audio files, and so on, in addition to camera raw files, JPEGs, DNGs, and so on. For audio files and the growing number of video files I have, I can effectively use Expression Media to handle just my audio/video, knowing I am going to go into Garage Band or Final Cut Pro to edit that content. Expression Media is both a PC and a Mac application.

Aperture

Aperture is a very intuitive application, as you would expect anything from Apple to be. However, its lack of support for today's metadata standards, as well as DNG, means it's just not a robust enough application to be suitable for what I need it to do.

On the downside, Aperture can read a DNG file into its cataloging system, but it can't export it. Further, if an application, such as Lightroom or the Adobe Camera Raw portion of Photoshop, stores color correction or other editing instructions in the DNG file, Aperture can't understand those. Aperture also does not support XMP metadata standards, so, for example, if you have added your contact information in the IPTC metadata fields in another application, Aperture won't handle or read that information. Aperture only supports legacy IPTC metadata. In addition, IPTC fields such as Rights Usage Terms are not a part of what Aperture will store or handle or allow you to edit—at least not in the current version.

As of this writing, I have high hopes that full IPTC metadata compliance will arrive in future versions, since Apple is a part of the formal Metadata Working Group. However, until a new version comes out that supports XMP, as well as reading and writing DNG files in an interchangeable format, Aperture just isn't the application that I would recommend. Lastly, Aperture is only a Mac/OS X application, so if you have a PC, you're out of luck. If Final Cut Pro's Mac-only approach is any indication, don't expect Aperture on a PC anytime soon.

On the upside, Aperture is a very intuitive application, probably more so than Lightroom. It is faster, in my experience, than Lightroom in many of its tasks. As with Lightroom, it does not support as many file types as Expression Media, but it does support a broad enough spectrum of file types for most every photographer, so this isn't an issue.

All three of the aforementioned applications are compatible with a wide variety of plug-ins, as well as working with the highly recommended Controlled Vocabulary Keyword Catalog keywording software and solution that will help you license more of your images as prospective clients search for just the right image online or in a stock photo agency database. For more information on Controlled Vocabulary, check out www.ControlledVocabulary.com.

Much of *The DAM Book* deals with the in-office, back-at-the-office, and in-studio scenarios. One of the challenges is adapting those processes to work in the field. Often, the client is on hand, looking over your shoulder and demanding that you deliver finished files—or at least midpoint images—on the spot. Further, although most clients will be comfortable with whatever file-naming convention you've chosen, there have been times when clients have insisted that we use their file-naming conventions, which are significantly different than what we were using.

I have found myself in more than one instance in which a CEO has wanted to see the images on our onsite digital workstation 10 seconds after having his photo taken. One solution would have been to use our wireless transmitter to deliver the JPEGs to the workstation as I was shooting, but that wasn't set up beforehand. Instead, we mounted the card and, without proper ingestion, dragged the entire image folder onto Photo Mechanic and let the subject see the take. The CEO wouldn't wait around for even five or six minutes for ingestion.

If we get some push back on whether the CEO likes the images, we find that it's often because of wrinkles, bags, or blemishes. We then, from the card, open the image in Photoshop and demonstrate some very rough retouching. This holds great appeal to the CEO, and on more than one occasion it has resulted in return engagements for other company executives. Is there a risk in browsing images on the card? You bet. Is there a risk in opening images from the card without ingestion? Ditto. But, many circumstances have you working on the fly, and the ability to improvise and give the clients what they want when they want it and to minimize the risk means a happy client.

NOTE

A word about our digital workstation. Although we could turn up with a G5 and a 30" monitor, in the end it's our laptop, but one that is set up to get online, process images, and such. We diminish the value of having such a powerful machine onsite when we refer to it as just a laptop. So, by referring to it as a digital workstation, it is given its proper due, and it is then accepted as a line item charge ("Digital Workstation - $xxx") on the invoice.

As mentioned before, in some instances clients have their own naming system. Mine for, say, an IBM CEO portrait would be:

YYYYMMDD_IBM_CEO_001.JPG

However, the client's might be a unique internal job number, followed by his employee number and then a sequence number. How do you integrate that? For me, onsite, I make note of their system and apply it if I have to deliver more than one or two images. Back in the office, I use my own system but utilize the metadata to store the client's filename so that when they call to locate the original image, to request retouching, or the like, instead of searching the filenames for that information, I search the metadata fields, and the image turns up. I'll do the work on the file, save it as a variation (Krogh refers to these variations as derivatives) using my file-naming structure, and then we deliver the images via FTP or on CD/DVD with the client's naming structure applied.

There are some limitations to file naming that you should be aware of as you alter the system to suit your own needs. From Controlled Vocabulary[1], a system developed by David Riecks:

> [T]he most important thing that a filename can do for your image collection is to provide a form of **unique identification** (or **UID**) for each digital "asset." However, if you wish to be able to exchange your image files with clients or colleagues (often using different computer operating systems), then you need to observe some standards for cross-platform compatibility to ensure maximum portability. Here are some recommendations to avoid potential problems.

[1] Controlled Vocabulary, at www.ControlledVocabulary.com, is primarily a system for keywording, but the website contains a large number of resources for establishing systems, keywords, and other metadata information. A review of the site for those looking to maximize their return on their image assets is mandatory.

Files should only contain numerals, letters, underscores, hyphens (in some cases), and one dot (more commonly known as a period). Some file-naming systems are cAsE sEnSiTiVe, so be sure to be consistent. In addition, there are limits to the length of file names, directory/path lengths, and such.

The most significant limitation to file naming is a legacy system that is running an operating system such as Windows 95 or others that use what is technically referred to as ISO9660, Level 1. These operating systems limit you to eight characters, plus a dot, and then three additional characters. Older, pre–OS X Macintosh computers have a 31-character limit, and ISO9660 has extended character lengths up to 64 characters. Most computer systems nowadays are Windows 2000/Windows XP or some flavor of Mac OS X. These systems allow for a maximum of 255 characters. Be careful, through: The total length of the file name and all the directories from the very top level down to the end of the file name cannot safely exceed 256 characters.

There are also systems for working with large volumes of images—25 GB, 100 GB, or more. I often find myself out on assignment for days at a time, generating 50 to 100 GB for one assignment. In those instances, the ingestion of the files can take all night, as well as the proper saving of the files to two external drives—one that always stays with you and one that stays in the hotel room or, in some instances, is shipped back to the office for post-production to begin.

The key, in my opinion, is to read the book and consider the principles and thoroughness of the workflow. Then, where it does not work for you and you've thought about how to change it, make those changes so that you are using your workflow in a way that suits your needs.

I fully expect that Krogh's *DAM Book* will continue to be updated and that others will perhaps come out with other systems and workflows. Until that happens, this book is a well-done basis from which to operate and then to evolve as your needs do.

Evaluating the Cost of Analog Archive Conversions to Digital: Is It Worth It?

How much are your analog images worth? If no one knows they exist, then not only are they not generating revenue, but they are depreciating. How's that? A photograph of a streetscape from, say, 1970 will immediately be recognizable as such, if for no other reason than the appearance of the cars. Photographs of the New York City skyline that include the World Trade Center immediately date the images as pre-9/11, so a travel guide looking for images of the skyline will opt for something more current. At some point, images become historic and are no longer suitable to illustrate timely people and events.

To evaluate an analog archive, you'll want to consider the subject matter. If you have close-up images of plants with their genus and species, those will hold their value for some time. Images of someone using a cell phone will be worth much less five years from now than they are now. Consider the use of a businesswoman in a suit using a portable cellular phone that is so large it's in a bag or the first generation of Motorola flip phones.

In my office, I took the time to review nearly 100,000 transparencies to determine which had potential. I made it a priority to convert the images from analog to digital, apply correct captions, and develop keywords that would maximize the potential licensing of each image.

Scanning your analog images once you select them from your overall collection of images can be done yourself, or you can outsource the service to one (or more) of several different service bureaus. The costs can range from $10 or so for a 60-MB 8-bit file to $40 or so for the same file from other providers. Some differentiate by using drum scanners; others use different scanners to accomplish the same task. Should you opt for one service, first try them out for 10 or 20 images and see what the results are. Negotiate a rate by committing to the chosen vendor a consistent quantity of images over a certain period of time or one large quantity of images. Consider the economics: If you choose your best 100 images and negotiate a rate of $10 per image, although that expense is $1,000, the investment should pay for itself with just a few licenses. After that, you can reevaluate an additional investment or await a sum that would allow you to have your archive self-fund its conversion.

Immediate Access to Images Means Sure Sales in a Pinch

The production of images and their proper keywording and captioning means that within a few moments, your clients should be able to locate and license images from you. In addition, you should be able to locate your images within your own office archives. The ability to do so can mean the difference between a license and a loss. There are a number of solutions, but I have come to the conclusion that the software offered by Controlled Vocabulary (www.ControlledVocabulary.com) for less than $100 is among the best to generate keywords.

Chapter 26
Licensing Your Work

Licensing is probably the single most important part of the revenue-generation segment of your business. If you succumbed to the contract that reads "you hereby transfer all right title and interest in your assignment images, including copyright, and further hereby acknowledge that your work shall be deemed a work-made-for-hire," then licensing your work is irrelevant to you but will be highly relevant to the person or company who hired you. You are nothing more than a day laborer in this cycle. You may, then, skip this chapter. To make matters clearer and more direct: Since licensing photography is the essence of your business, so-called "day laborers" could skip the book entirely.

In the previous chapter, I provided a few insights and workarounds to the work-made-for-hire issue. Now, I will put forth additional solutions for consideration using the licensing concept. Here's the problematic paragraph, to refresh your memory:

> Photographer hereby agrees to deem work produced under this agreement "work made for hire," or, if the work produced under this agreement cannot be deemed a "work made for hire," agrees to transfer copyright of the work to Client, provided that Client grants to photographer the right to use the work produced for self-promotional purposes.

Or, suppose you are working for a client that wants copyright but does not care if you want to license the images for editorial uses. This type of agreement sometimes comes into play when you are photographing celebrities for some clients. Since you cannot ever do anything with the images commercially without model releases, or perhaps the client sees that your sale of the images for editorial purposes would be beneficial and serve as additional promotion of those depicted in the images, they might agree to the following language:

> *Photographer hereby agrees to deem work produced under this agreement "work made for hire," or, if the work produced under this agreement cannot be deemed a "work made for hire," agrees to transfer copyright of the work to Client, provided that Client grants to photographer the right to use the work produced for self-promotional purposes, and for all editorial licensing, in perpetuity.*

Defining the World of Licensing

If your best client came to you and said, "Learn Spanish, or you're no longer going to get hired by us," would you? If your best client came to you and said, "The slang and odd language you use isn't conducive to a constructive dialog when we're working together. If

you can't speak proper English, we won't be able to work together anymore," would you drop the street talk and keep the client?

If you answered no to either of those questions, you need to think again. This is business, and if you want to do business (and keep doing business), you need to set aside any attitudes like that and realize that businesses do whatever they can to keep their clients. It's not personal or an affront to you, it's just business.

When a client thus comes to the determination that the language you've been using to describe your licensing is the equivalent of ambiguous street language and decides that they're tired of interpreting and reinterpreting what a specific term really means, it's time to bring some clarity to the discourse.

We will discuss several different issues that affect your licensing and could drastically affect your revenue if you are not attentive to them. Throughout this chapter, we will turn to a free resource for all photographers, the Picture Licensing Universal System, or PLUS, for short.

Just what is PLUS? From their website, PLUS is "a cooperative, multi-industry initiative—a three part system that clearly defines and categorizes image usage around the world, from granting and acquiring licenses to tracking and managing them well into the future. Through standardized language and a machine-readable coding architecture, image licenses become more transparent, more fair, and much simpler for everyone."

The PLUS website (www.UsePlus.org) goes on to outline each of the parts:

> **The PLUS Picture Licensing Glossary.** *The first component of PLUS is the picture licensing Glossary. Obviously, in order to reach common agreement on license parameters, we must have a common understanding of the language that forms a license. This free online listing, as well as being published in book form, was created and scrutinized by a broad cross-section of professionals.*

> **The Media Matrix.** *A hierarchal structure including all existing media and all options for the inclusion of images in all media, and applying an identifier to each type of media and to each option. Provides a standardized database for use in providing a common menu structure for the selection of media rights in applications and licensing platforms.*

> **The License Format.** *A standardized, machine-readable schema for expressing an image license. Allows for the expression of image rights in standardized fields, using standardized terminology. Allows image rights to travel within image files and other documents in a format that provides for automated embedding and ingestion of rights information by DAM systems, ecommerce platforms, web browsers, and all applications. Allows immediate access to image rights information by anyone in possession of an image file. Provides a roadmap for professionals to instantly understand how to express license information in a format that any other professional in any industry or location can readily understand.*

> **Media Summary Code.** *A means of encoding a license with multiple media usages into a string of characters that may be easily decoded into a human-*

readable license description in any language. Allows for highly efficient and precise communication and understanding of image rights offered, sought, or obtained, whether domestically or internationally.

PLUS Packs and Custom Packs. *License packages representing the most commonly licensed image rights. Allows photographers and stock agencies to offer familiar, uniform, convenient bundles of rights. Each licensor independently determines pricing. Photographers, stock agencies, and their clients may also create and share (over social networks and otherwise) custom packages precisely meeting their needs.*

PLUS-ID. *Globally unique persistent identifiers for entities, licenses, and images. Allows precise identification of any rights owner, license transaction, or image. Allows for highly efficient communication of rights and attribution information by embedding a single identifier in an image file, while storing all other metadata remotely in a publically accessible registry, preventing loss or manipulation of stored metadata by unauthorized parties. As the metadata is stored remotely, a license may be updated or renewed at any time without altering the metadata in the file and without issuing a new image file with new license metadata. The IDs forever refer to current contact information for the licensor, license, and image.*

I will go over each of these sections, with examples detailing how we use the system, so you can apply it to your licensing moving forward. As I do, it is important to understand that PLUS in no way addresses pricing or price negotiations. PLUS was built together with not just representatives of the photographic industry, including every major photographic trade association, but more importantly, all of the major stakeholders—those that buy/license/assign photography, design firms, stock agencies, and so on. This was truly a joint collaboration between all parties, not one group bringing a finished standard to be approved by the others.

PLUS truly is an effort that is long overdue. I remember, as a college student, reading literature about student housing that required all the electrical devices I was bringing in to be certified by Underwriters Labratories, designated by the sticker "UL listed." This was shorthand for, "This device has been certified to meet standards for fire safety…," and so on. In a doctor's office, when you get bloodwork done, the doctor simply checks a series of boxes that specify a known set of tests. The doctor does not need to give instructions on how to do the test; there is a standard. And, in the world of design and printing, there is the Pantone standard, so no one can argue over what color something is. Pantone set the standard for essentially every color imaginable, so when a client says, "My logo is Pantone 16-5804," everyone knows that the color is also Slate Gray. How would you describe Vibrant Green? Everyone has an opinion about that, but what shade, hue, and brightness? Pantone's answer? Pantone 16-6339. How about Fire-Engine Red? Well, using the Pantone Matching System (PMS), you might best identify that color as PMS 032, as differentiated from PMS 193, which is a different shade of red. The point here is that these numbers and letters specify an exact combination of all the colors in the spectrum, or a set of agreed-upon standards. To date, no universally accepted solution has existed for the licensing of photography, until PLUS came into being.

Thus, I will walk you through a variety of examples and language that you will encounter as you go about the business of licensing images.

Issues of Exclusivity

In many instances, clients will ask for—and in some cases require—exclusivity for the work you are producing for them on assignment. In addition, when licensing an image for stock, for the duration of the time the client is using the image for their own marketing efforts (during which time that image will become associated with their product or service), the client may want an exclusivity clause so that their competition will not be able to use the images. (In some cases, they will want no one at all to be able to use the images.)

These types of requests are reasonable, of course. A search for the term exclusivity in the PLUS glossary brings up:

Duration Exclusivity – Duration Exclusive

Definition: A right that, when granted, limits the rights of the licensor (and other parties offering licenses of the work) to further license or otherwise permit any third party to use the work during a specified time period.

Term In Use: "The client wants to purchase duration exclusivity *for five months."*

Exclusivity – Exclusive

Definition: Describes a right that, when granted by a licensor to a licensee, limits how the licensor (and other parties offering licenses of the work) May license rights in a work to a third party.

Additional Info: Exclusivity May be broad or specific. The rights grant May provide the licensee with exclusive rights to use a work singly or in any combination of: a specified media, industry, territory, language, time period, product, and any other specific right negotiated by the licensor and licensee.

Term In Use: "The advertising agency wants to license exclusivity *for using the image in printed matter."*

Geographic Exclusivity – Geographic Exclusive

Definition: Describes a right that, when granted to a licensee, limits how the licensor (and other parties offering licenses of the work) May license rights in a work to a third party for use in a specified region of the world.

Term In Use: "The client purchased geographic exclusivity *for the image in Europe."*

Industry Exclusivity – Industry Exclusive

Definition: A right that, when granted by a licensee, limits how the licensor (and other parties offering licenses of the work) May allow any third party to use the work in relation to a specified type or types of companies.

Additional Info: Often combined with other types of exclusivity, such as duration and geographic.

Term In Use: "The client purchased industry exclusivity *for automotive advertising."*

Language Exclusivity – Language Exclusive

Definition: Describes a right that, when granted to a licensee, limits how the licensor (and other parties offering licenses of the work) May license rights in a work to a third party for use accompanied by text in specified languages.

Term In Use: "The client purchased language exclusivity *for Farsi."*

Media Exclusivity – Media Exclusive

Definition: A right that, when granted by a licensor to a licensee, limits the right of the licensor (and other parties offering licenses of the work) to license the right to any third party to use the work in specified media.

Term In Use: "He could not grant a license to use that image for a newspaper ad campaign because he had already granted media exclusivity *of that image to another client."*

Non-Exclusivity

Definition: A type of right granted by the copyright owner. The licensor (and other parties offering licenses of the work) May license similar, related, or identical rights to another licensee at any time.

Additional Info: A purchase option that must be negotiated. Unless the right of exclusivity is expressly granted by a licensor to a licensee, any other rights granted under a license are non-exclusive by default.

Term In Use: "A competing magazine was able to use the same image on the cover because they had only negotiated for non-exclusivity *of the photo."*

Periodic Exclusivity

Definition: A right that, when granted by a licensor to a licensee, limits the right of the licensor (and other parties offering licenses of the work) to license the right to any third party to use the work during a specific period of time.

Term In Use: "Because of the periodic exclusivity *licensed for the image, it could only be used March 1 through March 31, 2006."*

Product Exclusivity – Product Exclusive

Definition: A right that, when granted by a licensor to a licensee, limits the right of the licensor (and other parties offering licenses of the work) to license the right to any third party to use the work in relation to a specified product category.

Term In Use: "The client decided to purchase product exclusivity *so he could avoid having the same image usage by his competitor."*

CHAPTER 26

Regional Exclusivity – Regional Exclusive

Definition: A right that, when granted by a licensor to a licensee, limits the right of the licensor (and other parties offering licenses of the work) to license the right to any third party to use the work in specified geographic regions.

Term In Use: "Because this client purchased regional exclusivity, *we cannot offer the same region to another client."*

Rights Exclusivity

Definition: A right that, when granted by a licensor to a licensee, limits the right of the licensor (and other parties offering licenses of the work) to license rights in a work to a third party.

Additional Info: An exclusive May be broad or specific. The rights grant May provide the licensee with exclusive rights to use a work singly or in any combination of: a specified media, industry, territory, or language, or for a specific time period, product, or other specific right negotiated by the licensor and licensee.

Term In Use: "The advertising agency wants to license rights exclusivity *for TV for a year."*

One common use of regional exclusivity would be for the travel writer/photographer. A newspaper in a particular region may want fresh content for their Sunday travel section, but they don't want their readership to have seen the story/photos before. Thus, they would require regional exclusivity for a period of time, or they may require first regional rights to the story that is proposed to them. This way, a travel writer/photographer could secure dozens of regionally exclusive assignments before heading out to do his or her story. This way, a story package that might pay just $1,000 for words and photos and might otherwise be higher than the costs of airfare and hotel for that trip could be $1,000 in one larger market, $750 in four midsized markets, and $400 in five small markets, generating $6,000 in one-time licensing fees to each of the markets.

Another example is the story of the U.K. photographer, name unknown, who had scandalous photos of a member of the monarchy. As the story goes, he licensed a rolling periodic exclusivity as each of the editions of competing papers came out. So, the paper that paid the most for the photographs got an exclusivity from 6:00 a.m. through 8:00 a.m. that morning for the first editions, and the paper with the second highest bid got an exclusive for the morning editions until noon, and the third paper got an afternoon exclusive on the images. This, as rumor has it, is an extreme example of periodic licensing exclusivity, but when the photos are such a big deal, these types of deals are workable.

One example that I have is an image I made for a client on assignment. The client was very concerned that the photo I dreamt up and presented in concept could end up being licensed to their competition. The only assurance that worked for them was exclusivity language by industry.

Markets You Will License Within

There are several different umbrella markets you will find yourself licensing within. They are:

▶ **Consumer.** PLUS defines a consumer advertisement as "commercial communication that is directed to members of the general public," whereas a consumer magazine is "a periodical targeted to the interests of, marketed and distributed to the public at large."

▶ **Trade.** PLUS defines a trade advertisement as "advertising that is directed to specific industries, professions, or special interest groups."

▶ **Editorial.** PLUS defines editorial use as "a use whose purpose is to educate and/or convey news, information, or fair comment opinion, and which does not seek or accept sponsorship to promote a product, person, service, or company."

▶ **Personal.** PLUS defines personal use as "only for private purposes and not related to business or commerce. No reproduction rights granted," and suggests, as an example, "She purchased a print for *personal use* and will hang it in her office."

What defines the use in each market is how a specific image is used. For example, if I made an image of a bride tossing her bouquet in front of the U.S. Capitol, that might be an image that could easily appear in a commercial advertisement for a bridal shop. It could also appear in the local magazine for editorial purposes about great locations to be photographed on your wedding day. Were the image used in the trade category, it could be in a trade magazine ad for bridal gown designers showcasing the popularity of that designer's work or in an article about the latest trends in gowns. Lastly, and the most obvious use of this photograph, would be for personal use by the bride in her wedding album. In many of these examples, I would, of course, be required to have a model release from the bride to exercise those rights.

In the end, the use of the image defines the market, not necessarily the party who initially commissions the work.

Rights Managed versus Royalty-Free

There is a great deal of debate over these two terms. Let's first define them, again courtesy of PLUS:

▶ **Rights Managed (also referred to as "RM").** "A licensing model in which the rights to a creative work are carefully controlled by a licensor through use of exact and limiting wording of each successive grant of usage rights."

▶ **Royalty Free (also referred to as "RF").** "Denotes a broad or almost unlimited use of an image or group of images by a licensee for a single licensee fee. License agreement typically specifies some limitations (e.g., resale of the image to a third party is usually prohibited)."

CHAPTER 26

It should go without saying, but I will say it anyway, that a long-term strategy of success and profitability will most assuredly come from maintaining a strong rights-managed approach to your images. There is often a short-term allure of taking several thousand of your images and posting them on a royalty-free site, but once those images are loosed on the photo-buying community in this manner, like the genie from the bottle, it is all but impossible to undo that. While you may see early spikes in revenue from an RF distribution, in short order it will drop off. Over the long term, RM is the surest way to protect your images and earn revenue from them.

Electronic Distribution

Within the context of the ever-growing field of digital/online distribution, knowing how the images will be used is key.

Here are a few digital/online distribution types:

▶ **Email blast.** "Distribution of a promotion, marketing, sales, or advertising message to a large quantity of specific recipients via a specific Internet protocol."

This is very similar to:

▶ **Broadcast email.** "Email distribution of a large quantity of messages containing promotion, marketing, or advertising."

▶ **Website.** It is important to specify here whether the use will be limited to the client's website, company blog, or even in a video on the company's website. It is possible that a company website video could be easily embeddable into other websites, as businesses look to have their videos used in a viral manner. Defining a website use is something along the lines of "use by client on their website only, as illustrated by a single website that exhibits a unified graphical appearance and is physically located on the same server on the Internet." This is, in this case, an incorporation of the definition of website from PLUS: "A collection of Internet accessible pages interconnected by HTML links, usually including a home page," along with the additional information that the PLUS definition page provides, "All web pages within a website typically exhibit a unified graphical appearance and are physically located on the same server on the Internet." Avoid using the phrase "web use," because it is extremely ambiguous and could mean all of these electronic distribution categories just as easily as it means one.

▶ **Web banner ad.** "A marketing or promotion announcement embedded in a particular Internet page, usually placed at the top or bottom of the screen."

▶ **Blog.** "A personal or professional diary or running commentary on an Internet page that May contain words, images, or other content."

▶ **Downloadable file.** Whether you are referring to a PDF, a movie (.MOV) file, an eBook, or any other type of downloadable file, defining what you mean when you say "downloadable file" is important.

I have several clients who consistently hire me to shoot images of their senior executives in action around Washington, for the sole purpose of illustrating client activities in and around Washington, as they write blog articles, so don't underestimate the value of blog licensing. Blogs, in many ways, are an informal version of a brochure or company newsletter/communication.

Caveats and Other Considerations

There is, of course, a time when you have the right to license an image, but not exercising that right is the better part of valor. I have, over time, worked for both the Republican National Committee and the Democratic National Committee. In each case, I have photographs of politicians with people who found themselves in uncomfortable news situations, and, had I licensed those images (as was my right to do), it would have placed the politician and, in turn, my client in a less-than-positive light. Thus, when a call might come in from a publication, saying, "Do you have any photographs of [politician X] with [donor/celebrity Y]?" my response has been, "I don't have anything for you. Sorry."

Other factors in licensing come up when there are multiple parties potentially involved. In Chapter 14, I addressed the issue of multi-party licensing agreements, where, for example, you have prospective clients for an architectural shoot that might include the architects, builders, contractors, and tenants.

In instances where you are granting a single-party license, it may be crucial that you specify whether the license is transferrable or non-transferrable. This could, in one instance, be a factor if a company is sold, and the asset (in the form of the license) may or may not transfer to the new owner. Or, if your client is a public relations firm, it is likely critical that they be able to transfer the right to use the images you produced for them to their client, who wanted you hired in the first place. If, on the other hand, you have an editorial client, you may not want that client to be able to transfer the rights to a third party, because it could allow your client to license reprints of the story (and your images) without compensating you, and this could result in significant losses in revenue. For a broader explanation of reprint rights, see "How to Work through a Contract Negotiation for Editorial Clients" in Chapter 13.

Then there is the concern of selling something you don't own. If I consent to being photographed while at an event or for a portrait for a magazine, the photographer can do certain things with that photo and cannot do other things. What photographers can do is license that image as stock for editorial purposes only, provided that the editorial use is not libelous. What they cannot do is license the image containing my likeness for commercial/corporate uses without my express written consent to do so, usually codified in the form of a model release. Yet, so many photographers I know license something they do not own, and doing so could get them in hot water. For example, just because I have a photograph of the President, that does not mean I can license that image for use on a commercial product or to suggest an endorsement of the product or service by the President. The metadata in the photographs that the White House releases of the President includes the following language:

> *"This official White House photograph is being made available for publication by news organizations and/or for personal use printing by the subject(s) of the photograph. The photograph may not be used in materials, advertisements, products, or promotions that in any way suggest approval or endorsement of the President, the First Family, or the White House."*

It is important to note that this image, while in the public domain, cannot be copyrighted. Under Title 17 of the Copyright laws, "Copyright protection under this title is not available for any work of the United States Government, but the United States Government is not precluded from receiving and holding copyrights transferred to it by assignment, bequest, or otherwise." However, even though it was produced by the Federal government and thus is not eligible for copyright protections, rights of publicity still protect against the use of the photographs in, for example, advertising.

When licensing images from an assignment, be sure to define what exactly the client is licensing. If, for example, you specify "produce images of two or three setups," it may not be clear that the client ultimately is licensing just one image from each of the setups. Specifying "produce images of two or three setups, with the final delivery being a single image from each setup" would be far more clear. Be cautious when you see language in a proposed contract that says you grant a license for a "body of work." In this case, if you shot two or three setups but made dozens of images from a variety of angles with a variety of poses, the client may be entitled to use all of the images from the shoot.

Also, be sure to set forth a specific duration for your license. It may be from the date of the shoot or the date of first use. In the end, making certain that the start date and end date are clearly defined is important. Also, within that timeframe, can the client use it just once or up to a specific number of times or quantity of items (such as posters, brochures, and so on)?

Proceed with Caution: The Retroactive License

When you learn of a copyright infringement of your work, one tactic in resolving unauthorized uses of one's images has been to offer the copyright infringer a retroactive license. This solution is often employed by photographers once the infringement is discovered, before engaging an attorney or understanding fully what the risks of doing so are.

Back in November of 2007, the Second Circuit Court of Appeals ruled that all retroactive copyright transfers and licenses are invalid. The case at hand was Davis v. Blige, where the finding of the court was that "retroactive transfers violate the basic principles of tort and contract law, and undermine the policies embodied by the Copyright Act." This case involved musical compositions, not photography, but the concepts are similar. The court, in this case, determined the retroactive licenses and assignments to be categorically impermissible.

This is differentiated from circumstances where a retroactive license is part of a settlement agreement. Thus, it is imperative that when you are considering the offer of a retroactive license to settle a matter, that it be done within the boundaries of what is legally set forth as an "Offer in Settlement." The terms of an Offer in Settlement, rules of evidence, are not admissible in a trial. For example, if you would have licensed an image for $2,500 to a

client, and the work was registered with the copyright office, and the client earned $50,000 directly attributable to your image's contribution to the product or service, you would potentially be entitled not just to that $50,000, but also punitive damages that could reach as high as $150,000 for a single infringement. However, if you suggest to the client you will take $7,500 for the license as a retroactive licensing fee, and you do so specifically outside of the boundaries of settlement talks, you may be limiting your remedies.

I strongly recommend you consult with a knowledgeable attorney in cases such as this. While I certainly am not a lawyer, nor am I offering legal advice, it might give you some protection if language that appears at the beginning of a letter to an infringer to whom you might want to offer a retroactive license or some other form of settlement included: "This offer is conveyed without prejudice and presented solely with the intent of discussing non-judicial avenues for a settlement of this matter."

When that language or something similar to it is not included, you could be limiting your opportunities. Respected copyright attorney Nancy Wolff comments on the Masterfile copyright infringement case, where Masterfile won $46,816.91, about how the court considered the amount of the retroactive license when awarding damages. Wolff wrote, in part:

> "Before finally bringing a lawsuit, Masterfile offered to enter into a retroactive license agreement with J.V. Trading for the three years that J.V. Trading infringed. Although J.V. Trading did not respond, the courts used this offer as guidance in assessing whether the damage award requested by Masterfile was reasonable."

In this case, which was precedent setting, the court upheld the concept of using multiples of an original licensing fee as the basis for an award. In this case, the amount was five times what would have been the original fee to license the images.

Although here we have been discussing a retroactive license, there is no lawful way to execute a document that would create a retroactive "work made for hire." If you produce an image and then sign a document after the image has been created that says the work is a "work made for hire," that contract will be found to be invalid. If you contemplate backdating the contract, you are giving a false impression, and your acts could be deemed to be a criminal offense under the 1968 Theft Act or the 1913 Forgery Act, or you could find yourself being charged with conspiracy to defraud. The only justifications for backdating are when both parties agreed to the obligations of the contract knowing fully and completely the terms of the contract, but for practical reasons were unable to execute the contract or, for example, are signing a contract that was previously lost. If a client suggests you backdate a contract in order to make an assignment a "work made for hire," your first response should be that your doing so could likely be found illegal and criminally actionable.

Selling versus Licensing

If your estimates refer to "sales," or if you say, "I will sell you this photograph for X amount of money," or if it says anything other than "license" or "licensing," you are setting yourself up for a huge headache. When I hear someone pose the question, "How much would you sell the photo for?" I cringe and then I object. Dictionary.com defines the words "sell" and "license" as follows:

Sell: To exchange ownership for money or its equivalent; engage in selling.

License: Official or legal permission to do or own a specified thing.

So, while you may "sell" a print, such as an 8×10, there is no license included to reproduce that print. When you buy a poster (or artwork) for your wall, you are not also obtaining a license to reproduce it for other walls in your home or to sell to others.

Although this might come across as a given for most people, if you refer to the selling of a photograph, there is an inherent expectation that you no longer own it. Never, never refer to what you do as *selling* an image. The correct term that should be used at all times is *licensing*.

You should not see revenue from your stock photography as sales from stock, but rather as licensing income. There are a number of books that deal only with negotiating and how to become good at it; the book doesn't have to be one specifically geared toward photographers. I've outlined several such books at the end of this chapter.

As noted earlier regarding exclusivity, one of the most ambiguous areas in photographic licensing is the language. Simply put, what is a brochure, versus a sales-slick, versus a custom-published magazine, and what the hell is an advertorial anyway?

Licensing Language and Examples

PLUS licensing information becomes a part of the photo's metadata, (so too, it is intended to appear in estimates, contracts, invoices, purchase orders, and image database systems), so the uses are denoted by a number, termed by PLUS as a PGID#. For the term *collateral*, it returns the PGID# 10610000 0100. To get there, search for the ambiguous term *collateral* on the PLUS website (see Figure 26.1).

Figure 26.1

Such a search returns the result shown in Figure 26.2.

Figure 26.2

When you click on the Collateral link, the site returns what is now an unbiased body's definition of what has heretofore been a term that has been misinterpreted (almost always to the client's best advantage), yet now has an agreed-upon definition by both those licensing photography and the largest organizations involved in licensing photography, from Getty to Corbis, the Picture Archive Council of America (PACA), and many smaller organizations. Thus, a broad cross-section of the business has agreed to a set of terms, and this can only lead to good for all photo licensing down the line. It is important again to re-emphasize that this was not the photographic industry preparing definitions for the approval of other industries; all the industries collectively co-wrote these definitions.

The definition is:

> Printed marketing and advertising pieces for use in direct request and personal contact, not in publications.

And PLUS provides additional information (see Figure 26.3):

> Often reflects a larger broadcast, print, or direct mail campaign. May include leaflets, brochures, pamphlets, and business cards, among many other possible uses. However, collateral is often misunderstood to comprise an even longer list of uses. Listing individual uses may be more practical for most licensing situations.

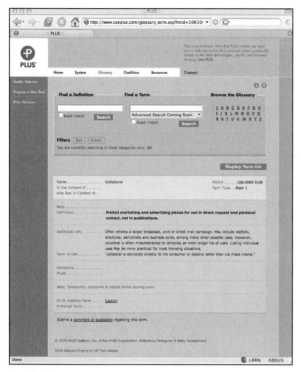

Figure 26.3

And then a sample of the defined term in use:

> Collateral is delivered directly to the consumer or dealers rather than via mass media.

Special attention should be paid to the last sentence of the "additional info" section, where it is noted:

> However, collateral is often misunderstood to comprise an even longer list of uses. Listing individual uses may be more practical for most licensing situations.

PLUS has done an exceptional job of establishing this structure and noting terms that carry risks or are too general and may create confusion. Collateral is one of these. Dictionary.com defines collateral as:

> Situated or running side by side.... Coinciding...or accompanying.... Serving to support.... Of a secondary nature; subordinate... Of, relating to....

The Formatting of a License

In Chapter 22, "Letters, Letters, Letters: Writing Like a Professional Can Solve Many Problems," we discuss the $70 million mistake over a misplaced comma. Interpretations of the U.S. Constitution's Second Amendment have sparked furious debate. How do you read the amendment?

"A well regulated militia, being necessary to the security of a free state, the right of the people to keep and bear arms, shall not be infringed."

The Supreme Court, in a case regarding the rights of a Washington D.C. man to keep and bear arms, decided in favor of the man, and not the government who sought to preclude him. However, for years (if we are to believe the Supreme Court has the final say), the Amendment was misinterpreted because of the commas.

Thus, the best way to format your license is not in paragraph form. A paragraph format requires a subjective interpretation by the reader.

Itemizing each of the primary elements of the license for your image is your best solution. This format should appear in several places: 1) on your contract (if it was an assignment); 2) on the delivery memo or accompanying paperwork that was sent with the images, whether in printed form or as a PDF; 3) on your invoice (whether assignment or stock); and 4) in the metadata of each image under the license (in both a natural language processing and a machine-readable format).

Before we go any further, let me explain the difference between the terms *natural language processing* and *machine readable*. Barcodes on products are the most familiar type of machine-readable identifiers. If, for example, you look on the back of this book, you will see a series of barcodes, and you know what the bookstore uses them for as it pertains to you— scanning the book to tell you how much it costs. However, after hours, for example, the bookstore may go through their entire inventory to check stock or look for books their inventory says exist but may have been stolen. Or the barcodes, when scanned by book category, could quickly provide guidance that a book has been misfiled and must be moved to another section. The entire management of this book you hold in your hands right now is done by that barcode. You, the reader, you have no clue what those fat and skinny lines say; you're only looking at the information such as "User Level: Beginner–Intermediate", "Category: Digital Photography," and the price. This book and countless other products carry both machine-readable and natural language–understandable information about the product.

In the instance of a visual image, the metadata contains a combination of natural language and machine-readable information. From category codes to camera serial numbers and captions, the format of metadata varies. For example, the date and time codes are determined in milliseconds since January 1, 1970, 00:00:00. Thus, the time 807926400000 is machine readable as Wednesday, 09 August 1995 00:00:00 GMT, for example. As another example, we have also been taught to interpret text within opening and closing quote marks as text that is a verbatim retelling of what someone said.

In the coming pages, I will build two examples and produce the natural language form and the machine-readable form.

We visit the PLUS website, and let's start out with a custom license for a client. We choose Select Custom Media, as shown in Figure 26.4.

CHAPTER 26

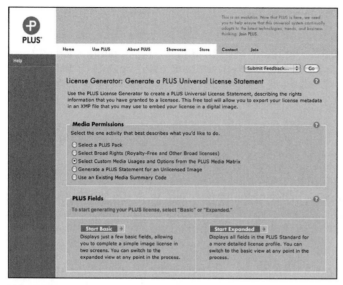

Figure 26.4
PLUS License Generator webpage.

Next, we choose Start Basic for this example. We enter in our name, the name of the end user, and the licensor. In this case, I have entered John Doe at the XYZ Widget Company (see Figure 26.5).

Figure 26.5
PLUS website License Generator webpage Part 1.

At any time, we could change the generator mode from Basic to Expanded if we felt we did not have sufficient customization options. By clicking Continue, we end up at the Permissions section. In this case, our client is an editorial magazine client with a single full-size image going on the cover of the magazine, with up to a 1 million circulation, with a one-month grant of use in North America, specifically the U.S.A., in English, non-exclusively.

Figure 26.6 shows the drop-down menu choices.

Figure 26.6
PLUS website License Generator Permissions selector.

When we click Continue, we are presented with the concise list of usages, and we can have up to 12 different types for a single license, which is really more than enough. Figure 26.7 shows how it looks.

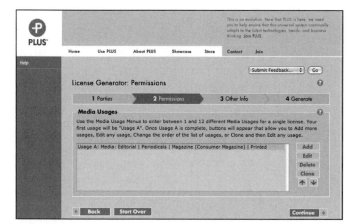

Figure 26.7
PLUS website License Generator Permissions summary.

Choosing Continue brings up the usage in a natural language format (see Figure 26.8).

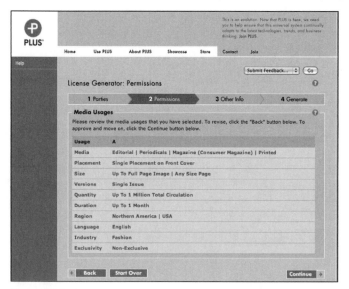

Figure 26.8
PLUS website License Generator Permissions review.

All that remains is to specify the license start and end dates, the status of any model/property releases, credit line requirements, and image information (see Figure 26.9).

Figure 26.9
PLUS website Other Info data entry panel.

The next screen provides you with the XMP file with all that information tucked neatly away, in both natural language formatting and machine-readable formatting. If this is your first time doing this, and you don't have an application such as Lightroom, which has a plug-in that allows you to automatically embed this license metadata when you ingest the images, you can download the PLUS License Embedder and Reader. The plug-in is an application that was created by photographer/developer Timothy Armes. If you're not using the plug-in, just click the Save XMP License File, as shown in Figure 26.10.

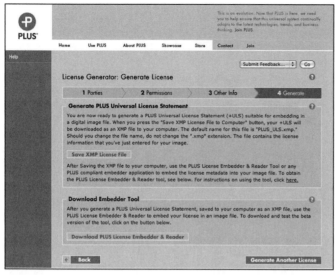

Figure 26.10
PLUS website License Generator Summary panel and License Generator.

The file then is downloaded onto your hard drive and is only a few hundred bytes in size.

If you want to read or view the contents of that file, you can do it in a variety of ways. Figure 26.11 shows the first screen of that file, located on the desktop of my computer.

Figure 26.11
PLUS XMP sidecar license as read by PLUS License Embedder & Reader application.

Down in the lower-right corner is the View Media Usages button, and by clicking that, you are immediately taken out to the Internet to have the Media Summary Code "decoded", as shown in Figure 26.12.

Figure 26.12
PLUS website decoder of the "machine-readable" code.

Returning to the Embed License in Image option from the application screen (or within the plug-in in your favorite image editing application, like Timothy Armes' Lightroom plug-in), you see the screen shown in Figure 26.13.

Figure 26.13
PLUS License Embedder & Reader that allows you to embed the license into a file's metadata.

Clicking the Embed PLUS License button gives you the affirmative response shown in Figure 26.14.

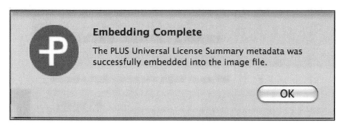

Figure 26.14
PLUS License Embedder & Reader confirmation notice.

Later in this chapter we'll go into exporting XMP using standalone applications. Figure 26.15 shows one such application—HindSight's Licenses solution, which is a part of their InView and StockView suite of solutions. It is PLUS standardized.

Figure 26.15
HindSight's License Exporter in the XMP format.

Thus, by opening Photoshop, choosing File > File Info, and going to the Advanced tab, you see what is shown in Figure 26.16.

Figure 26.16
Once the PLUS License Embedder & Reader has embedded the XMP that was generated by either the PLUS website or the HindSight export, that information appears as shown here.

And tucked away in that folder is all of the information you entered, which will travel with your image. What is amazing about this is that clients are already building into their enterprise-level digital asset management systems PLUS solutions that will allow these clients to either read our PLUS codes that we have embedded or, where they are not embedded by us, embed the language as the images are ingested into their systems, allowing them to track the images through their system, delete them from their system when the license expires, expand or renew them with photographers as their needs change, and otherwise make the management of their image assets more streamlined. Thus, PLUS not only benefits image creators, but it also helps clients manage the images we deliver.

Suppose, though, that you didn't want to go through all that trouble. You could have chosen from the initial screen Select a PLUS Pack, which is a preset package of licensing for a number of common uses. Here's a similar version to the one we just created:

> PPCO: Periodical Cover – One Issue: Use on the cover of a magazine, newspaper, or journal. Applies to a single printed issue of a periodical. Includes distribution of same issue on publisher's website. Allows reproduction of cover for promotional purposes.

In Figure 26.17, we've selected that instead.

Figure 26.17
PLUS license generation on the PLUS website.

The next screen shows what you see in Figure 26.18.

Figure 26.18
PLUS license generation details on the PLUS website.

This PLUS Pack encapsulates seven different licenses, itemized A through G, as shown in Figure 26.19.

Figure 26.19
An example of an extensive license generated on the PLUS website.

At this point, the process is the same, and you generate the license and download and embed it, as before.

To convey this license to the client, the natural language formatting is your best method. Here is the natural language format for the first license:

Media: Editorial | Periodicals | Magazine (Consumer Magazine) | Printed
Placement: Single Placement on Front Cover
Size: Up To Full Page Image | Any Size Page
Version: Single Issue
Quantity: Up To 1 Million Total Circulation
Duration: Up To 1 Month
Region(s): Northern America | USA
Industry(ies): Fashion
Language(s): English
Exclusivity: Non-Exclusive

Placing the above language on the contract, under a section called Rights Granted, and in the invoice and any accompanying printed delivery memo or PDF file will maximize the likelihood that your copyright will be protected. To be even clearer, separate the license to a dedicated page or, in the case of multiple licenses, a separate series of pages and title that page or attached series of pages "License." Doing this is common amongst software companies, and it gives you a document to file away safely. In the instance of a contract, just as there may be a reference to a price schedule in Exhibit A or a note to "see the attached Price Schedule, incorporated by reference here into this contract," so too could you say, "See the attached License, incorporated by reference here into this contract...."

Some Other PLUS Licensing Examples

For a printed brochure of up to 10,000 copies in all languages worldwide for a year:

Media: Advertising | Marketing Materials | Brochure | Printed
Placement: Any Placements on All Pages
Size: Any Size Image | Any Size Media
Versions: All Versions
Quantity: Up to 10,000 Copies
Duration: Up to 1 Year
Region: Broad International Region | Worldwide
Language: All Languages
Industry: All Industries
Exclusivity: Non-Exclusive

In this more general example, we may have left money on the table. A photo on the cover of a brochure should earn more than one inside. A larger photo should earn more than a small one. We also have not included the electronic or PDF version of the brochure. Further, consider that you licensed 10,000 copies with no duration, or you licensed a duration but no quantity. In both cases, you have likely left money on the table. By outlining a duration and a quantity, the client has a window of opportunity that they have purchased, and any

undistributed brochures must be destroyed when the duration ends—or the duration can be extended for an additional fee.

Consider the musical act that, when they see the image you made of them in concert, contacts you to license the image for posters that will sell for the rest of the worldwide tour over the next three years. At first, they will likely lowball on price and will try to get all rights/all permissions they can for that price, which is why writing a clear and concise rights package will ensure that there are no misunderstandings. Here might be a PLUS license for that:

> Media: Products | Merchandise | Poster (Retail Poster) | Printed
> Placement: Single Placement on Front Side
> Size: Up To Full Area Image | Up To 30 x 40 Inch Media
> Versions: Single Version
> Quantity: Any Quantity of Displays
> Duration: Up to 3 Years
> Region: Broad International Region | Worldwide
> Language: All Languages
> Industry: Arts and Entertainment
> Exclusivity: Non-Exclusive

Recognize in this example that you are licensing product rights to the band for which a model release would definitely be required. So, use language similar to "Model releases not applicable because image is being licensed to the entity appearing in the image, and the granting of this license is contingent upon the licensor granting to themselves the right to use the photograph for this purpose." It sounds circular and possibly silly, but if you read the case study in Chapter 20 regarding the textiles company I had an issue with, you will see that they attempted this same defense during our negotiations.

Evolving Toward PLUS

Going through the process of generating a client-specific license with exacting language and then embedding that language as natural language and machine-readable code is the epitome of a best business practice, and you should do it. However, while on assignment you may have time constraints or be missing information that is required to produce that machine-readable code or otherwise do things by the book. It has been said of military operations that no plan survives the first encounter with the enemy. Evolving that sentiment to licensing your photography, it could be said that no perfect license survives the client's first (and repeated) calls asking where the image is.

Suppose 20 percent of your clients are consumer editorial, and your client tells you they don't know how big the photos will run. If you just want the natural language version of the PLUS licensing language, building up a template for that could save you a lot of time, and cutting and pasting that text into your contracts, on the invoice, and into the metadata will add nominal additional time to your workflow. You could then produce a template for the 30 percent of your clients that are trade-magazine clients, the 40 percent of your clients that are PR/event-related, and the 10 percent that are personal uses (in other words, weddings, rites of passage, and so on). Here is an example of a template and how it would look for that

first 20 percent that are editorial. Once you understand this, play around with making templates on the UsePlus.com website for the other types of clients, so you can easily cut and paste the language below during the process of your image ingestion, when you are at the stage of adding metadata.

Editorial boilerplate example:

Media: Editorial | Periodicals | Magazine (All Magazine Types) | Printed
Placement: Single Placement on Any Interior Page
Size: Any Size Image | Any Size Media
Versions: Single Issue
Quantity: Any Quantity
Duration: Up to 10 Years
Region: Northern America | USA
Language: All Languages
Industry: Publishing Media
Exclusivity: Non-Exclusive

Suppose, the client also wants Internet use:

Media: Editorial | Periodicals | Magazine (All Magazine Types) | Internet Website
Placement: Single Placement on Secondary Page
Size: Any Size Image | Any Size Media
Versions: Single Issue
Quantity: Any Quantity
Duration: Up to 10 Years
Region: Northern America | USA
Language: All Languages
Industry: Publishing Media
Exclusivity: Non-Exclusive

You might ask why the duration is up to 10 years. You are granting this publication the right to use the photo, but you don't know when they will exercise that right. That said, they can only exercise it once, hence the repeated use of the word "single."

If a client suggests during the negotiations that they need exclusivity for the photo, don't just change "non-exclusive" to "exclusive." That may suggest they have exclusivity on that image for 10 years. In that case, try this:

Media: Editorial | Periodicals | Magazine (All Magazine Types) | Printed

Placement: Single Placement on Any Interior Page
Size: Any Size Image | Any Size Media
Versions: Single Issue
Quantity: Any Quantity
Duration: **30 days from date of first publication**
Region: Northern America | USA
Language: All Languages
Industry: Publishing Media
Exclusivity: **Exclusive**

These modifications might be better, but they could be interpreted to suggest that if you took 10 images, and they published one, the other nine are still exclusive until they use them. So, perhaps the duration could be:

30 days from date of first publication, or 90 days from date of assignment, whichever comes first

The key is to utilize the system. Further, it is important to have a start date to accompany the duration and to let the client specify the start date. When clients may not know the start date, which is often the case, ask them to make their best guess. Now, in the event that you have these templates that are not client specific, they do not include the client information. While not optimal, time pressures may require you to ship out or upload the images.

Figure 26.20 shows how you might have placed metadata in the Description tab.

Figure 26.20
The Description tab under File Info in Photoshop.

The next tab over is the IPTC tab, and several of the metadata fields, once entered in one tab, are automatically populated into other tabs. For example, the Description field becomes the Caption field, and so on. Here's where you would cut and paste the natural-language templated block of licensing text into the Rights Usage Terms field, as shown in Figure 26.21.

| Description | IPTC | Camera Data | Video Data | Audio Data | Mobile SWF | Categ ▶ ▼ |

IPTC Content

Headline:

Description: John Doe, CEO of XYZ Widgets Company, photographed on location outside their corporate headquarters on November 15, 2009.

Keywords: portrait; full length; outdoors; color; vertical; caucasian; suit; one person; 30–45 years

ⓘ Semicolons or commas can be used to separate multiple values

IPTC Subject Code:

ⓘ Semicolons or commas can be used to separate multiple values

Description Writer:

IPTC Status

Title:

Job Identifier:

Instructions:

Provider:

Source: John Harrington

Copyright Notice: ©2009 John Harrington

Rights Usage Terms:

```
Media:       Editorial | Periodicals | Magazine (All Magazine Types) | Printed
Placement:   Single Placement on Any Interior Page
Size:        Any Size Image | Any Size Media
Versions:    Single Issue
Quantity:    Any Quantity
Duration:    30 days from date of first publication or 90 days from date
             of assignment,whichever comes first
Region:      Northern America | USA
Language:    All Languages
Industry:    Publishing Media
Exclusivity: Exclusive
```

Powered By
XMP

Import... ▼ Cancel OK

Figure 26.21
The IPTC tab under File Info in Photoshop, showing the PLUS licensing information location.

NOTE

I graphically expanded the form field for the purposes of this example. The height of the form field in Photoshop is closer in size to the Copyright Notice field. Other elements may expand and contract depending upon the size of the content within the field.

Figure 26.22 shows that same metadata as it appears in the Library module of Lightroom.

Figure 26.22
The PLUS language as it appears in the metadata panel in Lightroom.

It is important to reiterate that this metadata is only human readable, and while best practices call for both human readable (that is, the natural language version) and machine readable, time pressures in the field may dictate otherwise. Remember, too, that while you are one person generating thousands of images a year, clients are using dozens or hundreds of photographers in that same year, receiving tens or hundreds of thousands of images, and they just can't open/view each image's license to read the rights. So, wherever possible, utilizing a machine-readable license is very important.

In instances where you are ingesting all your images without a known license at the time of ingestion, it would be extremely valuable to apply PLUS Pack PICR, which is "Internal Review - Use restricted to internal business review for inspection and/or editing purposes only. Excludes reproduction in comps or other design prototypes. No reproduction, distribution or other use of the image." This way, unless and until you actually do change the licensing language, no one will have a blank Rights Usage Terms field. Even so, including the end user, duration, and start date will be of value. You might write something like this in the Rights Granted metadata field:

PLUS Pack "Internal Review (PICR)." The use of this image is restricted to internal business review for inspection and/or editing purposes only. Excludes reproduction in comps or other design prototypes. No reproduction, distribution, or other use of the image, and this right is for the commissioning client only and shall expire no later than 30 days from the creation date of this image. For more information on the Picture Licensing Universal System (PLUS), visit USEPLUS.com.

Note that in all cases, it is possible for some software to strip (remove) all metadata, including the camera data, IPTC data, and the PLUS embedded code as well.

PLUS in Standalone Applications

Suppose you don't want to go to the web to generate your licenses. The ability to create these licenses on your own computer, without connectivity to the PLUS website, has its pros and its cons.

I'll address the downside first. On the occasion that there is a revised PLUS standard and additions of universally accepted licensing terminology (such as the evolution of images for blogs, and so on), there is the possibility that you won't have the latest update to the PLUS standard. At this time, that's really the only significant downside.

The upsides are significant. The first is the most obvious—the PLUS standard has been established, with a glossary printed in book form and online—however, in the unlikely event that the PLUS web presence goes away, having the ability to maximize your use of the standard with a standalone application is a significant benefit. Let me make one really important point here: Even if the PLUS website were to disappear and the PLUS Coalition were to dissolve, the terminology and standards developed would survive because it is a consensus system that no one group foisted upon another.

Further, you can produce licenses, codes, and so forth on your computer, store them for future use, and manage all your licenses. One answer is HindSight's InView and StockView solution. While you can generate your licenses online and paste the natural language text and/or machine-readable summary code into the Rights Granted metadata field using a word processing contract/estimate/invoice, so too could you use that language in applications such as Lou Lesko's BlinkBid or fotoQuote author Cradoc Bradshaw's fotoBiz. It is my sincere hope and desire that both BlinkBid and fotoBiz integrate PLUS into their software in future releases. InView/StockView integrate the PLUS license generator into their system with their currently available solution.

Click the Terminology button from their main menu, which HindSight calls Flow Chart (for a good reason), as shown in Figure 26.23.

Figure 26.23
The main menu of HindSight's InView & StockView application suite.

Figure 26.24 shows the screen that would allow you to write any type of license you wanted, but when you mouse over the word Custom, the text at the bottom of the window says "You are viewing the Custom panel. Click here to switch to the PLUS panel."

CHAPTER 26

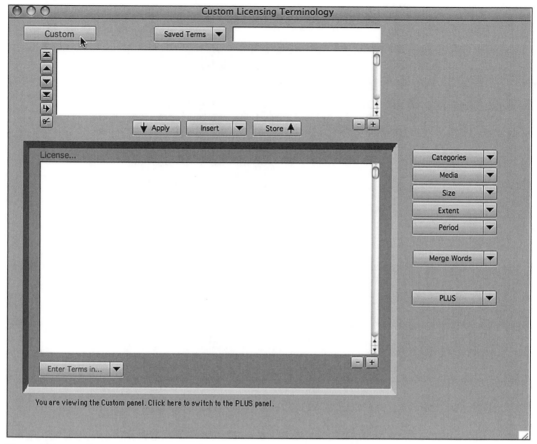

Figure 26.24
The Custom Licensing window in the Terminology panel of HindSight's suite.

Once you switch to the PLUS panel, there are 12 drop-down menus that, as you make your selections, the license builds both in natural language and in machine-readable text (if you choose), as shown in Figure 26.25.

Figure 26.25
The PLUS Licensing window in the Terminology panel of HindSight's suite.

Once the license details have been specified, you next switch to the License Constructor, which allows you to enter other details about the license (see Figure 26.26). The benefit of this is that all of this information will be inserted into the file's metadata.

Figure 26.26
The PLUS Licensing Constructor window in the Terminology panel of HindSight's suite.

What I've outlined here is one example of a best practice. Suppose, though, you decide that you only want to create one license and have that language be a part of your ingestion process in an application such as Photo Mechanic, Lightroom, Aperture, or any other such one. You could generate a generic license. Figure 26.27 shows an example of a generic license for one year for the U.S.A.

Figure 26.27
The PLUS Licensing window Media Summary in the Terminology panel of HindSight's suite, showing a one-year license for all uses.

Generating this license in HindSight's Terminology, on the PLUS website, or in any other solutions you are using then allows you to cut and paste the text in the Media Summary block into any other metadata field in any other application, and you are all set.

You might try creating several boilerplate licenses that are PLUS compliant. Suppose you want one so that you can send images to a prospective client for their non-exclusive review for the next month. Take a look at Figure 26.28.

Figure 26.28
The PLUS Licensing window Media Summary in the Terminology panel
of HindSight's suite, showing a one-month license for internal review only.

Figure 26.29 shows what it would look like if you were generating it on the PLUS website.

License Generator: Permissions			❓
1 Parties	2 Permissions	3 Other Info	4 Generate

Media Usages ❓

Please review the media usages that you have selected. To revise, click the "Back" button below. To approve and move on, click the Continue button below.

Usage	A
Media	Internal Company Use \| Internal Review \| All Review Types \| All Electronic Distribution Formats
Placement	Any Placements on All Pages
Size	Any Size Image \| Any Size Media
Versions	All Versions
Quantity	Any Quantity
Duration	Up To 1 Month
Region	Broad International Region \| Worldwide
Language	All Languages
Industry	All Industries
Exclusivity	Non-Exclusive

Figure 26.29
The PLUS Licensing Generator on the PLUS website, showing a one-month
license for all uses.

Suppose you regularly do public relations event work for businesses, and you want them to be able to use those images for all manner of PR for a period of one year. Figure 26.30 shows the block of text you could cut and paste from Terminology and use for all your ingestions.

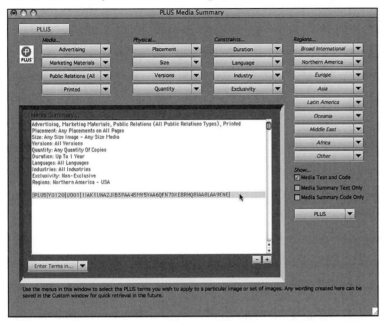

Figure 26.30
The PLUS Licensing window Media Summary in the Terminology panel of HindSight's suite, showing a one-year license for PR uses.

And again, generating the text on the PLUS website would look like what you see in Figure 26.31.

Figure 26.31
The PLUS Licensing Generator on the PLUS website, showing a one-year license for PR uses.

What other types of licenses might you use? For wedding photographers, the license should specify "personal use," so a bride does not think she has the right to use photographs of her when she starts a bridal boutique or give them to the gown maker so the gown maker thinks she can use them for marketing. For photographers who are covering events and selling images of athletes competing, "personal use" license language embedded would cover similar potential misuses. The list goes on and on.

To explore PLUS licensing for yourself, visit www.useplus.com, select the Use PLUS menu, and choose License Generator to make up your own licenses. Before you do that, however, explore the website, read about the PLUS Packs, and otherwise familiarize yourself with all that PLUS has to offer—free to photographers.

Chapter 27

Stock Solutions: Charting Your Own Course Without the Need for a "Big Fish" Agency

So, you've preserved your rights to exploit your images beyond the original assignment. Perhaps you've got a large library of analog images that have been gathering dust and depreciating, as outlined in Chapter 25. Determining the best outlet for your images is crucial to having your images seen by photo buyers and generating revenue.

Nowadays, there are a number of solutions. Prior to the Internet and digital files, most photographers delivered their images to one (or a select few) agents. The physical distribution of these images was time-consuming and costly. Further, to make the most out of your stock, the images had to be originals or high-quality duplicates in order to make the sale. Now, the wide variety of domestic and international outlets for images to be viewed and licensed has grown to a point where you have several options.

What's the Deal with Photo Agents These Days?

When photo agencies were handling physical images, there was a large amount of backend work. Often the agent handled processing, writing captions, affixing those caption labels to slide mounts, categorizing them, and filing them in their library, integrated into the tens or hundreds of thousands of other images. Each time a request came in, someone had to review the request, go around to all the file cabinets, pull the images, place them in slide pages, make a photocopy of the page, put it in an overnight package, and ship it. Then they had to call to determine usage, secure the safe return of those images, and re-file them for future licensing. During this time, those images were unavailable to other prospective photo buyers, and for timely news stories, the photo agents would produce duplicates of the images, splitting the cost of them with you against future sales. They would then re-caption and re-categorize the duplicated images. This required a considerable amount of time and effort and warranted a significant percentage of all licensing fees.

Times have changed. During the analog days, the common split for licensing fees was 50 percent, although if you had leverage, you could negotiate a 60/40 split in your favor. Although I considered the agency share to be high, there was little I could do beyond accepting it. Today and for the last five-plus years, online digital archives have become the norm. By some estimates, less than three percent of images licensed in the last year involved the handling of original film. Most (save for the unique or larger revenue) licenses are handled 100-percent electronically, with no person actually doing the legwork that created overhead costs. Servers in secure facilities house these images and generate revenue. Even so, agents have kept their percentages as high as when they had all that human overhead cost to contend with.

As analog agencies went out of business or were acquired by larger agencies, photographers seem to have forgotten that without them, the acquiring corporation was simply buying empty filing cabinets. As such, the photographers signed "under new ownership" contracts that waived the new companies' liability against lost images. In some cases, the "agents" whose responsibility it was to look out for the photographers' best interests were doing just the opposite.

Only in rare circumstances are these agents looking out for the interests of the photographers they are charged to represent. Quoting from the 2000 Annual Report of Getty Images:

> Our business model transfers seamlessly to the Web. Due to the nature of our product, our customers are able to search for the imagery they need, determine pricing, complete their purchase and have the product delivered—anywhere over the Internet. We don't need to acquire inventory, we don't need to maintain expensive warehouse space and we don't need to depend on a shipping service to deliver our product …. Getty Images reaps the promise of the Internet because our product cycle is completely digital—from the first customer inquiry to the final payment—enabling a pure e-commerce process …. For both Getty Images and our customers, it means increased productivity and lower costs.

Further, and in successive years, Getty on one hand points to their major expense as being royalty payments to photographers, and a few sentences later, they talk about working diligently to reduce their major expenses to increase margins and profits for the shareholders. Can you blame them? Although there is nothing wrong from a business sense with taking this approach, they are truly no longer looking out for the best interests of their photographers; instead, the bottom line is for shareholders. Further, they are not the only "agent" looking to do this; it's just that as the largest publicly traded company, they make a lot of public statements that bring this to light.

So how exactly are the large photo agencies looking to reduce the royalty payments they make to photographers? Well, if they have images of scenic vistas of cities around the world that were taken by photographers who provided those images to their agents, and then their agents were acquired by the larger agencies, those images—which are often very similar (for example, shots of the US Capitol with a blue-sky background during spring)—are being licensed by them, and they are paying a 50-percent royalty on that. Why not hire photographers as employees in each of these cities, and when they are not completing assignments, they can be instructed to shoot scenics of their locality's most popular

"postcard-type" destinations. In fact, by using aggregated data to show which subjects are selling best in each city, they could provide a prioritized list of subjects. When those images come in, because each image licensed from that group would not have the obligation of a royalty at all, 100 percent of each license would be returned to the "agency."

Armed with metrics that show 90 percent of photo buyers don't click past the second page of search results, and given that each page can show 15 thumbnails, assigning a higher ranking to these "wholly owned content" images so that they appear on the first and second pages means that the photographers whose work the agencies "represent" will be shown first only where no wholly owned content exists. As the agencies create the images, they can then bump stock images for which they pay a royalty to the second page and then to the third page. Because all "agency" contracts have stipulations that all captions, keywords, and metadata they assign to your images are theirs, they can freely duplicate the captions and keywords that return the best results and legitimately assign them to employee-generated works.

Although this example discussed scenics in some detail, concept images—from handshakes, to people on cell phones, to youths in activities—are quickly becoming full-blown production shoots by employee and overseas photographers, based upon sales reports showing which ideas and concepts are selling the best. The high-dollar advertising sales that were being split 50/50 with photographers are now being reshot—carefully, to skew so it's just shy of infringement—by those who get paid a work-made-for-hire day rate. Then, these reshot images are owned by the agency. Then, images that are wholly owned in these categories replace the lower-revenue-to-the-agency images. Sure, the 50/50 images still turn up, but deeper into the search results, to where statistics show few photo buyers will drill down.

So that's the deal with "agents" who work for "photo agencies." They're looking out less and less for those they are charged with representing and more and more to the bottom line for owners and shareholders. What's a photographer to do?

Personal Archives Online

There are a number of resources available to take charge of the licensing of your images, but it will take a bit of effort on your part. First, for those of you who have not bothered to caption or keyword your images, you'll need to start. In Chapter 25, I addressed the methods to best prepare your images with the proper metadata. There are, however, scores of articles and other information available from trade groups, such as the American Society of Media Photographers (ASMP), Stock Artists Alliance (SAA), Advertising Photographers of America (APA), as well as numerous other resources to get you thinking like a photo buyer, conceptually as well as literally, so you can understand what your image represents in both realms.

I have chosen to make my images available through the online service provider PhotoShelter. Previously, PhotoShelter and Digital Railroad were competing for photographers. In late 2008, Digital Railroad abruptly closed their doors, leaving countless photographers high and dry. They pointed to their client service agreement where they stipulated that you should not rely solely on Digital Railroad for your storage and that you should also keep your own copies. This didn't change the fact that Digital Railroad quite literally railroaded their clientele. Fortunately, PhotoShelter stepped in and helped out

many of the DR clients. The following sections contain descriptions of the PhotoShelter service and one other—IPNstock. Both options offer localized and geographically redundant protections (an important point that we discussed in Chapter 24), so your data is safe from not only drive crashes, but also from natural or manmade disasters.

PhotoShelter

PhotoShelter (www.PhotoShelter.com) offers a customized homepage model. You can assign (or map) a URL from your website to theirs. So, if your website URL is AmazingPhotosByMe.com, you can assign, through your ISP that hosts your website, library.AmazingPhotosByMe.com to link to your customized front page on PhotoShelter. By doing this, clients will still feel as if they are on your website.

Grover Sanschagrin, co-founder of PhotoShelter, puts his service this way, "More than just the ability to change a font and a background color and insert a logo—PhotoShelter can actually match the look/feel and page geometry for a truly seamless integration. We worked hard to develop a very unique system that allows photographers to add special PhotoShelter tags ("widgets") into their HTML, which allows them to insert PhotoShelter functionality into their design. If you compare several of the customization examples, you'll see just how different they can be." Sanschagrin goes on to address an important point about their archive system as a "true archive," contrasting the limits of other providers with theirs, saying, "Ours can handle 400+ image formats, including all RAW files and Photoshop documents."

PhotoShelter currently offers a cross-photographer search result from their own PhotoShelter.com portal, and they show any image that has been marked as publicly searchable.

Photographers can also selectively group together and create a "Virtual Agency." This is designed to give a group of photographers one common archive for marketing purposes (with the idea that there is strength in numbers), but when an image is sold, the buyer deals directly with the photographer, and no "agency" takes a cut of the sale. As a PhotoShelter member, you can opt into their Virtual Agency service—which is free—and your images will be shown during search queries. PhotoShelter continues to evolve and grow this offering, with new images and features that make it easy to use. For example, the members of SportsShooter.com, a popular photography website, have created their own Virtual Agency, which allows them to have a searchable image archive of member images, complete with e-commerce, with no technical knowledge or accounting at all.

Famed nature and wildlife photographers Art Wolfe, Thomas Mangelsen, and David Doubilet have joined together to form WILD Photography using PhotoShelter's Virtual Agency product, and they have stopped submitting their images to larger agencies, such as Getty Images.

"Neither the buyer nor the photographer has been well-served by existing agencies," said Art Wolfe. "We can provide a deeper and wider collection from our long careers and license them for less than the big agencies thanks to low overhead and a higher percentage going to us. With PhotoShelter's platform powering WILD, everybody wins."

Among PhotoShelter's 40,000+ clients are organizations such as Contact Press Images, Major League Baseball, the San Francisco 49ers, the Oakland A's, the Seattle Seahawks, as well as the Eddie Adams Workshop.

PhotoShelter contains an e-commerce capability and continues to evolve it in response to client and photo-buyer feedback. You can also opt in to offer images as prints—you set the pricing for the images, and PhotoShelter does the fulfillment, or you can opt to handle it yourself. You can also license your images as Rights-Managed using the integrated fotoQuote pricing grid. They also give you the ability to sell Personal Use licenses, which are digital downloads, usually at a slightly lower resolution, that cannot be republished or resold by the end user. (This is perfect for someone who wants to use an image as their computer desktop wallpaper.)

They have a free account that allows you to store 150 MB worth of images, but to really get the most out of their product, you'll need to step up to a paid account. Monthly fees begin at less than $10 (for their Basic plan) and increase as the amount of data you have online increases. If you'd like to customize the look and feel to match your own website or access their collection of premade website templates, you'll need to sign up for the Standard package at $29.99/month. They do not have an annual commitment requirement, they don't make you sign any contracts, and they don't charge you any setup fees.

There are price discounts available if you are willing to pay for a year at a time. Readers of this book can take advantage of a few special offers by entering this special code during signup:

ps6ZTNJH3T

Annual Basic Account - $109.00/year; Annual PhotoShelter Standard Account - Save 10% - $319.00/year; Annual Pro Account Special - Save $60! - $539.00/year.

In addition, I utilize PhotoShelter for a growing number of my client deliverables. I am discouraging clients from being shipped a CD, and instead advise them that for a fee comparable to CDs, which is outlined on the contract, they can view and download their images from an online gallery. More and more, clients like seeing their images online and can view them with clients all around the world as well, simultaneously discussing the images in real time.

In addition, we are utilizing PhotoShelter's real-time galleries capabilities. With an art director back at the client's office at a web browser, we are shooting and uploading directly into galleries for the art director to view while we are still shooting. This way, the art director can be seeing images immediately upon upload, allowing him or her to have input from the comfort of the office, rather than having to come out on the shoot. Of course, we have art directors who love to come on set because it gets them out of the office and lets them be creative. However, sometimes, when we can make it easy for them to view what's going on, they get to see the images without having to be where the pictures are being made.

PhotoShelter is also easy to use and set up, and they are responsive to client feedback on feature requests, bug fixes, and other changes.

IPNstock

IPNstock (www.IPNstock.com) was founded in 2000 by AURORA, a traditional photo agency combined with "new media" capabilities that started with a well-regarded collection of talented photographers. Within a fairly short period of time, IPN was handling a dozen

photo agencies and nearly 50 high-end photographers and was acquired by VNU, the parent company of *Photo District News*, which provided the needed marketing reach. Not long after, similar services, such as PhotoShelter, began offering their own style and level of services to photographers. IPN is different in that they operate very much like a photo agency, with a quality approval process to enter, and they present many marquee photographers who use their service. In addition, they advertise heavily in photo-buyer publications and are making a significant outreach to the photo-buying community.

They present themselves as a premium service, with exclusive imagery. IPN's co-founder, Brad Kuhns, outlines IPN's capabilities and functionality this way: "IPNstock is the only truly custom integrated solution. Almost all photographers and agencies migrate their current sites away from their current hosting providers. IPN adds its extensive technology capabilities behind the photographer's existing website, all with the photographer's custom branding. If a photographer does not have an existing site, IPN designers work with the photographer to create a site. The technology has been developed over the past six years and has been honed by the high volume needs of major agencies like images.com, Aurora, and Robertstock, who completely rely on IPN technology for all their needs."

They allow for up to 2,000 high-resolution images and ask for between a 48-MB and a 60-MB file, which is then saved as a JPEG. They will, however, take smaller files, and their monthly charge is just under $200, with just under $600 in setup charges. They require a two-year commitment. This works out to about a $5,400 required investment over two years, and IPNstock takes a 20-percent commission on all net revenues from licensing of images through their site. IPNstock is very similar to a collective photo agency, and there is an approval process—mostly qualitative—so that, say, amateur or erotic photography does not make its way into search results alongside your images.

Others

There are outlets other than these two. One solution is to take the expense and go it alone, marketing your images of a particular niche subject—say, plants via www.PlantStock.com or aerial images from around the world of cityscapes and landscapes via www.AerialStock.com. Both solutions, when marketed properly and established with an effective backend database, can produce lucrative results. The key is in finding a solution that works for you and employing it so that your images are out there and can be found and licensed to generate revenue. Otherwise, they are an under-utilized asset that is likely depreciating in value and taking up space in your filing cabinets or on your storage media.

There are also outlets that I recommend avoiding. They are services where you are competing for a "stock sale" of an image that has not been created yet and covering all the production expenses of doing so, for a small chance of being paid for that work. These agencies or services suggest that they are representing you and then send out the same request for an assigned image to produce. In the end, not only is there no guarantee that any of those who produced images will get paid for their work, but if the work is chosen to be used by the end client, then and only then will the selected producer of the images be paid,

and the rest will not. Another ill-conceived idea is "crowdsourcing," where those needing images will put out an open call in an online forum frequented by photographers, hoping for free or cheap results.

Another problematic roadblock to a long and illustrious career as a photographer is the microstock business model, where images are licensed for a dollar or two (or even pennies) for a one-time payment. Clients of some of these microstock services can download images in large blocks—250, 500, or 750—once and never have to pay again, for fees of $100 to $300 (or more) a month. Photographers earn less than a dollar—sometimes just 25 cents, sometimes 20 percent of the $1-plus download fees—only when their images are downloaded. These models are among those I recommend avoiding if you intend to remain in business for the long term.

Chapter 28
Care and Feeding of Clients (Hint: It's Not About Starbucks and a Fast-Food Burger)

Before I begin this chapter, let me dispel a myth. In fact, I shall go so far as to say it's a lie. The customer is *not* always right. Author Steve Chandler, who wrote the best-selling book *9 Lies That Are Holding Your Business Back…and the Truth That Will Set It Free* (Career Press, 2005) and I are in agreement on this. He presents it this way:

> You don't want every customer for your business. A lot of small-business owners make a big mistake by thinking that they should try to get any customer they can.

> The customer is always right—it's a lie. I mean, that's a huge lie. And that's something that small-business people have to really work against, because the customer isn't always right. Sometimes they're very wrong, and sometimes they're not just wrong, they're downright dangerous to you.

> There is another impact on this too…that I think is important in turning away a customer. And, that is the boost in morale if you have employees or partners or co-workers, and they witness that you have declined the business of a customer because that customer does not treat people correctly.

After you've sent a client the contract, and they've signed it and faxed it back, and then they call to say, "Oh, you need to sign off on our contract before we can pay you," *are they right?*

When a client says, "Gee, you're the first photographer I've spoken with who's had a problem with our contract. We need copyright to the work since we're paying you for the work," *are they right?*

When a client says, "I can find two photographers to do the assignment for what you're asking. I can't imagine it could, or should, cost that much for what I am asking you to shoot," *are they right?* (Maybe on this one, but that's another point discussed in an earlier chapter about pricing.)

Or this one: "I paid you to take the photographs, so I own them. You're out of your mind if you think I am going to pay you *again* when I want to reuse the photographs in the future." *Are they right?*

In my office, I have people working for and with me who are aspiring photographers and interns, and they are involved heavily in putting together contracts, handling client calls, and delivering final images. They all know my position on work-made-for-hire, copyright demands, all-rights grabs, and even demands that reprints from magazine articles be included in the assignment fee already agreed to. All are deal breakers. But it's not my employees' role to convey this; I do it. In fact, there is sometimes a keen relishment among my staff when telling me about a call and my need to call them back to resolve the issue. We have a policy in our office that those in the office may request to be on the line when that conversation takes place, so that if I'm not available to handle the issue at a later date, my staff and interns are versed in how to pinch-hit, and they then learn how to engage their own clients on the issue when they "leave the nest" to run their own businesses. They all know how the call will end—either I will succeed in conveying how those needs are not consistent with our policies, or we will part ways. My staff and interns enjoy hearing how circuitous the route can be to either destination. It's important that you make sure your staff goals are in line with your business goals, or you will have problems.

NOTE
I suppose everyone has his or her price. I have had clients indicate that they wanted all rights forever to an image. My quote of $25,000 to $30,000, along with the encouragement to reconsider their request first by limiting the geography to where their company does business, then by limiting the timeframe to, say, five years, and then limiting again to all uses except paid advertising placements has often still resulted in a comma in the licensing figure and a deal being struck that is acceptable to both parties.

We do turn away a quantifiable amount of business each month because of these demands. We—I—want clients who respect the value we bring to the assignment. Clients who demand copyright are dangerous. Clients who insist they must have all rights are wrong, and clients who insist that reprint rights be included without an additional appropriate fee are not right. I don't want these clients in my sandbox. None of them is playing fair.

They're Your Clients: Treat Them Like Gold

You must do everything within your power to honor the convenience of the client. When I get an unusual request from a client, I always respond, "I am more than happy to make that happen for you. That said, here are some options for you to consider." The first words out of my mouth are an affirmation that I will work to achieve what they've requested. Then, I outline alternatives, such as those that are a lower cost or a better choice they may not have considered. In this instance, when clients make a choice, they do so having considered options they might have not thought about before.

For example, suppose I am on assignment and a client representative is there, but he or she is not the final arbiter, or there are multiple stakeholders. At the end of the shoot, the representative might say, "We need three sets of CDs; can you ship them to these addresses?" My "I am more than happy to" ensues and then I outline an option. I'll suggest, "Here's a more efficient and more cost-effective solution: Why don't I put up a web gallery of images? That way, all the people involved can literally be on the same page at the same time, and then we can deliver (or retouch) just the images you need. It will cost less and save time." Frequently, the response will be, "Wow, that's a great idea!" And sometimes, the client really does need multiple CDs, and this dialogue also informs them that there will be additional costs associated with this request. It's a two-fer, because it attempts to solve a client's needs *and* it advises them of additional potential costs in a non-threatening manner, so they don't feel as if they are being nickel-and-dimed on additional charges.

Further, remember this: Once someone says he or she is your client, always treat that person like a client. Regardless of whether you're up for more work with them in the future, make sure you always hold that respect for their position. I can see in very rare instances that the client extent of the relationship might disappear and be replaced by a personal one, but those situations usually involve an exchange of rings and vows.

Oh, and one more thing about gold: Knowing how and from where clients came to you is of the utmost value. It allows you to determine where to continue mining for that gold, and, in turn, you can return their trust in you to complete the assignment by treating them like the gold that they are to your karmic and financial bottom line.

How to Improve the Odds That Your Clients Will Come Back Again

There are a number of things you can do to ensure that your first-time clients will become repeat clients. The first thing to do is figure out what role you are playing: Are you their first choice, fallback choice, or a benchwarmer called in when the first-stringer gets sick?

Steve Chandler discusses client growth—and retention—this way:

> If price is your only selling feature, you are in a losing battle...one in five customers doesn't need to fret about price. We have all bought things that were expensive but worth it. Price is just a detail, not the deal itself.... According to the latest income surveys, 20% of the population controls 47% of the disposable income. That means that one out of five people has so much money to buy things with that, relatively speaking, they're not concerned about the price at all. Does it make sense to focus your ad's message on something that doesn't concern them? ...[T]hose 20% are your ideal customers. Money is not the main factor in their decision to shop with you. You are. You are the main factor in their decision, and that's how you want it to be. Your quality, your service, your commitment to them. That's where you want it to be, because that's where your profit margin is, and that's where your database of lifelong customers comes from. Not from one-time price shoppers.

If you are the client's first choice, they are likely to become a return client. Simply continue to deliver at or above the quality of your last assignment, and the likelihood that this will continue is great. If they found you on the Internet or via a referral, then you'll want to be able to demonstrate that what you offer will meet and exceed what they are looking for. This will maximize the chances of their becoming a repeat customer.

If you're their fallback choice, tread carefully. Perhaps the client thought they could afford someone more expensive than you (perish the thought that these photographers exist!) but could not, and now you're the because-we-couldn't-get-so-and-so photographer. You have a bit of an uphill battle in this instance, but relish the challenge. I take the position that the masses stop at the mountain's base, but there is plenty of elbow room at the summit. Here, too, meeting and especially exceeding the client's expectations means that you could have a new repeat client.

On more than one occasion I have been asked by a client, "Are you available tomorrow? Our photographer came down with [*insert virus here*]." Here I am the second-stringer. Sometimes the referral came from the photographer who's sick, but often I am some offhand random referral or search-engine find. This type of client is almost always just grateful to have a body with a working camera on hand. The bar of success is set so low that it's an easy win. That said, don't sit back and coast through the assignment. Treat the client as if he or she is a regular one with high standards, and then meet those standards.

Think long and hard on this one: If you can offer a unique service that no one else has thought to provide or can provide, then you have a "hook" that surpasses the other photographers the client might consider, and this will further diminish the role that price plays in the decision-making process.

Steve Chandler makes this point in *9 Lies* on why customers return. They do so "for many reasons other than price. Once you believe this you will attract customers that will continue to prove it to you and verify your belief. Higher-value customers who like your unique offer are the ones that stay with you... the two car brands with the highest repeat-purchase rates are Lexus and Cadillac. Is that because of the price?"

If you seek to attract customers shopping you on price, they are not customers who will continue to contribute to you in the long run. These clients will continue to look (and will find) someone cheaper. You want customers who are willing to pay a premium for your services, but, more importantly, who will refer others who will do the same. Why grow your roster of clients with low-price shoppers that will consume all of your creative energy, leaving little time for well-paying customers—the ones you've always hoped to land?

Sometimes it's beneficial to let the client or art director feel that the idea you pitched is theirs (if you've secured the assignment—otherwise it's not kosher). In one instance, I came into a creative meeting with the job's art director, and her boss, the senior AD of this very reputable firm, joined us. He was extremely skeptical of me and what I brought to the shoot. I had been a "must have" from their client because I had a track record of delivering in previous work for them. During the meeting, I could feel the disdain directed toward me until I came up with a concept that was beautiful in its simplicity and met the client's messaging needs. The senior AD flipped like a switch and decided I was okay for the project

and then left the room. It was clear to me that his role there was to garner ammunition to shoot me down to the client, but by keeping my composure, I was able to win him over.

Subsequently, I was in a conversation with the client, who had initially alerted me to the fact that the firm was questioning my appropriateness for the assignment. I recounted the situation and when the switch flipped. The client stopped me and said, "That's a great idea! It was yours?" I said, "Yes, why?" She then said that in a recent meeting the senior AD had pitched that idea as his. Although my client, with whom I work frequently and closely, was happy to learn the facts, she never revealed that she knew it to anyone else, nor did I. As Robert Solomon, author of *The Art of Client Service* (Kaplan, 2008), notes by devoting an entire chapter to the subject, "Credit Is for Creative Directors."

Another point on ensuring that clients return: Manage client expectations from the outset and as the assignment progresses. If you're called upon to shoot an image of a speaker at a podium, and the podium has no signage on the front or behind it that you can include in the frame, I always say "Gosh, do we have any logos or other visuals that we can include on the podium or background? When I make these photos, the speakers could have been anywhere." This ensures that when they get the photos, it doesn't just look like a bloke at a box with a microphone, when they were expecting something more dynamic. Usually, the client can do something about it, but when they can't, I've let them know I am thinking about these details, and they now have a better idea of what they'll get.

If during pre-production meetings or calls the client is always talking about the importance of beautiful morning light, and then during the scout the day before we learn that there are large buildings or trees precluding that warm light, or the forecast calls for a foggy or overcast morning, I'll make a point of saying, "Well, let's see what we can do to warm up the light on this image, because Mother Nature's not going to come through with that morning light we wanted." Then I try to make whatever adjustments I can to the image with gels, front-of-lens filters, camera Kelvin adjustments, or tweaking in Photoshop as a last resort. However, I have managed the client's expectations here as well.

When there is a problem or issue that arises, you can demonstrate a style of communication that will keep clients coming back. Although many times you will be remembered because you were successful at troubleshooting issues related to what was in the frame, often your repeat business will come from how you handle issues unrelated to image content. By this, I mean client interaction. As I stated at the outset of this chapter, the customer isn't always right. Even when they are wrong, what they need more than being right is a feeling that you heard what they said, considered it thoroughly and thoughtfully, and looked them straight in the eye with sincerity when responding. How you handle the mistakes and misunderstandings that arise is an opportunity to distinguish yourself and earn (and earn back) clients who respect how you dealt with the issue.

Nadia Vallam, photo editor for W magazine, in a summer 2006 interview in *Picture* magazine, had this to say when asked what it takes for a photographer to get repeat business from them: "First the film. But I think beyond their eye, they must be good socially, because dealing with publicists, editors, and subjects can be tricky. And they must be confident, not cocky. In the photography world, everyone is vying for the same jobs, and while we hire for talent, it's very important that they're likeable."

In the restaurant business, less than stellar food can be offset by exceptional service, but even the best meal can be ruined by an unpleasant or unfriendly waiter. The general manager of the renowned Prime Rib restaurant serving the lobbyists and power brokers along the venerable K Street corridor summed it up this way when I asked him about it: "I can hire anyone and train them to take and deliver your order as well the details and the nuances of doing that properly. What I can't do is teach someone to be kind, courteous, warm, and friendly. We cannot hire a waiter and train him to be a gentleman, but we can and do hire gentlemen and teach them to be waiters."

The X Factor

I can't tell you the number of times that I got the job because I am easygoing and friendly, I deliver all the time on time, or some other reason totally unrelated to my creative vision, talent, technical expertise, and so forth. In other words, all those things that we worry about—prime lens or zoom, ISO 100 or 400 to get a smidge more depth of field, 3200k or 2900k—had little or no weight on the decision to hire me. There are those times when you just don't know what helped the client decide to hire you, and asking at an appropriate time can be useful.

More than once, I won a client that someone else lost because they failed to deliver when they said they would. Further, there's the client who came to you and then left for someone else, only to return. I call them the *prodigal client*.

In case you're not familiar with the parable, I shall paraphrase it here. In the gospel of best business practices, there is a tale of two clients. One is the faithful client, who never gives the photographer any trouble. The other is the client who demands more and more services and is critical when costs rise. Eventually, this client goes off to some other photographer, who will appease his demands at a pittance.

So goes that for a few years—until this former client finally realizes that he is accepting lesser and lesser quality services. Then he comes to his senses and returns "home."

The client is received with open arms, with nary a whisper across one's lips of the past or to whom the client fell prey. Instead, the photographer seeks to meet and exceed the expectations set by this prodigal client's previous experience—even though rates have increased since he last called.

While there is no jealous other client here, had there been, the photographer's response to them might have been to make merry, because the prodigal client who had been "dead" to him was alive again.

When a client returns, all I want to do is ask, "So, why have me back? What was wrong with photographer X?" Yet, I don't. It's just not very professional.

However, occasionally a comment gets made that "the previous photographer, among other things, was skittish and didn't want to get in to make the good pictures, but I know you can, so make sure you do that." I so want to ask more. Yet, again, I don't. I am simply happy to have an old client back.

I knew the level of service and image quality I was providing was superior to my competition, but to point that out—to call and say, "Why don't you want to use me?"— would have just been sour grapes. Instead, taking the high road of patience and perseverance and continuing to just do the best damn job you can is what ultimately makes the difference.

Take this path, and in the long run, you will have extremely loyal clients—especially the prodigal ones.

Rob Haggart, who writes the "A Photo Editor" blog, once wrote, "[J]ust because you are a phenomenal photographer, with a great style, doesn't mean clients will want to work with you. And, if you make it worse, you make it so that you can't take direction. This is a recipe for a lot of one-off clients, with little repeat business."

I also wrote, "If I said to you, after you botched a job or just were lackadaisical about your service/follow-up component of an assignment, that you would lose well over $10k, would you handle things differently?" in the blog article "Lost Income - Over the Long Term." And that is a cautionary tale about just how much losing a client will cost you over the life of your business.

We are in the business of making pictures—pictures people want, pictures people need. And those they want and need are the ones that actually fit into a story or a mocked-up layout for an ad. If you want to try something edgy, fill the client's request and then shoot your "something different" and offer it up. This way, the client has what they need, and if they like your second image, they might go to bat for it. Making a client have to take what you've given them—and only that—places them in an uncomfortable position, against deadline or additional costs for a reshoot. Instead, apply the rule of "one for thee, one for me."

We are also in the business of taking direction. Sometimes it's vague; sometimes it's (overly) specific. If people presume that you wouldn't deign to take direction—or, worse yet, you consider direction something to work opposite of—it ensures that you will get a reputation for being difficult to work with or for people to only work with you when their superiors press for it.

The overarching point is that you have to be easy to work with and deliver what the client wants.

A Couple Givens

The title of this section should actually be "A Couple Givens?" because while I assume things such as "your voicemail should sound professional" or "you should dress appropriately for the shoot," more often than not, I hear inappropriate voicemail messages, and I see photographers dressed completely inappropriately for the shoot.

Voicemail

Your voicemail is your clients' first experience with your business when you're not there. Having your kids record your message is a really bad idea. It's okay for your home line but not your business line. (You do have two, right?) Your voicemail message on your landline should be something like:

> Thanks for calling John Harrington Photography. We apologize we're not able to take your call right now. You may also try contacting John on his cellular phone at 202-255-4500. To leave a message here, please begin speaking after the tone. Thank you.

On your mobile phone, the message should be something like:

> Hi, you've reached the offices of John Harrington Photography. We apologize that John's not currently available to take your call. Please leave a detailed message, and John will return your call as soon as possible. Please begin speaking after the tone. Thank you.

The message should sound professional, with no background music. Write yours down and read it over and over for cadence. If you can't sound it out the way you want, ask a friend to do it for you. For a few hundred dollars, you can hire a professional voice talent to record it for you and e-mail you an MP3. Trust me—it's worth every dollar. I can honestly tell you that many clients and colleagues comment on mine, which was done by a professional radio personality I am friends with.

Appearance

Please, please, please dress the part. If you are going to photograph a CEO, wear a business suit. I can only imagine that shorts are suitable when you are shooting on a boat or a beach. Business casual (which does not include jeans, by the way) should be the lowest level of clothing style you should wear. Khakis and a jacket and tie for men, and a dark pantsuit and conservative blouse for women work in this arena.

Wear a tuxedo when everyone else is and a business suit when everyone else is. Blend in and don't stand out, especially when the client is at the shoot. So many times I have seen photographers who were inappropriately attired covering events.

I could go on and on about the manner of appearance and comportment, but suffice to say— dress for the station in life you want to be in, not the station in life in which you are currently stuck.

Do Something Unexpected, Something Value-Added

Before you do something unexpected, it is imperative that you begin your client relationship understanding just what the client expects from the assignment. Ask questions: Is this a brand awareness campaign or are you selling a particular product or service? Who is the audience—consumer or business-to-business? Are the images being produced as part of an ongoing campaign, or is this a one-off production? These questions and numerous others help you define what will be defined by the client (and hence you) as success.

Sometimes when I am working with an editorial client for the first time, I will get to the assignment, set up, and do assistant stand-in tests. Firing up the digital workstation (a.k.a. laptop), I will hop online (for editorial clients) and e-mail low-rez images. A note is

included about stand-ins and how I see this image fitting into the client's request. I then call to follow up as the assistant is resetting the equipment cases so that they are not all over the place, and we present a professional and organized appearance when the subject arrives. Often there is a "Wow, that looks great," and every so often there is a suggested change, which I accommodate. This creates buy-in with the client, and they can often use the image as a comp for the layout while we are preparing the final files for review and delivery once back at the office. Further, this can be a value-added service that will cause you to be remembered by the photo editor or art director in the future. In addition, if this is your first time working for this client, it immediately gives them peace of mind that they made the right choice in selecting you.

Other times, especially if there is an art director or photo editor onsite, I will make an effort to do a group photo of the subject(s) with the crew and client. It's usually a fun photo, and it almost always signifies the end of the shoot. When I'm home and the initial images have been delivered, I will make a point of making prints for the crew, but more importantly, a print for the client and AD/PE. I send those prints along with a note thanking the client for the opportunity to work together and telling them that I look forward to working with them again. Not only do they almost always post the photo on their wall or in an easily viewable location, which reminds them of the shoot (and me), but it is a conversation starter with their colleagues, who say, "Oh, that looks like a fun/cool/interesting shoot," which usually ends up with the AD/PE saying complimentary things about my easygoing style of work and such, causing more word-of-mouth marketing. Solomon again devotes a chapter of his book to the notion that "Great Work Wins Business; A Great Relationship Keeps It." In the chapter, he's not talking about the lunching kind of relationship, but the kind in which there is trust and collaboration, and your counsel is not only sought but valued.

U.S. News & World Report published an article—"What Springsteen Can Teach CEOs" (October19, 2007)—about Bruce Springsteen's ability to remain relevant and popular, unlike so many other acts of his era. This piece is a good jumping-off point to translate into how it applies to photographers. The first point was to always keep your clients at the height of expectation—continue to produce exceptional images and push yourself to deliver. The example used is of Apple, Inc. and their continued production of new products and product updates. Other points included the value of innovating, which could be applied to photographers as the importance of reinventing yourself and your images and style as you evolve. And, most importantly, love what you do. As photographers, we are as blessed with this privilege as we can be—don't underestimate how much better this makes your images and serves your clients.

There are numerous things you can do for your clients that can make a difference. Another example from my own experience is that I will leverage my status as a top-tier member of several frequent-flyer programs to the client's benefit. Most airlines typically extend upgrades to first class to members of these programs. On some airlines it's free, and you can confirm 24 to 72 hours before departure. On others, you pay a nominal $50 to $100 per direction, depending upon distance. (Any coast to Chicago, for example, can be $50, and coast to coast can be $100.) Knowing that the client is traveling alone, I will indicate to the airline that the client and I are travel companions, and then we are both upgraded to first class. Now, traveling on the same flight with a client in this capacity has a risk to it: If there

is only one first-class seat, you must not accept it and leave your client in coach! Also, as noted earlier, make sure that if your client is an agency, their client is not traveling on the same flight. That would make you and the agency AD look like over-spenders! Used judiciously, this tactic can be a really amazing way to let the client know that you value them. Of course, you'll be covering whatever charges for the upgrade. You should have that much wiggle room in your overhead to do this for them.

Feeding Clients: Fast Food and Takeout Coffee Won't Cut It. Cater and Bill for It!

There are a number of different assignment types, from rites of passage, to editorial, to corporate/commercial, and numerous others. For a number of high-end assignments, you can easily lose the assignment for no other reason than that you didn't include catering. This service is sometimes called *craft services*, after the company that feeds crew and stars alike on movie sets. If you are going to be doing an assignment that crosses a mealtime with an art director, photo editor, your client, or *their* client (who is also your client), make darn sure you include catering *as a line item*. It can always be struck, but it lets the client know that you are going to be taking care of them and you are paying attention to the details.

There are other things that may also go into this, such as a production trailer (a.k.a. motor home) where clients and art directors can relax while on location and where you and these stakeholders can review images from the shoot while crew and talent are outside prepping for the next assignment. Sometimes it is necessary to have the production trailer for makeup to be applied and such. Again, having a production trailer or catering as a line item as well indicates it can be struck, but also reiterates the idea that, "We're thinking about you and want to ensure you're comfortable while on set."

On-set lunch is not fast food, nor carryout from the corner deli (but at least that'd be a step up from fast food), nor homemade foods—unless you or your spouse is a gourmet chef who knows presentation and healthy recipes. Further, after winning the assignment, don't overlook the importance of the not-so-little details. Call the client and ask about particulars: Is there a vegan, a vegetarian, a low-carb dieter, or someone who requires that their meals be kosher? Then, call a catering service. It doesn't have to be one that's used to doing banquets (but it could be). It can be a gourmet delicatessen or a well-regarded restaurant in the local area. Call around where you are shooting, or if it's local, call places you know. Ask whether they can prepare meals and dishes to go or as platters that can be opened and set up by you (or, more likely, the assistants). Many will be more than happy to prepare their lunchtime-menu sandwiches, cold salads, and fruits and cheeses for you in an attractive manner. A gourmet coffeehouse can provide the coffee (and tea assortment!) and will make sure you have enough cream, sugar, stirrers, and cups to go around. Yes, Starbucks can and does do this, but there are also other options. For early shoots, breakfasts are often fruit, bagels, coffee and tea, Danish, and donuts. Don't skimp and stop at 7-11 or a gas station food mart. Go the distance! It makes a difference, and you are billing for it, as the client expects you to.

NOTE

A point about Starbucks: They did not start up their business looking to undersell the local coffee shop. Instead, they tripled the price of a cup of coffee by delivering a better customer experience with more choices and amenities and services than anyone else—by a long shot. Clients more often than not have a strong desire for a premium service and are willing to pay a premium for it.

If the shoot ends and the client suggests getting dinner (or lunch), you should already have a few suggestions about nearby and convenient options. Going so far as to have a faxed copy of the menu is definitely something to make the client remember you—even though some may suggest this is over the top. It would take no more than 10 minutes to do research on the Internet with a Zip code from a guide such as Zagat or a localized guide from the city's newspaper and then print out some menus and have them as a part of your shoot materials.

You should be prepared to pick up the bill, and an approximation of that may well have been in your estimate under "meals" or some variation of that. If not, offer to pick up the bill to make a good impression on the client. This means you should be the first one to reach for the bill when it hits the table or as it is coming to the table. If, as you do, the client says, "Oh, I'll take that," a courteous and sincere, "Are you sure?" will be followed by a "Yes, I'll take it" from the client. Then, it is critical that you accept and not argue about it. Just say thank you.

There is only one circumstance in which it is correct to split the bill, and that is when you are doing an assignment for a government agency or a private company that has a government agency contract. Many contracts stipulate the importance of these things as a part of what a government client or a company representing the government can legally accept, but do what you can to be the magnanimous one. The client(s) will remember it.

Lastly, I would also encourage—especially on big shoots where there are a number of crew members working with you, and also when the client is there—that you have a "wrap dinner." In some instances, you'll want to invite the client, and in other instances you'll want it to just be you and your team.

Deliver When You Say You Will or Sooner

Deadlines. Why is it that so many people have such little regard for deadlines? They're not maybe-lines, if-it's-convenient-lines, or whenever-you-want-lines—a deadline is a deadline. Period. If you can deliver sooner, and especially if it benefits the client, then do so.

For many of our clients, we started with a two-day turnaround, but then clients who had their photographs produced on a Friday wanted them Monday. So we changed that to a 48-business-hour turnaround. That means an assignment completed Friday evening at 9:00 p.m. will be ready by Tuesday evening at 9:00 p.m., which is too late to make an overnight delivery or courier service, so it's usually scheduled to go out Wednesday morning via courier. However, for overnight service we will ensure that the images are done in time for those service pickup times.

Sometimes a client will say, "I need you to rush those images, and I know there are rush charges." That's fine. Sometimes a client will say, "It'd help to have them tomorrow, but we can't afford the rush charges." It's these clients that will most appreciate an early delivery of your work.

Editorial clients typically do not want all the images at high resolution. They usually want a web gallery and final selects. We typically try to deliver these images within the PE's stated deadline, and often we'll do a quick web gallery the evening after the assignment. Because these are very low-rez files, there is usually little work (spotting and so on) that needs to be done for that size, so a batch action can make the galleries without much problem. This is appealing to many clients who arrive at their desks in the morning to find a gallery for their review.

Return E-Mails and Send Estimates ASAP

One thing that really cheeses me off is when I send a time-sensitive e-mail and the recipient sits on it. I am sure that clients feel the same way. In fact, I can be certain that I have received numerous assignments for no other reason than I sent my estimate within 10 minutes of the end of a phone call or e-mail inquiry. Many of these times I get e-mails back saying, "Wow, that was fast—thank you for this. We have a meeting on this in an hour, and having your paperwork will make a difference." Or, "I contacted two other photographers and have not gotten anything back from them. Thanks. The assignment is yours."

E-mails generated by you following a telephone call or in-person meeting are also critical. The subject line could be "Meeting Summary and Action Items," "Conference Call Summary and Action Items," or "Review of Meeting Decisions and Next Steps." Then, without rehashing the points, go through and list single-line items that were agreed to and the next steps to be taken. This creates an audit trail in the event that there is a misunderstanding later down the line. If both you and the client thought that the other was going to arrange for a special prop or background, and you both arrive on set without it, the finger-pointing will begin.

SUBJECT: Review of Meeting Decisions and Next Steps

Dear Client –

As discussed, here's where we are on the project:

- We arrive in Houston Saturday night and will be departing late Wednesday that same week. Our tickets will be booked by COB today.
- We will await your decision on hotel and will make our own arrangements. Please advise when you have.
- We are traveling with two assistants and hiring a local makeup artist and stylist.
- The basic outline of our schedule is scout day/shoot day and then scout day/shoot day for the second shoot.
- You've made contact with the location and personnel and have approved their wardrobe and look, or we will accept what we find during the scout and make the necessary adjustments once on site.
- The proposed creative of a large quantity of people with signs on sticks has been replaced by the smaller group of people with a large flag in the background.
- The procurement of the background flag and ballot box prop we both will do on the scout day.
- Our first preview gallery is due by COB Friday of that week.
- Final retouched and ready-for-press images are due by COB the following Friday and are dependent upon your own internal review, which will give us a minimum of two days for final post-production work, delivered in the Colormatch RGB colorspace, with guide print.

Please let me know if there are any changes to this. Thanks, and I am excited to work on the project!

Best,
John

Clients and New Approaches to Business

As you read and learn from this book and improve on your business practices, you'll have a problem. That problem is that all your clients have been trained to do things (by you) the wrong way. Free shipping/hand delivery, all rights/work-for-hire deals, no post-production charges, and so on. The question is "How do I get my clients to do all of this?" The short answer is that you don't.

It is highly likely that someone used to getting all manner of services and rights for cheap or free won't much like it when the prices are increased unexpectedly. Instead, as you grow your client base and new prospective clients come calling, these are the ones that get the new-and-improved you. Suppose you have a dozen clients that you know support and sustain you (albeit barely) in your current business model. Once you have achieved a few new clients under your new business model, you can present the new business model to a few of your old clients. "We've had a few policy and price changes in the last few months, so you'll notice a bit of a change in the paperwork we send over for shoots." Then, those old clients can take it or negotiate something with you—or not, and you've lost them, and that's okay. You just can't lose all your clients at once. You need to ease into your new business paradigm, and that includes easing clients into it, too.

Recommended Reading

Beckwith, Harry. *What Clients Love: A Field Guide to Growing Your Business* (Warner Business Books, 2003).

Chandler, Steve and Sam Beckford. *9 Lies That Are Holding Your Business Back...and the Truth That Will Set It Free* (Career Press, 2005).

Checketts, Darby. *Customer Astonishment Handbook* (Cornerstone Pro-Dev Press, 1998).

Solomon, Robert. *The Art of Client Service* (Kaplan Business, 2003).

Chapter 29

Education, an Ongoing and Critical Practice: Don't Rest on Your Laurels

It might come as somewhat of a surprise to some, but the fact is, I am not a graduate of a prestigious photography school or program. I do, however, have a four-year degree from a really great university, and I am certainly proud of that accomplishment. Much of my lighting experience came through trial and error on staff for a magazine that hired me more for my ability to make the impossible possible than for my technical capabilities with a 4×5 or my knowledge of how to use a Wing Lynch rotary tube processor. Once on board, I made every waking hour a study in how to light. I did this by reading books, talking to friends who knew much more than I did, and testing how soft-box sizes made a difference in transfer edges, as well as just what five degrees of change in temperature makes in the color of E-6 processing, not to mention the pH level of the city water!

Although I have lectured for about a decade at trade association meetings and tradeshows on a variety of subjects, I still relish the opportunity to learn from the presentations I am not giving, and even then, I hope to learn something from the audience questions that might cause me to view in a different light something I presented. When that happens, I make a note to myself to follow up on that or to reflect further afterward.

The worst thing that could happen would be for me to sit back and think, "Oh man, I don't need to know anything more!" Even physicians, who spend the better part of a decade learning how to save lives or make them better, attend annual seminars and read professional journals to stay current on the latest techniques that will make them better doctors. Lawyers do the same, learning about the latest precedent-setting cases and how those cases will affect their clients. All photographers should look to have a plan to regularly learn and grow from the knowledge bases of others.

Tony Luna, author of *How to Grow as a Photographer: Reinventing Your Career* (Allworth Press, 2006), has this to say about education:

> I have had the honor of being involved…showing portfolios…. There is one thing I can categorically say about those presentations: no one has ever asked me to show them a diploma of the talent I was representing…never asked where the talent I represented ranked in their graduating class. They just wanted to know if that

talented person could produce the work on time and on budget and infuse it with unique vision. Of course, if the talent had a solid, formal education in photography, the work should display a high level of professionalism, right from the start.... Education—scripted or by total immersion—sets the patterns for work ethic and discipline.... Douglas Kirkland gave this advice based on how he handles the subject [of education]: "Explore the latest technology. What I do is the following: I keep looking at pictures all the time, everywhere. I keep trying to extract from them. I don't want to copy them but I want to get some nourishment from them."

One of the common refrains I hear from those who intern for me is that they felt their college was a waste, and they should have come through my program or a similar one, and that real-world experiences far better prepared them for the freelance world.

I can see their point and understand that to a certain extent it may be true, but that degree is worth a great deal. That said, do not underestimate the lifelong value of a degree from an accredited institution of higher learning.

But what degree?

First things first—graduating from college is critical. Don't be an idiot and think that it's not worth it. So many people I know say that getting your degree is the ultimate test in being able to demonstrate that you can finish something you started. I agree with that sentiment.

From time to time, discussions arise about the qualifications for a particular teaching position being advertised. More than one has read, "Faculty members must have teaching experience at the college level and are required to maintain active participation in their field of photography." Active participation? I can't say I know a lot of professors who would fit that bill. A few, but not many. One read, "The perfect candidate for this job is someone who has an MFA in photography, plus commercial and teaching experience." And here's where I, along with others I've discussed these things with, have a bit of a problem. Requiring a master's? Surely this applies in fields such as English, the sciences, and so forth, but the arts? Maybe art history degrees, but for the field of photography, I just don't see it.

In large part, the inbreeding, tenure debates, and self-congratulation that goes along with being an academic are part of the problem with today's photographers who enter the real world with a diploma, $100,000 or so in debt, and no way to pay off that debt. Few schools are preparing their students with the tools they need to succeed in business, since freelancers are the new staffers. Many teachers are so wrapped up in the drama of academia that they forget to prepare their students for their post-school future.

I have a few colleagues and professors who have said that this book is on their required reading list. Bravo! I am not saying that this book is the end-all be-all answer per se, but it's at least an indicator that the professors even care about the issue of their photographers as soon-to-be self employed.

Continue the Learning Process: You *Can* Teach an Old Dog New Tricks!

Steve Chandler, noted in the last chapter as the author of *9 Lies That Are Holding Your Business Back...and the Truth That Will Set It Free*, cites as "Lie #8: I don't need help":

> This lie has you setting yourself up to fail. It has you insisting you've got what it takes. It has your ego and pride interfering with the success of your business...you have to put the success of your business ahead of false pride. You have to put the success of your business ahead of whether you might "lose face" or look weak.
>
> Most people are not fully committed to success; they are committed to looking good in the eyes of others. They may be somewhat committed to making a living, but that's a completely different thing!
>
> Tiger Woods uses a coach. When he got rid of his original coach, saying he could do it on his own, his game went downhill fast. Bob Nardelli, CEO of the Home Depot, has said, "I absolutely believe that people, unless coached, never reach their maximum capabilities."

One example of an "old dog" not only learning a few new tricks, but also helping grow them is photographer Tim Olive. Tim took years of experience and feeling burnt out, and he turned that around (after a lot of personal reflection) into Success Teams, which is a part of APA's offering to its members. Small groups of photographers (usually seven local to one another, but not always) gather on a regular basis to inspire and help grow each other's work, along with a professional coach. I highly recommend you check out the APA National website (www.apanational.com) for this and grow your career with the help and support of your fellow colleagues.

In *9 Lies*, Chandler goes on to say:

> No professional athlete would dream of going a day without coaching. Because their success is too important to leave to chance. They wouldn't dream of going it alone. Yet most small business owners are actually proud of going it alone! As if that said something about them. It does not. It says that they are not fully committed to success.

Make sure, though, that those giving advice, whether online or at seminars, are successful. More often than not, those who are espousing the principles of success and how to succeed are the ones who have run their businesses into the ground. There is nothing wrong with learning from past failures, but make sure they're doing really well now before you take their advice lock, stock, and barrel.

In addition, there are some on the photo-lecture circuit who have been out of the business for several years and are earning a living teaching what worked and was acceptable five or ten years ago (or more). Depending upon the content, their advice may be timeless, such as talking about the importance of the proper care and feeding of a client or a creative way to light a subject, but other information about contracts or the state of the industry as seen from

the front lines may no longer be applicable. If you're not sure about the timeliness of their advice, respectfully ask how many assignments they've completed in the last year for clients. This is one of several ways you can discern which insights they are sharing that are fresh and tested and which may not be.

Know What You Don't Know (Revisited)

Another point about this. If all you read was your community newspaper, you might not know about the war (regardless of when you read this, there's always a war somewhere) and how it's going. You might not know about the politician or big businessman who's the subject of a federal probe or just how the economy is doing right now. These things become points of idle conversation during meetings while a projector is being set up or you're awaiting a meeting participant. Although it's not smart to take a side about politics or religion, you can, by reading, engage the client and come across as knowledgeable. And always know what book you're reading, even if you've had it on your nightstand for the last three years.

If you're doing a lot of work with biotech companies, subscribe to their magazines. Try to learn about what's in their news and what photos they are used to seeing from a style standpoint. Use this to engage CEOs, engineers, and others during photo shoots or meetings. This holds true for any industry: Know what they know, which in the beginning is what you don't know...but you *will* know, and you will benefit from knowing in the long term by growing your bonds with the client and conveying to them that you care enough about their field to learn and be conversant about it.

If you find yourself being asked your opinion about, say, the drop in grain production in the Midwest and how it will affect food prices, and you know nothing about the subject, do not try to fake it. Ask an intelligent question (and anyone who tells you there are no stupid questions is just being nice), such as, "I'm not familiar with that situation. What was the basis for the report, and what do the analysts think about this long term?" Something like this will make it sound like you are interested in what the client is, and you're asking a question that puts the client in the position of power, where they can show off their understanding of the subject. You've allowed for the conversation to be opened up and continue, rather than just saying, "Oh, I've not heard about that."

Seminars, Seminars, Seminars: Go, Learn, and Be Smarter

One of the best opportunities to learn is from seminars. They are given at photo tradeshows by professional organizations annually or semi-annually. They are given monthly by some, such as APA, ASMP, and others. They are given as traveling road shows by software, film, and camera manufacturers, and they are given online as distance learning or podcasts. Almost always, they are well worth the nominal per-seminar fees that are charged. Although I feel fairly proficient in Photoshop, for example, I welcome the opportunity to watch someone else demonstrate how he or she uses it. Learning masking tricks, channel

sharpening, and noise reduction, as well as how to optimize images through high-dynamic-range (HDR) capabilities are among the more recent takeaways from seminars I have gone to. Seminars become especially useful when new versions of various software applications come out, and you can watch as these new features are demonstrated. It's much more engrossing to be shown than to read the manuals!

Understand going in that a program by a film manufacturer will probably include pitches for the product, and there are a number of other seminars at which speakers hock items they are paid to endorse or demonstrate. Although you will take away a lot of knowledge about those products or services, it should be abundantly clear what the presenter's relationship is with the sponsor. Sometimes a sponsor is covering the expense of the meeting; other times, there is more involved.

I learn best by observing. Others learn best by reading or listening and taking notes. If you are the type who best learns by observing an actual shoot, then attending a seminar that does not include this will reduce what you take away from the experience. Many seminars on computer programs will be in a lab format, where you actually sit at your own machine and practice. For me, that is more helpful than watching someone do the same thing without the interaction with the keyboard and mouse.

One last thing about seminars: The death knell for me is when the seminar is titled "Ansel Adams on Getting the Most out of the Zone System," and I arrive only to find him talking about all his photos and the challenges he surmounted in accomplishing them. Were it titled "An Evening with Ansel Adams," then I'd expect to hear his stories. If it's supposed to be an educational seminar and I end up hearing mostly "war stories," I'm going to be miffed. There are numerous photographers whose work I admire, whom I would greatly enjoy hearing speak about their experiences—their war stories—but I will choose those; I don't expect to hear about them during a seminar designed for me to learn about a style or technique.

Subscriptions and Research: How to Grow from the Couch

I subscribe to more than a dozen photo-related magazines. I usually learn something from each issue when I can find the time to read through them. When I find something that's important, I will tear out the article from the magazine and save it for later referral or a deeper read. There are a number of times when I find myself with idle brain cycles. Among them are when I'm temporarily indisposed when nature calls, during takeoff and landing while traveling, and when I arrive early for an assignment and have time to pass. These magazines and the torn-out articles have allowed me to maximize what would otherwise be unproductive time.

Another thing that I find myself doing is web research. When on a conference call or awaiting an instant message from a colleague or client or an e-mail that will allow me to move forward with contract or estimate preparation, with one ear to the call or one eye on my message notification icon, I will peruse blogs, review sites, and explore other resources online. It's simply amazing what information is out there, and other readers validate much

CHAPTER 29

of it. When a blogger posts something on a site about product capabilities, for example, other readers can (and will) comment on the fact or fallacy that's been presented. Of course, being sensitive to this, with a little effort you can separate the wheat from the chaff.

One absolutely untapped period of free time that photographers don't maximize is drive time. The time commuting, the time traveling to and from assignments, and that otherwise unproductive time in the car is frequently frittered away. You can rent audio books—almost all the recommended reading in this book is available as audio books—from the library, and within two weeks, you will have completed an entire book on self help, business growth, or the like. Although you might think that there is never enough time to read a book (and I hope you work to change that!), begin by listening to books in your car or on your iPod. It's an amazing untapped resource.

The Dumbest Person in Any Given Room Thinks He or She Is the Smartest

There is an ancient axiom: The only thing that a truly wise man knows is that he knows nothing. I have found myself in rooms full of rocket scientists (literally), where there were geniuses in residence, some parading around their intelligence like peacocks and others being more responsible stewards of their knowledge. Yet, take the rocket scientist out of his element, and that peacock's tail feathers wither. He might be an expert in his field, but he knows little about the endless specialties outside of his. As such, the peacock's attitude often causes him to miss opportunities to learn about other things.

One of the really wonderful things about the work I have done and the people I have worked with in the past is that I have had the privilege of being in rooms full of amazingly smart people. Their knowledge humbles me each time, and I take the opportunity to garner just a few insights into their field.

Chapter 30

Striking a Balance Between Photography and Family: How What You Love to Do Can Coexist with Your Loved Ones if You Just Think a Little About It

There is a verse in the Bible, Matthew 16:26, that translates to, "For what is a man profited, if he shall gain the whole world, and lose his own soul?" or "What shall a man give in exchange for his soul?" Now, if you're not a Bible reader, I am certain that there is a similar sentiment in the religious writings that you ascribe to, and if you are not a religious person, understand that this sentiment can, in the end-game analysis, translate to "You can't take it with you." Or, to quote George Strait's "You'll Be There" song, "I ain't never seen a hearse with a luggage rack."

There is an often-quoted yet misleading statistic that 50 percent of marriages end in divorce. This statistic is based at least in part on the statement that "approximately 2,362,000 couples married in 1994, and 1,191,000 couples divorced in 1994," put forth by the National Center for Health Statistics' Annual Summary of Births, Marriages, Divorces, and Deaths. Each year, with some fluctuation, this summary reflects that the number of divorces is half the number of marriages. This would be accurate were the length of marriage one year; however, the National Center reports that, in fact, the median duration of marriage for divorcing couples is 7.2 years and that most divorces occur within the first 10 years of marriage. These rates obviously fluctuate from year to year, but not by much.

As an integral part of divorce for couples with children, for men with children, understand this additional statistic *clearly*: 72 percent of the time, where custody of children was awarded, it went to the wife. Joint custody occurred only 16 percent of the time, and husbands were awarded custody only 9 percent of the time.

Regardless of what the exact numbers are, photographers have a higher divorce rate than people in almost any other profession. A study by the Missouri School of Journalism, which surveyed 2,100 news professionals in 2000, found the following highlights (or lowlights):

> **NOTE**
> The Missouri School of Journalism report was a survey of television and radio reporters, but it makes salient points that, in my opinion and experience, are valid for photographers as well.

- Two of every five persons surveyed said their jobs had caused marital problems.

- At least a third of the problems stemmed from too little quality time with spouses. Survey respondents said odd working hours caused problems in the marriages. One respondent called schedules "tough," reporting, "My wife works 9 to 5, and I work 3 to 11. It doesn't leave a lot of time together." Another respondent said, "Long hours and being called in on my day off is hard for my husband to understand." A male photographer even reported having his honeymoon interrupted by a news emergency.

- Some respondents reported missing "quality" time with their families. One respondent reported, "I wish I could be home for family, supper, and bedtime stories."

- Job stress is reported as problematic, too. Carrying the job and its stress home can also stress marriage. One respondent stated, "I bring home lots of stress and anxiety. It's difficult to talk about job problems at home because it upsets my husband."

- Job devotion is a factor, too. One respondent wrote, "I'm now separated from my second wife, who felt I was more devoted to news than to her. She didn't like the police scanners on in the car, living room, kitchen, and bedroom."

I hope this has made my point. This information above, if not heeded, is likely a harbinger of things to come if you don't focus on family and strike a balance.

When What You Love to Do Must Not Overwhelm Those You Love

It's easy to get caught up in the excitement of an assignment. For those in the news business, it's chasing news, meeting tight deadlines, and accomplishing editor demands. For commercial work, it's easy to lose yourself in the moment, which becomes hours, and when you look up at the clock, you've passed mealtime and your child's bedtime without so much as a "good night."

Photographer Rick Rickman, in an article for the SportsShooter.com website, makes several excellent points:

> One of the most interesting things about this business is the fact that so many photographers I know are more interested in doing well in some contest than doing well with nurturing their family or relationships. This business is brutal on relationships! The amount of hours spent at work is relentless. The amount of time spent away from home is endless, and the numbers of times photographers choose work over family needlessly is mind-boggling…. If we examine our photography carefully, in most cases we will find that if we work for 30 years at this craft, we may have a couple of chances in our lives that our pictures will actually have some effect or benefit to society or the world. If we're very fortunate, we may have an opportunity to do something good with our images…. Capturing a great moment is a wonderful thing, but does it hold a candle to having an opportunity to direct and shape the future of another human being? Truly having the chance to bring real good into the world is an enviable position to be in…I'm concerned that this industry has lost sight of what is truly important in the world. Photographers seem to think that winning a contest validates their existence…. I think that a prerequisite for a photographer to enter any contest should be a letter of recommendation from their spouse or significant other saying that they have done well with their lives and duties at home and they should be allowed to enter said competition. No letter, no entry!

Consider that divorce is an option for the ignored spouse, and as the statistics noted earlier, the likelihood is extremely high that you will not only lose your spouse, but almost all access to your children if you're a man. Do not exchange a meaningless award (in the grand scheme of things) for the sorrow you will feel each morning you wake up alone without your spouse, and, if you're a man, for the sorrow you will feel due to the great likelihood that you will also lose your children, save for a few visitation days a month.

Solutions for a Happier Spouse/Partner and Children

Unless you are on a critical deadline, you should make the time when your two-year-old says, "Wanna play with me?" Or when your six-year-old says, "Can you come and play outside?" Or when your teenager says, "Can you come help me with…?" And even if you *are* on a deadline, finish the deadline work and then seek out the now-departed child to re-engage him or her. When your spouse says, "Sweetheart, please come to bed/to dinner/home," be responsive.

CHAPTER 30

NOTE

When the first edition of this book came out, more than one colleague pointed out that this was the shortest chapter of the book. I noted to them that it also has the longest chapter title and was purposefully made into a chapter rather than being a part of some other chapter because of its importance. The messages in this chapter focus squarely on the family and provide background and insights into the importance of family. (And, actually, in this edition, this chapter is no longer the shortest in the book!)

One solution is to make certain you not only make time for dates, but you also are the instigator of planning those dates. Agreeing to go out and then showing up at the appointed time is not the same as telling someone not to make plans for Friday or Saturday night and then making reservations somewhere and arranging for tickets to a show or movie. Pack a picnic basket and head out for a nice lunch, or even plan a trip to a museum. Demonstrating that you are thinking about the other person and how he or she is important to you can ensure that your spouse or partner is happy.

For children, recognize that your schedule can and should make time for attendance at school functions, sporting activities, and such. Do not take the "out of sight, out of mind" mentality. Be a participant in their homework and field trips. Of course, your erratic schedule will likely preclude you from being a coach or going to all the games or recitals, but those absences won't be missed as much if you're there most of the rest of the time.

Take Your Kids with You

I have hanging in my office several images where I am carrying my camera bag on one shoulder, a camera bag that really contains diapers and a bottle on the other shoulder, and a BabyBjörn on my chest with one of my children strapped to it. In these situations, I had a two- to three-hour assignment or a project I wanted to work on, but for whatever reason my daughter needed to come with me. The rally on the National Mall celebrating the 30th Anniversary of Earth Day took place about six weeks after my first daughter was born, and she was there with me. Ditto an anniversary of Martin Luther King's historic speech on the steps of the Lincoln Memorial—my daughter and I were there while I was working.

In addition, as your child gets older, so, too, are your digital cameras, which makes them more or less safe to hand over to an eight-year-old. A few years back, I took my daughter to cover a protest march. It wasn't an assignment, but my daughter wanted to know what daddy did, and so rather than just tell her, I thought we'd make an outing out of it. So, I pulled out of the closet an old Nikon D1x, charged the battery, put an old lens on it, put it on Program, gave her a five-minute demonstration about how to use it, and off we went. Yes, I made a few photos I liked, but I was more concerned with not losing my eight-year-old, so she was my focus. She watched me take photos and took her own. She was excited about being out with daddy, and she quickly got the hang of previewing her images she had just shot on the back of the camera. She learned how much work it was—running and finding

the right spot as the marchers came by and carrying the camera. She was never more than 10 feet away from me, and I always had my eye on her. In the end, after a few hours, she was ready to go home—both tired and excited about "our assignment." With a bit of cropping, she had a few really nice photos to show mom.

Obviously, when you have clients on a shoot, unless your child is old enough to fill the role of photo assistant, you can't take your children. If I'd had to go to a protest where I was concerned for my child's safety, she would not have gone, even if she was strapped to my chest in a BabyBjörn. Yet, unlike Take Your Child To Work Day, which happens once a year, when you run your own business, you can take your child to work any day you want. It's likely that over time they will tire of it, but they will have lasting memories like my daughter, who says, "My dad takes me on photo shoots."

Dealing with the Jealousy of a Spouse or Partner

At points earlier in my wife's career (she's abundantly happy now!), there were times when she said to me, "You love your job, and I hate mine. That's not fair." That, dear reader, is when you help your spouse to find a new job and encourage him or her to take the time necessary to find one he or she loves. We are blessed by whatever higher power each of us believes in, because we have a gift or talent that can sustain us and that gives us pleasure day in and day out. Rather than get defensive, do everything within your power to see things from your spouse or partner's perspective.

Sometimes you have to protect your spouse from worrying about you. I know that might sound counterintuitive, but it's important to consider. If you're a freelance photojournalist traveling to a war zone or disaster site, a white lie may be in order (but avoid a straight lie). Don't say you're going to Arizona if you're really going to the Middle East. However, saying you're going to cover humanitarian efforts instead of that you are embedded in a combat unit will allow your spouse to worry less and focus on carrying on with life, your family's needs, and such. Of course you check in when you can, but don't talk about missing being ambushed by 50 yards or about a firefight that broke out after your helicopter took off. Vincent Laforet, Pulitzer prize–winning photographer, presented at the annual NPPA Northern Short Course in 2006. During a seminar entitled "Be Prepared," he said, "Sometimes the best thing I can do for my wife is be vague about exactly where I am so she won't worry, because when she's upset, I get upset, and I need to be focused on not only making pictures, but also my own safety, and worrying about her can't enter into the equation."

In my case, I am always out and about, usually in town, but frequently (less so now than when I was younger) I am traveling on assignment. For me, I love nothing more than coming home after being out all day and having nice evening at home. My wife, who's been in an office environment all day, wants to go out, get dinner, or such. I make a conscious effort to go out because it's important to my wife, and as such, it's important to me. Traveling for me is definitely work, and I so look forward to a home-cooked meal. However, weekend destinations are trips we make together when I'd rather be home. Sure, I enjoy them, and I especially enjoy that my wife and children are having a fun time, but I relish more being at home working in the garage or out in the yard with the family. Striking that balance is so important in situations such as this.

CHAPTER 30

Listening to Cues: What Those You Love Are Saying When They're Not Saying Anything

One of the refrains made by spouses of photographers is, "You love your camera more than you love me." The immediate response is always, "Of course not, sweetheart," or something to that effect. When you say that, you're not hearing what your spouse is actually saying, which is, "I want to spend time with you, and all you want to do is take photos."

It is extremely hard for a spouse to understand that, although it's not true that all we want to do is take photos, making photographs is as enjoyable to we photographers as whatever hobby our spouse or partner enjoys doing. We are blessed to be able to earn a living doing what we love.

Robert Fulghum's book, *It Was on Fire When I Lay Down on It* (Ivy Books, 1991), posits this question:

> Is my occupation what I get paid money for, or is it something larger and wider and richer—more a matter of what I am or how I think about myself?

It goes on to say:

> Making a living and having a life are not the same thing. Making a living and making a life that's worthwhile are not the same thing. Living *the* good life and having a good life are not the same thing. A title doesn't even come close to answering the question "what do you do?"

I would submit the notion that although what we do is work, it's not a job. However, we become so focused that we begin to ignore what's going on around us.

Often a spouse will begin to withdraw, and the dialogue about the day's activities may become perfunctory. Maybe your spouse decides to paint a room without talking to you about what color it should be. Or you may get the silent treatment if you don't notice weight loss, hairstyle changes, or such. I know I have fallen into that scenario, and getting out of the proverbial doghouse is an uphill battle.

Dale Carnegie, in his 1936 best-selling book, *How to Win Friends & Influence People* (Pocket, 1998), makes these points:

> ▶ When a study was made a few years ago on runaway wives, what do you think was discovered to be the main reason wives ran away? It was "lack of appreciation." And I'd bet that a similar study made of runaway husbands would come out the same way. We often take our spouses so much for granted that we never let them know we appreciate them.

> ▶ Abraham Lincoln once began a letter saying, "Everybody likes a compliment." William James said, "The deepest principle in human nature is the craving to be appreciated." He didn't speak, mind you, of the "wish," "desire," or "longing" to be appreciated. He said the "craving."

> ▶ The difference between appreciation and flattery? That is simple. One is sincere, and the other insincere.

▶ "Here is one of the best bits of advice ever given about the fine art of human relationships," said Henry Ford. "It lies in the ability to get the other person's point of view and see things from that person's angle as well as your own."

Carnegie's citation of others studies and sentiments on the subject is to this point: Listen to what is being said, pay compliments, and convey genuine appreciation for your spouse or partner.

Vacations: Really Not the Time to Shoot Stock

Do not, I repeat, *do not* bring your camera on a family trip or vacation, unless, without prompting, your spouse asks you to take pictures of the two of you, your children, or other family members. This time is not only a time for you to recharge your mental energy, but it's also a time to be away from your desk, workflows, and such. If you just can't stomach not having a camera, go out and buy the most expensive point-and-shoot-looking camera with a chip that is bigger than the most professional camera from just two years ago, and use that. Make sure it does not look like your work camera, and invite your spouse to take photos of you for a change! And do not hang back to make more images or schedule your walk along the beach for the golden hour. Enjoy the down time; there will be plenty of assignments waiting for you when you return.

CHAPTER 30

Chapter 31
Expanding into Other Areas of Creativity

Photographers' creative impulses are frequently not constrained by the still camera. Often, photographers evolve into videography or authoring books of fiction, fact, and even the beautiful coffee-table book. Most of the business insights in this book are applicable to other creative arenas, but it is of the utmost importance that if you are interested in branching out, you do so in a responsible manner.

All too often, I hear from my colleagues about individuals who have hung out their photography business shingle and are doing things that will hurt not only their own business, but also that of the photographic community of which they are becoming a part. As you evolve into another arena of creativity, I encourage you to do so in a manner that does not do harm to the community you are entering and sets you up on a positive first footing.

Video Services

Until you pick up a camera, capture some footage, and then sit down to edit, you will not realize just how much work goes into producing even a 30-second video. Unless your 30 seconds of footage is a single camera uncut, the need for a second point of view (usually with a second camera but not always), quality audio, a well-lit scene, and continuity of dialogue and a cohesive message, you will have a poor final product. Thinking in motion and about how you tell a story with moving pictures is far and away different from thinking about how you tell a story with one to three still images.

SHOOTING VIDEO ON STILL SHOOTS

There is a new wave of cameras that are capable of shooting both still and video in the same "still" camera. I put quotation marks around that because it's an electronic box with interchangeable lenses that looks like an old-style 35mm film camera, yet these cameras are capable of shooting in HD video. Be very careful about shooting video on still photography assignments. Clients and even locations where you may be photographing may get very upset with moving pictures being produced on a still shoot.

In some cases, however, clients are actually asking, "Hey, can you shoot a little behind-the-scenes [BTS] video of the shoot?" Recognize that this footage could make its way out onto the Internet and be a promotional vehicle for the client. Further, you are then responsible for making sure you have BTS footage.

In other cases, clients are very uncomfortable with BTS footage being captured. Things said on a set could be caught in the audio track and be embarrassing when it gets out. Other times, clients are leery of revealing how much work went into making a final beautiful photograph.

Many photographers like doing BTS video to show their friends and prospective clients as well. I have heard of more than one photographer who was fired because he or she was capturing BTS video from a "still" camera. It's a whole new world out there with the convergence of these dual-capability cameras, and you need to be careful.

During the course of the back and forth between the client/art director and myself, the possibility of BTS video is broached. I usually say, "I'd like to capture some behind-the-scenes video and maybe some point-of-view video of what we'll be doing. Do you have any objections to that?" Whatever the answer, you need to be okay with clients or art directors saying they would rather you not do it. Furthermore, when they say no, do not think you can be sneaky and hit the Record button on the camera without anyone seeing you do it. You'll get busted and likely lose that client forever. And worse, you could get sued.

Lastly, make sure your model releases for any subjects—as well as your crew—are signed for stills as well as motion pictures. And be sure that if your clients add on to their needs with the request that "we just need a little BTS video…," there should be an additional fee involved!

This book cannot by any means go into the depth necessary to teach you, the still photographer, even a small fraction of what you need to know in order to enter into the field of video services. Much of what you will need to learn first will come from learning the art of visual storytelling with moving pictures. Then you will learn how critically important quality audio is to a video piece. It has often been said that a video package with mediocre video can be saved by well-done audio, but even the best video package can be ruined by poor audio. Once you've learned about capturing video and audio, the tedious process begins. If you thought it took a lot of your time to do post-production on still photography after the fact, sitting in a video editing session makes you realize just how quick and easy still photography post-production is—relatively speaking.

For example, unless you are recording straight to a memory card, you will have to ingest the video footage in real time. This means if you captured two hours of footage, before you can do anything, you have to sit at your computer for at least two hours as that footage gets ingested, not to mention watching as it is ingested to log the activities on the tape. Then the editing begins. You can assume that for every minute of completed video, you will spend at least one to two hours editing, if not a great deal more.

One of the most significant differences between video and still photography is who owns the rights and how you license that content. The industry was established in large part based upon the Hollywood model, whereby many individuals contributed to the finished work. From camera operators to lighting, stylists, art directors, actors, special effects, and so on, that work becomes a collective work, and all those who contribute to the work expect that their work is a work-made-for-hire. Further, most end clients expect that whatever they pay you for the project includes their ownership of the video and that they can then do what they want with the footage. In many cases, a client will ask you to hand over the raw tapes, straight out of the camera. Although there are some rare instances where you might keep and be able to relicense video footage you shot for a client or generate additional royalty/relicensing revenue from that original client, don't count on it. Know going in that what the client is going to do with the footage has little to do with what your creative fees will be.

Also largely different from still photography is that video work sets out a fee to pay you as the camera operator, but you separately rent to the client the cameras, lighting, and other equipment needed for the shoot. Just as still photographers have 4×5, medium format, 35mm film and all manner of digital variations, so, too, do videographers have non-HD, HD 720i, 720p, 1080i, and 1080p, 16:9 versus 4:3, Red One Camera, lights, grip equipment, audio gear and so on. Each of these equipment types contributes to the end result, and moreover, if you own it, you rent it daily to the client as a line item.

Book Publishing

For the most part, there are three types of photographic books published—those that are self-published (often called *vanity press*) and those that are commissioned by a client, publisher, or author.

Vanity Press

When you have been working on a project for some time, or you have an idea for a really great project, it is only natural that you will get so close to it that you can't take a rational and realistic look at the commercial viability of producing the book. Then, when you approach a few publishers, hoping to get them to underwrite it or buy into your project after the fact with an advance, and you get rejection after rejection, it is only natural for you to get frustrated.

Enter vanity press. Simply put: No one who is legitimately in the publishing business with a track record and an understanding of the market thinks your book can be profitable, so you decide to design and publish it yourself, hoping to prove them wrong.

Good luck.

Underwriting the costs for design and printing of your book can be very expensive up front. I am not speaking here of a book like this one, but of pictorial books. The one saving grace to all of this is the rise of print-on-demand books that are arriving on the scene, which allows you to do all the design work and upload it to a service and then market the book. Then, when the book is ordered, in just a day or so it is printed, bound, and shipped out.

There are rare exceptions to this, where a photographer becomes successful with his or her own self-publishing efforts, but you're better off playing the lottery than thinking you will be the exception rather than the rule.

Publishing a vanity-press book then allows the photographer to say, "I just published a book," or otherwise expect that he or she will be honored (or at least respected) by the publishing community. The problem is, the publishing community in large part looks down on vanity press because those books did not pass through the appropriate academic and stylistic filters that are normally associated with the prestige of being a published book author. To that end, books such as Jeremy Robinson's *POD People: Beating the Print-on-Demand Stigma* (Breakneck Books, 2006) have been written. There are many other resources for being a print-on-demand author. Just go to Amazon and do a search for "print on demand" or execute the same search on Google. Realize, though, that vanity press is titled as such for a reason.

Commissioned Photography Books

From sewing books to cookbooks and educational projects for museums, I have had calls and submitted proposals for what I would charge to be the principal illustrator of these books with my photography. To date, I have produced three commissioned books for the Smithsonian, for which I was paid for all elements of the production of the book, from shoot days to travel days, travel expenses, time spent editing, and time producing the final prints/digital files. Further, I retained copyright to my work.

Often for cookbooks or other similar books, your name shares the front page as "with photographs by" alongside the name of the author. Generally speaking, the work you will do with the author and/or designer should be able to give you a good idea as to how many dishes (or whatever the subject is) will be photographed, from full-page images to smaller detail shots. Generally speaking, you should be looking for a single lump-sum amount to be paid for your work up front, regardless of how many books of that edition get sold. However, be sure that those images are for that first edition only, and be sure to provide a schedule of rates for second editions as a part of your contract, so you know the number is fair, and the author won't feel like you might hold the images hostage if the book is a hit. Taking the project on speculation and hopes of royalties is a very risky proposition and one that requires a lot of due diligence on your part so you know what you're getting into.

One of the most lucrative books you could be asked to produce would be a book about a business. Often, these are books that rely in large part on original photography, taken at plants and properties around the country or throughout the world. These books are used in the company's many waiting rooms in offices everywhere, used in sales presentations as leave-behinds, and even sold in company bookstores and gift shops. These books can also be produced by cities, counties, and states around the country to promote their locale or region as a good place to invest or open a business, or they can be used as gifts to visiting dignitaries. Philanthropic organizations, nonprofits, and other organizations like this also will commission smaller books to attract donors and to use as thank-you gifts. Whether for a business, a nonprofit, or a government entity, although there are a great deal of planning and

details to arrange, these books are among the most economically viable for you to work on when you are commissioned to do them. On the other hand, working on a long-term book project with a charitable organization can be a great pro bono project as well.

Co-Published and Retrospective Pictorial Books

A growing trend amongst established pictorial book (also referred to as *coffee-table book*) publishers is an instance where the publisher will commit to a project but expect that you will contribute $5,000, $10,000, or more to the costs to produce the book. In some instances, the publisher will only take on the book if you agree to buy 100, 250, 500, or more copies of the book—in essence, underwriting a significant part of the book yourself. In these instances, the publisher, knowing how hard it is to just break even on a pictorial book, will hedge the likelihood of a loss by getting you to commit to a quantity of the book yourself.

As you get older and carry a well-respected name, you may find yourself in the rarified air that is a retrospective book about your work. Often these are an overall retrospective of your life's work, or they are about a large body of work that you did. Usually, getting 250 or 500 copies of the book for you to give away or sell on your own is not unheard of and can often be in lieu of any payment for your photos in the book. Usually, however, you are not paying for a part of the production, as you are with a co-published pictorial book.

Chapter 32
Charity, Community, and Your Colleagues: Giving Back Is Good Karma

Dale Carnegie, author of *How to Win Friends & Influence People*, had posted the following over his bathroom mirror as a daily affirmation and perspective to act from:

> I shall pass this way but once; any good, therefore, that I can do or any kindness that I can show to any human being, let me do it now. Let me not defer nor neglect it, for I shall not pass this way again.

Robert Fulghum, author of *All I Really Need to Know I Learned in Kindergarten*, outlines these seemingly simple rules that really apply to all of society (or should):

1. Share everything.
2. Play fair.
3. Don't hit people.
4. Put things back where you found them.
5. Clean up your own mess.
6. Don't take things that aren't yours.
7. Say you're sorry when you hurt somebody.
8. Wash your hands before you eat.
9. Flush.
10. Warm cookies and cold milk are good for you.
11. Live a balanced life—learn some and think some and draw and paint and dance and play and work every day some.
12. Take a nap every afternoon.
13. When you go out into the world, watch out for traffic, hold hands, and stick together.

To me, that's a mantra for life. Take a minute to reread that. It really rings true.

Charity: A Good Society Depends on It

When a natural disaster strikes—from a tsunami, to a hurricane, to an earthquake or a terrorist act—it is human nature to join together and help those in need. It's obvious that it's necessary, and that it's a good thing. Following the terrorist strikes of 9/11, the American Red Cross and several other charitable organizations reported record donations, so much so that there was a concern among other charities for ailments and other worthy causes that the ability to collect donations to support their ongoing efforts would be impacted. In the short term, that was in fact the effect. Without your charitable contributions of time, money, or in-kind donations, those affected will not recover from a natural disaster or a life-threatening ailment that lacks a cure.

On a day-to-day basis, there are almost an infinite number of commendable charities that are worthy of your donations, and I encourage you to be generous. However, also be reasonable. One way to see just how charitable your donation might be is to ask whether the printer and designer are doing the work for free. If they are, then perhaps it's of value to do so as well.

Pro Bono Work: You Decide What to Do, Not in Response to a Phone Call Soliciting Cheap (or Free) Work

When the phone rings and it's the latest charity, that is not the time to decide to do pro bono work. I encourage every photographer I know, and with whom I discuss this, to choose charities or causes that are of interest to them and make outreach. By doing this, any guilt you might be feeling when the multiple calls each month come in from worthy causes seeking free or almost free work can be mitigated by your sense of the giving back for which you have already made arrangements.

Engaging the Photo Community: Participating in Professional Associations and Community Dialogue on Matters of Importance to Photographers

Most people are not loners by nature, although there are loners among us. The good thing about the Internet is that those loners can remain alone but lurk on community blogs, forums, discussion groups, and e-mail listservs; in doing so, they benefit without having to participate. For those who are not loners, participation not only benefits them, but also contributes to the easily accessible body of knowledge from which others can learn.

In addition, being active with photo trade organizations, such as the ASMP, APA, NPPA, EP, and PP of A, as well as the numerous specialty groups that will serve your particular niche, will benefit you greatly. Whether they are continuing education or lobbying on your behalf,

these organizations all make a difference in your everyday life. Other examples include organizations that work with a state to clarify sales tax issues as they apply to photographs; organizations that work with the federal government to protect your intellectual property from theft or the erosion of its value; and organizations that address important issues by, for example, engaging the Transportation Security Administration in a dialogue about the importance of allowing photographers an extra camera bag carry-on, just as they allow musicians with valuable instruments. You might not know that these organizations are doing things like this for you, but they work on things like this every day. Supporting these organizations with your membership dollars will ensure that this will continue, but moreover, the organizations will keep you informed of what they are doing and what they have done to warrant your continued membership.

Your Colleagues: They May Be Your Competition, but They're Not the Enemy

Many reasons why we are where we are today—in other words, the state of the business of photography—are because we treated our colleagues like the enemy and our price lists and contracts like nuclear launch codes. For years, retail stores posted their prices proudly. Why is it that there are only a handful of photographers who have their prices on their websites and make them easily available to those calling for more information? I encourage photographers to outline, in general terms, their pricing. It can be done with a caveat that all assignments are priced based upon their own unique factors, but nonetheless, the guidelines, when published, present an air of confidence that clients respect.

Even though you might feel as though those with whom you compete for assignments are your competition, consider this: There are truly few photographers who are in direct competition with one another for work. Niche services, unique styles, and other differentiators mean that it is very difficult to compare two photographers and suggest that they both bring identical skills and vision to the table.

On the rare occasion when you encounter someone for whom a negative karmic bank account is a way of life and who sees nothing wrong with backstabbing you, instead of engaging this person, getting enraged, or flying off the handle, take the high road. Early in my career, when I was approached by my photo agency, Black Star, to be represented by them, I was overwhelmed with excitement. A confluence of circumstances, including their regular photographer being on a long-term assignment out of town and their losing local assignments because of this, coupled with the quality of my work and my ability to begin working for them more so than "one here, one there" assignments, immediately meant I was the obvious choice for them.

When I shared this exciting news with two of my closest friends and (I thought) confidants, one of them, behind my back, actually called the agency to try to bump me and take that position. The photographer's representative called me and said, "Hey, we really want to work with you, but why would [the photographer] call us and tell us they heard we were looking for another photographer and offer to be that photographer?" My next opportunity to address this with my "friend" was when he came over to my photo department's photo lab,

where I was processing all his film for free (with my supervisor's permission). After loading the E-6 processor and turning on the lights in the darkroom, I asked about it. And the response I got was, "Hey, we're all going to be in competition someday, so it's fair game." It took all of my willpower not to flip the top of the processor open and ruin the film I was processing for free, but I did not. Although I did alter what I disclosed to this person from that day forward, I do continue to answer questions about how to price an assignment for this person from time to time. Yet I've never forgotten that backstabbing experience. But, I did everything I could to take the high road, and I do not regret doing so.

Do I consider that photographer my enemy? No, I do not. Dictionary.com defines an enemy as "a person who feels hatred for, fosters harmful designs against, or engages in antagonistic activities against another; an adversary or opponent." Frankly, I don't know any people toward whom expending that much energy is worthwhile. Having hateful feelings toward a person is an enormous waste of energy that can become all-consuming, and that energy can be better expended by doing something good. Sometimes, just ignoring a person who you think you might want to hate is the best solution. I am not suggesting you don't experience anger about things, but anger subsides naturally. Hate usually festers if left unresolved. And sometimes simply leading your life along a path of success is the best, most unintended form of revenge.

William Somerset Maugham was an English playwright who had one of the broadest audiences in the west. He was also, in the early part of the twentieth century, reported to be the highest-paid playwright. He once said, "The common idea that success spoils people by making them vain, egotistic, and self-complacent is erroneous; on the contrary, it makes them, for the most part, humble, tolerant and kind. Failure makes people bitter and cruel."

To that end, live up to Maugham's sentiment. I can tell you from experience that this holds true when dealing with celebrities. When working with the big, long-term, successful stars, I have found them to be agreeable and generally pleasant to work with. On the other hand, the latest flash-in-the-pan artists and actors, replete with handlers, managers, and such, are often the most difficult and egotistical, in my experience.

Reaching Out: Speaking, Interns and Apprentices, and Giving Back

There are several ways in which you can give back to the photographic community. For those considering the field, taking on interns or apprentices who are training or going to school to learn photography is a way to give back, as is simply creating an open dialogue among colleagues.

Whether to a high school, community college, or university class, taking the time to share with others your experiences can give prospective photographers an idea of what life is like as a photographer. They might have watched a Hollywood movie or a documentary about the life of a photographer, but hearing from a photographer—you—firsthand and being able to engage you with questions is invaluable. Young photographer Douglas Kirkland attended a lecture in 1964 given by *Life* magazine photographer and legend Gordon Parks. This

lecture moved Kirkland to recognize the enormous influence that photography can have and resulted in Parks becoming Kirkland's mentor and friend. In an April 2006 article by Kirkland on the website DigitalJournalist.org, Kirkland honored Parks by saying, "Gordon made me a different individual than I would have been had I never known him. He showed me that I had much greater possibilities that I realized."

One of the well-traveled paths of today's photographers has included internships or apprenticeships. I have maintained an intern program for more than a decade, with dozens of students and recent graduates spending time observing and asking questions—many for academic credit, and others for the experience and insights. Most have ended up as photographers or working in the photographic field.

Interns that you bring into your sphere of influence should not be expected just to sweep or file receipts. They should be exposed to as many facets of the realities of being a photographer as they possibly can during their time with you. Encourage them to ask questions, but set limits to these when the client is present. I advise my interns that they can ask any question they want, but that they need to be sensitive to asking questions when the client is present. Instead, I ask them to save the questions for my standard debriefing after the shoot. At that time, I encourage questions and prompt for them if there are none to begin the dialogue.

The worst thing you can do is to consider an intern as cheap labor to do only the grunt work around the office or studio. Instead, look at interns as people hungry to learn and to whom you owe an education in exchange for their assistance. Well-known photographer Gregory Heisler apprenticed under Arnold Newman in the 1970s, and the legendary Yousuf Karsh served as an apprentice first to his uncle in a photo studio in Canada. Karsh's uncle saw his promise and sent him to apprentice under photographer John Garo of Boston.

An open and respectful dialogue among colleagues can lead to inspirational experiences that can make a difference in the local community, as well as the world. Ansel Adams was first financed by a small insurance agency owner in San Francisco when Adams was 24. At 28, legendary photographer Paul Strand, on self-assignment in New Mexico, took the time to share with Adams his own negatives, which in turn convinced Adams of the potential value of photography as a form of fine art. Sharing positive and negative experiences among photographers can bring a group of photographers together, and each can grow through the encouragement and insight of the others.

Pay It Forward

I didn't write this book because I planned to become a writer. I didn't write it because I expected to be able to live off residuals. I wrote it as a vehicle to continue to be able to pay forward the knowledge that I learned, was given, or that otherwise came to me through osmosis. I did so because I made a karmic commitment to help whomever I could, and this book is one embodiment of that commitment...and certainly not the last.

CHAPTER 32

In Malcolm Gladwell's book, *The Tipping Point: How Little Things Can Make a Big Difference* (Back Bay Books, 2002), he writes about how small, sometimes, imperceptible things can make a big difference. He cites the tipping point for the shoe brand Hush Puppies as occurring sometime between the end of 1994 and the first few months of 1995. Their sales had dropped to 30,000 pairs of shoes worldwide, mostly to small towns and outlets across the country.

> At a fashion shoot, two Hush Puppies executives…ran into a stylist from New York who had told them that the classic Hush Puppies had suddenly become hip in the clubs and bars of downtown Manhattan…[then]…in 1995, the company sold 430,000 pairs of the classic Hush Puppies, and the next year it sold four times that…how did that happen? Those first few kids…were wearing them precisely because no one else would wear them…. No one was trying to make Hush Puppies a trend. Yet, somehow, that's exactly what happened. The shoes passed a certain point in popularity, and they tipped.

Gladwell goes on later to say:

> When we say that a handful of East Village kids started the Hush Puppies epidemic…what we are saying is that in a given process or system, some people matter more than others. This is not, on the face of it, a particularly radical notion. Economists often talk about the 80/20 Principle, which is the idea that in any situation roughly 80 percent of the "work" will be done by 20 percent of the participants.

Taking your success, you can turn around and help others who are climbing the ladder behind/below you and make a difference. You can be a part of that 20 percent and facilitate the tipping point. Running your business by adhering to standard business practices might seem to you a small, seemingly insignificant thing to the photo community at large, but your actions upholding reasonable standard business practices that apply across the board to every other business can make a difference. Through this, take the time to help others by both example and lesson. So, I ask of you: Take the insights you've gained from this book, and don't try to keep them a secret. Pay it forward.

Index

Numbers

401(k)s, 111

A

accountants
 bookkeepers, 156
 CPAs, 156
 IRS audits, 159-163, 165
 overview, 154-155
 tax preparation services, 155
accounting. *See also* IRS
 bank accounts, 140-141
 CODB, 128-129, 138-139
 credit cards
 categorizing expenses, 142-154
 EINs, 142
 interest expenses, 141-142
 software, 142-154
 drawing on accounts, 139-40
 efficiency, 138-139
 Excel, 131, 134, 147-154
 fraud, 130
 learning, 138-139
 longitudinal accounting, 138-139
 Payment Breakdown forms, 142-154
 QuickBooks, 127, 135-137, 147-151
 receipts
 categories, 135-138
 chart of accounts, 134-138
 clients, 128-134
 CODB, 128-129

 fees/rates, 131
 filing systems, 134-138
 IRS, 129-131
 software, 131-134
 time, 130
 vendors, 136-138
 writing checks, 135-138
 records (IRS), 129-131
 reimbursing, 139-140
 software, 127, 131, 134-137, 147-154
 Statement Breakdown forms, 142-154
active/passive tense (e-mail), 373
adapting (shoots), 20-21
ADCMW (Art Directors Club of Metropolitan Washington), 52
adding value, 468-470
additional insureds, 122-124
addresses (e-mail)
 finding, 374
 postal addresses, 372-373
adhesion contracts, 173-174, 286-287
administrative fees (slow-paying clients), 366-367
Adobe Bridge, 406
Adobe Lightroom, 406-407
adult releases, 344-345
advertising
 advertorial fees/rates, 99
 APA (Advertising Photographers of America), 52
 Payroll, 55-56
 releases, 355

 Success Teams, 477
 website, 477
 corporate/commercial contracts, 231
 fees/rates, 80, 99
Advertising Photographers of America. *See* APA
advertorial fees/rates, 99
advice (attorneys), 386, 389-391
aerial shoots, 25-26
agencies
 stock photos, 453-455
 virtual agencies, 456
airlines (cameras), 401-402
amendments
 corporate/commercial contracts, 222-223
 editorial contracts, 176-178
American Society of Media Photographers. *See* ASMP
American Society of Picture Professionals (ASPP), 52
analog, converting to digital, 410-411
anniversaries. *See* wedding contracts
APA (Advertising Photographers of America), 52
 Payroll, 55-56
 releases, 355
 Success Teams, 477
 website, 477
aperture, 408-410
appeals (IRS audits), 168-169
appearance, 270, 468
applications. *See* software

apprentices, 498-499

archives. *See also* asset
 management; backups
 captions, 406, 408-409,
 411
 converting analog to
 digital, 410-411
 DAM Book, 405-406
 keywords, 406, 408-409,
 411
 online stock photos,
 455-459
 CDs, 457
 Digital Railroad,
 455-456
 fees/rates, 457-458
 fotoQuote, 457
 IPNstock, 457-458
 licensing, 457-458
 marketing, 458
 online galleries, 457
 organizations, 456
 PhotoShelter, 455-457
 rights, 457
 virtual agencies, 456
 onsite/offsite, 400
 overview, 405
 recovering, 404
 rights, 318, 457
 software
 Adobe Bridge, 406
 Adobe Lightroom,
 406-407
 Aperture, 408-410
 browsers, 406
 Camera Bits Photo
 Mechanic, 406
 Expression Media, 407
 fotoQuote, 457
 iView MediaPro, 407
 overview, 406

**art directors (editorial
 contracts),** 179

**Art Directors Club of
 Metropolitan Washington
 (ADCMW),** 52

**ASMP (American Society of
 Media Photographers),** 52
 Paychex, 55-56
 releases, 355

**ASPP (American Society of
 Picture Professionals),** 52

assessing
 overhead, 107-109
 salary, 112-116

asset management. *See also*
 archives; backups
 captions, 406, 408-409,
 411
 DAM Book, 405-406
 keywords, 406, 408-409,
 411
 overview, 405
 software
 Adobe Bridge, 406
 Adobe Lightroom,
 406-407
 Aperture, 408-409, 410
 browsers, 406
 Camera Bits Photo
 Mechanic, 406
 Expression Media, 407
 fotoQuote, 457
 iView MediaPro, 407
 overview, 406

assistants. *See also* employees
 aerial shoots, 25-26
 fees/rates, 53-54
 lighting, 23-24
 location managers, 24
 makeup, 24
 pilots, 25-26
 producers, 25
 stylists, 24
 time, 23
 travel, 25-26

associations. *See* organizations

attachments (e-mail), 372-373,
 375

attorneys
 advice, 386, 389-391

clients (slow-paying),
 369-370

contracts
 corporate/commercial
 contracts, 234, 259
 reviewing, 384-385
 revising, 385
 writing, 385

e-mail, 372

fees/rates
 case establishment,
 388-389
 contingency, 389-390
 copy/fax, 388
 overview, 386
 retainers, 387-388
 telephone, 388

hiring, 383-384, 386

**Law Firm Portraits case
 study,** 235-250

overview, 383-384

releases, 355

retroactive licensing,
 422-423

rights infringement, 304,
 314, 316, 319, 322,
 324-326, 385, 422-423

audio
 books, 480
 camera noise, 16
 releases, 343
 video, 490

audits (IRS)
 accountants, 159-163,
 165
 appeals, 168-169
 bank statements, 166
 BMF, 163
 charity, 167
 communication,
 159-163
 EFTPS, 169
 e-mail, 166
 home, 167
 MFTRA, 163
 no change rate, 165

notification, 159-163
office, 167
overview, 159-163
preparation, 165-168
receipts, 166-168
reconstructing tax records,
 166
states, 168
statistics, 164-165
tax gap, 164-165

B

back of check amendments
 (editorial contracts),
 176-178
backup plans (shoots), 20
backups. *See also* archives;
 asset management
 cameras, 400
 communication, 393-394
 computers, 397-398
 ISPs, 393-394
 laptops, 397-398
 lighting, 401
 NAS, 400
 networks, 393-394
 onsite/offsite, 400
 overview, 393, 396-397
 recovering, 404
 redundancy drives,
 399-400
 software validators,
 402-403
 wedding contracts,
 270-271
 working drives, 398-400
banks
 accounts (accounting),
 140-141
 loans (business plans), 7
 statements (IRS audits),
 166
banner ads (rights), 420
bar mitzvahs. *See* wedding
 contracts
Bartleby website, 373

base rates, 63-67
BCCs (blind carbon copies),
 380
behind-the-scenes video, 490
Best Business Practices
 website, 306
bids (corporate/commercial
 contracts), 219-221
blimps, 16-17
blind carbon copies (BCCs),
 380
BlinkBid, 86-90, 92-93
blogs
 learning, 479-480
 rights, 420-421
BMF (Business Master File),
 163
bookkeepers, 156
books
 audio books, 480
 publishing
 charity, 493
 commissioned,
 492-493
 co-publishing, 493
 pictorial books, 493
 rights, 493
 vanity presses,
 491-492
boundaries (employees), 53
breach of contract
 case study, 359-360
 overview, 357-359
Bridge (Adobe), 406
brises. *See* wedding contracts
browsers (asset management),
 406
budgets
 corporate/commercial
 contracts, 229-230
 editorial contracts,
 179-180
building relationships,
 462-474
 adding value, 468-470
 clothing, 468

craft services, 470-471
deadlines, 471-472
e-mail, 472-473
equipment, 11
estimates, 472-473
follow-up, 472-473
food, 470-471
negotiating contracts, 278
online galleries, 463, 472
raising fees/rates, 474
voicemail, 467-468
business
 bank loans, 7
 BMF, 163
 business e-mail, 376
 business models, 4-6
 business plans, 7-8
 Business Software
 Alliance website, 303
 expenses (employees), 50
 insurance
 additional insureds,
 122-124
 business insurance,
 120-124
 cameras, 120-121
 certificates of
 insurance, 122-124
 disability, 119-120
 errors and omissions,
 124
 health, 117-118
 liability, 121-124
 life, 118
 office, 121
 overview, 117
 self-employment, 40
 taxes, 125
 umbrella policies,
 124-125
 wedding contracts,
 271
perspective, 1-3, 31
retirement plans, 111
salary

salary. *See also* fees/rates
 CODB, 112
 establishing, 112-116
 NPPA, 112
starting
 clients, 32, 41-42
 contracts, 32, 34-35, 40
 equipment, 32
 fees/rates, 31-33, 36-37, 40
 helping others, 31-33
 insurance, 40
 IT, 31
 marketing, 33
 part-time, 35-37
 planning, 37-39
 profitability, 39-40
 rights, 34-35, 39
 schedule, 33-34
 security, 33
 semi-professional, 35-37
 software, 32
 time, 33-34
 transitioning to self-
 employment, 27-31
 WMFH, 32, 38
 strategy, 3-4
 tactics, 3-4
business e-mail, 376
Business Master File (BMF),
 163
business models, 4-6
business plans, 7-8
Business Software Alliance
 website, 303
buyout. *See* rights

C

calculating fees/rates, 81-93,
 95-99
Camera Bits, 406
cameras
 backups, 400
 blimps, 16-17
 insurance, 120-121
 lenses, 12, 15

noise, 16
 optics, 12, 15
 selecting, 12
 travel, 401-402
captions
 asset management, 406,
 408-409, 411
 corporate/commercial
 contracts, 218-219
carbon copies (CCs), 380
case establishment (attorney
 fees/rates), 388-389
case studies
 breach of contract
 (textiles company),
 359-360
 corporate/commercial
 contracts
 law firm portraits,
 235-250
 national corporate
 client, 251-255
 regional corporate
 client, 256-258
 editorial contracts
 consumer magazine,
 203-215
 financial newspaper,
 196-202
 in-flight magazine,
 193-195
 portrait for university
 magazine, 184-192
 model releases, 349-351
 negotiating contracts
 (science competition),
 289-298
 rights infringement
 DMCA, 329-342
 third-party
 infringement, 323
 stock photos, 349-351
cases (equipment), 11
cataloging. *See* asset
 management
categorizing expenses (credit

cards), 142-154
catering
 building relationships,
 470-471
 corporate/commercial
 contracts, 221
CCs (carbon copies), 380
CDs
 negotiating contracts, 283
 stock photos, 457
certificates of insurance,
 122-124
change orders
 corporate/commercial
 contracts, 222-223
 editorial contracts,
 176-178
charity, 496
 book publishing, 493
 clients (slow-paying), 367
 fees/rates, 99-100
 IRS audits, 167
chart of accounts, 134-138
checks (accounting receipts),
 135-138
children
 family, 483-485
 minor releases, 344, 346
choosing. *See* selecting
christenings. *See* wedding
 contracts
circulation numbers (editorial
 contracts), 180
civil court
 case study, 359-360
 overview, 357-359
clients
 accounting receipts,
 128-134
 building relationships,
 462-474
 adding value, 468-470
 clothing, 468
 craft services, 470-471
 deadlines, 471-472

e-mail, 472-473
equipment, 11
estimates, 472-473
follow-up, 472-473
food, 470-471
online galleries, 463,
 472
raising fees/rates, 474
voicemail, 467-468
communication, 462-467
 employees, 462
 planning shoots, 21-22
contracts. *See* contracts
expectations, 463-467
finding referrals, 70-73
growth, 463-467
rejecting, 461-462
retention, 463-467
rights, 322-323, 461-462
self-employment, 32,
 41-42
slow-paying
 administrative fees,
 366-367
 attorneys, 369-370
 charity, 367
 collections services,
 367-370
 communication,
 361-365
 discounts, 366-367
 e-mail, 361
 late fees, 366-367
 overview, 361
 RMS, 367-370
 statistics, 365
 WMFH, 462, 474
clothing, 270, 468
coaching, 477
CODB (cost of doing business),
 57
 accounting, 128-129,
 138-139
 fees/rates, 57-58, 76-80
 NPPA, 76-77

overhead
 assessing, 107-109
 communication,
 108-109
 markup, 110
 overview, 107
 policies, 108-109
salary, 112
wedding contracts, 267
**COLA (cost of living
 adjustments),** 67, 76, 93-95
collateral
 fees/rates, 99
 PLUS, 424-426
collections services, 367-370
college, 475-476
color temperature shift, 10
commas (e-mail), 371-372
commercial contracts. *See*
 corporate/commercial
 contracts
**commercial use (editorial
 contracts),** 182-183
**commissioned book
 publishing,** 492-493
communication
 appearance, 270, 468
 backups, 393-394
 clients, 463-467
 employees, 462
 planning shoots, 21-22
 slow-paying, 361-365
 contracts
 communication,
 284-285
 negotiating, 277-278
 corporate/commercial
 contracts, 232
 editorial contracts,
 180-181
 e-mail. *See* e-mail
 family, 486-487
 fees/rates, 66
 IRS audits, 159-163
 learning, 478

overhead, 108-109
port forwarding, 395-396
telephone. *See* telephone
wedding contracts,
 269-270
community organizations. *See*
 organizations
comparing. *See* selecting
competitors, 95-99, 497-498
computers
 backups. *See* backups
 laptops, 15, 397-398
 Macintosh/PC
 comparison, 13-14
 monitors, 15
 productivity, 14-15
 selecting, 13-15
 software. *See* software
 speed, 14-15
**concessions (negotiating
 contracts),** 278
consistency (e-mail), 373
constitutional rights, 301-303
consultants, 44-46
consumer equipment, 9
**consumer magazine case
 study,** 203-215
consumer markets, 419
content (editorial contracts),
 174-178
**contingency fees (attorney
 fees/rates),** 389-390
**continuing relationship
 (employee status),** 48
contractors. *See also*
 employees
 business expenses, 50
 continuing relationship,
 48
 employees comparison,
 46-51
 equipment, 50
 fees/rates, 49-50
 firing, 51
 full-time, 48

hiring other contractors, 47-48
instructions, 46
integration, 47
location, 48-49
multiple employers, 51
order of services, 49
profit and loss, 50
quitting, 51
rendering services, 47
reports, 49
schedule, 48
software, 47
training, 47
travel, 50

contracts
adhesion contracts, 173-174, 286-287
attorneys
corporate/commercial, 234, 259
reviewing, 384-385
revising, 385
writing, 385
breaches
case study, 359-360
overview, 357-359
corporate/commercial
advertising, 231
amendments, 222-223
attorneys, 234, 259
bids, 219-221
budgets, 229-230
captions, 218-219
change orders, 222-223
clients, 219
communication, 232
dates, 227-229, 234-235
day fees/rates, 220
estimates, 219-221
fees/rates, 65
follow-up, 232
food, 221
Internet, 233

law firm portraits case study, 235-250
licensing, 219, 230-234
model releases, 232
national corporate client case study, 251-255
negotiating, 178, 229-233
organizations, 259
overview, 217-219
pitch campaigns, 231-232
post-production, 221
pre-production, 220
purchase orders, 224-229
quotes, 219-221
regional corporate client case study, 256-258
rights, 226-233
signatures, 219, 234, 261
stakeholders, 231
tech scouting, 221
third parties, 231, 233-234
triple bidding, 220
updating, 259-263
WMFH, 231
editorial
adhesion contracts, 173-174
amendments, 176-178
art directors, 179
back of check amendments, 176-178
budgets, 179-180
change orders, 176-178
circulation numbers, 180
commercial use, 182-183

communication, 180-181
consumer magazine case study, 203-215
content, 174-178
day fees/rates, 175
director of photography, 179
e-mail, 181
fees/rates, 174-178
financial newspaper case study, 196-202
guarantee against space, 174-175
hierarchy of roles, 179
in-flight magazine case study, 193-195
licensing, 177, 180-182
negotiating, 171-174, 176-183
objectionable terms, 172-173
overview, 171
personal use, 182-183
photo editors, 179
Playboy, 176-178
portrait for university magazine case study, 184-192
post-production, 175
pre-production, 175
reprint rights, 181
researching clients, 180
rights, 174-178, 182-183, 203
signatures, 174
software, 178
stamps, 182-183
stock photos, 180
telephone, 180-181
terms and conditions, 182
usage, 174-175

WMFH, 172, 176-177, 181

Word, 178

formatting licenses, 427

liquidated damages, 384-385

negotiating
 adhesion contracts, 286-287
 being rejected, 288-289
 building relationships, 278
 CDs, 283
 clients, 384-385, 461-462
 communication, 277-278, 284-285
 concessions, 278
 cooperation, 277
 creative solutions, 279-282
 deal breakers, 279-282, 284, 286-287
 e-mail, 283
 fees/rates, 66, 277
 follow-up, 288-289
 intimidation, 277
 learning, 277
 licensing, 273-274, 281-282, 287
 listening, 278
 makeup, 284
 multiple photographers, 284
 online galleries, 283
 over-the-transom, 276
 overview, 273-274
 planning, 287-288
 policies, 282-285
 prints, 284
 rejecting, 278-282, 284, 286-287
 retouching, 283
 rights, 34-35, 40-41, 273-274, 277, 284

rush services, 283
science competition case study, 289-298
silence, 278
speed, 283
splitting the difference, 278
strengthening position, 274-278
telephone, 276
time, 276
trust-fund photographers, 275
twelve rules, 277-278
upselling, 282-284
values, 277
WMFH, 278-279, 286
nonnegotiable, 173-174, 286-287
releases. *See* releases
self-employment, 32-35, 40
weddings
 backups, 270-271
 CODB, 267
 communication, 269-270
 dates, 269
 fees/rates, 59, 270
 insurance, 271
 liability, 270-271
 multiple photographers, 271-272
 negotiating, 269-270
 overview, 265-267
 payment, 269
 signatures, 269
 terms, 267-269
Controlled Vocabulary website, 408-409, 411
converting analog to digital, 410-411
cooperation (negotiating contracts), 277

co-publishing books, 493
copy/fax (attorney fees), 388
copyright. *See* rights
Copyright Office
 eCO, 305-306
 form VA (registering rights), 305
 date of birth, 309
 name of author, 308
 nationality, 309
 nature of authorship, 309
 nature of work, 308, 316
 overview, 306-307
 publication, 310, 317-318
 registration, 311-312
 rights, 311-313, 317-318
 signature, 313, 318
 title of work, 308, 314-316
 WMFH, 308-309
 year of completion, 310, 316
 website, 304
corporate/commercial contracts
 advertising, 231
 amendments, 222-223
 attorneys, 234, 259
 bids, 219-221
 budgets, 229-230
 captions, 218-219
 case studies
 law firm portraits, 235-250
 national corporate client, 251-255
 regional corporate client, 256-258
 change orders, 222-223
 clients, 219
 communication, 232

dates, 227-229, 234-235
day fees/rates, 220
estimates, 219-221
fees/rates, 65, 220
follow-up, 232
food, 221
Internet, 233
licensing, 219, 230-234
model releases, 232
negotiating, 178, 229-233
organizations, 259
overview, 217-219
pitch campaigns, 231-232
post-production, 221
pre-production, 220
purchase orders, 224-229
quotes, 219-221
rights, 226-233
signatures, 219, 234, 261
stakeholders, 231
tech scouting, 221
third parties, 231, 233-234
triple bidding, 220
updating, 259-263
WMFH, 231
correspondence. *See* e-mail
cost (employees), 43
cost of doing business. *See* CODB
cost of living adjustments (COLA), 67, 76, 93-95
court (small claims/civil)
case study, 359-360
overview, 357-359
CPA Directory website, 156
CPAs, 156
craft services, 470-471
creativity
fees/rates, 60-62, 66
negotiating contracts, 279-282
credit cards
categorizing expenses, 142-154

EINs, 142
interest expenses, 141-142
Payment Breakdown forms, 142-154
software, 142-154
Statement Breakdown forms, 142-154
CTO (lighting), 10
current events, 478
custom publishing (fees/rates), 99
customers. *See* clients

D

DAM Book, 405-406
data
backups. *See* backups
security
firewalls, 394
networks, 394
overview, 393
port forwarding, 395-396
date of birth (form VA), 309
dates
corporate/commercial contracts, 227-229, 234-235
date of birth (form VA), 309
deadlines, 471-472
wedding contracts, 269
day fees/rates
corporate/commercial contracts, 220
editorial contracts, 175
deadlines, 471-472
deal breakers, 279-282, 284, 286-287
deceased model releases, 353
deducting interest expenses (credit cards), 141-142
departments (employees), 44
digital, converting from analog, 410-411

Digital Millennium Copyright Act (DMCA) case study, 329-342
Digital Railroad, 455-456
director of photography (editorial contracts), 179
disability insurance, 119-120
disclaimers (e-mail), 373
discounts (slow-paying clients), 366-367
distribution (electronic licensing), 420
divorce, 481-483
DMCA (Digital Millennium Copyright Act) case study, 329-342
downloading rights, 420
drawing on accounts, 139-140
DriveSavers, 404
duration. *See* time

E

eCO (Electronic Copyright Office), 305-306
economy (fees/rates), 67
editing video, 490
editorial contracts
adhesion contracts, 173-174
amendments, 176-178
art directors, 179
back of check amendments, 176-178
budgets, 179-180
case studies
consumer magazine, 203-215
financial newspaper, 196-202
in-flight magazine, 193-195
portrait for university magazine, 184-192
change orders, 176-178
circulation numbers, 180
commercial use, 182-183

communication, 180-181
content, 174-178
day fees/rates, 175
director of photography, 179
e-mail, 181
fees/rates, 174-178
guarantee against space, 174-175
hierarchy of roles, 179
licensing, 177, 180-182
negotiating, 171-174, 176-183
objectionable terms, 172-173
overview, 171
personal use, 182-183
photo editors, 179
Playboy, 176-178
post-production, 175
pre-production, 175
reprint rights, 181
researching clients, 180
rights, 174-178, 182-183, 203
signatures, 174
software, 178
stamps, 182-183
stock photos, 180
telephone, 180-181
terms and conditions, 182
usage, 174-175
WMFH, 172, 176-177, 181
Word, 178
editorial markets, 419
education. *See* learning
efficiency (accounting), 138-139
EFTPS (Electronic Federal Tax Payment System), 169
EINs (employer identification numbers), 142
Electronic Copyright Office (eCO), 305-306
electronic distribution (rights), 420

Electronic Federal Tax Payment System (EFTPS), 169
Elements of E-Mail Style, 374
Elements of Style, 373-374
e-mail
building relationships, 472-473
contracts
editorial contracts, 181
negotiating, 283
IRS audits, 166
licensing, 420
PLUS, 420
rights, 420
slow-paying clients, 361
writing
active/passive tense, 373
attachments, 372-373, 375
attorneys, 372
BCCs, 380
business e-mail, 376
CCs, 380
commas, 371-372
consistency, 373
disclaimers, 373
Elements of E-Mail Style, 374
Elements of Style, 373-374
Europe, 371-372
faxes, 372-373
finding e-mail addresses, 374
"including", 373
interns, 372
jargon, 373
periods, 371-372
photos, 377-378
postal addresses, 372-373
punctuation, 371-372
salutations, 375-376
"shall", 371-372

signatures, 377-378
subject line, 375
summary letters, 378-379
templates, 376
thank you letters, 380-381
time, 376
tone, 375
wording, 371-375
embedding (formatting licenses), 427-439
employees
accountants
bookkeepers, 156
CPAs, 156
IRS audits, 159-163, 165
overview, 154-155
tax preparation services, 155
assistants
aerial shoots, 25-26
fees/rates, 53-54
lighting, 23-24
location managers, 24
makeup, 24
pilots, 25-26
producers, 25
stylists, 24
time, 23
travel, 25-26
attorneys. *See* attorneys
boundaries, 53
business expenses, 50
communication (clients), 462
consultants, 44-46
continuing relationship, 48
contractors comparison, 46-51
cost, 43
departments, 44
equipment, 50
fees/rates, 49-50, 53-54

firing, 51
full-time, 44, 48
hiring, 52-53
hiring other employees, 47-48
importance of, 43
instructions, 46
integration, 47
interns, 53-54, 372
IRS rules, 46-51
labor laws, 54
location, 48-49
marketing, 44-45
multiple employers, 51
order of services, 49
organizations, 52
part-time, 44
processing paychecks, 55-56
profit and loss, 50
quitting, 51
referrals, 52
rendering services, 47
reports, 49
representatives, 44-46
rights, 56
schedule, 48
temp agencies, 55
training, 47, 52
travel, 50
unions, 54
employer identification numbers (EINs), 142
end-user license agreements (EULAs), 78
equipment
blimps, 16-17
building relationships, 11
cameras
backups, 400
blimps, 16-17
insurance, 120-121
lenses, 12, 15
noise, 16
optics, 12, 15
selecting, 12
travel, 401-402
cases, 11
computers
backups. *See* backups
laptops, 15, 397-398
Macintosh/PC comparison, 13-14
monitors, 15
productivity, 14-15
selecting, 13-15
software. *See* software
speed, 14-15
consumer, 9
contractors, 50
employees, 50
generators, 16, 18
gyros, 16-17
lenses, 12, 15
lighting
assistants, 23-24
backups, 401
color temperature shift, 10
CTO, 10
selecting, 10-11
flash duration, 10-11
gyros, 16-17
renting, 17
optics, 12, 15
overview, 9
professional, 9
prosumer, 9
quality, 9
renting, 16-18
self-employment, 32
specialized, 15-16
storing, 11
errors and omissions insurance, 124
establishing salary, 112-116
estimates
building relationships, 472-473
corporate/commercial contracts, 219-221
fees/rates, valuing, 73-77, 95-99
EULAs (end-user license agreements), 78
Europe (e-mail), 371-372
Excel (accounting), 131, 134, 147-154
exclusivity (rights), 416-418
expectations (clients), 463-467
expenses. *See* fees/rates
Expression Media, 407

F

family
children, 483-485
communication, 486-487
divorce, 481-483
jealousy, 485
overview, 481-482
time, 482-484
vacations, 487
faxes (e-mail), 372-373
fees/rates
accounting (receipts), 131
administrative fees, 366-367
advertising, 80, 99
advertorial, 99
assistants, 53-54
attorneys
case establishment, 388-389
contingency, 389-390
copy/fax, 388
overview, 386
retainers, 387-388
telephone, 388
base rates, 63-67
buyout, 99
calculating, 81-93, 95-99
charity, 99-100, 367
CODB, 57-58, 76-80, 112
COLA, 67, 76, 93-95

collateral, 99

collections services, 367-370

communication, 66

contractors, 49-50

contracts. *See* contracts

corporate/commercial contracts, 65

creativity, 60-62, 66

credit cards, 142-154

custom publishing, 99

day fees/rates

 corporate/commercial contracts, 220

 editorial contracts, 175

discounts, 366-367

economy, 67

editorial contracts, 174-178

employees, 49-50, 53-54

estimates, valuing, 73-77, 95-99

free, 99-100

FTC, 95-99

IATSE, 63-64

late fees, 366-367

licensing, 78, 81-84, 88, 106

line items, 77-80

marketing, 70-73

media buys, 79-80

models, 66, 352

movies, 63-64

NPPA, 57-58, 112

odd-number pricing, 75

overhead

 assessing, 107-109

 communication, 108-109

 markup, 110

 overview, 107

 policies, 108-109

overview, 57-58, 69-73

percentages, 79-80

photojournalists, 64-65

PLUS, 415

price fixing, 95-99

pro bono, 99-100

products, 65

raising, 93-95, 474

renting equipment, 16-18

rights, 99

risk, 62-63, 75

RMS, 367-370

salary

 CODB, 112

 establishing, 112-116

 NPPA, 112

schools of thought, 76-80

self-employment, 31-33, 36-37, 40

selling/licensing comparison, 106

shipping charges, 5

software

 BlinkBid, 86-90, 92-93

 fotoQuote, 81-84, 92-93

 Hindsight InView, 91-93

 Hindsight Photo Price Guide, 83-87, 92-93

 Hindsight StockView, 91-93

 licensing, 91-93

 PLUS, 91-93

 QuickBooks, 92-93

software comparison, 78

still lifes, 65

stock photos, 457-458

studio rental, 65-66

surveying competitors, 95-99

time, 58-60, 66

unions, 63-64

uniqueness, 60

unit photographers, 63-64

usage, 77-80

video, 491

wedding contracts, 59, 270

WMFH, 100-105

files

 backups. *See* backups

 security

 firewalls, 394

 networks, 394

 overview, 393

 port forwarding, 395-396

filing systems (receipts), 134-138

financial newspaper case study, 196-202

finding

 clients (referrals), 70-73

 e-mail addresses, 374

firewalls, 394

firing employees, 51

flash duration, 10-11

flying, 401-402

 aerial shoots, 25-26

 cameras, 401-402

follow-up

 building relationships, 472-473

 corporate/commercial contracts, 232

 negotiating contracts, 288-289

food

 building relationships, 470-471

 corporate/commercial contracts, 221

form VA (registering rights), 305

 date of birth, 309

 name of author, 308

 nationality, 309

 nature of authorship, 309

 nature of work, 308, 316

 overview, 306-307

 publication, 310, 317-318

 registration, 311-312

 rights, 311-313, 317-318

 signature, 313, 318

 title of work, 308, 314-316

WMFH, 308-309

year of completion, 310, 316

formatting licenses, 414, 426-439

 contracts, 427

 embedding, 427-439

 invoices, 427

 lists, 427

 machine readable, 427, 431-433, 440-443

 model releases, 439

 natural language processing, 427, 431-433, 438, 440-443

 paragraphs, 427

 templates, 439-444

forms (model releases), 352-353

fotoQuote, 81-84, 92-93, 457

fraud (IRS), 130

FTC (fees/rates), 95-99

full-time employees, 44, 48

G

gear. *See* equipment

generators, 16, 18

geography

 employees, 48-49

 rights, 416, 418

glossary (PLUS), 414, 416, 424-426, 444

government employees (model releases), 353

graphics. *See* photos

growth (clients), 463-467

guarantee against space (editorial contracts), 174-175

gyros, 16-17

H

hardware. *See* equipment

health insurance, 117-118

helping others (self-employment), 31-33

hierarchy of roles (editorial contracts), 179

Hindsight InView

 fees/rates, 91-93

 PLUS, 444-451

Hindsight Photo Price Guide (fees/rates), 83-87, 92-93

Hindsight StockView

 fees/rates, 91-93

 PLUS, 444-451

hiring

 attorneys, 383-384, 386

 employees, 47-48, 52-53

home (IRS audits), 167

hospitals (model releases), 353

I

IATSE (International Alliance of Theater Stage Employees), 63-64

IDs (PLUS), 415

images. *See* photos

"including" (e-mail), 373

increasing fees/rates, 93-95, 474

industry, licensing, 416-418

in-flight magazine case study, 193-195

infringement (rights), 303-304

 attorneys, 304, 314, 316, 319, 322, 324-326, 385, 422-423

 clients, 322-323

 DMCA case study, 329-342

 Internet, 329-342

 legal language, 325-329

 licensing, 323-328, 422-423

 negotiating, 321-322

 Network Solutions, 330-342

 overview, 321-322

 registering, 322

 service providers, 330-342

 settlements, 325-329

 theft, 324

 third parties, 323

 time, 322

 types of infringers, 322-324

 WHOIS searches, 330-342

instructions (employees), 46

insurance

 additional insureds, 122-124

 business insurance, 120-124

 cameras, 120-121

 certificates of insurance, 122-124

 disability, 119-120

 errors and omissions, 124

 health, 117-118

 liability, 121-124

 life, 118

 office, 121

 overview, 117

 self-employment, 40

 taxes, 125

 umbrella policies, 124-125

 wedding contracts, 271

integration (employees), 47

interest expenses (credit cards), 141-142

International Alliance of Theater Stage Employees (IATSE), 63-64

international model releases, 353-354

Internet

 corporate/commercial contracts, 233

 learning, 479-480

 rights infringement, 329-342

interns, 498-499

 e-mail, 372

 employees, 53-54

intimidation (negotiating contracts), 277

InView
> fees/rates, 91-93
> PLUS, 444-451

invoices (formatting licenses), 427

IPNstock, 457-458

IRS. *See also* accounting
> accounting, 129-131
> audits
>> accountants, 159-163, 165
>> appeals, 168-169
>> bank statements, 166
>> BMF, 163
>> charity, 167
>> communication, 159-163
>> EFTPS, 169
>> e-mail, 166
>> home, 167
>> MFTRA, 163
>> no change rate, 165
>> notification, 159-163
>> office, 167
>> overview, 159-163
>> preparation, 165-168
>> receipts, 166-168
>> reconstructing tax records, 166
>> states, 168
>> statistics, 164-165
>> tax gap, 164-165
> employee rules, 46-51

ISPs (backups), 393-394

IT (self-employment), 31

iView MediaPro, 407

J-K

Jacobson Photographic Instruments website, 16

jargon (e-mail), 373

jealousy (family), 485

journals, 478-480

Kenyon Laboratories website, 16

keywords (asset management), 406, 408-409, 411

L

labor laws, 54

language (rights), 325-329, 417, 422-426

laptops, 15, 397-398

late fees (slow-paying clients), 366-367

late-paying clients. *See* slow-paying clients

law firm portraits case study, 235-250

lawyers. *See* attorneys

learning
> accounting, 138-139
> APA Success Teams, 477
> audio books, 480
> blogs, 479-480
> coaching, 477
> college, 475-476
> communication, 478
> contracts, negotiating, 277
> current events, 478
> Internet, 479-480
> magazines, 478-480
> overview, 6-7, 475-476
> priorities, 6-7
> seminars, 477-479
> software, 479

lectures, 477-479, 498-499

legal language (rights infringement), 325-329

legal matters. *See* attorneys; contracts; IRS

lenses, 12, 15

letters. *See* e-mail

liability
> insurance, 121-124
> wedding contracts, 270-271

licensing. *See also* PLUS; rights
> banner ads, 420

> blogs, 420-421
> collateral, 424-426
> consumer markets, 419
> contracts
>> corporate/commercial, 219, 230-234
>> editorial, 177, 180-182
>> formatting, 427
>> negotiating, 273-274, 281-287
> downloading, 420
> editorial markets, 419
> electronic distribution, 420
> e-mail, 420
> exclusivity, 416-418
> fees/rates, 78, 81-88, 91-93
> formatting, 414, 426-439
>> contracts, 427
>> embedding, 427-439
>> invoices, 427
>> lists, 427
>> machine readable, 427, 431-433, 440-443
>> model releases, 439
>> natural language processing, 427, 431-433, 438, 440-443
>> paragraphs, 427
>> templates, 439-444
> glossary, 424-426
> Hindsight InView/StockView, 444-451
> industry, 416-418
> language, 417, 422-426
> limitations, 421-422
> location, 416, 418
> marketing, 420, 424-426
> markets, 419
> media, 417
> model releases, 352-353, 439
> non-transferable, 421
> overview, 413

packages, 415, 435-439, 443-444

personal markets, 419

products, 417

publishing, 319

releases, 343, 348-351-353, 439

retroactive, 422-423

rights infringement, 323-328, 422-423

rights managed, 419-420

royalty free, 419-420

selling, 423-424

selling comparison, 106

software, 444-451

stock photos, 453-459

third parties, 421

time, 416-418, 422

trade markets, 419

transferable, 421

video, 81

websites, 420

WMFH, 413, 423

life insurance, 118

lighting

assistants, 23-24

backups, 401

color temperature shift, 10

CTO, 10

selecting, 10-11

flash duration, 10-11

gyros, 16-17

renting, 17

Lightroom (Adobe), 406-407

limitations (rights), 421-422

line item fees/rates, 77-80

liquidated damages, 384-385

listening (negotiating contracts), 278

lists (formatting licenses), 427

loans (business plans), 7

location

employees, 48-49

rights, 416, 418

location managers, 24

longitudinal accounting, 138-139

M

machine readable language, 427, 431-433, 440-443

Macintosh (PCs comparison), 13-14

magazines, 478-480

makeup

assistants, 24

negotiating contracts, 284

marketing

employees, 44-45

fees/rates, 70-73

PLUS, 420, 424-426

rights, 420, 424-426

self-employment, 33

stock photos, 458

markets, 419

markup (fees/rates), 110

Master File Transcript (MFTRA), 163

media buys (fees/rates), 79-80

media matrix (PLUS), 414

media rights, 417

Media Summary Code (PLUS), 414-415, 432-433, 449-451

MediaPro (iView), 407

memory cards (video), 490

MFTRA (Master File Transcript), 163

microstock (stock photos), 459

minor releases, 344, 346

models

business models, 4-6

fees/rates, 66

releases

adults, 344-345

attorneys, 355

case study, 349-351

corporate/commercial contracts, 232

deceased, 353

fees/rates, 352

formatting licenses, 439

forms, 352-353

government employees, 353

hospitals, 353

international, 353-354

licensing, 343, 349-353

minors, 344, 346

signatures, 351-352

states, 353

video, 490

witnesses, 351-352

monitors, 15

movies (fees/rates), 63-64

multiple photographers, 271-272, 284

N

name of author (form VA), 308

NAS (Network Attached Storage) backups, 400

national corporate client case study, 251-255

National Press Photographers Association. See NPPA

nationality (form VA), 309

natural language processing, 427, 431-433, 438, 440-443

nature of authorship (form VA), 309

nature of work (form VA), 308, 316

negotiating contracts

adhesion contracts, 286-287

being rejected, 288-289

building relationship, 278

CDs, 283

clients, 384-385, 461-462

communication, 277-278

concessions, 278

cooperation, 277

corporate/commercial contracts, 178, 229-233

creative solutions, 279-282

deal breakers, 279-282, 284, 286-287

editorial contracts, 171-174, 176-183

e-mail, 283

fees/rates, 66, 277

follow-up, 288-289

intimidation, 277

learning, 277

licensing, 273-274, 281-282, 287

listening, 278

makeup, 284

multiple photographers, 284

online galleries, 283

over-the-transom, 276

overview, 273-274

planning, 287, 288

policies, 282-285

prints, 284

rejecting, 278-282, 284, 286-287

retouching, 283

rights, 34-35, 40-41, 273-274, 277, 284, 321-322

rush services, 283

science competition case study, 289-298

silence, 278

speed, 283

splitting the difference, 278

strengthening position, 274-278

telephone, 276

time, 276

trust-fund photographers, 275

twelve rules, 277-278

upselling, 282-284

values, 277

wedding contracts, 269-270

WMFH, 278-279, 286

Network Attached Storage (NAS), 400

Network Solutions, 330-342

networks

backups, 393-394

port forwarding, 395-396

security, 394

no change rate (IRS audits), 165

noise (cameras), 16

nonnegotiable (adhesion) contracts, 173-174, 286-287

non-paying clients. *See* slow-paying clients

non-profits (charity), 496

book publishing, 493

clients (slow-paying), 367

fees/rates, 99-100

IRS audits, 167

non-transferable rights, 421

notification (IRS audits), 159-163

NPPA (National Press Photographers Association)

CODB, 76-77

fees/rates, 57-58

releases, 355

salary, 112

website, 58

O

objectionable terms (editorial contracts), 172-173

odd-number pricing, 75

office

insurance, 121

IRS audits, 167

online archives (stock photos), 455-459

CDs, 457

Digital Railroad, 455-456

fees/rates, 457-458

fotoQuote, 457

IPNstock, 457-458

licensing, 457-458

marketing, 458

online galleries, 457

organizations, 456

PhotoShelter, 455-457

rights, 457

virtual agencies, 456

online galleries

building relationships, 463, 472

negotiating contracts, 283

stock photos, 457

onsite/offsite backups, 400

OnTrack, 404

optics, 12, 15

organizations, 456, 496-497

ADCMW, 52

APA, 52

ASMP, 52

ASPP, 52

corporate/commercial contracts, 259

employees, 52

IATSE, 63-64

NPPA

CODB, 76-77

fees/rates, 57-58

releases, 355

salary, 112

website, 58

overhead (fees/rates)

assessing, 107-109

communication, 108-109

markup, 110

overview, 107

policies, 108-109

over-the-transom (negotiating contracts), 276

ownership rights, 304

P

packages, licensing, 415, 435-439, 443-444

Packs (PLUS), 415, 435-439, 443-444

paragraphs (formatting licenses), 427

parties. *See* wedding contracts

part-time
 employees, 44
 self-employment, 35-37

passive tense (e-mail), 373

pay. *See* fees/rates

paychecks
 amendments (editorial contracts), 176-178
 employees, 55-56

Paychex (ASMP), 55-56

payment (wedding contracts), 269

Payment Breakdown forms, 142-154

Payroll (APA), 55-56

PCs (Macintosh comparison), 13-14

percentages (fees/rates), 79-80

periodicals, 478-480

periods (e-mail), 371-372

personal markets (rights), 419

personal use (editorial contracts), 182-183

perspective (business), 1-3, 31

photo editors (editorial contracts), 179

Photo Mechanic (Camera Bits), 406

Photo Price Guide (fees/rates), 83-87, 92-93

photographers
 multiple photographers, 271-272, 284
 negotiating contracts, 284
 photo editors (editorial contracts), 179

photojournalists (fees/rates), 64-65

photojournalists (fees/rates), 64-65

photos
 archives. *See* archives
 asset management. *See* asset management
 e-mail, 377-378
 licensing. *See* licensing
 stock photos. *See* stock photos

PhotoShelter, 455-457

pictorial books (book publishing), 493

Picture Licensing Universal System. *See* PLUS

pilots, 25-26

pirating software, 78, 303

pitch campaigns (corporate/commercial contracts), 231-232

planning
 IRS audits, 165-168
 negotiating contracts, 287-288
 self-employment, 37-39
 shoots
 adapting, 20-21
 backup plans, 20
 client communication, 21-22
 overview, 19-20
 seamlesses, 20
 time, 22-23

Playboy (editorial contracts), 176-178

PLUS (Picture Licensing Universal System). *See also* licensing; rights
 banner ads, 420
 blogs, 420-421
 collateral, 424-426
 consumer licensing, 419
 downloading, 420
 editorial licensing, 419
 electronic distribution, 420
 e-mail, 420
 exclusivity, 416-418
 fees/rates, 91-93, 415
 formatting licenses, 414, 426-439
 contracts, 427
 embedding, 427-439
 invoices, 427
 lists, 427
 machine readable, 427, 431-433, 440-443
 model releases, 439
 natural language processing, 427, 431-433, 438, 440-443
 paragraphs, 427
 templates, 439-444
 glossary, 414, 416, 424-426, 444
 Hindsight InView/StockView, 444-451
 IDs, 415
 industry, 416-418
 language, 417, 422-426
 limitations, 421-422
 location, 416, 418
 marketing, 420, 424-426
 markets, 419
 media, 417
 media matrix, 414
 Media Summary Code, 414-415, 432-433, 449-451
 non-transferable licensing, 421
 overview, 414-416
 Packs, 415, 435-439, 443-444
 personal licensing, 419
 products, 417

retroactive licensing, 422-423

rights managed, 419-420

royalty free, 419-420

selling, 423-424

software, 444-451

third parties, 421

time, 416-418, 422

trade licensing, 419

transferable licensing, 421

websites, 414, 420

POD publishing, 491-492

policies

contracts, 271, 282-285

insurance

additional insureds, 122-124

business insurance, 120-124

cameras, 120-121

certificates of insurance, 122-124

disability, 119-120

errors and omissions, 124

health, 117-118

liability, 121-124

life, 118

office, 121

overview, 117

self-employment, 40

taxes, 125

umbrella policies, 124-125

wedding contracts, 271

overhead fees/rates, 108-109

port forwarding, 395-396

portrait for university magazine case study, 184-192

position of strength (negotiating contracts), 274-278

postal addresses (e-mail), 372-373

post-production

corporate/commercial contracts, 221

editorial contracts, 175

preparation. *See* planning

pre-production

corporate/commercial contracts, 220

editorial contracts, 175

pre-registration rights, 304

price fixing (fees/rates), 95-99

prices. *See* fees/rates

print-on-demand publishing, 491-492

prints (negotiating contracts), 284

priorities (learning), 6-7

pro bono work, 99-100, 496

processing employee paychecks, 55-56

producers (assistants), 25

productivity (computers), 14-15

products

fees/rates, 65

rights, 417

professional equipment, 9

professional organizations. *See* organizations

profit and loss (employees), 50

profitability (self-employment), 39-40

programs. *See* software

property releases, 344, 347

prosumer equipment, 9

publication (form VA), 310, 317-318

publishing

books

charity, 493

commissioned, 492-493

co-publishing, 493

pictorial books, 493

rights, 493

vanity presses, 491-492

custom (fees/rates), 99

licensing, 319

rights, 318-319

punctuation (e-mail), 371-372

purchase orders

(corporate/commercial contracts), 224-229

Q

Qdea website, 403

quality equipment, 9

QuickBooks

accounting, 127, 135-137, 147-151

fees/rates, 92-93

quitting (employees), 51

quotes (corporate/commercial contracts), 219-221

R

raising fees/rates, 93-95, 474

rates. *See* fees/rates

receipts

accounting

categories, 135-138

chart of accounts, 134-138

clients, 128-134

CODB, 128-129

fees/rates, 131

filing systems, 134-138

IRS, 129-131

software, 131-134

time, 130

vendors, 136-138

writing checks, 135-138

IRS audits, 166-168

Receivable Management Services (RMS), 367-370

reconstructing tax records (IRS audits), 166

records (IRS), 129-131

recovering backups, 404

redundancy. *See* backups

redundancy drives (backups), 399-400

referrals
employees, 52
finding clients, 70-73

region. *See* location

regional corporate client case study, 256-258

registering rights
eCO, 305-306
form VA, 305
date of birth, 309
name of author, 308
nationality, 309
nature of authorship, 309
nature of work, 308, 316
overview, 306-307
publication, 310, 317-318
registration, 311-312
rights, 311-313, 317-318
signature, 313, 318
title of work, 308, 314-316
WMFH, 308-309
year of completion, 310, 316
infringement, 322

registration (form VA), 311-312

reimbursing (accounting), 139-140

rejecting
being rejected (negotiating), 288-289
clients, 461-462
contracts, 278-282, 284, 286-287

relationships
building
adding value, 468-470

clients, 462-474
clothing, 468
craft services, 470-471
deadlines, 471-472
e-mail, 472-473
equipment, 11
estimates, 472-473
follow-up, 472-473
food, 470-471
negotiating contracts, 278
online galleries, 463, 472
raising fees/rates, 474
voicemail, 467-468
family
children, 483-485
communication, 486-487
divorce, 481-483
jealousy, 485
overview, 481-482
time, 482-484
vacations, 487

releasees (releases), 343

releases. *See also* contracts
APA, 355
ASMP, 355
attorneys, 355
audio, 343
licensing, 343, 348-351
model releases
adults, 344-345
attorneys, 355
case study, 349-351
corporate/commercial contracts, 232
deceased, 353
fees/rates, 352
formatting licenses, 439
forms, 352-353
government employees, 353
hospitals, 353

international, 353-354
licensing, 343, 349-353
minors, 344, 346
signatures, 351-352
states, 353
video, 490
witnesses, 351-352
NPPA, 355
overview, 343
property, 344, 347
releasees, 343
releasors, 343
resources, 355
trademark, 348-349
types, 344-349
verbal, 343
video, 343

releasors (releases), 343

rendering services (employees), 47

renting equipment, 16-18

reports (employees), 49

representatives (employees), 44-46

reprints (editorial contracts), 181

researching clients (editorial contracts), 180

resigning employees, 51

resources (releases), 355

retainers (attorney fees/rates), 387-388

retention (clients), 463-467

retirement plans, 111

retouching (negotiating contracts), 283

retroactive licensing, 422-423

reunions. *See* wedding contracts

reviewing contracts (attorneys), 384-385

rights. *See also* licensing; PLUS
archives, 318
banner ads, 420
blogs, 420-421

book publishing, 493

clients, 461-462

collateral, 424-426

Constitution, 301-303

consumer markets, 419

contracts
 corporate/commercial
 contracts, 226-233
 editorial contracts,
 174-178, 181-183,
 203
 negotiating, 34-35,
 40-41, 273-274, 277,
 284
 reprints, 181

downloading, 420

eCO (registering), 305-306

editorial markets, 419

electronic distribution,
 420

e-mail, 420

employees, 56

exclusivity, 416-418

fees/rates, 99

form VA (registering), 305,
 311-313, 317-318
 date of birth, 309
 name of author, 308
 nationality, 309
 nature of authorship,
 309
 nature of work, 308,
 316
 overview, 306-307
 publication, 310,
 317-318
 registration, 311-312
 rights, 311-313,
 317-318
 signature, 313, 318
 title of work, 308,
 314-316
 WMFH, 308-309
 year of completion,
 310, 316

glossary, 424-426

industry, 416-418

infringement, 303-304
 attorneys, 304, 314,
 316, 319, 322,
 324-326, 385,
 422-423
 clients, 322-323
 DMCA case study,
 329-342
 Internet, 329-342
 legal language,
 325-329
 licensing, 323-328,
 422-423
 negotiating, 321-322
 Network Solutions,
 330-342
 overview, 321-322
 registering, 322
 service providers,
 330-342
 settlements, 325-329
 theft, 324
 third parties, 323
 time, 322
 types of infringers,
 322-324
 WHOIS searches,
 330-342

language, 417, 422-426

limitations, 421-422

location, 416, 418

marketing, 420, 424-426

markets, 419

media, 417

non-transferable, 421

overview, 301, 304

owernership, 304

personal markets, 419

pre-registration, 304

products, 417

publishing, 318-319

reprints, 181

retroactive licensing
 (attorneys), 422-423

rights managed, 419-420

royalty free, 419-420

self-employment, 34-35,
 39

selling, 423-424

third parties, 421

time, 416-418, 422

trade markets, 419

transferable, 421

video, 491

websites, 420

WMFH, 100-105, 413, 423

rights managed, 419-420

risk (fees/rates), 62-63, 75

rites of passage. *See* wedding
 contracts

**RMS (Receivable
 Management Services),**
 367-370

roles (editorial contracts), 179

royalty-free rights, 419-420

**rush services (negotiating
 contracts),** 283

S

salary. *See also* fees/rates
 CODB, 112
 establishing, 112-116
 NPPA, 112

salutations (e-mail), 375-376

schedule
 employees, 48
 self-employment, 33-34

schools of thought (fees/rates),
 76-80

**science competition case
 study,** 289-298

searching (WHOIS searches),
 330-342

security
 firewalls, 394
 networks, 394
 overview, 393

port forwarding, 395-396

self-employment, 33

selecting

cameras, 12

computers, 13-15

lenses, 12, 15

lighting equipment, 10-11

optics, 12

self-employment. *See* business

self-publishing, 491-492

selling

licensing comparison, 106

rights, 423-424

seminars/speaking engagements, 477-479, 498-499

semi-professional self-employment, 35-37

service providers (rights infringement), 330-342

services

order, 49

rendering, 47

setting fees/rates. *See* fees/rates

settlements (rights infringement), 325-329

"shall" (e-mail), 371-372

shipping charges, 5

shoots

adapting, 20-21

aerial, 25-26

backup plans, 20

client communication, 21-22

overview, 19-20

seamlesses, 20

time, 22-23

signatures

corporate/commercial contracts, 219, 234, 261

editorial contracts, 174

e-mail, 377-378

form VA, 313, 318

model releases, 351-352

wedding contracts, 269

silence (negotiating contracts), 278

slow-paying clients

administrative fees, 366-367

attorneys, 369-370

charity, 367

collections services, 367-370

communication, 361-365

discounts, 366-367

e-mail, 361

late fees, 366-367

overview, 361

RMS, 367-370

statistics, 365

Small Business Administration website, 7

small claims/civil court

case study, 359-360

overview, 357-359

software

accounting, 127, 131-137, 147-154

archives/asset management

Adobe Bridge, 406

Adobe Lightroom, 406-407

Aperture, 408-410

browsers, 406

Camera Bits Photo Mechanic, 406

Expression Media, 407

fotoQuote, 457

iView MediaPro, 407

overview, 406

backup validators, 402-403

contractors, 47

credit cards, 142-154

DriveSavers, 404

editorial contracts, 178

fees/rates

BlinkBid, 86-93

fotoQuote, 81-84, 92-93

Hindsight InView, 91-93

Hindsight Photo Price Guide, 83-87, 92-93

Hindsight StockView, 91-93

licensing, 91-93

PLUS, 91-93

QuickBooks, 92-93

fees/rates comparison, 78

learning, 479

licensing, 444-451

OnTrack, 404

pirating, 78, 303

self-employment, 32

Synchonize! Pro X, 402-403

Word, 178

sound. *See* audio

Sound Blimp website, 16

space rate (editorial contracts), 174-175

speaking engagements/seminars, 477-479, 498-499

specialists. *See* employees

specialized equipment, 15-16

speed

computers, 14-15

negotiating contracts, 283

splitting the difference (negotiating contracts), 278

spouses. *See* family

staff. *See* employees

stakeholders (corporate/commercial contracts), 231

stamps (editorial contracts), 182-183

starting business

clients, 32, 41-42

contracts, 32-35, 40

equipment, 32

fees/rates, 31-33, 36-37, 40
helping others, 31-33
insurance, 40
IT, 31
marketing, 33
part-time, 35-37
planning, 37-39
profitability, 39-40
rights, 34-35, 39
schedule, 33-34
security, 33
semi-professional, 35-37
software, 32
time, 33-34
transitioning to self-
 employment, 27-31
WMFH, 32, 38
Statement Breakdown forms,
142-154
states
IRS audits, 168
model releases, 353
statistics
clients, slow-paying, 365
IRS audits, 164-165
still lifes (fees/rates), 65
stock photos
agencies, 453-455
case study, 349-351
editorial contracts, 180
licensing, 453-459
microstock, 459
online archives, 455-459
 CDs, 457
 Digital Railroad,
 455-456
 fees/rates, 457-458
 fotoQuote, 457
 IPNstock, 457-458
 licensing, 457-458
 marketing, 458
 online galleries, 457
 organizations, 456
 PhotoShelter, 455-457

rights, 457
virtual agencies, 456
overview, 453
StockView
fees/rates, 91-93
PLUS, 444-451
storing equipment, 11
strategy (business), 3-4
**strengthening position
(negotiating contracts),**
274-278
studio rental fees/rates, 65-66
stylists, 24
subject line (e-mail), 375
Success Teams (APA), 477
summary letters (e-mail),
378-379
**surveying competitors
(fees/rates),** 95-99
Synchronize! Pro X, 402-403

T

tactics (business), 3-4
tax gap (IRS audits), 164-165
tax preparation services, 155
taxes. *See also* accouning; IRS
insurance, 125
tax gap (IRS audits),
 164-165
tax preparation services,
 155
tech scouting, 221
telephone
attorney fees/rates, 388
contracts
 editorial contracts,
 180-181
 negotiating, 276
follow-up, 472-473
voicemail, 467-468
temp agencies, 55
temperature (color shift), 10
templates
e-mail, 376

formatting licenses,
 439-444
terms and conditions
editorial contracts, 182
wedding contracts,
 267-269
**Textiles Company breach of
contract case study,** 359-360
thank you letters (e-mail),
380-381
theft (rights infringement), 324
third parties
corporate/commercial
 contracts, 231, 233-234
rights, 323, 421
time
accounting (receipts), 130
assistants, 23
contracts, negotiating, 276
e-mail, 376
family, 482-484
fees/rates, 58-60, 66
licensing, 416-418, 422
planning shoots, 22-23
PLUS, 416-418, 422
rights, 322, 416-418, 422
self-employment, 33-34
slow-paying clients. *See*
 slow-paying clients
title of work (form VA), 308,
314-316
tone (e-mail), 375
trade associations. *See*
organizations
trade markets, 419
trademark releases, 348-349
training employees, 47, 52
transferable rights, 421
**transitioning to self-
employment,** 27-31
clients, 32, 41-42
contracts, 32, 34-35, 40
equipment, 32
fees/rates, 31-33, 36-37, 40
helping others, 31-33

insurance, 40
IT, 31
marketing, 33
part-time, 35-37
planning, 37-39
profitability, 39-40
rights, 34-35, 39
schedule, 33-34
security, 33
semi-professional, 35-37
software, 32
time, 33-34
WMFH, 32, 38
travel
 assistants, 25-26
 cameras, 401-402
 contractors, 50
 employees, 50
triple bidding
 (corporate/commercial
 contracts), 220
trust-fund photographers
 (negotiating contracts), 275
twelve rules of negotiating,
 277-278

U

umbrella insurance policies,
 124-125
unions
 employees, 54
 fees/rates, 63-64
uniqueness (fees/rates), 60
unit photographers
 (fees/rates), 63-64
updating
 corporate/commercial
 contracts, 259-263
upselling (negotiating
 contracts), 282-284
usage
 editorial contracts,
 174-175
 fees/rates, 77-80

V

VA form, 305
 date of birth, 309
 name of author, 308
 nationality, 309
 nature of authorship, 309
 nature of work, 308, 316
 overview, 306-307
 publication, 310, 317-318
 registration, 311-312
 rights, 311-313, 317-318
 signature, 313, 318
 title of work, 308, 314-316
 WMFH, 308-309
 year of completion, 310,
 316
vacations, 487
validators (backups), 402-403
value-added services, 468-470
values (negotiating contracts),
 277
valuing fees/rates, 73-77,
 95-99
vanity presses, 491-492
vendors (receipts), 136-138
verbal releases, 343
video
 audio, 490
 behind-the-scenes, 490
 editing, 490
 fees/rates, 491
 licensing, 81
 memory cards, 490
 model releases, 490
 releases, 343
 overview, 489
 rights, 491
virtual agencies, 456
voicemail, 467-468

W-Z

wages. See fees/rates
websites
 APA, 477

Bartleby, 373
Best Business Practices,
 306
Business Software
 Alliance, 303
Camera Bits, 406
Controlled Vocabulary,
 408-409, 411
Copyright Office, 304
CPA Directory, 156
EFTPS, 169
IPNstock, 457
Jacobson Photographic
 Instruments, 16
Kenyon Laboratories, 16
licensing, 420
Network Solutions, 330
NPPA, 58
PhotoShelter, 456
PLUS, 414, 420
Qdea, 403
rights, 420
RMS, 370
Small Business
 Administration, 7
Sound Blimp, 16
wedding contracts
 backups, 270-271
 CODB, 267
 communication, 269-270
 dates, 269
 fees/rates, 59, 270
 insurance, 271
 liability, 270-271
 multiple photographers,
 271-272
 negotiating, 269-270
 overview, 265-267
 payment, 269
 signatures, 269
 terms, 267-269
WHOIS searches (rights
 infringement), 330-342
witnesses (model releases),
 351-352

WMFH (work made for hire).
See also rights
 clients, 462, 474
 contracts, 278-279, 286
 corporate/commercial
 contracts, 231
 editorial contracts, 172,
 176-177, 181
 fees/rates, 100-105
 form VA, 308-309
 licensing, 413, 423
 rights, 100-105, 413, 423
 self-employment, 32, 38
Word (editorial contracts),
 178
wording (e-mail), 371-375
work made for hire. *See*
 WMFH
workers. *See* employees
workflow, 399
working drives, 398-400
writing
 checks (accounting
 receipts), 135-138

contracts (attorneys), 385
e-mail
 active/passive tense,
 373
 attachments, 372-373,
 375
 attorneys, 372
 BCCs, 380
 business e-mail, 376
 CCs, 380
 commas, 371-372
 consistency, 373
 disclaimers, 373
 Elements of E-Mail
 Style, 374
 Elements of Style,
 373-374
 Europe, 371-372
 faxes, 372-373
 finding e-mail
 addresses, 374
 "including", 373
 interns, 372
 jargon, 373

periods, 371-372
photos, 377-378
postal addresses,
 372-373
punctuation, 371-372
salutations, 375-376
"shall", 371-372
signatures, 377-378
subject line, 375
summary letters,
 378-379
templates, 376
thank you letters,
 380-381
time, 376
tone, 375
wording, 371-375
year of completion (form VA),
 310, 316